VANESSA PLACE

# 1: Statement of Facts

*Statement of Facts* is a book about limits and boundaries: physical, psychological, legal, literary, and conceptual. It is about speech and its transcription, and the strange distortions of language that have evolved to serve the legal system. It is about actions that leave a mark on the body and the soul. Most readers will find themselves disoriented and longing to escape from the scarred flesh of this text, but it is a journey worth taking because it reveals just how frail the fabric of justice is.

—Ken Gonzales-Day

By repurposing legal prosecution and defense documents of violent sexual crimes verbatim, *Statement of Facts* takes on issues too messy to benefit from further elucidation which only grow more disturbing presented in their purest case material form. For some, what *Statement of Facts* brings into the public square is salacious, but Place is in effect saying: 'I move the ball out of this arena and take it into this arena' in order to pump up the socio political volume on this legal/moral battlefield. Her definition of injustice is sweeping. *Statement of Facts* does not care what the reader thinks about content and in essence, Place's relationship to content is like Oprah Winfrey's to money. It is straightforward, and you are free to project onto it whatever you need to. However you respond to this fierce book, it is indisputable that *Statement of Facts* has carved out a place for itself as a touchstone of poetic push back. As Pasadena Superior Court Judge Gilbert Alston famously quipped in his dismissal of a 1986 rape case because the victim was a prostitute: 'A whore is a whore is a whore'—*Statement of Facts* counters by unflinchingly reminding us 'a rape is a rape is a rape.'

—Kim Rosenfield

*Statement of Facts* is poet/lawyer Vanessa Place's masterful demonstration of day-for-night writing. Alternately nauseating, cold, gripping, philosophical, and relentless, this volume is an analytical portrait of a writer writing in double-time, simultaneously producing legal language caught in the trap of trying (and failing) to secure the self-evident meanings of the factual; and poetic language procedurally measuring the way facts are fundamentally also instruments of violence, building toward the legitimation of a legal edifice from which no one can escape. These descriptions of heinous sex crimes, detached from their original function as depositions, are a treatise on contingency; a discourse on the moral lenses of narrative; and an institutional critique of the aesthetics and ethics of juridical administration.

—Simon Leung

Vanessa Place is a lawyer and, like Bartelby, much of her work involves scribing appellate briefs, that task of copying and editing, rendering complex lives and dirty deeds into "neutral" language to be presented before a court. That is her day job. Her poetry is an appropriation of the documents she writes during her day job, flipping her briefs after hours into literature. And like most literature, they're chock full of high drama, pathos, horror and humanity. But unlike most literature, she hasn't written a word of it. Or has she? Here's where it gets interesting. She both has written them and, at the same time, she's wholly appropriated them— rescuing them from the dreary world of court filings and bureaucracy—and, by mere reframing, turns them into what is arguably the most challenging, complex and controversial literature being written today.

—Kenneth Goldsmith

VANESSA PLACE

# Tragodía
## 1: Statement of Facts

Blanc
Press
Los Angeles, California

TRAGODÍA 1: STATEMENT OF FACTS
Blanc Press June, 2010
Los Angeles, California
© 2010 Vanessa Place
ISBN 13: 978-1-934254-25-7

Some portions of Statements of Facts appear in modified versions in *Exposé des faits* (France: éditions è®e); *An Anthology of Conceptual Writing* (Craig Dworkin and Kenneth Goldsmith, eds., Northwestern University Press); *Tina n°5* (France: éditions è®e); *mark(s)*; as the chapbook *Statement of Facts* (Norway: Audiatur); and as part of UBU Web's *Publishing the Unpublishable* series (#42).

Vanessa Place would like to thank Kenneth Goldsmith, Marjorie Perloff, Robert Fitterman, Kim Rosenfield, Teresa Carmody and Mathew Timmons.

# Blanc Press Los Angeles
*Freedom of the press is limited to those who own one.*
*When the rim is bent it will press against the works and*
*impede the proper action of the currents.*
blancpress.com

# TABLE OF CONTENTS

## STATEMENT OF FACTS

Prosecution Case

On October 21, 2007, Ben was 13 years old, living with his family in Los Angeles. At 4:00 that Sunday morning, Ben was sitting alone on his front porch, reading his Bible. Appellant was walking down the street; he stopped at the gate and asked Ben about smoking. Ben understood this to mean marijuana, and the two walked to an alley three blocks away, talking and smoking. (RT 2:1831-1836, 2:1849-1850, 2:1871)

In the alley, they continued smoking. Ben felt his pants coming down; he tried unsuccessfully to pull them up. Appellant was behind Ben. (RT 2:1836-1837, 2:1851) Ben felt appellant's penis penetrate his bottom, and remain there for five minutes. Appellant never asked Ben if he wanted to have sex. Ben had sex with appellant "out of curiosity." After Ben saw appellant ejaculate, Ben returned home. (RT 2:1838-1840, 2:1851-1852, 2:1869) Ben's mother Madison was on the porch;[1] she asked Ben where he had been, and he eventually told her. She became upset, he embarrassed. Ben wrote a statement about what happened, saying he had been forced, which wasn't true.[2] Ben wanted to have sex with appellant, but didn't want his mother to know that. Madison called the police. (RT 2:1840-1842, 2:1852-1853, 2:1866-1867, 2:1871, 2:1875)

Ben told the police the same story he told Madison, adding that appellant had initially asked him for help, and that appellant offered Ben weed, but that Ben did not smoke. Ben said he screamed as appellant pulled down his pants, and appellant ran away when a lady came outside and asked what was going on, then returned after the lady left.[3] The police took Ben to the hospital, where he was examined and a sexual assault kit collected. Ben told the examining nurse the same story he'd told the others. He was then interviewed by a detective at the police station, and identified appellant from a photo lineup. Ben initially lied during that interview, telling the truth only after the detective said he had some problems with Ben's story. Ben did not care about the consequences of his lies to appellant. When

---

1 Madison testified she woke up to use the bathroom and discovered Ben wasn't home. She called family members, then waited on the porch. She saw Ben walking up the street, a little out of breath. Madison questioned Ben; he told her that he would prefer to write down what had happened instead of telling her. (RT 2:1871-1874)

2 Ben said appellant pushed him against the wall, held his arms and raped him. (RT 2:1852)

3 The detective's investigation produced no other witnesses. (RT 2:1888)

VANESSA PLACE

Ben later discussed the case with the detective and the prosecutor, he told them a story similar to his first story, saying he had initially consented, then withdrawn his consent and been forced. Madison was not present during any of the police or hospital interviews. (RT 2:1842-1849, 2:1853-1865, 2:1867-1869, 2:1881-1882, 2:1885-1888, 2:1890, 3:2131) Ben knew it was a sin to lie and to bear false witness. At the time of trial, Ben's mother still thought he had been forcibly assaulted. (RT 2:1849, 2:1865-1866)

The detective arrested appellant the day after Ben's identification; appellant was subsequently examined at a different hospital, and biological samples collected. (RT 2:1883-1884, 2:1890) The registered nurse who examined Ben found no injuries. Anal and oral swabs were taken, as well as genital swabs, and these items were given to the police. Ben's physical examination was consistent with the history provided. It was also consistent with not engaging in anal sex. (RT 3:2102-2112) A Los Angeles Police Department serologist screened the rape kit, creating slides from the biological samples. (RT 2:2121-2125) The rectal and anal samples revealed sperm and skin cells: 20 sperm cells in the rectal sample, 45 in the anal sample. The samples were then sent for DNA analysis. (RT 3:2125-2130)

LAPD criminalist Susan Rinehart performed this analysis, creating a genetic profile from the forensic samples, then comparing that profile to the profiles in the reference samples. In DNA analysis, an examiner looks for short tandem repeats (STRs), or repeating gene sequences, testing thirteen genetic locations, and testing for gender. (RT 3:2139-2143, 3:2166, 3:2176) The first kit Rinehart analyzed contained Ben's rectal and anal samples, and his blood reference sample. The second contained appellant's reference sample. (RT 3:2145-2147, 3:2157-2158) Rinehart extracted the DNA from the samples, separating the sperm from the skin cells, quantified the DNA, and amplified the DNA for profiling by the genetic analyzer, which generates the peak heights that create the genetic profile. Rinehart prepared a report based on this analysis. Rinehart was not surprised at the low sperm counts in the samples, as a number of factors could reduce a count, such as lapsed time or condom use. She was not aware no condom was used in this case. (RT 3:2148-2156, 3:2158-2159, 3:2167-2169, 3:2175-2177)

The LAPD laboratory protocol recommends at least 1.0 nanograms of DNA for optimal amplification. Rinehart amplified .36 ng; smaller amounts of DNA have been successfully amplified. (RT 3:2172, 3:2214-2215, 3:2225-2227) There are also recommended minimum peak heights, though there

is no industry standard. The LAPD uses a 100 RFU (relative florescent unit) threshold; the FBI uses a 50 RFU analytical threshold, and a 200 RFU threshold to declare a match. The manufacturer of the analyzer used by Rinehart recommends a 150 RFU threshold. Reinhardt counted alleles at four locations that were below 200 RFUs, but above 100. (RT 3:2177-2183, 3:2188-2191, 3:2198, 3:2216-2217) At one location, locus D3S1358, there were 3 alleles attributed to one profile. Some people are triallelic. (RT 3:2184-2185, 3:2222) At two other locations, a non-matching allele was determined to be a "spike." (RT 3:2193, 3:219)

According to Rinehart's report, there was more than one person's DNA in the anal and rectal samples. She compared the mixture profile from the rectal sperm sample and found a minor profile consistent with Ben's; the major profile matched appellant's at 12 of the 13 locations. At one location, TPOX, a major type could not be distinguished from a minor type, as all had similar intensities. (RT 3:2153-2162, 3:2189, 3:2214) The epithelial fraction of the anal sample contained one location where the peak height was 274, over the manufacturer's and LAPD thresholds. Rinehart called it a spike. Spikes may be caused by such things as electronic fluctuations in the power source or crystals from the chemical solution. In her analysis, Rinehart deemed spikes peaks with 146 RFU and 270 RFU. The latter spike did not match appellant's DNA. Many factors go into determining whether a peak is a spike, including its shape and color distribution. (RT 3:2198-2202, 3:2218-2221, 3:2224, 3:2228)

Using FBI software, Rinehart computed the statistical likelihood of a random match from the rectal sample "B" if people were being drawn randomly one at a time in the general population — at 1 in 1 quintillion. A quintillion has 18 zeros after the one. There are six and a half billion people on earth. From the anal sample, Rinehart calculated a random match statistic of 1 in 10 quintillion. Rinehart was familiar with an Arizona study in which 122 people out of 65,000 matched at 9 loci, 20 people matched at 10 loci, and 1 person matched at 11 loci. Using FBI software, there is a 1 in 1 billion chance of having a match at 10 loci. Rinehart's results in this case were reviewed by a technical reviewer, who reanalyzed the electronic data and reviewed her written report. (RT 3:2162-2166, 3:2203-2213, 2:2221-2225)

Defense Case

No affirmative defense was presented.

## STATEMENT OF FACTS

### Prosecution Case

Appellant is Ava's uncle, known as "Chavelo"; at the time of trial, Ava was nine years old. The summer Ava was eight, she and her four sisters frequently visited their aunt and uncle, who lived down the street, spending the night two or three times a week.[1] Another man lived there at the time, Andreas from Columbia. (RT 1256-1262, 1277, 1317, 2183-2185, 2190-2191, 2216)

Appellant started touching Ava that summer, sometime after school ended for the year. (RT 1303) Appellant touched Ava's "private" (genitals) on more than one occasion, both over and underneath her clothes. (RT 1272, 1274, 1278, 1303) He touched her in the bedroom, and on the living room couch. The first time he touched her may have been in August. One Sunday morning, after spending the night at her uncle's house, Ava and her sisters were in the living room, watching TV when appellant called Ava into his bedroom. He told her to lie down next to him, and touched her private underneath her clothes. She took a bath,[2] appellant called her back to bed, told her not to tell her doctor, mom, dad, aunt, or teacher, then he and her aunt took the girls to McDonald's. (RT 1271-1278, 1320-1322, 1324, 1327)

One Monday in September, appellant was lying on the couch; Ava was sitting next to his feet with her sister. Appellant called Ava to him, put a red blanket over her lap, and touched her privates over her clothes. Ava's mother telephoned, and the girls had to go home; they had not spent the night. (RT 1279-1282, 1328-1333) During another visit, also in August, Ava and her sister Sonia were sitting on the big living room couch watching TV while their sister Viol did her homework on the little living room couch, and their aunt cooked in the kitchen. Ava's aunt called Sonia to her, leaving Ava alone on the couch. Appellant went to the bathroom, then the bedroom, then stood by the curtain that served as his bedroom door and gestured for Ava to come. Ava didn't want to go because she knew appellant was going to "touch me in my private with his," as he had done before. (RT 1284-1288,

---

1 Appellant and his wife babysat the girls before that summer as well. (RT 2215)

2 On cross-examination, Ava testified she took a shower before watching television with her sisters; after touching her, appellant told Ava not to tell her doctor, teacher, mom, dad, sisters, or police, then he took a bath. (RT 1322-1325, 1327)

1334-1335, 2187) She shook her head no, and stayed on the couch, watching TV. Appellant picked her up, looked towards the kitchen, and carried Ava to the bedroom, cradling her like a baby. (RT 1289-1292, 1335, 1337)

Appellant put Ava on the bed, then put his private on her private; Ava felt a little drop of "grease" on her private, and appellant "peed" on the bed. Appellant told Ava her aunt would make him wash the "clothes," and left for the bathroom. After appellant returned, Ava's aunt walked in, spoke with appellant, and Ava went back to the living room couch, where she stayed until her mother phoned for the girls to go home. (RT 1292-1296, 1336, 1338)

On another occasion, Ava tried to keep appellant from pulling down her underwear by squeezing her legs together tight; appellant took down her underwear, she pulled them back up, and he pulled them back down. Appellant touched her private, and told her not to tell anyone, again specifying the doctor, teacher, her mother or father, sisters or aunt. Appellant said if Ava told, he would go to jail. At first this made Ava sad, because she did not want appellant to go away, but then she became angry because she did not want the abuse to happen, and then was happy at the thought of appellant in jail. (RT 1300-1302, 1338-1339, 1346)

Once, Ava's mother noticed Ava's underwear was wet and smelled of semen. She asked Ava about it, but Ava said she didn't know how it got there, and walked away. So her mother put Ava's underwear in the wash and told herself not to think about "this evil of what's happening." (RT 1305-1306, 2211, 2226) Ava's mother did not ask appellant's wife about the underwear. (RT 2212-2213)

The last time appellant touched Ava was at her house. (RT 1303) Ava's private hurt when appellant touched her: it felt like "poking." It also hurt later when she went to the bathroom. (RT 1302) Ava went to the doctor because her private was bothering her, "like, when you put alcohol on your cut, but kind of worse than that."[3] Ava's mother saw blisters "like blisters that you get when you get on the monkey bars." The blisters itched. The doctor asked Ava what happened, but Ava didn't want to say. The doctor gave Ava pills to take every day for a month, and the blisters went away. They returned; Ava had to take the medicine again. The blisters again went away, and again

---

3 Ava complained to her mother about pain during urination; her mother gave her medicinal tea for three days. When the pain didn't abate, her mother checked her vagina, saw a blister, and took Ava to the doctor. (RT 2196-2197, 2218-2221) Ava had never had blisters on her vagina before. (RT 2199)

returned. Ava went back to the doctor, and saw Dr. Kaufman. (RT 1306-1309, 1311-1313, 1318, 2197)

Ava still didn't want to tell about appellant, but after Dr. Kaufman told Ava's mother that Ava had not been bad, her mother said not to be scared, just say what happened. (RT 1314) Ava was frightened, afraid her mother would get angry with her for not telling sooner. (RT 1267-1268, 1271, 1320, 1345) But Dr. Kaufman and her mother "were begging" Ava to talk, so she began answering the doctor's questions. (RT 1268-1270, 1319, 2198)

According to Dr. Kaufman, Ava came in on September 29, 2000, complaining of pain on urination and constipation. (RT 1803-1804) She had itching in her vagina, no family history of herpes,[4] and no history of oral herpes. Multiple red-based lesions were discovered on Ava's vaginal wall, before the hymen. Cultures from the lesions tested positive for Herpes Simplex Type II. (RT 1804-1807, 1830-1831) During a follow-up examination on October 6th, Dr. Kaufman told Ava and her mother that Ava had a sexually transmitted disease; both began to cry. The doctor asked Ava if anyone had touched her. She did not want to answer,[5] so the question was repeated "a few times," as Dr. Kaufman tried to impress upon Ava how "important it was to find out" in order to protect her health "and the health of other children" as "other children were in danger besides her." (RT 1296, 1808-1810, 1812-1815, 2201) As the doctor continued to "encourag[e] her" to speak, Ava and her mother became distraught, her mother urging her daughter to speak, and then Ava "blurted out" that her uncle had touched her.[6] This prompted Ava's mother to cry harder, and rock against the wall, holding her chest. (RT 1811-1812, 1815, 1827-1828, 1831-1833, 1836-1838, 1852, 1854, 2200-2201) Ava said her uncle touched her with his fingers, indicating her groin, and that the last episode had been four days earlier; she did not say she'd been touched with any other body part. (RT 1851, 1853-1855) The doctor filled out a child abuse report for police; the police were contacted, and arrived approximately 45 minutes to an hour later. (RT 1825-1827, 1841, 1850-1851) [7]

---

4 Ava's mother and father do not have herpes, nor do the other children. (RT 2199)

5 Ava didn't tell her mother because she didn't want her mother to get angry and spank her. (RT 1270, 1319, 1344-1345)

6 She first said something in Spanish, including the word "Tio," then answered in English, saying her uncle touched her. (RT 1835-1836)

7 Ava, her mother, and two of her sisters were left alone in the exam room to wait for police. (RT 1844)

During the interview, Ava said the first incident with appellant occurred during the first week of vacation after the second grade, which would have been the end of June, 2000. Ava told police she was sitting on the couch when appellant put his hand in her pants and his finger against her private part; she said it felt "like hammers." (RT 2119-2120, 2147) Ava said appellant touched her approximately ten more times on the couch that summer, about every time she visited. Once, appellant touched her vagina with his penis; during late July or early August, he put his private part "in a little way" until she felt "like stuff inside of mine, like water." They were in the kitchen at the time. (RT 2120B2124, 2142, 2148, 2154) Another time appellant approached Ava from behind while she stood in the living room; he put his hand in her pants and rubbed her genitals. Another time, appellant came up behind Ava as she stood near her sister at the kitchen table and ran his hand over her genitals, over the clothes. Ava's mother was sleeping in a nearby bedroom. (RT 2124, 2150-2151) Another time, Ava thought she was bleeding after appellant touched her genitals; she checked herself in the bathroom, but there was no blood. (RT 2124, 2151) Another time, appellant "made bathroom" on the bedroom sheets as he touched her. (RT 2125, 2151)

Ava told police that she told Dr. Kaufman because he said "you don't want this to happen to your sister." She hadn't said anything before because she was afraid no one would believe her, and she would be spanked. (RT 2126, 2151-2153, 2177) After Ava told her mother and Dr. Kaufman what had happened, Ava's mother told Ava to keep it a secret. (RT 2163-2164, 2176) Ava referred to appellant in the interview as "the one who hurt me." She also said appellant hates church, and didn't like or help his wife. In response to her aunt telling Ava not to tell about the touching, Ava told her aunt that she'd "better get another man." (RT 2127, 2135, 2155, 2159, 2165, 2173-2174)

At the time, appellant was working as a pastry chef at Wolfgang Puck's restaurant on Sunset Boulevard;[8] the officers called the restaurant manager and asked appellant be sent to the front of the restaurant for questioning. Appellant was arrested shortly afterwards leaving by the back door. He became wide-eyed when he saw the officer stationed there. (RT 1638-1641, 1907-1910, 1913, 2193)

---

8 Appellant's shift began at 2:00 p.m., and ended at 11:00 or 12:00 p.m.; he had Mondays and Tuesdays off. (RT 2194, 2217) Appellant testified he was not a chef, just "a worker" with pastries. (RT 2456)

Tragodia 1: Statement of Facts

A physician/expert in forensic child sexual abuse testified he reviewed the records of the sexual assault examination performed on Ava on October 12, 2000, as well as her general medical records and prescriptions from October 20th; the examinations were performed by very experienced nurses. Ava tested positive for herpes simplex on September 29th, at which time she complained "Chavelo rubbed his privates on my privates. He put his private in my private." (RT 1521-1526, 1529-1531, 1540-1541, 1554, 1617, 1631-1632, 1816-1817)[9] Also reported were accounts of specific acts described by Ava, including an annotation that masturbation occurred both over and under her clothing, her use of the word "grease" as coming from appellant, and the use of lubricant. (RT 1532) Symptomology included vulvar discomfort and dysuria (pain while urinating), and vaginal itching, in addition to the herpes diagnosis/symptomology. There was no sign of trauma to the vaginal area. (RT 1533B1534, 1541-1542, 1544, 1546, 1549-1550, 1596-1597) Ava's description of her activities with appellant were consistent with the transmission/presence of genital herpes,[10] as well as with the lack of vaginal trauma. (RT 1542-1543, 155-1546, 1549, 1551-1552, 1558-1561, 1566, 1605, 1633-1635)

Genital, or Type II, herpes[11] in prepubital children is transmitted by direct sexual contact, or perinatally, from mother to child during birth. Direct contact is generally skin to skin contact.[12] A typical outbreak of genital herpes lasts from 12 to 20 days, with initial outbreaks often being more severe than subsequent manifestations; the incubation period from exposure to expression is between two days and two weeks. Someone with genital herpes transmits the virus most easily for the 10 to 12 days before the ulcerative lesions begin to scab, which inhibits infection of others. There are periods in which an infected person will be asymptomatic, but may still transmit the disease through a partner's abraded or traumatized skin. (RT

9 At some point between the September 29th and the October 12th appointments, Ava's mother told her doctor that appellant had been complaining of pain during urination, and was seeking or had sought medical treatment. (RT 1842-1843, 1846)

10 The expert noted he was "not presented with any alternative explanation" for the transmission of herpes to Ava, and assumed, for purposes of his opinion, Ava's description of her activities with appellant was accurate. (RT 1611, 1624-1625, 1634)

11 Oral herpes is Herpes Simplex Type I. (RT 1570) The designations "genital" and "oral" refer to the type of virus, not to its location; though Type I is generally above, and Type II below, the waist, one could be infected with either virus in either location. (RT 1614)

12 It is possible to pass the virus via urine or semen. (RT 1615)

1568-1571, 1574-1575, 1614, 1620)[13] As between oral and genital herpes, genital herpes can be the more problematic for someone with an otherwise compromised immune system. (RT 1572) Herpes is not clinically susceptible to fomite transmission: it cannot be transmitted from living organism to inanimate object to living organism. (RT 1609-1610, 1633) It is also possible to auto-inoculate, to transmit the virus from one part of one's body to another by touching. (RT 1613-1614, 1622) It is estimated approximately 25% of the adult American population has Herpes Simplex Type II, and 80 to 90% have been infected with Type I. (RT 1615)

Genital herpes is treated with antiviral agents, such as Ayclovir. Zovirax is a trade name for Ayclovir. (RT 1576-1577) The medical consequences of genital herpes may include potentially limiting sexual activity during outbreaks, the need to medicate, pain, discomfort, itching, dysuria; some women may develop cervical inflammation, leading to vaginal discharge. A woman with genital herpes who becomes pregnant may have to deliver by Caesarian section if the virus is active at the time of birth. (RT 1577-1578, 1622B1623) Infants inoculated in the birth canal by their mothers can develop a severe form of infection, which can lead to herpes encephalitis, which is potentially fatal. (RT 1578) The psychological consequences of genital herpes are inhibited sexual activity, or inhibited emotions about sex. (RT 1578) Alternatively, those with herpes may have very few or infrequent outbreaks, and the majority of those who are infected are never aware of their status because they are either asymptomatic, or experience only a mild one-time outbreak. (RT 1616-1617)

Bottles of Ayclovir and Zovirax were recovered in a post-arrest search of appellant's home. (RT 2128-2131) On October 4, 2000, appellant was treated for an initial outbreak of genital herpes, and given a prescription for Zovirax tablets. (RT 1579-1582) On October 12th, appellant told a nurse at the jail that he has had genital herpes since 1997; on October 13th, appellant told another jail nurse that he was "prone to herpes." On December 21, 2000, appellant was examined and found free of herpes symptomology; on April 2, 2001, appellant's blood tested positive for both Herpes Simplex Types I and II. (RT 1583-1584, 1586-1591, 1594-1595) A SavOn document and pill bottle indicated appellant was taking Zovirax on May 9, 1996. (RT 1585) Appellant told Ava's mother that he had "an infection" before Ava's disclosure during

---

13 This includes mildly traumatized skin, such as from scratching. (RT 1620)

her second doctor's appointment. Ava's mother told appellant's wife that Ava was on antibiotics in the same conversation. (RT 2175, 2203-2206)

Ava was given a prescription for Acyclovir on September 29, 2000; she has had five outbreaks since her September 29, 2000 diagnosis, and was treated for lesions on February 22, 2001. At the time of trial, she was on a year-long maintenance/prophylactic dose of the antiviral medication, with a diagnosis of recurrent Herpes Simplex Type II. (RT 1596-1605, 1817-1822) Assuming the contacts with appellant took place between June and October 2, 2000, the last two contacts being around September 2nd and October 2nd, it would be reasonable to conclude Ava was exposed on the September 2nd date. (RT 1607-1609, 2207-2209) It is possible to test samples of the virus to identify type and strain; no comparative tests between strains of Type II virus were done in this case. (RT 1627-1630)

A forensic psychologist testified on the Child Sexual Accommodation Syndrome, a thesis advanced in 1982 to the effect there is no typical way for children to disclose sexual abuse; the theory has proven important in assessing and treating child sexual abuse. Tenets of CSAS include the inhibitory effects of threats made by the adult to the child to keep the abuse secret, of adult authority in the abstract on the abused child, and the phenomenon of self-blame and the accommodation of abuse among children, including the phenomenon of "playing possum" while being abused; accommodation being commonly part of an effort to reconcile abuse by a caretaker with the child's continued survival. (RT 1858-1870, 1872, 1874, 1876-1879, 1897) Disclosures of abuse are generally made in stages, the child initially hinting, or sending conflicting or unclear messages to see if he will be believed. (RT 1870-1871, 1880, 1894) Where the abuse is repeated, accounts may become an amalgam of experiences, rather than a cohesive and consistent narrative; accounts may also become muddled due to repetitive interviewing. (RT 1880-1882, 1895-1896) The purpose of CSAS is to establish children do not disclose abuse in any single fashion, or on any particular schedule: disclosures may occur after months or even years of abuse. (RT 1872, 1876, 1882, 1885, 1892) CSAS is not an aid to truth-seeking, or to discovering cases of sexual abuse. (RT 1891-1892)

In hindsight, Ava's mother remembered thinking appellant was especially attentive to her and generous to Ava and her sisters, taking them to McDonalds after they spent the night. Ava's mother recalled being at the

99¢ Store and telling her daughters she didn't have money for something; they asked appellant, he quickly gave them money, which made Ava's mother think "something's going on here." (RT 2205, 2214, 2222) Appellant once told Ava's mother that he wanted to die because he was sick all the time.[14] (RT 2205) One day that summer, Ava, her sisters and her mother were at the kitchen table when Ava said she had no reason to live and wanted to die. When her mother asked why, Ava said there were a lot of "bad people" in the world. Pressed by her mother, Ava just said she didn't want to live. (RT 2210-2211, 2225) At the time of trial, Ava was going to therapy once a week. (RT 2231-2232) Ava's mother never liked appellant. (RT 2230)

Defense Case

Appellant and his wife babysat Ava and her sisters on occasion. (RT 2416, 2426-2427) The last time they babysat, the girls came over around 5:00 or 6:00 p.m. on a Monday night; appellant and Ava sat on the sofa while her sisters and aunt sat on the floor, eating nachos and watching TV. (RT 2416-2417, 2428, 2431-2432) Appellant never picked Ava up, never carried her to the bedroom, never put her in bed, and never touched her genitals. (RT 2417-2418) The girls spent the night twice, on Saturdays; appellant didn't remember anything special about the sleep-overs. He would arrive home from work at about 1:00 a.m., after everyone had gone to bed; his wife would get up, make him something to eat, and they would go to bed, Ava and her sisters asleep on the mattress beside the bed. (RT 2419-2420, 2432, 2434) Ava never got in bed with appellant in the morning.[15] Appellant never pulled her hair or pulled down her underwear. (RT 2420, 2433-2435) Appellant never brushed against Ava's genitals at her house, or fondled her as she stood at his table. (RT 2422) Appellant has never been alone with Ava or her sisters. (RT 2418, 2435-2437)

After the girls spent the night, appellant and his wife would take them to McDonald's. He would buy the girls gifts at Christmas, and felt they were like his family. (RT 2421, 2426, 2435) Appellant did not recall telling Ava's mother about his medication, or about having an infection; he contracted

14 Appellant did not remember saying this. (RT 2452-2453)

15 Appellant has lain on the mattress with his wife, while Ava lay on the other side of his wife. (RT 2466-2467)

herpes many years ago, maybe in 1996 or 1997. (RT 2415, 2423, 2444, 2449-2450, 2452, 2460) [16]

Appellant was arrested at work: his manager told him to come with him, and opened the kitchen door. The police were waiting when appellant stepped outside. (RT 2456-2457) Appellant was surprised when he was arrested because he never had any problems with the law, and didn't know what the accusations were. (RT 2453, 2457-248) There was no reason Ava would make up such a charge: Ava's family and appellant have been close, and help each other as needed. (RT 2423-2426, 2454, 2462-2463) Appellant never touched Ava's genitals, never put his private part against her private part, never put his fingers in her vagina — he never "committed such an atrocity." (RT 2418, 2421, 2423)

---

16 Appellant did not recall telling the detective he had herpes before he was married. (RT 2443) He did not use a condom when he had sex with his wife; he did not have sex with his wife when he was infected. (RT 2445-2446) Appellant did not recall telling the detective that he used a condom when he had sex while infected. (RT 2446) He only learned in 2000 that it was not safe to have sex with someone during an infection. (RT 2446-2447) It was stipulated that appellant told the detective he had herpes before he was married, he used a condom when he had sex with his wife, and Ava's family has supported him from time to time. (RT 2468-2469)

# STATEMENT OF FACTS

## Prosecution Case
### Tabethna: counts 2, 5, and 22

Tabethna met appellant on November 14, 2002, at 69th and Figueroa. She was walking to McDonald's, and decided to take a back way because she saw Officer Rene Minnick talking to some other prostitutes. Tabethna knew Minnick as "Blondie," and several women had warned Tabethna to stay out of Minnick's sight if she wanted to avoid arrest. From Gage to Florence to Figueroa is known as a "ho track": pimps there were hassling prostitutes, yelling at the women to leave their current pimp and work for them. Tabethna had a pimp, had been working, and wanted to be left alone. (RT 2:390-395, 2:417-418, 3:461, 3:574)

About two blocks from McDonald's, Tabethna noticed a man was following her in a car. She'd seen the man on Hollywood Boulevard before; she started walking faster, then cut down to the back street, still followed by the man, driving with a dog.[1] Tabethna saw appellant sitting on a porch in front of a house, and then he was "right close to my face." The rule on the street is if a prostitute looks a pimp in the eye, she's chosen to work for him. Tabethna assumed appellant was a pimp because he was black. Tabethna didn't want to look at appellant because she didn't want to get in trouble with her current pimp: she turned around, he got behind her, putting his arm on a nearby gate, she moved to the right, and he put his other arm on the gate, barricading Tabethna. Tabethna did not try to push appellant away because he was bigger than she was. Appellant asked Tabethna who her folks were, meaning who was her pimp. Tabethna pointed at her right calf, where her then-pimp's name ("Chosen") is tattooed.[2] Appellant asked Tabethna if she knew who he was, Tabethna shook her head, appellant told her Mac- Bone or -Bob. When Tabethna decided to talk to appellant, she became "out-of-pocket," essentially giving appellant permission to take her. This consent is one of the rules of the game: the game dictates that once a prostitute has a pimp, that prostitute can't get "out of line" with another pimp. This includes

---

1 On cross-examination, Tabethna testified the man was actually appellant's mother, driving the Escalade. (RT 3:456-459)

2 Tabethna did not want to have the tattoo; her then-pimp did it to her. Chosen was Tabethna's pimp for three years. Tabethna refused to give Chosen's name to Officer Minnick. Tabethna called Chosen "Daddy," a common term of affection a prostitute has for her pimp. (RT 2-412, 2:410-420, 3:462-463, 3:471)

eye contact and conversation; if a prostitute doesn't "stay truthful" to her pimp, the pimp will beat her. (RT 2:395-402, 2:419-420, 3:457, 3:460-461, 3:463-464, 3:4700-471, 3:473-474, 3:477)

Tabethna noticed the man that had been following her was coming down the street, and told appellant that the guy had been harassing her. Appellant said the man was his cousin and wouldn't bother her while she was talking to him. Appellant's mother then came out of the house and said, about Tabethna, "I like her." Appellant told Tabethna he had a ho named Cherry, who Tabethna resembled, and he wanted Tabethna to be "on his starting lineup." Tabethna thought he meant his first set of hos, the women who "control[] the other females." (RT 2:402-405, 2:419-420, 3:455-456, 3:459-460)

Appellant said that he had prostitutes in Florida, that he was world-wide, and that Tabethna could choose where she wanted to go. Tabethna was scared, she wanted to leave. Appellant said she could get into the green Cadillac or the black Escalade parked in front of the house, but either way, she was going to get into one of the cars. He said they could do this the easy way, she could go over and get in on her own, or the hard way; he did not provide an example of the latter. Getting into the car could have meant either being interviewed about working for appellant or going to a different track to start working for him.[3] Appellant was calm: according to Tabethna, when a person is calm, they're not really angry, "but if you make them angry, they could get physical." Appellant never got angry or physical with Tabethna, and the trouble Tabethna would have had for talking to appellant would have come from Chosen. (RT 2:405-408, 2:410-411, 2:422-423, 3:451-453, 3:459-460, 3:469-472, 3:476)

At that point, Officer Minnick drove to the corner of 69th; Tabethna stared at her, so Minnick would see that Tabethna needed help. Appellant's mother told appellant that he should take her with him or else Blondie would get her; Tabethna told appellant to let her go, she didn't want to go with them even if Blondie might get her. Appellant didn't take his arms from the gate until his mother came down with appellant's telephone number written in eyeliner on the back of a receipt. Appellant told Tabethna she should use the number whenever she was ready "to sum it up." (RT 2:408-412, 2:421-

---

3 On redirect, Tabethna testified that getting interviewed for prostitution involves more personal questions; it would not have been Tabethna's choice to be interviewed by appellant, but she did not feel she could refuse. (RT 3:467-469)

422, 3:452-456, 3:474-476) After appellant released her, Tabethna walked towards Minnick, Minnick asked Tabethna if she was okay, said she'd seen that Tabethna was in trouble, and "faked an arrest" at Tabethna's request. If a prostitute reports a pimp to police, she can get beaten or killed. Appellant was standing at his gate while Tabethna talked to Minnick; his mother was walking towards them. (RT 2:412-416, 3:454-455, 3:458, 3:477) Tabethna has been arrested in the past for loitering, and in April 1999, she stole her brother's car. (RT 2:416-417, 3:466)

At the time of trial, Minnick had been a Los Angeles Police Officer for seventeen years. On November 14, 2002, she was on patrol, looking for prostitution activity along the "Figueroa Corridor," a "track" worked by Los Angeles area prostitutes. Minnick had seen three young women at the corner of 68th and Figueroa, who she took for prostitutes; a line of ten cars with single male drivers was parked behind the women. When Minnick parked her patrol car, the vehicles disappeared, and the women walked away. (RT 3:496-3:500)

A few minutes later, Minnick was flagged down by a tire store owner, who asked her to remove two of the women from his shop; afterwards, she spotted Tabethna walking down Figueroa, then next saw her standing with her back against a chain link fence as appellant stood in front of her, one arm around each side, holding the fence. There was an aqua green Cadillac parked against the curb, and a black Cadillac Escalade illegally parked in the crosswalk, its passenger door open. Minnick thought appellant might be the person she'd talked about with Officer Shea[4] earlier that day, she radioed Shea, and made eye contact with Tabethna, who would look at her, then look away. Minnick was unsure whether Tabethna was in trouble or wanted help, so she continued to watch until another unit arrived. The Escalade was moved across the street, legally parked, a forty- to forty-five-year-old black woman with a large dog got out and walked over to appellant and Tabethna. Minnick never saw appellant touch Tabethna or heard him threaten her, or heard Tabethna ask appellant if she could leave. She never saw Tabethna show appellant a tattoo.[5] (RT 3:500-505, 3:507, 3:514-519, 3:572-576, 3:580)

---

4 Shea testified the nature of the area's prostitution activity had changed from "the nasty, alcohol drug user, to a more attractive, youthful, hair-matches-the-nails matches-the-shoes type," the more attractive the prostitutes, the more attracted the johns. (RT 3:573-574, 3:581, 3:584-585)

5 When Minnick and Shea interviewed Tabethna, Tabethna showed them her tattoo and said it meant she was "chosen" by a pimp. She did not say her pimp's name was Chosen: she said she

After a few minutes, appellant released the fence and Tabethna walked to Minnick. The other unit detained Tabethna till Shea arrived; Shea identified appellant as "Mac Bone," according to Shea, he did not speak to appellant, Minnick said he did. They agreed Minnick talked to Tabethna. Tabethna was being evasive and hesitant in her answers, and kept looking down the street. Minnick told Tabethna she wanted to help her, Tabethna said she was afraid to talk on the street, and would rather go to the station.[6] Tabethna was handcuffed by the other officers and transported in the back of a patrol unit. When Minnick and Shea interviewed Tabethna, she gave them a piece of paper with a telephone number written on it. (RT 3:505-511, 3:518, 3:577-578, 3:581-582, 3:583-585, 3:591)

Joncey: counts 11, 12, 13, 14, 15, 16 and 21

Joncey was seventeen years old at the time of trial; for the past six years, she's told police she was five years older because she is a prostitute, and didn't want them to know she was a minor. At trial, Joncey testified she did not remember, or did not want to answer, a number of questions.[7] Joncey did testify that she told Detective Haight that in November 1998, when Joncey was eleven, she met appellant at a Greyhound bus station in San Bernadino, and he took her to Los Angeles. She testified she did not tell appellant she was eleven at the time, and said she did not remember whether she told the detective she told appellant her age, or if appellant told her that she was pretty and he would take her on a date, or if he gave her his telephone number or if she agreed to date appellant. Joncey testified she never told appellant her age. (RT 4:684-690, 4:693, 4:708-709)

Joncey did not remember telling the detective she called appellant and met him at an auto body shop, that he showed her photographs of girls in short-shorts and stilettos, or whether he asked her if she wanted to look like the girls in the photos. She did not remember telling the detective that appellant said she would look like those girls if she stayed with him, that he would buy her pretty clothes, or that she told appellant her parents didn't care about her, so she should go with him. Joncey testified she went with

___

called her pimp "Daddy," and didn't know his real name. (RT 3:519-520)

6 Shea testified it was his idea to take Tabethna to the station. (RT 3:578, 3:582)

7 When Joncey was asked to testify at appellant's preliminary hearing, she laid on the floor and refused to leave because she had "nothing to say." After police put restraints and shackles on Joncey, she screamed and kicked, saying she didn't want to go. (RT 4:686-687)

appellant of her own free will, and he did not force her to do anything. (RT 4:690-692, 4:694, 4:709-710)

Joncey did not remember if she went to a motel with appellant, or whether appellant told her he was a pimp and the women in the pictures were his whores. Joncey testified she didn't know appellant as a pimp. She did not remember appellant asking if she would whore for him, or promising her pretty clothes, or saying her parents didn't care for her, or letting her call them, and when there was no answer, saying that if they were worried, they would have been there, or that she then agreed to work for him. She did not remember telling the detective appellant said never take less than $50 for "head," explained "head" meant oral sex, or that a customer should touch her breasts or she should fondle the customer's penis to make sure the person was not a police officer. Or that if she was going to a hotel with a customer, she should first call appellant, or bring the money to appellant right after sex, or that if she did all this she would be rewarded with pretty clothes and appellant would take care of her. (RT 4:692-695)

Joncey testified she did not remember telling the detective appellant then took her shopping for new clothes and had her hair and nails done, or that later, two black men arrived, appellant told Joncey to just do what they say, and one of the men took out his penis and said, "Just do it, suck my dick." She did not recall saying she left that night to try and get away, but appellant found her and brought her back to the motel, where she and appellant took showers and appellant asked if Joncey'd ever had sex and she said no, and that she didn't know anything about sex. (RT 4:695-697) Joncey did not remember telling the detective appellant laid on the bed, took out a condom, explained to Joncey how to put it on his erect penis, and repeatedly demanded Joncey orally copulate him until she complied, then a short time later told Joncey to lay face up and put his penis in her vagina, or that she demanded he stop because she was in pain, but that he did not stop until he decided to do so. She did not remember telling the detective that the next morning appellant introduced her to his other prostitutes, or that in the evening, appellant took her to a house party in South Los Angeles. (RT 4:697-699)

Joncey did not recall telling the detective that at the party, another of appellant's prostitutes, a woman named Cinnamon, told Joncey to stay with her, that she would show Joncey how it's done. Or that Cinnamon was approached by a man at the party; she told Joncey to follow them into the

back yard, where Cinnamon orally copulated the man, was paid, then told Joncey, "That's how it's done." Later at the party, another man approached Joncey, they had sex, Joncey felt bad afterwards, but felt better after being paid. Joncey did not recall telling the detective she told Cinnamon she got paid, Cinnamon told her to give the money to Mac Bone, she told Cinnamon she wasn't going to, Cinnamon told appellant that Joncey was refusing to pay him, appellant took the money from Joncey's bra, Joncey told appellant it was her money, she earned it, and appellant said, "Bitch, it's my money. All of your money is my money." She did not remember telling the detective appellant slapped her repeatedly, or that she dropped to the floor so as not to be hurt, or that appellant slapped and choked her and said not to get him mad, did she want him to go to jail. Or that they returned to the motel, or that the next day appellant asked Joncey if she was mad because he'd hit her, and to stop her from being angry, took her to Disneyland. (RT 4:699-702)

She did not recall telling the detective that a few days later appellant drove her to Figueroa to start street-walking, telling her to touch customers in the groin to make sure they weren't law enforcement, and if they refused to be touched, to get out of the car. Or to look at the license plate to see if it was an undercover police car. Or never to get into a car with a black man or girls because they would try to recruit her to work for another pimp, or never to make eye contact with a police officer, as she could then be stopped. Or saying that for the rest of the day, she performed various acts of prostitution and gave all the money to appellant. Or that she worked seven days a week, sometimes earning up to $1,500/day, or that appellant took her and other prostitutes to Arizona, Washington D.C., New York, Nevada and Florida to work, taking her to Pico and Alvarado beforehand to get a false identification card for flying. (RT 4:702-704)

She did not recall telling the detective that appellant's mother asked her to prostitute for appellant because he was in jail, or that she did so, giving the money to appellant's mother. Joncey told police her name was Monica, and gave them an incorrect age; she also gave the name Monica when she was arrested on April 19, 2003, and gave a birth date of October 25, 1982. Joncey always gives 1982 as her date of birth, and always gives a different name. She couldn't recall what name she used during a June 18, 2004 arrest; she said she was from Las Vegas, and was charged with giving false information to police. She testified she did not recall that she was arrested four days before she was interviewed by the detective on October

13, 2003, and did not remember whether she spoke to the defective to avoid prosecution for her arrest. Joncey has been arrested "a lot" for prostitution. She did not recall telling the detective appellant had a car, and did not recall working on February 26, 2002. She did recall an incident where a man came up to her on Sunset and Serrano, saying, "You're going to work for me, bitch. You're mine. Come the fuck with me," and yelled, "She is mine, this is my bitch, she works for me." Joncey did not know the person, though they were arrested together.[8] (RT 4:705-708, 4:710-716, 4:727)

Joncey did not tell police she was working for appellant when she was arrested on February 26, 2002, June 6, 2002, April 19, 2003, October 9, 2003,[9] April 10, 2004, or June 18, 2004. Joncey testified she's been a prostitute since she was eleven, has worked "everywhere," never worked for a pimp, did not give money to appellant, lived "everywhere," and has stayed in group homes since she was thirteen. She always runs away from the homes to go back to work. Joncey pays her own way, and likes her life. (RT 4:720-721, 4:729-735) The police did not offer Joncey any useful assistance with her old arrests or cases; she doesn't really expect any, or any in the case she picked up the night before she testified. They did offer to get her off the streets and out of jail, but she does not want to quit prostituting. Joncey didn't have a choice whether to testify, and was mad that she had to come to court. (RT 4:706-707, 4:723-726, 4:731-732)

Detective Haight testified that he interviewed Joncey at Los Padrinos Juvenile Detention Facility in October and November 2003, and at San Bernadino Juvenile in March 2005: Joncey told him appellant was her pimp, she met him at a Greyhound bus station in 1998 when she was eleven years old, and told him she was eleven years old, appellant got her telephone number, called her, they met at an auto shop, he showed her photographs of provocatively-dressed women, told her he could take her places, buy her things, she agreed to go with him to Los Angeles, once in Los Angeles, they went to a motel, he told her he was a pimp, had her call her parents, told her they didn't care for her because they didn't answer, she agreed to be a prostitute for him, he explained the rules of prostitution, took her shopping, took her where there were two black men, one of whom

---

8 On re-direct, Joncey testified she did not remember if the man was appellant, or if appellant was arrested that night. (RT 4:731)

9 On re-direct, Joncey testified she did not remember telling an officer that she was working as a prostitute for appellant. (RT 4:731)

made her orally copulate him, she ran off, appellant found her, brought her back to the motel room, demanded they had sex, appellant teaching Joncey how, her complying, not wanting to, he took her to a house party, she met a prostitute named Cinnamon, Cinnamon befriended her and showed her how to prostitute, Joncey orally copulated someone at the party, and was paid. Joncey has always been cooperative in being interviewed by the detective, though she did not want to testify, refused to testify at the preliminary hearing, and refused to speak to defense counsel. (RT 4:736-759)

Nikki: counts 3,4,9, 10, 18 and 19

In May 2001,[10] Nikki had just turned seventeen years old; she met appellant at the Slauson Super Mall, he told her she was attractive and he had something she could do. They dated for a couple of weeks, going out to eat at various fast food places.[11] One day, after they got something to eat in Hollywood, appellant pointed out a girl walking down the street wearing nightwear. It was about 5:00 p.m.. Appellant asked Nikki if she thought she could go out there. Nikki asked appellant what he meant, he said she knew, she said what, he said it's easy, she said she didn't know what he was talking about, he said let me see if you could turn a trick, she said what does a trick mean, he said a john, she said she didn't know what that was, he said it's when you offer "him a little something that you got," she said what do you mean, and he said, "you're going to sell your pussy." Nikki said she'd never done this before, didn't know anything about it, and was scared. Appellant told her no one was going to hurt her, it was easy: "look at them, they doing it." He told her the rules: don't look at a pimp; don't let them know you're a "loose bitch" because someone could easily pimp on you; let them know you are strong; when a trick comes up, talk to them, ask them if they want a date; make sure the trick is not a cop by touching them or having them touch you; charge nothing lower than $50.00, charge between $80.00 and $100.00 for

10 On cross-examination, Nikki remembered she'd testified at the preliminary hearing that she met appellant in April 2001. Her birthday is May 22nd; the first time she had sex with appellant was after her seventeenth birthday. At the preliminary hearing, she testified he forced her to have sex before her birthday. On re-direct, she testified she wasn't good with dates. (RT 5:866-870, 5:913-916) A detective who interviewed Nikki on October 8, 2003 in front of the Natural History Museum testified that he and his partner tried to pinpoint dates to find out if the events fell within certain statutes, but Nikki was not specific, giving approximations, which the detective would "narrow down." Nikki said she first met and was raped by appellant before her seventeenth birthday, they narrowed down the date to April 2001. Nikki also said the knife incident was on or around the Fourth of July. (RT 5:951-965)

11 On cross-examination, Nikki testified she ran away from home that summer because of problems with her family. (RT 5:892-893)

sex, and nothing over $80.00 for head.[12] Appellant dropped her off, saying to call after she turned the trick, she did, he had her meet him and give him the money, started to leave, he asked her where she was going, she said home, he said "this ain't no money," and asked her to go back out, she said she was scared, he said to do just one more, she did, and continued working for appellant. Nikki was scared something might happen to her on the street. (RT 4:771-772, 4:776-786, 4:813, 4:817-824)

While she worked for appellant, Nikki lived from motel to motel. She "car-dated," worked motels, and worked tracks at Figueroa and 66th and 65th, Sepulveda, Long Beach, and Phoenix. (RT 4:786-787, 4:824) She also had sex with appellant; "a couple of times," he forced her. Once was around her birthday in 2001: he said to meet up, that he wanted to fuck, she said she was tired, he insisted, she said she didn't want to, he said, "it's not what you want, it's what I want." Appellant told her to lay down, she refused, he told her to shut up and lay down, she did, opened her legs, he started to put his penis inside, she told him to stop, he slapped her and pulled her head up and down by her braids and "kept throwing it in hard." The penetration hurt, Nikki kept asking appellant to stop and he told her to shut the fuck up, and continued until he finished. He got off Nikki, laid on the floor; she laid on the floor; he told her to get up and suck his penis. Nikki didn't want to argue or get hit, so she did it. (RT 4:787-792, 5:907)

There were other occasions on other days when appellant forced Nikki to have sex, "too many to count." One summer, a few months after Nikki started working for appellant, when Nikki refused to orally copulate him, appellant put a knife to her neck and told her she'd better do what he told her to do, and to suck his penis. Nikki said, please, please, and appellant looked at her "like if he was crazy," "like if he wanted to eat me." She complied; appellant said, "You picked the right option, bitch," and continued to hold the knife to her neck as she orally copulated him. As she did, appellant said if she hadn't have done it, he would have done something to her. She ignored

---

12 She told investigating officers she earned $800 to $1,000/day; she did not recall telling them she earned $200 to $300 a trick. (RT 4:843) She saved some money to get away, which she hid from appellant, but could not recall the amount. She did not recall telling police she saved $1,200, or that appellant found the money and believed her when she said it was bail money in case she needed to bail him out. Nikki would hide trick money in her shoe or sock or bra, or stash it in some bushes before giving it to appellant. Once she hid money from appellant in her vagina; appellant tried to have sex with her, she said no, appellant found the money, and asked her why she had money in her privacy. Appellant beat her: when pressed for details, Nikki repeatedly said she didn't want to talk about it. The court then struck all testimony about this beating. (RT 4:846-847, 5:898-901, 5:905-906, 5:915-920)

him, he said he wanted to have sex with her "in her behind." Nikki said no, please, she'd never done that before. Appellant said he wasn't going to hear that, to get off the floor on her knees and take off her pants, she said please, please, still holding the knife, appellant said he wasn't going to hear that shit, she said please, please; he said what did you think, did you think I was only playing with it, and started swinging the knife, saying, what you going to do. Nikki begged, appellant asked her if she wanted him to cut her, she said no, he said he wasn't going to ask her anymore, so she bent over for him and he put his penis in her anus. It hurt. (RT 4:792-798, 5:906-907)

During the two years, Nikki worked for appellant she went home and ran away again about ten times; once, appellant called her and told her to come outside and get into the car. He was waiting two houses down in a shiny rental car. Every time Nikki ran away, appellant would pick her up at her house.[13] She stopped running away after he threatened her and her family. If Nikki refused to work, appellant would hit her. Once he hit her with a hotel phone, and once with a knife handle. He pulled a gun on her more than once, once saying that she had to stop running off or he would use it on her. On July 4, 2001, appellant threatened Nikki with a knife, saying if she left, he'd do some harm to her and her family. (RT 4:798-804, 4:848, 5:911-912) There were other women working for appellant at the time; Nikki saw him threaten them with the gun as well. Nikki tried to convince some of the others to leave, but no one ever did because they were scared. Nikki has been to appellant's mother's house. Appellant's mother sometimes picked the women up or picked up their money in her black truck. (RT 4:804-807, 4:812-813, 4:824-826, 5:886-887)

Appellant once told Nikki that you are never supposed to tell on a pimp, if the police ask you, tell them you don't have a pimp, and don't mention his name. He said if you tell on a pimp, you get ten stabs to the chest, and a "black eye on the game," meaning you are no longer in the game and pimps and hos will kill you. Nikki did not want to testify because she was scared: a couple of weeks before she testified, she was coming back from the store, pushing her son in a stroller, and a man got out of a dark car and grabbed her and said if she testified against Mac Bone he'd have something done to her. Another man, a relative of appellant's, came up to Nikki and said he'd kill her. She recognized him, but would not identify him in court. (RT 4:807-811)

---

13 Nikki testified on cross-examination appellant picked her up from "a lot of places," including the tracks and the Dorothy Brown School. (RT 4:846)

On cross-examination, Nikki testified she did not remember telling detectives on August 13, 2003 that she worked for appellant from September to November 2002, or telling them on October 8, 2003 that she worked for appellant for twenty-two months, beginning in April 2001, or telling other officers after her prostitution arrest on April 9, 2002 that she had only been a prostitute for three weeks and two days, or testifying in December 2003 that she worked for appellant for eight months to a year. She recalled telling another officer in January 31, 2005 that she was a prostitute for one to two years. She denied telling two officers on April 9, 2002 that she worked for four pimps, and could not remember what name she gave the arresting officers. On November 6, 2002, she was handcuffed, but not arrested, by two officers, who asked her if she knew appellant. She said she had worked as a prostitute for a few months, but denied saying she told them she started working for a pimp who beat her, or that appellant had approached her and said he'd take better care of her and protect her. Nikki testified appellant was the pimp she was telling them about. The man who beat her was her boyfriend. She told the officers she started working as a prostitute for the money; they offered to help her get off the streets. On October 8, 2003, she told officers she didn't want to be a prostitute because of appellant and because of abuse by tricks. Nikki denied telling an arresting officer on December 7, 2003, that she was prostituting to make money for Christmas. She has been previously arrested under the name Nicole Jackson, a name provided by appellant, but could not recall the birth date she used with that name. She has used her real name and birth date when arrested, but does not remember how many times. Those times, she didn't like lying to the police. She missed about four months of school while prostituting, and had to make it up. Her school would send a bus to get her because she was under house arrest; she wouldn't be there when the bus arrived. (RT 4:825-827, 4:831-838, 4:840-842, 4:850, 5:870, 5:872-876, 5:878-885, 5:887, 5:895, 5:907-911, 5:921-922, 5:927-928)

Nikki testified against appellant at his 2003 preliminary hearing, and has been arrested a few times since. She was not promised anything in exchange for her trial testimony. After appellant's arrest, Nikki has not worked for a pimp. She is no longer a prostitute, and has had a job with a paycheck since November 2004. She has had two non-prostitution jobs. (RT 4:811-814, 5:887-888, 5:921)

At 6:40 a.m. on April 9, 2002, Officer Edan D'Angelo, assigned to Hollywood Vice and working undercover, was stopped at a red light. Nikki

walked by, they made eye contact, the light changed, D'Angelo made a U-turn, stopped at the curb, and Nikki got into D'Angelo's car.[14] (RT 3:597-603, 3:605)

## Rochelle: counts 7, 8 and 20

On January 11, 2003, Rochelle was thirteen years old; appellant came up to her at the Greyhound bus station on East Seventh Street, and asked if she was lost, or in trouble, or needed help. Rochelle told him that she'd run away, appellant asked if Rochelle wanted to go with him, Rochelle said, "If you don't rape me, okay," appellant said he wouldn't rape her, and she left with him in an older blue Cadillac.[15] They stopped in front of appellant's mother's house, and appellant ran in while Rochelle waited in the car. At appellant's house, they sat on the couch and talked: appellant told Rochelle he was a pimp, and asked Rochelle's age. Rochelle said she was sixteen. A girl left the apartment while they talked; otherwise, they were alone. Rochelle slept on the couch that night, appellant in his bed. Appellant was "very nice." (RT 5:984-990, 5:1006-1007)

The next day, appellant and Rochelle went for a drive; when they returned to appellant's apartment, Coco, the girl who'd left the night before, was sleeping on the couch. Appellant told Rochelle the girl had a "pretty good job." He gave Rochelle make-up, she got dressed with Coco, and they went to the Sunset track. Rochelle was wearing a blue sweater, jeans, and flip-flops. She understood she was going to sell herself for sex, though she had never done it before. Appellant didn't ask Rochelle to prostitute herself: Coco told her about the track after appellant told Coco to get ready to go on track. Appellant told Rochelle always use a condom, get money first, and to call him or his half brother if she got into trouble. He gave her about seven condoms, telling her not to look at black guys because they are pimps and if she looked at them it meant she wanted to be with another pimp. He also said not to get into cars with Aryans, a race with dark hair and eyes that has a history of doing really bad things to prostitutes, and to make a trick feel her breast and try to see his penis because that means he's not a police officer. Rochelle had never orally copulated anyone before; she orally

---

14 D'Angelo and his partner testified they had no independent recollection of any specific events. (RT 8:1323-1326, 8:1328-1338)

15 On cross-examination, Rochelle said she testified at the preliminary hearing she told appellant she was in town visiting her cousin and was not a runaway. She said appellant asked what color her eyes were, she said blue, he asked if she wanted a place to stay, she said if he didn't rape her, he promised he wouldn't, and she left with him. (RT 5:1013-1014)

copulated appellant before they left so she'd know what she was doing. At the preliminary hearing, Rochelle said Coco taught her, using a banana.[16] Rochelle felt she'd put herself in the situation by running away from home; appellant was "really nice," and she had nowhere else to go. (RT 5:990-999, 5:1014-1017, 5:1022-1023, 5:1025)

Rochelle stayed with appellant for four days. He offered her food, but she wasn't very hungry. Appellant was also very nice to Coco. Rochelle never saw appellant hurt or beat anyone or call anyone bitch or ho. There was a white woman working for appellant, but they dropped her off somewhere because she wanted to get out of the game and get an education. (RT 5:996, 5:1001, 5:1018-1019, 5:1023)

Rochelle got $80 for oral sex, $100 for sex; appellant gave her the price ranges, but Rochelle decided what to charge. The first time, she didn't' ask for money, and the trick didn't give her any. She told appellant about it, but he didn't care, just told her to be careful next time and ask for the money first. Rochelle gave her money to appellant, just like Coco. Rochelle did not want any of the money for herself; she felt empty inside at the time, and safe knowing appellant. The fourth day, Rochelle got arrested. She called appellant from the foster home, he came and got her, and when he found out how old she was, bought her a bus ticket. She was to meet her parents in Las Vegas. (RT 5:999-1002, 5:1017-1018, 5:1024, 5:1028)

Appellant told Rochelle going home would be in her best interest; they argued: Rochelle wanted to stay with appellant, and ripped up the ticket. Appellant made her call her parents, who bought her another ticket. Appellant took Rochelle to the bus station and watched her get on the bus to make sure she went; Rochelle would still be on the streets if appellant hadn't sent her home. Rochelle ran away again in August or September 2003. She went to appellant's house, but couldn't find him, she went to the track, and was rearrested. Appellant never tried to have sex with Rochelle, and never threatened her with violence. He told Rochelle that if she went out of pocket another pimp would take her and that pimp could hurt her; Rochelle did not want to go out of pocket because she did not want to get hurt. She went out

---

16 Rochelle didn't say she orally copulated appellant at the preliminary hearing because she didn't want to tell anyone. She didn't tell the detective because she hated the detective "very much." Rochelle did tell the defective appellant told Rochelle she was too young to get a job, but needed to work to survive, but she lied about this. Rochelle lied to the detective because she didn't want to go home. (RT 5:1022-1027)

VANESSA PLACE

of pocket once, and appellant didn't get mad, just told her not to do it again. Rochelle really liked appellant. (RT 5:1002-1004, 5:1020-1021-1023)

Unity: count 6[17]

On August 13, 2003, Unity was seventeen years old, standing at a bus stop on Gage and Figueroa. Appellant drove up in a green Cadillac and gestured her over; he asked where she was going, she said she was waiting for a bus, he said wasn't it hot outside, she agreed, he asked if she'd prefer a ride. Unity said she was going to her boyfriend's house in Inglewood. She talked to appellant for about ten minutes, appellant again asked if she'd like a ride, she said she would. Appellant drove to a different house in Inglewood, first calling the occupant, then meeting him outside to talk. Afterwards, appellant drove around looking to buy marijuana;[18] next, he went to a woman's house, staying for fifteen minutes. After leaving, appellant asked Unity if it was all right if he kept her a little longer. She said yeah. Unity told appellant her name was "Ree-Ree." (CT 1:145-146; RT 6:1080-1088, 6:1095, 6:1097)

Appellant drove back to 69th Street, stopped the car, made a call, and drove to a bail bondsman near County Jail. They then went to a Motel Six in Hollywood: appellant got another call and told Unity they needed to pick up a friend. Unity testified she did not recall telling Haight that appellant said it was time for him to tell her "what he really was." Unity and appellant drove to Van Nuys; appellant was talking to a woman on his phone, telling her to walk down from the police station to meet them. They picked up the woman, named "Special," and went to a car dealership, where appellant looked at a truck. Appellant asked Special if Ree-Ree was going to buy him the truck; Unity laughed. (CT 1:150; RT 6:1088-1096-1098)

They drove back to the motel; Unity didn't want to go, but didn't say anything because she was scared. Appellant said he hadn't told Ree-Ree what he actually was yet, but thought she had an idea. He asked Unity what she thought he was; she didn't answer; he said he was a pimp. Unity didn't say anything. Appellant said Special was his ho, that Unity was a bitch, asking if she knew the difference. Unity said she didn't, appellant said a ho gets paid for fucking and a bitch fucks for free. Special took a shower. Unity

17 The preliminary hearing testimony of the witness was read to the jury because of the witness's unavailability. (RT 6:1078-1080)

18 On cross-examination, Unity testified she voluntarily smoked marijuana with appellant "the whole time I was with him" that first day. (CT 1:145-146, 1:149)

sat on one end of the bed, appellant on the other. Unity did not try to leave, or call home or her boyfriend. Appellant went downstairs, and Special told Unity appellant wanted them to come down. They did, got back into appellant's car, and returned to 69th, stopping along the way to eat at Tommy's. Unity did not ask anyone for help. At the preliminary hearing, Unity testified nothing happened; she did not recall telling Haight she street-walked at that time. (CT 1:149-151; RT 6:1098-6:1105)

It was night by then,[19] and Special was talking to her friend Mercedes on the phone about how Mercedes had "gotten into it with her daddy, which is her pimp." Special told Mercedes they were coming to get her, and they drove to Hawthorne and met Mercedes. Mercedes was afraid to get into "Special's daddy's car." Special called appellant "daddy," appellant told Unity earlier that his name was Bone. Appellant got out of the car to interview Mercedes, returned alone, and they drove back to 69th. Special was wearing very short shorts, stilettos, and a tank top; she told appellant she wanted to work on Century Boulevard; he drove to Century Boulevard, and Special got out of the car. Appellant and Unity drove to a back street, Special called and said she'd been stopped by the police, and appellant and Unity then picked her up at a liquor store. Unity did not call anyone from the pay phones at the store, or ask anyone for help. (CT 1: 119-123, 1:145, 1:151-153; RT 6:1104)

Appellant did not explain the relationship between pimp and prostitute, or what a prostitute is supposed to do; he explained the rules of a pimp, the difference between being in and out of pocket, and about not talking or looking at another pimp. Appellant said pimping was a sport, non-violent, that pimps do everything for their prostitutes. Unity, appellant and Special all slept in appellant's car that night. (CT 1:124-125, 1:150-151)

The next day,[20] appellant asked Unity if she would go on a date; she understood that meant to find a trick. She said no, she was scared. Appellant said he'd find a better place for Unity to go, and drove to Imperial Highway. Appellant told Unity how to question the trick, how to make him touch her breasts to prove he wasn't a police officer. Appellant gave Unity

---

19 There was a stipulation that the preliminary hearing transcript for December 4, 2003, pages 16 through 68, and 68 through 77, be incorporated into the trial record by reference so the court reporter at trial did not have to re-record the testimony. Objections and sidebar conferences were not included in the readback. (RT 6:1105, 6:1109) The December 4 preliminary hearing testimony thus referenced appears at CT 1:93-154: the CT citations above refer to those portions of the transcript not re-recorded at trial.

20 On cross-examination, Unity testified she went with appellant to the Hollywood courthouse that day, but only appellant went inside. (CT 1:146-148)

some condoms, said to always use them, and to get somewhere around $50 for oral copulation; she told Haight appellant said $100 for intercourse and $50 for "head." Appellant said Unity might not always want to go to a hotel, and might have to do a car date, to never let anyone approach her on a main street, and not to go on a side street. Unity told Haight she repeatedly refused to leave the car, but didn't know if she asked to call her mother. (CT 1:125-131, 1:154)

Unity eventually got out of appellant's car, and got a date, but the man just talked to her for ten minutes and gave her $20. Unity and Special returned to the car, gave appellant their money, and they drove to 69th and Figueroa. Unity testified nothing happened there; at some point, appellant drove Unity to Arizona. Appellant said Special better make money for him when they got to Phoenix; he also told Unity he was "sick of you bitch not working for me, not making me any money." (CT 1:133-140) They stopped in Parker the second night, sleeping in the car at the Flying J truck stop. Unity went to the bathroom, called her boyfriend, then the police, saying she'd been kidnapped. The police told Unity to stay at the truck stop, but appellant and Special came looking for her, so she got back in the car. The car was later stopped by the Arizona police. (CT 1:141-144)

The Investigation

Detective Kenneth Haight is a Vice supervisor, specializing in prostitution, assigned to investigate appellant, known as "Mac Bone." On August 15, 2003, Haight interviewed Unity with her mother and boyfriend in attendance. Unity gave Haight two Trojan condoms, a lottery ticket, and a handwritten telephone number, 323-707-5180. After the interview, Haight arranged for appellant to be extradited from Arizona. On August 16, 2003, Haight interviewed Tabethna, and sent two other detectives to interview Nikki, speaking with her himself on August 20th; on September 2nd, Haight picked up appellant in Parker, Arizona, and transported him to the Los Angeles County Jail. On September 19th, Haight located Rochelle, and interviewed her at Los Padrinos Juvenile Hall, where he interviewed Joncey on October 13th: because prostitutes are reluctant to come forward, detectives will go to detention centers to talk to juveniles already under arrest for prostitution, who are more likely to cooperate. (RT 3:612-622, 3:624-639, 6:1043)

Joncey told Haight she had sex with one of the men at the party appellant took her to that first night, and she didn't enjoy the sex, but liked getting the money. Joncey said another prostitute, Cinnamon, told her to

give appellant the money, Joncey didn't want to, told appellant it was her money, appellant hit, slapped and choked Joncey, took the money from her bra, and explaining all her money was his money. Appellant told Joncey that if she acted "like that," he could end up in jail, and Joncey cried and felt bad. Joncey said the next day, appellant apologized and took Joncey to Disneyland. Appellant introduced Joncey to street prostitution via the Figueroa track: he told her then rules and put her to work. Joncey told Haight she made up to $1,500/day, and worked seven days a week. She and other prostitutes also worked in Arizona, Washington D.C., New York, Florida and Nevada; appellant took her to buy false identification so she could fly. Haight talked to Joncey just after she'd been arrested, and Joncey indicated she was still working for appellant at the time of the interview: appellant's mother told Joncey appellant was in custody and needed money, so Joncey was to give her money to appellant's mother for appellant. The majority of the interview covered that first week Joncey worked for appellant. Joncey was fairly accurate in establishing the time frame of the sexual assault as being between November 1 and 30, 1998. (RT 6:1043-1054, 6:1056-1057, 6:1063-1064, 6:1069-1070)

Haight described Nikki's demeanor during her preliminary hearing testimony as "terrified": she was shaking, her breathing was rapid, she cried, and used her hair to cover her face. Her voice quivered and was high-pitched. When Unity testified at the preliminary hearing, she also seemed nervous/agitated, becoming uncooperative, her speech rapid. Joncey did not appear at the preliminary hearing: the detective was unable to locate her after her release from the detention center. Haight promised to testify on Joncey's behalf in her most recent criminal case. None of the witnesses were completely cooperative, which is not unusual because prostitutes are afraid of their pimps. Their pimp is their protection, the person who disciplines them and acts as their family. Prostitutes tell police that it's the prostitute's fault that she's a prostitute; the detective has to explain it is not the prostitute's fault, they are victims. The length of time someone has been a prostitute affects their willingness to testify against a pimp: prostitutes are indoctrinated into "the game," and part of the game is learning their role and the pimp's role. (RT 3:639-646, 6:1064, 6:1073-1075)

"The game" is street-walking. The rules include a proscription against associating with anyone outside the game besides johns, or customers. The indoctrination process is aimed at fulfilling the needs of the prostitute: if she

wants love, the pimp provides it, if friendship, friendship, if clothes, clothes: this is the "hook." After the prostitute earns money or "pluck," the pimp praises the prostitute. If the prostitute does anything outside the rules — talks to another pimp, doesn't want to work, doesn't show up as scheduled — there's retribution, or discipline. Discipline can be either physical or psychological; the physical ranges from a slap to a shooting. Though the rules may vary slightly from pimp to pimp, the core rules remain the same. For example, the choosing rules include the maxim that a woman with a pimp cannot look at another pimp. If a prostitute makes eye contact with another pimp, that pimp has the right to talk to the prostitute and get her to work for him. If a pimp catches his prostitute talking to another pimp, he may beat her. (RT 3:646-649)

A track is an area of street prostitution; the main tracks in Los Angeles are the Figueroa corridor, Sunset Boulevard, Santa Monica Boulevard for men, Lincoln Boulevard, Sepulveda Boulevard, and San Fernando Road. Prostitutes on the track are usually supervised by their pimps. An "automatic" is a prostitute who can work without her pimp around because her pimp is not worried about losing her to another pimp. The indoctrinated prostitute gives the pimp all her money, some even bringing money when he is jailed. It is not uncommon for prostitutes to hold money back to be able to buy something for themselves, but the woman is subject to discipline if the pimp finds out. (RT 3:649-651, 4:732-733) It is difficult to get prostitutes out of the game: there is a high recidivism rate, and the longer someone's been a prostitute, the harder it is to get her to stop. (RT 3:652)

Appellant went to prison in 1993 and 1996, in 1997 for a parole violation, and in 1998 for being a felon in possession of a firearm. (RT 7:1124-1126)

Expert Testimony: Dr. Lois Lee

Dr. Lee has a PhD in social psychology and law degree, and is a member of the California State Bar. She is the founder of Children of the Night, the only program in North America specifically designed to provide intervention for child prostitutes. Children of the Night has a twenty-four hour hotline and an on-site school; the children range in age from eleven to seventeen, there are boys and girls, though mostly girls, and they are from all over the United States. Dr. Lee has researched prostitution and worked with prostitutes since 1973, has met thousands of prostitutes, spoken with

over one hundred pimps, and testified as an expert ten or twelve times. There was a 1985 CBS movie about Dr. Lee titled "Children of the Night." She is the author of several articles on female sexuality and her dissertation was published and documented by a Playboy documentary. She wrote a paper called "The Pimp" about pimping strategies which is used to train law enforcement, and teaches at the Police Academy. (RT 7:1127-1130)

According to Dr. Lee, there are twenty-two "tried and true" strategies used by pimps in recruiting and keeping prostitutes. Prostitution is "an apprenticeship program": a pimp will initially look for a young girl who is lonely, alienated, preferably sexually abused, who has no strong ties to the community or her family. She may be found on a bus bench late at night, at an arcade, a mall. School-age girls are accessible, the younger the prostitute, the more a customer will pay. A pimp will recruit a prostitute by giving her "the deep quiz," finding out what she cares about, and using that to keep her in the role of prostitute, as well as finding out if there will be any consequences to his pimping her. Recruitment strategies may involve taking the girl to dinner, buying her clothes, "sweet talking" her, telling her the world only wants sex from her, as proven by previous sexual abuse by family members. Other men on the street may proposition her, and the pimp will set himself apart by not sexually abusing her, but by using sex as a reward, or by having unprotected sex with her while insisting her prostitution partners use condoms. Non-consensual sex may also be used as a punishment, as a humiliation tactic. A pimp may sexually initiate an inexperienced girl. Prostitution is presented as a solution to a temporary problem, such as a need for money or protection. The pimp will tell each prostitute he loves her the most for a different reason, and that the particular reason cited is the most important reason, thus ensuring the women will compete according to his expectations. (RT 7:1130-1133, 7:1135-1138)

The more successful the pimp, the more prostitutes he has. Opposite types are paired to ensure competition within the team, and between teams. The woman can talk to other prostitutes, but never about her pimp. There is a "degradation ritual": pimps punish prostitutes via sex or a "pimp stick," typically a heated coat hanger used to hit the backs of the legs. Punishment is meted out for acting outside the pimp's control: the pimp may feel he needs to guarantee the prostitute will not leave, will not inform on him, will not choose another pimp. Violence is a common tactic, as is violence followed by love-making, which confuses the prostitute. Prostitutes are typically afraid to

leave their pimp because there are not many places to go: they may run into another pimp at a homeless shelter or be arrested by police, and battered women's shelters won't accept them for fear of pimp retribution. Saving money is considered stealing from the pimp, and other prostitutes will tell if one is skimming. (RT 7:1132-1134)

Prostitutes are told to deny there are pimps to police, though 99% of street prostitutes in Los Angeles have pimps. Pimps may show up in street situations, and may bail out his prostitutes if he has the resources to do so. The longer a woman prostitutes, the more invested she is in the competition with other, younger, prostitutes. Pimp-prostitute relationships mirror traditional marriages by having well-defined male and female roles. Pimps usually respect and admire women who know the rules of the game and do not allow other men to exploit them. One hundred percent of all pimp and prostitute relationship are based on mistrust: pimping is a "con game." (RT 7:1134, 7:1148-1151)

A girl may like her pimp, see him as a rescuer from other abusers. Girls refer to their pimps as "daddy," the other prostitutes as "sisters-in-law," the pimp and other prostitutes are a "family." A prostitute may be intimidated by a pimp; pimps sometimes work together to use each other's prostitutes as an example to other women. A prostitute might seek a police officer's help, depending on the officer and the incident. It would not be unusual for a pimp to pick up a sixteen-year-old girl at a bus stop, spend two days with him, and be afraid to work as a prostitute. The two-day period would be a time of strategically introducing the girl to prostitution, an introduction which could include marijuana or alcohol use. Taking the girl out of state would not be unusual and would increase her dependence on the pimp. The girl might then be terrified to testify against the pimp because of his friends on the street who would seek retribution. Nobody likes a snitch. (RT 7:1138-1142)

It also would not be unusual for someone who had worked as a prostitute from eleven years old to seventeen years old to be working on "automatic," under less supervision: the pimp may stage performances to ensure her continued compliance, such has having the girl think she's killed someone, the pimp telling her he's paid a large sum of money to protect her, so she has to work for him until it's paid back, or else he'll turn her over to the police. A prostitute may continue giving money to an incarcerated pimp because she loves him or believes she will be hurt by others still out on the street. It would be common for a prostitute to deny she has a pimp, and to

say she enjoys prostitution: this is "denial of responsibility," the pimp denying responsibility for the woman's prostitution. Many prostitutes will never testify against their pimps for fear of retribution against them or their families. Similarly, a prostitute may recant prior testimony against the pimp, or lie to police about how long she's prostituted, for fear of community disapproval or other criminal penalties. (RT 7:1142-1146)

It is not uncommon for a woman to continue prostituting even after she has testified she hates prostituting: without adequate resources or alternatives, such a woman sees herself as locked in. A woman may be embarrassed about her prostitution, even after some years as a prostitute. Having a pimp baby is the best way out of prostitution, having a trick baby is not afforded the same status. (RT 7:1146-1148)

Defense Case

Michaelia is appellant's cousin; Michaelia lives in New Orleans, where she owns a contracting company. Appellant has visited his cousin several times. The second week of April 2001, appellant came to work with Michaelia's company: he worked for her three or four times during that period. There was a brief overlap where Michaelia was in Los Angeles while appellant was in New Orleans, but Michaelia returned the following week and had a birthday seafood boil at her home which appellant attended. (RT 6:1036-1042)

Appellant is the father of Katie's eight-year-old grandson. Until 2002, the family celebrated Katie's grandson's birthday every year around July 5th, combining the birthday with a Fourth of July barbeque at appellant's grandmother's house. The 2001 celebration took place on the July 4th weekend: it was a big party, the streets were blocked off in the neighborhood, and everyone came to the barbeque. When Katie arrived at 1:00 p.m., appellant was already at the party, putting meat on the grill. Appellant stayed until Katie left, at 11:30 or 12:00 that night; everyone stayed in the front of the house, having drinks, fixing plates and tending the grill. Appellant and Katie's daughter "were arguing up and down the street" about the party. (RT 7:1198-1203, 7:1205, 7:1207-1209)

Chris is appellant's uncle. Chris visits with appellant's grandmother and her husband frequently, sometimes once a week, sometimes three or four times a day. He also visits appellant's mother. The family has a Fourth of July celebration every year at appellant's mother's house: it's a big party, with

fireworks and as many as two hundred guests. Appellant has been at the celebrations, but Chris could not specify which years. (RT 7:1220-1227)

Suze is Nikki's mother: when Nikki was a teenager, Suze told Nikki's principal that Nikki was a habitual liar and a drama queen. Nikki lied about abuse, and thought she saw humans with bird heads. According to Nikki's mother, at the time of her testimony at the preliminary hearing and trial, Nikki no longer lies: from her participation in the Dorothy Brown School, counseling, and getting off medication, Nikki is "a new person." While Nikki was at the school, a bus would sometimes pick her up, and Nikki would sometimes miss school. Suze found out "later" that Nikki had been prostituting. (RT 7:1168-1170, 7:1172, 7:1174-1179) The school principal recalled Nikki missed school, but never four months at a time; she may have missed fifteen consecutive days in March 2003, when she was pregnant, in addition to shorter periods of time before her pregnancy. No special school bus is sent to pick up students, though Nikki sometimes came to school on a bus. (RT 7:1181-1186, 7:1189-1191)

A senior investigator for America West Airlines testified appellant was on flights from Los Angeles to Phoenix, then Phoenix to New Orleans on April 12, 2001. On May 2, 2001, appellant was flying from New Orleans back to Los Angeles. Both flights were stand-by, "guest passes," or free flights given him by an unidentified airline employee. (RT 5:933-949)

Appellant's parole officer testified appellant's Penal Code section 969, subdivision (b) packet indicated appellant was arrested on January 16, 1998, was sent to state prison on April 14, and paroled on February 26, 1999. He was re-arrested on November 24, 1999, released after a parole hold was placed on him on April 22, 2000, and re-arrested again on August 31, 2000. He was released on February 28, 2001, and discharged from parole on January 22, 2003. (RT 7:1230, 7:1233-1246)

Detective Munoz testified Nikki told him that appellant treated her "nice," "typically as a woman," for the first two weeks of their relationship. Appellant's behavior changed after he asked her to start prostituting: appellant turned into a "gorilla pimp," a pimp who uses force and fear to make sure his prostitutes stay in line. Nikki told the officers appellant took her to work in Pasadena, Phoenix, Las Vegas, and Austin, Texas. She saved $1,200 while working for appellant, saying she made about $800 a night, and would hide $150 to $200 each night in her vagina when out of town and in stash spots on the street when in Los Angeles. Appellant once confronted Nikki about

$1,200, and she said she was saving the money in case he needed bail. According to Nikki, appellant bought her explanation. Nikki said appellant beat her on occasion, but did not say he beat her on this occasion. Nikki told the detective she wanted to quit working for appellant, and wanted to quit prostitution, but that appellant would hurt her if she tried to leave. She said appellant also threatened her mother and grandmother, once pulled a knife on her when she threatened to go, and beat her when she tried to leave. Appellant beat Nikki with a "pimp stick," coat hangers and a baseball bat. A "pimp stick" is any device used to control prostitutes with force/fear, and can inflict substantial injuries. Nikki said appellant raped her and forced her to have oral sex on several occasions, and would beat her when she refused sex; appellant also did not feel he had to use a condom, unlike the street johns. Nikki told detectives appellant sometimes put a pillow over her face to suffocate her while raping her. Nikki said she also had consensual sex with appellant a couple of times a week: the forced sex mostly happened at the Magic Carpet Hotel. Nikki tried to escape from appellant on about forty different occasions by imploring a cab driver to take her away, but appellant would purse the cab, take her back and beat her. (RT 5:966-983)

Alejandra Sampson is a Los Angeles police officer; on November 6, 2002, she was working with a partner, Officer Shaun King, on 69th and Figueroa. They transported Nikki to the station that night, where King interviewed her. King testified he warned Nikki about loitering for prostitution while she was on the street, and interviewed her about a pimping investigation. On the street, Nikki said she had no pimp; she was looking around, seemingly frightened. King and Sampson were in uniform at the time. Nikki said she was afraid someone would see her talking to police and tell Mac-Bone. King said they'd do their best to help protect her; she said she was scared she'd "get beat." Two black men walked by, Nikki said one was Mac-Bone's cousin, and he'd tell appellant. Nikki pleaded with the officers not to talk to her. King continued talking, and Nikki said she wanted out of the lifestyle. (RT 7:1248-1276)

Nikki was cooperative about being transported to the station. During the interview, she said she'd been working for Mac-Bone for about a month or a month and a half, that she'd worked for another pimp before appellant, and Mac-Bone had approached her, telling her he would not beat her like her previous pimp. Appellant said he would protect her on the street and give her a place to stay; he put her up at the Magic Carpet Motel, with four

or five other prostitutes, some of whom were underage. If the women did not earn the money they were expected to earn, appellant would beat them. Nikki also said appellant had sex with the women, including those who were underage. She said the sex was forceful. Nikki told King she had tried to keep one young girl out of the lifestyle, and appellant beat her when he found out. King arrested Nikki for prostitution on March 8, 2004. (RT 7:1277-1302, 7:1304-1307)

Officer Ruben Lopez was working vice on December 7, 2003; he stopped Nikki after seeing her enter and exit a car: he recognized Nikki from a previous arrest. Nikki told Lopez she was working as a prostitute to make money for Christmas. (RT 8:1311-1314, 8:1350)

# STATEMENT OF FACTS

## Prosecution Case

On October 16, 1998, a woman called 911; according to the dispatcher, the caller was crying, screaming, "pleading for her life." The woman said she'd been tied up and raped, and had struggled to the phone, dialing with her tongue. The caller was afraid her assailant would return; she did not say she'd been smoking crack or losing consciousness. Units were subsequently dispatched to the location. (RT 2:1208-1215)

One of the Compton patrol officers who responded to the radio call heard a woman crying inside the home. She unlocked the door with her feet, and the police entered the house. The woman was laying on the living room floor, wearing only a white blouse, her knees and ankles bound with tightly knotted bed sheets. Her elbows and wrists were bound behind her back. Her mouth was gagged with a piece of bed sheet and bound with duct tape, wrapped around the back of her head. She was crying. (RT 2:1217-1224, 2:1227-1231) The officer untied the woman, cutting the duct tape out of her hair. (RT 2:1225) There were cut up bed sheets and a pair of scissors on the floor next to the woman. Police recovered crack cocaine pipes, a hypodermic needle, an empty Ziploc baggie with cocaine residue, and an unwrapped condom from the bedroom next to the living room. The condom was on top of the bed; the other items were on top of the dresser. (RT 2:1233-1237, 2:1244-1245, 2:1247, 2:1249) They found an elderly woman in another bedroom, who said she'd been sleeping. (RT 2:1238, 2:1246)

As another patrol unit was dispatched to the house, they saw a red Nissan matching the description of the suspect's car. The unit gave chase; a few seconds and a hundred yards away, they found the car crashed and empty. Appellant was the registered owner. Shortly thereafter, the officers learned appellant had been arrested. (RT 2:1254-1269)

The preliminary hearing testimony of Virginia was read. Virginia testified that at 11:30 p.m., on October 15, 1998, she was at home when her manager came in and told her there was "some business" outside: Virginia provides sex for money. She went outside, and the manager indicated a red Nissan. Appellant was driving. Virginia got in the car and they drove to appellant's house, agreeing on a price of $50, half of the money before, half after. There was no mention of bondage sex. (RT 2:1270-1274, 2:1281-1283)

47

Once inside, they went into appellant's bedroom; he gave her $25, and they sat for a while, watching TV, doing cocaine, and drinking small bottles of wine. Appellant orally copulated Virginia, then told her he had to leave and get some crack. She waited for him, drinking and dozing off. When she awoke, appellant was squatting over her. She was bound, her hands taped together in front of her, her legs spread apart and taped to the bottom bed board. She was wearing her bra, but her pants and panties had been removed. She had not agreed to be tied up. Virginia asked appellant what he was doing. He said, "You're fixing to get raped." Virginia had dozed off twice before appellant left; he asked her if she was tired, she told him she was sick. (RT 2:1274-1276, 2:1284-1288)

Appellant taped Virginia's mouth. He would get up periodically, seemingly nervous, taking hits of cocaine. He digitally penetrated her three times, and "felt" her. He removed the tape so that Virginia could orally copulate him. He orally copulated her. He was "very rough," pulling her hair. At one point, Virginia said that he didn't have to do this, that all he had to do was ask her, even if he didn't have money to pay. Appellant said he didn't care. He told her "ask Keisha. She's done it before." (RT 2:1277-1280, 2:1289-1290, 2:1295-1298) After he was finished, appellant left, telling Virginia not to try to get away. She got one hand free, and rolled and scooted to the phone, dialing 911 with her tongue. As she moved across the floor, she saw a little old lady standing in the next room. She asked the woman for help, saying appellant was raping her. The old woman ran back to bed. Virginia had never met appellant before that night: she didn't notice anything unusual about appellant's penis or scrotum. (RT 2:1280-1284, 2:1291-1295, 2:1298)

Virginia was starting to withdraw from heroin that night, and was nodding/dozing on and off throughout the incident. She had three 12-oz bottles of Cisco before falling asleep. (RT 2:1285, 2:1287-1288)

It was stipulated that testimony that there was a shot fired in relation to the pursuit was irrelevant to the case, and that appellant did not have a gun and did not shoot or fire a gun. (RT 2:1239, 2:1270) It was also stipulated that Virginia testified at appellant's preliminary hearing on February 8, 1999, sometime after 1:30 p.m.; Virginia was pronounced dead on February 9, 1999 at 6:45 a.m. (RT 2:1299-1300/1500)

Evidence Code section 1108: M

On May 12, 1995, M lived a block away from appellant in Nickerson Gardens. She was then free-basing cocaine. That evening, M was at home

with her children when appellant came by to get his cocaine pipe. Appellant asked M if she wanted to go to his house to get high; she said she did, and later walked to appellant's house. (RT 3:1502-1505)

Once inside, M went into a bathroom. The lights went off. When they came back on, appellant had a knife at M's throat. He told her to undress; she refused. After some back and forth, appellant threatened to "do it" to M's 13-year-old daughter, D. M agreed to undress, and appellant threw her onto a mattress in a bedroom. He tied M's hands behind her back, tied her legs and ankles, and gagged and taped her mouth. Appellant orally copulated M, had her orally copulate him, then vaginally penetrated her. He asked M how would she like him to do that to her daughter. She said to leave her daughter alone. (RT 3:1504-1508, 3:1512)

Appellant told M to call D and tell her to bring M some money. He said he would kill her if she didn't get D to come.[1] When D arrived, at about 11 p.m., appellant pulled her inside. M heard D screaming, "Mommy, Mommy." Appellant put a knife to D's throat and told her to undress. He threw D naked onto the mattress next to M, who was still bound. M watched appellant rape her daughter. Appellant next took M and D into another room, saying he would kill them if they didn't cooperate. He went back and forth between M and D. the rest of the night. He also vaginally penetrated M in front of D as he touched D; D turned her back. At some point, appellant put a vibrator in D's vagina. He had her orally copulate him. D had never had sex before that night, and told appellant that it hurt. (RT 3:1509-1511, 3:1515-1519)

Appellant released the two at 8:30 or 9:00 a.m. M took D home, then went to her other daughter's preschool and told the teachers what happened. They called police. (RT 3:1511-1512, 3:1519-1520) D and M never met Virginia. (RT 3:1519-1520)

## Defense Case

Jeanmarie Klingenbeck is the public defender who represented appellant at the preliminary hearing. Virginia appeared to be "nodding off" during the proceedings: she would close her eyes, lower her head, then jerk herself awake. Virginia looked like she was under the influence of heroin. She seemed confused. Klingenbeck is not a drug recognition expert. (RT 3:1527-1539)

---

1 D testified that appellant called her and told her to bring money for her mother. (RT 3:1515)

Dr. Jorge Dubin is a surgeon/psychiatrist who has treated drug/ alcohol addicts. He reviewed Virginia's autopsy report, which indicated that the cause of death was a multiple drug overdose and interaction with methamphetamines, cocaine, heroin and morphine. Given Virginia was pronounced dead at 6:45 a.m. on February 9, 1999, her death came within 15 to 16 hours after her preliminary hearing testimony. According to Dubin, Virginia was a chronic drug user, specifically of heroin. The heroin metabolite stays in the system for about seven hours; if someone was nodding off, that would indicate they were under the influence. Someone under the influence can answer questions in a responsive manner. If someone is in a blackout, they could do things that they would not recall once sober: they might agree to something and not recall the agreement once sober. Drug combinations can exacerbate blackouts. (RT 3:1540-1546, 3:1548, 3:1553-1554) If someone ingested three bottles of 18% malt liquor and was using cocaine and heroin during a short period of time, and said they had a blackout, that would seem honest. (RT 3:1546-1547) Dr. Dubin could not say whether Virginia was under the influence during the preliminary hearing. (RT 3:1550-1552)

Appellant testified that he had committed the offenses against M and her daughter and felt terrible about it; he pled no contest to a 20-year sentence because he knew he was guilty. He did not plead guilty in the present case because he is not guilty. (RT 3:1803, 3:1823-1824, 3:1839-1840)

The first time appellant saw Virginia was outside a Mexican market when she wiped his windows for money. The next time, she was babysitting for a friend. A week or so later, appellant told his friend that he wanted to see her. They went to Keisha's apartment; when appellant went to pick up Virginia, he saw her talking to John Smith, who used to date (and beat) appellant's ex-, Bonita. (RT 3:1803-1806)

Appellant and Virginia agreed on a fee of $25 for bondage sex. In 1998, one could get a prostitute in Compton for a $5 hit of rock cocaine: the extra money offered here was because appellant wanted "something special." They stopped en route at a market and appellant bought Virginia a large bottle of peach Cisco and a pack of Salems. Once at appellant's house, they smoked some cocaine, Virginia drank Cisco, then "got sick," kept passing out. Appellant asked if she was okay, she said she needed her heroin outfit; appellant took her back to her van, she got her needle and drugs, and returned to appellant's home where she injected herself. (RT 3:1806-1809, 3:1816, 3:1819-1821, 3:1827-1828, 3:1832-1833, 3:1838-

1839) At some point, appellant left to find more heroin for Virginia because she kept nodding off. As he was driving back, he saw police cars parked at the corner; he weaved through them because he was on parole and had drugs on him. He rolled through a stop, turned, the police shot at him, and he took off. (RT 3:1811-1814, 3:1828-1830, 3:1833-1838)

Appellant did not orally copulate Virginia, she did not orally copulate him. Appellant was frightened of HIV; they ended up not doing anything because Virginia kept getting sick and needing more drugs. At the time, appellant shaved his pubic area; he had been stabbed once by his wife, and was visibly scarred. His scrotum is exceptionally large. (RT 3:1809-1811, 3:1815-1817, 3:1822, 3:1827) Appellant did not threaten to rape Virginia: there was no need, as he'd already paid her for sex. He never hit her. He couldn't have sat on top of her as she orally copulated him because he had a water bed and weighed about 200 pounds at the time. (RT 3:1811-1812, 3:1841-1842) If appellant referred to M as a bitch, it was not personal. To appellant, every woman is a bitch. (RT 3:1825-1826)

It was stipulated that appellant had been previously acquitted of assault with a deadly weapon upon a peace officer. (RT 3:1845)

Rebuttal

Officer Albert Archuleta interviewed appellant at the station on October 16, 1998; appellant had no problem understanding and waiving his rights, or providing a lengthy statement. He told Archuleta that he had made two trips to get Virginia heroin, and that she gave him her $25 fee back to buy the drugs. Appellant did not appear under the influence. (RT 3:1845-1851)

# STATEMENT OF FACTS

## Prosecution Case

Jane Doe #1 [Doe] is appellant's wife; at the time of trial, they had been married five years, and been together seven. They had three children together: CJ, KJ and TJ. Doe had two other children: Jane Doe #2 [Jane] and John Doe [John]. Jane and John spent every other weekend at their father's home; he picked them up Fridays between 6:30 and 7:00 p.m., and Doe picked them up in turn on Sundays around 6:00 p.m.. As of December 5, 2003, appellant's family was living in El Monte. Appellant's mother Hilda, her boyfriend, Jose, and Jose's brother Mario had also previously lived with the family.[1]3 (RT 714-716, 914-916, 1038-1039) Until October, 2003, Doe had been working as personnel coordinator, handling payroll and human resource. (RT 915-916)

During the first few years of their relationship, appellant had not been physically violent with Doe: he would throw or break things when they argued, but he never hit her. Appellant told Doe that he would rather break things than hit her. Appellant was psychologically abusive, telling Doe she was stupid, she didn't know how to speak, and she should take English classes. Appellant would get upset and begin to belittle Doe if she didn't use the right words or disagreed with appellant. (RT 916-917)

## Count 1 [Jane Doe #1] [2]

At some point in January, 2001, Doe took her children out of the house for a couple of hours because appellant was breaking things; she returned after he promised to change, saying he had an "upset problem" he needed to address. Appellant told Doe if she left again, he would kill her and have a "shoot-out" with police. (RT 918-919, 1040-1042, 1212-1213)

..................................

---

1 Jose moved out during the first week of July, 2003, after living there a year and a half to two years. Appellant's mother moved out in 2001, though she sometimes babysat for appellant and Doe, and was at the house on several occasions between November 11 and December 5, 2003. (RT 1039-1040)

2 Because of the number of counts, the Statement of Facts has been organized so each charged count acts as a heading to that recitation of fact; the end of each count is indicated by an ellipsis, after which the narrative resumes. Facts not included in the narrative (such as expert testimony) are separately labled. For the Court's convenience, the named victim(s) of each count has also been designated.

In November, 2003, Doe and appellant went on a weekend pheasant hunting trip, leaving Friday, the 7th, and returning Monday, the 10th.[3]5 When they returned, they found Doe's personal belongings from work had been sent to her; she'd quit her job on October 23rd after appellant taped Doe and Charles, a co-worker, talking on the telephone, and accused Doe of flirting with Charles. Doe denied having a sexual relationship with Charles,[4]6 but on the 24th, appellant told Doe she had to either quit her job or divorce appellant. Doe returned to work that day to finish the payroll. Upset, appellant came into her office looking for Charles and asking Doe if she'd "warned" Charles. Appellant asked Doe for Charles's home telephone number. Later, Doe went to get the three younger children from the babysitter; as she was talking to the sitter, appellant came in and told her Jane had tried to commit suicide. (RT 920-924, 946, 1042-1044, 1213-1217, 1273)

Appellant and Doe went to the hospital, and Doe stayed with her daughter. After the 23rd, Doe was not allowed to leave the house unless accompanied by appellant or his mother: appellant told her he was afraid she would get in touch with Charles if she was alone. Appellant also told Doe he would hire someone to hurt Charles. (RT 924-915) The day they returned from their hunting trip, appellant found a get well card Charles had given Doe; appellant did not believe Doe's explanation about the card, saying he wanted her to take a lie detector test. (RT 926-927) For the next several days, appellant continued to ask Doe about Charles, telling her he knew they'd had a relationship and she might as well tell him the truth. Finally, on the 12th, Doe took appellant into the garage and admitted she and Charles had been involved. Appellant became "really upset," called his godparents, told them Doe had cheated on him with Charles, and asked them to talk to Doe. (RT 927-931, 1288, 1296-1297)

Count 9 [Jane Doe #1]

Doe started talking to appellant's godfather; appellant went outside, then returned, said he wanted to die, and shot his .357 into the ceiling. He lowered the gun, and Doe took the weapon away from him and removed the

---

3 On cross-examination, Doe testified she was armed with a shotgun during the trip, but did not fire it. Appellant killed three pheasants. She had gone on other hunting trips with appellant, and had handled weapons before. (RT 1043, 1214, 1282-1283, 1307) A photograph taken during the November 7th trip depicted Doe in camouflage, holding a shotgun and a dead pheasant. Doe said she didn't kill the bird. (RT 1305-1307)

4 Doe began her affair with Charles in January, 2003; according to Doe, the affair lasted ten months. Appellant asked Doe previously if she'd been having an affair with Charles, and Doe had lied, denying the liaison, approximately five times. (RT 1216-1217)

bullets. She returned to the telephone, told appellant's godfather what had happened; after appellant talked to his godfather, appellant started to walk out of the garage, saying, "You should be thankful that I got these godfathers that can talk me out of things." (RT 927-931, 947, 1217-1220, 1303)

Count 6 [Jane Doe #1]

As appellant walked past Doe, he kicked her in the leg with his boots, leaving a laceration and large bruise on the back of her leg.[5]7 (RT 931, 1221-1222)

Counts 7, 8 and 10 [Jane Doe #1]

They went into the house; by this time, it was 5:00 to 6:00 p.m.. After the children went to bed, appellant called Doe into the living room and told her he wanted her to "feel his pain" over her relationship with Charles. Saying "I want you to feel what I feel," he took a folding knife, pinched the skin of her arm and put the knife through the folded skin so she would have a scar like his. Doe tried to grab the knife, cutting three of her fingers; appellant told her not to worry, she would not bleed to death as there were no major veins in that area. He put a sock on the cut, then got a first aid kit and cleaned and dressed the wound. (RT 931-935, 1224-1226, 1288) The next day, appellant began punching Doe in the arm and calling her a whore. (RT 936)

Counts 11, 12 and 13 [Jane Doe #1]

On Monday the 17th, around 9 or 10:00 a.m., Doe was cleaning the house: her youngest child was napping and the older ones were at school. Appellant asked Doe if she was ready for a whipping. He took her to the back bedroom, folded a brown leather belt, told her she was dirty, a whore, and deserved whipping. Appellant hit Doe on the back with the belt, asking her if it hurt. Doe said it did and to stop; appellant refused. After being struck in various places, Doe fell at the edge of the bed; appellant said, "Get up, bitch. Get up," and hit her again. Appellant struck Doe between six to ten times, bruising her back, legs, and butt. (RT 936-938)

Count 14 [Jane Doe #1]

The next day, appellant, holding a black belt and the brown belt, took Doe to the back bedroom and told her to take off her clothes. She did, appellant hit her with the brown belt on the legs and back, Doe cried and tried to block the blows with her hands and arms. Appellant told Doe he was going to use his "new" belt, folded the black belt and hit Doe on the back,

---

5 There was no photograph of this injury: all photographs were of Doe's injuries as of December 5th. (RT 1223-1224)

lower legs, and butt, four or five times. Appellant put the belt on the bed, pushed Doe onto the edge of the bed, told her to move to the middle, she did, he removed his clothes and had intercourse with her, saying, "Hold me, bitch. Act like if you like it." Doe laid there, crying and shivering. She did not want to have sex with appellant, though she did not let appellant know this because she was afraid.

……………………………………

After appellant ejaculated, he told Doe he was going to whip her more, and hit her four or five times on her lower legs and back. As he was doing so, the belt broke; appellant told Doe she'd broken his new belt. Doe received many bruises from the whipping, and had a belt mark on her upper left thigh at the time of trial. (RT 938-943, 1226-1229)

On the 19th and 20th, appellant constantly questioned Doe about the affair,[6]8 calling her a whore and a bitch and punching her on the arm, once or twice each time, leaving more bruises. (RT 944, 947)

Count 15 [Jane Doe #1]

On Friday, the 21st, at 3:00 or 4:00 p.m., appellant told Doe he wanted to know which motel she and Charles had used. Doe drove appellant to the Sierra Inn Motel; appellant wanted to know which room; Doe told him room 107; appellant became upset, called Doe a bitch and backhanded her in the chest. Doe lost her breath and fell forward, crying. Appellant said he didn't care if it hurt and punched her arm twice, causing bruises to the arm in addition to those on her chest. Appellant then had Doe drive home. (RT 947-951)

…………………………………

From November 21st until appellant's December 5th arrest, appellant hit Doe in upper arm once or twice every day except Sunday, when they went to church. He began hitting Doe in the face after she complained of the injuries to her arms, and so bruised her cheeks and "busted" her lips. Appellant may not have hit Doe on the 22nd as there was a Boy Scout event that day. (RT 968-972)

Counts 17, 18, 19 and 20 [Jane Doe #1]

---

6 A list of questions about Doe's relationships with Charles, found in appellant's 2003 day planner, was introduced. Calendar pages from October 2003 to December 2003 were also introduced: the entry for October 23 reads, "Planted my cassette recorder on phone," October 24th reads, "Hell begins." November 20th: "Beat [Doe]"; November 24th: "Beat [Doe]"; the entry for November 25th is a circled "B" and Doe's name. December 3rd reads, "Made agreement with [Jane]," and is marked with an asterisk and a heart. December 4th: "Nite Nite." All entries were in appellant's handwriting. (RT 1292-1296, 1302-1303)

On the 24th, appellant came home drunk around 5:00 p.m.. The children were in the front of the house and he and Doe were in back. Appellant took a nine-millimeter gun out of the gun safe underneath the bed, said, "You bitch. I want you to die. I want to kill you," and shot, once at the mattress and once at Doe, who was standing in front of the bed. (RT 951-960, 1230-1231) Appellant emptied the chamber, returned the gun, grabbed Doe, said she cheated on him, was dirty and a whore and he felt like throwing up. Appellant brought Doe to the bathroom, vomited, then took her by the neck, pinned her against the mirror and choked her. Doe was coughing, losing her breath; appellant said he wanted to kill her, then released her. (RT 960-962)

Count 22 and 23 [Jane Doe #1]

From November 24th to the 28th, appellant told Doe she should report Charles to the police for raping her. Doe refused. On December 1st, appellant told Doe that Jane had been molested by Charles once when Doe took Jane to work. Doe was shocked; appellant wanted to file a report against Charles, and told Doe to also report Charles for raping her, saying if it went to trial, the jury would believe Jane because of Doe's report. Appellant and Doe got Jane from school and took her to the Sheriff's Department, where she and Doe gave statements to the officers.[7][9] When Doe asked Jane about the molestation, Jane did not answer. Appellant said something to Doe about this being a way to make Charles "pay," and that Doe wasn't worth going to jail for. (RT 964-967, 1231-1232) On the 1st and 2nd, appellant hit Doe on the upper arm with his closed fist, and used his knuckles to hit her head, leaving bruises on the arms and bumps at the top of the head.[8] (RT 991-993, 1233-1234)

Count 24 [Jane Doe #1]

On Wednesday, December 3rd, appellant questioned Doe about the affair while they were in the garage office, asking her if oral sex was involved. Appellant became upset and punched Doe in the chest, bruising her; she fell back and began crying. He told her to get up, that he didn't care if it hurt because she was worth nothing, a whore, dirt, a bitch. Appellant asked Doe, "Why can't you be brave enough about your daughter? Why don't you commit suicide?" He opened his folding knife and told her, "Make sure that

---

7 Doe spoke to the officer alone for about fifteen minutes while appellant and Jane waited in the lobby; she did not say anything about appellant. (RT 1232-1233, 1238)

8 At the preliminary hearing, Doe testified she did not specifically remember what acts occurred on which date. (RT 1234)

you do it right, or – or if – if the paramedics come and they take you to the hospital, you better say that those bruises were done by two women that hit you." Doe didn't understand; appellant told her she was "so stupid that you wouldn't commit suicide the right way," and walked into the house. Doe became emotional, went inside, began talking to her children, became emotional again, but stopped when appellant entered the room. He asked her what she was doing there, she said she wanted to be with her kids, and he walked out. (RT 979-985)

................................

Doe went to the back bathroom, and found her daughters taking a shower; her oldest daughter asked her what was wrong, Doe, crying, said, "Oh, nothing. There's nothing wrong," and left the room. She returned to the bathroom ten or fifteen minutes later, and was talking to her daughter when appellant came in, said Doe was a bad mother and a whore, he was going to send Doe to a Christian home for a year, and Jane would become his wife. Previously, appellant had told Doe he wanted to have an affair with a co-worker for revenge, but he'd never mentioned Jane. Neither Doe or Jane believed what appellant was saying; appellant told Jane it would be okay, then took Doe to the bedroom and told her she had better tell Jane to do this or he would kill Doe. (RT 985-989)

Appellant took Jane into the bedroom to talk. When they came out of the bedroom, appellant told Doe she'd better tell Jane it was okay; Doe told Jane it was going to be okay, appellant echoed this, adding, "See, your mommy is not going to get mad." Appellant then kissed Jane on the mouth. (RT 990)

Counts 25 and 26 [Jane Doe #1]

The night of December 3rd , around 10:00 or 11:00 p.m., after the children were asleep, appellant had Doe sit on the living room couch as he punched her in the stomach six to ten times. Appellant told Doe he wanted her to feel pain, that she was dirt, a whore, and that he was not hitting her as he would hit Charles. After Doe repeatedly tried to block the blows with her hands, appellant got a pair of handcuffs, handcuffed her arms behind her back, returned her to the sofa and punched her in the stomach three to five times. Doe later had bruises on her arms and stomach. (RT 972-976, 979)

................................

On December 4th, appellant stayed home with the other four children and sent Doe to the mall with Jane to buy Jane some lingerie. Appellant told

Doe she could buy herself one as well. At the mall, Doe told Jane that "it" wasn't right, adding she had no idea what appellant had said to Jane earlier.[9] Doe did not attempt to get help because she was afraid appellant would hurt her children and the rest of her family. (RT 994-998, 1240) Appellant had Doe and Jane model the lingerie for him that evening as he sat on the bed with the sixteen-month old, giving the baby to Jane as he caressed Doe, then telling Doe to take the baby and Jane to stand in front of the bed.

Count 30 [Jane Doe #2]

Appellant touched Jane's breasts for a minute, then told Doe and Jane to change. At some point, appellant said he wanted to sleep with Jane, which Doe understood to mean he wanted to have sex with her. (RT 998-1001, 1022, 1242-1244, 1289)

Count 27 [Jane Doe #1]

At 10:00 or 11:00 p.m. on December 4th, appellant and Doe were in the living room; the children were asleep. Appellant told Doe the agreement with Jane was that she was to be "a full wife," and he would have intercourse with her. Appellant then hit Doe in the stomach, said, "Oh, I know what I'm going to use," went to the garage, returned with a stun gun, and used it on Doe's legs. When he shocked Doe, her legs went up, he asked if it hurt, and Doe said yes. Appellant shocked Doe six to ten times on each leg, leaving "electrical shock dots"; at some point, appellant gave Doe a blanket to bite on, stopping the shocks when Doe said she was urinating on herself. (RT 1002-1006, 1021)

Counts 28 and 29 [Jane Doe #1]

Appellant told Doe to change; afterwards, he had her remove her pants and underwear, and inserted a mag flashlight twice into Doe's vagina. After the first insertion, appellant said "This is how much it went in," indicating an inch and a half. Appellant said he was going to put the flashlight further in, reinserted and removed the flashlight, indicating it had penetrated about twice as far the second time. Doe told appellant after the first insertion that it hurt and asked him not to do it again; appellant said he didn't care. She yelled during the second insertion because of the pain. (RT 1006-1010, 1012, 1286-1287) On redirect, Doe remembered that after appellant removed the flashlight the second time, he told her she was bad, a bitch/whore, and

---

9 On cross-examination, Doe repeatedly testified she did not tell Jane to sleep with appellant to keep the family together; when asked what she would say if her daughter testified to this effect, Doe remembered she had, in fact, said this to Jane. (RT 1241-1242)

tapped the top of her vagina with the flashlight. That night she slept in the back bedroom with the rest of the children while Jane slept in the middle bedroom with appellant. Appellant told Doe he wanted to "sleep" with Jane that night, but did not say he wanted to have sex with her. (RT 1290-1291, 1304)

## Count 33 [Jane Doe #1]

On December 5th, at about 10:00 a.m., appellant came into the back bedroom and told Doe he did not love her anymore because she was a cheater, whore and dirt. He backhanded her across the face, she fell on the floor in a fetal position, crying. He said, "Get up, bitch," she said she was hurt, he said he didn't care, kicked her in the tailbone with his boots, and picked her up by her hair. Looking at Doe's face, appellant noted she was going to get a nice bruise from the hit. He told Doe to go into the living room, where he asked her where she wanted to go with their relationship. (RT 1012-1014, 1034-1035)

....................................

Doe said that as appellant obviously didn't love her anymore, why didn't they get a divorce. Appellant told Doe he'd let her keep the three littlest children, and she said she'd take her two oldest ones to her mother's house. Appellant told Doe to "get the fuck out of here," went into the back room and laid down with the three sleeping children. Doe went to the middle bedroom and began packing; appellant came into the room, asked her what she thought she was doing, and told her she was not going anywhere. He took her back to the living room and had her kneel in front of him, telling her, "You are going to do everything that I tell you to do. You are nothing. You are dirt." He then told her to bark like a dog; she did. He said, no, act like a cat; she did. He said no, not like that, to use her hands like a cat; she did. He kicked her in the chest, she fell back and refused to get up, he said she was an object, like dirt, and he was going to sweep the floor with her: he grabbed her clothes from her chest and stomach, swept her to the front of the room and let her go. (RT 1014-1017)

Appellant asked Doe why she was crying, she said her body hurt, she had a headache, he asked her if she wanted something for her headache, she took some Advil, he told her to sit down, asked what she wanted to do, she said watch television. Around 11:15, the telephone rang. Appellant answered, said something about bruises, and told the caller his wife had been in a fight with two women. He mentioned Doe's niece, M. As appellant

was talking, he opened the front door and walked downstairs. Doe peeked out and saw a police car; she became nervous because appellant told her if the police came for him, he would kill her, and that he was smarter than the police because he knew about explosives. (RT 1017-1019, 1246)

Doe's niece had called Doe that day because she and her family were concerned that they hadn't heard from Doe for some time; she talked to Doe, and Doe asked to borrow some money. Doe and appellant had decided to borrow from M to pay their mortgage: they were low on funds because Doe had quit her job and appellant was no longer working as a journeyman electrician. Doe did not ask Poole to take her to the police or to a hospital because she was afraid. (RT 1019, 1223-1224, 1238-1239, 1289) M arranged to meet Doe at a bank in Pasadena, they met about 5:00 p.m.; Doe was crying and shaking. After M and Doe had the loan notarized, they went to the parking lot, where Doe told M what had been happening. Doe was hysterical. M took Doe to a gas station, bought a disposable camera, and photographed Doe's injuries.[10] Doe had bruises "all over her body." Poole told Doe she would go to the police with the evidence; after Doe left, M and her family had the photographs developed at a drugstore and took them to the police station, talking to an officer between 10:00 and 10:30 p.m.. (RT 904-910, 912-913) M's family then went to appellant's house afterwards, waiting until police allowed them entry. Doe was shaky, scared, and happy to see them. (RT 910-912)

As a day-to-day matter, from November 11th until December 1st, Doe would sometimes drive her children to school without appellant. She had her own car, and keys to that car. On November 24th, appellant was out of the house for a few hours, drinking. Appellant slept at night, and there was a telephone in the house, though Doe testified she could not use the telephone even while appellant was sleeping; when appellant was awake, he would listen to Doe's calls on an extension. When appellant left the house, his mother would be there: of the twenty five days at issue, appellant's

---

10 Later, police photographed the injuries. (RT 1021, 1024) Doe identified these photographs, detailing injuries variously described as "bruises on top of bruises" on her left arm, defensive bruises, bruises on her left forearm, bruises on her right arm, bruises on her legs, other leg injuries caused by appellant's belts (scars at the time of trial), kicking and his taser gun, head injuries, an injury to the eye, and "busted lips" from a slap and a backhand hit. Doe could not move her left arm for two to three weeks after appellant's arrest; her leg wound took about three weeks to heal, though the area was still "hard" at the time of trial. (RT 1024-1038, 1297-1300)

mother was present eight to ten days, during the day.[11] During this time, Doe made no attempt to contact police, to appraise family members of what was happening, or to send her oldest children to their father for safekeeping. Doe said some or all of her children were home during the charged events, thought none of them saw what occurred. Two of the recovered weapons were registered to Doe, the 9-millimeter and one of the shotguns; she'd taken classes in using the 9-millimeter gun, and had gone with appellant to a firing range to shoot. (RT 1235-1238, 1244-1246, 1272-1273, 1280-1282, 1301-1302)

By December 5th, Doe was angry with appellant: he'd made her quit her job, ended her affair with Charles, wasn't working himself, and put her in a position where she had to borrow money from her niece. She did not, however, report appellant to police to exact revenge. (RT 1256-1259) She loved appellant. (RT 1300)

Count 2 and 3 [John Doe and Jane Doe #2]

One day[12] while in the living room, appellant accused John of taking money from his wallet. John said he hadn't stolen the money; after repeated accusations/denials, John said, "Maybe it's my sister." Appellant told John to put a shirt under his shirt, saying, "When I shoot you, I want you to pretend to cry. And then she will say that she did it." Jane came by, and appellant asked her if she'd taken his money; she said she hadn't, but "Daniel" had stolen some. Appellant then told John to take off the shirts and sit on the sofa. John and Jane sat on the sofa and John said he'd taken some quarters from a change jar, but that was all. Appellant brought out Kurt's B.B. gun, pumped it once, and asked John again if he'd taken money from his wallet. John said no, appellant shot John six or seven times in the stomach, John told appellant to stop, but appellant did not. John cried while being shot, and has scars from the shooting. Appellant shot Jane two or three times in the knee, making her cry. Jane told appellant to stop, she hadn't stolen his money. John and Jane's six-year-old brother Rocky came into the room; appellant pointed the gun at Rocky and asked if he'd stolen money from appellant's wallet; Rocky cried and said no. (RT 717-721, 723-724, 731-732, 736-737)

---

11 Doe said she told appellant's mother he was hitting her with a belt, and showed her the bruises; she also told his mother she was afraid for her life. Appellant's mother told Doe not to worry, he would not do anything to her, and to do as she was told. (RT 1272-1273)

12 John could not remember when this happened; on cross-examination, he said Rocky was five at the time. (RT 729-730)

Jane testified the incident took place between July and August, 2003; both John and her seven-year old brother were on a living room couch; appellant said he wanted to talk to her, and asked her and her brothers if they'd taken money from his wallet. Appellant started shooting at John, John jumped, began crying and saying he didn't steal the money. Appellant told John he didn't believe him, and shot him again.[13] Jane started crying, appellant said she was probably crying because John was being punished for something she did, and shot at her. Jane said she did not take the money; appellant shot John about six times, pumping the gun between shots, hitting John's shins, upper right thigh, arm and ribs. Appellant hit Jane's shins and her upper right thigh, then turned to Rocky and told him if he was stealing, appellant would shoot at him. Rocky said he wasn't stealing; appellant pointed the gun at Rocky, but did not shoot. (RT 1339-1345, 1347, 1535-1537) Though the shooting hurt, Jane did not receive any permanent injuries, just bumps where the pellets skidded on her shins. (RT 1345-1347)

...............................

After shooting John and Jane, appellant put mace on John's face, spraying a Q-tip and putting the Q-tip under John's eyelid; it did not hurt because the mace was too old. John did not say anything about the mace before trial because he "forgot that it happened." No one else was left in the room at the time. (RT 722-723, 727-729, 734-736, 738) John did not tell his mother about the B.B. gun incident, or show his scars to her. He did not tell anyone about the extra shirts, or the plan to fool his sister, until he testified. (RT 733, 737) Appellant usually punished the children by throwing something, such as a plastic chair, at them or hitting them. When appellant was mad, he would throw his black flashlight at the wall or the television. (RT 1348-1349)

One day after school, appellant told Jane her mother was having an affair: he said he was going to get a divorce and take Jane's sisters and brothers away from her and her mother. Jane went to be back room, got some glass from a sliding door appellant had broken, and cut her wrist. She did not want to kill herself, just "not to hurt anymore." Appellant called the ambulance and Jane went to the hospital. (RT 1349-1351)

On December 3rd, Jane was combing her hair after taking a shower when appellant and Doe came into the room; appellant told Jane he and

---

13 On cross-examination, Jane said she did not see John get shot in the stomach; she saw him put on an extra shirt, but did not see him take it off, or hear appellant tell him to take it off. (RT 1536-1537)

Doe had agreed he would take Jane's virginity. Doe did not speak. Jane was shocked, and asked appellant if he was joking; he said he wasn't, and asked Jane if she wanted time alone with Doe so Doe could reassure Jane daughter that she was in agreement. Jane and Doe went to the back room, Jane asked Doe if Doe really agreed, Doe paused and nodded. Doe said the agreement would keep appellant from going with another woman while she was "in the home." Jane thought Doe seemed forced to agree: Jane had never seen appellant hurt Doe, but had heard them arguing, had heard him hit her a few times, and had heard Doe fall to the ground. (RT 1352-1356, 1538, 1540-1543) Appellant came in the room, Doe left, and appellant told Jane that Doe was going to a Christian home for a year, during which time Jane would act as appellant's wife. Jane didn't say anything, but felt disgusted. (RT 1354-1355, 1503, 1540-1541) Appellant told Jane she had to kiss him in front of Doe to show that she agreed to the agreement; Doe returned to the room, and said if Jane didn't kiss appellant, the agreement would be broken and Jane would separate the family. This scared Jane, who then agreed to the agreement. Appellant kissed Jane, putting his tongue inside her mouth. She pushed him away. (RT 1504-1506)

Count 30 [Jane Doe #2

When Jane came home from school on December 4th, appellant said she and her mother were going to buy lingerie. They did; Jane thought if they didn't comply, appellant would take away her brothers. Jane did not confront her mother during the shopping trip because she "didn't feel comfortable talking about it." At some point, Doe told Jane she was going to stay with appellant for four years until Jane finished high school, then they all would move away. Doe said she did not feel comfortable taking Jane to buy the lingerie. When they returned, appellant told them to try on the lingerie after dinner. Jane finished eating, put on the lingerie, and went into the back room to find appellant laying on the bed. Doe was also on the bed, also wearing her new lingerie.[14] Jane testified her youngest sister was not there. Jane stood in front of the bed, and appellant rubbed and squeezed her right breast. He told her to change back into her clothes, and as she walked out of the room, noted she had a "nice ass" for the shorts. (RT 1509-1513, 1543-1544, 1546, 1549-1550)

---

14 Jane noticed bruises on Doe's arms and legs; she did not ask Doe where they'd come from. Doe was limping. (RT 1514, 1522, 1550)

After Jane changed, appellant told her that he wanted to sleep with her that night. Jane felt "weird and disgusted," but didn't say anything. She finished her homework, and was laying down with her little sister when appellant told her to put on the lingerie. She changed, got into the bed usually used by appellant and Doe, and covered her face with a blanket. (RT 1514-1517) Appellant came to the bed, removed his shirt and boxers, and told Jane to take off her top; she did not, he got mad, saying she was not cooperating, she removed the top, laying on her side and covering herself with the blanket. Appellant hugged Jane from behind, and she felt his penis and pubic hair on her butt. He rubbed her breast, and kissed her back. Jane fell asleep. She woke up at some point during the night, put her top back on, peeked in on her sleeping mother and siblings, and went back to bed with appellant. (RT 1517-1521, 1535) At school the next day, Jane did not tell anyone what happened. (RT 1521)

Count 32 [Jane Doe #2]

After Doe left to meet Myra on December 5th, appellant told Jane he wanted to have sex with her. She did not respond. Appellant told Jane's brothers to stay in the living room and watch a movie, and told Jane to go to the back room and undress. Jane thought appellant would hit her if she did not comply; she went back and took off her pants and shirt. Appellant came in and became angry, saying she had to remove all her clothes. Jane told appellant she had her period, appellant said that was okay, it would be easier for his penis to go in because blood was a natural lubricant. Jane said she would leak on the bed; appellant got a green towel and put it on top of the bed. Jane removed her bra and underwear, appellant pushed her on the bed, climbed on top of her and put his penis in her vagina. Jane began crying, told appellant it hurt, and repeatedly asked him to stop. Appellant said to wait because he was not finished. Five to ten minutes later, appellant took his penis out of Jane's vagina and wiped her with a couple of baby wipes. As Jane got her clothes, appellant "smirked," and said, "We just moved on a step." Appellant told Jane not to worry about getting pregnant because he "tied his tubes." Afterwards, Jane's legs hurt, she couldn't walk straight, and it burned when she went to the bathroom. (RT 972, 1522-1529)

Count 31 [Jane Doe #2]

Shortly thereafter, appellant took Jane into his office, unzipped his pants, took out his penis, grabbed Jane's hand and made her grab his penis

and testicles. Appellant told Jane it was all right because "it" was clean. (RT 1529-1533)

......................................

Jane was fourteen years old in November and December, 2003; she and her brother John were picked up by her father from appellant's house around 6:00 p.m. on the 5th, and never returned. Jane did not tell her father what happened until the next day because she didn't know how he would respond. Her father took her to the police, and she was subsequently examined by a nurse. (RT 1335-1338, 1533-1534) Appellant never threatened Jane with physical harm. (RT 1547)

Counts 42 and 43 [Charles]

On December 2, 2003, appellant picked Jane up from school, took her to his office and told her Doe's co-worker/paramour had raped Doe. Appellant said he wanted to put the man in jail and was going to take Doe and Jane to the police station to file a report; he said he wanted Jane to lie and accuse the man of molesting her. Jane said she didn't want to, but appellant threatened her with separating the family, saying he was going to take her brothers and sisters away from her and her mother. (RT 1506-1508) Jane then agreed to file the false report; she went in the living room with appellant and told Doe she'd been molested. The three of them went to the police station and gave their statements. (RT 1508-1509, 1538-1539, 1548-1549)

Count 44 [Charles]

Charles worked with Doe. On October 24, 2003, appellant called Charles four times, saying he was going to "get" Charles anywhere he saw him, he was going to hit him, he was "going to do something where it would hurt me the most, with my family," and he "played pretty hard." Charles did not answer the telephone after that, but was afraid: he thought appellant would hurt him because of his affair with Doe.[15] Charles stopped parking his car in the public lot and began parking inside the company; on two occasions, people at work told Charles appellant had come by and videotaped Charles's car.[16] Charles did not see appellant at work. (RT 754-758, 760-766, 768, 770-774) At some point, Charles was called to the Sheriff's station and questioned

---

15 Charles testified the affair lasted two years. (RT 765)

16 Davido also worked with Charles and Doe: he testified he once saw appellant videotaping Charles's car at work for twenty or thirty seconds. He didn't remember when this occurred as he "didn't give it any importance" because "a lot of people go in and out of there." (RT 1261-1265) It was stipulated the car seen by Davido was Charles's car. (RT 1570)

about allegations he'd raped Doe and Jane; Charles never raped either one. (RT 759, 765-766)

Count 4 and 5 [Jose]

For about two years, Jose rented the front bedroom in appellant's home while Jose was dating appellant's mother. Jose was asked to leave in July or August, 2003; just before being asked to leave, Jose picked up appellant's wallet from the top of a living room shelf. Jose started to take the wallet into his room, to take five or ten dollars for cigarettes. Jose did not have permission to take either money or wallet. When Jose opened the wallet, it exploded "like when you burn a little firecracker." Jose was not hurt by the explosion. (RT 741-748) During Jose's initial police interview, Jose first said he knew nothing about the wallet or any explosion, then said all he knew was what he'd read in the newspaper, changing his story after the officer indicated scientific tests could be done to find out what happened. (RT 749-751)

Counts 34, 35, 36, 37, 38, 39, 40 and 41 [Weapons Counts]

On December 5, 2003, patrol officers responded to the house, arresting appellant outside. After appellant was transported to the station, an officer approached Doe, who began to shake and cry. (RT 668-670, 1246) The officer and Doe went inside, after calming down,[17] she gave the officer a knife, a wallet,[18] a day planner, and keys to the living room and closet gun safes, as well as indicating where various weapons were located throughout the house, and the location of a second gun safe in a back room closet.[19] One weapon was recovered in a bedroom, six were taken from the closet gun safe, including a Bushmaster Caliber .223 semi-automatic assault rifle. Semi-automatic handguns and a stun gun were recovered from the living room safe. Other family members arrived while the police were at the location; none of them provided the officers with the locations of any weapons.

---

17 While still upset, Doe said, "I'm so scared. He threatened to kill me and my family." (RT 682) When the officer showed Doe the stun gun and asked if it had been used against her, her eyes grew wide and she jumped backwards approximately three feet, hit the living room wall, turned her head and nodded yes. (RT 691-692)

18 Doe testified appellant showed her the wallet after it had exploded and told her he'd booby-trapped it; someone had been stealing money from appellant, he'd confronted the children, but they'd denied taking anything. (RT 1285-1286)

19 Doe testified she gave the officers the handcuffs, the flashlight, the stun gun, the boots, the knife, appellant's wallet, and the keys to the second gun safe, which were kept in the first. She indicated where some weapons were, and showed them the second (back bedroom) gun safe. (RT 1247-1250, 1255, 1267) At the preliminary hearing, Doe testified someone had to call appellant in jail to find out where the keys were. (RT 1253-1255, 1266-1268, 1271-1272)

Throughout, the children were in a back bedroom, asleep. (RT 670-683, 688-692, 1247-1250)

Another officer collected a pair of men's boots that Doe said appellant kicked her with; there was a large bed and a bunk bed in the children's bedroom: when the sheets to the large bed were stripped, two gunshots were identified as pointed out by Doe, one into the ground through the carpet and floor, and one into the mattress and box springs. The bullet remnant from the ground shot was unable to be recovered, the expended round from the mattress was found in the box springs by the technician. (RT 694, 697-699, 702-704, 710-711) The garage had been converted into an office: there were gunshot holes in the ceiling which Doe showed the officer. (RT 701, 704, 711-712) Two cannons were recovered from appellant's home; cannon ammunition was retrieved from a green box inside the garage: the green box contained a tin container and a plastic container with powder.[20] One held muzzle reloading and the other, propellant. There was a cord/fuse tied inside the box and fourteen golf balls. Handgun, shotgun, and rifle ammunition was also recovered at the scene. None of the guns were fingerprinted. (RT 704-706, 712) A book entitled "How to Own a Gun and Stay Out of Jail" was found in the office. (RT 706-707) Doe was present at the time of the search. She seemed nervous and worried until she received a call on her cell phone: she then became angry, yelling, "That son of a bitch. That motherfucker. God damn him." She was very upset afterwards: Doe testified this was the first time she learned appellant had raped Jane, though she knew he "was touching her." (RT 708-709, 712, 1023, 1242-1243)

A crime scene technician identified photographs of the weapons and ammunition at appellant's home, including photographs of a modified shotgun, small cannon, a Kershaw Brown folding knife, a black leather wallet containing electrical wiring, a belt, broken in the middle and hanging by a thread, a stun gun and case, a set of handcuffs with key, and a Mag flashlight. (RT 654-666)

Battered Women's Syndrome

Dr. Nancy Kaser-Boyd is a clinical and forensic psychologist specializing in psychological assessment and family violence. Battered women's syndrome is a set of psychological effects of living with violence or being exposed to violence; forced sex is a form of battering. There is a

20 Doe testified appellant made the cannons. He carried his knife with him on his belt, and kept a 9-millimeter gun in a fanny pack next to the bed at night. (RT 1284)

severity rating scale used to gauge the level of abuse: zero would be no battering, ten would be shooting, strangulation to unconsciousness, or an attempt to kill someone. At level nine, the abuse might include burning, cutting, attempted drowning, choking, rape with or without an object, verbal threats to kill or a botched attempt to kill. Not every woman who is battered develops battered women's syndrome: it is typed to the severity of the battering and the attendant threat to safety: at the lower levels of one to three (name calling, shoving), the full syndrome does not necessarily manifest. At the higher levels, eight or nine, a larger percentage of women will develop the syndrome. Sixty to sixty-five percent of women at battered women's shelters have battered women's syndrome. (RT 1309-1314)

Battering causes severe emotions met in turn with severe defense mechanisms: high levels of fear/anxiety and a sense of danger countered with emotional numbness/denial or minimization of that danger. In the most extreme trauma cases, people develop "disassociation": the feeling they are living through a movie rather than experiencing the reality of something. "Flat affect" is the description of one's trauma without emotion; flat affect itself is a clinical symptom of trauma disorder, though there will be points at which the affect is broken through and the defense cannot contain the sadness/fear: this breakdown is further sign of trauma. (RT 1314-1318)

More severe battering can involve sadistic behavior; sadism is a defense mechanism manifest by someone who copes with feedings of vulnerability/hurt by hurting back. Masochism is "extremely rare" in battered women's syndrome: a masochist will not break down when describing sexual assault/battering, but will rather evidence an "odd smile." Battering relationships can go through long periods of normalcy, abuse reoccurring during times of high stress or anger. The batterer may also feel regret or shock at his actions. The battered woman feels helpless, though twenty-five percent of battered women fight back, some to the point of killing their abuser.[21] Over time, the battering/elevated levels of fear become disabling, leading the woman to feel more trapped and more helpless. Infidelity is uncommon, though it signals an attempt to get kindness/nurturance from another relationship. (RT 1317-1323, 1325, 1331)

---

21 The expert testified in those situations where a woman kills her abuser, the woman typically used whatever weapons she had access to in the home: a kitchen knife, a gun, a car. In cases involving guns, it was almost always the spouse's weapon. The battered woman who kills as a last resort, usually in defense of herself or her children. (RT 1321-1323)

There are a variety of reasons why battered women commonly do not leave their abuser: children, economics, love of the abuser. Some women simply do not have a place to go. Many women at lower levels of abuse leave because of the lower level of fear: at higher levels of abuse, women are afraid of being killed for leaving, and many women who do leave are subsequently killed by their former partner. As a general rule, "fear is what keeps people in the home."[22] (RT 1319, 1323-1325, 1328-1329) There are factors particular to an individual which makes her more susceptible to battered women's syndrome; as a rule, the longer a woman stays in an abusive relationship, the more likely she is to develop the syndrome. (RT 1325-1328) Dr. Kaser-Boyd did not interview Doe, though she met her in the elevator prior to testifying. (RT 1326-1327, 1331)

The Sexual Assault Examination

A sexual assault nurse examiner testified she examined Jane and Doe; Doe had multiple bruising on upper and lower extremities, abdomen, chest, face, head and lips, consistent with a history of physical abuse. There were two marks on her right forearm in the granulosis stage of healing, the pre-scab stage; Doe said the marks were the result of a stab wound. There were red dots on her upper thighs, consistent with Doe's account of being tasered. A bruise is not easily color-dated: a yellow bruise may be brand-new to 72 hours old, while red, purple or blue bruises may be any age. The results of Doe's examination were also consistent with sexual assault, specifically with Doe's account of forced intercourse four days earlier and the two flashlight penetrations. The results of Jane's examination was consistent with sexual assault: there was petechie (red mark indicating tissue damage) and redness in the hymen, or vaginal opening, a tear in the hymen, and a toludine blue positive test result indicating tissue damage. Doe was trembling and crying intermittently, and kept her body bent or hunched forward during the interview; Jane was tearful and quiet. (RT 1552-1556, 1560-1565, 1568-1569) The physical findings from the sexual assault examination were also consistent with consensual intercourse. (RT 1566-1567)

Defense Case

---

22 A woman at the lower level of abuse, involving disparaging remarks about her intelligence, attractiveness, etc., may also find it difficult to leave because of the damage to her sense of competency, as opposed to her fear of physical retribution. A near-death experience, such as choking, may further immobilize someone. (RT 1328-1330)

Hilda is appellant' mother; she lived with appellant and Doe from 1997 until 2001. Between November 11th and December 5th, Hilda babysat for the family almost every day from 7:30 a.m. to 7:00 p.m.. She never saw appellant hit or kick his wife. Appellant and Doe did argue, especially after appellant found out about Charles. (RT 1572-1576) During this same period, Doe left the house twice a week to pick the children up from school; she went to the store "every day." Appellant would not go with Doe every time, and also went alone to take his son to school. Sometimes Doe was armed with a handgun: Hilda saw her putting the handgun in the safe as well as saw her with the gun outside the safety box. Doe never said anything to Hilda about appellant beating her. Hilda saw a "small bruise" next to Doe's mouth and cuts on her fingers. Hilda told Doe to leave appellant's house because she had been unfaithful to him and he would not forgive her. Hilda would do anything for her son, did not want to see him in trouble, and was telling the truth. (RT 1576-1580)

Rebuttal

It was stipulated Hilda told a member of the District Attorney's office that between November 11th and December 5th, she visited appellant's home four to five times.

## STATEMENT OF FACTS

### Prosecution Case

Appellant has a Sony video camera and a tripod; he kept the tripod in the master bedroom, the camera in the loft. (RT 7:515, 8:643) Appellant and his girlfriend once videotaped themselves having sex in the master bedroom: the taping was with her knowledge and consent. When they had sex, appellant would ask his girlfriend to do and say certain things. She likes being told what to do in bed. She also likes "dirty talk," "dirty conversation," and it arouses her when appellant said things like "Who is your master." At times, she asked appellant to say these things, and she introduced the activity into their relationship. Appellant also slapped his girlfriend during sex, also with her consent and without violence; she liked having her butt slapped, and would ask appellant to lightly slap her face. Appellant choked her with a belt a couple of times: she consented to the choking, but didn't like it, so they stopped. Appellant never caused his girlfriend to do anything she did not want to do. She plays with the word "no" during sex: sometimes "no" means "no," and sometimes "no" is "playing rough." The videotape reflected all this. (RT 7:516-519, 7:533-534, 7:536-542, 7:589-591, 8:614-618, 8:621-622, 8:644, 8:654-655, 8:676, 8:683)

In 2002 or 2003, appellant's girlfriend met an African-American girl named Na'weh at appellant's house. Na'weh is the other woman on the tape taken from appellant's apartment. Appellant's girlfriend thought Na'weh was about 27 years old when they were introduced, and that she'd seen Na'weh five times since. Appellant's girlfriend had seen Na'weh drink wine, but never saw her intoxicated. She was aware appellant and Na'weh were in a sexual relationship for a couple of months in 2001. (RT 7:519-521, 7:544, 8:642, 8:666, 8:684) Once, when appellant and his girlfriend were in the master bedroom, Na'weh got into bed with them and began touching the girlfriend's hair and arms, as if she was coming on to her. Na'weh had been drinking wine earlier. Appellant's girlfriend told Na'weh to stop it, she wanted to go to sleep. Na'weh continued to touch appellant's girlfriend for a while, then stopped. Appellant was awake. Na'weh never complained appellant did anything to her against her will. (RT 7:529-531, 8:613-614, 8:644-651, 8:653, 8:658-659, 8:684)

Appellant's girlfriend did not know if appellant had any other tapes of him having sex with other women, including Na'weh, and was only aware

of the one cassette. She did not know Na'weh was on the same tape as her encounter with appellant, and, until trial, had never seen that portion of the tape. The tape of appellant and his girlfriend includes the "dirty talk" and other acts she described, and the transcript was accurate.[1] She was shy at first during taping, but began to enjoy it: she was not shy about the activities or language depicted on the tape. (RT 7:531-535, 7:589-591, 8:615, 8:643-644, 8:652, 8:667)

A Pasadena detective testified the videotape was recovered pursuant to a search warrant served on appellant's apartment on May 10, 2003. A camera, tripod, television and other video equipment were found in front of the bed. The tripod was at the foot of the bed, the camera was not on the tripod. The camera was attached to a monitor in the apartment's loft, with a tape inside. There were no other homemade videos in the apartment. Police were unable to identify the African-American woman on the tape; they referenced their reporting system to see if an African-American woman had complained of sexual assault. There were no complaints. The name Na'weh was unknown to investigators before trial; it would have been difficult to locate someone with just a first name and general description. If someone had come in and complained of sexual assault, the police would have gotten that person's name, address, and other identifying information. (RT 8:741-745, 9:769, 9:773-777, 9:783-9:784, 9:793-794)

The videotape

According to the transcript of the tape,[2] Jane Doe told appellant "light, light," called him "Baby," said "Oh, God." When appellant said "Spread it," "Put it up in there," or asked her if she wanted "to ride my cock," Doe responded, "Mmnh" and "Mmnh-mmnh." Appellant said, "Uh-huh," Doe said, "No." Appellant asked yes or no, Doe said, "Unh-huh." Appellant

---

1 It was stipulated the girlfriend portion of the tape took place in appellant=s master bedroom. (RT 8:720) According to the transcript, appellant's girlfriend said she didn't like being taped. Appellant told her to orally copulate him, and to spread her legs. He told her how to pose, when to turn around, to lick her lips and to "play with your pussy." She orally copulated him, he orally copulated her. She said she wanted to have sex with appellant's friends, she wanted "everybody's cock." Throughout the tape, appellant's girlfriend said she didn't want to see the camera, complained she was too skinny, and wished she'd put on makeup; appellant said he was going to show the tape to his friends and people wanted to see "a total whore" on tape. (CT 2:451-456)

2 People's Exhibit No. 2; the jury was provided copies of the transcript, and the tape was played for the jury in segments, and in its entirety. Before the tape was played, the court admonished the jury the tape was the evidence, and the transcript only an aid for following that evidence. (CT 2:432; RT 9:797-799))

slapped Doe, and told her to "put your ass up. In the air." He asked Doe if she liked being slapped; Doe said, "Oww," then, "Baby." (CT 2:433-435) Doe told appellant to "Stop it.... I hate it. Don't do that," then said, "Mmnh," "Ahh," and, periodically, "Oww." Appellant asked Doe if he could "come up inside" her, told her to say "thank you, master" and to thank him "for filling me with cum." Doe repeated the phrase twice. After appellant said he was going to "work your pussy," Doe said, "Ahh" and "yeah," numerous times, as well as "yeah, baby." She told appellant she "loved it," then to stop it. Appellant asked Doe to show him her vagina and orally copulate him; he next told her to "[t]ake your fuckin' hands off your pussy," followed by the sound of slapping. (CT 2:436-442) Doe said, "Oww," and told appellant to stop doing that. There was further slapping/spanking sounds, Doe again told appellant to stop, he told her to orally copulate him, she said no, then did, he asked her if she "liked cock," there was more slapping, Doe said, "Aww. Baby," then, "Stop it. Stop it," then "Aww. Okay. Baby. Aww." Another slap, she complained he was hurting her; appellant asked if he could orally copulate her, then if he could ejaculate inside her. Doe said "I can't," appellant told her to "spread it," she said, "Aah. Baby," and the tape ended. (CT 2:442-447)

Defense Case

Patti testified she'd known appellant about six years; they had a sexual relationship at one point, involving four or five encounters over the course of one year. There was never any sort of violence in their relationship, or any activity done against Patti's will. At times, they would have sex when intoxicated, but Patti was never so intoxicated that she didn't know what she was doing. Appellant told Patti he was divorced and had a girlfriend, but they had an open relationship. (RT 9:806-812, 9:819-820, 9:822-823) Patti had never seen the video of Na'weh and appellant; when the tape was played for Patti, she indicated the woman appeared to be "tired or laying there," and testified sex between that woman and appellant was similar to that between Patti and appellant. Patti did not testify appellant ever videotaped any of their sexual encounters. (RT 9:816-819)

Appellant testified that he has only ever had one tripod, and leaves it next to the TV, by his guitar, at the foot of the bed. Appellant's bed is large, and there's only five feet between bed and wall, so "everything is kind of at the foot" of the bed. There is a lot of furniture in the apartment, and not much room. Because appellant traveled frequently, he bought a fairly expensive

camera, which he leaves on the tripod. It is a digital camera that uses digital analog tape: the tape is fed into a computer, then transferred to a DVD or another viewing format. When police found the camera, it was in the loft, attached to the computer for data transfer; appellant brought it up to learn how to download the images. There was another tape inside of appellant's children's birthday parties. (RT 9:884, 9:890-892, 9:955-958)

When appellant met his girlfriend in 1998, he was going through a difficult break-up with his then-wife; he told his girlfriend he was not looking for a committed relationship.[3] In the five years since they started dating, appellant has had sexual relationships with about five other women. He did not share the details of those relationships with his girlfriend, or have sex with someone else in front of her. He would tell her if she asked whether he was having sex with another woman; his girlfriend knew when appellant was seeing Na'weh. Appellant did not know if his girlfriend was having sex with other men, and did not ask. (RT 9:919-921, 9:961-9:964, 9:991-992, 9:995-9:998, 9:1007-1010, 1012)

Appellant met Na'weh sometime in 2001 or 2002: he had gone to Moose McGuillucuddy's by himself, and around 1:30 a.m., as the bar was closing, appellant started walking to a taco stand. Passing an alleyway, he saw Na'weh; she asked him to stand in front of her, he did, and she urinated in the alley. Na'weh was a young, attractive African woman; she invited appellant to go to her place, he went, and they had sex. Na'weh was very smart, a "party girl." She and appellant dated for a month and a half, going out drinking, then going home to have sex. Na'weh sometimes showed up at appellant's apartment at 3:00 or 4:00 in the morning, dressed in a short skirt and stiletto heels, back from another party, ready to have sex. Appellant did not necessarily know how intoxicated she was on those occasions.[4] (RT 9:948-950, 9:952, 9:1011-1013, 9:1017, 9:1028, 9:1034)

---

3 Appellant's sexual relationship with his girlfriend progressed over time into a more aggressive type of sex: she liked to be slapped, appellant had never done that before. Appellant likes to do what the women he has sex with want him to do; if he "talks dirty" to them, and they don't like it, they will tell him. (RT 9:942, 9:1005-1006, 9:1028-1029)

4 Appellant remembered the night Na'weh came over while he was in bed with his girlfriend. Na'weh needed a place to stay because she'd been dropped off after a party, so appellant let her stay there. Appellant recalled Na'weh was in bed, and appellant on the couch, then later, appellant moved back into the bed and went to sleep. It is a big California king bed, so appellant didn't see Na'weh do anything, though he heard his girlfriend and Na'weh talking. (RT 9:1013-1015)

On one of these visits, Na'weh told appellant she'd just been at a party in Hollywood, in bed with a blond woman, and the men at the party videotaped them. Na'weh said it was fine with her; it seemed to arouse her. Appellant turned on the camera and they had sex.[5] He slapped Na'weh's buttocks and told her what to do, as he had on other occasions. She had also called him "master" during other encounters. If Na'weh didn't want appellant to do something, she would have said; saying "ow" or "no" intercut with her sounds of pleasure as depicted on the videotape wasn't uncommon, it was just how the sex was between them. She also called appellant "Baby" on the tape, and was sexually excited. There was nothing in the taped encounter that led appellant to believe Na'weh didn't want to be there or didn't fully appreciate what was going on. Her behavior then was consistent with their other sexual encounters; appellant assumed Na'weh enjoyed them because she continued to show up at his apartment to have sex with him. Na'weh was never resistant when they had sex: they had a good time together while it lasted. Na'weh was a very strong woman, domineering, who, like appellant's girlfriend, enjoyed more aggression in bed.[6] Appellant never hit Na'weh to make her do something she did not want to do. Appellant did not know how much Na'weh had to drink the night he taped them, but did not believe she was intoxicated to the point where she did not know what he was doing. Na'weh has never complained about what happened between her and appellant that night. (RT 9:950-953, 9:1005-1007, 9:1016-1028, 9:1031-1036)

-

---

5 They had started having sex that night on the living room floor. (RT 9:1030)

6 Appellant taped one encounter with his girlfriend, and one with Na'weh. There were no other homemade sex recordings. On the girlfriend portion of the tape, when she and appellant talk about showing the video to others, it was part of the Afantasy@ scenario they were creating: the tape was not intended for anyone else to see. No one ever saw the videotape before the Pasadena police: it was Aburied away.@ Appellant did not tape Patti, and would not tape someone without consent. (RT 9:942-944, 9:958-959, 9:1003-1004)

# STATEMENT OF FACTS

## Prosecution Case
## Robert Owen, Ph.D.

Robert Owen got a Ph.D. in clinical psychology in 1987; he has been in private practice since 1989. Dr. Owen ran two sex offender groups for ten years, has treated groups of sexual assault victims, and has evaluated sex offenders for probation treatment for the Public Defender's Office in Santa Barbara and San Luis Obispo Counties. Dr. Owen has been appointed to evaluate sexually violent predators since 1996, and been trained by the Department of Mental Health (DMH) on sex offending, on antisocial psychopathic men and on predicting future sexual offenses. (RT 4:339-341) The DMH protocol for evaluating sexually violent predators (SVPs) involves reviewing documentary materials, including probation reports, police reports, complaints, abstracts of judgments, prison files, psychiatric records, medical information and daily logs, inviting the person to an interview, and discussing the person's adjustment with hospital personnel. (RT 4:341-342, 5:611) There are three criteria for determining if someone is an SVP: first, whether he has been convicted of two qualifying offenses; second, whether he has a diagnosed mental disorder; and third, whether he is likely to reoffend because of that disorder. (RT 4:342)

Dr. Owen finds forty percent of the men he examines fit the SVP criteria, appellant was one of those men.[1] Dr. Owen first evaluated appellant in 2001, reviewing the relevant material; appellant declined to be interviewed. It is not uncommon for some men to refuse an interview. Appellant's qualifying offenses were convictions for rape in 1978 and sodomy in 1982. The 1978 rape involved a fifteen-year-old girl: her car was by the side of the road, he helped her, and later picked her and her five-year-old child up at home, and took her to his house. He drove into his garage. He closed the garage door; the child became frightened, appellant turned on the headlights and tried to kiss the child's mother. She refused; he offered her money to allow him to suck her breasts. She said no, he grabbed her by the neck, choked her, and brought her into the back seat. The little girl went into the front seat. Appellant took off the mother's panties and raped her, first masturbating himself in order to get an erection. Appellant told her there was no use crying because, "ain't nobody gonna help you." Appellant also threatened to kill the

---

1 According to Dr. Owen, half of 1% of registered sex offenders are SVPs. (RT 5:664)

victim if she didn't cooperate. The victim had a rash on her neck for a month and a half from the choking, experienced a return of seizures she'd had when younger, and became pregnant as a result of the rape and had the child. Appellant went to prison for this offense. (RT 4:343-347, 5:663-664)

The victim of the 1982 sodomy conviction was the fourteen-year-old son of appellant's live-in girlfriend: appellant had been out on parole for six months when he began anally sodomizing the boy. There were multiple incidents of appellant overpowering the boy, sometimes pushing his head into a pillow to muffle his cries. Appellant also threatened the boy. Once, appellant sodomized the boy in the back seat of a car while appellant's brother was driving. On another occasion, appellant drove the boy to a secluded lighthouse and sodomized him. The boy was terrorized by the offenses, and subsequently went into counseling. (RT 4:347-349)

After determining appellant was convicted of the requisite offenses, Dr. Owen examined appellant's sexual and criminal history, relying upon The Diagnostic and Statistical Manual of Mental Disorders for the consensus opinion of what constitutes a mental disorder. The DSM-IV is published by the American Psychiatric Association, is regularly updated, and is "the accepted manual" in the psychiatric profession. According to Dr. Owen, a "diagnosis" refers to a medical condition/disorder of a pathological nature. The SVP law does not require a DSM diagnosis, just a "diagnosable disorder," though all agreed-upon diagnoses are in the DSM. (RT 4:349-351, 4:402-404)

Dr. Owen diagnosed appellant with Paraphilia, Not Otherwise Specified (NOS), nonconsenting persons, and personality disorder with narcissistic antisocial features. According to Dr. Owen, paraphilia is "in the book," on page 566; a rapist is also given as an example in the DSM casebook, though the example isolates arousal triggered by lack of consent,[2] and the manual is the greater authority. Paraphilia is a condition that lasts a minimum of six months and involves behaviors, fantasies or urges towards, in appellant's case, nonconsenting persons. There is a "thinking element" to the disorder; appellant has a problem with entitlement, and seeing women as sexual objects. Appellant has an emotional problem: shallow emotions, aggressiveness, and callousness, and behavioral problems. Appellant has seventeen years of behavioral problems; the requisite six month diagnostic

2 Dr. Owen felt appellant was aroused by lack of consent because he would rape though he had an available consensual partner. He did not believe the fact appellant asked for consent was relevant. (RT 5:674-675)

period may be any six month period. If someone had a parpahiliac period decades earlier and had been free of any such desires since, Dr. Owen would still diagnose that person as having a paraphilia, but would note the lack of ongoing symptoms. No recent overt act is necessary: to have a currently diagnosed mental disorder, "one doesn't need to show current symptoms." (RT 4:351-353, 4:412-414, 5:607-608, 5:610, 5:658-663, 5:673-674)

Among appellant's behavioral problems was an arrest on April 23, 1975 for battery on a police officer; a January 5, 1977 charge of kidnapping, rape, and sodomy involving a seventeen-year-old girl for which appellant was acquitted; in March 1977, while jailed for petty theft, appellant was charged with forcing a male inmate to orally copulate him. Appellant was acquitted of the oral copulation and convicted of the petty theft. On October 4, 1977, appellant pled guilty to assault with a deadly weapon: he took a shotgun into a bar, made threats, left, returned a few days later with a knife, argued with the bartender, a patron intervened, and he cut the man's finger. November 1997, appellant pled guilty to driving under the influence. While on bail for the 1978 rape of the fifteen-year-old, Appellant was arrested for raping another woman on January 17, 1978: he asked a woman out, they went to a bar, played pool, she said she was tired, he agreed to take her home but drove her to an isolated location instead. She declined to have sex with him, he choked her, removed her tampon, and raped her. This case was consolidated with the other rape case, appellant pled guilty to the earlier offense, and was sentenced to five years. (RT 4:353-357)

Appellant was paroled in April 1982, then violated for possessing a knife. For the 1982 sodomy, appellant was initially sentenced to 57 years in prison, based on ten counts of conviction. Appellant was later able to plead to two counts and received a lesser sentence, paroling in 1992. Appellant's parole was relocate in 1994 for failing to report his address; on May 12, 1994, according to a parole violation report, appellant met two women one night, they went with him on his boat to Catalina; all were drinking. Appellant and one of the women went below deck, appellant ordered the woman to undress, she did, appellant undressed and ordered her to orally copulate him. The woman said no, appellant slapped her, the woman complied, appellant ejaculated in her mouth and the woman vomited. Appellant became angry, slapped the woman again and demanded she orally copulate him again. Appellant continued slapping the woman and attempted to strangle her. Afterwards, appellant claimed the encounter was consensual. Appellant also said, "I

should have thrown the bitch overboard." Appellant's parole was violated for operating a boat while intoxicated: the State was unable to locate the woman, so the sex charges were dismissed.[3] Appellant was re-released into the community on April 12, 1995, and re-violated a year later for driving fifty miles outside his county of residence and not being home when told to be by his parole agent. (RT 4:357-359, 4:363-365, 5:657) These violations were significant as indicating appellant did not care much for rules, and did not want to be supervised in the community as a sex offender. Noncompliance with supervision is correlated with recidivism. (RT 4:365, 5:666-667)

According to Dr. Owen, a diagnosed mental disorder is "a congenital or acquired condition that affects a person's volitional or emotional capacity to the extent they pose a menace to the community." Appellant's paraphilia diagnosis was based on his history of sexual deviance dating from the 1970's to 1994; appellant has multiple victims, and has targeted boys, girls, women and men. Appellant has shown a "wide diverse sexual interest," and "incredible callousness" in his offenses. Going to prison, being arrested/publically humiliated as a sex offender does not stop appellant. There is a pattern of sexual offense unabated by consequence. Although appellant has not raped anyone in prison or at Atascadero, there are all signs of his "sexual lies" and anger. (RT 4:368-370, 5:662

In his 2001 evaluation, Dr. Owen documented the following remarks attributed to appellant by hospital staff: in 2000, "I swear on my father's graveyard I did not cuss out you stupid lazy fucking bitch. Let me tell you something, that fucking bitch can take it up her fucking ass and her faggot husband too." Appellant's harsh and vulgar language reflect his underlying values and attitudes towards women, his rage, and his sexualized anger. Dr. Owen's 2005 evaluation was "replete" with appellant's vulgar outbursts, particularly towards women: every couple of months there would be a staff notation. On May 3, 2005, the notation indicates appellant made two remarks "in a derogatory manner" towards staff: "Somebody needs to get a job. What are you looking at?" June 5, 2005, hospital staff reported appellant was "Extremely argumentative and hostile. Complaining of other mentally ill patients being forced with medication and then he used the words "Asshole. Fuck you, I could sue you.'" "I'll take care of you, fuckhead. Fuck yourself,

---

3 Dr. Owen based his conclusion about the reasons for the dismissal on the report=s notation that the victim was a transient; he did not determine whether failure to locate the victim was the actual cause of dismissal, as stated in the parole report, or if the case was not filed in the first instance. (RT 5:669-672)

fuckhead. You're a fucking asshole fuckhead. Now you want to fight me."
Other remarks were in Spanish. June 9, 2005: "Confrontational with female
lead, advised he had been ordered hot tray for breakfast. He said, "You
mother-fucking bitch. You think you can decide what hot meal I'm getting.'"
When asked to leave the meal area, appellant threatened legal action;
according to the notation, his body was tense and his hands clenched.
That same day: "It's my First Amendment right to cuss you out whenever I
feel like it. I'm the only one around here that deserves respect." After being
placed in room seclusion for threatening staff: "You're a whore, fuck you,
your mother's a whore, fuck you, you fucking white trash." Also from the
9th: "If you think I'm going to bend over and kiss your ass you're wrong.
Fucking bitch." There was a separate incident in which appellant was placed
in restraints for fighting, and another for threatening staff. Appellant has been
transferred between units because of staff problems. At times, appellant is
"condescending and syrupy sweet," and other times, "extremely angry or
even threatening." Appellant tends to verbally sexualize his anger, and his use
of the phrase "shove it up your ass" disturbed Dr. Owen, given appellant's
sodomy conviction. (RT 4:370-375) In Dr. Owen's experience, paraphilia is
a chronic disease like alcoholism. It cannot be gotten rid of, but it can be
managed by avoiding high-risk situations. Appellant has done nothing to
treat or diminish his paraphilia: he refuses to participate in the excellent and
comprehensive treatment program at Atascadero. (RT 4:375-376, 4:400)

Narcissistic and antisocial personality disorders are also chronic.
Appellant's narcissism means he is an arrogant, self-absorbed man who is
oblivious to other people's needs, feels entitled to gratify his own, and tends
to be very irritable if they are not met. Hospital staff report appellant is very
sarcastic, quickly annoyed and demeaning to personnel. This narcissism is
also reflected in the circumstances of appellant's convictions: he gets very
angry when sexually rejected, as evidenced by his violent response when the
fifteen-year-old rape victim refused to kiss him, and hitting the woman on the
boat.[4] (RT 4:376-378, 5:662) The antisocial behavior includes all the previously
mentioned incidents and convictions: appellant is "a man who doesn't
really care to follow the law or conditions imposed upon him." Appellant
usually targets women, including hospital staff, though not exclusively. (RT
4:378-380) Dr. Owen diagnosed appellant as having Personality Disorder,

---

4 Most sexual predators do not rape in state hospitals because the environment is so highly
controlled. (RT 4:380)

not otherwise specified (NOS); he could not diagnose him with Antisocial Personality Disorder in the absence of any juvenile convictions, and could not diagnose him as having a narcissistic personality disorder absent manifestations during early adulthood. Antisocial behavior tends to diminish with age, though this doesn't mean its underlying values or more subtle traits disappear. (RT 4:381-382, 4:414, 5:661-662)

Dr. Owen found appellant was likely to reoffend: appellant has an egregious past, nothing has ever stopped him from reoffending, and nothing's happened since his confinement to prevent him from reoffending. The criticism of clinical predictions is they tend to be "flawed;" the other approach is an actuarial assessment. For this, Dr. Owen performed a Static-99 evaluation of appellant; Static-99 is a scoring worksheet based on Dr. Hanson's study of 20,000 Canadian sex offenders which is a "moderate predictor" of whether someone is going to reoffend. There are ten factors to be ranked, including young age, whether the person's lived with a lover for two years, non-sexual violence, number of prior sentencing dates, stranger victims, male victims, and, ranked heaviest, prior sex offenses. Mental disorder was not predictive, and Dr. Owen was unaware of any study which suggested it was. Each factor is ranked zero, one, or three, the factors are added, and the individual ranked low, medium, or high risk. A score of six or more is considered high risk; appellant had an eight. Those with an equivalent score had a 39% chance of reoffending within five years, a 45% chance within ten years, and a 52% chance within fifteen years. (RT 4:383-388, 4:395, 4:400-401, 5:623-628, 5:630-633, 5:646-649, 5:663-665, 5:667)

According to Dr. Owen, the Static-99 is the most commonly used instrument in making these assessments, and has been studied and peer-reviewed in Sweden, Canada, the United States and England; most of the studies result in similar accuracy rates, thus cross-validating Hanson's study. The "receiver operating characteristic" (ROC) measures the accuracy of an instrument: the ROC can range from .5, a flip of a coin, or half-accurate, to 1.0, accurate each time. The ROC of the Static-99 is .71, "right in the middle." Dr. Owen noted many men are not apprehended for their sex offenses because many victims don't come forward, out of shame, or embarrassment. Therefore, in terms of rates of recidivism, the Static-99, as it predicts the likelihood of conviction of a new sex offense, is a more conservative indicator. (RT 4:388-390, 4:395-396, 5:628-629, 5:665)

The first of the ten static factors is youth—whether the person is under the age of 25 at the time of the assessment. Appellant was 54, so he scored a zero.[5] Second, whether the man ever lived with a lover for two years; appellant said he had, and was scored zero. Third, index of nonsexual violence: whether the most recent offense was for a violent offense in addition to a sexual offense; appellant scored a zero. Fourth, prior nonsexual violence; appellant had a prior assault, so he scored one. Five: prior sex offense: number of prior sex offenses, appellant got a three, the highest possible score, based on six prior offenses, including his two convictions and past charges.[6] Six: prior sentencing dates: appellant has more than four, so he scored one point. Seven: non-contact sex offenses: zero. Eight: unrelated victims; appellant scored one. Nine: stranger victims; some of appellant's victims were strangers, including the victim on the boat and the one in County Jail: one point. Ten: male victims; the sodomy victim was male, one point. (RT 4:391-395, 5:623, 5:641)

Dr. Owen interviewed appellant on May 24, 2004; the interview was taped. Dr. Owen asked appellant if his anger bothered him, or if it got him in trouble. Appellant said no, "It makes me pleased. I express myself." Appellant said he could control his anger because he had control over himself and his personality. When asked about alcohol, appellant laughed and said it had never been a problem; he said he did not have sexual fantasies, and had been with prostitutes a few times. Appellant consistently denied committing the offenses for which he was convicted until his 2004 interview; Dr. Owen felt this admission was because it was now more convenient for appellant to

---

5 On cross-examination, Dr. Owen testified the likelihood of a fifty-year-old man with a score of 6 reoffending was 25%. Age is more of a factor in reducing recidivism for rapists than for child molesters. In the original study, there were only 14 offenders over fifty; in Dr. Hanson's 2005 report, there were 32. Given appellant's behavior, Dr. Owen did not think age would significantly mitigate risk, especially with the availability of Viagra or testosterone patches. (RT 5:633, 5:040-644, 5:666)

6 Dr. Owen considered all charges, whether proved or not, because the behavior alleged was consistent with appellant=s history and therefore true. The reported rape on the boat was very detailed, though the probation violation was not sustained, and the other woman on the boat and another guest stated the victim and appellant were Alovey together,@ the victim left the boathouse to buy cocaine after appellant refused to give her drug money, and then appellant and everyone else went to sleep. Appellant=s version of events was consistent with the witnesses. The complaining victim had bruises on her arms, neck and face, which the other woman attributed to a fight with the victim=s boyfriend. The account of the jail assault was similarly detailed. Even if Dr. Owen only considered convictions, he would probably still conclude appellant was likely to reoffend. (RT 5:649-655, 5:657, 5:669, 5:680)

VANESSA PLACE

"submit."[7] This had no effect on appellant's diagnosis, as denial is unrelated to risk of reoffense. Appellant said, "no one deserves to be raped." When asked if he would ever undergo treatment, appellant said no, that "this is not about treatment." Dr. Owen also performed a mental status exam, finding no evidence of psychosis. (RT 4:396-400, 5:630)

Years ago, "parpahiliac coercive disorder" was considered for inclusion in the DSM; after considerable discussion and debate over whether to include rape as a type of paraphilia, the panel developing the paraphilia diagnosis rejected rape as a specified paraphilia. On page 567 of the DSM-IV, paraphilia NOS was identified as a residual category, including "less frequently encountered" paraphilias, such as telephone scatologia (obscene phone calls), necrophilia, partialism (exclusive focus on one body part), zoophilia (animals), coporphilia (feces), calciphilia (enemas), urophilia (urine). Dr. Owen agreed these were less frequently encountered than rape, and that the omission of rape from the list of paraphilias NOS was "not accidental." Dr. Owen did not believe that by diagnosing appellant with paraphilia, NOS, nonconsenting persons, he was bypassing the consensus-rejection of rape as a form of paraphilia. Dr. Owen felt there were "political reasons" rape was not included: that rapists would then use the diagnosis as a mental defense, though most rapists are not parpahiliacs. Dr. Owen testified the APA does not like the civil commitment law and has "attacked" actuarial assessments and paraphilia diagnoses. (RT 4:404-409, 5:627-628, 5:660-661, 5:676)

Dr. Owen was familiar with Amy Phenix's rebuttal to Dr. Sreenivasan's article on whether antisocial personality disorder alone could be an acceptable SVP diagnosis;[8] Dr. Owen felt appellant differed from the ordinary recidivist because most of his offenses were sexual, there was a compulsivity to his offenses, as evidenced by their commission while he was on parole/bail/probation, and there was a pathological component evidenced by his ability to achieve an erection while abusing his victims. (RT 5:612-614, 5:662) According to Dr. Owen, appellant's paraphilia was acquired, though

---

7 In his interview, appellant simply said, "I submit," when asked about the offenses. Dr. Owen was aware that many patients felt if they admitted their offenses, they were confessing a mental disorder, and if they denied them, their denial would evidence a lack of accountability, further proof of a mental disorder, "damned if you do, damned if you don't." (RT 5:655-656)

8 This appears to refer to Vognsen and Phenix, "Antisocial Personality Disorder Is Not Enough: A Reply to Sreenivasan, Weinberger, and Garrick," *J. Am. Acad. of Psychiatry and the Law* 32:440-2, 2004, a rejoinder to Sreenivasan, et al., "Expert Testimony in Sexually Violent Predator Commitments: Conceptualizing Legal Standards of 'Mental Disorder' and 'Likely to Reoffend,'" *J. Am. Acad. of Psychiatry and the Law* 31:471-85, 2003.

he did not know its etiology. If appellant were released into the community, and remained sex offense-free for five years, and was then re-evaluated, Dr. Owen would still diagnose a current mental disorder based on the prior history, though the assessment of dangerousness might change. (RT 5:622-623, 5:637-638)

Dawn Starr, Ph.D.

Dawn Starr received her B.A. in psychology in 1978 from Creighton University in Omaha, Nebraska, her M.A. in human behavior from United States International University in 1990, and her Ph.D. in 1986 from the California School of Professional Psychology. She worked at Atascadero State Hospital for nine years, half the time as a treating psychologist, and half in admissions, doing evaluations. Since being licensed in 1986, she has also done juvenile probation, mentally disordered offender, pre-sentencing, and Child Protective Services evaluations in private practice. She began doing SVP examinations in 1996: in terms of initial inmate evaluations, Dr. Starr currently finds 10 to 15% meet SVP criteria. Two-thirds to three-quarters of SVPs at Atascadero are diagnosed with pedophilia, the remainder are paraphiliac. (RT 7:1276-1278, 7:1285-1286, 7:1335)

Following DMH protocol, Dr. Starr first evaluated appellant in January 2001; appellant declined to interview at that time, and at the time of the second interview, June 3, 2004. Dr. Starr's last evaluation was in July 2005. In her 2001 interview, Dr. Starr noted that on March 18, 1997, appellant said "women are only good for one thing: fucking." On March 24, 1997, he called a female staff member a "fucking bitch" "old hag" and "fucker." On May 13, 1997, he referred to a female staff member as a "puta," a derogatory Spanish term for a woman. Relative to another incident, appellant said, "fuck that punk-ass bitch," "tell him to stick the radio up his ass," and "move over, you faggot." Shortly thereafter, when told to keep his hands to himself, appellant grabbed his crotch, pulling up and saying, "fuck you, punk," until removed to a secure location. On August 8, 1997, appellant approached a female staff member, saying, "I love you, I want you," when the staff attempted to redirect appellant, he said, "beat me, beat me." On September 26, 1997, appellant said, re: staff, "Get that cunt out of my face. If she wants to be that way, she'll get what Randy got."[9] On December 1, 1999, appellant called a shift supervisor a "fat mother fucker," and said, about staff, "That faggoty son of a bitch, he can kiss my ass." In 2000, appellant was noted as having a pattern

---

9 Randy was another staff member assaulted by another patient. (RT 7:1317)

of asking female staff to go to a secluded area where he would complain about other staff. On March 3, 2000, a notation indicates appellant didn't participate in treatment, was verbally abusive to staff and often "preyed or picked" on weaker patients. Appellant is one of Dr. Starr's more problematic patients: he can be nice if he wants something but is very demanding, hostile and threatening. In her June 2004 evaluation, Dr. Starr noted the hospital's notes that appellant often complains of being disrespected but does not focus on what he's done wrong; there were eighteen incidents of verbal abuse of staff from August to October 2001. In May 2002, he said to a female staff: "Fuck you. Shove it up your fucking ass, you fucking cop you. You turned out to be a "ho. You fucking bitch." In June 2002, he said, in Spanish, to male staff: "Stupid mother-fucker, who is your little bastard at home? You're such a fucker"; to a female staff, something to the effect of "put it in your mother's asshole"; "fucking fag." In the October 2002 report, there were 31 behavioral and 14 verbal abuse incidents. On April 11, 2003, appellant got angry and threw his eggs on the floor; on July 12, 2003, he was transferred because of a fight; on July 16, 2003, he spit in someone's face; on August 19, 2003, he assaulted a sleeping patient; in September 2003 he was placed in wrist constraints, in October 2003 in seclusion for abusive behavior; in February 2004, he was put in seclusion and told staff, "you're my servant." Additional staff abuse in May and September 2004, another patient assault in September. May 2005, hostile towards staff and other patients. The notation on April 3, 2001 states appellant can be "syrupy sweet" and then turn hostile and negative is consistent with his attempts to ingratiate himself with his victims; an August 2003 Treatment Team Conference note states appellant is demanding, intrusive, argumentative, and grossly insulting, especially with women. Dr. Starr believes appellant has two SVP diagnoses: paraphilia, NOS, and personality disorder, NOS with antisocial and narcissistic features. Paraphilia, NOS includes rape, as demonstrated by the example cited in the DSM-IV-TR case book.[10] Appellant's paraphilia diagnosis was based on his predicate offenses, as well as his volitional impairment, shown by his reoffending and by his 1994 prison write-up for using a razor blade to threaten the life of an inmate, and get sexual favors from that inmate.[11] Appellant has

10 Dr. Starr was familiar with the appendixed DSM-IV-TR annotation stating a particular pattern of paraphiliac arousal must be present in order to assign the specific diagnosis. Dr. Starr did not believe this meant specification was required. (RT 8:1536-1537, 8:1560-1561)

11 In an earlier SVP trial, there was testimony that a probation officer's report included a statement that while appellant was in jail on the rape charge, he and other inmates sexually

had consensual partners as well as a preference for nonconsensual sex. (RT 7:1279-1288, 7:1315-1329, 7:1341-1346, 7:1359-1364, 8:1502-1509, 8:1517, 8:1526, 8:1553-1563)

In Dr. Starr's opinion, appellant is likely to commit future sexually violent predatory offenses:[12] in addition to his mental disorder, he has a severe personality disorder. Dr. Starr performed a Static-99 assessment on appellant, and gave him a 9, one point each for never having a two-year intimate cohabitation, prior nonsexual violent conviction, more than four prior sentencing dates, stranger victims, and male victims, and three points for three prior sex offenses. Dr. Starr believes the resulting recidivism risk is an underestimation because only new sex offense convictions were considered in the original study, and many sex offenses either are not detected or the person pleads to a non-sex charge. Dr. Hanson believes it is a 5% underestimation; Dr. Dennis Doren believes it may be 20%. (RT 7:1288-1293, 7:1304-1305, 7:1346-1349, 8:1511-1512, 8:1566, 8:1570)

Dr. Starr also considered protective factors, such as intervening disability or prolonged lack of reoffending while in the community, and dynamic risk factors, such as age. According to Dr. Hanson's research, high-risk men, like appellant, 50 to 59 have a 24% fifteen-year reoffense rate. Dr. Starr "was aware" there were people between the ages of 50 and 79 who have committed sex crimes. Appellant does not have an appropriate release plan to prevent reoffending, including attending treatment: appellant said he would get a job and needed no sex offender or anger management treatment. Anger management would be very important to appellant, as he does not appear to be "burning out." (RT 7:1306-1308, 7:1311-1314, 7:1317, 7:1334, 8:1570-1571)

Dynamic factors are factors appellant can change, such as his ability to have a sustained intimate relationship with a woman, self-regulation, attitudes towards sexual assault, and difficulty following rules, such as for parole. Appellant's paraphilia precludes his self-regulation, as does his impulsivity, hostility, poor problem-solving, and his two "Cluster-B personality disorder[s]." Appellant's attitude towards sexual assault is demonstrated by his failure to show remorse, remarking on the 1978 rape:

---

assaulted a 22-year old; Dr. Starr thought appellant was ultimately convicted of petty theft in the case. Dr. Starr had not seen the report itself. Dr. Starr did not review the police report regarding the boat rape allegation, but read the probation officer's report. (RT 8:1527-1529, 8:1532-1534)

12 Predatory offending includes offenses against acquaintances. That appellant rapes people who can identify him speaks to his volitional impairment. (RT 7:1312, 7:1358-1359)

"Do you think I would spoil my car by screwing that bitch on the seat. I love my Mercedes Benz too much for doing that." Appellant has consistently denied sexual misbehavior and stated the staff notes are likewise baseless. The combination of a paraphilia and a Cluster-B disorder is synergistic, resulting in a much higher risk of recidivism. (RT 7:1330-1331, 8:1512-1513, 8:1516-1517, 8:1654) Appellant's personality disorder is evidenced by much of the same behavior as cited in support of his paraphilia diagnosis.[13] Appellant has also committed other antisocial acts, such as drunk driving and assaults. Appellant is aggressive and lacks empathy, has significant anger, and is impulsive. He says he is "entitled" and devalues others, preying on those he sees as weaker.[14] Many people in prison have antisocial personality disorder; Dr. Starr believes this diagnosis alone is sufficient to sustain a SVP finding. There is disagreement in the field on this point. (RT 7:1329-1330, 8:1519-1522, 8:1653-1564, 8:1571-1572)

The Department of Justice sexual recidivism study is not an actuarial instrument because it used non-high risk offenders, studying them for three years. According to Dr. Starr, 39% of the DOJ subjects were back in custody by then, most child molesters rearrested within the first year. Reincarceration would artificially reduce reoffense rates. Dr. Starr agrees with the ASTA that actuarial instruments should be used in risk assessment. Dr. Starr felt personality testing was inappropriate for risk assessment of appellant because his defensiveness would result in a Afake good profile." Appellant's arousal on the P.P.G. assessment was significant, as measured by Dr. Hanson's report and other P.P.G. equipment. The M.M.P.I. test was invalid as not reality-based — appellant lied. Situational or preferential rapist is not terminology widely accepted in the psychological community as diagnoses or as included in risk assessment. Empathy is insignificant. (RT 7:1293-1300, 8:1544-1546, 8:1564-1565)

Cheryl Milloy's 2003 six-year study of eighty-nine Washington men referred for SVP evaluation but deemed not to qualify, including those being considered for recommitment, found 57% were felony reoffenders, 40% for

---

13 Dr. Starr felt appellant's past offenses were consistent, including in the use of excessive force. Charges are better predictors of recidivism than convictions, according to Dr. Hanson, according to Dr. Starr. (RT 8:1524-1526)

14 Dr. Starr felt there was no indication appellant initially attempted consensual sex with his victims, noting appellant's ability to maintain an erection and ejaculate while choking someone. Dr. Starr recalled that in 1978, appellant and the victim exchanged phone numbers, she visited his home the day before the rape, he offered her money for sex, and asked to kiss her, all of which may be prelude to consensual sex. (RT 7:1349-1355)

offenses against others, 29% for new felony sex offenses. Dr. Starr believed this a better study than the DOJ study because it focused on higher-risk individuals for a longer term. (RT 7:1300) According to Dr. Starr, according to Dr. Hanson, if a person uses sexual terminology in disagreements with others, there is likely to be an underlying sexual preoccupation. The Milloy study was not published in a peer-reviewed journal. (RT 7:1320, 7:1335-1337)

Predicate offense: Kevin

Kevin testified he was fourteen years old in 1982, living with his mother in San Pedro. In June 1982, appellant moved in, living there until February 1983. In September 1982, Kevin showed his mother a rash; a couple of days later, appellant asked to see it, took down Kevin's pants, and started to rub Kevin's penis. Kevin tried to push appellant away, appellant dropped his pants, turned Kevin onto his stomach, and tried to insert his penis into Kevin's rectum. Kevin struggled, yelled "no," cried, and appellant stopped. In November, appellant came into Kevin's room and began to play wrestle, as he had on other occasions. Appellant got Kevin's pants down; Kevin struggled and said "no," and began crying. Appellant told Kevin to bite appellant's finger for the pain, Kevin did not. He was afraid something would happen to him or his mother if he did not submit. Kevin was afraid of appellant because he had seen appellant knock someone out once outside a restaurant, and Kevin's mother and appellant had fought over appellant's infidelity. On those occasions, Kevin would be sent to his room, but could hear appellant call his mother "bitch" and "cunt," and heard things being thrown or hitting the floor, furniture moving, etc..[15] Before the abuse, Kevin and Appellant had a good relationship. (RT 5:681-687, 5:702-704)

On December 3rd, Kevin was doing homework in his room when appellant again took his pants down; Kevin again struggled and protested, but appellant was able to penetrate him. On December 9th, Kevin went motorcycling with appellant in an open field. When they drove up, appellant turned off his lights, took out his penis, and asked Kevin to touch it. Kevin did not remember if he did so, but recalled struggling, and remembered appellant masturbated himself and ejaculated, wiping himself afterwards with a mechanic's rag. At some point between December 29, 1982 and January 1983, appellant initiated another play wrestling encounter, Kevin fought back harder, and appellant became a little more violent. He held Kevin down, took

---

15 During this time, Kevin went on a trip to Nebraska with appellant, again, because he was afraid not to go. (RT 5:704-705)

down Kevin's pants, and put his penis in Kevin's rectum. Sometime between January 29th and February 17th, appellant took Kevin four-wheel-driving in Kevin's mother's Jeep, driving across streams and rivers with appellant's brother and some other cars. Appellant and Kevin separated from the group, appellant let Kevin drive, then appellant drove to a secluded area and told Kevin to take off his wet pants and put them under the heater. Kevin said he didn't need to change because he'd put on dry socks. Appellant became upset, told Kevin to take the pants off and go in the back seat to make sure the jack and tow cable were there. Kevin did so, turning around as appellant was climbing into the back seat. Appellant was aggressive, forcing Kevin onto his stomach and sodomizing him. (RT 5:688-695) Appellant typically began each molestation with some sort of "comfort" or "play," becoming angry only after being refused. If Kevin continued to say "no," it would get more violent. (RT 5:705-709)

The final incident was on February 13, 1983; appellant and Kevin went motorcycle riding with someone named Butch; appellant had been drinking. Afterwards, they drove Butch home, and Kevin said he was tired. Appellant drove to an empty house, turned off the lights and told Kevin to take off his pants. Appellant began to masturbate and orally copulate Kevin, telling Kevin to "cool it" when Kevin pushed appellant's head away, saying if Kevin refused, then, "I'm going to fuck you." Kevin struggled his hardest, trying to get his pants untangled; appellant put his finger in Kevin's rectum and pushed Kevin's head towards his penis. Appellant slapped Kevin, repeating he was going to "fuck" him. Appellant also wanted Kevin to masturbate himself to erection because he wanted Kevin to sodomize him. Kevin could not get an erection; appellant turned him over, and sodomized him to ejaculation. After each molestation, appellant told Kevin that no one needed to know about Athis," and that Kevin was his "poppy," a Spanish term of endearment for "son." (RT 5:695-699) After Kevin came home on February 13th, his mother noticed he was depressed, and Kevin eventually told her what happened. His mother got appellant out of the house, but appellant came back inside through a kitchen window. (RT 5:699-701, 5:709)

## Defense Case
### Raymond Anderson, M.D

Raymond Anderson received his Ph.D. from U.C.L.A., interned at the Los Angeles Veteran's Administration Hospitals and Clinic, was appointed

Chief Psychologist of the Wisconsin Sex Crimes Facility in 1966, moved to California and became the Chief Psychologist of the Mentally Ill Offenders Unit, servicing all Los Angeles County jails, then Chief of the Community Treatment Program for Sexual Offenders. He also worked for the parole department treating sex offenders/violent offenders, and, in 1978, founded a clinic that treats sex offenders and assess sexual offense. Dr. Anderson has taught at the University of Wisconsin, U.C.L.A. and U.S.C., is a member of the APA, the Association for Treatment of Sexual Abusers and the California Coalition on Sexual Offending, and has given presentations at the Los Angeles County Psychological Association and the Association for Treatment of Sexual Abusers. He has published articles on the revision of the foreign sex inventory for diagnostic purposes and group psychotherapy techniques. At the time of trial, Dr. Anderson had qualified as an expert witness on sexual deviancy and related mental disorders about 350 times. (RT 6:903-907, 6:974, 6:979-980, 7:1216)

There are no guidelines in the DSM for a diagnosis of paraphilia, NOS, nonconsenting persons: though many State examiners use this phrase in their reports, such a classification was considered and rejected by the APA for DSM inclusion. Dr. Anderson personally believed paraphilia, NOS, nonconsenting persons was an unaccepted diagnosis based both on the 1999 APA Task Force report that rejected inclusion and because the paraphilia NOS category is reserved for rarer disorders. Something as common as rape would have its own diagnostic classification, if it were an acceptable diagnosis: its omission is intentional. The DSM sets forth a number of diagnoses which would be qualifying mental disorders under the SVP Act, including mental retardation, conduct disorder, bipolar disorders, delusional disorders, pedophilia, sadism, and certain types of personality change due to general medical condition. Conduct disorder cites rape as a possible expression of that disorder. (RT 6:909, 6:911-915, 6:919-924, 6:1011-1012, 7:1246-1247)

To diagnose a paraphilia, there must be clear evidence that the object of the paraphilia is the focus of the sexual arousal.[16] (RT 6:927, 7:1250) Dr. Anderson opined there were people who did have a paraphiliac interest in

---

16 The authors of the DSM case book also note most rapists are committed by men with nonparphilic sexual preferences, many of whom have antisocial personality disorder. Dr. Anderson stated the majority of those in prison can be diagnosed with antisocial personality disorder. In the casebook example, the authors clarified the rapist showed no signs of antisocial personality disorder which would otherwise explain his behavior. (RT 7:1244-1250, 7:1264)

rape, and that should be included in the DSM-IV. Such a disorder would be manifest by a strong desire to have coercive sexual contact: the coercion is the focus of arousal. Approximately seventy percent of this sort are break-in rapists, involving primarily stranger rape, a Acomplex fantasy," and a very distinctive, ritualistic modus operandi, such as forcing the victims to dressing a certain way or marking them with lipstick, or leaving messages on mirrors. Often, the rapes have been fantasized about for a number of years before commission, and may have been rehearsed, and precautions taken against apprehension, making these rapists more difficult to catch. (RT 6:924-927, 7:1243, 7:1247, 7:1260) A rape done simply to accomplish sexual release, with no regard for the consent or feelings of the other person, is "just a means to an end." (RT 6:927)

Dr. Anderson's evaluation of appellant included several interviews, psychological testing, and a penile thismograph examination. (RT 6:908, 7:1222-1223, 7:1256) He reviewed appellant's predicate offenses, finding no evidence the 1978 rape of the fifteen-year-old was motivated by a preferential arousal for forced sex: from the official account of the offense, it appeared that had the girl consented to sex, it would have been just as satisfying or more satisfying to appellant than the rape.[17] Appellant attempted to have consensual sex, offering to pay for sex. Kevin's molestation also did not indicate a preferential desire for coercive sex because had Kevin agreed to sex, there would have still been sexual contact; again, the force was necessary to accomplish the act. Kevin's testimony that appellant would initiate contact by putting Kevin in a Acomfort zone" is indicative of seduction, not forced attempt.[18] The logic that someone who has been imprisoned for rape, and rapes upon release must be specifically aroused by sexual coercion is belied by the number of situational rapists who repeat offend. Situational rapists want sex, not coerced sex. There is not enough evidence to support the inference that someone must have a specific preference for coercion if he coerces sex even though he has a willing partner; it is equally possible the person wanted variety and couldn't get it or couldn't get it quickly enough. Married men frequently act on their extra-marital sexual attractions. Repeated acts of rape no more establish a mental disorder than repeated acts of theft

17 On cross-examination, Dr. Anderson described appellant's behavior as "outrageous, unacceptable, but not necessarily deviant. Criminal." (RT 7:1212)

18 Dr. Anderson evaluated appellant first on the assumption the unadjudicated sex offenses were true, then assuming they were not true: it made no diagnostic difference, as all began as attempts at seduction which turned to situational rapes. (RT 6:967-968)

establish kleptomania. (RT 6:927-933, 7:1206-1207, 7:1212-1214, 7:1232-1233, 7:1250-1251, 2:1262-1263)

Dr. Anderson found no current evidence of appellant's mental disorder as diagnosed by the State's evaluators. Though paraphilias are chronic, it is inappropriate to base a diagnosis of a current mental disorder on historical evidence plus lack of treatment. The DSM notes various degrees of remission, depending on the length the individual remains symptom-free; these remissions also apply to paraphilias. The DSM notes if a disorder, such as pedophilia, is chronic, and state what disorders appear to decrease with age, such as frottage or exhibitionism. (RT 6:933-936)

It is inappropriate to use Static-99 for SVP qualifying purposes as the test is standardized according to all sex offenses, not sexually violent or predatory offenses; as much as it predicts anything, it predicts minor sex offenses. Dr. Hanson's follow-up studies noted the marker was for any sexual reoffense: in an e-mail, Dr. Hanson stated that he thought reoffenders had committed primarily violent offenses, but this belief has not been published. A recent Department of Justice study of over 9,600 offenders, a third of whom were from California, indicates minor sex crimes outnumber serious violent sex crimes by four to one. Dr. Anderson has never heard of the Static-99 being used to determine mental disorder. (RT 6:937-941, 6:971-972, 6:988, 7:1232. 7:1234)

The Static-99 is Avery inaccurate" in terms of predicting sexual recidivism as its correlation with the rate of minor sex offenses is quite low; a study by Sjostedt and Grann demonstrated the test was unable to predict serious sexual offending at all. An earlier study by Sjostedt and Langstrom indicated it could predict minor sex offenses, and could be used cautiously so long as there was no problem with false positives, i.e., if there would be no harm done by scoring someone as high risk who is not. The correlation rate is .33,[19] and though Dr. Hanson deemed this a moderate correlation, Dr. Anderson felt it was low, given its application. A .33 correlative means that in the three-year follow up figure - 3.5% for reoffending - there will be 90% false positive mistakes (those put at high risk who do not reoffend) and 10% false negative mistakes (those put at low risk who do not reoffend). Some experts have suggested the Static-99 be used only for screening and not for

---

19 This differs from the R.O.C., which omits "low-base-rate," or infrequent occurrences. A .71 is not clinically useful; to be clinically useful, a test needs at least a .58 correlative. (RT 6:946) The MMPI, for example, has a .27 correlation rate. (RT 7:1223-1226, 7:1258)

determinations of release or dangerousness, but Dr. Anderson stated that to be 90% accurate about false positives, the high risk score would have to be 2, which would include everyone in the SVP population. (RT 6:941-949, 7:1226-1227)

The Static-99 is designed for people around thirty-five years old; at sixty, everyone has low reoffense rates regardless of score. It is inappropriate to consider anything beyond a four or five year period in assessing future dangerousness based on present mental disorder; the DOJ study used a three-year follow-up period.[20] The Static-99 was based on a particular population, drawn from a particular jurisprudential environment, which affects things like prior sentencing dates and convictions. There have been no studies on its efficacy as applied to California. Another critique of the Static-99 is the groups are too heterogeneous: one man's three may be very different from another, and the more homogenous a sub-category, the more accurate the reoffense rate.[21] ADecision trees" that isolate subgroup factors, are more accurate. (RT 6:949-951, 6:954, 6:971, 6:989-992)

Dr. Anderson reviewed Drs. Starr, Owen and Sharma's reports on appellant; Dr. Sharma evaluated appellant in 1979 to determine if he was a Mentally Disordered Sexual Offender based on the 1978 rape. In testing appellant, Dr. Anderson used personality functioning tests and sexual tests, cognition and empathy scales, and intelligence tests; though the ATSA suggests using the best validated actuarial instruments, Dr. Anderson does not believe the Static-99 has achieved sufficient validation as a risk predictor. Appellant was totally free of any major psychiatric disorder, there was no significant result to the plethysmograph examination. On all relevant tests, appellant belonged to the category of situational sex offenders. Situational offenders get sex the way robbers get money, by criminal means, ignoring the rights and welfare of the victim. Most rapes are situational. There are no studies to indicate whether situational offenders are more or less likely to reoffend than preferential offenders; Appellant appears to have improved since his 1994 parole revocation, and is testing more like a sexually normal

20 Forty-three percent of the DOJ offenders were rearrested for a new crime, and it was not always possible to tell whether the new offense was sex-related. (RT 6:990)

21 These rates may be counterintuitive: one small-sample Ohio study found that men with one sex offense had a recidivism rate of 11%, two sex offenses, 12%, two prior sex offenses, 8%, and three priors, no recidivism. (RT 6:957)

person than a situational offender.[22] Dr. Anderson did not believe appellant currently suffers from a diagnosable mental disorder which would qualify him as an SVP: that someone may be dangerous does not mean that danger is caused by a mental disorder. Dr. Anderson computed appellant's risk of reoffense by taking the DOJ three-year recidivism[23] statistics—7.4% for someone with a prior arrest/conviction—increased that percentage to 9% for five years, then halved that amount because of appellant's age,[24] leaving a reoffense potential of 4.5%.[25] (RT 6:951-953, 6:958-973, 6:975-979, 6:984-994, 6:1003-1020, 7:1205, 1207-1212, 7:1214, 7:1218-1225, 7:1227-1228, 7:1235-1235, 7:1257-1258)

In Dr. Anderson's opinion, appellant does not suffer from a preferential rape disorder: his rapes were most likely criminal decisions made to have sex with the victims, rather than coercion being a necessary element of his arousal. (RT 7:1253-1254)

Dr. Kaushal Sharma

At the time of trial, Dr. Kaushal Sharma had been a medical doctor for thirty-five years, a psychiatrist for thirty-two, and a forensic psychiatrist for twenty-eight. Dr. Sharma has been primarily self-employed, conducting psychiatric examinations for legal entities. He has been on the U.S.C. School of Medicine faculty since 1977, and is a clinical professor in the Department of Psychiatry section of Psychiatry and Law; he has been on the faculty at the U.C.I. School of Medicine since 1979, and is a clinical associate professor of psychiatry. He has been on the Los Angeles Superior Court psychiatric examiners panel for twenty-eight years, and acts as a consulting psychiatrist at the Mental Health Superior Court, in addition to other government agencies.

---

22 When asked about the significance of appellant's verbal outbursts, Dr. Anderson noted appellant's improvement in going from physical assaults to verbal insults, specifically on staff. There's no research showing profane language is a marker for future violent sexual behavior, and many non-sex offenders use the same language; use of derogatory language towards women does not contradict appellant's sexual orientation towards consenting relations with adult women. Appellant also verbally demonstrates feelings of warmth and affection; he hates the Atascadero staff. (RT 6:994-996, 6:998-1000, 7:1202-1205, /:1239-1241)

23 A November 2003 study by Patrick Langan and Schmidt Derose. (RT 6:969-970)

24 At the time of testing. It should be two-thirds the amount at the time of trial. (RT 6:969) According to his interview with appellant, appellant's problems began around the age of twenty-five; appellant also has had a problem with drinking. Appellant does not want to rape anymore, and appears to have a lowered sex drive. His potential to reoffend is in the "low single digits." (RT 6:1013-101)

25 On cross-examination, Dr. Anderson noted that Hanson's study indicated the correlation between a history of parole violation and sexual reoffense is .15, or 1%. The R.O.C. of .73 for failure to comply with supervision is a weak correlative. (RT 6:1002)

He has also done examinations on attorneys for State Bar purposes, and physicians for the California Medical Board. He has testified "a few thousand times," and has presented, published, co-accomplished and co-authored more than one hundred papers in forensic psychiatry, some on assessment of dangerousness in sex offenders. He is the chair of the Ethics Committee for the Orange County branch of the APA, and a distinguished fellow of that organization; a fellow of the American Academy of Forensic Science; a member of the American Academy of Psychiatry and Law; a part-time employee at the Norwalk Metropolitan State Hospital; and on staff membership at County U.S.C. Medical Center since 1977. He is familiar with the SVP law, and has conducted those examinations. (RT 8:1660-1665, 9:1832-1834)

According to Dr. Sharma, there must be a diagnosed disorder for SVP purposes; in this respect, personality traits are to be distinguished from personality disorders. Paraphilia, NOS, can be an accepted psychiatric diagnosis: it is a catch-all category, but does not include merely uncommon sexual desires.[26] Rape is not a paraphilia. People may commit rape Abecause they are jackasses" or schizophrenic, or retarded, or Abecause they are simply rapists." If a person cannot become aroused or perform without forcing or fantasizing forcing the other person, that is a paraphilia. If someone has a consensual partner and periodically Ais a real bastard" and rapes, that is not a paraphilia. Someone who had nonconsensual sodomy with a fourteen-year-old boy over a six-month period might be diagnosed with either pedophilia or hembehphelia, attraction to postpuberal minors. (RT 8:1665-1672, 9:1818-1822, 9:1825)

There is no correct diagnosis outside those currently authorized by the DSM. The DSM case book is an aid for those without the training or experience to use the DSM unassisted, is not a diagnostic manual, and does not have the authority of the DSM. The DSM is the authoritative text in North America and England; the World Health Organization publishes the International Classification of Diseases, which does not include a diagnosis for personality disorder. If a clinician cannot specify a paraphiliac attraction, they cannot be diagnosed with paraphilia, NOS. Profanity is no indicator of paraphilia, and is not a diagnostic criteria. To sustain a paraphilia diagnosis, there must be symptoms in the recent past, a time frame difficult to measure; however, the absence of symptomatic behavior for a length of time would

---

26 It is not a diagnosis recognized by most practitioners. (RT 9:1826)

negate the diagnosis.[27] (RT 8:1672-1677, 9:1803-1807, 9:1811, 9:1836-1837, 9;1844)

A personality disorder, NOS, with antisocial and narcissistic traits does not mean impairment of volitional capacities: Atraits" are not symptoms, and do not constitute a diagnosis. Compulsion and pathology are two hallmarks of paraphilia. Out of the forty SVP evaluations he's done, he's found 15 to be SVPs. Dr. Sharma opposes being appointed for SVP evaluations because he believes there is Aa lot of hocus pocus going on." The doctor has diagnosed people as having personality disorder, NOS, antisocial personality disorder. One of the criteria is juvenile history: absent that information, the proper DSM diagnosis would be adult antisocial behavior, not personality disorder, NOS. Someone who is antisocial is at odds with social norms, willing to take what he can, believing he is right; someone with narcissistic traits is abnormally self-centered. Antisocial disorder is a AV-code" or non-mental disorder. Personality disorders are stable over time. Dr. Sharma evaluated appellant in 1979, but has no opinion as to whether appellant has a current diagnosable disorder. (RT 9:1810-1811, 9:1831-1832, 9:1837-1838)

Dinko Bozanich

Dinko Bozanich was formerly a Los Angeles County Deputy District Attorney; he prosecuted a 1982 murder case against Donald Luebbers, using appellant as a witness in the 1986 trial. Appellant's testimony was important to the Luebbers case, and he risked being seen as a rat by testifying. Appellant told Bozanich that it was okay to rape but not to kill. At the time of the Luebbers trial, Bozanich knew appellant had been convicted of sodomy; the prosecution knew no deal could be proffered in exchange for his testimony, and Bozanich did not attempt to intervene for appellant in appellant's prosecution. In between appellant's coming forward and his trial testimony, his conviction was reversed and remanded. (RT 8:1627-1643)

Rebuttal

Robert Jordan was the Kevin prosecutor. Appellant was initially convicted of ten counts, and sentenced to 57 years. The case was eventually remanded based on appellant's improper impeachment. On remand, the trial court was to weigh whether the priors should have been allowed. Before this hearing, homicide detectives told the court what appellant had done in the

27 When asked, Dr. Sharma testified he was familiar with Atascadero's "so-called" treatment program; the chance of remission improve with treatment. (RT 9:1834)

Luebbers case. The court felt that because appellant had done something for the prosecution, he should get some consideration, and sixteen years was an appropriate sentence to settle the case. Because Jordan was concerned about losing the impeachment hearing, and did not want to retry the case as the victim's memory had faded and the case was hard won in the first place, he accepted the two-count plea and sixteen-year disposition. (RT 8:1644-1659)

# STATEMENT OF FACTS

<u>Prosecution Case</u>
<u>Counts 1 and 2</u>

On December 23, 2004, fourteen-year-old Iliana was living with her mother, father, and Fausto, a relative of her mother's. Iliana and Fausto had their own bedrooms; Iliana's father and mother slept in the living room. That morning, Iliana's father went to work about a quarter to eight, his wife having left five minutes before, and Fausto around 6:00 a.m. Iliana was still in bed, on school vacation. Before her father left, he put the phone in Iliana's hand: the day before the bathroom window screen had been torn. (RT 1:335-336, 1:348, 1:352-353)

Iliana heard knocking at the front door; she answered, and a man asked for a bucket of water for his car because it was frozen. Iliana got a bucket from the kitchen; after the man returned the bucket, Iliana listened to the living room radio for a while, then took a bath, leaving the door closed. An hour later, wrapped in a towel, she walked into her room. (RT 1:353-356)

There was a man behind her door, his face covered with one of Iliana's shirts. She could see his eyes, but had never seen him before. The man had a butcher knife belonging to Iliana's family, and was pointing it at Iliana. The man told Iliana to get on her knees so he could tie her up. She did. He tied her hands in front of her, using her belts. He told her to sit on her bed and drop her towel. She did. The man started touching her breasts and inside her thighs. He told her to open her legs, and looked at her vagina. He still had the knife in his hand. (RT 1:356-360)

The man said to go towards Fausto's room and lie face down on the bed. He covered her with a blanket, and began going through the house: Iliana heard him in Fausto's room, her room, and the living room. The man returned and asked Iliana how old she was, where she went to school, was she a virgin, and if she wanted to "do it" with him. Iliana told him her age, where she went to school, that she was a virgin, and did not want to do it with him. The man went through the house again, again returned, and told Iliana to turn around. (RT 1:361-364) Iliana was on her back, hands still tied, still covered by the blanket. The man got under the blanket, telling Iliana to close her eyes. She heard his belt buckle, he got on top of her, and put his penis in her vagina. Iliana pushed him away with her legs; he asked why she was pushing him away, she said it hurt. He asked if she wanted him to go

slower and she nodded. He went slower, then fast again, then stopped and got out. Iliana thought he ejaculated. At some point while on top of her, the man asked Iliana for jewelry and money. (RT 1:364-368, 1:374)

The man told Iliana to turn face down, and went through the house. He returned and asked if Iliana wanted to get dressed and take a bath. Iliana said she didn't want to stand up because she was naked; she was looking at herself in the mirror, away from the man. The man asked if she wanted a cover, she said she did, he covered her with the blanket, and she went to her room. She dressed, untying her hands in the process. The man asked why she was covering herself, as he'd already seen her. He had her go into the other room, and told her to stand or sit in the corner. She stood. He tied her arms and legs with belts and put her in Fausto's closet, closing the closet door, moving a cabinet in front of the door. The man said he would be out in five or ten minutes, went through the house once more, and left. (RT 1:367-372) After the house was quiet, Iliana braced her back against the wall and pushed the door open. She looked to see if the man was still there, then went to her neighbor's house.[1] She told her neighbor someone had broken in, and the police were called. (RT 1:371-373)

Iliana also called her father, telling him a man had come into the house. Her father called 911 and went home: the police were there when he arrived, and "everything was tossed around" in all the rooms. Iliana was outside. Some jewelry, a watch, Mexican money, shoes, and Fausto's DVD player, speakers and a laundry bag were missing from the house. There was a chair outside and underneath the bathroom window; the fabric covering the window had been lifted, and the kitchen window screen was on the ground. The shirt the man had around his face was in the living room, and the knife was on Iliana's bedroom chair. (RT 1:337-340, 1:343-345, 1:375-376)

As Iliana's father was leaving that morning, he noticed a man watching him; the man was wearing a black or blue cap, and a blue and yellow waterproof jacket. The man seemed suspicious, and Iliana's father studied his face carefully. He identified appellant as that man. He also told an officer at the scene about the man, told another officer when he identified his

---

1 Tonya lived next door; on December 23, 2004, as Tonya, her daughter and husband were leaving, Iliana, their fourteen-year-old next-door neighbor, came up to them and said someone had entered her house. Iliana was crying, upset; Tonya told her to calm down, put Iliana in their house, and called 911. Tonya waited until after Iliana's father came home before leaving. (RT 1:320-324)

property, and told a male detective, describing the man two or three times. (RT 1:345-348-350)

The forensic nurse who examined Iliana found linear red marks on both wrists, consistent with binding, a tear and laceration in Iliana's hymen, bruising to the fossa navicular in the posterior fourchette area, and a large amount of moist secretion coming from her vaginal opening. The injuries to her hymen were consistent with intercourse. Two swabs were taken from the left side of Iliana's neck and cheek, four interior and two external vaginal swabs, and two anal swabs; the swabs were preserved for further testing. A microscope slide was made using the vaginal secretions: non-mortal sperm were detected, and the slides were preserved for testing. A blood sample was also taken. (RT 1:373, 2:602-611)

The deputy sheriff in charge of the investigation was aware of the burglary three blocks away; based on the previous burglaries, he decided to conduct a surveillance of the area from 5:00 a.m. to noon. At 5:30 a.m. on December 28th, the officer, dressed in casual clothes and driving an unmarked vehicle, saw someone about a block from the surveillance area dressed in a yellow-hooded sweatshirt, with a blue beanie underneath the hood, wearing dark gloves. The man was about 6' tall, thin, muscular. The officer lost sight of the man while attempting to turn and follow him; twenty to thirty minutes later, the officer saw him again, stopping him at gunpoint with the assistance of a patrol unit. (RT2:630-634)

The man, identified as appellant, said he lived there, pointing to a house. The officer went to that house, obtained permission to search by the occupants, and searched appellant's bedroom. A DVD player, matching the description of the one stolen from Iliana's house, was on top of the dresser; a pair of shoes matching those described by Iliana's father were under appellant's bed. In the closet was a metal box with a key, inside were several pieces of jewelry described by Iliana's parents as having been taken. There was also Fausto's driver's license, social security card and Mexican National card; Fausto's laundry bag was in a dresser drawer. Speakers and a cell phone were later recovered pursuant to a search warrant. (RT 2:635-641, 2:646)

A Los Angeles Sheriff's Department Crime Laboratory criminalist analyzed the evidence samples taken from Iliana, and detected semen on the hospital slides. A DNA analysis was performed on the vaginal secretion sample and the blood reference sample: first, sperm cells were separated

from non-sperm cells in the vaginal sample, the segregate DNA amplified, then profiled. The profile of the non-sperm cells was compared with the profile generated by the blood reference sample; the two profiles matched. The profile of the sperm cells was compared to a profile of appellant's reference sample, and also matched. According to the F.B.I.'s statistical calculator, the rarity or frequency of that profile is one in 1.6 quintillion (one followed by eighteen zeros) in the Caucasian population, one in 1.8 quintillion in the Black population, and one in 587 quadrillion (one followed by fifteen zeros) in the Hispanic population. There are about six billion people on earth: it would take 97 million earths to find that same profile. (RT 2:611-621)

"Pull-ups" are testing artifacts, peaks which suggest the presence of DNA in various color-coded areas where DNA is not truly present. Over-saturation of a sample can cause pull-ups: if a sample shows a level of over 4,000, it suggests there may be a pull-up. According to the analyst's bench notes, at least seventeen pull-ups were noted in several different areas of the control sample and the male vaginal sample. Over-saturation can also result in "split peaks"; a split peak was noted in the bench report. Peaks before or after alleles could be testing artifacts, these were also noted. The analyst said this did not affect the interpretation of the results. (RT 2:621-627)

Iliana never got a good look at the man and was unable to identify him. (RT 1:377)

Count 5

On December 23, 2004, Jenny was living on seven blocks from Iliana's family, a five to seven minute walk. That morning, Jenny's bedroom window was cracked open so the electrical cord for the Christmas lights could be plugged into an interior outlet. The windows opened vertically, and Jenny had blinds on the windows, which were drawn. At 6:00 a.m., as Jenny was running her bath, she listened to a message on her answering machine, then went into the living room to retrieve her cell phone from her purse. She returned the call and the phone, put her purse on her bed, and took her bath. Thirty to forty-five minutes later, she went back to the bedroom, noticed the room was extremely cold, the blind was hanging down, and wind was coming through the room. Jenny opened the blind; her screen was out on the grass, alongside a long piece of wood with a hook on it. She continued to get ready for work, and realized her purse was missing. In addition to the silver cell phone, the purse had Jenny's wallet, credit cards, makeup bag, appointment and phone books, and $60 or $70 in cash. (RT 1:311-316) By

the time Jenny spoke to the police, about 9:30 or 10:00 a.m., her purse and most of its contents had been returned. The money and cell phone were still missing. (RT 1:316-320)

Detective Anthony Olague of the Los Angeles County Sheriff's Department interviewed appellant twice, on December 28 and 29. There was another detective and a certified Spanish-language deputy present for both interviews. (RT 1:326-328) A search warrant was served at appellant's residence on the 28th, and a silver cell phone recovered. In the interview on the 29th, appellant said he took the phone during a street burglary: he took a screen off a bedroom window, reached in and took a purse on the bed. Appellant said he took a purse with money, kept the phone and cash, and threw the purse in a back alley near the residence. He spent the money. Appellant also said he broke into a house with a girl inside. The cell phone serial number was registered to Jenny. (RT 1:328-333, 2:641-647)

The police interview

The interview begins with Detective Olague asking appellant what part of Mexico he was from, how long he's been here from Mexico, and where he's worked. Appellant says Tetiucan, nine months, five of which were spent in Modesto, working in the fields. Appellant says he moved to Los Angeles from Modesto, first living in Gardena, then Huntington Park, finally moving to Pico Rivera. There is a discussion about appellant's three-year-old son, living with appellant's mother-in-law in Mexico, and whether appellant will teach him to play soccer. There is a general discussion about favorite soccer teams. Olague asks appellant how long it's been since he's seen his son; appellant says one year, Olague sympathizes, then says he needs to talk to appellant about some things that are hard to talk about. Appellant says, "Okay." (CT Supp.1:2-17)

Olague tells appellant he needs to read him some "rights in English,"[2] afterwards, appellant says "it's fine like that" without a lawyer. Olague asks appellant if he knows why he's been arrested; appellant says he "got into a house to rob." In response to Olague's questions, appellant says he doesn't know when or where the robbery occurred. Olague asks a series of questions trying to identify the location; appellant doesn't know, but says he went in through a kitchen window from a door in the alley. (CT Supp.1:17-25)

---

2 According to the bilingual transcript, the rights were translated into Spanish at the interview. (CT Supp.1:18-19)

Olague asks appellant if there was a "young girl," appellant says, "No, she was a girl." Appellant didn't know she was inside, and hid in the bedroom and put on a hat when he saw her. He had a knife from the kitchen. When the girl came out, appellant tied her with a belt and sat her on the bed. He told her not to make noise, and asked her if there were things of value. She spoke to him in English, which he didn't understand. Appellant looked, but didn't find anything. He took her towel off, he touched her breasts. He did not touch her butt or vagina. He went with her to another room, she said she was cold, he told her to lie on the bed and cover herself. She did; appellant looked for things in the room. Next, he told her to get dressed, tied her up and locked her in the closet. He did not "decide to be with her," did not put his penis inside her vagina. (CT Supp.1:25-30, 33-39)

After Olague tells appellant that the girl is saying that appellant was not mean to her, but that there is evidence of "some things," he asks appellant if appellant put his penis in the girl's vagina. Appellant says, "If I say, my wife won't find out?" Olague says he's not going to tell her. Appellant says he doesn't want his wife to know. Olague reassures appellant; appellant says he went to bed with the girl, but did not put his penis in her vagina. Olague says it's better to admit a mistake, and why make the girl suffer more, because she is ashamed. Olague asks again whether appellant put his penis in the girl's vagina, appellant says yes. Olague asks if appellant asked the girl if she liked it; appellant says yes.

Olague asks if the girl then screamed; appellant says yes. Appellant asked the girl if she wanted him not to continue, she said yes. Appellant did not remember ejaculating. Afterwards, he put her in the closet and left. (CT Supp.1:40-45)

Appellant said if it hadn't been that house, it would have been another: he needed to send money to Mexico, and didn't have any. He did not go into any other house. He put what he took in a bag, including some gold things, a chain, a watch, about six rings, and a "device." He left the DVD behind, and there was no money. (CT Supp.1:46-57)

Defense Case

There was no affirmative defense presented.

# STATEMENT OF FACTS

## Prosecution Case
### Amanda: counts 1, 2 and 3

On February 28, 2005, seventeen-year-old Amanda was living with her mother and her twelve-year-old sister in Lennox. They had lived there for about a year and a half: their apartment[1] had one bedroom, with two beds, and one entrance, which had a metal security door and a wooden interior door. There was a security window in the bedroom that could be opened from the inside, and two barred windows in the front room. When Amanda came home about 8:00 p.m., the lights were off and the doors were unlocked: Sandy had gone to do the laundry, and Amanda did not have a key.[2] There were two keys to the apartment; Amanda had lost hers. Sandy and her daughters often left the doors unlocked for each other, and when Amanda came home, she left the door unlocked for her sister and mother. (RT 3:370-376, 3:407-408, 3:410-411, 3:436-439, 3:463)

Once inside, Amanda made something to eat, then went to the bedroom, and laid on her mother's bed to watch a movie. She fell asleep, waking when she felt a knife point poking her neck. Appellant was standing by the bed, holding the knife in his right hand. Amanda could see appellant in the light from the television and from outside. She'd never seen him before; he had a mustache, and was wearing something like a bandana on his head, covering his hair. Amanda started screaming, appellant told her to shut up, be quiet, he wasn't going to hurt her. Pointing the knife at Amanda's stomach, appellant asked if she had money. Amanda said she had $45.00. Appellant knelt beside the bed and told Amanda to wait, to take her pants off, that he wasn't going to hurt her. As Amanda struggled, trying to push him away, appellant unbuttoned her pants and pulled them off her right leg. He licked Amanda's vagina, telling her to let go of herself and that he wasn't going to hurt her. He also removed her sock and licked her toes. Amanda understood appellant to mean that if she let him do what he said, he wouldn't hurt her. Amanda did not want appellant to orally copulate her; she was crying, saying

---

1 Flanked by two other apartments: the neighbors to the left were in the process of moving in. Amanda did not know if any of her neighbors were home on the 28th. (RT 3:408-410, 3:456)

2 On cross-examination, Amanda testified she'd come from her boyfriend's house: he picked her up from school at 3:00 p.m., they got something to eat, then went to his home around 6:00 p.m.. After about an hour, Amanda went home, taking his car. Amanda's then-boyfriend was Gustavo. (RT 3:400-406)

she'd give him anything he wanted, money, things, so he could leave. She told him to leave, and closed her legs. (RT 3:376-383, 3:412-423, 3:456-457)

Appellant tried to open Amanda's legs, but could not. He told Amanda to get the money. She retrieved $20.00 from her dresser and gave it to appellant. He pushed her to her bed and tried to kiss her, she spit on him and pushed him. Amanda heard a knock at the front door: it was Carla, calling for Amanda to open the now-locked door. Appellant zipped his pants and started looking for the knife, which he said was Amanda's. He told Amanda to open the window, and when she couldn't, he did, and climbed out. Amanda closed the window and opened the front door for her mother and sister. Amanda was crying; she told her mother what happened, and her mother called the police. (RT 3:382-387, 3:423, 3:434, 3:446-447, 3:463-464)

Sandy speaks Spanish; she called the police twice, as it took two and a half hours for the deputies to arrive. Amanda, no longer crying, talked to the officers,[3] described appellant and showed them the knife, which Sandy found under the teddy bear on Amanda's bed. It was one of the family's kitchen knives. Amanda lied to the deputies about her boyfriend driving her home from a friend's house because she was scared: she's underage and has no driver's license.[4] She also told the officers that she would not be able to identify her assailant, and that she woke up because she felt someone standing over her, started screaming when she saw a black man standing there, and this was when he put the knife to the left side of her neck. Amanda said the man reached down and started unbuttoning her pants, saying he was not going to hurt her if she gave him what he wanted. She said the man took her pants and panties off her right leg, kissed her stomach, and

---

3 The patrol deputy testified Amanda was crying during the interview, and seemed hesitant to discuss the incident. Sandy pointed out the knife in the bedroom. In her narration of events, Amanda never said anything about her assailant licking her vagina or kissing her. Amanda declined medical or psychological treatment. (RT 4:612-639)

4 Amanda also lied at the preliminary hearing about Gustavo driving her. (RT 3:400) At trial, Gustavo testified he loaned Amanda the car, she left around 7:00 p.m.; he got a call from her at 11:00 p.m., and she was hysterical, crying, "talking sad." She told Gustavo someone broke into the house and had a knife at her neck, and described a sex act which was committed against her. At the preliminary hearing, Gustavo did not say he'd loaned Amanda his car because he was trying to protect her: she's not allowed to drive. Gustavo told Detective Newman that he drove Amanda home and had a friend pick him up at her house at 9:00 p.m., leaving his car with Amanda. He also testified at the preliminary hearing that he'd gone into the house and watched part of the movie with Amanda that night before leaving. (RT 3:469-475, 3:487-499, 4:602, 4:608-609)

moved towards her pubic area. She kept her legs closed; the man tried to pull them apart, telling her not to do that, he wouldn't hurt her. Amanda told the deputies the man then asked for money. She said she got up and got him $25.00 from her dresser, but couldn't find any more money.[5] After talking to the deputies, Amanda called Gustavo, told him what happened, and told him to tell police he drove her home that night. (RT 3:387-391, 3:394, 3:423-431, 3:433-434, 3:447-448, 3:454-455, 3:457-459, 3:465-467, 4:617-639)

A few days later, Amanda was interviewed at home by Detective Newman; a few days after that, she was taken to a police sketch artist, who drew a picture based on Amanda's description: a man in his mid-twenties, wearing a cap.[6] After the sketch was done, Amanda said it was "the kind of person" she remembered. During her interview with Detective Newman, Amanda said her family did not have any keys to their apartment. She also said appellant orally copulated her for a few seconds before she pushed his head away, that appellant was holding the knife throughout, and that he tried to turn off the television, but just succeeded in switching the channel, then turned on the bedroom light as Amanda pled with him not to hurt her. Amanda said when she told appellant to stop orally copulating her, saying she'd give him whatever he wanted, that he then asked for money. (RT 3:391-394, 3:436, 3:439-441, 3:443-446, 3:448-449, 3:459-462, 3:465)

On March 17, 2005, about three weeks after her attack, Amanda called Gustavo at 1:00 p.m.; Gustavo sounded scared, nervous. After speaking to him, Amanda went home. She found police officers around her house looking for someone, and her mother standing outside, hysterical. Sandy told Amanda what had happened, Amanda did not know who had hurt her mother. After Sandy was taken away in an ambulance, Amanda walked up to one of the police cars and saw appellant inside. She told one of the officers appellant was the same man who attacked her, then started crying

---

5 On cross-examination, Amanda could not remember not telling the deputies appellant had orally copulated her. (RT 3:430-431, 3:433) She testified she held her legs tightly together, appellant used a lot of force trying unsuccessfully to pull them apart. (RT 3:433-434)

6 The graphics specialist who drew the forensic description of Amanda's assailant testified the procedure for drawing a composite sketch involves a cognitive interview with the witness, filling out a graphics form, using details supplied by the witness, and composing the drawing. Amanda described someone with "a doorag tied in black [sic], and the black comes down to the eyebrows." The eyebrows were black, medium thickness; brown eyes, medium width, smaller vertically; wide nose, medium width lips, medium fullness; medium chocolate complexion; black mustache; oval shaped face. Looking at appellant, the graphics specialist noted he had a prominent nose. (RT 4:642-668)

and throwing up.[7] (RT 3:394-397, 3:455) Amanda also identified appellant as her assailant at the preliminary hearing, and at trial: she is positive it was him. (RT 3:397-398)

Sandy testified the apartment was on the first floor, the building parking lot had an unlocked gate, and there was no other form of security. The wooden door could not be locked because the lock was broken. Sandy called the owner several times to have the lock fixed, but the owner never properly repaired it. The family has moved. On February 28th, Sandy and Carla went to the Laundromat, and were gone for about three hours. Sandy left her key to the security door in her purse inside the apartment because she knew Amanda was going to be home. Amanda lost her key a week before. When Sandy and Carla returned, they had to knock on the locked metal door for fifteen minutes until Amanda responded. Sandy was surprised Amanda wasn't answering, and thought she'd fallen asleep. When Amanda came to the door, she wouldn't look at Sandy. Sandy turned Amanda towards her and asked her what was going on; Amanda said, "Can't you see this black guy got in here?" Amanda had been crying, and was angry, and her mascara had run all over her face. Sandy asked Amanda what happened, Amanda said the man threatened her with a knife, he threw her on the bed and was "touching me all over." (RT 4:672-678, 4:681, 5:956-962)

Amanda told Sandy the knife was on her bed. Sandy found the knife under a stuffed animal; the knife belonged to the family, and was usually kept with the spoons in the kitchen. Amanda was not wearing underwear, just a T-shirt and pants. Sandy called the police on her cell phone, telling them a man had gotten in and tried to rape her daughter, and had threatened her with a knife. The police did not arrive right away: Sandy called two or three times, there was no answer the last two times; the officers came about two hours after the first call. Sandy told the officers a little of what happened, and Amanda explained more. After taking a report, the sheriffs left, and Amanda called Gustavo and told him what happened. (RT 4:678-681, 5:962, 5:964-965)

On November 30, 2004, Sandy was stopped for a traffic violation, she and Amanda were taken out of the car, and were subsequently arrested for giving the officers false names. Sandy testified the officers found the false identification card in her bag: she gave them the false information because

---

7 On redirect, Amanda testified the security door appeared to have been pulled away from its frame sometime that day. (RT 3:455-456)

she is in the country illegally, and doesn't have any identification. She needs the false i.d. to work. (RT 3:388, 3:449-451, 4:680, 5:962-964) After Amanda's attack, the family still left the wooden door unlocked sometimes. They got a key for the security door. (RT 3:453-454, 5:927)

Sandy: counts 4, 5, 6, 7 and 8

On March 17th, Sandy dropped Carla off at school at 7:00 a.m.,[8] and went to look at a potential apartment: she knew their apartment was not secure, and they needed to move. She left the door unlocked because she was coming back right away; her key was in a bag inside the apartment. She went to the new apartment, found out the manager was not there, bought McDonald's tea and an apple pie for breakfast, and returned home around 9:30 or 10:00 a.m., going straight to her bedroom. The doorframe was not pulled out when she came in, there was no wood on the ground. Everything was just as she had left it. Sandy was watching television and resting before going back to talk to the manager at the other building. Her purse was near the bed; that morning, she'd put $225 in an envelope and the rest of her rent money in a compartment inside the purse. (RT 4:681-684, 5:913-922, 5:924-926)

Sandy was very tired, falling asleep; about an hour and a half later, she opened her eyes and saw a man walking through her bedroom door, a knife in his hand. The knife was about 8" long, and was one of Sandy's kitchen knives. The man was appellant. Sandy had never seen him before. She was surprised, as she thought she'd locked the metal door from the inside. Appellant put the edge of the knife to Sandy's neck and said, "I will kill you if you make any noise." Sandy pled for him not to hurt her, he asked if she had money, she said yes, he asked where it was, she asked if she gave him money, was he going to hurt her, he said no, she gave him $200 from her bag next to the bed, he put the money in his pocket and asked her where she kept more, she told her in the drawer, he told her to leave it there, not to get up. She said fine, for him to leave and not hurt her. (RT 4:684-693, 5:922, 5:926-933, 5:935-938) Appellant grabbed Sandy's hand, said to come here, and began lifting his shirt with one hand. He told her to take off her clothes; she said no, please go. She said she wasn't going to call the police, and for him to go. He said he was not going to leave until he was done with

---

8 On cross-examination, Sandy testified a male friend gave her and Carla a ride to school, then took Sandy to McDonald's, and drove her back home before going on to work; he does her many favors, and she did not want to identify him. (RT 5:915-917) Sandy also testified that at the time of the assault, she was 5'2" and weighed 125 lbs. (RT 5:965, 5:9700-971)

her. Sandy thought appellant was going to kill her, or rape and kill her.[9] (RT 4:693-694)

Appellant pulled Sandy; she said, no, please, that God was looking at him and that her daughters would be home soon. Appellant kept staring at her and telling her to take off her clothes. Sandy sat up; appellant told her to "lay down" and take off her clothes. Sandy said, "No"; appellant said, "What?" Sandy said "No," appellant said, "What?" and grabbed the knife. Appellant's eyes were "maniacal, hysterical." Appellant threw Sandy down, pulled up her blouse, and put down the knife. Sandy told him not to do that, and started to grab the knife, appellant told her not to do that, to take it easy, relax. Sandy said she couldn't, and asked appellant to give her the knife; he asked if she was going to scream or make any noise, she said no. Sandy testified she'd already thought about letting appellant "spend a lot of time" there, making him waste time because she had her cell phone and could call the police from the bathroom. Appellant put his hand under Sandy's bra and squeezed her breasts, hurting her. She asked him not to hurt her; taking up the knife again, he told her to take off her pants. She said okay, thinking she would obey appellant, do whatever he said because "why would I want my daughters to be all by themselves." Sandy took down her pants, appellant pulled them off. She did not want to take off her panties, after pulling back and forth, and arguing, appellant grabbed Sandy by the neck, squeezed her tight, and told her she was going to do this or he was going to kill her here. At some point, appellant put the knife back on the bed, telling Sandy not to move it. She agreed. (RT 4:694-698, 4:700)

Sandy had screamed once or twice, but no one heard her, and appellant told her to shut up. He also periodically picked up the knife, putting it in front of her. She continued to think about letting more time elapse by cooperating. She didn't take off her panties, but promised she would, saying she had to go to the bathroom. She told appellant he could stand outside the bathroom if he wanted to; surreptitiously picking up her cell phone, she went into the bathroom, pulled down her panties and sat on the toilet. The door was half-closed: she was trying to make him trust her, and so was looking at him as she tried to dial the police with her left hand. Using the bathroom mirror to see into the bedroom, she saw appellant wait a moment outside the

---

9 At the preliminary hearing, Sandy testified she tried to run away when she first saw appellant, but appellant stopped her. At trial, she testified she wasn't able to move when she saw him. (RT 5:933, 5:972-973)

bathroom before going into the bedroom and through her purse. She realized appellant had the envelope containing the rest of her rent money, and saw him put it in his pocket. The envelope, related to the false i.d. charge, had a return address of the Sheriff's Department, Sandy's name on the front, and about $200.00 inside. Appellant's pants were unbuttoned, he pulled them down. (RT 4:699-707, 5:942-955)

Sandy was confusing the numbers on the phone; unable to get a call through, she decided to call Gustavo. She told him there was a black guy there and to call the police. She said he wanted to kill her with a knife and to hurry up. Gustavo told her he'd call and to just stay there. Sandy said, "Yeah. Entertain him." She left the bathroom slowly, to gain more time, asking appellant why he'd lied to her. She said appellant told her he'd leave after he took the money, and asked why he wanted to keep hurting her. Appellant's pants were down, and he was rubbing his penis over his underwear. Appellant said everything was okay, that as soon as he finished with her, he'd leave. Sandy said he was stealing her rent money and still terrorizing her. Appellant said to sit down, she sat on her bed, he pushed her down and told her to take off her panties. He looked angry and seemed kind of desperate. Sandy sat back up and said she'd called the police, and they were coming. She saw appellant's i.d. was on the floor and pushed it towards the bed with her foot. He started looking for his i.d., asking her where it was and saying she'd taken it. She said she hadn't, and that he should look under the bed; when he went to look, she started running, he ran after her, grabbed her by the hair, pulled her, said come, she started screaming, and he put a chokehold around her neck with his arm, squeezing with all his might. (RT 4:707-712, 5:940-942, 5:955-956)

Appellant put Sandy face down on the bed. She thought it wasn't possible she was going to die at the hands of this mean sadistic man, and that she should slack her body and not move. She lost her mind and could not fight anymore. When appellant saw Sandy wasn't moving, he turned her over, grabbed her hips and pulled down her panties. Later, she had bruises on her hips from the grabbing. He told her, "like this," and touched her breasts and rubbed her vagina. He began orally copulating Sandy, holding her hips; it took a long time. Appellant got up and put Sandy's hand on his penis. She grabbed it, then let go, asking him not to do anything else, just go. (RT 4:712-717)

Appellant put on his shirt and pants and began touching his chest and penis. He told Sandy to open her legs. She said she couldn't, she had her period. Her period had stopped two days earlier. Appellant said it didn't matter, just to hurry up; he told her to come to the edge of the bed, and pulled her legs. Sandy crossed her legs, and continued to say no. Appellant put his penis on top of Sandy's vagina, opened her legs and told her not to move; she closed her legs and pulled herself up. Appellant became angry, telling Sandy he would kill her if she didn't cooperate, and asking for his knife. Sandy had hidden the knife; appellant found it, and repeated his threat. Sandy told him to give her the knife, and took it from his hand. Appellant agreed, telling her not to scream and asking if everything was okay. Sandy said yes, took the knife and threw it on the floor behind the bed. (RT 4:718-721)

Appellant pulled Sandy, saying something about kissing his part. Sandy didn't understand; appellant grabbed the back of her head and put her mouth on his penis. She continued to protest, he told her it was okay. The oral copulation lasted "just for an instant": Sandy pushed him away immediately, and he took her hand and put it over his stomach, forcing her to caress him. Appellant told Sandy to lay down, she did, then sat up and began knocking on the wall. Appellant asked what she was doing, Sandy told him to go, someone could call the police, who were going to come. Appellant got angry and asked for his knife back. He pulled Sandy and opened her legs, telling her to stop playing and cooperate. Sandy said it was all right. Appellant put his hand on her breasts and grabbed his penis; he was trying to penetrate her, but she was "very closed." Sandy told him not to hurt her. He asked where he could find cream, she told him, he got some, and put it on his penis. She told him it was late and asked him to go. He got angry, pulled her to him, and penetrated her. She began to bleed: it was painful, and she felt as though she was being ripped apart. (RT 4:721-726)

Appellant continued to penetrate Sandy; she bled every time he pushed his penis in deeper. At some point, she pushed him with both hands, and he got up and went towards the bathroom, saying it was okay, he didn't care if she was bleeding. She sat up, and cleaned the blood from her vagina with a nearby napkin. Appellant started masturbating in the bathroom sink while looking at himself in the mirror; Sandy thought appellant was going to come back and continue hurting her, and that he would kill her because he knew she would accuse him and call the police. She wrapped a pair of pants around her waist and ran through the bedroom door and out the front door.

She started knocking at the neighbors' security door, screaming for help. No one was home.[10] (RT 4:726-733)

Sandy was going towards the street when she ran into police officers coming through the gate.[11] Crying, Sandy told them to go to the back of the building, they did, and returned with appellant, who they said was jumping from the window.[12] The bedroom window was closed throughout the encounter: there was a glass window with a metal security mesh over the window. Sandy identified appellant as her assailant, and the officers took the envelope from appellant's pocket and asked Sandy if it belonged to her. They said she'd get her money back after they took appellant to jail. The officers did not speak Spanish, and called someone who did. Sandy explained to that person what happened. By this time, Amanda was there; the officers called an ambulance, which took Sandy to a medical facility. Sandy was vomiting en route. (RT 5:902-907, 5:912, 6:1211-1214, 6:1229-1232)

According to Sandy, she was examined several times at the rape treatment center. Her throat was "highly affected": she couldn't talk, her voice was "highly irritated," and there was an external bruise. Her stomach, vagina and waist were sore. She told the nurses as best she could about her attack, but could not give details because she was embarrassed. She told them about the oral copulation, the knife and appellant's threat that if she called the police, he would return. (RT 5:907-911, 5:9976-978, 6:1232-1234, 6:1237-1239) Later that night, Sandy spoke to Detective Joe Espino for an hour; they did not discuss Amanda's attack. He returned Sandy's money. (RT 5:910, 5:968-969, 6:1365, 6:1369, 6:1382-1385, 6:1388, 1399-1400)

---

10 One of Sandy's neighbors testified she heard Sandy screaming for help in Spanish; she went outside, and saw Sandy running from the garage towards the patio, wearing only a T-shirt. Hernandez gave Sandy a pair of pants, and the polica arrived. The neighbor did not hear any screams or other noises before she heard Sandy outside. (RT 6:1202-1209, 6:1394-1396)

11 Detective Espino testified the gate, which leads to the carport, is unlocked and accessible to the public. (RT 6:1365-1366)

12 The officer-witness testified when he and nis partner ran to the back of the building, they saw appellant run from the building to a wall, then try to jump over the wall. A blue knife and an envelope with Sandy's name was found on appellant. When they escorted appellant through the courtyard, Sandy started yelling "that's him.: The interview with Sandy was brief because she was hysterical; even the Spanish-speaking deputy had a difficult time communicating with her. The deputy noted the door security screen appeared pulled from the wall; in the apartment, a bloody paper towel and panties were by the bed. Detective Espino saw these same items when he went through the apartment. The officers learned of Amanda's assault when they interviewed her at the scene. (RT 6:1214-1228, 6:1240-1252, 6:1261-1264, 6:1269, 6:1272-1274, 6:1375-1378)

Gustavo testified that when he answered his phone on March 17th, Sandy said somebody was in the house trying to rape her. She couldn't talk, and was scared and crying. She told Gustavo to call the police or call somebody to help because the guy was hurting her. Gustavo hung up and called Detective Newman. Newman told Gustavo to call 911. Gustavo called 911, then went to the house, arriving twenty to thirty minutes later: Amanda was outside crying, and a lot of police were in the area. Gustavo noticed the security door was hanging off its frame, which he'd not seen before. He also saw a piece of wood on the ground, but did not know if it was part of the door frame. (RT 3:475-485, 3:499-500, 4:602-604, 4:608)

While the officers were detaining appellant at the scene, he spontaneously said, "She invited me in." Amanda came up to the patrol car, looked in the back seat where appellant was sitting, began crying and walked away. She told one of the officers that appellant was the same person who raped her, and began to vomit. (RT 6:1228-1229, 6:1249, 6:1264-1268, 6:1270-1271) During appellant's forensic examination, he spontaneously asked the officer, "At what point is it considered rape?" The officer did not respond. Appellant said, "You're all charging me with the wrong crime. If anything, you should be charging me with home invasion." He also said, "She let me in." The officer told appellant several times that it would be in his best interests not to talk. (RT 6:1235-1237, 6:1267-1268)

The physical evidence

It was stipulated no fingerprints were found on the knife used on February 28th. A forensic identification specialist testified he was not surprised no fingerprints were found because fingerprints are very fragile, and there is a good possibility that wrapping a knife in a paper towel for transportation would wipe off any prints. Someone could also use a knife without leaving prints if the person's hands are calloused, or dirty, or if they'd just touched another item, like a piece of paper or cloth. Fingerprints are made of amino acids, fluids, and water: it takes time for them to rejuvenate after touching something. The knife handle is also somewhat porous, and fluids would be absorbed into it, so that its cracks might not hold a print. (RT 5:980, 5:982, 5:984-985)

The forensic identification specialist took photographs of the apartment on May 17th. The doorframe looked as if it had been pulled away from the wall mounting, and there was a nail or screw some distance from the wall. There were no prints on the doorframe, which had a deteriorated

surface from which it would not be easy to get prints. There were no prints on the interior of the window. There was a serrated bread knife behind the bed on the floor. There were no prints on the knife: the knife could have rubbed against the bedding, and it is difficult to obtain prints from the handle's matte finish. (RT 5:985-991, 5:998-1014, 6:1375-1376, 6:1380, 6:1396-1398)

The forensic nurse who examined appellant testified appellant was cooperative, soft-spoken, and made poor eye contact. A Woods lamp was used to scan appellant's skin for bodily secretions; there was a positive reaction on appellant's upper right thigh, which was swabbed for DNA specimens. Appellant's penis, scrotum, palms were also swabbed, and an oral swab taken. Appellant had no injuries. (RT 6:1276-1299)

The nurse who interviewed Sandy testified Sandy said she had urinated once at home; she complained of pain to her neck, back, her right side, her vaginal and groin area, and in her abdominal area. She said she vomited in the ambulance on the way to the hospital. She said she was threatened with a knife, but not injured. She said the man gestured for her to be quiet, and said, "Don't say nothing. I like you. I want to make love to you." She said he pulled her hair and pulled on her head; he spoke English, and she did not understand much of what he was saying. Sandy said the man put his right arm across her neck in a chokehold, and also held her by the neck with his left hand. She said he threatened to kill her and her family. Sandy said she was vaginally penetrated by penis and finger, she orally copulated her assailant, and was orally copulated by him. She said she had been home alone, in bed, with the door locked. She remembered hearing the door open, waking to see the man in her room with the knife. She said the man took off his clothes, pulled her head onto his penis, put his mouth on her genitalia and his tongue into her. He tried to penetrate her; when she resisted, he put his left hand on her neck to strangle her, using his other hand to force her legs apart, and forcing his penis inside. Sandy said she was kissed on the mouth, her breasts fondled. She said that at the end of the episode, the man went into the bathroom to masturbate, and she fled naked into the hallway. Sandy was unsure if the man ejaculated. Sandy described her assailant as a black male, thin face, between 5'6" and 5'8", thin and muscular. According to the nurse, Sandy was tearful and cooperative. The nurse did not recall any visible bruising. (RT 6:1301-1322)

The nurse who examined Sandy testified she performed a Woods lamp exam, which was negative. Sandy said she was grabbed by the front

of the neck, on the back, and on her breasts, and that she had pain in her neck, back, and abdominal area. She said the assailant scratched her right index finger, and complained the roof of her mouth was tender when she swallowed. There were three small abraded areas at the vaginal entrance, which appeared fresh and were lightly bleeding. The abrasions could be caused by skin stretching or rubbing. There was tenderness in the labia minora to the extent the nurse was unable to perform a speculum exam. There were no visible bruises. These injuries were consistent with Sandy's history. Swabs were taken of areas where Sandy said there was contact with the assailant. Sandy was cooperative; she cried periodically. (RT 6:1326-1362)

A criminalist in the forensic biology section of the LASD crime lab testified she screened three small stains on the bedroom floor for semen; the stains tested possibly positive, and samples were collected. At the laboratory, the samples also tested positive for blood, and sperm cells were detected. The samples were preserved for DNA analysis. Sandy's rape kit was analyzed: the oral, anal, vaginal and external genital samples tested negative for semen. The external genital and anal swabs tested positive for amylase, an enzyme found in high concentrations in saliva. This was consistent with oral copulation. The vaginal, anal, and external genital swabs tested positive for blood. These samples were also preserved for DNA analysis. (RT 6:1402-1416, 6:1418-1419, 6:1424-1427) The criminalist examined appellant's rape kit, analyzing the penile, thigh and scrotum swabbings for amylase: the penile and scrotum swabbings were positive, the thigh sample had a weak level of the enzyme. The thigh sample screened positive for semen. These samples were preserved for DNA analysis. Fingernail scrapings from appellant's rape kit were not analyzed for DNA testing. (RT 6:1420-1423, 6:1427-1429)

The senior criminalist who performed the DNA analysis received anal and external genital swabs from Sandy, and penile, scrotum, and right thigh swabs from appellant, as well as a semen stain from the bedroom floor and oral reference samples from Sandy and appellant. DNA is the acronym for deoxyribonucleic acid, the chemical that controls the structure and function of all the body's components. Half a person's DNA comes from the mother, half from the father. It is found in the cell's nucleus: cells that contain a nucleus include white blood cells, sperm cells, organ and tissue cells, and epithelial cells, commonly found in saliva and vaginal fluid. (RT 7:1438-1443)

The samples here were tested using the Identifiler system, a kit which examines fifteen regions of the DNA; these regions are called STR's or "short tan [sic] repeats." STRs vary from person to person, and are thus an excellent source for identification. In DNA analysis, genetic profiles are generated from evidence samples and from known victim/suspect samples. The two samples are then compared. The first step of DNA analysis involves extraction and quantitation, recovering DNA from the evidence samples by cutting the samples, putting them in a tube, and adding chemicals to open the cells and release the DNA. Next, the DNA is put in a separate tube and quantitated. The second stage is amplification of the DNA: chemicals from the Identifiler kit are added to a small amount of extracted DNA, and the tubes put into a thermocycler, which goes through a series of heating and cooling cycles. The chemicals attach to the fifteen STRs and copy those regions. The third step is typing; the amplified DNA is put into a genetic analyzer, and the analyzer separates the fifteen testing regions, enabling the examiner to look at the regions independently. (RT 7:1443-1445)

The criminalist obtained DNA profiles from all the samples received, and performed a differential extraction to separate sperm from non-sperm cells on the evidence containing semen. The profile from the anal sample matched Sandy; there was no foreign DNA depicted. The profile from the external genital sample also matched Sandy, again, there was no foreign DNA. Appellant's right thigh sample contained a male and non-male fraction: the male fraction matched appellant's DNA, the non-male (epithelial) fraction was consistent with a mixture of at least three individuals. Sandy and appellant were both included as contributors to the mixture, and the major contributor profile was consistent with Sandy. The third individual is unknown. Inclusion means someone cannot be excluded. The penile sample was also consistent with three donors, including Sandy, appellant, and an unknown third person. The floor stain matched appellant; the scrotum sample contained Sandy's DNA. The DNA from the unknown third contributor probably came from appellant, as there was no foreign DNA detected on Sandy's anal swab. (RT 7:1445-1450, 7:1453-1461)

Making no assumptions about the number of potential donors to the mixture, and including appellant and Sandy as possible contributors, the criminalist generated a combined probability of inclusion statistic for the scrotum sample of 1 out of 6,671 in the Caucasian population, 1 of 11,520 in the black population, and 1 of 5,675 in the Hispanic population. The criminalist

testified he was able to extract a clean profile matching Sandy's genotype from the right thigh sample, which generated a combined probability statistic of 1 of 47.5 quadrillion in the Caucasian population, 1 of 214 quadrillion in the black population, and 1 of 125 quadrillion in the Hispanic population. The carpet stain resulted in a random match of 1 in 831 quadrillion in the Caucasian population, 1 in 1.5 quadrillion in the black population, and 1 in 2.3 quadrillion in the Hispanic population. There are approximately 6.5 billion people in the world; the probability of inclusion statistic is the probability that someone else would have that same genetic profile. (RT 7:1450)

Tape of 911 call

Gustavo tells the Lennox Sheriff's station operator that someone is trying to get inside his mother-in-law's house. Gustavo says he's calling from a cell phone, gives the apartment address, and says "the guy" is "trying to do" something to his mother-in-law, who speaks only Spanish, and it is the same guy from before (CT 1-123-124; RT 4:604-605, 4:607-608)

Defense Case

There was no affirmative defense presented.

# STATEMENT OF FACTS

## Prosecution Case

Sara lives in Los Angeles with her husband, Rence; other members of her family live in the area, including her sister Ruth. Appellant was Ruth's significant other, and they have three children together. Sara had known appellant for 13 years; their families got together during the holidays and on weekends, and their children went to the same school. Sara went to the gym alone a few times with appellant when Ruth wasn't feeling well. (RT 2:603-609, 3:1541-1542, 3:1545, 4:2109-2113, 4:2136)

On January 12, 2005, Sara had been living with her husband, children, and parents-in-law for about 14 years. Sara and her family slept in the house, her in-laws in the refurbished garage. The bedrooms are located in the back of the house: there was an entrance from the alley to the bedroom, via a door that is close to a sliding gate which also leads to the garage. This back door to the house is about 27 feet from the garage; there are three doors in the back of the house. The sliding gate is locked only at night. (RT 2:609-618, 3:1537-1540)

The morning of January 12th, Sara took her daughters to school, returning home around 8:00 a.m. She opened the gate, parked her car, put some wash in the machine inside the garage, and walked towards the French doors to her bedroom. She noticed a key in one of the locks, and thought her mother-in-law might be inside.[1] As Sara opened the door, someone inside the room pulled her in by her hair. She could only see the person's silhouette: he was covered in black and pointing a gun at her. He pulled her head down, and closed the door.[2] The man was wearing black fabric gloves, a ski mask, and baggy black clothes. (RT 2:620-633, 2:636-638, 3:1540-1544, 3:1549-1554, 3:1558, 4:219)

The man took Sara to the bed, pinned her down, and removed her pajamas and underwear. He did not speak. Sara told him to leave her

---

1 As far as Sara knew, only she, her husband, daughters and in-laws had keys to the house. Ruth did not have a key. The locks had been changed sometime before the assault due to a burglary. Sara's house had been burglarized several times before the assault; once, a key had been left in the door. The family thought it was someone who knew them because the thief knew where Sara's daughters hid their money and where Sara kept her purse. There was no sign of forced entry. Sara's sister Paula and her husband were burglarized after they received some money to buy a car: Sara thought the same person was responsible. (RT 3:1544-1548, 3:1551, 4:2138-2146)

2 Appellant's name "popped into" Sara's head when the man pulled her head down. (RT 2:145)

alone, that her sister Patty was on the way. She struggled; at some point, he put a pillow on her face, covered her eyes with a pair of nearby sweat pants, and tied her hands behind her with shoe string. The man put his penis in Sara's vagina, withdrawing and reinserting his penis two or three times, then penetrating her anus with his penis, and digitally penetrating her vagina.[3] The digital and anal penetrations were painful; Sara recalled being penetrated while face down on the bed, and seeing the gun on the bed. Sara offered the man her purse, telling him to take whatever he wanted. He emptied the purse and she thought he took some cash. She heard the gate being opened, and the man pulled her into the bathroom. (RT 2:638-645-900, 2:1227-1238, 2:1250-1251, 3:1559-1561, 4:2103-2104, 4:2120-2126, 4:2129-2135, 4:2434-2440)

As the man gently put his hands on Sara's back to guide her, she thought it was appellant: the man touched her back the same way appellant put his hands on everyone's back at family gatherings. The man also seemed to know where the bathroom was. (RT 2:645-900, 2:1236, 2:1238, 2:1244, 4:2103-2105, 4:2440-2442) The man put Sara in the shower and closed the shower and bathroom doors. Sara locked the doors, waited until she heard the man leave through the front door, then called 911.[4] She told the operator that she didn't know her assailant. (RT 2:1239-1244, 4:2106, 4:2441-2442) The police arrived and Sara was subsequently taken to the hospital for an examination.[5] (RT 2:1252-1254, 3:1523-1525, 3:1528-1531, 3:1535, 3:1554, 4:2102)

The nurse practitioner who examined Sara described her as placid and cooperative. The woods lamp scan was negative for bodily fluids; the nurse collected vaginal, cervical, anal, external genital, and breast swabs. Sara described the assault and her assailant, and said she was numb. There were ligature marks on Sara's wrists, and an abrasion on her knee; her hymen

---

3 She could not recall if the man penetrated her before or after he tied her hands. (RT 4:2136)

4 The 911 tape was played; on the tape, Sara says she has just been robbed and raped. She describes her assailant as 20 years old, wearing black shoes, black hooded sweater, black gloves, dark pants, and carrying a white gun. She didn't recognize him, but said someone had robbed them before, using keys, and it might be the same person. (CT 3:240, 3:263-272; RT 2:1246-1247, 2:1249, 2:1251, 3:1563) At trial, Sara testified that she thought it might be appellant. (RT 4:2147)

5 The deputy sheriff who interviewed Sara at the scene said she was sobbing, and told him she'd been raped. She also gave him the shoestring she'd been bound with. (RT 3:1502-1505, 3:1520, 3:1526-1527, 3:1531, 3:1554-1557, 4:2154-2155) A set of keys were retrieved from the lower lock of the exterior door leading to the bedroom. The key in the lock also unlocked the house's other exterior doors as well as the gate. (RT 4:2156-2159)

and vagina were bruised, consistent with blunt force pressure. There were fresh abrasions on her anal area, consistent with friction. These injuries were not consistent with consensual sex. There was no injury to the scalp, though this is not inconsistent with having one's hair pulled. (RT 3:1828-1851, 3:1855, 3:1874-1882, 3:1885-1886, 3:1890-1896) Sara's demeanor was consistent with post-traumatic stress disorder. (RT 3:1910, 3:1917-1918)

Sara never saw another person in the room. (RT 2:1238) At first, she did not want to think that appellant was her assailant because he was part of the family, and so told the police at the scene and the nurses at the clinic that she'd been attacked by a stranger. She told Detective Pacheco her suspicions about appellant while at the hospital. She also asked her husband and daughter to call her sister Patty and find out if appellant had been at work that day with Patty's husband. (RT 2:1245, 2:1257-1258, 4:2106-2109) A few days before the assault, Sara saw appellant outside the back of her house. She thought this was strange because it was a weekday morning, between 8:30 and 9:00, when appellant would normally be at work. (RT 2:1255-1257)

William was appellant's neighbor in January 2005. Sometime in February, appellant approached William and asked William to "back him up." Appellant said he'd done six armed robberies with another guy, and some people were after him. Appellant asked William to contact the Sheriff's Department and let them know that someone had forced him to do the robberies. Appellant told William there were six robberies, including one on Olympic Boulevard in Montebello. Appellant said that he was in front of his house when a man took him at gunpoint to do the robberies. He offered William money to back him, but William refused the offer. Appellant told William not to tell appellant's wife. William told appellant to call the cops. (RT 2:903-910, 2:918-922, 2:1206-1207)

Two weeks later, appellant asked William again to contact friends at the Sheriff's Department and tell them that a man forced appellant at gunpoint to participate in some robberies, then two men took him to his sister-in-law's house and forced him to rape his sister-in-law and her daughter. Appellant said not to tell his wife until he had a chance to talk to the police. William again told appellant to call the police himself; William subsequently learned appellant had gotten William's son Andrew to lie for him. Appellant was arrested two days later. (RT 2:909-915, 2:925-930, 2:1204-1205, 2:1207-1208) A month or two afterwards, William was approached by two young men who asked if Ruth still lived there; William said she'd moved out. The

men said appellant didn't do anything, William said he didn't need anything, and the men left. William has been convicted of petty theft, evading police and spousal abuse. (RT 2:915-918, 2:1203)

William's son Andrew was 20 years old at the time of trial; sometime in 2005, appellant asked Andrew if he had seen a man talking to appellant, or forcing appellant into a vehicle. Andrew said he'd seen appellant talking to people in the morning, but didn't see anyone forcing appellant into a car. Appellant told Andrew to tell Paula that he knew about the story; Andrew didn't know why. An hour later, Andrew told appellant's sister-in-law that he saw appellant talking to a man in a black hood who then told appellant to get into his car. Andrew said the man had a gun.[6] (RT 3:1802-1809, 3:1815-1820, 3:1825) The story wasn't true, and Andrew never repeated it. (RT 3:1810-1811, 3:1813-1814, 3:1821-1824)

Julio lives with Sara's sister and has known appellant for about 10 years, seeing him at least twice a month during that time. Several weeks before January 15, 2005, Julio saw appellant in the alley, about five houses down from Sara's house, between 6:30 and 7:30 a.m. Julio was driving slowly, appellant was five feet away, on foot. Appellant lived about five miles away. When appellant saw Julio, he turned around and grabbed his cell phone. Usually they say hello.[7] (RT 2:1210-1224)

On March 2, 2005, Sara's daughter answered the telephone at her mother's house. She heard a recorded message saying it was a collect call from jail, and appellant's voice saying, in Spanish, "Have mercy on me, please. Sara, have mercy on me." Sara's daughter hung up. (RT 4:2444-2453)

Detective Gil Pacheco spoke to appellant and his brother-in-law at their jobs on February 11, 2005, and asked appellant if he had been working on January 11th. Appellant said he had. Appellant and Luis then provided oral reference swabs, as did other male relatives at other times. According to Pacheco's report, Sara told him at the hospital that she thought it was someone she knew, but did not identify anyone by name. Sara later gave

---

6 This conversation was memorialized in People's Exhibit No. 14, an audiotape played at trial. According to the transcript, the conversation was taped on February 14, 2005, and took place between appellant, Mark, and Paula. On the tape, Mark says that about a month ago he saw a dark-skinned man wearing a black hood point a silver hand gun at appellant. They then got in the car and left. (CT 3:284-286; RT 3:1809-1810, 3:1816, :1819) Mark subsequently left a telephone message for the prosecutor, transcribed in People's Exhibit No. 16, stating that he told a private investigator that he didn't see anything. (CT 3:287-288; RT 1813)

7 Sometime after the attack, Julio told Sara that he'd seen appellant in the alley. (RT 4:2117)

Pacheco the names of all male family members.[8] (RT 4:2161-2165, 4:2178-2183, 4:2188-2190, 4:2403-2414, 4:2424, 4:2426-2428) Several weeks later, Paula called Pacheco and said appellant might have more information. Pacheco called appellant, appellant came to the station to talk. (RT 4:2165-2166, 4:2419-2421)

During this interview, appellant told Pacheco that he had been at the assault, but as a victim. He said after returning home from taking his children to school that morning, he was approached by a Hispanic man with a gun. The man told appellant to get back into his car and drive; they drove to a nearby park, and the man had appellant get into another car already parked. Inside, appellant noticed a second man, dressed in black. The first man drove, handing his gun to the second; they asked appellant to take them to the house where his sister-in-law lived, "the closest one." Parking two houses away from Sara's house, the men watched her sister drive away with a child. (RT 4: 2166-2167, 4:2415) The men ordered appellant out of the car, and the man in black told appellant to go to the back of Sara's house while the man followed. At the gate, the man gave appellant a set of keys and told him to open the gate. Appellant was directed to the back door and given another key to open that lock. Appellant said he purposefully left the keys in the lock to warn Sara. (RT 4:2167-2168)

Once inside, appellant was blindfolded, his hands were tied behind his back, and he was put on the ground. A minute later, he heard the gate and door open, then heard a struggle in the bedroom. Several minutes later, he heard the man walk Sara to the bathroom and close the door. Appellant got up; the man removed the blindfold and untied his hands, telling him not to call the police or he'd be killed. Appellant walked out the front door to his car. Appellant said he was afraid for his life, and regretted not going back to check on Sara. (RT 4:2168-2169)

While repeating his story, appellant added that during the struggle, the man in black picked him up and pulled his pants and underwear down. He heard a condom wrapper, and his body was put between Sara's legs and pushed against her vagina. He felt the man's hand between his penis and Sara's vagina. Appellant did not penetrate Sara, and did not have an erection. The man pulled up appellant's underwear and pants, and heard the man take Sara to the bathroom. Later that day, appellant came back to check

---

8 Sara came to the station to pick up a copy of the police report and told Pacheco that appellant told Diane something about the assault. (RT 4:2418)

on Sara, saw police cars at the house, got scared, and left. (RT 4:2169-2176) Pacheco told appellant that Sara said she had been penetrated during the assault; appellant said Sara was lying. (RT 4:2176) Pacheco requested DNA testing of appellant's swabs after appellant's arrest. (RT 4:2417-2418)

Mary Keens, a senior criminalist in the forensic biology section of the Los Angeles Sheriff's Department Crime Laboratory, examined the rape kit taken from Sara and the attendant reference samples. Semen was detected on the vaginal, rectal, right buttock, and external genital samples; those samples and the reference samples were sent for DNA analysis. (RT 4:2703-2728) The DNA analysis was done by Sean Yoshii, another senior criminalist. (RT 4:2709)

Paul Coleman is a senior criminalist in the forensic biology section. Yoshii examined the rape kit samples as well as reference samples from appellant and Sara. Coleman identified a DNA analysis report prepared by Yoshii; Coleman was Yoshii's peer reviewer at the time the report was prepared. He reviewed Yoshii's report and agreed with its conclusions. (RT 4:2730-2736, 5:3011-3012)

The forensic samples were preliminarily separated into male and female fractions. According to Yoshii's report, the genetic profiles extracted from the male fraction of the vaginal sample was a mixture of three people. The major contributor profile matched the profile of Sara's husband, and Sara and appellant were included as possible minor contributors. Analysis of the male fraction of the external genital, right buttock and rectal samples resulted in the same general profiles. Statistics were generated based on these profiles; these statistics composed a "likelihood ratio," meaning the relative likelihood of anyone else contributing to the profiles detected. In his calculations, Yoshii assumed there were three donors. The vaginal sample resulted in the likelihood match of 1 in 286 individuals; the external genital sample a ratio of 1 in 6,112 individuals; the rectal sample, 1 in 5,911 individuals; and the right buttock sample, 1 in 3,089 individuals. When the likelihood ratio was computed for all three profiles, the mixed profile had a ratio of 1 in 46 billion individuals. If Sara's husband had consensual intercourse with Sara 52 hours before the assault, and Appellant had intercourse with her on the day of the assault, Coleman would expect Sara's husband to be less of a contributor. However, there are many variables that could affect that expectation, including failure to fully ejaculate. (RT 4:2736-2748, 4:2750-2769, 5:3002-3010, 5:3012-3023)

Defense Case

Marc Taylor is a forensic scientist and director/owner of Technical Associates, a private laboratory in Ventura. He has a M.S. in zoology, and has done the course work for a M.S. in cellular biology. Previously, Taylor worked for the L.A. Coroner's Office, where he studied criminalistics and serology. Taylor began studying and performing DNA analysis in the 1980s, and is an active member of the American Academy of Forensic Sciences and the California Association of Criminalists. Taylor has taught DNA analysis at California State University, Los Angeles, and lectured at the Ventura Sheriff's Crime Laboratory. Taylor's laboratory is not accredited, but follows the industry guidelines and does proficiency testing; Taylor is certified by the American Society of Crime Laboratory Directors as a technical leader/manager. Taylor's laboratory employs six criminalists. (RT 5:3024-3031, 5:3041-3042, 5:3050)

Taylor's independent testing of the forensic samples in this case resulted in a "cleaner" separation of the nonsperm and sperm fractions. This enabled a clearer reading of the profiles, which confirmed the LASD results. Taylor found the results inconsistent with the history provided given Sara's husband was the primary contributor to the sample, and the amount of his sperm was especially high for a sample collected 52 hours post-intercourse. Based on Taylor's back calculations, there was about ten times the amount of Sara's husband's DNA compared to appellant's DNA in the vaginal and rectal samples. The right buttock sample contained more of an even mix. (RT 5:3032-3039, 5:3042, 5:3051-3052, 5:3059-3062) Taylor agreed there were factors which could lead to Sara's husband being the primary contributor, including whether there had been full ejaculation by the assailant. Appellant's profile was included in all four samples. (RT 5:3045-3047, 5:3063-3064)

The likelihood ratio attested to by Coleman included an assumption as to the number of contributors. The statistic generated absent this assumption, the "combined probability of inclusion," would result in a much more modest ratio, though Taylor did not compute these statistics. This calculation should have been done as well; the recommendation of the NCR II that a likelihood ratio should be used is related to the use of an older testing protocol. There is no reliable genetic evidence that only three people contributed to the mixture, and there is no evidence that more than three people contributed. (RT 5:3039, 5:3047-3048, 5:3052-3057)

Appellant testified that Sara's sister was his former partner; they had three children together. He has known Sara for over 14 years, seeing

her twice a week at family gatherings. Appellant went to her house alone once in a while when she called him for something, and they went to the gym together several times. Appellant put his hand on Sara's back while at the gym, to show her how to work one of the machines. (RT 5:3069-3072, 5:3074, 5:3303, 5:3342) Sara has had plastic surgery; appellant's comments about her breasts were made in the context of a family discussion of her various surgeries. (RT 5:3074-3075, 5:3302)

Appellant was not working on January 12, 2005. That day, he got up around 6:00, dropped his child at school at 7:00, and started driving to the gym. He saw Sara driving at the corner of her street, and she signaled him to stop. He did, and she asked him to come to her house, giving him some keys and telling him to wait for her there. (RT 5:3075-3078, 5:3103-3107, 5:3304, 5:3323, 5:3326) Appellant went to the house through the front yard door, which was unlocked. He put one of the keys in the lock, saw Sara arrive, and went to help her open the gate, leaving the keys in the lock. Sara seemed nervous. Appellant followed her to the house; she had a set of keys in her hand. Appellant followed Sara into her bedroom. Sitting on a sofa, appellant asked where her mother-in-law and sister were. Sara said no one was going to be there. (RT 5:3079-3084, 5:3305-3306)

Sara got down in front of appellant and said she missed going to the gym with him. Appellant said it was probably better because people might think badly of them for him going to her house when her husband was not home. He stood, because he felt there was something going on. Sara stood, grabbed his hands, sat on the bed and pulled him towards her. Appellant fell partially on top of Sara; she was red and nervous as she undressed. (RT 5:3084-3088, 5:3099-3100) Appellant pulled his pants down, and penetrated Sara, but became afraid when she didn't look happy. Sara kept moving, causing appellant's relatively small penis to fall out; he reinserted it three or four times, going into her "front and back part." He then stopped and asked what was wrong. Sara asked why appellant was asking. Appellant said it couldn't go on, and would disgrace both of them. Sara asked why he didn't finish. She was angry as she dressed, and told appellant that he was going to be sorry. Appellant left, went to the gym, and went home. He did not say anything to Ruth about the incident. (RT 5:3088-3091, 5:3107-3115-3300, 5:3311-3315, 5:3326, 5:3340-3342)

A week or so later, appellant saw Sara at their children's school. She told him not to tell her sister, and that she'd called the police that day,

telling them someone had showed up at the house with keys and a gun and sexually assaulted her. She told appellant she'd said the man had a silver gun and was dressed in black. Later, a detective came to appellant's work and took a DNA sample. Appellant called Sara afterwards, telling her about the police visit. (RT 5:3092-3095, 5:3318-3321, 5:3325, 5:3327-3330, 5:3333-3336, :3344) Days later, appellant approached Andrew to asks him to lie and say appellant had been forced to participate at gunpoint. Appellant lied to the detective because he was afraid that Ruth would leave him and he would lose his children if the truth came out. He did not speak to Andrew's father, William. (RT 5:3096-3097, 5:3307-3309, 5:3316-3317, 5:3322-3324, 5:3338-3340, 5:3343)

Appellant did not wear a ski mask or gloves to Sara's house on January 12, 2005, and did not burglarize Sara's house. He remembered speaking briefly to Julio, and being on his cell phone that morning. In 1988, he pled guilty to stealing a car: he didn't steal the car, but knew it was going to be stolen. (RT 5:3098-3099, 5:3102-3103, 5:3330, 5:3332-3333, 5:3342)

Appellant never wanted to have sex with Sara. (RT 5:3344)

Rebuttal

At 8:30 a.m. on January 12th , Clarence Melara was working in the alley behind Sara's home. He saw someone dressed in black jeans, boots and a hooded black sweatshirt. He could not see the man's face. Melara thought the man was about 5'7", 150 lbs. The man was walking towards Sara's house. (RT 5:3346-3355)

## STATEMENT OF FACTS

Prosecution Case

At the time of trial, Katrina was 17 years old; in September 2005, she was 16. Appellant has been her stepfather since she was a baby. (RT 1:151-154) At trial, Katrina testified that she made up most of her allegations against appellant because she was angry at him, and that there was only one incident of abuse, which had occurred in 2004. Katrina denied any untoward touching when she was 8 years old, and all subsequent allegations of improper touching. Katrina testified at the preliminary hearing that appellant touched her inner thigh when she was 8, while she was sitting on appellant's lap as he drove to a video store. She also testified that he touched her breasts ten to fifteen times, had intercourse with her beginning in 7th grade, oral copulation from the time she was 13 to 15, took photos of her breasts and vagina on three occasions, and sodomized her once when she was either 13 or 14; she said the last event occurred when she was 16. The next time appellant wanted to have intercourse, Katrina refused, and appellant hit her in the mouth. At trial, she did not recall some of the prior testimony. (RT 1:156, 1:161-165, 1:173-174, 1:188-192, 1:194-203, 2:223-229, 2:231–236, 2:238-241, 2:246-256, 2:334)

The incident that Katrina testified did occur happened in June 2004, when Katrina was 14 years old. She tried to push appellant off, but did not feel appellant forced her to have sex. She did not recall other details because she wanted to forget that it happened. This incident resulted in Katrina getting pregnant; Katrina had an abortion on August 9, 2004. Appellant paid for the abortion with a cashier's check for $375; Katrina recalled getting two shots and going to sleep for a long time. She bled for approximately two weeks, which was why Katrina could not go swimming when the family went to Las Vegas. Katrina was mad at appellant for this, and told him so. (RT 1:180, 1:209-210, 2:230, 2:269-271, 2:275-276, 2:280-285, 2:302, 2:349) Katrina denied any other incidents of intercourse. (RT 2:221-223, 2:236-237, 2:349) Appellant hit Katrina in the face after she "back talked" him. (RT 2:241-245, 2:278, 2:300, 2:302-303)

In September 2005, Katrina wrote a letter to her mother, alleging her molestation, and saying she was not sorry about her mother's pain because

she was angry that no one would believe her.[1] Katrina testified that she was angry when she wrote the letter because her parents had taken her out of the tae kwon do class taught by her boyfriend. Her parents told her that she could no longer take the classes because of cost, but told Katrina's aunt that they didn't want her seeing Glen. (RT 1:174-181, 1:204-208, 1:211-213, 2:258-260, 2:285-287, 2:290-291, 2:298-299, 2:333-334, 2:345) Katrina spoke to Glen on the telephone daily; they dated for about a month and a half. (RT 2:288-289)

Katrina spoke to the school nurse on September 29, 2005,[2] and a Harbor UCLA clinical social worker on October 5, 2005, repeating all of her allegations of abuse, including allegations about the initial touching, and allegations that appellant made Katrina orally copulate him and have intercourse with him starting in 7th grade. Katrina did not recall telling the social worker that she was afraid an investigation would hurt her chances of going to college. (RT 1:181-184, 2:245, 2:260-262, 2:292, 2:296-297, 2:349-350, 2:355)

According to the social worker, Katrina agreed to tell the truth in her interview. Katrina said appellant made her orally copulate him, undress in front of him, and have sex with him. Katrina said appellant began having sex with her when she was in the 7th grade, and that she was much younger the first time appellant abused her. On that occasion, he put her on his lap while they were driving to a video store and touched her genital area over her clothing. Appellant transitioned to touching Katrina under her clothing: the first time this happened, he told her to sit on his lap in the computer room, then spread her legs apart and touched her genitals. Katrina said the most recent incident occurred the day before her 16th birthday: appellant came into her room, said he needed to talk to her, and told her to undress. Katrina said if she did not undress, appellant would "help" her undress. She also said appellant once hit her when she refused to undress, resulting in a busted lip.

---

1 Katrina testified she didn't tell anyone about the abuse until she wrote her mother. (RT 2:285, 2:292)

2 The nurse testified that Katrina reported being sexually abused by appellant on September 29, 2005; she had a "flat affect," showing little emotion as she described being progressively molested from the age of 8 years old, stating that the molestations occurred when her mother was at work, and that she had an abortion as a result of the abuse. Katrina was concerned about her younger sister. The nurse contacted the police. The nurse never saw Katrina with any injuries. (RT 1:135-138, 1:139-144,1:147-148) The nurse testified the vagina heals very quickly from sexual assault, and sexual assault exams are often not done on children. Exams may have no physical findings, also consistent with a history of abuse. (RT 1:138-139)

On another occasion, appellant ejaculated on Katrina's lower back; during that incident, appellant told Katrina to "Relax. Let me in" when she tensed her thighs. (RT 2:354-364, 2:380-381) Katrina said she discovered she was pregnant in August 2004 after taking two home pregnancy tests at appellant's suggestion. Appellant called an abortion clinic, but was told Katrina had to make her own appointment. She did, appellant got the funds, and she paid the clinic. (RT 2:365-367, 2:369)

Katrina said that on other occasions, appellant would get on top of her in bed, touch her breasts, put his penis in her vagina, and ejaculate on her back. Appellant ejaculated inside Katrina on three separate occasions, once accidently, saying, "Oh, shit." Another incident in the family computer room occurred when Katrina's brother was showering; appellant told Katrina to get on her hands and knees, put clear jelly on her buttocks, and sodomized her. She bled, and was hurting. (RT 2:363, 2:369-373) Katrina said that when she was in 10th grade, appellant picked her up from school on Mondays and Fridays, took her home, had sex with her, then picked her mother up from work. When Katrina was in 5th grade, she asked appellant why he abused her, and he said it was because she was special. (RT 2:381-383) Appellant showed Katrina pornography and told her to do what the woman was doing. He also took a nude photograph of Katrina and turned it into a glass etching. (RT 2:383-384)

Katrina said she did not report the abuse earlier because it had been going on for so long that she thought she could put up with it until she left home. Katrina told her mother what was happening during a discussion about why Katrina was getting into trouble; she was afraid to tell her mother because she thought her mother would tell appellant. She was also afraid an investigation would interfere with her school performance, and did not want to break up the family. (RT 2:373-378, 2:380) Katrina thought her mother didn't believe her because she still spoke to appellant, and did not call police. (RT 2:378-379)

According to the social worker,[3] recantation is not uncommon. Victims recant because the victim is physically, emotionally, and economically

---

3 Teresa Rubio was the social worker who interviewed Katrina; at the time of trial, Rubio had been a clinical social worker for 7 years, and had conducted approximately 300 forensic interviews of children between the ages of 3 and 17. She had a master's degree in social work from UCLA, and was working at the Harbor UCLA Medical Center in the Child Sexual Abuse Crisis Center. Previously, she worked for the Department of Children and Family Services as a children's social worker. (RT 2:354-355, 2:383-384, 2:387-388)

dependent on the abusive caregiver, or because the non-offending parent doesn't believe the child. There may be family pressures to recant; some victims recant because they want to avoid disrupting the family. Adolescents are particularly aware of the negative consequences of disclosure. (RT 2:384-387) Children are admonished to tell the truth in an interview, but sometimes they do not, and sometimes the social worker would not know this. Sometimes, too, the recantation is true. (RT 2:388-390, 2:396-397)

On September 29, 2005, Katrina was interviewed by police. She reiterated the account of the first touching, as well as other incidents. (RT 1:184-186, 2:230) The night before her interview, she had online chats with Glen in which he advised her how to act with the police. He also told her that she'd be contacted by Long Beach officers the following day. Glen told Katrina that they wouldn't believe her if she didn't show some emotion,[4] and to think about him in order to get teary-eyed. Katrina did not recall writing to Glen that she just wanted everyone to know the truth. (RT 2:293-295, 2:303-304, 2:338-339, 2:344)

Katrina first told her mother that appellant only had sex with her once. This report occurred before they went to San Diego in October 2006, where they stayed until January 2007.[5] (RT 2:266-267) On January 23, 2007, Katrina spoke with her assistant principal, saying she was upset with the prosecutor because she did not want appellant to spend his life in prison. (RT 2:267-268)

Katrina wrote a letter to the prosecutor on December 9, 2006, and one to defense counsel and the prosecutor on November 8, 2006. (RT 1:186-187, 2:277, 3:339-340) She did not appear at a prior trial: the November 8th letter stated that she missed her father, had forgiven him, and did not want him to go to prison. She asked the prosecutor to drop the charges, saying she had lied about all but the one incident and had been angry when

---

4 Katrina testified that she was emotional: Glen told her not to get "overly" emotional, and she had said she never got "overly" emotional – not that she wasn't emotional at all. (RT 2:350-353)

5 According to school records, Katrina was absent without a medical excuse from October 30 until November 17, 2006, and from November 22 until December 5th, 6th, or 7th. In her meeting with the assistant principal, Katrina said she was afraid of the court process and that her mother did not want the case to go forward. Katrina was also concerned about the rigors of her physics class. Katrina said she didn't want appellant to be incarcerated for life; when the assistant principal asked her how long appellant should be imprisoned, she said for the length of time he abused her. Katrina said appellant had been abusing her since she was 6 or 7 years old, and that she'd had an abortion. On December 5, 2006, the case against appellant was dismissed because the prosecution was unable to proceed. Katrina's absences had no scholastic ramifications. (RT 2:315-330, 2:346-347)

questioned by police. Katrina indicated she was frightened about getting into trouble. (RT 2:262-265, 2:279, 2:340-343, 2:348)

At the preliminary hearing, Katrina testified that the first incident occurred when they were on their way to a video store: Katrina was sitting on appellant's lap as he drove, and appellant touched her inner thigh. Katrina testified appellant touched her breasts 10 to 15 times from when she was 8 years old until she was 10, touching her over her clothes, and rubbing her nipples. Appellant also put his mouth on her breasts between 15 and 20 times when she was 14 and 15 years old. (RT 1:173-174, 1:188-189, 1:190-192) Katrina testified that starting from when she was about 10 years old, appellant made her take her pants down and get on her hands and knees. He would get behind her, and move his penis against her; this happened three times when she was 10, and more than 5 times when she was 11 and 12. They began having intercourse when Katrina was 12 years old, starting sometime after Christmas. (RT 1:193-198, 1:201, 2:223-224) They had intercourse twice when Katrina was 12. The first time they had sex was on a bed in the supply room: it was right after appellant had moved back into the house after he and Katrina's mother fought, and he'd moved out. Appellant was not working at the time, and Katrina's brother was in the house watching TV in the living room. Katrina told appellant to leave her alone. During intercourse, Katrina would try to push appellant off her, but he would just continue. (RT 2:223-229, 2:238-239, 2:256) Katrina testified that appellant sodomized her once when she was 13 or 14. (RT 1:199-21)

Katrina testified she found out she was pregnant when she was 14; it was a Friday in August, and her brother was in the shower. After taking the pregnancy test, she and appellant had intercourse, and appellant ejaculated inside Katrina. They then went to get Katrina's mother and go to a Thai restaurant. Throughout their engagement, appellant only used a condom once, when Katrina had her period. (RT 2:231-235) Katrina testified at the preliminary hearing that the last sexual encounter she had with appellant was right before she turned 16. It was the day before Katrina's birthday party, and she and appellant had intercourse before Katrina's aunt arrived to help clean the garage. (RT 2:225, 2:239)

One night Katrina was in her room, ready to sleep, and appellant called her to follow him. Katrina told appellant she was tired, and to leave her alone; appellant went in the backyard, knocked on Katrina's window, and told her to come outside. She refused, he came into her room and hit her in the

face, causing her lip to swell. Katrina followed appellant into the computer room; appellant told her to undress, she did, and he said, "You need to start listening to me." She got dressed and went back into her room. Appellant did not touch her. (RT 2:239-241, 2:257) Katrina also testified appellant took nude pictures of her breasts and vagina on two separate occasions before 6th grade, and a full body nude photo when she was a sophomore. Appellant showed Katrina the digital photos, and etched one of them on a piece of glass, which he also showed Katrina. (RT 2:246-250)

Katrina testified appellant orally copulated her when she was 14, on no more than two occasions. He orally copulated her 3 to 4 times when she was 15. She orally copulated him 2 to 5 times when she was 14, and 10 times when she was 15. (RT 2:251-254) Katrina told appellant several times that she didn't like what he was doing. When she asked him why he did it to her and not his other daughter, he said Katrina was "different." When Katrina said she didn't want to do something, appellant told her that she had to do whatever he told her to do, and then it would stop. (RT 2:254-255) Katrina testified she did not report appellant until September; it had nothing to do with her parents saying she could not see her boyfriend. (RT 2:258)

According to Katrina's friend Portia, Katrina came into anatomy class on September 29, 2005 crying. Portia asked what was wrong, and, Katrina, after making Portia guess, said that her stepfather had raped her. Later, Katrina said the activity began in 7th grade,[6] and she'd had an abortion because of her stepfather. Katrina said she told her cousin Christy, and her mother, but that her mother didn't believe her. Portia went with Katrina to the nurse's office, and was later questioned by police. (RT 1:67-74, 1:78, 1:84-85, 1:87) According to Katrina, she was not crying that day in class, though she cried on another occasion after her cousin called her. (RT 2:295-296, 2:332)

Portia never saw Katrina with black eyes or bruises. If Katrina had been significantly injured, Portia would have known. Katrina complained her mother was too strict: she didn't like Katrina dating boys, and wanted Katrina to get good grades. Katrina was not allowed to go to parties in middle school. (RT 1:86-87, 2:80-82) Glen and Katrina dated during 2005, when he was a senior. (RT 1:82)

Katrina's boyfriend met Katrina in high school, when he was in 11th grade, and she was in 10th. They began dating in August 2005, while Katrina

---

6 Portia told police that Katrina said the abuse began when she was 8 years old. (RT 1:88)

was taking his tae kwan do class.[7] Sometime in the beginning of September, Katrina's boyfriend thought Katrina was being "distant," in a text message, Katrina said something was bothering her. Her boyfriend called Katrina, and she sounded as if she'd been crying. Eventually, Katrina told him that appellant had been molesting her since she was 8 years old, and that she'd had an abortion. Katrina's boyfriend asked why she didn't fight, and she said that she'd tried, and that appellant once split her lip. Her boyfriend repeatedly advised Katrina to go to the police, but Katrina said no one would believe her because appellant was an important man in the community. (RT 1:90-95, 1:99, 1:106-109, 1:112-113, 1:115, 1:118)

Katrina's boyfriend's parents work for the police department. Katrina did not want him talking to them, but Katrina's boyfriend told his mother that night. The next day, he told Christy what Katrina had said. Her boyfriend spent the next several days convincing Katrina to report: one of Katrina's objections was that people wouldn't believe her story because she wasn't very emotional.[8] Her boyfriend told Katrina to cry when talking about it so people would believe her. Sometime in late September, he went to the school nurse, and Katrina's parents took her out of his class. (RT 1:95-100, 1:114-115, 1:117-119, 1:123-125)

Two and a half weeks later, Katrina's boyfriend broke up with her so as not to interfere with the case against appellant. Two days after they broke up, Christy beat up Katrina's boyfriend. Katrina initially said she was going to go through with the court process, but then dropped it until Glen spoke to the nurse. Her boyfriend told Katrina in a text message that she was going to be contacted by the police. (RT 1:100-101, 1:119-122, 1:124-125)

Detective Aaron Eaton interviewed Katrina at school on September 29, 2005;[9] in the interview, Katrina said the first time appellant touched her was when appellant was driving to the video store. She sat on appellant's lap and he touched her vagina. Katrina was about 8 years old. In the next series of events, appellant would tell Katrina that he needed to talk to her about

---

7 They saw each other three times a week during class, but not very much outside of class because of the demands of Katrina's homework and her parents' not allowing her out. They spoke on the telephone two hours a day and text- and instant- messaged. Katrina's boyfriend did not know if Katrina's parents were aware of their relationship. Her boyfriend never saw Katrina with any injuries. (RT 1:109-114)

8 Katrina told the social worker that she told Glen that she rarely shows emotion. (RT 2:379)

9 The detective also spoke to Glen, Portia S., and the clinical social worker who had interviewed Katrina. During her interview with Det. Eaton, Katrina did not cry. She smiled. (RT 3:511-515, 3:517-518, 3:520-521)

something in the computer room; when she went into the room, appellant would tell her to take down her pants. If Katrina did not comply, appellant took down her pants for her. Appellant would tell her to get on her hands and knees, undress, and rub his erect penis against her anus and vagina. Katrina did not know how many times this occurred: it happened once or twice a week while her mother was at work. (RT 3:485-490, 3:499-502)

When Katrina was 12, appellant began having sexual intercourse with her sometime in December. Some of the episodes occurred in the computer room, some in a supply room. Katrina could not say how many times this occurred, but that it hurt the first time.[10] The routine would be the same: appellant would call Katrina into the computer room, and have her undress for sex. Appellant did not wear a condom, and would ejaculate on Katrina's back; she cleaned herself with baby wipes, or appellant would tell her to shower. (RT 3:491-493, 3:499-500, 3:502-504) Katrina asked appellant why he didn't do this to Claudia, appellant's biological daughter, and appellant said Claudia was "different." (RT 3:489)

In August 2004, Katrina felt sick; appellant had her take a home pregnancy test. When the result was positive, appellant took Katrina to a family planning clinic and tried to make an appointment for her to have an abortion. The clinic said Katrina would have to call herself, and she did. Appellant took her to the clinic on August 9th, stopping beforehand at a 7-Eleven to get a cashier's check for $375 to pay for the procedure. According to the clinic worker, Katrina was at seven weeks gestation. (RT 3:493-494, 3:504-505) Katrina said the latest incident of abuse occurred on August 26, 2005 (RT 3:515, 3:519)

The detective asked if any incidents were documented; Katrina said appellant once took a picture of her naked from the neck down, and etched the picture into a piece of glass. Katrina didn't know where the glass was. Katrina said she'd written a letter to her mother, and that the letter was at home. (RT 3:495-496, 3:505-508) Katrina said she hadn't told anyone else. (RT 3:502, 3:519)

Det. Eaton and his partner went to the house; appellant arrived home while Det. Eaton was speaking to Katrina's mother. When told of Katrina's allegations, appellant seemed upset, saying he couldn't believe he was

---

10 In a later interview, Katrina said it happened "hundreds" of times. According to the detective, it is not uncommon for children to disclose more details in subsequent interviews. (RT 3:520-525)

being accused of molesting his own stepdaughter, and he had a very good relationship with her. Appellant denied having sex with Katrina. He said he took her to an abortion clinic, but did not tell his wife because he didn't want to upset her. Appellant said Katrina paid for the abortion. Appellant's home was not searched; Katrina retrieved her letter from her bedroom. Appellant gave the detective printouts of Katrina's chats with Glen from the night before. (RT 3:496-498, 3:505-506, 3:508-511, 3:513, 3:520, 3:534)

Physical Evidence

A slide was prepared from a tissue sample taken from the uterus during Katrina's August 9, 2004 abortion. According to the laboratory report, the estimated gestational age of the pregnancy was seven weeks. (RT 2:398, 2:400-405, 3:481) A slide tissue sample is preserved in a paraffin block for two years; tissue shavings are kept for eight years after that. (RT 2:405-410) A clinical and anatomic pathologist examined the slide and concluded there was evidence of intrauterine pregnancy. (RT 3:482-484) Katrina's sample was released to Det. Eaton in November 2005; Det. Eaton took this sample, along with reference samples collected from appellant and Katrina, to the Long Beach Genetics Laboratory. (RT 2:410, 2:414-416, 3:524)

Dr. John Taddie performed a DNA analysis on the samples. Taddie received BS in microbiology from Penn State University and a Ph.D. in molecular biology from Cornell; he did three years of post-doctoral research at the Salk Institute studying cancer biology, and worked at Long Beach Genetics Laboratory from 1997 to 2006, acting as laboratory director/general manager beginning in 2001. At the time of trial, Taddie was an expert witness/ consultant for Laboratory Corporation of America, and had testified 45 times as an expert. (RT 2:417-420)

DNA is a genetic material present in all cells. Half the material is inherited from the mother, half from the father. In DNA testing, chemicals are introduced to open the cells, exposing the nuclei and the DNA. This solution is mixed with a commercially available test kit to amplify the 15 significant genes via copying by polymerase chain reaction, or PCR. Once amplified, the genes can be identified by number. In testing products of conception, there are fetal and maternal elements; part of the testing is to identify the fetal components. (RT 2:422-433) Taddie performed this analysis on the reference and paraffin samples in this case, and compared them: in a paternity analysis, the fragment that matches the mother's profile is subtracted, leaving the father's profile. If the father's profile does not exclude the male

reference sample, either the male reference sample came from the father, or the male reference sample matches the father's genetic profile by chance. After Katrina's profile was subtracted, appellant could not be excluded as the father. There was a combined likelihood, or combined paternity index, that appellant randomly matched the father at each test site of one in 17.5 billion. (RT 2:433-449)

Defense Case

Appellant has been part of Katrina's life since she was 1 year old; Katrina's mother and appellant married when Katrina was 3. Appellant and his wife have a son, who was 12 years old at the time of trial. Katrina's mother works as a medical records director, and has worked in that capacity since Katrina was born. From May 1995, when Katrina was 6, to November 2003, when she was 14, her mother's hours at the hospital were Monday through Friday, 8:30 a.m. to 5:00 p.m., but were flexible. During that period, appellant worked Monday through Friday as a loan underwriter at various locations, including West Hollywood, Pasadena, and Irvine. Because of traffic, appellant left the house at 7:00 a.m., returning home between 7:00 and 8:00 p.m. (RT 3:545- 549, 3:572-574) Since 2003, Katrina's mother has worked at another hospital under the same flexible schedule; appellant's schedule has also remained the same. (RT 3:550-551)

Katrina was in public school until 5th grade, when her parents put her and her brother in a parochial school that had daycare until her mother picked them up at 6 p.m. Before 5th grade, Katrina stayed at a neighbor's house after school until her mother got her after work. If the children were home sick, their mother called in sick to take care of them. (RT 3:551-553) Katrina's mother knows her boyfriend from Katrina's tae kwan do class. Katrina started class in August 2005; her mother found out Katrina was dating on August 21, 2005. Katrina's mother disapproved of the relationship because she wanted Katrina to complete school. Portia was one of Katrina's best friends. (RT 3:553-556, 3:566)

Her mother became aware of Katrina's allegations of abuse on September 2, 2005. On September 29, 2005, Tessie spoke to Det. Eaton about Katrina's allegations. Katrina never gave her mother a letter. The first time Katrina's mother was aware of the letter was when the detective showed it to her. (RT 3:546-568, 3:571, 3:574) In November 2006, she went to San Diego with the children; she decided to take them away at the time set for

appellant's trial because Katrina was stressed, her mother was stressed, and her son was in and out of the hospital because of stress. (RT3:568-570) Katrina's mother has never observed any indication that Katrina did not want to be around appellant. (RT 3:570)

## STATEMENT OF FACTS

Prosecution Case

Kendria is appellant's niece; she lived with appellant and his wife from June, 1999, until May, 2001, or from the time she was ten until almost thirteen. (RT 610-611, 617, 914-915, 937-938, 958) While Kendria was living with appellant, he tried to make "passes" at Kendria: he would walk past her in the hallway and try to grab her breast. Kendria would push appellant's hand away. (RT 611-613, 642) Once, while driving, appellant tried to put his hand in Kendria's shirt and touch her breast; she pushed his hand away, and when they arrived home, appellant told his wife to yell at Kendria for not minding. (RT 613-614) Appellant stared at Kendria while she was sleeping. (RT 640) Kendria told appellant's wife, Frances, about the passes, but Frances didn't do anything. (RT 616) When Kendria told appellant she was going to tell the police, he said there was no use in telling because they would both get in trouble. (RT 616)

One night, when Kendria was twelve, Frances decided they would all sleep by the fireplace because it was cold. Frances spread bedcovers on the floor and laid down; appellant laid next to Frances, and Kendria laid between appellant and a table. Kendria was in a sleeping bag, which would unzip if she moved. (RT 617-619, 627, 664-665, 667-668) Kendria dozed off quickly, but woke later when she felt appellant's hand go into her underwear and touch inside her vagina. Appellant told Kendria he wanted to get on top of her; Kendria pulled appellant's hand out and yelled, "you're sick." (RT 619-622, 669-671) Frances woke and asked what was going on; Kendria told her, and her aunt sent her to her room while she and appellant talked. Sometime later, Frances brought Kendria back to the living room, and said appellant was crying, and had denied touching Kendria. Frances did not call the police, and told Kendria not to tell anyone, that they would "keep it in the house." (RT 622, 643-644) Frances also told Kendria she didn't believe her, and Kendria should just tell her aunt she was making it up; Kendria could tell Frances didn't believe her, so she told Frances "I'm making it up." (RT 644)

Before Kendria felt appellant's hand in her vagina, she also felt appellant's hand on her breast, inside her nightgown. She immediately grabbed his hand and "threw it," then scooted closer to the table and went back to sleep. (RT 615, 626-627, 668-669)

Before living with appellant, Kendria lived with her grandfather and grandmother in Georgia. When Kendria first moved to appellant's house, her mother lived there as well for the first few months. Kendria's grandfather and legal guardian also lived in Southern California while Kendria was living with appellant. Kendria would go on day trips with her grandfather once in a while. Kendria knew he loved Kendria and would have protected her: her grandfather was always telling Kendria she could come stay with him. After Kendria left her aunt and uncle, she returned to her grandmother's home in Georgia for about a year, then stayed with her mother and her mother's husband in Texas for about a year, then moved back in with her grandmother. (RT 632, 634-635, 645-647, 654, 656-657, 913-914, 927-930, 934, 99)

Because of her aunt's reaction to Kendria's complaint, Kendria didn't feel she could tell anyone until she "got away from it all." She didn't tell her grandfather because she didn't feel like talking about it, and didn't want to ruin their good time together. Appellant seemed to get upset when Kendria visited her grandfather, finally saying that Kendria's grandmother said Kendria couldn't see him anymore. (RT 643-644, 646-647)

Kendria didn't tell her mother about appellant's touchings while her mother lived with her and appellant; when asked why, Kendria said, "I'm not really sure because I don't remember." (RT 655, 980) Kendria loves her grandmother; Kendria know her grandmother would do anything to protect her, and feels comfortable talking to her grandmother. Kendria didn't tell her grandmother because talking about appellant put "a lot of pressure" on Kendria, and Kendria is "sensitive." When Kendria's grandmother would call Kendria at appellant's house, Frances would say Kendria was unavailable even when she was standing right there. Kendria couldn't call her grandmother back when she was alone in the house because appellant and Frances had the long distance "turned off" the telephone. (RT 648-652)

Kendria finally told her grandmother a week or two after leaving Kendria's mother's house; her grandmother then told her mother. (RT 657, 663, 920) At that time, Kendria also told her grandmother her mother didn't buy her any clothes, didn't feed her or her sisters, always walked around nude, even in front of Kendria's little brother, and took nude pictures of herself. Kendria said she found a photo depicting her mother naked while her stepfather is taking a photo of her naked mother. Kendria also said her mother beat her once for half an hour because she got dye on the couch.

Kendria said her mother favored one of her daughters and abused and neglected the other. (RT 657-658, 662-663)

Kendria said she told her mother appellant stared at her every morning when he woke her up; after Kendria got used to the time difference, she told appellant she didn't need him to wake her anymore, but he persisted. Kendria thought he was trying to "see something" when she would get up and adjust her nightgown. (RT 640-642) Kendria said her mother told Kendria that once she woke up and appellant was staring at her. (RT 642)

Appellant gave Kendria a Valentine's Day card while she was living in his apartment. The preprinted card, signed by appellant, read: "I want you. I need you. I love you. Think you can handle all that? Happy Valentine's Day." Kendria thought the card was inappropriate; Kendria and her mother gave the card to the police when they reported appellant. (RT 622-626, 975) Sometimes, Kendria and her aunt would buy greeting cards together: Frances would get cards for appellant to sign. That Valentine's Day, Kendria and Frances bought cards at Target. Kendria didn't remember who gave her appellant's card. Kendria did not tell her aunt the card made her uncomfortable. (RT 672-674, 676)

In October, 2001, Kendria and her mother met with officers at the Signal Hill police station to report appellant. They returned one or two weeks later to turn the Valentine's Day card over to police and for Kendria to phone appellant while the officers recorded the call. (RT 628, 630-631, 915-920)

During the call, appellant said he missed talking to Kendria; Kendria said she didn't want to talk to appellant because he was "always trying to touch me all the time when I was there." Appellant said, "Oh, cut it out. You know I've never disrespected you." Kendria disagreed, and appellant replied, "Well, you used to pick at me all the time, so I used to pick back at you." Kendria said she never picked at appellant, and appellant disagreed, noting Kendria had pinched and bitten and "bothered" and kicked and "everything else." Kendria admitted she had, but explained it was because he "touched on" her. Appellant said, "you know, nothing ever happened, and maybe that's - that's a good thing." Kendria said appellant never should have touched her, and appellant replied that he "told [her] years ago how wrong stuff like that were." When Kendria asked why appellant touched her "and stuff" if it was wrong, appellant responded, "... whatever might've incidentally happened is - is past, and everybody's living. Nobody's dead, and ... I don't think it's worth even... bringing up, you know." Kendria said it was to her, and appellant

said, "if I owe you an apology, or something, dear, I apologize...," and went on to say he thought they were friends. Kendria said if it had been a regular relationship, that would have been fine; appellant said "there's nothing more, ever been more than just a regular relationship"; Kendria said the relationship had been "gross, disgusting, and sick," appellant said, "Well, Keni, look, whatever may be bugging you, I sincerely hope that - oh - you know, you get over it." When Kendria brought up the touching again, appellant asked her "where are we going with this, here?" Kendria asked appellant where he was going, appellant said, "I'm not going nowhere. I'm fine. Are you fine? I miss my niece," and said he'd asked her grandmother to have her call him. Kendria hung up. (CT 64-66; RT 675)

Frances was Kendria's disciplinarian: if she did something appellant disapproved of, he would tell Frances, and she would punish Kendria. (RT 637) At the preliminary hearing, Kendria testified appellant slapped her three times during an argument about the touching. Kendria may have bitten her uncle; she kicked him when he slapped her. (RT 635-636)

One day, Frances locked Kendria out of the apartment, so Kendria kicked the door in. The apartment manager came and said Kendria had to leave. (RT 639) The incident with the sleeping bag occurred shortly before Kendria moved out of appellant's apartment. (RT 665, 671)

Appellant was 46 years old at the time of his arrest. (RT 677-678)

Defense Case

Shalesia is Kendria's mother; Anthony is her stepfather. Kendria was raised mostly by Shalesia's mother, Estelle, because when Kendria was an infant, Estelle told Shalesia she couldn't take Kendria with her when she moved out. Shalesia called the police, and Estelle claimed to have custody of her granddaughter; the police told Shalesia that she would be arrested if she took Kendria, and ordered her off the premises. From then on, Estelle has had primary custody of Kendria. (RT 904-905, 920-921, 934)

In October 2001, Kendria came to live with Shalesia and Anthony after she left her grandmother's house after leaving appellant and Frances' house. Kendria stayed with Shalesia for five months; during her stay, Shalesia and Anthony chastised Kendria for walking around the house in just a towel or "skimpy clothes" after showering. Anthony said this was particularly inappropriate to do in front of him. Shalesia did not walk around the house nude, but sometimes went downstairs in her bra and panties to get milk

for her newborn; Kendria would have been asleep at these times. (RT 906-907, 931-932, 934-935) Shalesia and Anthony fed Kendria on a regular basis, and provided her with clothes. Anthony did not take nude photographs of Shalesia in front of Kendria, nor has he ever taken nude photos of Shalesia in front of any of her children, nor has anyone ever taken a picture of Anthony photographing Shalesia nude. (RT 907-908, 935) Shalesia never told Kendria that appellant watched her sleep. (RT 905)

After Kendria moved out, she accused Shalesia of child abuse and neglect. Shalesia was subsequently investigated; no charges were brought based on those allegations, and her children were not removed from her home. (RT 909-911) At some point after Shalesia found out Kendria had accused appellant of abuse, Shalesia called the police to say she didn't believe Kendria. The detective told he someone from the district attorney's office would contact her, but no one did. (RT 911-912, 916)

Shalesia thought Kendria was lying because Shalesia's known appellant a long time: he never made advances towards her, and it didn't make sense that Kendria was constantly seeking his full attention, jumping on him, always wanting to play. Kendria's principal and teachers had previously called Shalesia about her daughter's inappropriate behavior with boys at school. Shalesia was molested as a child; Kendria's behavior didn't seem like that of a child who was nervous or scared. (RT 922, 926, 931-933)

Appellant and his wife moved to their current apartment in March or April, 2001. (RT 938-939, 949) The apartment was a one-bedroom, and Kendria was not on the lease. After they moved, Kendria came home from school one day without her house key. She tried to pick the lock with a pair of scissors, breaking the scissors off in the lock. She ripped the screen off the window, then went to the rental office, told them she lived in the apartment, and demanded to be let in. The rental office called appellant at work, charging him for the damage Kendria had done to the door. Because of this incident, appellant had to either upgrade to a larger unit, or send Kendria back to her grandmother. Appellant couldn't afford a bigger apartment, so Kendria had to return to Georgia. (RT 949-950)

Appellant was at work when Kendria made the police-recorded call. When appellant said they would "pick" at each other, he was referring to those times Kendria would irritate him to the point of losing his temper: she would bite him on the arm, kick his legs and his "private area," trying to get his attention while he was watching TV or playing solitaire on the

computer. Kendria also liked to sneak in and scare appellant, jumping at him from underneath his bed. Appellant apologized on the tape for those times when he reached for her in anger: a couple of times, appellant tried to pinch Kendria back, but caught himself, realizing he was wrong. Kendria also tripped a couple of times, trying to get away from appellant. (RT 939-942) The "incidental thing" appellant referenced had to do with allegations Kendria had made against another adult male right after she came to live with appellant; based on those accusations, appellant had "preach[ed]" to her such conduct was wrong, and had forbidden the man from coming to the house. (RT 942)

One night during the 1999 holidays, they all slept in the living room: appellant and his wife under their bedcovers, and Kendria in her sleeping bag. They did so because Kendria wanted to go to a slumber party, but was not allowed to because she'd gotten in trouble the last time she'd gone. That night, they played cards and rented videos. After watching the movies, everyone went to sleep. At some point, appellant woke, feeling someone at his side, nudging his shoulder, then repeatedly pushing at his lower body with a hip or something. Half-asleep, appellant pushed away, and started to tell his wife he didn't think it was appropriate to do anything near their niece, when he heard Kendria say he was crazy. Appellant woke to find Kendria out of her sleeping bag, lying next to him. Then appellant's wife woke, and asked what Kendria was doing near them. Appellant told her she needed to talk to Kendria. (RT 943-946, 959-973, 979) Appellant was upset. He got up, and went to bed. (RT 946-947)

Kendria called appellant "Preacher Man" because he used to "preach at her" about how to grow up and be a lady. (RT 939-940) Appellant never slapped Kendria; Kendria slapped appellant once when he got between her and his wife, who were fighting. (RT 947) Appellant discussed Kendria's behavior with Estelle, and the possibility of Kendria returning to Georgia, but Estelle wouldn't accept her. Appellant wouldn't let Kendria's grandfather come visit because that's what her grandmother requested. (RT 947-948) Appellant's wife buys cards for him to sign all the time. Appellant did not recall buying or giving Kendria the objectionable Valentine's Day card, although he did sign it. Appellant did not think the card was inappropriate under all circumstances, but saw how it might be perceived as improper under these circumstances. The card's cover had a hippopotamus with hearts.

# STATEMENT OF FACTS

## Prosecution Case

At the time of trial, Tye was ten years old; appellant is her great uncle.[1] Tye knows appellant as Uncle Jackie. Vondra is appellant's girlfriend; Tye's aunt Lashaune is Ki-Ki, her children are Jimarcus and Azibo, and her husband, Zee. Brie is Tye's mother; Brie's boyfriend is Remy. (RT 4:1340-1342, 4:1372)

The first time appellant touched Tye was at Ki-Ki's house. Tye was in Jimarcus's room; appellant touched inside Tye's vagina with his finger. Appellant undressed Tye, and held her by the shoulders hard while she kicked. Tye screamed and ran to her aunt in the kitchen; appellant chased her down the stairs. Zee was also home, and Brie was sleeping on the couch. Tye didn't tell any adult what happened because appellant said if she ever told anyone, he would call the welfare people on her mother, and would kill her. Tye was afraid. (RT 4:1346-1357, 5:1592-1596, 5:1599-1600, 6:1858-1859) Three days before, appellant made Vondra's children turn their heads as he rubbed Tye's vaginal area outside her clothing. Tye didn't tell anyone about this incident before trial. (RT 5:1513-1515, 5:1642-1644)

The second time appellant touched Tye was also at Ki-Ki's. Tye's mother left, and appellant called the children one by one into the boys' bedroom.[2] After Tye went inside, appellant took down Tye's clothes, got on top of her on the bed, and "started humping" her. His penis was touching Tye's vagina; he was holding her by the shoulders. He licked Tye's chi-chis, or breasts. Tye bit appellant's hands and neck, and kicked him. Appellant let Tye go. She ran downstairs, then returned upstairs. After Tye came back, Jimarcus went into the room. The door was closed: Tye could hear Jimarcus crying and screaming. (RT 4:1357-1365, 4:1368-1369, 5:1515, 5:1596, 5:1599-1601, 6:1864) Jimarcus was crying when he came out of the room. He went to the bathroom, and was bleeding from his butt. Jimarcus and Tye cleaned up the blood with a towel, and Jimarcus threw the towel and his underpants in an outside trash can. Jimarcus's dad put Vaseline on

---

1 Tye's mother was twenty-four at the time of trial; appellant was a couple of years older. Before anything happened with appellant, Brie told Tye appellant touched her when she was a little girl, and to stay away from him. (RT 6:1838-1839)

2 On cross-examination, Tye said this was the first incident. She also testified the first incident occurred on September 27, 1998, the second the 28th, the third on the 29th, and that she could not remember any other dates. (RT 5:1596, 5:1644-1645)

Jimarcus's butt, but Jimarcus didn't tell his dad why he was bleeding. (RT 4:1369-1370, 6:1831-1835, 6:1858) Azibo, who was two or three, went into the room after Jimarcus. Tye could hear Azibo crying and screaming in the room; he came out holding his penis. (RT 4:1370, 6:1857)

The third time appellant touched Tye was at Vondra's apartment. Appellant told Tye to massage his arm, and said he would whip her with a cane if she refused. During the massage, appellant flipped Tye over, got on top of her, and held her by her shoulders. He touched her vagina with his hands, and put his penis in her vagina. Tye pushed appellant's hands, and kicked his leg accidentally, causing it to bleed. Appellant got mad; appellant's right leg is amputated below the knee. Tye noticed that appellant's eyes were red. (RT 4:1371-1380, 5:1601-1603, 5:1609) Tye did not tell anyone what happened because appellant said he would kill her and call the welfare people on her mother, and that they would take Tye away. (RT 4:1381)

The fourth time was again at Vondra and appellant's apartment; Tye was in the bedroom, massaging appellant's arm and massaging and picking dead skin off his amputated leg, as he'd taught her. Vondra was in the kitchen; the bedroom door had a key deadbolt. Appellant undressed Tye, took her by the waist, removed her pants, but not her underwear, turned her on her back and got on top of her. Appellant was not wearing shorts or underwear. He began moving back and forth, his penis touching her vagina. He rubbed her vagina with his hands. Tye got away, climbing out the window and running around the corner to a park where her mother was. Appellant chased Tye halfway out the yard, tearing her blouse and telling her not to come back.[3] Tye told her mother she didn't want to go back to appellant's apartment; they returned to get their things, and went to a motel. Brie told Tye to stay away from appellant. (RT 4:1381, 4:1385-1399, 5:1504-1507, 5:1603-1614, 6:1822-1824, 6:1826-1829, 6:1849, 6:1866-1867)

The fifth incident was at Ki-Ki's: Jimarcus, Azibo, and Vondra's three children were sleeping on Jimarcus's bed. Appellant came into the room with a "no-smoke" bottle containing crack and blew smoke in the children's faces. Tye saw the crack rock, recognizing it from when appellant, Shereece and Don used to sell drugs. The children started coughing, and appellant said he'd kill them if they told. Jimarcus and Tye agreed not to tell so they

---

3 On cross-examination, Tye could not remember if appellant was wearing his prosthesis. Tye had testified previously that her cousin Loray picked her up and drove her part of the way to the park. (RT 5:1612-1613, 6:1829-1831)

wouldn't be taken by the welfare people. (RT 5:1507-1513, 5:1516, 5:1614-1618, 5:1621-1626)

The last time was on October 2, 1998, at appellant's apartment; before Ki-Ki dropped Tye off that day, Tye told Ki-Ki she didn't want to stay there. Ki-Ki left her inside the apartment, and Tye fell asleep on the living room floor. Vondra suggested Tye watch TV in her and appellant's room. Tye fell back asleep on the bedroom floor, and Vondra and appellant "started humping." Slimy "white stuff" came out of appellant's "thing," and appellant told Vondra to take a shower because she stank. After Vondra left, appellant told Tye to close the bathroom and bedroom doors. She did, they watched TV for a while, then appellant grabbed Tye by the shoulders, pulled her down, grabbed the top of her head, and made her lick his penis. Tye was screaming. Appellant put his hands over Tye's mouth, laid her across the bed and undressed her. He got on top of her, put his fingers in her vagina, moved them around, put his fingers to his nose, sniffed them and wiped them on the bed, then inserted his penis in her vagina. It hurt badly; Tye felt appellant's penis get bigger. Tye screamed, and appellant put a pillow over her mouth. (RT 5:1520-1535, 5:1626-1633, 5:1638-1639, 6:1811-1812, 6:1821-1822, 6:1835-1837)

Appellant moved up and down; Tye couldn't breathe, and felt as if she was going to faint. Appellant told Tye she was "going to die tonight" and if she didn't die, she would go to the welfare people. White stuff came out of appellant's penis. The shower stopped, Tye began to bleed a lot. Appellant put a sock in Tye's underwear and told her to go to the living room. (RT 5:1532-1538, 5:1588, 5:1638-1641, 6:1850) Tye continued to bleed, appellant told her to go to the tub, and said he was going to tell Vondra that Tye started her period. Tye bled on the bathroom floor and in the tub; there was also blood on the bedroom walls and on the bedcovers. Tye showered, but continued to bleed. Appellant brought her a pad, and Vondra called Tye's mother. Appellant told Brie that Tye was bleeding and to come get her; he also hung up on Brie about five times, laughing. (RT 5:1538-1543, 5:1636-1638)

Brie took Tye to buy pads. Tye didn't tell her mother what happened because she didn't want to go to the welfare people. They returned to Vondra's apartment, then drove in Brie's car to Tye's step-grandmother Joceyln's house with Brie's boyfriend, Remy. At Joceyln's, Tye went into the bathtub; she was still bleeding heavily, and three blood clots came out of

her in the toilet and bath. Tye vomited when she got out of the tub. She kept changing clothes because she was bleeding so heavily.[4] (RT 5:1543-1550, 5:1561-1569, 5:1571-1587, 6:1840-1844)

About midnight, Brie and Tye took a taxi to Remy's house. Remy drove Brie's car home. Tye fell asleep, still bleeding. She woke, no longer bleeding, but in pain. Remy said something wasn't right, and that Tye needed to go to the hospital. Brie said if they went to the hospital, they would tell her if Tye had been touched.[5] Tye then told Brie what happened. The paramedics came and took Tye to the hospital. (RT 5:1551-1558) At the hospital, Tye was examined, given pain medication, and interviewed by a police officer. According to Tye, her vagina was "cut." She was examined later at a second hospital. (RT 5:1558)

Tye was interviewed by Detective Marquez, and told him the truth about when the last incident occurred. She did not tell the detective about other touchings. (RT 4:1342-1342, 6:1843-1844) Tye was eight at the time of the touchings, and did not yet have her period. (RT 4:1370, 6:1907-1908)

Tye's cousin Jimarcus was seven years old at the time of trial. Jimarcus's mother's nickname is Ki-Ki. Once, when Jimarcus and his mother were at home, appellant called Tye into Jimarcus and his brother Azibo's room. (RT 4:1324-1328) Jimarcus heard Tye crying for a minute when she was in the room with appellant; she had tears on her face when she came out. Appellant then called Jimarcus into the room. He also called his sons Romain, Reidel, ReeRee and Reshay in one at a time; Jimarcus heard them crying as well. (RT 4:1328-1337)

On October 2nd, Tye's aunt Ta-Ja'e was in the bathroom at Joceyln's house when Tye and Brie arrived; a 3" large clot of blood fell from Tye when Tye went to the toilet, and blood was running down her legs. Tye looked scared, and said her private was burning. Ta-Ja'e thought Tye had her period. Brie had Tye get into the bathtub; when Ta-Ja'e saw the amount of blood in the water, she told Brie she didn't think this was due to a period. Brie gave Tye three or four pads to use after she was dressed. Tye began vomiting

---

4 Tye identified a series of photographs of her bloody clothes, and of appellant's boxers, the bedclothes, the sock he put in her underpants, a sheet, a towel she stepped on in the bathroom, and a pair of socks that fell into her bathwater. There was blood on the wall, but Tye didn't see any blood on the wall before she got into the shower. (RT 5:1561-1569, 5:1571-1587, 5: 1646-1655, 6:1813-1820, 6:1847, 6:1851-1856, 6:1869-1870)

5 Tye testified appellant was the only one who ever touched her vagina. Tye recognized a dildo that Vondra kept in her closet, but didn't know what it was. (RT 5:1633-1636)

and passing out, complaining her stomach hurt, she felt hot, and asking her mother for help. Brie called a medical hotline; the hotline said Tye's reaction was normal. Ta-Ja'e told Brie to take her daughter to the doctor. Brie called Remy for a ride, Remy refused, they argued for two hours, then Brie and Tye took a taxi to the hospital. Brie told Ta-Ja'e not to talk about Remy when she testified; Ta-Ja'e said she wouldn't lie. (RT 6:1908-1934)

Los Angeles County Sheriff's Department Detective Carlos Marquez identified a series of photographs of appellant and Vondra's apartment, items given him by Joceyln and Brie, and items taken from the hospital at the time of Tye's examination.[6] To find appellant, Marquez went to his former apartment, and did a computer search of appellant's previous addresses, contacting law enforcement in those jurisdictions. Three to four months and forty to fifty telephone calls, later, Marquez located appellant. Marquez also made a number of attempts to talk to Vondra, setting up three meetings she missed, ultimately interviewing her three months after the initial report.[7] As part of his investigation, Marquez requested serology and DNA testing on various items. (RT 6:1935-1952, 8:2477-2479, 8:2483-2484, 8:2505-2506, 9:2705, 2710-2713)

Marquez interviewed Tye on October 8, 1998: she was very withdrawn, afraid to talk, and visibly upset. It is common to do follow-up interviews in molestation cases because victims are hesitant to tell all the details in the initial interview. Marquez next interviewed Tye on October 6, 1999, and she was in a much better mood. Tye said she began bleeding after appellant put his penis in her vagina. She also told Marquez about an incident in which she climbed out of a window; she did not say appellant came through the window. During the second interview, Tye reported the incident involving Jimarcus and talked about appellant licking chi-chis; she said her mother was present during some of the incidents, and that she saw

---

6 There was a deadbolt lock on appellant's bedroom door. (RT 8·2507)

7 Vondra testified she eventually told Marquez that she'd been using drugs with appellant and Brie on the 2nd. Brie had left just before Tye arrived, Tye was lying on the living room couch while Vondra had taken a shower, Vondra told Tye to shower, Tye began crying while Vondra was dressing, Vondra went into the bathroom and saw Tye was bleeding from her vaginal area while complaining of stomach pain. Vondra told appellant that she thought Tye started her period, and asked him to get some pads. Vondra cleaned Tye and paged Brie; she sat with Tye in the children's room. Keiara was crying and wanting her mother. Vondra left, Tye came and asked to lie with Vondra. Tye laid behind Vondra, her face to Vondra's back. Vondra did not tell the detective Tye was bleeding too much for a normal period. Brie came and got Tye. Vondra was scared during her interview because Det. Marquez told her that she was lying and he would take her children if she didn't tell the truth. (RT 11:3330-3331, 11:3369-3389)

white stuff from appellant's penis on the bed. (RT 8:2480-2483, 9:2702-2703, 9:2706-2709)

On February 1, Marquez was informed that appellant might be staying with relatives in Compton. Marquez alerted Compton police, and they arrested appellant at approximately 12:00 p.m. Marquez and Fletcher interviewed him in the station's interview room later that day. When Marquez first saw appellant in the jail hallway, appellant said he was happy to see him, was tired of running and was "ready to get this over with," and wanted to talk about the case. Marquez said they would talk, and started walking to the interview room. appellant was not handcuffed, but was on his knees. Appellant is very agile: while being transferred from the Compton station, he "sprinted" to the police car, although he was cuffed and without crutches or prosthesis. (RT 8:2484-2490, 8:2512-2516, 8:2523-2524, 8:2527, 9:2717-2718, 9:2720, 9:2725-2726)

Once in the interview room, appellant began talking about the case. Marquez interrupted to say that he needed to read appellant his rights. Appellant said he understood the rights subsequently read, and that he wanted to talk. Appellant said that on the date of the incident, Queisha dropped off Tye at appellant's house right after Brie left. Appellant attempted to page Brie to get Tye; appellant had been using narcotics for three days, and did not want to take care of Tye. He said Tye started to cry, and he noticed she'd begun bleeding. He continued to page Brie, and got Tye some pads from a neighbor. Brie took Tye home a couple of hours later. Appellant said Brie had gone to buy narcotics, and that he had tried to intercept her before she made the purchase. (RT 8:2490-2495, 8:2516, 8:2526, 9:2702, 9:2718-2723, 9:2727)

Marquez said he had evidence that Tye had been sexually assaulted, appellant's story was not correct, and that he wanted to give appellant an opportunity to tell his side of the story. Appellant nodded, started to cry, and said, "Yeah, I did it." Marquez asked him to explain; appellant said he was in bed, Tye came into the room after he told Vondra to take a shower because she smelled bad. Tye got into bed next to appellant, undressed, touched his penis, and started orally copulating appellant without him saying anything. Appellant told Tye to stop orally copulating him because he didn't like being orally copulated. He touched Tye in her vaginal area, she continued coming on to him, he put his erect penis on her vaginal area, rubbing the outside for quite a while. After ten minutes, he inserted his penis in her vagina, and made

a thrusting motion; he said his penis was only inside for a little while and that he only put it in a little bit before taking it out because Tye said "ouch." Tye began bleeding vaginally; she dressed, and sat on the living room couch. Appellant denied digitally penetrating Tye, and said he had intercourse with Vondra in the bed after the incident with Tye. (RT 8:2495-2498, 8:2504, 8:2509-2511, 8:2524-2527)

Appellant said he was sorry for, and ready to pay for, what he had done. He said he ran after the episode because he didn't want to be arrested as he was very skinny from cocaine use and was under the influence of cocaine. At the time of his interview, appellant said he hadn't used cocaine for about a month; he was thinner then than at the time of trial, but not skinny. Based on Marquez's training and experience, appellant did not appear to be under the influence of narcotics during questioning. At the end of the twenty-minute interview, Marquez shook appellant's hand, and thanked him for talking. Appellant was also cooperative in giving a blood sample. (RT 8:2500-2504, 8:2512, 8:2520-2532, 9:2704, 9:2706, 9:2719-2720, 9:2727-2730)

Tye was examined by a nurse practitioner on October 3rd;[8] the nurse observed blood on the exam table and blood clots and lacerations in the vaginal vault, but no active bleeding. A straddle injury occurs when a female straddles something and injures her genitals: Tye did not have a straddle injury. The nurse opined something larger than Tye's vaginal opening caused her injuries, and there was probably friction involved, based on the bruising/tearing. There was a moderate to large amount of blood; no large blood clots were detected. The nurse also thought there had been repeated injury, or more than one penetration, as there were multiple injuries. No sperm was detected, consistent with repeated urination, bathing, bleeding and a lapse in time. The hymen was not present. A dildo, inserted repeatedly, could have caused the injuries; eight-year-old girls don't usually use dildos. A tampon could have ruptured the hymen. Tye had taken Midol, a pain reliever for menstrual cramps, before the exam. The nurse would have expected Tye to experience pain when urinating, sitting, and walking; Tye was tearful. The nurse considered the injuries substantial, but not life-threatening, and that they would take several days to several weeks to heal, the pain and

---

8 The nurse practitioner had done ten medical-legal pediatric exams at the time of trial; Tye was her first examination. She consulted with an ER physician on the case. (RT 7:2116-2120, 7:2127)

discomfort lasting several weeks. (RT 6:1952-1955, 7:2102-2142, 7:2147-2158)

A second nurse practitioner, an expert in sexual assault examinations,[9] examined Tye on October 23rd; Tye was upset and tearful, afraid the exam would be painful.[10] Tye said she had been raped by appellant: appellant had put his penis in her mouth, three fingers in her vagina, and his penis in her vagina. Tye reported bleeding, and said appellant had put socks in her vaginal area to stop the bleeding.[11] Tye said when she started crying, appellant told her to shut up, and that she'd started her period; Tye said she didn't know what that meant. The examination was very painful. Tye could not tolerate the examination like other children, and appeared very psychologically traumatized. The nurse found healing trauma to the genital area, including granulation (new) tissue and old blood. Part of the hymen was fully amputated, as was part of the vaginal tissue at the posterior fourchette, and there were a few tiny clots. The hymen had transections/tears in two areas. There was partially-resolved petechial hemorrhaging around the urethra; the vaginal area was very red. Tye had the most severe and substantial sexual abuse injuries the examiner had seen: vaginal injuries heal at the rate of about 1 millimeter every 24 hours; Tye had significant visible injuries three weeks after the initial report. The nurse opined Tye's injuries were caused by forced vaginal penetration with something much larger than the vaginal opening. The dildo could have caused the injuries; a toothbrush could not. The injury was consistent with penile penetration. The nurse was unaware of any reported instance of a prepubertal child using a dildo for sexual gratification, as such use would be extremely painful. The nurse would test for the presence of semen, but bleeding, urination, bathing and time delay affect the likelihood of detection. The presence of blood clots

---

9 The nurse practitioner had done about 300 child sexual assault exams at the time of trial, and had formulated an opinion in each one, consulting with a physician if necessary. She consulted with Dr. Astrid Hager of USC on Tye's case. (RT 8:2402-2403)

10 It took three weeks to do the second exam because Brie did not keep Tye's earlier appointments. (RT 9:2715-2716)

11 At the time of the exam, Tye was not developmentally ready to start her menstrual period; Tye and Brie also denied that Tye had begun menstruating. Tanner Stage measures sexual development from a young child's level 1, no hormonal effect, to level 5, adult sexual development, including full estrogenation. Absent estrogenization, gynecological exams are very painful. Tye was a Tanner 1-2, indicating very slight estrogen effect, as well as the beginnings of secondary sexual development. (RT 7:2205-2210, 8:2426, 8:2441-2442)

indicates significant bleeding, which can lead to loss of consciousness. (RT 7:2167-2165, 7:2184-2205, 7:2206-2207, 8:2403-2447, 8:2452-2462)

Vondra's mother, Joceyln, checked appellant's apartment at about 1:30 p.m. on October 2nd, bringing a pair of rubber gloves, as was her habit. When she arrived, she noticed the door had been kicked in and the furniture ripped up. Jocelyn went into the children's room, and saw a pair of girl's shorts and panties, both bloodied. There was also blood on the mattress. In appellant and Vondra's bedroom, Jocelyn found a bloody comforter and a dildo in the middle of the bed. Jocelyn put the clothing, bedspread and dildo in a garbage bag. She then discovered blood on the bathroom floor and walls. Jocelyn took the garbage bag home, storing it in her garage. Over the next few months, Marquez repeatedly contacted Jocelyn about Vondra's whereabouts. Jocelyn acted as intermediary, setting up meetings between Vondra and the police, at which Vondra did not appear; Jocelyn did not tell the authorities where her daughter was. When Jocelyn called Vondra, she could hear appellant's voice in the background. Jocelyn eventually gave the garbage bag to Marquez. (RT 6:1873-1902, 6:1963-1940, 11:3368-3369)

Brie was interviewed by a deputy sheriff at the hospital; she was angry, and began crying. Brie said her daughter had been molested by her Uncle Jackie. She said Tye had been bleeding from the vaginal area, that there had been two blood clots, and that Tye had to change underwear twice. When Tye called her mother and said she was bleeding, Brie thought Tye was starting to menstruate. Tye told Brie she wanted to be taken home. (RT 4:1248-1252, 4:1258-1261, 4:1283-1284, 4:1291, 4:1293, 4:1296) Tye was withdrawn, and Brie was concerned at the extent to which Tye was bleeding. Eventually, Tye told Brie Uncle Jackie put his penis in Tye's mouth, put three fingers in her vagina, then inserted his penis in her vagina. The next morning, Brie took Tye to the hospital. (RT 4:1261-1264, 4:1292)

Tye was crying during the assault examination. She told the attending deputy[12] that the day before she had been watching TV on the floor of Uncle Jackie's apartment when Uncle Jackie told his girlfriend Vondra to take a shower. After Vondra left, he told Tye she could lie on the bed. He lay down next to her, pulled down his pants, and put his "pee-pee" in her mouth. He put his hands over Tye's mouth when she started to scream. After taking his

---

12 The deputy participated in a search of appellant's apartment, and gathered into evidence shorts, underwear, a sexual assault kit and a sanitary pad from the hospital. The deputy alerted area law enforcement to the offense. (RT 4:1270-1282, 4:1295)

penis out of her mouth, appellant put two fingers in her "coo-coo," then put his penis in her vagina. Tye tried to push appellant away, kneed him in the groin, and bit his neck. Tye described appellant's penis as getting bigger and described him ejaculating. Appellant left the bed, and Tye called her mother. (RT 4:1264-1270, 4:1294-1295)

A Los Angeles Sheriff's Department criminalist assigned to the forensic biology section of the laboratory tested the apartment items for blood, and detected blood on the girl's clothing, the boxer shorts, the towel, the socks, the comforter, the pads, and the dildo. The criminalist noted that the sexual assault kit was taken seventeen hours after the last incident; he would not expect to find semen in the vaginal vault if there was ejaculation outside the vagina. If there was ejaculation on a sheet, he would not expect to find semen in the kit. Bleeding and urination can potentially wash away semen, as can wiping the genitals; taking a shower decreases the amount of a semen sample, and bathing would greatly increase the sample amount. There was no visible semen found. A DNA test was performed, though the criminalist indicated it was of limited value because the source of the blood was known. (RT 7:2222-2246, 7:2247-2253)

A LASD forensic scientist trained in forensic DNA typing testified DNA is a genetic chemical in the body which occurs in every cell in the body throughout life; it is useful in forensics because one sort of DNA sample, such as blood, from a crime scene may be compared to another kind of DNA sample, such as saliva. There are two types of typing techniques, R.F.L.P. and P.C.R.: in R.F.L.P. typing, a sequence of steps are gone through, including extraction of DNA from a crime scene and from a suspect's reference sample, ending with an X-ray film which is visually interpreted by the criminalist to see if the genetic profile taken from the evidence matches that from the references samples. Samples must share all six genetic markers to be considered a match in R.F.L.P. analysis. After a match is declared, the criminalist determines how rare the profile is in the three main reference populations: Caucasian, black, and Hispanic. (RT 8:2464-2467, 8:2469)

The criminalist performed a series of tests on the evidence, using reference samples from Tye and appellant. A blood stain from the bedspread matched Tye's sample; the match possibility would be 50 trillion in the Caucasian population, 4 trillion in the black population, and 27 trillion in the Hispanic population. It is a very rare DNA pattern. (RT 8:2467-2476)

## Defense Case

Appellant was thirty years old at trial; he lost his leg an inch above the right ankle after a childhood accident. Appellant has worn prosthetic devices since he was seven years old, but did not have a working prosthesis on October 2, 1998, when he was staying at Vondra's apartment. Vondra's three children lived with her mother while appellant lived with Vondra. (RT 9:2769-2772, 9:2836-2840, 11:3330-3332, 11:3351)

On October 2nd, appellant was at the apartment, smoking crack with Vondra, Remy and Brie. The group had been smoking for three or four days;[13] appellant did not know where Tye was during that time. Brie and Remy left the apartment about 4:00 p.m. to buy more crack, returned, and the group continued smoking. Ki-Ki and Zee dropped Tye off around 10:00 p.m.; appellant was upset that they brought a little kid where adults were getting high. (RT 9:2773-2778, 9:2829-2830, 9:2844, 11:3331-3333, 11:3352-3353)

Appellant never touched Jimarcus's rectum or rear end, and never saw Jimarcus bleeding from the rectum. People did not come through appellant's bedroom to "check on him" with the children; when appellant was not doing drugs, he played and baby-sat some of the children, including Tye, Jimarcus, and Azibo. Appellant babysat at Ki-Ki's house, and at Shontecia Kane's house. No one came into check on appellant while he was playing with the children; no one ever told appellant not to play with the children. There was never an incident where appellant was in a bedroom at Ki-Ki's with Tye and Vondra's children and he told them to look away. The bedroom door at Ki-Ki's was broken, and appellant never closed it. (RT 9:2772-2773, 9:2831-2835, 9:2840-2843, 10:3021-3024, 10:3035)

Appellant had sex with Vondra sometime before Tye arrived;[14] about 10:30 p.m., appellant told Vondra to take a shower because she smelled. Tye was in the bedroom, watching TV with Vondra and appellant. Everyone was dressed. While Vondra showered, appellant told Tye to leave the bedroom, and she went into the living room and lay on the couch. Appellant's door was unlocked and closed, the bathroom door left ajar. Vondra returned naked from the shower, and dressed in the bedroom. (RT 9:2778-2784, 9:2844-2845, 11:3334-3335, 11:3337-3338, 11:3344, 11:3356, 11:3358-3359)

---

13 Appellant did not remember anything about September 27th through the 29th beyond getting high at his apartment. He estimated the group used about 48 grams of crack over the four day period. (RT 9:2830-2831, 9:2834, 10:3020-3021, 11:3355)

14 Vondra testified they had sex at 2:00 or 3:00 p.m. (RT 11:3334)

Appellant did not talk to Tye while Vondra was in the shower. He did not touch her vaginal area, and never touched her vaginal area. (RT 9:2784-2785, 9:2804-2805) The dildo was Brie's. (RT 9:2786, 11:3339) Tye took a shower after Vondra; appellant first noticed Tye was bleeding after her shower. Tye was crying, Vondra went to check on her, and said she'd started her period. Appellant saw Tye naked in the bathroom, blood running down her leg. Vondra gave Tye a pad borrowed from a neighbor; Tye laid down in the children's room, then asked if she could lie on appellant's bed. Vondra held Tye, comforting her as she lie between appellant and Vondra; everyone was fully clothed. After paging Brie several times, Brie came, took Tye to the store to get pads, returned about ten minutes later, and left again about ten minutes after that. Appellant smoked more crack while they were gone. (RT 9:2787-2791, 10:3003-3004, 10:3008, 10:3029-3031, 10:3037-3038, 11:3336, 11:3345-3350)

Appellant identified Vondra's bedroom from the series of photographs taken on October 3rd. The room was messy, and the mattress stained. The deadbolt on the bedroom door was broken and unused. Appellant did not know if the stains were blood; on October 2nd, neither he nor Vondra saw blood on the hall or shower walls. He did not recall seeing blood on the shower floor. Vondra did not see blood in the skin or on the hall wall. The mattress was already stained and filthy. Appellant identified his boxers: there was no blood on them when he left them on the bathroom floor earlier that day. There was blood on the comforter after Tye sat on it; he did not recall seeing Vondra's blood on the comforter.[15] The bedroom window is about five feet above the ground, and leads to the backyard. There is a five-foot brick wall with a locked wooden gate enclosing the back yard. Appellant never climbed over the wall, never chased Tye out of the bedroom window into the yard, never saw her climb the wall, never grabbed or ribbed her T-shirt. (RT 9:2792-2802, 10:3021, 11:3340-3343, 11:3357-11:3358)

On October 2nd, appellant left Vondra's apartment for a few minutes to buy more crack returning about 1:00 a.m. on the 3rd. Appellant also paged Remy, and spoke to him. Appellant and Vondra had intercourse again, and appellant rested until morning, when his brother and Zee woke him up and said the police were looking for him because Tye had been molested.[16]

---

15 Vondra didn't recognize the comforter. (RT 11:3344)

16 Zee testified Lee Burke went to find out if the allegations were true; Zee did not recall anyone telling appellant the police were looking for him, but noted that he was "a little high" at the time,

Appellant and Vondra stayed at a friend's house down the street for a couple of days, then moved on to other friends, in other locations. Appellant was afraid, paranoid from drug use. He weighed about 160 lbs. at the time; at trial, he weighed around 240 lbs. (RT 9:2802-2805, 9:2830, 9:2845, 10:3004-3013, 10:3017, 10:3031, 11:3322-3323, 11:3336, 11:3345, 11:3354, 11:3362-11368)

Appellant was arrested at his sister's house in Compton at 11:00 a.m. on February 1, 1999, and ordered out of the house with his hands up. Appellant complied, was handcuffed, his hands behind his back, dragged on his knees to the police vehicle, and thrown inside. His request to put on his prosthesis was refused. Appellant was transported to the Compton station and put in a cell; Marquez and his partner arrived two hours later. By that time, appellant was also hungry and thirsty. (RT 9:2805-2808, 9:2812-2814, 9:2846, 10:3014, 10:3032, 10:3036)

Appellant smoked fifty dollars worth of crack before his arrest, and was paranoid, "tweaking." Appellant was released from the Compton cell by two uniformed officers, who told him he was to be interviewed. Appellant walked out on his knees; he did not say anything to Marquez. The detectives flanked appellant en route to the interview room. Marquez sat across from appellant during the interview; the other man sat behind appellant. The interview lasted forty-five minutes. Marquez said he was there to talk about the charges. Appellant did not say he was happy to see the police, or that he was tired of running. (RT 9:2814-2819, 10:3018, 10:3024-3027, 10:3036-3037)

Marquez read appellant his rights, and told him he was accused of molesting Tye. Appellant said he didn't do it, that he was just there. Appellant said he didn't know how Tye began bleeding. As appellant continued to deny guilt, Marquez leaned over and repeatedly yelled, "You know you did this" until appellant finally said, "Whatever, man." Appellant was still paranoid, scared, and wanted more drugs: when he said what the officers wanted him to say, they didn't do anything to him. After the interview, appellant was handcuffed and taken to Twin Towers; he crawled on his knees to the undercover car.[17] He did not talk to the officers en route, or shake Marquez's hand at the end of the interview. (RT 9:2820-2827, 9:2846-2858, 10:3015-3016, 10:3028)

---

and upset about Keiara. He didn't notice any blood in the apartment. (RT 11:3323-3329)

17 Appellant demonstrated walking on his knees and hopping to the jury. (RT 9:2825-2826)

Latondra was eleven years old at the time of trial; Tye is her cousin. At a birthday party at Aunt Sophie's house in May 1998, Tye was in the bathroom with the door closed; Latondra and her cousin Bree looked under the door. Tye had pulled her panties away from her, and was inserting and withdrawing a toothbrush an inch inside her vagina about eight times. She looked like she was in pain because she had her eyes closed, but seemed to be enjoying it. Latondra told Aunt Nell what she'd seen, Aunt Nell made Tye sit in a corner till her mother came, and that was the last time Latondra played with Tye. Sometimes Tye would try to kiss her cousins; Latondra also saw Tye try to touch another person's private parts. (RT 10:3040-3055, 10:3065-3074, 10:3079-3110, 10:3112)

Queisha is Ki-Ki; Brie is her sister. Her children are Jimarcus and Azibo.[18] In October 1998, Tye had been regularly staying with Queisha because Brie was "always gone in the streets." Queisha's live-in boyfriend at the time was Zee. (RT 10:3113-3228)

On September 27, 1998, Tye was with Brie at Vondra's house; on the 28th, she was at Queisha's. On October 2nd, Queisha took Tye to Vondra's house between 3:00 and 3:30 p.m.; Brie wasn't there, so they went to Tye's grandmother's house, returning to Vondra's about 5:00. Queisha dropped Tye off because she'd had a fight with Brie, and did not want to have any contact with her. She told Brie she'd keep Tye during the week, but Brie was responsible for her on the weekends. Appellant and Vondra were in the apartment when Queisha and Zee dropped Tye off. Tye was not bleeding, crying, or complaining of pain; she did say that she did not want to be left at the apartment. Queisha told her that her mother would be there soon.[19] (RT 10:3118-3121, 10:3134-3140, 10:3151, 11:3312-3316, 11:3318-3319)

The night of October 2nd, Brie called Queisha, and told her she thought Tye had been molested. Tye was bleeding from the vaginal area; Queisha knew Tye did not go to the hospital until 10:00 a.m. the following day. (RT 10:3121-3123, 10:3141-3148) Appellant babysat for Queisha and Zee at their home before, playing with the children in various areas of the house; they would laugh and make noise, but nothing unusual. Queisha checked on them if they were too loud or too quiet. Neither Queisha nor Zee

---

18 Alternatively spelled "KeeKee" and "Aja" throughout the transcript; Zee is also spelled "ZZ."

19 Queisha thought Tye didn't want to be at Vondra's house without her mother or other children there; she also thought Tye didn't like Vondra's house because she didn't have the snacks and entertainment options Queisha provided. (RT 11:3306)

ever found blood in the upstairs bathroom. Zee never put numbing cream or Vaseline on Jimarcus's rectum; on October 3rd, Queisha talked to Jimarcus about whether appellant molested him, and Jimarcus repeatedly denied having been molested. (RT 10:3123-10:3126, 10:3154-3155, 11:3310-3311, 11:3317-3318, 11:3320-3322)

On October 6, 1999, Queisha spoke to her aunt Dewanna, who told her Jimarcus had accused appellant of molesting him, and Brie had taken Jimarcus to be questioned by Marquez. Queisha would not have objected to the officer talking to her son, but was upset that she wasn't asked. Queisha talked to Jimarcus again, and he sad appellant put his penis on his stomach and eye. Jimarcus also said appellant blew smoke in his face. Jimarcus was taken from Queisha and Zee and put in protective custody on October 7th because of the allegations against appellant. Marquez told Queisha that he was trying to contact Brie; he did not indicate that he needed to speak to Queisha. Queisha had no interest in protecting appellant, but didn't know what to believe. (RT 10:3126-3134, 10:3148-3150, 10:3152-3156, 10:3159, 11:3319)

Rebuttal

Remy could not say if he was smoking crack with appellant, Brie and Vondra on October 2nd. He was not smoking with them when Tye was bleeding. He picked up Brie earlier that day because she and her sister had an argument, and they got Tye from Queisha. While he and Brie were at his father's house, he received strange pages, which Brie said were Tye's birthdate. She called appellant's house, and told Remy they needed to pick up Tye because she had started menstruating. He drove to Vondra's, where they found Tye lying on appellant's bedroom floor.[20] Brie took Tye into the bathroom, then to the store to get something for the bleeding. Remy and appellant smoked crack while they were gone. When Brie and Tye returned, Tye was shivering under her blanket and making post-crying noises. Remy dropped them off at Brie's father's house, about five minutes away; there was blood on the back seat where Tye had been sitting. (RT 11:3391-3405, 11:3420, 11:3422-3423)

Remy returned to appellant's house, but no one was there. Brie called Remy; he did not want to pick them up: he did not understand what was going on with Tye at the time. Brie and Tye took a cab to Remy's, Brie

---

20 According to Remy, Brie did not have a dildo. (RT 11:3415-3416)

said she'd changed Tye's pad twice, using two or three pads each time. Remy said she should call the 1-800 number for the hospital; the hospital said it was normal, Remy told Brie to talk to Tye, and he went to sleep. Remy was woken by Brie screaming and crying. Tye was also crying, saying, "He did that to me." Remy asked who, and Tye said Moosey. Tye said he put his thing in her mouth; Remy couldn't remember if she said he put it anywhere else. Later, Remy took Tye to her hospital appointment. (RT 11:3405-3319, 3:3423-3426) Remy has three prior felony convictions, two for spousal abuse, and one for possession of a controlled substance while armed. (RT 11:3416-3417) Remy did not put his penis in Tye's mouth or vagina. (RT 11:3421, 11:3424, 11:3428-3429)

Two Los Angeles County Sheriff's Department deputies observed appellant hopping various distances at various times during trial, without any problems. Appellant is "very agile," and can move at a "fast walk." Appellant can also do a fast walk on his knees, and carries things while hopping or walking on his knees. (RT 11:3456-3443)

Marquez interviewed Jimarcus on September 8, 1999; he had spoken to Queisha about talking to Jimarcus, but she refused to bring him in, so Brie and Ta-Ja'e drove Jimarcus to the interview. Jimarcus told Marquez that when he was four or five years old, appellant touched his private parts while Tye was in the room, and once put his finger in Jimarcus's butt when Tye was not in the room. Jimarcus said these touchings happened at his house and at appellant's house. Marquez notified Queisha, who was angry with him for talking to Jimarcus. She would not respond to the allegations, and accused the detective of brainwashing her son. Jimarcus was taken from her on October 7th; Marquez subsequently contacted Queisha about having Jimarcus examined, but she refused to take him to the hospital, and did not want to cooperate with any further interviewing The children were put in foster care because of Queisha's lack of concern about the abuse. (RT 11:3444-3452, 11:3463-3469)

While in court, appellant congratulated Marquez on his promotion. (RT 11:3452) During Marquez's interview with Vondra, she said she and appellant went from the place down the street to Los Angeles, and then to Compton, and that the blood in the apartment was Tye's. Vondra began crying, said she was sorry for assuming Tye had started her period, that the bleeding was too extreme, and there was blood everywhere Tye laid down.

(RT 11:3453-3456) Remy told Marquez he was concerned that Tye made it to her medical examination. (RT 11:3456)

# STATEMENT OF FACTS

## Prosecution Case
### Gabrielle: counts 1, 2, 14 and 15

Gabrielle was 8 years old at the time of trial; she didn't like appellant because of what he did to her.[1] Appellant rubbed Gabrielle's "front butt," her pelvis, under her uniform pants and underwear. Appellant did this more than once: he was sitting down, she was on his lap, sitting on one of his legs. Other children were in the room watching a video about learning. The lights were off. Gabrielle was mad and scared; she thought she would get in trouble. (RT 5:1850, 5:1855-1862, 5:1870-1873, 5:1877, 5:1880, 5:1884-1885)

Appellant took Gabrielle's hand and put it on his weenie, over his clothes, and had her rub it back and forth. It felt sort of soft. Gabrielle was sitting in appellant's lap; appellant put his jacket over their laps. This happened more than once. After appellant touched Gabrielle, he gave her pretzels. (RT 5:1862-1865, 5:1885-1886, 5:1888)

Gabrielle didn't tell because she was scared "they" would be mad at her. Her mom found out when Kesare came to Gabrielle's house and told the babysitter. Gabrielle saw Kesare and Hailey sit on appellant's lap. When Hailey was sitting on appellant's lap, Gabrielle was sitting on the carpet, watching a video, and looking back. Boys never sat on appellant's lap. Later, Gabrielle talked to Det. Minor; she did not remember telling Minor that she didn't see anyone else on appellant's lap. She did not remember what "culita" means, "culo" is either the front or the back of the butt. (RT 5:1874, 5:1878-1881)

On January 25, 2005, Gabrielle's mother Deloris spoke to the babysitter of one of her daughter's classmates. She then asked Gabrielle if anyone had ever touched her. Gabrielle said appellant would sit her on his legs and put his hand underneath her underwear. Once he unzipped her zipper. He also put her hand on his private parts. Gabrielle was scared when she talked to her mother. (RT 5:1914-1920)

Del. Rebecca Minor interviewed Gabrielle on January 27, 2005; Gabrielle circled the breast, belly button, vaginal, back and butt areas on Minor's anatomical drawing to indicate where appellant touched her. Gabrielle demonstrated how appellant put his hand down her pants and inside her "cola." "Telingo" referred to the front pelvic area. When Gabrielle said

---

1 When Gabrielle spoke to Minor, she said she didn't like appellant because he wasn't in her family. (RT 5:1882-1883)

appellant's telingo was "soft," she picked Minor's badge as also being "soft." Minor asked how appellant's telingo felt, and Gabrielle said "like a rock." (RT 7:3069, 7:3072, 7:3074-3079) Gabrielle's first language was apparently Spanish; Minor did not use a certified Spanish speaker for the interview. (RT 8:3395-3397)

Taped Interview of Gabrielle[2]

Det. Minor asks Gabrielle if she knows what day it is or what month it is. Gabrielle says she knows a song, but can't remember. Minor says the date, asks Gabrielle how old she is. Gabrielle says six. She is in kindergarten. Minor asks questions about colors and counting, asks about her family and toys. (CT 4:889-897) Minor shows a drawing of a naked girl; Gabrielle identifies various body parts such as head, feet, hands. She identifies a body part as "colita." (CT 4:897-901)

Minor asks if Gabrielle likes appellant; Gabrielle says no because he's not in her family. Gabrielle circles parts of the girl's body that you are not supposed to touch. "Pompos" is one part. It is the same as "cola." Minor asks if anyone has ever touched Gabrielle where she didn't want to be touched. Gabrielle says, "my teacher." Minor asks the teacher's name, Gabrielle says, "Mr. L." Gabrielle says she was sitting on appellant's feet at school when he touched her. She was watching a video and the lights were off. (CT 4:902-905, 4:909-910) Gabrielle says appellant touched her two times under her clothing. He touched her with his "woo," it was soft. Gabrielle didn't do anything when appellant put his hand out; she didn't know what to tell him. Minor says that's okay because she's just a little girl. She did nothing wrong. (CT 4:904-907)

Gabrielle says appellant made her put her hand on his telingo: it felt like a rock. (CT 4:907, 4:909) When appellant touched her cola, his fingers went inside. (CT 4:907, 4:909) Minor asks if Gabrielle wants to be in appellant's class; Gabrielle says no. Minor says Gabrielle did nothing wrong, nothing is her fault. (CT 4:911)

Minor asks if it's good or bad to tell the truth. Gabrielle says it's bad to tell lies, you would get into trouble and can't play the Playstation. Gabrielle says she told the truth. Minor says thank you and that everything that happened is not Gabrielle's fault. Minor says Gabrielle told her that when she was sitting on appellant's leg, he touched her cola with his hand and

2 Based on the transcript admitted into evidence as People's Exhibit 27. (CT 4:865, 4:888; RT 7:3069-3071)

had her touch his telingo, and it was soft. Gabrielle says yeah. Minor asks if Gabrielle touched him over or under his clothes, Gabrielle says over. (CT 4:912-916) Gabrielle says appellant's the only one who ever touched her. Gabrielle says she didn't tell her mom because she was scared: she thought she was going to get in trouble. (CT 4:918-919)

Minor says she wants to make sure she knows exactly what appellant did. She asks how Gabrielle was sitting when appellant touched her; Gabrielle says on one of appellant's legs. Appellant touched her inside her clothes, inside her cola. Appellant did this two times on two different days. Appellant had Gabrielle touch his telingo two times outside his clothes: he told her to give him her hand and he put it. It was soft. (CT 4:919-923)

## Kesare: counts 3 and 4

Kesare was 7 years old at the time of trial. Appellant had been her kindergarten teacher. Kesare doesn't like appellant because he touched her private place. She was wearing a skirt and tights; appellant was reading a book in front of the class, Kesare sitting on his lap. Appellant held the book in front of them and rubbed Kesare with his finger. (RT 6:2112, 6:2141, 6:2145-2150, 6:2155, 6:2163-2167, 6:2171-2172, 6:2174, 6:2177-2178, 6:2180-2183)

The second time appellant touched Kesare, the children were in line waiting to get their homework stamped. Appellant picked Kesare up, put her in his lap, and rubbed her with one hand while he stamped her work with the other. He touched her over her underwear. (RT 6:2151-2153, 6:2156, 6:2174-2175, 6:2178-2180) Kesare did not see appellant touch any other children. He sometimes gave the children pretzels. Kesare told her mother what happened. (RT 6:2155, 6:2180-2182)

According to her mother, Osana, Kesare came home from school in September 2004 and said her teacher touched her private part. Kesare said the children were sitting on the floor, and appellant asked who wanted to read a book with him; Kesare raised her hand, appellant picked her, sat her on his lap, put the book in front of them and began reading and touching her over her clothes. Kesare pushed his hand away. On January 24, 2005, Kesare told her mother that she did not know why her teacher had touched her private part again. Osana asked why Kesare sat on appellant's lap again and why she hadn't pushed his hand away. Kesare said children lined up to get their homework stamped, when it was her turn, appellant put her on his

VANESSA PLACE

lap and touched her; she didn't push his hand because he was the teacher. (RT 6:2111-2114, 6:2121, 6:2124-2129, 6:2136)

Osana didn't tell anyone after Kesare's first report because she didn't want to hurt appellant, and because she believed that if she talked to Kesare, it would not happen again. After the second report, Osana called another class mother, asking if her daughter had said anything about appellant. Two days later, Osana confronted appellant with Kesare's allegations; appellant said it was customary to have children sit on his lap, but that he was incapable of touching Kesare. They agreed it would be better for Kesare not to sit on appellant's lap. Appellant also said maybe Kesare had been confused: maybe the paper he was reviewing or the cover of the book he was reading had rubbed her, and she had mistaken this for him. Osana thought appellant was a good teacher. (RT 6:2115-2119, 6:2122, 6:2125, 6:2130-2132, 6:2138-2140)

That day, Det. Minor came to Osana's home. Later that day, Osana asked Gabrielle's babysitter to ask Gabrielle's mother if Gabrielle had any problems with appellant. (RT 6:2123) Minor interviewed Kesare on January 26, 2005, bringing in Sgt. Cuevas to translate after the interview began. Kesare identified the arm and vaginal area on the anatomically correct diagram as where appellant touched her. (RT 8:3311-3313, 8:3318-3319, 9:3614-3616, 9:3618-3619) According to Cuevas, leading questions, repetitive questions, and the presence of an authority figure can influence a child to give untrue responses in an interview. The word "victim" was used 67 times during Kesare's interview; Cuevas did not know if Kesare understood the term. If she did, it could have suggested appellant was guilty. (RT 9:3619-3620, 9:3623-3626, 9:3636)

Interview of Kesare[3]

Kesare is 5 years old. Minor says she's going to ask questions in English, and Bill will ask in Spanish. Kesare is asked about family members. She is friends with Gabrielle, and she is in kindergarten. They discuss the difference between truth and a lie. (CT 5:1059-1072) Minor discusses parts of a girl's body based on a drawing. Kesare says the teacher grabbed her "there." She doesn't have a word for it. The butt is private. People aren't

---

3 Based on the transcript read into evidence. In the transcript, Kesare is transcribed as "Ceasar." (CT 4:885, 5:1151) Lt. Bill Cuevas testified he translated during the interview; his primary language is Spanish. He did not know the extent of Kesare's proficiency in English. (RT 7:2774-2775, 8:3447, 8:3450, 9:3612-3618, 9:3626-3630)

supposed to touch the arm, the place where you go to the bathroom, or the butt. (CT 5:1072-1082)

Appellant touched Kesare "where we pee from." He touched her with his right hand index finger. He touched her almost every day, "a little," like 100 times. (CT 5:1082-1087) Appellant touched her outside her underwear with his right index finger when she was wearing a blue dress. They were in class, appellant sitting in a chair, stamping the homework, and Kesare sitting on his left leg, reading. (CT 5:1088-1104)

Kesare doesn't remember the last time appellant touched her. The first time, she was reading a book about a sad cat while sitting on appellant's leg. The class was lined up, chatting. (CT 5:1104-1118) Kesare sits with her friends. She was wearing a blue dress; appellant touched her outside her underwear. (CT 5:1118-1127) When she was in class today, she had shorts on and didn't sit on anyone's lap. Appellant touched Juliet when she was wearing a dress; he was checking her homework. Appellant also grabbed Kesare's arms because she is a bad leader. He grabs hands when reprimanding the students. (CT 5:1127-1145)

Phoebe: counts 5 and 6

At the time of trial, Phoebe was 8 years old, in third grade. Appellant was her kindergarten teacher. Appellant touched Phoebe's private: she was sitting on his lap, wearing her uniform skirt, they were reading a story in front of the other kids, who were seated on the rug, listening. Appellant touched Phoebe once.[4] Phoebe did not feel good, and was scared. Afterwards, appellant gave Phoebe a pretzel. Girls, including Hailey, got to sit on appellant's lap. Phoebe did not remember telling the officer that she and another girl once sat on appellant's lap at the same time. (RT 6:2448, 6:2452, 6:2455-2461, 6:2465-2469)

On January 24, 2005, Phoebe's mother Viola talked to another classroom parent; she asked Phoebe if someone had touched her body. Phoebe said a little boy grabbed her. Viola asked if a teacher ever touched her. Phoebe was worried her mother was going to hate her or hit her; Viola said she wouldn't. Phoebe wanted to take a shower; after her shower, she said appellant had grabbed her private thing. She was sitting on appellant's lap as he read to the class, and appellant touched her on top of her underwear. Appellant had asked who wanted to read with him, picking Phoebe. (RT 6:2404-2408, 6:2414-2417, 6:2420-2424, 6:2431, 6:2439-2441) Phoebe said

---

4 Phoebe did not remember telling Det. Minor that appellant didn't touch her. (RT 6:2464)

that another time, she and another girl were both sitting on appellant's lap when he touched her over her underwear. (RT 6:2425, 6:2442)

Viola had seen some behavioral changes: a month earlier, Phoebe rubbed her privates after her shower. Viola told Phoebe this was wrong. Phoebe also didn't want to go to school one day. Viola once found teddy bears in Phoebe's backpack; Phoebe said the teacher loaned them to all the kids. The windows of appellant's classroom were usually covered in colored paper. Viola would drop Phoebe off at school; she never saw any children sitting on his lap. (RT 6:2408-2413, 6:2419, 6:2426-2428, 6:2434-2438)

Viola waited outside the room during Phoebe's police interview; at one point coming in so Phoebe could sit on her lap. Scared, Phoebe briefly left the room, leaving the door open. Irma then spoke to the officer about how her daughter had been acting. (RT 6:2429, 6:2441, 6:2445-2446) Viola got a letter from the school about appellant's arrest. (RT 6:2432)

Det. Carrie Mazelin interviewed Phoebe on January 29, 2005; the interview was recorded. At first, Phoebe sad she was not touched. Mazelin then left Phoebe in the interview room, going to an adjacent room to speak with Phoebe's mother in private. Mazelin told Viola what Phoebe said, Viola told Mazelin what Phoebe had disclosed, and Phoebe came into the room and sat on Viola's lap. Mazelin again asked Phoebe what happened, Phoebe said she told her mother something. Phoebe became uncomfortable; Mazelin let Phoebe return to the interview room to get her crayons, leaving the doors open between the rooms. While Phoebe was in the other room, Mazelin and Viola quietly discussed her behavior; the interview resumed, Phoebe on Viola's lap, Viola providing physical reassurance. (RT 6:2474-2480, 7:3006, 7:3020-3022, 7:3038-3039, 7:3043-3044, 7:3052-3054)

Phoebe said appellant touched her private area outside her pants twice while she was sitting on his lap, reading a book. Boys do not sit on appellant's lap. This portion of the interview was not recorded because Mazelin did not want to make Phoebe feel uncomfortable. (RT 6:2481-2483, 7:3023, 7:3040-3041, 7:3044-3046, 7:3055-3056) At the time of this investigation, Mazelin had been investigating sex crimes for five and a half years, had attended various classes and received additional training on child abuse and sex crimes; she had interviewed almost 100 children by the time she did these interviews. (RT 7:3005, 7:3036)

Mazelin is concerned about contamination and suggestibility; repetitive questioning can lead to a child giving a different answer, as it implies

the previous answer was incorrect. Yes or no questions limit the child's ability to provide a narrative. Mazelin was not worried about Phoebe's interview being contaminated: Phoebe couldn't read anything that would influence her responses, and she understood truth-telling. Phoebe had spoken to her mother, and Viola's voice can be heard saying "yes" and "no" on the tape. Mazelin did not think her interview techniques influenced Phoebe's answers, though she told Phoebe that other girls had talked about sitting on appellant's lap, that it would make Phoebe feel better to "talk about it," and that Mazelin "needed" Phoebe to talk about it. Mazelin also repeatedly asked Phoebe about appellant although Phoebe initially denied anything happened. According to Mazelin, "sometimes you have to direct" small children. "False denials" are common with children because they are afraid of getting into trouble or are embarrassed. There are also false reports; Mazelin had no reason to believe Phoebe was making a false report. (RT 7:3006-3013, 3:3017-3019, 7:3025-3035, 7:3037-3038, 7:3047-3052, 7:3058-3059)

Interview of Phoebe[5]

Mazelin talks to Phoebe about her bracelet and princesses; Phoebe says she is 6, and in kindergarten. (CT 4:927-929) Phoebe says nobody likes it when you tell a lie, it is bad; it is good to tell the truth. (CT 4:931-933) Phoebe says private parts are private because no one is supposed to look or touch; if someone does, you tell his mommy. No one ever touched Phoebe on her privates; if they did, she'd tell her mom. (CT 4:935-936)

When it rained, Phoebe's class would stay inside. When Mazelin asks if Phoebe ever sat on appellant's lap, Phoebe says, "Who told you?" Mazelin says some of the other girls said they sat on his lap, too; Mazelin's "police friend" also told her. (CT 4:936-939) Mazelin asks Phoebe to say more about appellant. Phoebe says she saw some other girls sit on appellant's lap, Perdita and Hailey. Mazelin says she's going to talk to Phoebe's mother, and ends the interview. (CT 4:940-942)

The interview is recommenced with Phoebe and her mother. Mazelin asks Phoebe if she told her mother that appellant did something to her; Phoebe says yes, Mazelin asks what, Phoebe tells her mother that "I don't want to talk," and "I want to go home." She refuses to tell, and tells her mother to tell. Mazelin says she's not in trouble: she needs Phoebe to be

---

5 Based on the transcript admitted into evidence as People's Exhibit 30. (CT 4:861; RT 6:2485, 6:2487)

brave and tell the truth, so she can keep kids safe. Phoebe wants to color; the interview is concluded. (CT 4:943-945)

Hailey: count 7

Hailey was 8 years old at trial. Appellant had been her kindergarten teacher.[6] Hailey didn't like appellant because he touched her privates one time. He called her to his chair, told her to climb into his lap, gave her a big bag of pretzels, put a black jacket on top of her lap, unzipped her pants, pushed away her underwear with his finger and touched her while she ate the pretzels. It was a "little hurt." Appellant told her it felt good. Afterwards, she went to the bathroom. The rest of the class was watching an ABC movie, the lights off. Appellant called other girls back to his chair with him before he called Hailey; once Hailey saw Gabrielle sitting in appellant's lap. (RT 6:2185, 6:2189-2197, 6:2199-2206, 6:2209, 6:2211-2215)

She told her mother Jessica what happened; Jessica got a call from Osana, then talked to Hailey. Hailey initially denied anyone had touched her, then said appellant touched her privates. She said appellant sat her on his lap, covered her with a black jacket, unzipped her pants and touched her with his finger. Hailey was worried her mother would be angry at her. Jessica contacted the police,[7] later taking Hailey to a doctor. (RT 6:2195, 6:2218-2222, 6:2224-2226, 6:2234-2235) Hailey did not remember telling the police that she had an imagination named Lucy who told her that appellant was going to touch her. She remembered telling her about "green stuff": appellant put it in her private. (RT 6:2207-2208) Jessica has seen appellant at school wearing a black jacket. During her first teacher conference, Jessica told appellant that Hailey had something to tell her. Appellant said, "Oh, no. No." Jessica assured him that Hailey was happy in class. (RT 6:2222-2223, 6:2226-2230) Jessica got a letter from the school about a meeting about appellant, she arrived late, and did not speak to the other parents. (RT 6:2232-2233)

Julie Lister is a nurse practitioner at the Los Angeles County U.S.C. Medical Center in the Violence Intervention Program, working in the area of

---

6 At trial, Hailey didn't recognize appellant as her former teacher. (RT 6:2189)

7 Officer Brenda Iglesias took a counter report from Jessica at 8:05 p.m. on January 25, 2005. Jessica said Osana called and told her that appellant touched Kesare. Hailey was with her mother: Hailey said she was sitting on appellant's lap, he put a black jacket over her legs, unzipped her pants, and touched her vaginal area under her underwear with one hand. The class was watching a movie, and appellant told her not to tell her family. Hailey said "Gaby" was also touched. Hailey said her imagination's name was Lucy and Lucy told her that her teacher was going to touch her, and he did. She said her imagination meant that when someone touches you, you have to tell. (RT 9:3638-3657)

sexual assault since 1997. Sexual assault exams follow a standard protocol, known as the Sexual Assault Response Team process, set forth in two forms. (RT 4:1656-1661) On January 26, 2005, Lister examined Hailey; she was direct and matter-of-fact during the interview. Hailey said appellant sat her on his lap, covered her with a black jacket, unzipped her pants, moved her underwear aside with his finger, and "poked" and rubbed her. She said appellant likes to talk about private parts, and that he told her she would like it. Hailey said it was scary and she did not like it. (RT 4:1661, 5:1891-1893) Lister conducted a forensic examination of Hailey: she had no external genital injuries. Lister did not examine the interior of the vagina or cervix because it would have been too painful for Hailey and was unwarranted by the external exam. The examination was consistent with the history Hailey provided. Lister did not examine the other girls in the case. (RT 5:1893-1895, 5:1899-1908)

Minor interviewed Hailey on January 25, 2005; during that interview, Hailey drew an arrow to the vaginal area of the anatomical diagram to indicate where appellant touched her. To demonstrate how appellant touched her, Hailey rubbed her vaginal area with her finger. When Hailey said appellant touched her with his "three hands," she indicated her fingers. (RT 7:3080, 8:3308-3311) Hailey had been interviewed before Minor spoke to her. She was confident Hailey understood the difference between the truth and a lie. She mentioned the "green" thing that appellant touched her with eleven times: the green thing was appellant's wet finger. (RT 8:3417-3426, 8:3435)

Interview of Hailey[8]

Minor discusses that it is good to tell the truth; Hailey says if you lie to your mommy and daddy they won't like you. Hailey is 5, and appellant her teacher. (CT 4:949-953) Minor shows Hailey a picture of a naked little girl, Hailey identifies the parts, including the chi-chi's. There is another part that Hailey does not know the word for; there are two private parts, which no one is allowed to touch. (CT 4:953-956) Hailey says when she was in the back on Friday, December 2, her teacher touched her in the private, and there was "little green stuff there." She was sitting on his lap, he opened her zipper and touched her under her pants, using three fingers. Minor asks Hailey how appellant got under her clothes; Hailey says because he's a teacher and gets mad at people. Appellant touches her every Friday when she's sitting on his

---

8 Based on the transcript admitted into evidence as People's Exhibit 31. (CT 4:865; RT 7:3081-3082/3300)

lap. Appellant asked Hailey if she liked it, but she didn't. Appellant touched her one time. It was a "big hurt." (RT 4:957-962, 4:965-967)

Hailey's cousin Gabrielle also sits on appellant's lap, but appellant doesn't touch her. Hailey can't go back to school because she has to talk to the principal about appellant, and the doctor told her not to go anymore. (CT 4:962-964) Minor asks Hailey again how many times appellant touched her and what he touched her with; Hailey says he "put a little green thing in there." No one took it out, the doctor said it made her private hurt. Hailey says appellant did it really hard: the green thing is used for the butt. The green thing was on his finger. It was dark green; he put it in first, then his fingers. The green thing was wet and looked like appellant's "mocos." No one has ever done something like that before to Hailey. (CT 4:967-973) Hailey says Gabrielle saw, but no one else. Appellant "doesn't do" boys. Minor and Hailey talk about the tape recorder and cartwheels, and her imagination. (CT 4:973-976)

Minor asks Hailey to demonstrate what appellant did to her with a stuffed bear. Hailey says appellant had his hand in her privates for 50 hours, or 3 hours, which is "a little." Hailey told him she didn't like it; appellant said she did. They sat in the back of the class; the rest of the class was watching the video. Appellant said, "Don't tell no one." (CT 4:980-984)

Ivette: counts 8 and 9

At the time of trial, Ivette was 9 years old and in third grade. Appellant was one of her kindergarten teachers, Ms. C. was the other. She liked appellant "a little": she liked that appellant gave the children stickers, but did not like that he touched them in their privates. Ivette identified where she went to the bathroom as her privates. (RT 4:1518, 4:1524-1525, 4:1538, 4:1581-1584)

The fourth or fifth day of school, the class was watching a video in the classroom, lights off, when appellant touched Ivette's privates. She was next to the white board, sitting on one of appellant's legs, her back towards appellant's side. Appellant rubbed Ivette's privates over her pants with his hand. Ivette was scared. After appellant touched Ivette, he gave her stickers. (RT 4:1525-1531, 4:1534-1536, 4:1541, 4:1561, 4:1563-1564) Other girls in the class also sat on appellant's lap. Appellant would call them up by name. (RT 4:1532-1533, 4:1541-1542, 4:1562, 4:1568) Appellant touched Ivette more than one time; he never put his hand inside her pants or panties. The

first time was probably the first day of school.[9] Appellant was the only teacher in the room. No parents were present. The last time was in February: there were no other adults in the classroom. (RT 4:1533, 4:1542-1543, 4:1546, 4:1564-1566, 4:1569, 4:1586) Demi and Taylor were touched in the same day and way as Ivette, at around the same time. The other students were facing the other way, sitting on the rug or in their seats, watching the video, but Ivette saw appellant by the light of the T.V. (RT 4:1550-1560, 4:1586, 4:1588-1590)

Ivette eventually told her parents; she didn't tell them after the first time because she thought she was going to get in trouble. No one else has ever touched Ivette's privates. (RT 4:1532) According to Ivette, appellant was "a little bit mean" because he yelled a lot at the children. (RT 4:1540-1541)

On direct, Ivette testified she first heard that appellant was arrested on the news. On cross-examination, she testified her grandmother told her, then she saw it on the news. She knew appellant had been arrested before she talked to the detective, but did not know what appellant had been arrested for. Before Ivette told her parents what happened, she talked to classmates Demi and Taylor about appellant touching her. When she talked to her parents, they also talked about appellant being in jail. (RT 4:1544-1546, 4:1549-1550, 4:1556-1557, 4:1573)

Consolata is Ivette's grandmother. Sometime after Christmas 2003 or early January 2004, Consolata was watching Ivette and three other grandchildren when she saw Ivette taking down another granddaughter's pants and underwear while they were inside a playhouse. The other girl tried to turn around, and Ivette told her to keep looking at the toy she was playing with. Consolata took Ivette aside and asked what she was doing. Ivette denied doing anything. Consolata asked if anyone had done that to Ivette. Ivette didn't answer. Consolata persisted, asking about uncles and cousins; Ivette said no. Ivette named her 3 year old brother. Consolata said he couldn't do that, and asked if it was someone at school.[10] Ivette began crying and said it was her teacher. (RT 4:1597-1601, 4:1603-1604, 4:1606)

Consolata asked when "he" did this; Ivette was crying too hard to answer. Consolata asked again, Ivette said it happened in the classroom, and that "he calls me to the black chair." She also said the teacher would

9 Ivette told the detective that appellant touched her at the end of the day, around 2:15. Ivette could not tell time in kindergarten. (RT 4:1548, 4:1570-1572)

10 Consolata told Minor that she asked Ivette if a teacher had done it. (RT 4:1607)

also take one of Ivette's friends to the black chair. Consolata told Ivette's mother Nieve what Ivette said either the following day, or the day after that. (RT 4:1602-1603, 4:1605-1609)

Sometime during the school year, Nieve asked the school to move Ivette to another class because she wasn't learning at grade level. Ivette also disclosed something to Nieve, and was having behavior problems: she cried when Nieve dropped her off at school, saying she didn't want to go. When the year began, Ivette loved going to school. (RT 4:1615-1618, 4:1638-1639, 4:1653) After Consolata talked to Nieve, Nieve talked to Ivette: Ivette said appellant touched her private parts. She said appellant would put a video on, call the girls to the back of the room and sit them on his lap. She said appellant touched Demi and another girl. Nieve did not ask for more information. (RT 4:1618-1622, 4:1633-1636, 4:1644-1646)

Nieve didn't do anything other than move Ivette because she didn't want to believe it was true. After Ivette was moved, her behavior changed dramatically: she loved going to school, her work got better, and she stopped crying when she was dropped off. (RT 4:1622-1625, 4:1652) On February 7, 2005, Nieve found out appellant had been arrested, so Nieve told Ivette's father what Ivette had said. He and Nieve talked to Ivette in Nieve's car. They told her a teacher had been arrested for doing bad things to kids; she said, "Oh, was it like what Mr. L. did to me where he used to give me stickers?" She then repeated her previous account. (RT 4:1627-1631, 4:1641-1643, 4:1645-1649) Nieve called the police. She did not speak to the parents of any of the other children, and does not know them or their children. (RT 4:1632-1633, 4:1636, 4:1645)

Ivette has lied before, but never about anything like what she said happened with appellant. Nieve told Minor that she didn't report Ivette's accusation earlier because Ivette made up stories all the time. (RT 4:1631-1632, 4:1636-1637, 4:1655)

Minor interviewed Ivette on February 11, 2005; to identify where appellant touched her, Ivette circled the vaginal area of the anatomical diagram used during the interview. When asked to demonstrate how appellant touched her, Ivette rubbed the table with her fingers. Ivette's interview took place after the parent meeting at the school. Minor took notes during the interview, discarding them after she prepared her written statement. (RT 7:3060, 7:3067-3069, 8:3378, 8:3388, 8:3390)

Interview of Monique[11]

Minor talks to Ivette about having her ear pierced, games and counting. They discuss truth and lies, establishing it is bad to tell a lie. (CT 4:987-1000) Appellant was Ivette's teacher. (CT 4:1003) Ivette identified private parts as parts no one is supposed to touch. Appellant touched Ivette's private more than one time. She had to sit on his lap when it was almost time to go home. (CT 4:1005-1008) Appellant touched her with his hand over her pants. The rest of the class was watching a video about fire safety. (CT 4:1008-1009) Ivette says appellant touched all the girls, naming Demi and Taylor. Ivette says she saw appellant touch them over their clothes. Ivette didn't tell because she was scared she was going to get in trouble. The first time appellant touched her was the first day of school and the last time was because she moved to a different room. (CT 4:1009-1012) Ivette knows appellant is in jail and says it is a good thing. (CT 4:1013-1014) Minor asks how appellant touched Ivette; she says he rubbed it, and rubbed it until they got all the stickers. Ivette didn't know why they got the stickers. Minor goes over the details again; Ivette confirms. Minor asks about telling the truth; Ivette says it's good to tell the truth. (CT 4:1015-1020)

Candie: counts 10 and 11

Candie was 9 years old at trial; her kindergarten teacher shared the classroom with appellant, and Candie helped appellant before the bell rang, sharpening pencils. Sometimes there would be one or two other girl in the room at the time. (RT 5:1812, 5:1819, 5:1829-1833) Appellant touched Candie's private in the classroom many times: appellant would sit in his chair, pick Candie up and put her in his lap, her legs straddling his. He touched her with his finger under her panties. After he touched her, she would get stickers and leave the classroom. After Candie left the classroom, she peeked in the window and saw him washing his hands. She didn't know if appellant touched the other girls as well. (RT 5:1820-1824, 5:1826, 5:1836-1840, 5:1842-1844, 5:1846) Candie was a little scared. (RT 5:1824, 5:1827)

In February 2005, Candie's mother Suze saw a TV news item stating that a teacher at her child's school had been arrested for child molestation; she asked Candie if any teachers had hurt her. Candie put her head down and did not answer. Suze let the matter drop. Another student's mother later told Suze that appellant had been arrested. Suze asked Candie if she liked

11 Based on the transcript admitted into evidence as People's Exhibit 34. (CT 4:865; RT 7:3061-3062)

her teacher, Mr. L., and Candie said yes. She asked why Candie was drawing pictures for appellant, and if appellant had ever touched her. Candie put her head down, and asked if she was going to get in trouble.[12] Marlee did not pursue the issue. Once, Suze went into the classroom to deliver something and saw Candie sitting on appellant's lap while the other children watched a video. (RT 5:1929-1935, 5:1940-1950, 9:1958-1961)

On March 3, 2005, Suze talked to Candie again. Candie did not want to talk in front of her father; they went into Candie's room, Suze asked if appellant had touched Candie, Candie said, "If I tell you, is he going to get into trouble?" Suze said to tell the truth: if appellant did something bad, he needs to stay in jail. Candie said she would help appellant sharpen pencils in the morning and he would sit her on her lap and touch her privates, then give her pencils and stickers. Candie said appellant hurt her really hard when he touched her vagina. Candie kept asking if appellant was going to get into trouble, and if his wife was going to get mad. Candie said Christine, Maria and Genesis went with her to appellant's room, and he touched them as well. (RT 5:1935-1938, 5:1950-1951)

Six months earlier, Candie complained of her genitals hurting. The area was red and irritated. Suze treated Candie with diaper rash ointment. The condition went away, though there was some redness a few months later. (RT 5:1938-1939, 5:1952-1956) Suze has not spoken to other parents in the case. (RT 5:1939)

Minor interviewed Candie on March 4, 2005, after the parent meeting at school, and after appellant's arrest. A number of Candie's answers indicated she had outside information about appellant touching children. (RT 8:3357-3361, 8:3365-3378)

Interview of Candie[13]

Candie is 7 years old; Mazelin talks to her about her family, counting, and colors. They talk about lying and telling the truth: lying is bad. (CT 4:1023-1030) They talk about Candie's current teacher, and her kindergarten teacher. Candie liked her teacher. (CT 4:1031-1040) Candie says she went to a counselor because appellant was touching "the little girl." Candie draws a

---

12 Candie testified Suze told her appellant was in jail; she said appellant touched another girl. Candie went to see a counselor, and talked to Minor. She talked to her mother about appellant touching her; (RT 5:1833-1836, 5:1842, 5:1845, 5:1847, 5:1951-1952)

13 Based on the transcript admitted into evidence as People's Exhibit 36. (CT 4:863; RT 7:2786)

girl, identifies the "chachitas," butt and vagina as private parts. (CT 4:1040-1043)

Candie says appellant hurt a little girl because he touched her. Appellant touched Candie's vagina once at school: he put his hand on her skirt or pants and touched her under her clothes.[14] He washed his hands after. She knocked on his door, he let her in to sharpen the colored pencils, he said, "That's enough," she sat on his lap, and he touched her when she got stickers. (CT 4:1043-1046)

No one else saw because it was before school started. Appellant touched Christine when she came with Candie. Candie says appellant did this to her when she was in second grade. (CT 4:1046-1049) She says it hurt because appellant was putting his hand in her vagina. Candie didn't tell appellant to stop because she thought he would get mad. She didn't' tell anyone what he was doing because she thought she was going to get in trouble. She knows appellant is never going to get out of jail; Candie's mother told her it was in the newspaper and that appellant touched another girl who Candie did not know. Candie is telling the truth. (CT 4:1049-1054)

In 2004/2005, S.G. was the assistant principal where appellant taught kindergarten. The 2004 school year began on September 7, 2004; according to teacher training programs, children are not allowed to sit on teachers' laps.[15] (RT 3:1260-1265, 3:1306-1310) Attendance rosters are kept, which includes class rosters. Candie was a student from kindergarten through part of second grade. Ivette was moved from appellant's class on February 27, 2004 because her parents weren't satisfied with her progress. Appellant shared a classroom with K.S. Appellant also teamed with G.L., although in 2004/2005, appellant had the room to himself. (RT 3:1266-1270, 3:1313-1315)

After appellant's arrest, a letter was sent in English and Spanish to parents, saying appellant was not going to return, that he was on administrative leave. The letter did not explain why. A meeting was held for concerned parents; a representative from the Police Department, the Assistant Director of Pupil Services, and a district translator were present. Specific allegations were not discussed. A subsequent letter was sent

14 Det. Minor testified she demonstrated three hand gestures; Candie chose the one involving Minor's rubbing her fingers against the table. Candie circled the vaginal area of the anatomical diagram when asked where she was touched. (RT 7:2789-2790)

15 According to S.G.'s preliminary hearing testimony, there was nothing stated against the practice, it was an "unsaid" thing that it was inappropriate. (RT 3:1309-1310)

from the school superintendent stating a teacher had been arrested for inappropriate behavior involving children, and the teacher was incarcerated and on unpaid leave. (RT 3:1270-1275) Appellant's classroom has one door on the east side of the room, and large windows on the north side, covered with colored mini-blinds. There is a student desk area, a rug area for stories, and white board/focus wall area. (RT 3:1277-1286, 3:1315-1320) The ideal classroom setup has a lot of open areas; appellant's room has barriers, or areas where children could hide. (RT 3:1286-1303) There was an unlocked door linking appellant's classroom to Ms. M's classroom. Sometimes parents and other teachers would visit the class unannounced. (RT 3:1311-1312, 3:1321) S.G. evaluated appellant once, giving him an "above average" evaluation. (RT 3:1306)

R.M. was the principal from August 2003 to December 2004; during that time, appellant was team teaching. In May 2004, R.M. spoke to appellant about reassigning him to fourth or fifth grade. Appellant "strongly wanted" not to teach upper grades. Appellant said he would go to his union if R.M. enforced his reassignment; R.M. did not reassign appellant. R.M. visited appellant's classroom at least once a week; the room was cluttered, sectioned-off, not as open as other kindergarten classes. Appellant's desk was isolated in the corner of the room. The windows were mostly covered in colored butcher paper with drawings on them, which was not uncommon. Appellant wore a black leather jacket in winter.[16] R.M. never saw appellant act inappropriately with children, and never saw any children on appellant's lap. It would be inappropriate to have students sit on a teacher's lap. R.M. told police he didn't think appellant would ever hurt students. (RT 7:2704-2717, 7:2720-2732, 7:2734-2746)

Capt. James Smith was present at the school meeting regarding appellant; he provided general information about appellant's arrest, including date and charges filed. Smith said the investigation was ongoing, and advised parents to contact Minor if they had specific concerns. Smith knew one of the victims' parents were present, but did not recall whose parents. (RT 7:2750-2752, 7:2757-2764)

Minor arrested appellant on January 27, 2005 at his home. After taking appellant's property, she told him she would like his cooperation. Appellant said he was cooperating, and that he "expected this to happen."

16 Det. Cuevas testified that when he contacted appellant at school on January 26, 2005, appellant was wearing a black jacket. (RT 7:2775, 7:2778)

The day before, Minor spoke to appellant at school, telling him that a student had accused him of committing a lewd act. Appellant did not ask who made the allegation, and did not deny the allegation. (RT 7:2784-2786, 8:3341-3343, 8:3429)

Before conducting the interviews in this case, Minor had received special sex offense and sex offense investigation training. Repetitive and leading questioning could lead to suggestibility; a child sitting on a parent's lap could influence the child not to be truthful if the person was the abuser, or if the person participated in the interview. Minor did not agree that children were more suggestible than adults. Minor interviewed the children apart from their parents; after the interviews, she did not provide parents with details of their child's statement, but told them the child had disclosed inappropriate touching. None of the victims changed their answers during the course of their interviews. (RT 8:3321-3322, 8:3336, 8:3344-3352, 8:3433-3434) As far as Minor knows, none of the victims are related. (RT 6:3427-3428)

Defense Case

N.W. was a volunteer from 1999 through 2005, working in K.M.'s class, the room next to appellant's. She went to appellant's class quite often, usually via the adjoining door. There were differences between the way appellant had his classroom set up and the way the classroom was depicted in the prosecution's photographs; the classroom in the photos was too neat. (RT 9:3674-3682, 9:3690, 9:3696-36)

N.W. saw appellant with a child sitting on his knee, not his lap: the children running up and jumping on his lap. She never saw two children on his lap at once. N.W. has had "many children" sit on her lap: they climb up because they want comforting, or during story time. Appellant typically sat in the middle of the class at a work table. He sat in his chair when videos were playing. Appellant gave stickers and pretzels as rewards. Kindergarten classes rotated teachers for 25 minute periods, according to subject. N.W. never saw appellant act inappropriately toward a child. (RT 9:3682-3687, 9:3693, 9:3695-3702, 9:3728-3729)

K.M. taught kindergarten in the class adjoining appellant's. The door between rooms was never locked, and Ms. M walked into appellant's room unannounced. Ms. M never saw appellant act inappropriately towards any children. She never saw a child sitting on appellant's lap while he sat in his chair; occasionally, she saw boys and girls climb onto his knees. Ms.

M has had children sit on her lap: sometimes it's easier to instruct them, sometimes they just get onto your lap automatically. Ms. M could always see what appellant was doing when the children were sitting on him because the tables are so small. (RT 9:3708-3718, 9:3729-3730, 9:3734-3735, 9:3736-3737)

Ms. M knew Candie from team teaching, and because Candie visited Ms. M before school, as she did appellant. Candie never seemed reluctant to go to appellant's class, or upset when she left. (RT 9:3719-3722) All the teachers give rewards; Mr. L. gave stickers, Ms. M had a treasure chest. (RT 9:3722, 3:3733) Ms. M considered appellant a good friend, and she respected him as teacher and felt he was an asset to the school. (RT 9:3724-3726, 9:3730, 9:3734)

G.L. had been teaching in the classroom that became appellant's classroom for 20 years when appellant was hired. They worked together from 2000 through 2004, team teaching for part of the school day, overlapping classes for another part. Mr. L was in the classroom with appellant approximately 90 percent of the time. From 2003 to 2004, Mr. L was in Ms. M's classroom and K.S. was team teaching with appellant; Mr. L was constantly going into appellant's class during that time. The kindergarten teachers also rotated classes. Appellant's class was designed for primarily Spanish speaking children. Mr. L saw appellant constantly helping the children; he and appellant changed desks and tables often. Mr. L never saw appellant act inappropriately towards any of the children. (RT 9:3906-3913, 9:3918-3924, 9:3935)

Mr. L saw girls sitting on appellant's lap once or twice. He never saw two children sitting on appellant at once. Many teachers turn the lights out when playing a video in class. Mr. L vaguely remembered a child sitting on appellant's lap during a video. Mr. L has also had children jump on his lap, but does not allow it as a practice. He does not believe it is inappropriate, but once told appellant he thought it might look like the wrong thing to do: the front door to the classroom is always open, the class is by the street, and parents, who are always coming by door, might misinterpret the gesture. Several teachers allow students to sit on their laps, and there is no policy proscribing it. Appellant's door was generally open, and the door between adjoining classes has no lock. Appellant gives stickers as rewards. (RT 9:3913-3916, 9:3926-3932, 9:3935-3936)

Mr. L thought appellant was an excellent teacher, as well as a very religious man with a strong moral character. (RT 9:3920-3922, 9:3926-3927, 9:3934)

V.H. taught fourth grade for 13 years, and knew appellant from about 1994 to 2005. In 2005, appellant taught Ms. H's English learners class. The students were receptive to appellant; none of them sat in his lap. Ms. H went to appellant's classroom when students were present: she never saw appellant behave inappropriately with any students, and never saw students sitting on his lap. (RT 9:3937-3946, 9:3949)

Ms. H believes appellant is very caring and nice man, an active church member and good teacher. When Ms. H taught kindergarten, she let students sit on her lap; it was age-appropriate. (RT 9:3946-3951)

J.C. met appellant in 1988 through her church; she was 9 years old when they met, and 27 at the time of trial. From the time J.C. was 9 until she was 20, she occasionally visited appellant, sometimes for extended periods. Appellant has a very high moral character, and is a caring and honest person. (RT 9:3952-3957)

Steve W. was appellant's pastor in two churches, and had known appellant for 17 years. Appellant is an upstanding individual: he was a Sunday school teacher at both churches. Everyone thinks highly of appellant. (RT 9:3958-3966)

Appellant's 24-year-old son has seen his father teaching. The students were very receptive. Appellant's son filmed his father teaching for an open house project in 2003, and otherwise visited his classroom several times. He never saw appellant behave inappropriately with any students. Appellant is member of Pathe Community Church, where he taught Sunday school and participated in church activities. He was also involved in Republican party planning for his Congressional district. Appellant's son characterized his father as very fair: he raised his sons with a very clear idea of right and wrong and appropriate consequences. Appellant was very supportive of his children. Everyone says positive things about appellant. (RT 9: 3968-3977)

Laura Brodie is a clinical and forensic psychologist, in private practice since 1996. She has a Ph.D. from Biola University, and a post-doctoral fellowship with the LAPD. Her dissertation concerned how social workers determine child sexual abuse; Brodie has worked as a rater of children's statements to discern credibility, worked with children in the area, and reviewed taped social worker interviews to assess the credibility of

abuse reports. Brodie has co-authored two articles on experiments involving credibility factors, one study involving over 100 transcripts. She has reviewed 150 to 200 interview tapes for both prosecution and defense to see if the child's report was contaminated by the interviewer, and testified twice in the areas of contamination/suggestibility. (RT 10:4227-4732, 10:4240, 10:4268-4269, 10:4270, 10:4281, 10:4283)

Children's brains are more pliable than adults'; they defer to adults. If an adult asks repetitive questions, children will change the answer, believing their initial answer wrong: they tend to say what they think the adult wants them to say. Five or six year olds may be more or less suggestible, depending on I.Q. and maturation. Interviewer bias or confirmatory bias is a suggestibility, implicated in the use of leading questions, or questions that suggest a particular answer. Yes/no questions may either suggest an answer, or may suggest the first answer was wrong. It is important to ask open-ended questions and to elicit narrative answers: having a child choose between several answers is not an open-ended question. An interview should not start with a question implicating a teacher. Hypotheticals should be avoided as children tend to interpret them concretely. (RT 10:4732-4237, 10:4267-4270, 10:4275-4276, 10:4286-4287)

Source memory is the knowledge of where information comes from; small children do not have source memory, and will incorporate something that they heard happened to someone else as an experienced memory of their own. Contamination can occur when an interviewer or parent gives a child information which the child incorporates into the child's account of what happened. Information taken from the media could influence a child's statement. (RT 10:4237-4340, 10:4246)

The recommended interview pattern involves establishing rapport with the child, communicating the serious nature of the conversation, and determining if the child can distinguish the truth, and has a grasp of the language used in the interview. Waiting until the end of an interview to see if the child understands the truth is problematic as the interview has been conducted without the assurance that the child knows he is to tell the truth, rather than just answer questions. (RT 10:4240-4242) If one parent called another parent and reported inappropriate touching, and the second parent then asked her child if she had been inappropriately touched, the child's response could be compromised, as there would be an emotional component to the questioning, and the transmission of information that there

# Tragodia 1: Statement of Facts

*Tragodia 1: Statement of Facts*

was touching, or touching of the private areas, to the child. (RT 10:4242-4244) If a grandmother repeatedly asked a crying child if she'd been touched, then asked whether a series of the child's relatives, and then whether her teacher, had touched her, this could be evidence of contamination. The crying could indicate the child believes she is in trouble. If parents are told as a group that a teacher was arrested for inappropriate touching, and a child is then questioned about inappropriate touching, this could contaminate any accusations. Any situation in which information is transmitted to the child runs the risk of the child simply reproducing the information. (RT 10:4244-4248)

If a child spoke of her imagination having a name and telling her that her teacher was going to touch her, and that then he did, this could suggest the child was developmentally unable to distinguish fantasy from reality. Use of another police officer to translate during a police interview might lead to suggestion or contamination if the child understood more English than the interviewer believed; the presence of two officers could be intimidating. Persistent questioning after a child denies being touched puts stress on a child; according to the relevant literature, a parent should never be present during an interview. An interview could definitely be contaminated where a child has denied being touched, left the room, returned after the mother and interviewer have discussed the denial, and continued the interview sitting on her mother's lap.[17] Telling a child who initially denied being touched that telling is the right thing to do suggests the child must tell to "help" mommy or the police officer. (RT 10:4248-4260, 10:4266, 10:4271-4273, 10:4279, 10:4282-4283) The effect of any contamination cannot be quantified. (RT 10:4278-4280)

If a child referred to a teacher touching another child, or to the person going to jail, the interviewer should attempt to find out where the child got that information. A statement from a child who reported hearing something from both her mother and the school could be contaminated: the interviewer should ask what information the child got from which source. (RT 10:4261-4266, 10:4277) A child may be more reluctant to disclose abuse by someone seen on a daily basis. (RT 10:4285)

Interviews should be taped to check for nonverbal cues. Repeating information can either be repetitive questioning or a prompt for more disclosure. (RT 10:4258, 10:4276-4277, 10:4283)

---

17 Some children will not talk without a support person present. (RT 10:4272)

Appellant has been a teacher since January 1978; his first assignment was teaching kindergarten through 2nd grade in the City of Commerce. Before coming his current school in 1999, appellant also taught 2nd and 4th grade, middle and high school. While teaching kindergarten, appellant volunteered to teach 2nd through 4th grade Saturday English class. Appellant has a bilingual cross-cultural specialist credential, as well as his regular teaching credential, reading credential, and supervising administrative credential. Appellant is a life-long Spanish-speaker. (RT 10:4298-4307, 11:4594-4598) Appellant has received various awards for teaching, including a certificate from the Board of Education for 25 years of outstanding service, and two nominations for the Disney award for creative teaching. (RT 11:4546-4549)

During the first two years appellant was at the school, he shared a classroom and cooperatively taught with G.L. Mr. L's aide, a Miss K., was also present, and continued visiting the class after Mr. L left. During the next two years, appellant team taught with K.S., who also used an aide. The classroom was not as depicted in the photographs; the students' tables were against the wall, and other items, such as the easel and book center, were in different locations. The room was cluttered, the walls and windows were covered differently. The doors between appellant and Ms. M's classrooms cannot be locked. Appellant had 20 to 25 students in his class each year. (RT 10:4307-4312, 10:4319-4345, 10:4355-4356, 11:4577) The principal asked appellant several times to change to fourth grade; that grade has at least 40 students per class, and the curriculum is very demanding. Academic performance goes down, and parents tend to blame the teacher. Appellant did not recall saying he would go to the union. (RT 11:4586-4589, 11:4632)

Appellant showed educational videos to assist in English language learning. He did not sit in the back of the classroom while students were in the room; during videos, he walked around the room or sat at a student table. Appellant never called the girls to the back of the room during a video. Videos were shown at the end of morning session. Appellant had an open door policy: parents or other faculty could come into the classroom any time. At some point, the school instituted a policy whereby parents had to call ahead to visit, but appellant otherwise did not know when someone would stop by. Ms. M came into appellant's room at least twice a day, always unannounced. Mr. L came in as well, staying anywhere from a few seconds to an hour and a half. The principal and vice principal came in during videos. (RT 10:4346-4354, 10:4361-4362, 10:4366-4369, 11:4511, 11:4514, 11:4519-

4520, 11:4578-4579) Appellant gave stickers and fast food certificates as rewards for work well done. Appellant kept the stickers at his desk; the children lined up to get stickers and stamps on their homework. The pretzels were kept in and on appellant's desk, and in a cabinet; children could also help themselves if they were hungry. (RT 10:4354, 11:4570-4577, 11:4593, 11:4631) The children began learning the days of the week the first day of kindergarten. (RT 11:4527-4528) Appellant did not give out teddy bears, but children could borrow them as part of a reading exercise. (RT 11:4585, 11:4631-4632)

Ivette began in appellant's class in September 2003, leaving in February 2004. She was a shy child with a perception problem; she seemed troubled and despondent, and was frequently late. K.S. and Ms. C's classes started later than appellant's. Nothing happened in class to cause Ivette to be sad: she improved while in appellant's classroom. Appellant never touched Ivette inappropriately. (RT 10:4356-4358, 10:4361, 10:4364, 10:4370, 10:4373, 11:4512) B.E.A.R.S. is a system of rotating groups of children between teachers according to subject matter. Two weeks after Ivette was transferred to Ms. C.'s class, she was rotated back into appellant's classroom: there was not much difference in her behavior post-transfer, though she had some new friends and improved writing skills. (RT 10:4370-4373)

Candie came early to help Ms. M in her classroom; she was in Mr. L's class while he team taught with appellant, and would sometimes wait 5 to 10 minutes in appellant's class for Mr. L. Candie entered through the adjoining doors, which were kept open because appellant did not want to be alone with any student. Sometimes Candie came with other students, coming in about twice a week to sharpen pencils. Candie never sat on appellant's knees; he never touched her inappropriately. (RT 10:4376-4381, 10:4385-4386, 11:4512, 11:4514-4515, 11:4528-4529)

Gabrielle[18] was very assertive; she spoke slightly more English than Spanish. Appellant thought Gabrielle enjoyed school. Gabrielle's mother usually waited in the classroom for 10 or 15 minutes after dropping her daughter off in the morning. Gabrielle sometimes sat on appellant's knee; she wanted to pass out pretzels and stickers. Gabrielle sat on appellant's knee occasionally while transitioning between activities, but never while the class watched a video. He never touched her inappropriately. (RT 11:4515-4518, 11:4520-4523, 11:4584 )

---

18 Referred to as "Gabbie" during appellant's testimony. (RT 11:4515)

Phoebe was very close to her mother; she wanted to do well in school, and had a few close friends. She spoke a little more than half English. Phoebe's mother came to appellant's class at least 3 times a week, staying 5 to 10 minutes each morning. Phoebe never sat on appellant's knees; appellant never touched her inappropriately. (RT 11:4523-4526, 11:4591)

Hailey spoke about 30% Spanish. She was often late to class, usually absent on Mondays and Fridays, and did not apply herself. Appellant met her mother in parent conferences. Once when appellant asked Hailey's mother if anything had changed at home, her face changed. Appellant never touched Hailey inappropriately. (RT 11:4529-4532, 114534-4536, 11:4538, 11:4591-4593) One day, Hailey complained that one of the boys was under her table touching her private parts. The boy said he was just crawling under the table; the children agreed they were still friends, and that was the end of the matter. Appellant has never made an abuse report because the incident didn't rise to the reporting level. (RT 11:4555-4559, 11:4626-4627, 11:4630)

Kesare was a conscientious student, an overachiever. She spoke 90% Spanish; appellant met both her parents in the beginning of school, and her mother would spend 10 or 15 minutes at the beginning of each class in the classroom. On January 25, 2006, Kesare's mother told appellant that Kesare felt she had been touched while sitting on his lap during story time: appellant said he would never do such a thing, and would be happy not to have Kesare sit on his knee again. Appellant thought perhaps the spine of the book had touched Kesare. Kesare returned the next day and did well. Appellant never touched Kesare inappropriately. Appellant did not recall Kesare sitting on his knee while he was stamping homework. (RT 11:4538-4545, 11:4559-4570, 11:4580) Appellant never told any child not to tell their family anything, and never put a jacket across a child's knees. (RT 11:4531-4532, 11:4545)

Appellant has carpel tunnel in both hands, resulting in numbness, loss of strength and dexterity. In March 2005, appellant had surgery on his right hand to sever the tendon, which alleviated pain and improved use. When Candie was visiting appellant's class, he suffered from arthritis in his knees and no cartilage in his left knee. Appellant wears an Ace cover on both knees for heat. During cold weather, his knees are very painful: appellant would never pick up a child and put him on his knees. Appellant has had a back problem since he was 12 years old. (RT 10:4382-4384, 11:4581-4583)

Children will jump onto teachers' laps or knees because they are spontaneous and like to be close. When children jump on appellant's knee,

he makes sure they don't fall off, finds out what they need and moves them on to what they should be doing. Both boys and girls climbed onto appellant's knees; he only recalled Kesare sitting on his knee during reading time. He did not have a practice of sitting students on his knees, and did not have Ivette sit on his knees while the class watched a video. There was never a school policy about children sitting on teachers' knees. Appellant does not have children sit on his lap, as that would not be appropriate. Mr. L once told appellant that an aide told him it was not appropriate to have children sit on teachers' laps. (RT 10:4363-4364, 10:4365-4366, 10:4374-4375, 11:4513, 11:4523, 11:4526, 11:4544, 11:4583-4584, 11:4598-4602, 11:4618)

On January 26, 2005, Minor and Cuevas spoke to appellant in the principal's office, telling him that there was a victim who said he had touched her. Appellant said, "Isn't it an alleged victim," and Cuevas agreed. Minor said she would follow up later with appellant. Two days later, appellant was put on leave. (RT 10:4311-4315, 10:4317, 11:4613-4615, 11:4623-4624) At about 5:30 p.m. on January 27th, Minor came to appellant's home and said she wanted to speak to him; appellant said he expected this to happen, was told not to speak to her, and needed to see a lawyer. He walked outside, and Minor put him under arrest. (RT 10:4316-4318, 11:4615-4617) Appellant has a knee-length black leather jacket and a black sports coat. (RT 11:4590-4591, 11:4633, 11:4635-4637)

After his arrest, appellant told Ronald Markman that all the named victims claimed they sat on his lap: appellant meant his knees. Appellant said he was physically accessible to his students, meaning he is in the same room as they are. He denied touching the girls inappropriately, and felt the false accusations had snowballed out of the parents' need to believe their children. (RT 11:4610-4612, 11:4637-4642) Appellant believes the children were misdirected and beguiled into not telling the truth. He did not have any particular problems with his accusers, though Gabrielle's mother blamed him for Gabrielle's lack of English proficiency. Appellant thought Kesare was simply mistaken. (RT 11:4549, 11:4617-4626, 11:4628)

It was stipulated that on March 13, 2005, the Pasadena Star News published an article stating appellant had pled not guilty to seven counts of child molestation stemming from students' complaints. "Losangelestimes. com" printed an article on March 16, 2005 that stated appellant had been arrested for lewd conduct and pled not guilty. (RT 11:4646)

Rebuttal

Ronald Markman spoke to appellant on July 8 and 11, 2005; appellant said that in his experience, female students sat on his lap because boys did not spontaneously climb onto him. He has always been physically accessible to his students for supportive reasons. Appellant thought the allegations against him occurred because parents got together and compared notes. Appellant denied the charges. (RT 11:4647-4652) When Cuevas and Minor arrested appellant, appellant said he had been instructed not to speak to them. (RT 11:4653-4656)

## STATEMENT OF FACTS

### Prosecution Case

On May 31, 2001, thirteen-year-old Alex and her fifteen-year-old friend Camille told appellant they were going to skip school, and arranged to meet him at a nearby park. The three met as planned, then decided to go to appellant's friend Jon's house, walking there through the river bed. (CT 42-47; RT 605-611, 643-647, 649, 680-681, 683-684, 696-698) After they got to Jon's house, the four retired to Jon's bedroom. Appellant and Jon were lying on one bed in Jon's room while the girls laid on another. All were bored. Appellant went to the store and bought soda for Camille and two 40-ounce bottles of 211 Steel Reserve beer for Jon and himself. (CT 48; RT 611-614, 650-652, 684-686, 698, 701) Alex wanted beer, so appellant let her have some of his.[1] (CT 49; RT 614-616, 652, 686, 698-699)

Appellant got drunk. (CT 15, 50, 60) Alex felt sick; she went to the bathroom and threw up twice. (CT 55; RT 616) The boys also smoked drugs from a "bag"; according to Alex, appellant smoked a little, but it was mostly Jon. Jon offered some to Alex and Camille, but they refused. (RT 619-620, 654-655, 687, 699)

By this point, appellant and Alex were lying on one bed, and Jon and Camille on the other. (CT 51-52; RT 620-621, 653) Camille told appellant and Alex to kiss. (CT 52) They began kissing; they had kissed once before, a week or so earlier. (CT 53-54; RT 687-688) Camille and Jon also kissed; Jon touched Camille by accident on her chest and apologized, but Camille said, "it's okay." Jon videotaped Alex and appellant kissing. (RT 687-688) After awhile, Camille wanted to leave, and the foursome proceeded to appellant's house. (CT 55; RT 621-622, 688, 702) Alex was dizzy; she had trouble standing, and felt sick. Appellant and Camille had to help her jump the fence around the river. (RT 622-623, 657-659, 689, 702-706, 715-716)

At appellant's house, they watched television for awhile in the living room. Appellant had another beer, Alex went to the bathroom, threw up

---

1 Alex originally got appellant's telephone number from Camille because she liked appellant. For about a month before they spent the day together, Alex called appellant every day to talk. She asked him several times to ditch school with her. Appellant told police that during one of these conversations, Alex told him that she liked to drink. (CT 49; RT 644-646, 672, 682-683, 700) Alex said she and appellant had never talked about drinking. (RT 617) While they were in Jon's room, Alex picked up appellant's beer from a table and began drinking it. (RT 652, 699)

again, returned, grabbed appellant's hands, and led him to his bedroom.[2]
He joined her on the bed and they began kissing and giving one another
hickies. Appellant gave Alex a hickey on the neck and breast; Alex gave
appellant a hickey on the neck. (CT 55-58, 67; RT 623, 625-628, 659-662,
689-690, 706-707, 709) Camille knocked on the bedroom door; appellant
answered the door, then left the room, returning with a condom.[3] (CT 60; RT
635, 663-634, 709-710) Appellant and Alex resumed kissing. (CT 60; RT 632)
Alex pulled appellant's shirt and pants off and put his hand on her shorts to
unbutton them. (CT 62-63; RT 632-633, 663) Appellant was "hung over," so
drunk that the room was spinning and he felt out of control. (CT 61; RT 331)
They took their clothes off, and appellant put his penis in Alex's vagina.[4] He
had an erection. (CT 63-64, 70; RT 631, 636-637, 664, 667) Appellant told
police he did not ejaculate. (CT 72) Alex did not think appellant was still erect
after they finished; she remembered appellant throwing away the condom.
(RT 638, 665-666)

Alex and appellant got dressed and returned to the living room. (RT
638, 666, 693, 712) Alex's stomach hurt, and she threw up twice in appellant's
bathroom. Everyone watched television for a while, then went back to the
park. At the park, Alex told Camille what happened with appellant.[5] Alex was
then picked up by her uncle. (CT 70, 73; RT 624, 639, 669-671, 694, 712-713,
717-718)

That night, Alex told her mother she had ditched school. She did not
tell her mother she had sex. (RT 640-641, 667-668) Alex had never ditched
school before, and was afraid she was going to get into trouble. Alex was

---

2 Appellant told police that he suggested Alex lie down in his room. Camille testified that she
and Alex went from the bathroom to appellant's room and began reading a letter of his; appellant
caught them, and asked that they leave the room. The girls went back to the living room, then
Alex grabbed appellant and pulled him into the bedroom. (RT 707-708)

3 Camille testified that she was worried appellant and Alex were going to have sex; she threatened
to call the police, but appellant told her he wouldn't do anything to Alex, and asked for his letter
back. She returned the letter. Appellant and Alex went into the living room, stayed for a couple of
minutes, then Alex took appellant back to the bedroom. (RT 692, 710-711) Appellant told police
he got up to check on Camille, who was still watching TV. He then returned to the bedroom. (CT
60) Appellant did not remember whether he used a condom. (CT 69-70)

4 Appellant told investigators he did not put his penis inside Alex; after further questioning, he
said he "guess[ed] we had sex," but that the investigators were "forcing" him to say this. (CT
64-66, 68; RT 333-334, 338) He did not have sex with Camille. (CT 71; RT 334)

5 Camille testified that Alex did not throw up and did not tell her about appellant while they
were in the park, but rather later that evening, during a telephone conversation. (RT 693-695,
713-714)

even more afraid her mother would be even angrier if she found out Alex had sex with appellant. (RT 668, 676, 697)

The next day, Alex's principal lectured her about skipping school. (RT 669, 714) During their conversation, the principal asked Alex where she had gone; Alex said she went to Jon's house, but didn't initially tell her what happened there. After an hour's conversation, and a number of requests for further information, Alex told the principal she had sex with appellant. (RT 669-670, 674, 677) The principal spoke with Camille, then called the police. (RT 670)

Alex was examined at the hospital. (RT 671, 675) Alex's mother was angry with her after she found out about the sex, but was also concerned for Alex. (RT 677-678) Alex was punished for ditching; her family no longer trusts her as they did before. She feels that she has been punished for having sex. (RT 677-687)

Appellant thought Alex and Camille were in the eighth grade. Alex thought appellant knew how old she was; appellant told police he didn't know her exact age. (CT 50-51; RT 673) Appellant was 18 years old at the time; he was a student in the special education section of El Rancho High School. (RT 329-330) Alex didn't know how old he was. (RT 673)

Alex did not like appellant. (RT 618) She wanted to have sex with appellant. (RT 642)

Defense Case

On June 1, 2001, Alex was examined for sexual abuse at the Women's and Children's Hospital. (RT 908-909) During her interview, Alex told the nurse that she had done "some kissing" with appellant and had consensual "vaginal/penile penetration." (RT 910, 919-921, 925, d930-931) Alex's physical examination indicated that her hymen was intact, and that there was bruising around the perihymenal area and labia majora, or outer vaginal lips. (RT 912-914, 918, 925-927, 929, 931) There was no bruising or tearing in the hymen, the posterior fourchette (the area leading to the hymen), the fossa naviculars (the base of the hymen), the labia minora. Alex did not complain of soreness. (RT 913-914) The injuries were consistent with the history Alex gave in her interview. (RT 918, 927, 929-930)

Alex was completely developed, or physically matured. (RT 928-929)

## STATEMENT OF FACTS

### Prosecution Case
### Miranda: counts 1 through 31

February 8, 1991 was Miranda's twenty-third birthday. That night, she and a group of friends, including Arianna, went to the Sushi Café in West Hollywood. The plan was to leave the restaurant around 10:00 p.m., and go to Carlos and Charley's, a nearby nightclub. Miranda had driven her boyfriend, and two other people to the restaurant. Arianna had to park a couple of blocks away. When they left the restaurant, Miranda decided to walk Arianna to her car. Miranda's boyfriend and another person were to follow in Miranda's car, pick up Miranda, and then go to the club. By the time Miranda and Arianna reached Arianna's car, Miranda's car was no longer in sight, and they decided to drive back to the restaurant. Both Miranda and Arianna were intoxicated. Miranda did not see anyone doing drugs at the restaurant, and did not do any herself. (RT 2:702-713, 3:1244-1249, 3:1252, 3:1258-1259, 3:1524, 3:1533-1537)

After a couple of blocks, Miranda pulled over so Arianna could get out of the car and vomit. Appellant and another man came up to the women; the other man had a gun. Miranda screamed, the men said something in Spanish, which Arianna said meant they wanted the women to get back into the car. They did, and the men directed the women to an apartment building parking lot in an unfamiliar part of the city. The underground lot was gated, and opened via a remote. (RT 3:1249-1256, 3:1264-1265, 3:1537, 3:1552)

Arianna and Miranda were taken to a third-floor apartment and led to a couch. Two other men, "really hardcore gang members," were either there, or arrived shortly after.[1] One of the other men was G.B.H., the other (Suspect 4) died before trial. The four men joked and chatted. The women sat on the couch for fifteen to twenty-five minutes, until two women and another man arrived. Miranda ran towards the door; the man with the gun (Suspect 1) grabbed her and took her into one of the bedrooms, and appellant brought Arianna to that bedroom as well. (RT 3:1265, 3:1267-1275, 3:1553-1554, 3:1556-1557, 3:1559-1565, 3:1592-1593, 3:1600, 3:1605-1606)

---

1 Miranda had difficulty remembering the sequence of events, as the trial took place fifteen and a half years after the incident. The chronological accuracy of her recall was also affected by her heightened emotional state at the time. (RT 3:1267-1268, 3:1584-1586, 3:1591, 3:1602, 3:1604)

The bedroom door was closed and locked; Miranda and Arianna were told to sit on the twin bed. Suspect 1 told the women to undress, and said they just wanted to see them naked. Appellant said they'd better do it because "this guy is crazy," and would shoot them if they didn't. Miranda was crying and screaming "no."[2] Suspect 1 pointed the gun at the women, and one of the men tried to rip Arianna's shirt off. Suspect 1 pulled the trigger, and the women heard a click. The women undressed, and their clothes were put in the closet; Miranda was led into a connecting bathroom by Suspect 1. He locked the door,[3] turned on the shower, and raped her from behind in the shower. He said something about drinking his milk, pushed Miranda's head onto his penis, and ejaculated. Miranda spit. She heard banging on the bedroom door; it was the two other men, asking to be let in. The women begged the men not to let the others in, but "they did." (RT 3:1275-1280, 3:1283, 3:1572-1574, 3:1578-1579, 3:1581-1582, 3:1595-1597, 3:1603)

Suspect 1 returned Miranda to the bathroom and raped her while sitting on the toilet; Miranda could hear Arianna screaming in the bedroom. Someone was banging on the bathroom door. Suspect 1 pushed Miranda off, bent her across the sink, opened the door, and began raping her from behind as G.B.H. came into the room. G.B.H. put his penis in Miranda's mouth; the two men then switched positions. Suspect 1 left the bathroom, returned, took Miranda from that bathroom through the bedroom, through the living room and into another bathroom. (RT 3:1280, 3:1284-1290)

Suspect 1 locked that bathroom door, put Miranda on the sink, and put his penis in her vagina. Someone was banging on the door, saying to open the door; she heard Arianna screaming. At some point, Miranda was on all fours or on her knees on the floor, and remembered orally copulating Suspect 1 as well as being vaginally penetrated by him. Five or ten minutes later, Suspect 1 opened the door and G.B.H. came in and began vaginally raping Miranda. Suspect 1 left. G.B.H. had Miranda orally copulate him; Suspect 4 came into the bathroom while G.B.H. was vaginally raping Miranda, and put his penis in Miranda's mouth. (RT 3:1290-1296, 3:1603)

Miranda's screaming irritated the men. Suspect 1 returned, raped Miranda again, and returned her to the first bathroom. Miranda saw Arianna being raped by the three other men on the bedroom's twin bed as Suspect

2 Miranda testified she screamed for help for the first four hours they were in the apartment, but nobody came, or called the police. (RT 3:1277, 3:1580-1581)

3 He no longer had the gun. (RT 3:1284)

198

1 led her to the bathroom, where he raped her on the floor. Miranda was "continuously screaming," and G.B.H. got mad. Arianna told Miranda to stop screaming or the men said they would kill them and throw them in the trash can. Miranda didn't stop; G.B.H. put the gun to her head and pulled the trigger. The gun clicked, but did not fire. (RT 3:1296-1300, 3:1202, 3:1306, 3:1566-1567)

Miranda stopped resisting. Suspect 1 continued raping her; G.B.H. put his penis in her mouth and urinated. The men were laughing. Miranda was taken into the darkened bedroom, put on the larger bed and raped and orally copulated by two of the assailants; the four men switched positions and partners every fifteen to twenty minutes for the next three and a half to four and a half hours. Miranda could not remember all the positions she was put in, just that the assault was constant. At some point, Arianna was moved to the same bed as Miranda. Once, when appellant began to anally penetrate Miranda, she told him he'd get an infection. He left, and returned with a plastic grocery bag around his penis. The other men laughed at him; he removed the bag and sodomized Arianna instead. Arianna screamed. Miranda was able to see appellant because the bedroom door was cracked open, letting in light from the kitchen.[4] (RT 3:1300-1311, 3:1321-1322, 3:1538-1541, 3:1577, 3:1598)

Miranda estimated Suspect 1 raped her thirteen to fourteen times, and she orally copulated him eleven to thirteen times. Appellant had Miranda orally copulate him a minimum of six times, and raped her at least four or five times.[5] Miranda orally copulated G.B.H. sixteen times; he raped her twelve to thirteen times. Miranda orally copulated Suspect 4 seven to eight times; he raped her six or seven times. Appellant was the last person who raped Miranda; G.B.H. was the last person she orally copulated. (RT 3:1322-1326, 3:1557)

The two women were in the apartment for about seven hours. G.B.H. and Suspect 4 left the apartment first; appellant and Suspect 1 continued assaulting the women for another fifteen to twenty minutes. Appellant then

---

4 On redirect, Miranda testified she had no difficulty seeing the men throughout, though sometimes it would be dark; the men talked and laughed between themselves, she had a little bit of difficulty distinguishing voices. Suspects 1 and 2 were similar in shape as were Suspects 3 and 4. (RT 3:1598-1600, 3:1607-1609)

5 At the preliminary hearing, Miranda testified appellant vaginally raped her "maybe two times," and orally penetrated her twice. At trial, she said those numbers were not accurate, and that all numbers were minimums. (RT 3:1558-1559, 3:1591)

got up, and threw Miranda's clothes at her. Arianna was in the shower with Suspect 1. Miranda told Arianna that they were letting them go, then went into the bathroom and saw Suspect 1 raping Arianna on the shower floor. Arianna got up and dressed, and appellant, armed with a gun, escorted them out of the apartment. (RT 3:1325-1329, 3:1554)

He led them into the parking structure, and began looking in various cars for a remote. Arianna's car was still in the garage. Miranda just started walking, and she and Arianna went out via a pedestrian gate. They saw a car parked illegally on the sidewalk, and a traffic enforcement officer came up and asked if that was their car. Miranda said no, but they needed help; appellant was gone. Miranda said they'd been kidnapped and raped, and asked the officer to take them to the police. The officer said that would be against regulations, but had them walk beside his car as he drove to a nearby pay phone, where Miranda called the emergency number.[6] She explained what happened, and before she could hang up, seven or eight patrol cars were at the pay phone. (RT 3:1329-1333, 3:1337-1339, 3:1542-1549, 3:1587-1590)

The officers had the women go upstairs and identify the apartment; they did, also identifying appellant and another suspect from Polaroids found in the apartment: Miranda screamed when she saw appellant's picture. None of the assailants were in the apartment, but the two women and the man who'd been present were still there. (RT 3:1334-1336, 3:1339-1341) Miranda and Arianna were then taken to the hospital for examination; Miranda did not have a clear recollection of events at the hospital. (RT 3:1341-1344, 3:1532, 3:1555)

Miranda described her assailants to police, specifically identifying several tattoos: "G.B.H." in 3" block letters across G.B.H.'s stomach; G.B.H.'s chest tattoo of a girl wearing a sombrero; a tattoo on the back of someone's neck, perhaps a chain; a set of boxing gloves and a small "Leeward" tattoo on Suspect 4; and "Maria" in cursive. (RT 3:1344-1346, 3:1511-1517) Miranda identified Suspect 4 and G.B.H. in February 28, 1991 photo lineups, and testified at G.B.H.'s trial. (RT 3:1507-1510) She remembered some of the men were drinking beer; she did not see anyone using drugs. (RT 3:1524-1525, 3:1593-1594)

---

6 On February 9, 1991, Los Angeles parking enforcement officer Ernest Dunton was approached by two women who wanted to get into his car. The women said they=d been raped, that a weapon was involved, and then looked behind them. No one was there. Dunton is not allowed to let people into his car; he escorted them to a nearby phone, then flagged down a passing patrol unit. (RT 2:682-700)

After the attack, Miranda did not leave her home for six months, except for counseling or to meet police, and did not go to a restaurant for a year. She worries about her eighteen-year-old daughter; she does not trust anyone, and has never married. Whenever she has to participate in a prosecution, she either cannot sleep, or has nightmares. She no longer celebrates her birthday. (RT 3:1519-1524)

Arianna: counts 32 through 101

Arianna arrived at Miranda's party around 7:30 p.m., parking two blocks from the restaurant. After a couple of hours, the party was going to move to Carlos and Charley's, so she and Miranda went to move Arianna's car. Miranda was going to drive because Arianna was "really drunk." As they drove, Arianna began to get sick, and asked Miranda to pull over. Miranda did, Arianna got out of the car, threw up, and two men came up; one (Suspect 1) had a gun, and told the women to get back into the car. The man spoke Spanish, Arianna's native language. The other man (Suspect 2) said the man with the gun was really unpredictable and they should do as he said. (RT 3:1612-1620, 4:2106, 4:2117)

Suspect 1 directed Miranda; Arianna sat in the front passenger seat and translated. They drove east, to an apartment building with an underground gated garage. They drove in, parked, and were taken to a third-floor apartment via an outside stairway. (RT 3:1621-1626, 4:2107, 4:2120-2121) The men told them to sit on the sofa; two other men (Suspects 3 and 4), who looked like gang members, entered,[7] and the four men started whispering among themselves. At some point, Miranda tried to run to the door; Suspect 1 told her to stop, and pushed her back on the sofa. Miranda started hyperventilating; Arianna said they needed to take her to the hospital, but no one responded. Three other people then arrived, two women and a man. Arianna tried to talk to the women, but the suspects stood in a row between them so she couldn't speak. The other women and man went into another room. (RT 3:1626-1636, 4:2132, 4:2145-2147)

Suspects 1 and 2 told Miranda and Arianna to go to the bedroom; Suspect 1 was waving the gun, and appellant was telling them to do as Suspect 1 said, because "he will use the gun." Inside the bedroom, they closed the door and told the women to undress. Miranda cried, said she had

---

7 Arianna subsequently learned that appellant was Suspect 2, Suspect 3 was R.C.J., and Suspect 4, X.M; Suspect 1 remained unidentified. During the assault, Suspect 3 was referred to as "Psycho," Suspect 4 "Tripper"; someone was called "Nardo." (RT 4:1813-1818, 4:1872, 4:2120-2121, 4:2203)

a daughter and wanted to go home. Arianna said please don't do this and to let them go. Appellant said all they wanted was to see them naked and they wouldn't touch them. The women kept saying no; Suspect 1 pulled at the top of his gun, which clicked, pointed the gun at them, and said he would shoot if they didn't do as they were told. In her interview with the prosecution and police, Arianna said Suspect 1 told appellant that he'd kill appellant if appellant didn't "do her."[8] Appellant repeated the women should do as they were told, Suspect 1 pulled on Arianna's top, and Miranda and Arianna undressed. The men removed the women's clothes, Suspect 1 said he was going to take Miranda, and appellant should take Arianna. (RT 3:1638-1642, 4:2135-2138)

Suspect 1 took Miranda to the bathroom; appellant threw Arianna on the larger bed. There was a small roll-away bed off to the side. Arianna could see the bathroom from the bed, though she couldn't see Miranda the entire time. As appellant started to penetrate Arianna, she shifted position, moving towards the wall as she told him that he did not need to do this, there were three of them against the one with the gun. Appellant continued trying to penetrate her. Arianna began pounding on the wall as she shifted her hips; appellant threw his hands in the air and said she was not cooperating. There were four or five partial penetrations while she moved towards the wall, and three or four partial penetrations after she reached the wall. (RT 4:1806-1811, 4:2139, 4:2142)

Suspect 1 came out of the bathroom and put the gun to Arianna's head. He said, "If she doesn't cooperate, you shoot her," and gave the gun to appellant. Appellant held the gun to Arianna's head; she stopped resisting, and he raped her. Appellant next put Arianna on her hands and knees and vaginally penetrated her from behind: his penis would slip out of her, and he would have to reinsert it. This happened at least three times before appellant repositioned Arianna on her back. He then penetrated Arianna two or three times in this position, his penis again falling out, until he put her again on her hands and knees, and again had the same problem: three or four separate penetrations/attempts at intercourse. Arianna thought appellant's penis was too small. Appellant changed Arianna's position four to six times, with a minimum three to five penetrations each time she was in a different position. (RT 4:1811, 4:1813, 4:1818-1824, 4:2150)

---

8 On cross-examination, Arianna said she felt this was playacting. (RT 4:2137-2138)

Suspects 3 and 4 pounded on the bedroom door, and came inside. Appellant withdrew from Arianna, saying that they weren't supposed to come in yet. Miranda and Arianna asked not to let them in, and Suspect 1 came out of the bathroom, saying, "We're not done with them yet," and telling them to wait in the living room. Suspects 3 and 4 went into the living room, appellant closed the bedroom door and said he was going into the bathroom with Miranda. Suspect 1 got on the bed with Arianna, had her masturbate him, orally copulate him, and then he vaginally penetrated her. He would alternate between these three actions until appellant left the bathroom and opened the door for Suspects 3 and 4. Suspect 1 seemed disappointed. (RT 4:1824-1825, 4:2142-2143, 4:2147-2149, 4:2166)

Suspect 3 and 4 went to the bed and fondled Arianna, putting their fingers in her vagina and touching her breasts while laughing and chatting as she pleaded with them to stop. Arianna was digitally penetrated three to five times. Suspect 3 went to the bathroom, telling Suspect 4 that he was going to have Miranda to himself; Suspect 1 returned to Arianna's bed, where Suspect 4 joined him. Suspect 4 fondled Arianna for a moment, stopped, said, "Oh, what the hell," undressed and had Arianna orally copulate him while he fondled her. Suspect 1 and 4 switched places periodically so Arianna was always being orally penetrated by one while the other was vaginally penetrating her. The two changed positions at least five times, and there were at least five acts of oral and five acts of vaginal penetration per suspect during this time.[9] (RT 4:1825-1826, 4:1830)

Appellant came to the bed and raped Arianna; either Suspect 1 or 4 was standing by the bed. Miranda was screaming in the bathroom. Suspect 3, standing by the wall, said Miranda had to shut up; appellant gave the gun to Suspect 3, who pointed it at Miranda, who dropped to her knees, Suspect 3 put the gun to Miranda's head and pulled the trigger. There was no shot, and the men laughed and called Suspect 3 "Psycho." Suspect 3 told Miranda that it was her lucky day: there were two bullets in the gun. (RT 4:1835 1839, 4.2143-2145)

At some point, someone was trying to anally penetrate Miranda; she said she had something bad and they would catch it. Appellant said he

---

9 Arianna could not relate a specific sequence of events after this: she could not say what happened or how many times. (RT 4:1834, 4:1841, 4:2126-2127)

had used a condom, and told Suspect 4 to just wash it.[10] Arianna didn't feel a condom, and didn't see anyone wash anything. Appellant said if Suspect 4 didn't want to use the condom, he should get a trash bag or bread bag from the kitchen. Suspect 4 left, returning with a bag. Appellant was trying to anally penetrate Arianna; she was crying and in pain.[11] Suspect 4 told appellant that if he wasn't going to do it right, don't do it. Appellant then vaginally penetrated Arianna. Appellant partially anally penetrated Arianna at least three times. (RT 4:1842-1847, 4:2111-2112)

At another juncture, Arianna was on the small bed with appellant and Suspect 4 when she heard Miranda screaming because Suspect 3 urinated in her mouth. The others were laughing. Arianna started making comments, asking one man if his "Madre" tattoo was the name of his last rape victim, asking another if "Maria" was another victim, and if this was the only way they could get women. Suspects 3 and 4 said they wouldn't do this to their mother, but that they did it all the time, she'd be surprised how many women are found in the trash can, and they were going to shoot the women so they would end up in the trash can. (RT 4:1847-1849, 4:2111)

Suspects 3 and 4 took Arianna to the master bathroom; Suspect 3 said he was going to have his way with her, and Suspect 4 left. Suspect 3 turned out the light, and made Arianna get on her knees and orally copulate him. She felt bumps on his penis and turned on the light, saying he was sick with something. He became upset, turned off the light, and told her to just suck it, and said he was going to ask her if she was enjoying herself and she was going to say she was.[12] He reinserted his penis in her mouth and said, "Are you enjoying this, bitch?" She said no, and he punched the left side of her face, repeating the directive. (RT 4:1849-1853, 4:2110, 4:2206)

Suspect 4 re-entered the bathroom and took Arianna to the small bed; Miranda was on the big bed with one or two men. Periodically, one woman asked the other if she was okay. At some point, Miranda was on top of one of the men; when Arianna asked if she was okay, she noticed

---

10 Former patrol officer McKeown testified Miranda said one of the suspect used a condom and washed it out. (RT 4:2200)

11 Arianna told the patrol officer that Suspect 1 anally penetrated her. (RT 4:2200)

12 Arianna testified there was another occasion when one of the men put his penis in her mouth and it tasted sour or citric; after the garbage bag/condom discussion, someone said something about putting lemon on their penis. When appellant was trying to anally penetrate Arianna, she complained of burning, and a comment was made that it was probably because of the lemon. (RT 4:2110-2112)

Miranda was staring straight at the wall like a "zombie." Miranda didn't answer Arianna after that. (RT 4:1853-1855) Arianna thought a TV was on, and someone opened the bathroom door to let some light in the room. (RT 4:1855, 4:2127-2128)

The men kept rotating the women; Arianna estimated she was penetrated by each suspect ten to twenty times: at least ten oral copulations, at least ten vaginal penetrations, except Suspect 3, who would lose his erection. Arianna thought he penetrated her vaginally five times, ten times orally. Suspect 4 vaginally penetrated Arianna five to ten times. At some point, Suspect 3 had a long knife in the bathroom; he bent Arianna over the toilet, touched the knife to her throat,[13] and tried to anally penetrate her. She screamed in pain, and asked him to stop. At another point, appellant put Arianna at the foot of the bed on her hands and knees and vaginally penetrated her five to ten times, then moved her to her back and penetrated her again, moving her legs to the side, and four additional times with her legs extended up to her chest. Arianna told appellant earlier she was a virgin; during this episode, appellant said she was not a virgin because she was taking it very well. Arianna did not know which suspect was in which part of her for the next several hours until it began to get light. (RT 4:1856-1871, 4:1873, 4:2113-2114, 4:2122, 4:2128, 4:2130-2131, 4:2166)

Suspect 1 took Arianna to the shower and told her to wash up while Suspects 3 and 4 were in the bedroom with Miranda. Suspect 1 washed Arianna's vagina, and had her masturbate and orally copulate him at least three times as he did so. He also partially penetrated her vagina at least three times, but was having trouble maintaining his erection. Miranda came into the bathroom and told Arianna that they were letting them go, and that Suspects 3 and 4 had left.[14] As Arianna got up, Suspect 1 asked her to keep "doing this." Arianna refused, and left. Miranda took their clothes from appellant, handed Arianna her clothes, they dressed, appellant dressed, and went to the garage. Appellant had the gun tucked in the back of his pants. (RT 4:1873-1877, 4:2151-2152)

Appellant told the women to get into Arianna's car while he got a remote. They got in the car, then decided to get out and walk. Appellant

---

13 The knife, recovered by police, had a 33" blade and a 4" handle. At the preliminary hearing, Arianna testified Suspect 4 had the knife. She told the patrol officer it was appellant. She also thought there may have been two guns. (RT 4:1867, 4:2128-2132, 4:2165, 4:2200)

14 On cross-examination, Arianna said Suspect 3 came in wearing a shirt, and said, "This is not over. I will be back, and I am going to get you." (RT 4:2151)

returned, and they all walked through a pedestrian exit to the front of the building. Appellant told them to wait in the stairway as he stood behind them; he left for a few seconds, and returned saying that they were getting a remote. Whenever a car drove past, appellant would step back and reach towards the gun. Outside, a car was illegally parked on the lawn. A parking enforcement car pulled up, the officer asked if that was their car; Miranda said no, then told the officer that they needed help. The women turned around, discovered appellant was gone, and approached the officer, telling him to get the police and take them out of there. The officer couldn't take them in his car, but offered to drive next to them to a telephone booth, and waited with them until the police arrived. (RT 4:1878-1881, 4:2107-2110, 4:2153-2159)

Miranda did most of the talking to the police because Arianna was "in a really bad place" at the time.[15] They walked back to the building, because the officers needed the women to go into the apartment. Arianna couldn't at first, so Miranda did. After being reassured of her safety, Arianna also went upstairs and showed the officers where the attack took place. None of the suspects were present, but Arianna saw appellant's picture on a dining table. Arianna was confused, and vomited.[16] They were transported to the hospital and interviewed and examined. Arianna was not very cooperative at the hospital because she just wanted to go home. (RT 4:1882-1887, 4:1891, 4:2103-2105, 4:2161-2165)

At some point, Arianna described some of the suspects' tattoos to police and hospital staff: an unfinished chain on the neck; one that read "Maria," one "Madre," and one "G.B.H."; one of a "Q" with a curly tail; a kneeling woman with one exposed breast; and little boxing gloves and a street name. Arianna identified photographs of the tattoos/suspects: Suspect 4 had the boxing gloves; Suspect 3 had the kneeling woman, the street name "Leeward" and Madre tattoos. (RT 4:1887-1891)

Arianna "became a different person" after the attack. She went to counseling, sought medical treatment, and became isolated from friends and family. She could not be alone, but the only person she could be with

---

15 On cross-examination, Arianna testified that she did not recall exactly what she told police or hospital staff in terms of who did what to her how often; she remembered only appellant and Suspect 3 attempted to anally penetrate her, and all suspects vaginally penetrated her. (RT 4:2122-2126)

16 Arianna did not recall ingesting drugs or alcohol after being kidnapped, and did not use drugs before her kidnapping. (RT 4:2105)

was Miranda. She hated "her own people" and could not be around people speaking Spanish. (RT 4:1891-1894, 4:2161)

The physical evidence

At the time of trial, Anita McKeown was a LAPD lieutenant; at the time of the offense, she was the patrol officer responding to the radio call. She and her partner were flagged down by the parking control officer. She saw two young woman, shaking, sweaty, emotionally distraught: they kept trying to hide, and said they were scared because there was a gun. It was difficult to get the women's statement because they were in shock: they continually screamed from physical pain, were emotionally scattered, and Arianna vomited on McKeown's shoe. Eventually, the officers got the Leeward Street address, and some physical descriptions of the suspects. The officers locked down the perimeter, and McKeown drove the women to the hospital. (RT 4:2181-2199, 4:2204-2209)

Richard Wall was the morning watch field supervisor at Rampart Division on February 9th; responding to a patrol unit call, he went with the women to Apartment 303.[17] Two women and a man were in the apartment; Miranda identified them as being present during the assault; they were arrested for aiding and abetting and taken to the station. A knife was found in the bathroom medicine cabinet, and about $2500 recovered from the floor.[18] A number of signed documents were found. One of the women pointed to a photo in an album and identified the person as one of the attackers. (RT 2:633-643, 2:644-651, 2:654-664, 2:665-681, 2:914-916)

A search was done of various databases for the various aliases, resulting in the discovery of an "Donato," who lived within a block of the crime scene, booking photo and prints of this person were obtained, and subsequent search indicated the person also went by another alias, which led to issuance of appellant's arrest warrant. "Wanted" fliers were made, a teletype sent to other law enforcement agencies, and appellant's fingerprints sent to the F.B.I. national database. (RT 2:917-925)

Miranda told the doctor who performed her sexual assault examination that she had been assaulted from 11:00 p.m. February 8th until 6:30 a.m. February 9th: she was abducted and assaulted by four Hispanic men, each of whom vaginally penetrated her, both digitally and with their

---

17 According to Wall, Arianna was extremely distraught and difficult to talk to; Miranda provided all the information about the assault. (RT 2:639-640)

18 No gun was found. (RT 5:2497-2498, 5:2502)

penises. There was no anal penetration; all four had her orally copulate and masturbate them. Miranda said two of the suspects used a condom, and reported fondling, licking, kissing by all four on her vaginal area, ears, and neck. She had two bite marks or "hickies" on her neck. Miranda said a gun was put to her head, and the trigger pulled, but there was no bullet in the gun, and they threatened to kill her if she screamed or ran. Though the examination took place fifteen years before trial, the doctor recalled Miranda's account of the third suspect urinating in her mouth, and that both Miranda and Arianna were quite upset. (RT 5:2703-2705, 5:2708-2722, 5:2766-2769) Miranda's pelvic examination disclosed pain in the cervix and the right side of her vaginal area; there was white fluid in the vaginal area. Her abdomen was tender, probably from trauma. There were no bruises. The examination was consistent with the history provided. Swabs were taken, and samples taken from aspirate washings. (RT 5:2722-2726, 5:2728-2735, 5:2760-2761, 5:2778-2779)

Arianna was in severe distress at the time of her examination; she reported having been sexually assaulted by four Hispanic males, one of whom had an abnormality or rash on his penis. Three of the four vaginally penetrated her with their penis, one penetrated her rectum, all four had her orally copulate and masturbate them. One used a condom and lubricant; three of the four fondled her. She was threatened with a gun, and one suspect grabbed her jaw: the jaw was painful and swollen, consistent with trauma. One suspect attempted to choke her, two threatened to kill her. After the assault and before the exam, Arianna urinated, wiped her genital area, showered, and gargled. (RT 5:2736-2745, 5:2750-2752, 5:2754-2756, 5:2758, 5:2765, 5:2773-2773) Arianna's physical examination indicated the vaginal and rectal areas were tender to palpitation, but normal in appearance. There were no bruises. Samples were taken. The examination was consistent with the history given. (RT 5:2745-2747, 5:2760-2762, 6:2764, 5:2767-2768, 5:2778-2779)

A Hollywood Division officer was called to medical facility to collect clothes and the rape kit; her partner was a Spanish speaker. (RT 2:716-722) Booking photographs from appellant's December 12, 1990 arrest were verified; a fingerprint expert determined appellant matched fingerprints taken on four different arrest dates, under three different names. (RT 4:2170-2179)

Collin Yamauchi is an LAPD criminalist specializing in serology and DNA typing; at the time of trial, he had worked in the LAPD laboratory for

16 years. The lab is certified, and has established procedures to minimize evidence contamination and document chain of custody. In 1991, the police department used conventional serology rather than DNA technology, analyzing bodily fluids for blood typing, and forensic samples for variance in blood types. Eighty percent of the population secrete enzymes used in typing in other fluids as well; for those individuals who are non-secreters, any secreted types would be foreign. In a rape investigation, various swabs of bodily fluids are collected and preserved, as well as blood samples from the victim and her clothing. (RT 2:929-946, 3:1205-1206, 3:1216-1220, 3:1235-1241)

Sperm was found in the samples taken from Miranda's vaginal aspirate and vaginal swab, and in Arianna's vaginal swab sample. Sperm was also detected in the women's underwear; no other sperm were found. No antigen activity/blood secretion was found in either Miranda's vaginal or oral swabs. Miranda's blood type is O, she is a non-secreter. A, B, and AH" (O) antigenic activity was found in Miranda's underwear: possible donors would be blood types A, B, AB and O. A and H were found in Miranda's vaginal aspirate. Enzyme tests were performed relative to the reference samples provided: G.B.H. was a secreter, and could have contributed to the mixtures found. There would have to be another donor, type A. Arianna's vaginal swab and her underwear indicated antigenic activity, consistent with her blood type, A. G.B.H. could also have been a donor, as they share the same blood type. One-third of the population is type A, half of the population is type O, and 12 to 15% are type B. (RT 2:946-964, 3:1229-1230)

Samples in which semen was detected were sent to Genetic Design for DNA testing, including exemplars from G.B.H. and X.M. DNA consistent with G.B.H. was found in Miranda's vaginal aspirate; this DNA is found in approximately 7% of the Hispanic population. X.M. was excluded. Both G.B.H. and X.M. could be included as donors to the sample taken from Arianna's underwear. Miranda's underwear sample was not consistent with either X.M. or G.B.H. (RT 2:965-975, 3: 1203-1204, 3:1215, 3:1233) In 2003, Miranda's underwear sample and appellant's oral reference swab were sent to Cellmark for DNA typing. (RT 2:975, 3:1208-1213, 3:1220-1229, 3:1234)

In December 2002, an LAPD detective went to Nogales, Arizona, to retrieve appellant after Border Patrol matched his fingerprints to the warrant. In his intake form, appellant stated his name, his date of birth, and previous address. He listed a common-law wife in Honduras, and a brother whose

location was not specified. Appellant indicated he had no contacts in the United States. The detective had booking photo of appellant taken in 1991; after appellant saw the photo, his demeanor changed. (RT 2:903-912)

Andrew Purdy had been the supervising detective in the Hollywood sex crimes division; none of the occupants of the apartment building were cooperative in the investigation. The police submitted certain facts about the case to Channel 11's "L.A. Most Wanted" television show, and a feature news story on the Channel 2 news, both of which requested leads from the community; none were forthcoming.[19] A crime flyer was circulated with appellant's photograph, and various leads developed, resulting in appellant's identification. (RT 5:2450-5461, 5:2477-2479, 5:2496, 5:2498, 5:2503)

G.B.H. was later identified as one of the assailants, and his tattoos matched those described by the victims. At the time, G.B.H. lived a block away from appellant's apartment. X.M. was also identified, his "Leeward" and boxing gloves tattoo matched to the victims' description. X.M. was deceased; blood samples taken from his coroner's autopsy were sent for DNA analysis, as were samples from G.B.H., and sent to Genetic Design laboratory. DNA samples were taken from appellant and sent to Cellmark; samples were taken from Arianna and Miranda during the rape examination, and their nothing was collected. (RT 5:2461-2470, 4:2474, 5:2482-2485, 4:2489-2492)

Purdy participated in Det. Lambkin's interview of Miranda and Arianna, and was present during their district attorney interview. The interview was stopped because they became very emotional, just as they were in previous court proceedings, and at appellant's trial. (RT 5:2473-2473, 4:2496) It is six to seven miles from Café Sushi to the Leeward apartment. (RT 5:2471-2472)

The DNA evidence

In 1990, Charlotte Word was a laboratory director at Cellmark Diagnostics, a private DNA testing company; at the time of trial, she had between fifteen and twenty published articles on DNA identification testing, had lectured on the topic, and had been court-qualified as a DNA expert approximately 200 times. Cellmark has been certified by the American

Society of Crime Laboratory Directors/Laboratory Accreditation Board since 1994. (RT 5:2403-2411)

Word explained DNA is genetic material, equally inherited from one's mother and father, and certain portions which differ between individuals can be identified, and once identified, a sample may be compared with an unknown sample. If the known individual's genetic types are not present in the unknown sample, that individual is excluded as a source of the unknown sample. Certain loci which differ between individuals can be tested via a PCR, or polymerase chain reaction, process which copies DNA portions, amplifies the amount of DNA, and analyzes the genotype. The regions being sought are STR, or short tandem repeat regions. The numerical attributions given STRs refer to the number of copies that individual has, such as 10, 15: 10 from one parent, 15 from another. If a person differed in genetic makeup at a loci that was not tested, that person would be excluded, which is why test results only refer to possible inclusion. (RT 5:2411-2419, 5:2446-2448)

In March 2003, Word received a reference sample taken from appellant, a reference sample from Miranda, and a panty cutting; the samples were assigned to one of the Cellmark analysts under Word., who performed the typing procedure using two kits, the Profiler Plus and the CoFiler. It is not uncommon to only type one unknown sample. The panty sample contained sperm; another process was performed to extract sperm from non-sperm DNA. While ideally male and female DNA would be completely separated, frequently the separation process results in a mixed source sample. Word reviewed the analysis, and sent the report to LAPD. (RT 5:2419-2425, 5:2436, 5:2439, 5:2442-2449)

At least three individuals contributed to the non-sperm portion of the panty sample; one of the profiles was consistent with a woman contributor, and at least one of the donors was male. The results of the analysis were consistent with appellant and Miranda being two major sources, and a third individual being a minor source. The sperm fraction was consistent with two major male donors, appellant being the primary donor, and possibly a third minor donor, perhaps Miranda. A statistical calculation was made using a population database to determine the likelihood that someone would have the same genetic profile as appellant: 1 in 290 quadrillion in the African-American population, 1 in 84 quadrillion in the Caucasian population, and 1 in 33 quadrillion in the Hispanic population. (RT 5:2425-2438)

Defense Case

Earl Fuller is a board-certified gynecologist; he examined the sexual assault examination reports prepared for Miranda and Arianna. Responding to a hypothetical, Dr. Fuller stated that if two women were repeatedly raped by four men over the course of five hours, he would expect to find trauma in their vaginal areas. It would be "almost unheard of" to undergo blunt force trauma, which all intercourse is, for five hours from four different people, and not have some form of trauma, even minor trauma. Factors which would exacerbate the level of trauma would include not having had children, fear, as adrenalin causes blood vessels to contract, and prior intercourse: subsequent rapes would inflict less trauma than initial rapes. If someone had never had anal intercourse and was nonconsually sodomized, Dr. Fuller would expect to see trauma, including tearing or abrasions. Even if someone had consensual sex over the same period of time, Dr. Fuller would expect to see redness, probably swelling or tenderness. None of this was present in these examinations. Dr. Fuller is aware of studies indicating that 70% of cases involving penetration of children result in no medical injuries, but does not believe them. Dr. Fuller is primarily employed by the defense, though he believes the defendant guilty in one-third of his consultations. (RT 5:2786-2790, 5:2803-2804, 5:2812, 5:2818, 5:2826-2828, 5:2833, 5:2835)

Richard Wunderlich is a forensic courier, picking up evidentiary samples from various agencies and transporting them to laboratories. Biological evidence is always sealed and refrigerated; in this case, he picked up samples from the LAPD, six sealed envelopes which were released according to standard procedure, as well as a seventh item that was not listed. Wunderlich took the items back to his office, put them in the freezer, then hand carried them to Technical Associates. On a later date, Wunderlich was asked to retrieve the samples, which he did, returning them to the investigating officer. (RT 5:2849-2850, 5:2854-2862)

Det. Lambkin took notes during the initial prosecution interviews with Arianna and Miranda. During the interview, Arianna said all four suspects stood between them and the two women who came into the apartment, and one of the suspects told the women to go to bed. Arianna told the suspects she had to go to the bathroom, they got up, and tried to go to the door; appellant grabbed Miranda. Suspect 3 was "Psycho," Suspect 4 "Tripper." Miranda said Suspect 1 put the gun down as he was assaulting her. She thought he put in a closet. Miranda said she could see Arianna

being assaulted in the bedroom at the same time. Miranda and Arianna had difficulty putting the events into sequence; the interviews were not lengthy because the interviewers did not want to subject the two to further emotional stress. (RT 5:2863-2877)

Toxicologist Dr. Lee Blum of National Medical Services, a multi-accredited laboratory, explained cocaine and metabolite cocaine (metabolized cocaine) are commonly detected in biological samples via immuno-assay and gas chromatography mass spectronomy (GCMS). The GCMS separates mixture components depending on the molecular characteristics of the drug tested for; in an immuno assay, the analyst looks for a change in color, indicating the presence of absorbents at a certain wavelength, which indicates the presence of a certain amount of cocaine. Dr. Blum tested the evidence[20] and reference samples in this case, finding a cocaine metabolite in (#13) vaginal swab; cocaine and a cocaine metabolite were found in Miranda's vaginal swab, and Arianna's oral swab.[21] No cocaine was found in the reference samples. One of the cocaine metabolites found in Arianna's oral sample is a byproduct of cocaine ingested with alcohol. The GCMS tests were sensitized because of the age and small size of the samples; the immuno assay tests were negative based upon the sample amount. A study has found that 80% of currency has trace amounts of cocaine, and that cocaine can be easily transferred hand-to-hand. Dr. Blum was unaware of any specific studies on the detection of cocaine in vaginal fluid, though cocaine is found in many other body tissues and fluids. (RT 6:3326-3398)

According to forensic toxicologist Dr. Raymond Kelly,[22] cocaine cannot normally be absorbed through the skin in significant quantities so as to constitute a useable dose. Snorting cocaine allows absorption through the mucous membrane of the nose; the vagina is a similar area, as is the mouth. Cocaine can be detected in very old dried samples, such as its presence in the hair of a 4,000 year old Incan mummy. Cocaine is primarily

---

20 Mark Taylor, president and laboratory director of Technical Associates, received the evidence and reference samples from Wunderlich, and sent them to Dr. Blum on December 29, 2003; they were returned to Taylor on April 22, 2004, then returned to the LAPD. The DNA testing that Technical Associates did on appellant's reference sample was consistent with Cellmark=s results. (RT 6:3456-3463)

21 Cocaine and cocaine metabolites were also found in vaginal sample "number 20" and rectal sample "number 22," and cocaine in vaginal sample "number 13." Counsel has been unable to identify which sample is Arianna's and which is Miranda's. (See e.g., RT 5:2469, 5:2733-2734)

22 Dr. Kelly formerly worked for one of National Medical Services= laboratories, though not the same laboratory as Dr. Blum. (RT 6:3434)

excreted through the urine and feces; it can also be eliminated in skin oil and perspiration, and has been detected in semen. It is not possible to produce a cocaine metabolite without cocaine being present in the body. Testing oral fluid is an effective approach to detecting cocaine. Blood can also be tested, and will be collected in medical facilities in tubes that include biological preservatives, though cocaine degrades in blood samples over time. (RT 6:3401-3415, 6:3432-3439, 6:3447)

Cocaine degrades or dissipates in blood in about half an hour; cocaine in a blood sample stored without a preservative dissipates in a matter of weeks, and cocaine metabolite would also normally not be present in detectible amounts. Cocaine stored in a sample with a preservative is still not completely stable, and will degrade slowly. Freezing, then thawing, blood samples destroys cocaine. (RT 6:3415-3422, 6:3441-3446) Dr. Kelly reviewed the National Medical Services laboratory report; it cannot be determined whether the cocaine detected in the analysis came from the person ingesting the drug, or from the drug being introduced into the person during an assault or via some other form of transference/contamination. It would be possible to transfer cocaine from a penis to a mouth and/or vagina, either from putting cocaine directly on the penis, or from touching the penis with hands that had touched cocaine. The detection tests are non-quantitative, and it is not surprising that the passage of time degraded the samples, even the dry samples. Dr. Kelly was familiar with the currency/cocaine study, but did not know if those trace amounts were ever detected on or in people who handled a large amount of cash. (RT 6:3422-3432, 6:3439-3445)

In February 1991, Quinta was twenty-five-years-old; she was taken to appellant's apartment by Belinda and J.C, who had just moved in together. The three had been at a bar, drinking and dancing, and Quinta decided to sleep at her friend's place because she was drunk and her sister and children lived nearby. When they walked into the apartment, appellant was sitting on the sofa with a woman. The woman was laying down, her head on appellant's legs. There were beer bottles around. Quinta noticed two couples and one or two other men. She didn't know the other men, but thought they were gang members. One of the women had a "bad" eye, one smaller than the other, and light black hair down her back. Neither woman approached Quinta, and she didn't speak to them.[23] Quinta went into Belinda and J.C.'s bedroom

---

23 Mayra didn't feel comfortable with the gang members: she was wearing a mini-skirt and a lot of gold, and thought they would steal from her. She asked Jose I. to take her to her sister's, but

while Belinda had a beer with one of the other men. Quinta fell asleep[24] about an hour after arriving at the apartment, and heard no screaming while there; she was later awakened by police, arrested, questioned, jailed, and released several days later. Quinta didn't know appellant lived in the apartment: she lived there with J.C. and her sister for six or eight months, and knew appellant[25] and J.C. were friends. Quinta denied telling police that her sister knew appellant, and had his photo on the wall, or that she came to the apartment looking for Belinda, and ran to the bedroom when she saw the "cholos." (RT 7:3604-3667, 7:3670-3702)

Appellant testified that he was not arrested under his true name; in 1990 and 1992 he was convicted several times of possessing cocaine for sale, using a third name in the 1992 arrest. He has also used other false names, false addresses and fake dates of birth. (RT 6:3002-3005, 6:3114, 6:3036-3041, 6:3046-3050, 6:3058, 6:3064, 6:3068-3072, 6:3074-3075, 6:3114)

In 1991, appellant earned his living selling cocaine; he lived in the Leeward apartment with his uncle[26] and Acosto. Appellant remembered that on the evening of February 8th, Arianna and Miranda and a group of three other men got together to party; the women were looking for drugs, and the two men had come to collect appellant's weekly "rent money," money he paid them so he could sell drugs on the street.[27] Appellant had met Miranda twice before, when she'd bought drugs on the weekend: that night, Miranda and Arianna approached appellant and Suspect 1, who was also selling drugs, outside on the street at 10:00 or 11:00 p.m., looking for cocaine. Appellant thought it was one of their birthdays, and they looked as if they'd been drinking. The two were in their car; appellant had his car parked nearby. He moved his car into the parking garage, the women and Acosto followed in the women's car, then followed appellant to his apartment, where the party began. (RT 6:3005-3013, 6:3017, 6:3023, 6:3037, 6:3085-3087, 6:3104-3106)

---

he told her not to worry about it. (RT 7:3651)

24 Mayra was sleeping on the floor; Belinda and J.C. were on the bed. (RT 7:3658)

25 She couldn't remember if appellant went by Tito or Hernando. (RT 7:3607)

26 At the time of trial, appellant did not know where his uncle was. (RT 6:3050)

27 Appellant didn't know one of the men was named G.B.H. until trial; he had not seen G.B.H. until the night Miranda and Arianna came over. The other man, "Boxer," was the person appellant usually paid rent to, though he would usually be accompanied by other gang members. Rent was $50 or 2/16th of a pound of cocaine. (RT 6:3064-3066, 6:3082-3085)

Miranda and Arianna did not pay appellant for the cocaine because they were all partying. Appellant speaks some English, the conversation was in English and Spanish. After about an hour, the other two men arrived. Appellant had about $2500 in cash in the apartment, to be used to buy more drugs. Jose had recently rented one of the apartment bedrooms; he arrived with two women between 2:00 a.m. and 3:00 a.m.; the two women went into Jose I.'s bedroom to sleep, and Jose followed as the party continued. (RT 6:3015-3021, 6:3053, 6:3079-3082, 6:3106-3108)

When Jose and the women arrived, appellant was sitting on the couch with Miranda and the rest. About an hour after they left, appellant hugged Miranda and told her she was pretty, and ended up having sex with Miranda in his bedroom, leaving Arianna in the living room with the other men, still drinking and doing drugs. Afterwards, Miranda and appellant returned to the living room, rejoining Arianna and the others. Appellant noticed Arianna and another man kissing, and they all began to have sex in the living room, appellant with Miranda. Appellant did not remember whether he had sex with Arianna, though he saw the other men having sex with both women. This went on for another hour, followed by more drinking/drug use. At about 5:00 a.m., the rent men left, and Acosto and appellant stayed with Arianna and Miranda until the women decided to leave. At 5:30 or 6:00 a.m., appellant escorted them to the parking garage to get his remote for the gate, and the women went outside. Appellant next saw them talking to the parking officer; he returned to the apartment. When he saw them leave with the officer, and then saw a police car at the corner, he took his drugs and some cash and went to a friend's house. Appellant moved to San Francisco a month later. Appellant never returned home: a friend in the building said the police had searched the apartment. Appellant thought they were looking for drugs. There were no guns in the apartment. The $500 found by police could have been either appellant's or Acosto's money. (RT 6:3021-3031, 6:3033-3034, 6:3038-3039, 6:3041-3046, 6:3050-3056, 6:3075, 6:3081, 6:3091, 6:3094-3103, 6:3108-3113)

Appellant was subsequently arrested in San Francisco for selling drugs, and incarcerated under another name. After his release, he went to Oakland, then to Honduras in 1994, staying for five years. He was arrested in 2002 in Arizona by immigration officials. (RT 6:3032, 6:3039, 6:3076-3077, 6:3114-3115)

Appellant did not threaten the women with a gun, did not kidnap them, and did not force them to have sex. (RT 6:3034)

Rebuttal

On February 9, 1991, Patricia Blake was a LAPD patrol officer; she participated in the interview of Quinta, which her partner translated. Quinta told Blake that her sister lived in another apartment in appellant's building, and had appellant's photograph on her wall. Quinta knew appellant as Tito. Quinta said that on February 8th, at 11:00 p.m., she knocked on the door of appellant's apartment looking for Belinda, and saw two cholos sitting on the sofa, and a third, older, man sitting with two Hispanic women. The people seemed as though they'd been drinking. After appellant told Quinta that Belinda wasn't there, Quinta left. Quinta said she was afraid that one of the men would kill her sister. (RT 7:3706-3711, 7:3714-3718) Blake interviewed Quinta's sister, who gave the officer appellant's photo. (RT 7:3711-3712)

Andrew Purdy testified the forensic and reference samples were not refrigerated or frozen when he picked them up after the G.B.H. trial in 2003. (RT 7:3719-3721, 7:3728) Appellant's apartment was located in another part of the building than the window that appellant testified he was looking out when he saw the police car. As part of Purdy's initial search for appellant, the officer looked in various databases to see if appellant had been arrested in another jurisdiction. He did not discover the 1991 San Francisco arrest until after appellant had been released. Purdy learned that "Boxer" was "Tripper," and "Psycho" was "Porky," i.e., G.B.H. At the time of the assault, there were many areas in Hollywood to buy cocaine, much closer to Café Sushi and Carlos and Charley's than appellant's apartment. (RT 7:2372-3728)

# STATEMENT OF FACTS

## Prosecution Case

Judith is appellant's wife; they had three children together: Lidia, seven years old, Maite, six, and Tomas, four. Appellant and Judith met when Judith was almost 17;[1] they spent the first few years of their marriage living on base at Fort Irwin.[2] (RT 1507-1508, 1588, 2102-2103) On April 21, 2002, Judith was working late at the base shoppette when appellant called to tell her he would not be coming home, and to find a ride home by herself. Upset that appellant was with his girlfriend, Manda, Judith got a lift home, leaving the children with the babysitter. A male coworker stopped by later to see how she was doing; appellant returned to the house while the man was still there and subsequently beat Judith with his feet and fists. Appellant called Judith a bitch, hit, kicked, and choked her.[3] Judith cried, begging appellant to stop. As a result of the beating, Judith's face was bruised and swollen, she received hairline fractures across her nose, slight nerve damage to her eye, resulting in a flickering sensation for about seven months, black and swollen eyes, bruises on her breasts, stomach, legs, back, collarbone, feet, behind the kidney, knee and hand, and abrasions to her breasts and legs.[4] Judith

---

1 Judith was twenty-five at the time of trial. (RT 1551)

2 They also lived on base in North Carolina for nearly two years; having their first two children during that time. According to Judith, the relationship was "pretty good": she stayed home with the children and appellant was gone a lot. Judith didn't drive or have an income, but appellant gave Judith whatever money she needed, and drove her where she wanted to go. They moved from North Carolina to Barstow, where Fort Irwin is located. In Barstow, Judith was "stuck" at home with the children, as appellant would not let her walk anywhere. Six months later, they moved on base. Judith then became depressed: she was recovering from a miscarriage, taking Prozac, raising the children without a support system; appellant became physically abusive, and began seeing other women. In 1998, Judith discovered appellant had impregnated another woman; she confronted appellant, he slapped her and told her to mind her own business. At some point, Judith attempted suicide in front of appellant by taking a number of pills; appellant told her to go ahead. She vomited, ending the attempt. (RT 1892, 2103-2115, 2210-2212) Judith went to the Fort Irwin emergency room on December 26, 2000 because she was having suicidal thoughts. Appellant was again seeing another woman, and Judith was tired of the physical abuse. (RT 1589, 1892, 2112-2113) On recross, Judith testified she was president of the Family Support Group for appellant's unit at Fort Irwin, the Family Support Group was part of a base-wide Family Readiness Group. (RT 2199-2200, 2210)

3 The day before, Judith used the car without permission, and appellant "smacked," choked and pushed her. (RT 2209)

4 Judith testified on redirect she ran outside after being beaten; appellant caught her and held her until the military police removed his hands from her. She also testified she cried for help during the beating, and appellant told her to call her mother. She called the operator to get the long distance connection, and the operator put her through to the military police emergency

had immediately filed for divorce after the beating. Appellant didn't want a divorce. (RT 1508-1518, 1521, 1524, 1809-1811, 2122-2125)

Appellant went to jail as a result of the incident; Judith visited him in jail so he could see their children and so that they "might be able to have a civil relationship."[5] Appellant apologized while he was in custody, saying he wanted his family back. After appellant's release in December, while their divorce was pending, Judith continued to allow the children to visit appellant, dropping them off at his mother's house every other weekend or so.[6] (RT 1518-1520, 1526-1527, 1591, 2190, 2197-2198) Though appellant wanted to reconcile, Judith knew Manda had delivered appellant's baby during his incarceration, and that Manda was living with appellant's mother.[7] Appellant also brought Manda to their house when Judith was home. Judith and appellant fought over this, and appellant pushed and slapped Judith, telling her he would kick her ass if she didn't stay in the room or if she said anything to Manda. Once before, when Judith tried to leave the house they shared, asking for a divorce, appellant said she could only leave with what she'd come with, then made her undress to her underwear and told her to go. Judith took off her clothes and walked out the door, but appellant pulled her back inside, slapping her and calling her stupid. (RT 1522-1523, 1843) Appellant told Judith he would get custody of their children because she didn't have any means of support, whereas he had military benefits and housing. (RT 1523, 1843-1844)

Judith testified she did not report any abuse before 2002 because she didn't know what she would do if she "didn't have anything," because she was worried about her children, and because she thought people would believe appellant and not her. Judith also testified she had tried to report a few times before 2002, and thought some of the neighbors may have reported seeing appellant chase her outside. (RT 1525-1526, 1843-1844)

---

number; the military police heard appellant throw the telephone and Judith pick it up and put the battery back inside, then told her they were on their way. (RT 2128-2129)

5 On cross-examination, Judith put the number of jailhouse visits between one and ten; she went to the jail with members of appellant's family, including her children. The first time she visited, she left the children outside with a relative. (RT 1805-1806)

6 On cross-examination, Judith said she went to appellant's mother's house less than ten times between February and May, 2003. Once, she and appellant sat outside together in appellant's car, talking. (RT 1807, 1881-1883)

7 Judith also began dating someone during appellant's incarceration. (RT 1886)

In February, 2003, Judith and appellant had an argument in which Judith said she wanted appellant's mother to return the children after visits rather than appellant; appellant countered by telling Judith she would not get the children back unless she gave him half her tax refund and quit working on base. The argument continued; Judith went to the sheriff's department the next day to pick up her children, but they had not been returned by appellant. The following day, Judith saw a family law attorney. In family court, Judith and appellant agreed appellant would have visitation every other weekend, and from Thursday through Sunday on the first week of the month. A restraining order proscribed contact between appellant and Judith.[8] (RT 1527-1529, 1534, 1807) A few weeks later, appellant and Judith began speaking on the telephone, and subsequently saw one another at the Sheriff's station while exchanging the children: these contacts were initially simple and utile, gradually evolving into civil conversations and then into spending time together with the children, and child-related activities, such as going to back to school nights together.[9] The divorce was still in progress, though appellant was still against it, and when the subject came up, appellant would become angry or irritated. Appellant asked to see Judith without the children; Judith didn't recall whether she met with appellant alone or not. (RT 1534-1537, 1808, 1847, 1883) Appellant did not spend the night with Judith once she moved to Rosamond, though he once spent the night at her apartment. (RT 1846, 2124-2125)

On May 1, 2003, Judith and her mother[10] went to drop off the children at the Palmdale Sheriff's Station; after waiting twenty to twenty-five minutes for appellant, Judith called his cell phone. Manda answered, and told Judith appellant was on his way. Thinking appellant would be angry at her for calling, Judith had the sheriffs escort her, her mother, and her children into the station to await his arrival. (RT 1538-1540, 1821) Appellant came

---

8 Judith testified probation officer Jayde C. escorted appellant's mother to one of the pick up/drop offs.

9 Including a trip to the mall in which "family" Easter pictures were taken of appellant, Judith, and the children. Judith thought they'd done five to seven family events together away from the house during the 90 day period from February to May. (RT 1808-1809, 1883, 2237) Judith testified there had also been drop-offs and pick-ups at appellant's mother's house during this time. (RT 1884)

10 Judith asked her mother to accompany her because she and appellant had been fighting recently about her working at Edwards Air Force Base and dating someone. Judith thought appellant would be mad at her for calling because he'd told her the day before that he was no longer seeing Manda. (RT 1539-1540)

in, the sheriffs asked him if he needed an escort, appellant said, "We don't need a fucking escort," and made some loud remarks to the children about having an audience. Appellant, the children and Judith walked out, and Judith sent her mother back inside to get an escort; the escort came outside, and the exchange was completed. (RT 1541) At about 7:45 a.m. the next day, appellant called Judith to tell her Lidia did not have her jacket; Judith said Lidia had the jacket; appellant disagreed, said he needed the jacket, and that Judith had to meet him to drop off the jacket; Judith refused; appellant said if she didn't meet him, he would come to her house. Judith agreed to meet appellant at a McDonald's in Rosamond. (RT 1541-1542, 1826)

Appellant was already parked in the McDonald's lot when Judith arrived; he approached her car, tried the locked passenger door, then reached through the partially unrolled window, unlocked the door, put their three-year-old son in the back seat, and got in the front. Judith was yelling at appellant, asking him what he was doing, telling him to stop and get out. Appellant rummaged through the glove compartment and the center console, silently going through Judith's things, then pulled the front of Judith's shirt down to her stomach.[11] Judith hit appellant three times on the arm because he was not listening to her. Appellant got out, took their son and returned to his truck, leaving without the jacket. Judith went to work; en route, she realized her wallet was missing from the passenger seat. Her wallet contained her ID, which she needed to get on base. (RT 1543-1547, 1813-1814, 1824-1828, 1848, 1855, 1888, 2118, 2130) By the time Judith reached the base gate, she was crying; she told the guards appellant had taken her wallet, and they detained her and had her report the theft to the Sheriff's Department. An hour and a half later, appellant called Judith at work, denying he'd taken the wallet. He asked Judith what he could do to make her believe him, and she told him she just wanted the wallet and the $240.00 inside, which she needed to pay bills. Appellant told Judith he'd give her money if she needed it, he still needed the jacket, and the children wanted to see her, saying she could meet him later. (RT 1547-1549, 1825, 2521-2524, 2529-2534)

11 A few days later, Judith signed a temporary restraining order statement under penalty of perjury which said appellant pulled at the waist of her pants "to see down it." In that statement, the word "skirt" had been stricken, and Judith testified "it's possible" she had handwritten the word "pants" above the overstricken word. The TRO statement also indicated Judith was going home when she realized her wallet was missing. Judith did not recall ever telling the deputy sheriff who took her report that she saw appellant reach into her purse and take her wallet. In her family law deposition, Judith said appellant attempted to look down her shirt and pants. (RT 1813-1821, 1830-1832)

Judith agreed to meet appellant at the Lancaster Wal-Mart. Appellant was parked in the lot when she arrived;[12] she parked, went to his truck, tried to open the back door to see the children, it was locked, so she went to the front door, opened it, said hello to the children, and asked appellant for her wallet. Appellant again said he didn't have it; Judith was upset, appellant told her to relax, and get inside the car to talk. Judith got inside the truck. Appellant seemed calm and "mellow." Appellant told Judith he didn't take her wallet, and they soon began arguing, she, about the money she no longer had to pay bills, he, about the person she was dating. At some point, Judith began to cry because appellant was telling her she had to stop seeing the man and was saying "some pretty hurtful things," such as that she had no right to date because they were still married, that the person she was dating was not going to love her and didn't care about her children. (RT 1549-1553, 1822, 1855, 2723)

Appellant put the car in reverse, and drove through the lot; Judith told him to stop, asked him what he was doing, and opened the door to get out. Appellant pulled Judith in, grabbing her left breast, pushing her back against the seat, and telling her to "stop acting stupid." Judith heard one of her daughters crying, and her youngest daughter say, "Mommy, please don't leave." (RT 1553-1555, 1856-1859, 1870) Judith closed the door; she pleaded with appellant more than three times to take her back to the parking lot; she couldn't recall whether appellant answered. Trying to get appellant to return her to her car, Judith said she was hungry, that the children were hungry, that she had things to do.[13] Appellant drove to a Sizzler's parking lot, yelled at Judith to stop crying, and clean her mascara. He did not threaten Judith, or physically force her to come with them: he was "stern." They walked inside, and appellant took their son to the restroom while Judith and the girls went to the front of the restaurant and placed their order. Their youngest daughter, Maite, was "very friendly" with the woman

12 At trial, Judith testified she arrived around 2:30 p.m.; at the preliminary hearing, she said she got there about 4:15 p.m.; at the family law deposition, Judith testified she was supposed to meet appellant around 2:00 p.m.. (RT 1833-1834)

13 At the family law deposition, Judith testified she "got" appellant to go to Sizzler's; at the preliminary hearing, she testified she told appellant she was hungry, and "got to go to Sizzler." In the signed declaration in support of the TRO, Judith stated, "for some inexplicable reason [appellant] pulled into a Sizzler Restaurant." Judith also stated appellant "forced" them all into the restaurant. (RT1860-1863, 1865, 2131, 2176-2178, 2189)

taking the order; Judith was "upset and very nervous."[14] She didn't feel there was any way to reason with appellant. The cashier said something to Judith about Judith's appearance, but she did not ask the cashier for help because appellant came out of the restroom just then with their son.[15] Judith paid for the food, and appellant let the family to a booth, the children sitting on one side, appellant and Judith on another. Appellant told the children to be quiet, and they were: Judith usually helped Tomas with his food, but didn't; Maite is usually very social, but she was very quiet as well.[16] Appellant kept his arm around Judith; if Judith moved away from appellant, he leaned closer. (RT 1556-1560, 1585-1587, 1849-1851, 1863-1864, 1866-1867, 1871-1872, 2130, 2134, 2173, 2712, 2724)

Appellant told Judith he would not divorce her, and if she tried to divorce him, "there were going to be problems." Judith resumed crying, saying she still wanted the divorce, and asked appellant to take her back to the truck. He did, and as they drove, he asked her when she would see him again, and why she hadn't been seeing him. Judith got quiet, and appellant called her a bitch, saying she didn't have the balls to say anything to him in his presence. Judith called appellant an asshole, appellant raised his hand, Judith asked him if he was going to hit her, he said she hadn't pushed him that far, and that she would know when she'd pushed him that far. (RT 1560-1564, 1869) Appellant tried to grab Judith's crotch a couple of times; she pushed him away and told him not to touch her. Appellant continued driving, pulling over on a cross street as he told Judith he wanted "a piece of ass." She told him he wasn't going to get it, he said he would. Judith asked

14 Jessica took Judith's order at Sizzler: she testified Maite said her daddy tried to kill her mommy, something "involving her foot and her leg and a car... like out the window or something like that." Jessica said Maite didn't seem cheery, the older girl seemed scared, and the mother started to cry. Jessica asked Judith if everything was okay, and Judith said she didn't need anything; appellant and the little boy came out of the restroom and everyone composed themselves. Judith never said she was being kidnapped or otherwise indicate she was there against her will. Jessica testified appellant "forcefully" wiped Judith's tears while they were seated in the booth. Judith did not eat. Jessica did not call the police because she didn't think Judith was the endangered mommy. (RT 2472-2476, 2478-2481)

15 On cross, Judith testified she was afraid to tell the Sizzler's employees she was being kidnapped; she was more afraid that evening than she had been that morning, when she'd hit appellant in the McDonald's parking lot because appellant had her son, she had her daughters, appellant had a vehicle, she did not have a vehicle. She thought of telling the waitress, but did not. She did not think of running, or writing a note to the waitress, or calling 911 from the nearby telephone, or drawing attention to herself and appellant. (RT 1851-1852)

16 Judith ordered a double Malibu chicken meal for herself. She did not order any food for appellant. She paid for the food. (RT 1867-1869)

appellant what would give him the right, he said she was his wife. (RT 1564-1566, 1583, 1872)

He stopped the car and told the children to get in the back trunk space and play. They did. Appellant told Judith again he wanted a piece of ass and to take off her pants.[17] She said no, she didn't want to do that. Appellant pulled at her pants and yelled at her; she lowered her pants, afraid "things could get worse."[18] Appellant told Judith to suck his dick; she said she didn't want to, that the children were in the back. He yelled at her to suck his dick, put his hand behind her neck, and forced her head onto his exposed, erect penis. Appellant moved his hips, moving his penis into Judith's mouth. Judith choked; appellant held up her head; she moved to the passenger side, he slid to the middle, lifted her by her hips, and put her on top of him.[19] Crying, she told him to stop, he slid her underwear to one side, fondling and digitally penetrating her. She begged him to stop, but did not raise her voice because of the children.[20] Appellant penetrated her vagina with his penis, and held her with his hand against her back until he ejaculated. (RT 1567-1572, 1591, 1847, 1872-1873, 1893, 1896-1897, 1901-1902, 2492, 2718, 2721, 2727-2728)

After ejaculating, appellant released Judith. She moved to the passenger seat, spilling semen from her vagina on his pants. Appellant said, "God damn it. Look what the fuck you did," and cleaned himself with her clothing. Judith pulled up her pants; appellant told the children to get

---

17 In her TRO statement, Judith indicated appellant made the piece of ass comment after stopping and telling the children to play in the back. (RT 1873-1875)

18 In her TRO statement, Judith said appellant ordered her to take off her pants, she refused, begging him not to "do this" in front of the children, appellant "became fierce with his demand" that she remove her pants, she refused a third time, and appellant pulled at her pants, succeeding in "tearing them open, and pulling them down." At trial, Judith said this was not true. (RT 1894) Judith testified appellant had pressured her into having sex before during their marriage; on those occasions, appellant told Judith he would "get it" from someone else if he didn't "get it" from her, and Judith would then capitulate, lowering her pants. Judith testified this was different than that, noting appellant had never forced her to orally copulate him before. (RT 1888, 1890-1891, 1894, 2125-2127)

19 Judith weighed 131 pounds. (RT 1898)

20 In the TRO statement, Judith averred appellant quickly pushed her underwear to one side and jammed his penis inside her; she said she "screamed in pain." Judith testified she did not have time to do more than "scan" the statement. (RT 1591-1592, 1829) Judith testified she gave a handwritten statement to her attorney's assistant, who then prepared the typewritten TRO statement. (RT 1908-1909, 2182, 2203-2207, 2749-2758) Other inaccuracies in the statement included a notation that Judith lived with her mother. (RT 2158-2165)

back in their seats, they did,[21] and appellant drove past a jail, telling Judith to "get a good look at it," adding he already had one strike thanks to her. Judith thought appellant was trying to make her "feel guilty." Appellant took Judith to the Wal-Mart, asked when he could see her again; she said not until Sunday at 6:00 p.m. at the Sheriff's station. Appellant said that wasn't good enough, Judith said 1:00 p.m., and appellant let her leave. Judith said goodbye to the children; appellant asked for a kiss goodbye; Judith couldn't recall if she kissed him on the cheek, or if she moved away when he tried to kiss her. (RT 1572-1575, 1583-1584, 1903-1906, 2167, 2728) As Judith said goodbye to her children, she saw Lidia's jacket; appellant smirked and said, "Oh. There it is," and Judith left.[22] (RT 1576, 1578, 1903, 2174)

Judith drove to the Rent-a-Center to pay her bill;[23] S.H., a store associate who knew Judith, asked her if everything was okay. Judith told her what happened. S.H. asked Judith if she was going to the police; Judith wasn't sure, because she'd violated the restraining order by agreeing to meet appellant. S.H. told Judith she should at least go to the hospital. Another associate followed Judith to the hospital.[24] (RT 1578-1582, 1905, 2425-2427, 2729)

---

21 She also thought the children were unaware of what exactly was going on, though she heard them say "stop yelling" at some point. (RT 1585)

22 Seven-year-old Lidia testified she was "happy" when the family was driving to Sizzler. She remembered her mother crying that day, but didn't know why. She remembered her mom crying and opening the door to get out of the car and said she was "scared," and "almost started crying." Her dad yelled cuss words at her mom, but her mom didn't yell at her dad. Lidia was sad at the Sizzler because her mom was crying; her mom cried when they drove to the desert afterwards. In the desert, appellant quietly told her mom to take off her pants and told the children to get in the back of the car. After a while, they got back in their seats and left. Lidia's mom was crying. She went to her car and left. (RT 2224-2231, 2235-2240) Five-year-old Maite testified she got upset when her dad pulled her mom back in the car when she tried to escape. Maite said her mom was crying, and her dad was saying "bad things." Maite told the woman at the Sizzler about her mother's escape attempt. After Sizzler, they went to the desert; her dad told the children to get in the back and her mom and dad talked. Maite heard her dad tell her mom to take her pants off. (RT 2459-2466, 2706-2707, 2713, 2746)

23 Judith testified she never got her wallet back from appellant and he never gave her any money. She had money to pay the Rent-A-Center bill from home; she stopped on her way to Wal-Mart and got her bill money and her weekend money. (RT 1580, 1854) On redirect, she characterized this as her emergency money. (RT 2129)

24 The employees testified Judith was upset when she came to the Rent-a-Center; she was crying quietly. S.H. asked Judith if she was okay; Judith said she'd just had an "altercation" and had been raped by her "soon-to-be ex-husband." S.H. asked Judith if she wanted to call someone, but Judith said no one would believe her. S.H. got busy with work and asked the other employee to check on Judith; when h sat on the couch next to Judith, Judith darted two or three spaces away from him. Judith told the employee she had been raped by "her babies' father" in his car in the "middle of nowhere." (RT 2404, 2406-2410, 2424-2426) Judith said appellant met

Judith told the interviewing detective that she met appellant at the McDonald's parking lot; he got into her car, they got into an argument, appellant grabbed at her chest, then left. Afterwards, Judith realized her wallet was gone. She also said that later that day, she spoke to appellant, met him at the Wal-Mart, they argued about her dating, he began driving, she tried to get out of the car, he pulled her back in by her left breast and drove her to the Sizzler; appellant took their son to the bathroom, Maite talked to the cashier, Judith began crying as appellant came out of the bathroom, so Judith told the cashier everything was fine. After leaving the Sizzler, appellant drove towards Avenue H, pulled over, telling Judith, "you know what I want," when she said she didn't, he said, "a piece of ass." Judith said appellant pulled at her pants, she eventually pulled them down, appellant unzipped his pants and tried to force her head on his erect penis. After less than a minute, she pretended to choke, he allowed her to lift her head, then grabbed her by the hips and put her, facing forward, on his lap, inserting his penis in her vagina. Appellant digitally penetrated Judith before putting his penis in her vagina. After ejaculation, Judith moved from appellant's lap, semen spilled from her onto appellant's pants, he became angry and wiped the semen off his pants with a piece of cloth. As they were driving back to the Wal-Mart, appellant told Judith to take a good look at the passing jail, because he already had one strike. Judith told the detective she saw her daughter's jacket in the car as she was leaving appellant's car.[25] (RT 2496-2506) Judith was "very emotional" during the interview, as well as during an earlier interview. (RT 2507, 2707-2709, 2714)

Los Angeles County Sheriff's Department criminalists testified vaginal and external genital slides taken from Judith contained sperm; differential extraction was performed on swabs taken from those samples, and the ensuing samples then genotyped and compared to reference samples taken from Judith and appellant. The female fraction of the vaginal sample was consistent with Judith, the male fraction consistent with appellant. The random match probability in the Caucasian population would be one in 1.3 quintillion; in the Black population, one in 198 quadrillion; in the Hispanic

---

her at Wal-Mart, and drove towards Avenue H, where he raped her in the car with the children there. Judith kept telling the employee it was her fault, and was reluctant to go to the hospital. (RT 2414-2420)

25 Appellant was not examined post-arrest for neck scratches; Judith's pants were untorn. (RT 2510-2512, 2704, 2710-2711)

population, one in 132 quadrillion. (RT 2435, 2437-2440, 2447-2449, 2484-2490)

Judith testified appellant "pressured intercourse" on her "many times" during their marriage. She also testified appellant at times threatened to "kick [her] ass," and, when she said she would call the police, he told her to go ahead, that "jail would only hold him so long" and as long as she had the children, he would always know where to find her, she would be "the first place he would go...." Appellant never used a weapon on Judith, but said his training in the Infantry made his hands a weapon; in the past, appellant has hit, choked, and slapped Judith. Once, after she refused to look at him during an argument, he duct-taped two glass-framed art works to the sides of her head so she would have to look at him. (RT 1888, 2115-2116, 2133-2134) At the time of trial, Judith was still married to appellant. (RT 1823)

Defense Case

Jayde is a group supervisor with the Department of Probation; she and appellant's mother attend the same church. Jayde was aware there was a restraining order issued against appellant in 2003 proscribing contact between appellant and Judith. Jayde saw appellant and Judith together during the year after the restraining order was issued, having a "very casual, comfortable conversation." Jayde told appellant and Judith the order prohibited each of them from being on or near property where the other resided, and not to have any contact, via telephone or anything else, with the other person. Jayde explained the restraining order to Judith in front of the Palmdale sheriff's station: Judith was "very sarcastic," "hostile," "agitated, aggravated" towards Jayde. Jayde has seen appellant's children with his mother at church. Once, after appellant's daughters got into a car with appellant's mother for a scheduled visit, Judith told her daughters in front of Jayde they didn't have to see their dad if they didn't want to, and they didn't have to go with their grandmother. Jayde testified Judith was making the girls uncomfortable: the girls then acted "standoffish" to their grandmother in a way Jayde had not previously seen. (RT 2763-2768, 2770-2778)

Appellant's mother testified appellant and Judith were together "many times" after appellant's release from jail: at her house, at Wal-Mart, in appellant's car, at the sheriff's department, exchanging the children. Judith called "several times" after appellant's release, Judith gave appellant's mother her telephone number to give to appellant. When appellant was in

jail, his mother visited Judith and told her to "think about things." (RT 2781-2785)

Maha Ghraibeh is a family nurse practitioner: she examined Judith on May 2, 2003 and noted no abnormalities such as bruising on the left breast, or side/flank. There were no "mounting injuries" as might be found on someone forcibly pulled onto a perpetrator. There was no physical finding to support a theory of forced physical intercourse: this is not uncommon: the crux of forcing in this case results on the truthfulness of the victim. Ghraibeh has only had two cases involving victim injury. Judith's examination was consistent with her history. (RT 2792-2807)

# STATEMENT OF FACTS

## Prosecution Case
### Matthew: count 1

On March 25, 2004, Matthew was four years old; he was living with his mother, Bonnie, and father, MK, in a Long Beach apartment. The family had been living in the ground-floor apartment for about six months. The building had two levels: in early March 2004, appellant and his partner moved into an upper-level unit. The day appellant moved in, Matthew brought Bonnie to appellant's apartment to see if he could play bubbles or shaving cream with the other children. That night, appellant told the family that he had been a police officer in New Mexico for ten or fifteen years, was studying to become a nurse, and to call him "Tiger." Appellant said he liked children, and it was all right with him if they played at his house. After appellant left, Bonnie told MK that she didn't think this was a good idea. (RT 2:618-621, 2:624, 2:643, 2:655, 2:663-664, 2:670, 2:673, 2:721, 2:724-726, 2:752-753)

The children in the small complex liked to play at appellant's apartment; according to MK, he often found his son playing at appellant's house, rather than at a friend's home, or in the complex courtyard. MK and Bonnie told their son repeatedly that it wasn't right for little children to be playing in adults' homes. They never asked Matthew what he and his sister did at Tiger's house, though they thought appellant may have given the children candy and yogurt. Bonnie once heard appellant call to the children when they were outside and offer them ice cream. (RT 2:620, 2:625, 2:644-645, 2:656-657, 2:663, 2:722-724, 2:727, 2:750, 2:908-909) According to Matthew, appellant gave the children "lots of stuff," and he had fun at Tiger's house, playing Power Ranger, climbing on appellant's bunk bed and having a shaving cream fight. Matthew testified he was never alone with appellant. (RT 2:674-676, 2:703-705)

On March 25th, MK came home from work a little after noon; his then-five year old daughter was sitting outside, planting flowers near the complex. He did not see his son. MK went into his apartment and asked Bonnie where Matthew was, she said he was outside playing. After MK said he hadn't seen Matthew, Bonnie went out to look for him; she checked all the apartment doors, they were all closed. She returned home briefly, then went outside and started calling her son. Three to five minutes later, Matthew came out of appellant's apartment. According to Bonnie, Matthew came running

inside "like he was running for his life"; he was wearing a button-down shirt, half tucked-in.[1] Matthew's shirt had been fully tucked when Bonnie had last seen him. According to MK, Bonnie walked in the house with Matthew, telling him it wasn't right for him to play at Tiger's house. Bonnie said she just told Matthew not to play at an adult's house. (RT 2:625-630, 2:642, 2:648-653, 2:691, 2:717-721, 2:727-731, 2:738-739, 2:746-748, 2:758-759)

According to MK, Matthew went into his room and played for forty-five minutes, then wanted to go back out and play; Bonnie said no, Matthew became upset, Bonnie reiterated that it wasn't right for Matthew to go to an adult's house, and Matthew said, "But Tiger makes me feel good."[2] When asked what he meant, Matthew said, "Tiger tickles my pee-pee." Asked to explain, Matthew said, "He pulls my pants down and he bites my pee-pee." According to Bonnie, she told Matthew that if he played with adults or bigger kids, they were going to hurt him; Matthew then said Tiger had "tickled" his pee-pee. Her husband asked Matthew if he was telling the truth, Matthew said yes, Bonnie asked how Tiger tickled him, and Matthew said, "With his mouth. He bite my pee-pee." JRC said Matthew never used the word "pee-pee" before: his parents referred to his "thing."[3] His parents asked if Tiger did anything else, Matthew said no, and his parents called the police. (RT 2:630-634, 2:652-657, 2:664, 2:731-735, 3:906-907)

Appellant bit Matthew's penis two or three times while Matthew was on appellant's bunk bed. Matthew testified it hurt.[4] Matthew didn't remember if appellant said anything to him at the time. Appellant had a stuffed black and white tiger that he bit, telling Matthew the tiger was going to "get" him. Appellant touched Matthew with the tiger. Matthew couldn't remember if he was referring to appellant or to the stuffed tiger when he told his parents that "tiger" bit him. At trial, Matthew thought the stuffed tiger was what tickled and bit him on the pee-pee.[5] Matthew didn't tell his parents what happened

1 On cross-examination, Ava testified that she never told police about Matthew running, or looking scared, because they never asked her. (RT 2:743-746)

2 Ava testified Matthew never said anything about feeling good. (RT 2:734, 2:750)

3 MK lived with his family "most of the time" since his son's birth. (RT 2:660) Matthew testified he started referring to his pee-pee when he was a baby, "like ten months ago." Ava testified Matthew always called his penis his pee-pee. (RT 2:686-687, 2:750, 3:903)

4 Matthew did not recall telling the officer that appellant bit Matthew while he was sitting at the computer. (RT 2:692)

5 On re-direct, Matthew testified Tiger "the man" bit him; on re-cross, Matthew testified it was the tiger, i.e., the stuffed tiger. (RT 2:711, 2:713-714) Ava never heard about a stuffed tiger before trial. (RT 2:755, 3:902-903)

because he didn't want to get grounded. According to Matthew, he knew appellant for about a week, and went to his house once or twice with his sister. Bonnie thought Matthew had been in appellant's apartment twice, including on March 25th. (RT 2:676-680, 2:690, 2:694, 2:700-702, 2:708-712, 3:904, 3:987) The police arrived, and the family was briefly questioned, Matthew interviewed without his parents,[6] and his clothes collected for DNA sampling. Matthew said he liked going up to Tiger's house, that they played shaving cream fights, and Power Rangers; when asked if Tiger had touched his pee-pee, Matthew stood up, pulled down his pants and underwear, pointed to his penis, and said Tiger bit his pee-pee. When asked how many times, Matthew said five. Matthew was taken to the hospital for examination. When the family returned home, they saw two other police officers next door. (RT 2:635-639, 2:643, 2:662, 2:664-670, 2:688-690, 2:705-708, 2:735-738, 2:741-743, 2:751, 4:1325-1329, 4:1334-1340, 4:1353-1355, 4:1357-1360, 4:1362-1364)

Long Beach Detective James Newland interviewed MK and Matthew, and oversaw the collection of Matthew's clothes. Det. Newland interviewed appellant at the hospital; appellant said he'd lived with his partner at the complex for two weeks, had a thirteen-year-old son living in New Mexico, and had been a police officer for fifteen years in New Mexico. Det. Newland subsequently received documents from the Gallup, New Mexico, Police Department which indicated appellant was hired as a police officer in 1986 and terminated in 1989.[7] Det. Newland did not know when appellant was a reserve officer. During Det. Newland's interview of Matthew, he first ascertained Matthew knew the difference between the truth and a lie, and then that Matthew understood concepts like numbers and spatial terminology. Matthew said that after his sister left Tiger's apartment, Matthew's pants were down and Tiger bit his pee-pee, and tickled it with his tongue. He said it didn't hurt. Matthew described bunk beds, and said he

---

6 MK told the officers both his son and daughter visited appellant quite often. (RT 2:643-644) The only difference in Matthew's behavior that MK had noticed was that during the two weeks appellant lived in the complex, Matthew began telling his father that he loved him. Ava noticed no change. (RT 2:661, 2:751)

7 The patrol officers had questioned appellant at his apartment, asking him if he'd been a police officer. Appellant said he was an officer in New Mexico for fifteen years; appellant affirmed Matthew had come to his apartment that day, and that children visited his apartment all the time. He said he had locked the door to stop them from coming in. When told of the allegation against him, appellant said Matthew's a strange kid. He said he only touched the children in the complex when hugging them good-bye. (RT 4:1329-1333, 4:1340-1345, 4:1351-1352, 4:1356, 4:1364-1367)

was on the top bunk. In a subsequent interview, Matthew said Tiger licked his pee-pee. (RT 4:1214-1219, 4:1225-1229, 4:1241-1247, 4:1250-1251, 4:1254, 4:1266, 4:1281, 4:1303)

According to Bonnie, Matthew has told the truth ever since the family began to study the Bible, three or four years ago. Matthew knows to always tell the truth because that pleases God. (RT 2:733-734)

Physical Evidence

Oral swab, urine, and blood samples were taken from appellant by a forensic nurse examiner. The nurse also examined Matthew, and found nothing beyond pre-existing bruises and abrasions. Matthew told the nurse that appellant "bite me and tickled me with his tongue. Now it feels better." He said the nurse might help him with his penis, and that appellant "touched my pee-pee with his tongue." Oral external and internal swabs were taken from Matthew, as well as external penile, anal and scrotal swabs. The clothes he was wearing were collected as evidence; another set of clothes, worn the day before, was taken and examined. (RT4:1304-1323)

A senior criminalist at the Los Angeles County Crime Laboratory screened Matthew's sexual assault kit and the confiscated clothing for body fluids; the clothing was screened visually and using an alternate light source. There was an apparent urine stain on the front of one of the pairs of underwear, and a faint brown stain in the back; presumptive semen tests were negative. That underwear was mapped for the presence of amylase, an enzyme concentrated in saliva. Two areas that appeared to have the highest concentrations were then sampled, but found insignificant. An amylase diffusion was performed, and part of the front panel interior identified as having a high amylase concentration. That area would be about two inches down from the front waistband, and two inches in from the right leg hole. Two other samples were taken, one from farther down the center front panel, and another from an unstained area in the interior crotch lining. (RT 5:1504-1521, 5:1528-1532, 5:1539-1540)

A cellular sample was extracted from the three areas; that sample was tested via an amylase diffusion, and the cellular material from that test slided, stained and examined microscopically. The criminalist tested another pair of Matthew's underwear which also appeared to have a urine stain on the front. This process indicated a high level of amylase in the samples taken from the first pair of underwear, the pair labeled March 24, 2004, and weak levels in the second pair, the pair worn by Matthew to the examination. The

highest amylase concentration in the second pair of underwear was found in the front pelvic area. There was no sperm detected in any of the samples. The positive samples were sent for DNA testing. (RT 5:1519-1526, 5:1528, 5:1532-1539) Amylase was not detected on the scrotal or perineum swabs, and the test was inconclusive on the external penile swab. (RT 5:1527)

Paul Coleman is a senior criminalist at the Los Angeles County Sheriff's Crime Laboratory; he majored in biochemistry at the University of California, Berkeley, and received his Ph.D. in biochemistry from the State University of New York, Buffalo, in 1972. Dr. Coleman did post-graduate work from 1972 to 1976 at Columbia University, and worked at the University of Southern California and Children's Hospital in Los Angeles from 1976 to 1989, when he joined the Sheriff's Department. Dr. Coleman has been doing only DNA casework since the very early 1990's, after being trained in RFLP analysis at the F.B.I. Academy. (RT 5:1542-1543)

DNA is an acronym; the salient facts of DNA for forensic purposes is that individual DNA is unique, that it does not change over time, and that each person inherits half of their DNA from their father, and half from their mother. (RT 5:1545-1547) There are two types of evidentiary samples in DNA cases: "forensic unknowns," those samples for which the biological source is attempting to be identified, and reference samples, samples taken from an identified contributor. In this case, Dr. Coleman received two forensic unknown samples: one DNA extract from Matthew's underwear, and another substrate sample from the same pair of underpants which was not identified as having any biological fluid. The forensic sample had been quantitated; the laboratory does not use samples below .2 nanograms. A nanogram is one-billionth of a gram. Dr. Coleman also received reference samples from Matthew and appellant. (RT 5:1543-1545, 5:1547-1549)

Polymerase chain reaction (PCR) is a laboratory process in which commercial kits, in this case those from Applied Biosystems, are used to amplify short tandem repeats (STRs), areas of the DNA that are highly variable between individuals. The PCR kit copies and amplifies, or multiply copies, thirteen genetic regions. Commercial primers are mixed with the genetic sample and put into a thermal cycler which performs the amplification; a fourteenth gene, the gender-marker amylogenen is also amplified. The PCR process is used world-wide for human identification. In appellant's case, Dr. Coleman amplified the forensic sample to 1.5 nanograms; the substrate

sample was not amplified because there was insufficient material to produce a genotype. (RT 5:1549-1556)

The results of Dr. Coleman's amplification were compiled in a chart which compared the genetic data taken from the forensic sample — the underwear labeled March 24, 2004[8] — and the genetic data taken from the reference samples. The amylogenen indicated the samples were generated from male DNA. At each genetic point, or loci, there should be two alleles, or genes, from each contributing individual. For example, in Matthew's reference sample, the alleles found at locus vWA were 17, 17, indicating he'd received the same gene from both parents.[9] The number of alleles taken from the forensic sample indicated the presence of more than one source, as more than two alleles at any locus means a mixed source sample. In this case, there was an unequal mixture; the profile of the major contributor to the mixture matched Matthew's reference sample. The elevated level of amylase could be attributed to either saliva or urine, though higher levels are associated with saliva. Based on appellant's reference sample, appellant "could not be excluded" as the minor contributor. For example, at one locus, the forensic sample showed the presence of a 15, 16, and 17: Matthew was a 16, 17 at that site, and appellant a 15, 16. Dr. Coleman opined appellant's 16 was "masked" by Matthew's 16, and therefore, appellant could not be excluded as a contributor based on the profile at that locus. On the CSF1PO locus, only Matthew's two alleles, 11, 12, were detected; appellant is a 11, 14 at that site. Dr. Coleman stated there was a 14 allele, but it was Glenow threshold" at that site. Dr. Coleman had specifically "looked for it," and "wanted to see if it was in there." But because the threshold was so low, Dr. Coleman could not use it for recording purposes. The weakness of the 14 at that locus may have been due to the minor contributor's allele failing to amplify sufficiently to reach threshold requirements. There were no alleles found that would have excluded appellant as a source. (RT 5:1557-1566, 5:1588, 5:1604-1606)

After including appellant as a potential contributor based on a profile comparison, Dr. Coleman performed a statistical computation to determine the data's significance. The most conservative calculation is the combined probability of inclusion, which determines the random match probability: i.e., if one takes a random population of same-race individuals, the chance

8 (RT 4:1316-1317, 5:1516, 5:1531-1533)

9 The numbers simply represent the number of reiterations or copies of the STR contained within that locus. (RT 5:1562-1563)

there would be another individual that could not be genetically excluded as a potential donor. In this case, the random match in a Caucasian population would be one in 21 million; in an African-American population, one in 90.6 million, and in a Hispanic population, one in 5.4 million. Another calculation, the likelihood ratio calculation, was less conservative, as it included an assumption that the stain had two contributors and that Matthew was one of the contributors. According to Dr. Coleman, the likelihood that both Matthew and appellant contributed to the forensic sample is "100%," because it is one in 2.4 billion times more likely that appellant and Matthew composed the sample than Matthew and a random Caucasian man, one in 5.7 billion times more likely than Matthew and a random African-American man, and one in 566 million times more likely than Matthew and a random Hispanic man. (RT 5:1566-1573)

The forensic sample was independently tested by Dr. Taylor at Technical Associates. Dr. Coleman reviewed Dr. Taylor's report, but did not see the supporting data. According to Dr. Coleman, there was no significant difference of opinion between his and Dr. Taylor's findings. Because Dr. Taylor used a different commercial kit, he tested nine loci, which would result in smaller ratios. Dr. Taylor apparently detected semen in one of the samples taken from the underwear, though "very very few spermatozoa," and found no Y chromosome.[10] Dr. Taylor also found a high correspondence in that sample between Matthew's profile and an unknown contributor's profile, suggesting that the unknown contributor was related to Matthew, and most probably was Matthew's father. As demonstrated in a 1996 study, one possible explanation for this would be that laundering a semen-stained garment in a washing machine with other garments could result in transference of small amounts of semen. Fluorescence, such as used by the other criminalist, will "wash out" most semen markers. Sperm cells adhere more strongly to cotton fibers than saliva. Dr. Coleman was familiar with a paper co-authored by Dr. Taylor which argued DNA could be easily transferred upon contact so that one person could transmit the genetic material of someone they had touched to a third person. (RT 5:1550, 5:1573-1581, 5:1585-1593)

Locard's Principle maintains whenever two bodies are intimate contact, there's always the possibility of reciprocal transfer of genetic material. If there was a copious amount of fresh saliva on a stuffed animal and that portion of the stuffed animal touched a child's belly button, this

---

10 Dr. Coleman pointed out the improbability of this. (RT 5:1589)

could theoretically result in DNA transfer. (RT 5:1594-1595, 5:1598-1600) If Matthew's penis had been in appellant's mouth five hours before Matthew's examination, Dr. Coleman would expect to see amylase on the penile swab, absent washing. there was no such material. There are many variables, however, to account for this absence. (RT 5:1600-1604, 5:1607-1608)

Defense Case

Nicholas Bachert was a former Long Beach police officer who had acted as back up for the female patrol officer who interviewed the family. After Matthew was interviewed, the officers arrested appellant at his apartment and took him to the hospital for examination. (RT 6:1802-1813, 6:1815-1822)

Mark Taylor is a forensic scientist; he has a B.S. in zoology, and completed master's course work in cellular biology. He worked for the Los Angeles Coroner's Office as a criminalist, has taken F.B.I. courses in criminalistics and crime lab photography, courses in forensic medicine, classes from Serological Research Institute in body fluid identification and serology testing; he began studying DNA analysis in the mid 1980s, studying molecular biology and DNA analysis technology. Taylor is a member of the California Association of Criminalists, the American Academy of Forensic Scientists, and attends the annual international symposium on DNA testing sponsored by Promega. He has published an article in the Journal of Forensic Science on genetic amplification, and has qualified as an expert over one hundred times in federal and state courts in the United States and in other countries. (RT 6:1832-1837, 6:1853, 6:1869)

Taylor's laboratory is a private laboratory, and therefore ineligible for government certification. Taylor is certified by the American Society of Crime Laboratory Directors as a Technical Leader and Technical Manager. The laboratory tests and retests thousands of samples each year, verifying the results of other laboratories' testing, and, in turn, having their results verified by other laboratories. Technicians also take independent blind proficiency tests twice a year. One of the techniques developed by Taylor's laboratory, which increased the yield of spermatozoa from stains and swabs, has been adopted by a number of other laboratories, including the California Department of Justice Laboratory, the largest state DNA lab. Most of the work done by the laboratory is done for the defense, though Taylor does work for the prosecution as well. The prosecution is usually associated with

a particular police department or sheriff's department laboratory. (RT 6:1854-1865, 6:1868, 6:1870, 6:1874-1875)

Taylor's laboratory has performed numerous transference studies: transference in DNA simply refers to the movement of genetic material from one location to another. The more liquid the material, the easier it is to transfer. Saliva is transferrable. One study involved a male partner licking his female partner's breast; the pair then went to sleep. Twelve hours later, the woman's breast tested positive for her partner's DNA. If someone bit or licked the stuffed tiger's nose and then the tiger came in contact with another individual or object, saliva could be transferred. If saliva got near the belly button area of a child, and the child pulled up his underwear, the saliva could be moved to the underwear. If the underwear was then pulled down, the saliva could transfer to a lower portion of the underwear. (RT 6:1837-1845, 6:1865-1866) Assuming someone bit, kissed, or licked a child's penis, and the child did not subsequently wash, amylase would be expected to be found on a penile swab taken four or five hours later. The Sheriff's Department Laboratory did not test the penile shaft swab; Taylor did. (RT 6:1845-1846, 6:1871-1872)

There were low levels of amylase activity on Matthew's penile swab, which could be attributable to urine. A AY" chromosome was detected in the underpants; there were higher levels of DNA in the stained portion of the underwear, and very low levels of sperm. A differential extraction was done to separate the sperm cell DNA from other DNA. There was a higher level of X chromosome in the unstained area, indicating a mixture with female DNA; some of the female DNA carried over into the non-sperm fraction, so the resulting profile could be Matthew and a female. Male DNA that did not match any of the reference samples was also detected in a mixture taken from the stained section. However, the very low level of sperm DNA indicated a possible transfer in the wash, and could be attributable to MK. Sperm DNA is hardy: if MK and Bonnie had intercourse, and then her underwear was washed with Matthew's, that could lead to such genetic residue. (RT 6:1848-1853, 6:1875)

The videotaped interview

Defense Exhibit No. F was a videotape of the interview with Matthew; the tape was played for the jury, but the transcript was objected to by the prosecution. (CT 1:88-140; RT 6:1824-1825)[11]

---

11 Counsel will request this exhibit be transferred to the Court pursuant to California Rules of Court, rule 8.224.

Rebuttal

      Det. Newland testified the transcript of the videotape was not consistent with what he heard on the tape: specifically, that he believed some "inappropriate" things had transpired between appellant and Matthew, versus the "appropriate" things indicated in the transcript. Det. Newland affirmed he never believed the child was lying in any way. (RT 6:1826-1829)

## STATEMENT OF FACTS

Prosecution Case

On October 31, 2001, Carmen took her two youngest children to a Halloween party; after returning home, she realized she needed juice and milk for the next day. She told her husband she was going to the nearby K-Mart, leaving their Inglewood home around 9:00 p.m. (RT 40, 42-43) Carmen drove her minivan to the store, bought the milk and juice, and returned to the parking lot. She unlocked the back of the van and loaded the groceries; when she approached the driver's door, "B" grabbed her by the neck from behind and pulled her backwards. Appellant then ran up to the passenger side of the van, saying "bitch, get in." (RT 44-48)

A struggle ensued; eventually, the two dragged Carmen into the van. Carmen screamed for help as appellant took Carmen's keys, and B held her while appellant started the van. (RT 47-49, 51-52) A passerby had seen Carmen arguing with someone outside the van; the witness first thought it was a domestic dispute, and continued walking. When he saw Carmen being pulled into the van by two men, and heard her screams for help, the witness attempted to summon an armed security officer from K-Mart to intervene. Another witness who saw Carmen pulled screaming into the van ran into the store, got some paper, told store attendants to call the police, ran back outside, and wrote down the van's license plate number. Several other people came out of the store to note the plate number and color of the van as the van drove off, Carmen inside, still screaming. (RT 111-116, 118-123)

As appellant drove, Carmen asked the men to let her go. B said he didn't want to release her because she would tell, then asked for directions to "the 10," saying, "We want to go to Texas." When Carmen asked if he meant the freeway, B said yes, that they wanted to go to Arizona. (RT 52-55) Carmen gave them directions, and B held a broken bottle an inch from her neck and said they would cut her throat if she were lying. (RT 55-57)

Angry, Carmen insisted she be released; she told the men she had two children and a husband, whom she loved and wanted to see again. She suggested they drop her off at a corner, warning them that "it's going to be worse" if they didn't let her go. When the van reached the 110 Freeway, G began to get angry, accusing Carmen of lying about the directions. Carmen explained that the 110 leads to the 10, but smelled alcohol on B's breath and realized he was drunk. (RT 57-60) Meanwhile, appellant continued driving,

quiet and "stiff." (RT 60) B kept patting the left side of his chest or jacket pocket, saying he and appellant had guns. Carmen did not see any weapons other than the broken bottle. (RT 63-65)

B asked Carmen about her purse, she said it had fallen in the front of the van when she was pulled into the back. (RT 60) B asked her name; she told him. He retrieved the purse, and began thumbing through her credit cards, saying she'd be killed if she lied about her name. (RT 61, 63) Speaking in Spanish, appellant demanded something from B, who turned to Carmen and asked if she had an ATM card. Carmen does not speak Spanish, though she knows a few words, and remembered appellant said "dinero" before B asked if she had money. She told B she just had change from the five dollars she'd taken to buy the juice and milk. (RT 61-63)

After appellant left the 10 Freeway for another freeway, B told Carmen they were going to kill her and dump her body in the desert. Carmen slipped off her sandal and began hitting B in the eyes and mouth, causing his mouth to bleed. B tried to attack Carmen with the broken bottle; she wrested it from him, dropping it between the driver's window and the passenger seat as she unlocked the driver's door. She wanted to jump, but the van was going too fast.[1] The air pressure from outside pushed the door closed. Still struggling, B asked Carmen what she'd done with the bottle, she said she'd thrown it outside. (RT 65-71)

B threw Carmen face down on the van floor, put his knee or foot on her back and told her to calm down. (RT 73-75) She did, he put his hand down the back of her pants, his finger in her vagina, then into her anus. He went back and forth between vagina and anus for about five minutes, approximately ten times. Carmen asked B to let her up as he continued to tell her to calm down. (RT 75-79) When he allowed her to get up, she turned down the air conditioning, which appellant had on high. (RT 79)

Next, B told Carmen to take off her jacket. She refused, and he removed it for her. (RT 79) At some point, B had tossed Carmen's glasses in the front of the van. He also tore off her silver necklace and threw it to the floor. (RT 72-73) B lifted Carmen and pulled her to the back bench, asking her to lay the bench down. Carmen said she didn't know how; B sat on the bench, sat Carmen beside him, took down his pants and underwear, and pushed Carmen's mouth onto his penis. (RT 80-82)

---

1 Maria did not know exactly how fast; earlier, B indicated appellant was going over 100 mph., but Carmen could not see the speedometer. (RT 70)

Carmen orally copulated B for five to ten minutes. She asked him if he had AIDS, he took a condom from his pocket, put it on, and had her resume sucking his penis. Five minutes later, B began feeling Carmen's breasts, removed her shirt and bra, and started sucking her nipples and fondling her. Appellant was still driving. (RT 83-85) B made Carmen remove her pants; he sat her on his lap facing him, putting his penis in her vagina. This lasted another ten minutes, until B had Carmen turn around, and he put his penis in her anus. During this, B made "sexual sounds," such as grunting. The air conditioner was turned on, then off; the radio turned up loud and then off. Appellant was still driving. (RT 86-88, 99-100)

After about five more minutes, appellant exited the freeway and drove into an abandoned gas station. He stopped the van. The three sat quietly in the dark for a minute or so, appellant restarted the van, and drove down a road parallel to the freeway. He parked near a telephone pole and some tumbleweeds, turned off the engine, climbed over the console to the back of the van, taking his pants down as he moved. (RT 89-91)

Appellant began licking Carmen's breasts and vagina, then put his penis in her vagina; B still had his penis in Carmen's anus. After a couple of minutes, appellant removed his penis and sat down on the bench, looking sleepy. B got "smart alecky," telling Carmen that she liked "doing it" with two men. Carmen agreed: she thought if she pleased them, she would be able to escape. B asked Carmen to orally copulate both men together; Carmen turned towards the two and, as she was promising to do so, put one leg over the middle console into the front of the van. The men had their pants down, appellant dozing "in and out." (RT 92-96, 101)

Carmen jumped over the seat, unlocked the door and ran around the back of the van and down the street, wearing only her socks. (RT 101, 141-142) She went to a gas station; the cashier put her inside, gave her a pair of coveralls to wear, and called police. Carmen was hysterical, telling the attendant she'd been raped and abducted from Inglewood. (RT 102-105, 141-144) Responding to the radio call, a San Bernardino County Sheriff's Department sergeant found and followed the van on the Interstate 40, about sixty miles from the gas station into which Carmen had escaped. The van was initially traveling at 120 mph, then slowed to between 100 and 105 mph. At some point, papers and clothing were dumped from the van: a small pink and white bloodstained Mickey Mouse pillow, a white towel with a blue

stripe, a couple more towels, and a pair of women's underwear.[2] (RT 203-206, 209-213, 218)

The freeway eventually narrowed to a single lane, and the van slowed to between 55 and 60 mph. The sergeant continued following the van until it pulled over somewhere near mile marker 62. No sirens or lights had been activated to effect the stop; the officer then put on the overhead lights, drew his rifle and ordered the driver to turn off the ignition and throw the keys out the window. Appellant was the driver, B the front passenger. There was a third occupant. (RT 207-209, 215-217) Appellant had scratch marks on his right temple, near the hairline, and a number of bruises on his back and side. B was scratched on the wrist and lower back, and a few red marks in his hairline. (RT 217-218)

The Inglewood police arrived, and escorted Carmen to the hospital, where she was examined and treated for cuts to her hands, and bruises and scratches to her neck, knees, back, and arms. (RT 105-108, 150) There was an abraded area at the fossa navicularis and the cervix was swollen and slightly bleeding; the anus was very red, swollen, "beefy," and bruised. These injuries were consistent with penile penetration, and the assault history provided by Carmen. (RT 146, 153-157) The sexual assault nurse examiner found the history and physiology consistent with rape. The injuries, particularly the anal injuries, were among the top ten percent of the worse injuries the examiner had seen to an intestinal tract as a result of rape. (RT 157-158)

A detective testified it took one hour and 25 minutes to drive the 92-mile route from Inglewood to Hesperia, driving at 70 to 80 mph. The area around the gas station is desert, abutted by an unlit vacant lot with trash and tumbleweeds. (RT 168-172)

Appellant's Statement

Appellant was interviewed by a detective at the Inglewood police department the day after his arrest. (RT 173-175) Appellant said he had taken the keys to a 2000 or 2001 silver Honda van from a "defenseless" woman, "like taking candy from a child." (RT 176-177) Appellant drove the van; he wanted to go to Arizona. At first, appellant was unsure about the direction, then saw a sign to Barstow, and headed there. Appellant said he touched Carmen on her breast, but "didn't have an opportunity to touch her" anywhere else. Carmen was afraid of him. (RT 177-178, 180) Appellant was

---

2 Carmen's credit cards, a cell phone, pager, two strollers, jackets, and bottles of milk and juice were later found inside the van. (RT 218-219)

the driver the entire time: he once saw Carmen in the rear view mirror when he looked in the back of the van. When followed by police towards Barstow, appellant drove about 105 mph, he was not trying to run away, but wanted to leave the state because he was afraid something was going to happen. (RT 179, 181)

Appellant said he did not have any kind of sex with Carmen. (RT 180) Appellant was not aware there was any sexual activity going on until they were off the freeway, though the detective could not at first remember "where he said exactly he knew what was going on in the back seat." (RT 181-182) Appellant told the detective he did not become aware of "any activity in the back of the van until they reached an area that was dark and outside the city." (RT 196-197) Appellant said he never penetrated Carmen, though the detective feigned having DNA evidence to the contrary. (RT 197, 199-200)

Defense Case

There was no affirmative defense presented.

# STATEMENT OF FACTS

## Prosecution Case
### Douglas Korpi, Ph.D

Douglas Korpi received his Ph.D. in 1977 from the California School of Professional Psychology; he has been performing SVP evaluations for the State since the inception of the SVP law, and contracted with the Department of Mental Health (DMH) to perform an SVP evaluation on appellant.[1] (Supp. RT 23-24, 28, 72-73) Dr. Korpi first evaluated appellant in April, 1998, interviewing appellant for approximately two hours as part of that assessment. In 2002, appellant declined to be reinterviewed by Dr. Korpi.[2] (Supp. RT 28-29, 73, 76, 88, 89, 92) Dr. Korpi's re-evaluation consisted of reviewing appellant's criminal and institutional history, diagnosing a predispository mental disorder, and determining appellant's risk of recidivism.[3] (Supp. RT 29, 89, 92-95, 191) Based on these factors, Dr. Korpi decided appellant met the SVP criteria. (Supp. RT 70)

Appellant's first qualifying conviction stemmed from an incident on December 20, 1977: sometime between 11:45 p.m. and 1 a.m., appellant entered a woman's bedroom[4] wearing only his underwear, his face covered with "something white." Appellant jumped on the bed, said he would hurt the woman if she didn't shut up, jabbed something in her side, pulled her nightgown over her head, and raped her. At some point, appellant said he would not kill her children so long as she cooperated. After appellant was finished, he tied her hands with a cord, gagged her, dragged her to the bathroom and barricaded her inside. (Supp. RT 30-31, 71) The second qualifying offense occurred on September 21, 1986: appellant entered another woman's[5] bedroom at 3:00 a.m., put his hand over her mouth, a

---

1 Until 2002, the State paid evaluators $100 an hour for evaluations; since 2002, the State pays a flat fee of $2,000 for an initial evaluation, $2,400 for an update. Evaluators are still paid $100 an hour for court-related activities, such as testifying. (Supp. RT 77 79) Some 60 to 67% of Dr. Korpi's $350,000 annual income comes from his DMH work. (Supp. RT 81-82, 191)

2 Dr. Korpi always advises the patient he does not have to participate in the interview and anything he says may be used to determine his SVP status. (Supp. RT 96-97)

3 Dr. Korpi did not interview the hospital staff, as suggested by the DMH guidelines. Though he acknowledged such a practice is desirable, particularly when the patient refuses to be interviewed, Dr. Korpi said it didn't seem necessary as appellant seemed "open with me" during the 1998 interview, and the records appeared otherwise complete. (Supp. RT 75-76)

4 The woman's name was Connie; appellant was a casual acquaintance. (Supp. RT 30, 33-34)

5 The woman's name was Brenda; she did not know appellant. (Supp. RT 32, 34)

knife to her throat, and told her to roll onto her stomach and he wouldn't hurt her. Appellant cut off the woman's underwear, attempted to enter her from the rear, then raped her. After ejaculating, appellant fondled her breasts, kissed her back, and rubbed the knife across her back several times. (Supp. RT 32-33)

To find someone meets the SVP criteria, the individual must have an emotional or volitional incapacity that predisposes him to commit a sexually violent act. (Supp. RT 35-36) Dr. Korpi diagnosed appellant as having paraphilia, or "sex disorder," and antisocial personality disorder; Dr. Korpi also assigned appellant substantial drug and alcohol problems. (Supp. RT 34) Paraphilia is a generalized term taken from the DSM-IV TR, a diagnostic "dictionary" for mental health workers. Paraphilia contains multiple categories, including pedophilia, zoophilia, exhibitionism and fetishes; appellant's paraphilia, clinically designated as "Paraphilia, Not Otherwise Specified" (Paraphilia, NOS), a preference for nonconsensual sex.[6] Unlike specified paraphilias, the DSM-IV does not articulate diagnostic criteria for generalized paraphilia. To sustain a generalized paraphilia diagnosis, someone must evidence the preference for at least a six month period, and the preference must cause social discomfort: in appellant's case, his first offense occurred in 1977, when he was 21 years old, his second in 1986, when he was 31. In between these offenses, he was convicted for attempted assault to commit rape; there was also another alleged attempted rape. The social discomfort was appellant's own negative feelings about his behavior and the disruption in his social/occupational functioning caused by his incarcerations. Appellant recognizes rape is wrong and empathizes with his victims. (Supp. RT 34-38, 108-112, 115-117, 140-141, 192)

A paraphilia diagnosis by itself does not include any impairment of emotional or volitional capabilities. That appellant's paraphilia affects his individual volitional capacities is evidenced by his desire not to rape: though appellant does not want to rape, he does rape, and is incarcerated as a result. Following his release, he reoffends, is reincarcerated, and upon release,

---

6 Not a paraphilia identified by the DSM-IV; those who assembled the DSM-IV rejected rape as a form of paraphilia because 90 to 95 percent of rapists do not suffer from a sexual disorder. (Supp. RT 112-115, 140-142, 193) The two DSM-IV criteria listed for Paraphilia are: "recurrent intense sexually arousing fantasies, sexual urges or behavior, behaviors generally involving one of three things: nonhuman objects, the suffering or humiliation of one sexual partner or children or other nonconsenting persons over a period of at least six months" and the urges or behaviors "must cause marked distress or interpersonal difficulty." These criteria apply to all paraphilias; subtypes have additional definitions. (Supp. RT 203-206)

reoffends again. "Social reprimand" and prison do not affect appellant's ability to "contain himself." (Supp. RT 39, 137-140) The majority of rapes are done by "bad people" not mentally ill offenders. The difference between a serial rapist and a bad person is the serial rapist works from a pattern: appellant enters his victim's bedroom "around midnight," covers his or his victim's face, and "usually" has a knife. His victim always has children, facilitating his ability to keep her under control. There is not excessive violence, though rubbing his knife across the last victim's back showed a relishing of violence more common in serial rapists. (Supp. RT 40-41)

There are three basic approaches to evaluating the likelihood of future sexual violence: the pure clinical approach, or record review; the experiential approach, taking into account the evaluator's practical experience and the relevant subject literature; and the actuarial approach, a numbers-based risk assessment using an "actuarial tool." In Dr. Korpi's assessment of appellant, he employed a multi-axial approach, reviewing appellant's total history and using an updated Static 99, which tabulates ten selected factors from an individual's history that correlate to recidivism.[7] (Supp. RT 42-43, 122, 142-143) Each factor is worth one point with the exception of prior sex offenses, which has a maximum score of three as the most robust indicator of recidivism. Appellant got two points on that item because of his two prior charges. Other points were awarded for having more than four previous sentences, having unrelated victims, having stranger victims, and not having lived with a lover for at least two years.[8] Stranger victims and unrelated victims count as separate points. Appellant had a score of six,

<hr>

7 The Static 99 is a predictor of sexual offense recidivism in general, not sexually violent recidivism in particular. The American Psychiatric Association disapproves the use of such actuarial tools; the American Psychological Association does not. (Supp. RT 143-145) When appellant was evaluated in 1998, evaluators used the precursor test to the Static 99, the RRASOR; the RRASOR analyzed four factors. (Supp. RT 196-197) The ten Static 99 factors, put in terms of positive scored points, are: (1) whether the offender was under the age of 25 at the time of the first offense; (2) no two year period of intimate cohabitation; (3) whether the most recent offense was violent; (4) prior history of nonsexual violent convictions; (5) number of prior sexual offenses; (6) number of prior sentencing dates; (7) convictions for noncontact sex offenses; (8) unrelated victims; (9) stranger victims; and (10) male victims. All factors are scored either zero (inapplicable) or one (applicable), except prior sexual offenses (#5), which scores from zero to three, the past being the best prognosticator. (Supp. RT 246-252)

8 Dr. Korpi noted appellant lived with someone for a year and a half or a year and eight months, coming "merely close" on this count. (Supp. RT 57) Had appellant cohabitated another four months, his risk assessment would have dropped from 6 points to 5, or from a 52% chance of reoffending within 15 years to a 40% chance. It was not clear from the records exactly when appellant began living with that partner, though Dr. Korpi did not think it reasonable to assume they started cohabitating in the beginning of 1977. (Supp. RT 159-160, 165-166)

which is considered high risk. The error rate of the Static 99 is 8.4% for an individual in appellant's risk category. (Supp. RT 44-48, 149, 156-159)

This score was then compared to a meta-analysis of 28,000 individuals and the six risk factors identified in that study, including sexual deviance and criminality. In terms of deviance, there are again six factors: on the risk side of the equation, appellant suffers from a diagnosed sexual deviance, has prior sex offenses, has stranger victims, has unrelated victims; on the protective side of does not target minors, does not vary his offenses, and is over the age of 25. That appellant was 21 when he committed his first rape was a neutral factor. According to Dr. Korpi, the first three factors are the most significant: appellant therefore has moderate sexual deviance. (Supp. RT 49-52, 157-158)

There are six components to criminality: antisocial personality disorder, high score on the Hare psychopathy checklist, treatment performance, parental (i.e., maternal) relationships, history of nonsexual crimes, minimum two-year cohabitation with a lover. Antisocial personality disorder is evidenced by "getting in trouble on a consistent basis," and irresponsibility. Antisocial personality disorder is demonstrated by early onset of bad behavior: appellant said he'd committed fourteen to twenty burglaries by the time he was 16, started stealing cars by 15, and began using drugs and alcohol at 13. A pattern of lying is also significant: appellant's foster stepmother said he used to steal from friends and lie; appellant was arrested for forgery. Impulsivity is telling; appellant has a history of impulsivity, including early drug and alcohol use, going AWOL in the Army after hitting a sergeant, and two CDC violations for fighting. Appellant has a demonstrable history of irresponsibility: many jobs, failure to pay child support.[9] In terms of empathy and remorse, Dr. Korpi felt appellant's behavior towards his victims was proof of his callousness. (Supp. RT 52-54, 56, 166-172, 197-198)

A score of 30 out of a possible 40 on the Hare psychopathy checklist is deemed extremely indicative of recidivism; appellant scored an inconclusive 22. Next, Dr. Korpi considered appellant's treatment record: given appellant does not believe he has a sexual disorder, he has not sought

---

9 Dr. Korpi could not recall whether the nonpayment of child support was due to an agreement between appellant and his ex-wife that her new husband would assume financial responsibility as part of his adoption proceedings. If that was the case, Dr. Korpi noted, that would affect use of nonpayment as antisocial indicator. (Supp. RT 169)

treatment. Appellant was separated from his parents at an early age[10] and so did not have a good relationship with his mother. (Supp. RT 54-57) Again, appellant has a history of nonsexual crimes, and did not live with a lover for over two years. (Supp. RT 57)

Dr. Korpi assessed appellant's treatment status relative to social support and intimacy subsets: again, as appellant does not believe he suffers from a sexual disorder, there is no social support group to sustain him upon release. Appellant's difficulty with intimacy is shown by his lack of long-term intimate relationships, his thirty consensual sexual relationships,[11] and his proclivity to rape. Appellant has no prospective appropriate intimate partner waiting for him should he be released. With regard to sexual self-regulation, sex offenders tend to masturbate to deviant fantasies when they become upset; treatment teaches them to talk about their problems with others instead. Appellant briefly participated in treatment in the beginning of his incarceration, attending some sessions of the first phase of a five-phase program.[12] Because of appellant's lack of treatment, he does not have this training, or training to alter his masturbatory fantasies to nondeviant subject matter.[13] (Supp. RT 58-60, 68, 172-173) On whether appellant was "attitude tolerant" about sexual abuse, appellant has historically appeared both remorseful and unremorseful; most recently, appellant has exhibited genuine empathy. (Supp. RT 60) The "huge" factor against appellant here was that appellant did not think he had a sexual disorder, i.e., he does not think he will do it again. (Supp. RT 60, 175-176)

With regard to general self-regulation, appellant has issues with problem-solving and anger, as shown by his history of fights, including hitting his sergeant, his wife telling police she was afraid of him, and fights while in custody. Dr. Korpi noted appellant had not fought since 1995, so this factor was neither "plus or minus." And some of appellant's displays of anger have been "even noble": in one instance, appellant defended a friend, in another,

---

10 Appellant has variously told interviewers he lived with his mother and grandmother until he was 11, or his father and paternal grandparents. (Supp. RT 56)

11 Dr. Korpi testified this number, while high, was not abnormal. (Supp. RT 185)

12 Phase one is a class about the benefits of therapy, phase two, as described by Dr. Korpi, is the "first sex treatment so you learn what would happen in phase two," phase three teaches participants about sex offenses, recidivism, the Static 99. (Supp. RT 68) A prerequisite to participation is admission to having a sexual disorder; this admission could be used in later court proceedings. Dr. Korpi thought this "kind of unfair." (Supp. RT 180-183)

13 Because appellant had not discusses his fantasies, Dr. Korpi did not know what he masturbated to; this factor, then, was "silent." (Supp. RT 60)

he stood up to staff because of their treatment of another friend. Appellant does not have problems with supervision: he is liked by male and female staff members, who describe him as quite cooperative and pleasant. Appellant's age operates in his favor, as rape recidivism decreases with age, "bottom[ing] out" around the age of 60; appellant was 47 years old at the time of trial. (Supp. RT 61-62, 100, 103, 176-177, 183-184) Appellant's history of drug and alcohol abuse is relevant to his ability to self-regulate and cooperate with supervision, and should appellant drink or use again, it might start him "in the wrong direction." Appellant has not participated in Narcotics or Alcoholics Anonymous meetings while at Atascadero;[14] he engages in self-treatment via prayer. Hanson's study indicated a neutral value to the effect of religious beliefs on recidivism. Appellant has not had any drug or alcohol-related incidents during his confinement, though both drugs and alcohol are readily available. (Supp. RT 68-70, 185-187)

The Static 99 was based on Hanson's study of rapists and recidivism, comparing rapists to child molesters, and those who molest within and outside the family. The study involved 4700 individuals; the data on rapists indicated that after the age of 50, only 32 individuals reoffended. Those individuals were subsequently studied by Belindan, who discerned a continuum of high risk pursuant to the Static 99, combined with a series of dynamic variables. Under the Static 99, those with a score of 6 or higher have a 52% chance of being convicted of another sexual offense within 15 years of being released from custody. Within 5 years, 39% reoffended, and within 10 years, it seemed 45% reoffended. Risk of recidivism is slightly overestimated for someone in appellant's age group. (Supp. RT 64-67, 142-143, 153-155)

In Dr. Korpi's opinion, sexual disorder is like sexual orientation, i.e., "some people rape." (Supp. RT 63, 134) Appellant's SVP evaluation was based first on his high Static 99 score and his longstanding paraphilia, and second, his antisocial personality disorder diagnosis. These two factors, coupled with appellant's lack of treatment, led Dr. Korpi to conclude appellant was likely to reoffend. (Supp. RT 70) A 1998 Hanson study and a separate study by Janice Markovitz indicated there was no relationship between treatment and recidivism. In 2002, Hanson did another study which showed 15% of untreated offenders reoffended, versus 9% of treated offenders. (Supp. RT 177-179)

---

14 Appellant did attend AA meetings in the beginning of his confinement, but stopped once he discovered they too were not confidential. (Supp. RT 182-183)

There is no indication appellant has committed sexual offenses in addition to his convictions, either in- or outside an institutional setting. (Supp. RT 98-99) If appellant had committed the same number of rapes and not been apprehended or not felt significant remorse, he would not be diagnosed with paraphilia, though he might be diagnosed as a psychopath. Absent the fourth rape, Dr. Korpi probably would not have diagnosed paraphilia. (Supp. RT 117-118, 130-132, 194, 198-201) That appellant's life "so falls to pieces" around the time of his offenses suggests appellant is "giving in to temptation" when he rapes, rather than freely choosing to rape. (Supp. RT 129)

Dr. Korpi agreed it would be "double-dipping" to add the same factor twice; some of the Static 99 factors are duplicated in other analytic variables. On cross-examination, Dr. Korpi said he based his evaluation on appellant's Static 99 score. (Supp. RT 161-165) As a general matter, appellant's antisocial personality disorder and substance abuse do not predispose him to rape, but are recidivism risk factors. (Supp. RT 38-39) Incarceration has no affect on recidivism risk, though appellant has "made the best of his time." (Supp. RT 189-190) Dr. Korpi found appellant cooperative, pleasant, reasonable, forthcoming, and "easy to deal with." (Supp. RT 98)

John Hupka, Ph.D

John Hupka received his Ph.D. in clinical psychology in 1990; the bulk of his private practice consists of contract work for the courts and the DMH, and much of that work involves SVP evaluations. (Supp. RT 215-216, 275-276, 279, 281-284) As a general matter, about 60% of the individuals Dr. Hupka has assessed have met the SVP criteria. Dr. Hupka assessed appellant on May 19, 1998; appellant was prefatorily advised of the potential consequences of a positive evaluation, and signed a waiver agreeing to be interviewed. Dr. Hupka attempted to reinterview appellant in 2002, but appellant refused to participate. (Supp. RT 219-220, 265-266, 287, 289, 295, 300; RT 287)

As part of his evaluation of appellant, Dr. Hupka reviewed appellant's criminal records, including his offense records, probation officer reports, custodial write-ups, and other items in his central file relative to his incarceration. Dr. Hupka examined the psychiatric records in appellant's medical file; because appellant had not received sex offender treatment, there were no program records to review. Dr. Hupka did not interview hospital staff. (Supp. RT 221-222, 281, 290-292, 301) Based on his old interview and

new review, Dr. Hupka determined appellant met the SVP criteria. (Supp. RT 222)

Dr. Hupka based this opinion on the three DMH categories used to determine SVP status: prior offenses, diagnosed mental disorder, and likelihood to reoffend. (Supp. RT 222, 225, 276) In finding the requisite priors, Dr. Hupka read the probation reports from appellant's rape convictions. (Supp. RT 223-224, 292-295, 306-308) Appellant told his probation officer the 1979 assault with intent to commit rape stemmed from a burglary; when he was interviewed about his most recent offense, appellant said he had stolen his victim's purse and checks, which was why he entered that residence. Appellant also indicated he was under the influence of alcohol both times. (RT 243-244)

Dr. Hupka diagnosed appellant as having Paraphilia, NOS, sex with nonconsenting persons. Dr. Hupka explained that in the DSM-IV, the "bible of diagnostic mental health disorders," paraphilia is defined as persistent sexual deviance, i.e., an aberrant sexual urge present for at least six months which causes some sort of impairment in an individual's life. (Supp. RT 225-226, 270; RT 230, 237-240, 303) Unlike other paraphilias, there is no specified rape paraphilia because most rapists do not suffer from a sexual disorder: rape is "something bad that they do," the rape an incident rather than a condition. (Supp. RT 226-228; RT 230-236, 304-305) The number of rapes and attempted rapes is indicative of this condition versus event status.[15] Another indicator is the presence of a rape modus operandi: appellant carries a knife, threatens his victims. (Supp. RT 228-229; RT 250, 253, 256)

Appellant's sexual disorder affects his life as it has resulted in his incarceration; it affects his emotional functioning as he derives sexual pleasure from the pain and suffering of his victims. His volitional capacity is impacted because he is not "absolutely" in control of his urges: when Dr. Hupka interviewed appellant, appellant was appalled by his behavior, on the other hand, appellant repeatedly engages in such behavior despite social efforts to stop him.[16] (Supp. RT 233-234; RT 240-242, 249-250, 301-302) When interviewed by a probation officer in 1987, appellant said he had "no

---

15 Dr. Hupka distinguished between someone who is drunk and rapes "a very situational thing," and someone like appellant, who rapes while intoxicated, but is "well in control" at the time. This sexual disorder is also to be distinguished from mental disorders where the individual is psychotic, or doesn't know what he is doing. (Supp. RT 229-232; RT 242-243)

16 Dr. Hupka noted appellant can control his sexually violent behavior, evidenced by the three years between his release from prison in 1983, and his 1986 offense. (RT 312-313)

idea" why he raped, though he desperately wished he knew. To Dr. Hupka, this demonstrated appellant's "Doctor-Jeckle-and-Mister-Hyde" persona, and his higher chance of reoffending. (Supp. RT 235-236, 299)

Dr. Hupka gave appellant a Rorschach test which indicated appellant functions well in the absence of stress; when stress is present, appellant becomes angry and explosive, and turns to paraphilia. Appellant thus appears to have "very few internal resources for coping with life," and tends to act out erratically under stress. However, during his incarceration, appellant did not act out when his father suddenly died; for the most part, his behavior has been "quite good" in custody. (Supp. RT 237-238, 269; RT 251, 256-258, 293-294, 313) Appellant has never engaged in aberrant sexual conduct while incarcerated, probably because the custodial setting does not fit his rape modus operandi. Similarly, an incarcerated alcoholic may be able to not drink, though alcohol is available. Appellant stopped drinking in 1994. (Supp. RT 238, 302-306; RT 258-259, 294-295, 305-306) Paraphilia for nonconsenting persons does not go away: as with alcoholism, the predisposition is constant, necessitating a relapse prevention plan, such as the treatment offered at Atascadero. Appellant has not participated in treatment beyond the first phase, thus failing to mitigate his risk factors. Participation in treatment mandates admission of having a sexual disorder; in declining to participate, appellant has cited the lack of confidentiality and his belief that he will no longer engage in substance abuse and sex offenses. (Supp. RT 239-242, 255, 298-299; RT 238-239, 247-249, 289-291)

Based on the Hanson study, appellant's age might lead Dr. Hupka to consider him no longer at risk of reoffending. Generally speaking, frequency of sex offenses declines with age; however, those with a high risk of reoffending continue to have an elevated risk throughout their 40s and 50s. By 60, the recidivism rate is virtually non-existent, though this may be due to a lack of data, as referenced by Dr. Doran's study.[17] (Supp. RT 242-245, 272-273; RT 266-270, 273, 296-297) Dr. Hupka gave appellant 7 points on the Static 99, one point each for his lack of a two-year intimate cohabitation, his history of prior nonsexual violent convictions (his assault on his sergeant),[18] his prior sentencing dates, having unrelated and stranger victims, and two points

17 Doran did not further refine this study by offense type, though extrafamilial child molesters, for example, have a higher recidivism rate than rapists. (RT 270-2712)

18 This came from the probation report; even if appellant denied this was the reason for his discharge, Dr. Hupka would have scored appellant based on the report. (RT 277-279)

for his two prior sex offense convictions. (Supp. RT 245-252, 279-280; RT 260, 281-283, 298, 308-309, 312) A score of 6 or above is considered high risk for reoffending. (Supp. RT 253-254; RT 261-263, 309-312) Dr. Hupka then looked to the most robust empirically-driven reduction of risk factors, but was unable to discern anything that militated against appellant's risk classification. (Supp. RT 255-258)

Appellant had other indicators of increased risk of recidivism, including evidence of paraphilia, as shown by his prior offenses, and various criminological variables, including prior sentencing dates, indicative of antisocial personality disorder, and developmental variables, particularly the lack of a maternal relationship. Additionally, because of his lack of a long-term intimate relationship, appellant has a demonstrable incapacity for intimacy.[19] Dr. Hupka did not diagnose appellant as having antisocial personality disorder in 1989, but has changed this diagnosis based on his new review of the case, and his growing conviction that appellant has an antisocial personality. (Supp. RT 258-263, 266-267; RT 274-275, 285) Dr. Hupka noted the "overlap" of certain factors. (Supp. RT 259-260; RT 283-286)

Dr. Hupka next considered protective variables, specifically whether appellant had been able to remain offense-free in the community for five years post-release: appellant's incarceration negated this factor. Appellant's age was a nominal factor in mitigation;[20] based on his record, Dr. Hupka assumed appellant has no social support system or social influences waiting for him in the community. (Supp. RT 263, 265, 272-273; RT 273, 286-287) Appellant's religious conversion is a positive factor, but does not address his paraphilia. (RT 292)

The most important factor in Dr. Hupka's assessment was appellant's high Static 99 score, coupled with the "general body of risk factors." An individual's Static 99 score will not change. There is no current behavior that indicates appellant's paraphilia is still active, or that appellant is still antisocial; at the time of trial, appellant had not acted out his paraphilia for 17 years. (Supp. RT 268; RT 245-248, 254-255, 265, 294, 299-301) According to Dr. Hupka, appellant is a "remarkably nice guy," "cooperative. Pleasant, sincere... just a thoroughly likeable gentleman." (Supp. RT. 274-275)

---

19 To this, Dr. Hupka added allegations of appellant's substance and the single allegation of physical abuse made by appellant's wife during their relationship, as well as appellant's commission of sex offenses during his marriage. (Supp. RT 267-268; RT 287-289)

20 For example, a 60-year old with a high Static 99 score will not be assessed any differently than a 33-year old with the same score. (RT 266-267)

## Defense Case
### John W. Podboy, Ph.D.

John W. Podboy received his Ph.D. from the University of Arizona in 1973; he was a state psychologist from 1975 to 1980, and has had a private forensic psychology practice since that time. Dr. Podboy formerly contracted with the DMH to perform SVP evaluations, but now primarily works for the defense. He finds about a third of his evaluees meet the SVP criteria; when he worked for the DMH, he found about 75% of evaluees were SVPs.[21] (RT 317-322, 323, 387-388)

Dr. Podboy believes the treatment program at Atascadero is largely unsuccessful: only about 20% of the patients participate, and no one who has participated has been returned to the community. (RT 323, 400) The SVP evaluations currently performed unduly emphasize historical data, including police and probation reports, items not ordinarily relied upon in a psychological evaluation. Typically, a psychological evaluation stresses current functioning, the present day-to-day adjustment of the individual. (RT 323-324) DMH evaluators use actuarial instruments, a relatively recent phenomenon originally developed by insurance companies to determine risk. (RT 324) In January 2002, the American Psychological Association published an article in its journal to the effect that actuarial instruments are not scientific, and use of them in a courtroom context undermined the credibility of psychologists. The American Psychiatric Association disapproved the instruments in a 1999 position paper, which found it an abuse of psychiatry to civilly commit individuals under the guise of mental illness absent evidence of mental illness. Specifically, the APA condemned elevation of criminal conduct into a diagnostic axis. (RT 325-327, 362) Mental illness is often a biological problem; the problem with the civil commitment process is there is neither predicate evidence of such a sort of illness, or any real attempt at its amelioration. (RT 327)

Appellant was evaluated by Dr. Podboy on May 4, 1999, July 27, 1999, February 8, 2000, May 22, 2001, August 15, 2001, and October 3, 2002. (RT 328) Appellant is very bright, well-informed, and "easy to talk to." He was extremely remorseful about his offenses, and appeared to have good self-regulatory skills, though he has not received any medical treatment for any psychiatric disorder. (RT 329, 331, 401) For example, the death of

---

21 Dr. Podboy explained the discrepancy by noting that in 1996, when SVP evaluations were in their infancy, the DMH was seeing "the worst of the worst." (RT 388-389)

appellant's father caused him significant emotional stress, but did not result in any untoward behavior on appellant's part. (RT 332) Appellant was formerly very dependent on drugs and alcohol, though he did not cite this as an excuse for his criminal offenses. Appellant admitted his crimes, and regretted them. He has held a job in the hospital upholstery shop for a number of years, and when he thought he was becoming overweight, embarked on a self-developed exercise program which resulted in a 40 pound weight-loss. Appellant reads a lot and gets high marks in his various educational pursuits, including paralegal school: he is "pretty intellectual, a "pretty serious and level-headed person." (RT 331-335)

Appellant was involved in a serious car accident in 1985: his arms, upper torso, abdomen, and thighs were severely burned, he was hospitalized for two months, and had to wear a specialized healing suit for another six months. As a result of this incident, appellant was physically disfigured and over time, emotionally sensitized to the pain of others. Appellant has expressed his wish that he could undo his offenses because of the pain they caused others; Dr. Podboy indicated this empathy seemed genuine, which is unusual.[22] (RT 330-331, 401-402)

Appellant has not fully participated in the Atascadero treatment plan because of its lack of confidentiality; what is discussed in treatment is included in patient records. Appellant feels the purpose of the hospital plan is not bona fide treatment, but ongoing containment. Dr. Podboy concurred, estimating no more than 20% of patients participate in "so-called treatment phases," while other patients complain about sexual acting out throughout the facility. The mix of offenders also mandates a variety of treatment modalities, from psychopharmacological interventions to cognitive behavioral treatment. Hospital staff suffers from high turnover, and female employees are subject to the gauntlet of inappropriate patient behavior, from comments to masturbation to physical and/or sexual assault. Dr. Podboy found the amount of patient sexual transgression surprising; the effects of

---

22 In 1979, appellant told a probation officer he felt nothing for his victim, indicative of antisocial personality disorder; in 1987, he said he disliked authority and did not know why he raped, indicative of antiauthoritarianism and potential mental disorder. (RT 433-435) Though there were contributing factors which might militate against concluding these remarks manifest mental disorder (his substance abuse, for example, and the dissolution of his marriage) there is no longer any evidence of these attitudes in any event. Noteworthy in this regard is the constant surveillance patients are under and the attendant constant subjugation to authority: had there been an instance of real antiauthoritarianism, it would have been documented. (RT 436-438, 452-455)

such license are first, someone unable to control his behavior in custody will never be released into the community "and for good reason," and second, those who do not participate avoid group situations, saying they would rather be in state prison because of the "toxic atmosphere" at Atascadero. (RT 336-343, 350-351, 404, 436)

The usual tenets of psychologist-patient confidentiality are not observed at Atascadero, so what would be confidential communications routinely become part of patient files. Confidentiality is "the cornerstone" of the psychotherapeutic enterprise; the lack of confidentiality undermines treatment as patients feel the purpose of the proffered therapy is to gather information "to keep them there." This fear is well-founded: patients are encouraged to expand on events that may have transpired 20 to 25 years earlier, though there is no therapeutic need for further review. (RT 351-353)

Dr. Podboy examined appellant's records: in 1978, appellant was found not to be a Mentally Disordered Sex Offender, which had a similar prerequisite of dangerousness[23]. (RT 343-344) Dr. Podboy also reviewed Drs. Hupka and Korpi's evaluations, and while he respected their opinion, he disagreed with it. Appellant meets the first SVP criteria, but not criteria two and three. (RT 344, 405-408) Appellant told Dr. Podboy that reinterviewing with Drs. Hupka and Korpi was useless, as they would simply revisit his history and continue to say he was mentally disordered though there was no proof of such a disorder. (RT 354-355)

Pursuant to the DSM-IV, paraphilia, NOS, while an umbrella term denoting a variety of common conditions, does not include rape. Rape is itemized in another portion of the DSM-IV as a problem related to abuse/neglect, a "v-code" condition[24] not considered indicative of mental illness as such though it may be the focus of clinical attention. (RT 356-359, 409, 420, 448-451) Rape is not included in mental disorder nomenclature because most psychologists and psychiatrists deem rape "a criminal act," an assault which in the "overwhelming majority of cases" is not reflective of a mental disorder. Adding antisocial personality disorder to the mix does not transform rape

---

23 In one early evaluation, appellant was diagnosed as having passive-aggressive personality disorder, a diagnosis Dr. Podboy found "strange." (RT 455-456)

24 Dr. Podboy stated even serial rapists more accurately suffer from psychosis as a motivator rather than paraphilia. For one's paraphilia to meet the SVP criteria, one would have to derive sexual pleasure from the specific locus of the fetish, not from the nonconsensual sex itself. In other words, a sadomasochistic rapist derives sexual pleasure from the pain he inflicts, not from the sex itself, just as a pedophile derives pleasure from the fact he is having sex with someone under the age of 13. (RT 410-417)

into a mental disorder: there is a distinction between personality disorders and mental disorders, and while many of those who have come into contact with the criminal justice system have antisocial personality disorders, these are not mental disorders amenable to psychological treatment. (RT 359-361, 363, 420-422) Most individuals burn out on antisocial behavior around the age of 40, and the best interim treatment is confinement, not medication. (RT 361) Age also decreases the effects of paraphilia. Paraphilia by itself does not predispose one towards engaging in certain sorts of sexual behavior: the hallmark of paraphilia is compulsivity, which appellant absolutely does not manifest either sexually or in any other area of his life. Paraphiliac compulsion would not lie dormant for sixteen or seventeen years, regardless of someone's confinement status.[25] And given the concentration of mentally disordered individuals engaging in sexual misconduct at Atascadero, "it's the unusual person" who evidences the self-control to stay within the rules of the institution (RT 364-369, 447-448)

　　If appellant's criminal history supports a secondary diagnosis of antisocial personality disorder, that disorder is "certainly in remission" based on the present and more recent past.[26] (RT 367, 382-383) Dr. Podboy indicated appellant's greatest recidivism risk factor would be if he were to reuse drugs and alcohol; given appellant had nine years abstinence at the time of trial, Dr. Podboy considered such a relapse unlikely. (RT 369-370, 408)

　　In his evaluation, Dr. Podboy found appellant to have good self-regulatory skills: he manages himself appropriately, sets goals and works towards them, and, unlike many of his peers, there is no indication appellant has acted out sexually while confined. Appellant "is maturing" and has reflected on the harm he has done. He wants to make amends, as demonstrated by his "uniformly positive" hospital records. (RT 345-348, 447) Appellant's ability to conform remains constant despite contrary peer pressure and an environment of conflict; appellant has also stopped drinking since his confinement, remarkable for someone with a serious history of drug and alcohol abuse. Again, Dr. Podboy felt this indicated appellant's continuing maturation; in Dr. Podboy's words, appellant has been "prosocial for many years." (RT 349-350, 370)

---

25 Evidence of compulsion need not manifest in physical assault: many times compulsivity will surface in things like patient drawings of the fetish object or scenario. (RT 448)

26 In this regard, Dr. Podboy noted appellant received an "undesirable" discharge from the Army for going AWOL; "undesirable" differs from "dishonorable." (RT 383-384)

Age is also a factor in maturation; according to a recent APA publication, rape recidivism drops after 25 due to reduced testosterone levels and attendant aggression, and other age-related health factors. Though appellant did reoffend after that age, he has a current history of prosocial behavior as well as age-related problems (orthopedic, visual) that make it less likely he would do so again. (RT 376-381, 384, 451) Dr. Podboy had not read the Doran article, but was familiar with its conclusions, specifically its finding that age has a less ameliorative effect on child molesters than rapists. (RT 381) Dr. Podboy assigned a global assessment functioning (GAF) score to appellant; in this common assessment technique, a psychologist scores an individual's ability to manage his life. High-functioning individuals would score 100, someone who needed assistance getting meals and taking medication would score in the 40 to 45 range. The global assessment functioning score is a subjective psychological evaluation approved by the DSM-IV. Despite the fact appellant is in an institutional setting, it would be "easy" to score appellant at 80 or 85 because he is self-directed, manages his own diet, tends to his own needs, seeks appropriate medical treatment, and develops and pursues his own educational programs. Appellant has learned to avoid problems with himself and with others. The DMH did not give appellant a GAF score, though there was no explanation for that lapse, or for the failure to provide a narrative counterpart, i.e., a written assessment of appellant's functioning. (RT 370-373) It is not standard practice in any psychological evaluation to disregard a patient's current behavior. (RT 446-447)

As a general matter, Dr. Podboy believes it is "very, very" difficult to predict dangerousness. The Static 99 is a great "work in progress," incorporating significant factors, but should not be used to promulgate mathematically precise numbers about future behavior. There are also issues of subjectivity embedded in the test, as well as duplication of factors appearing in other assessments. (RT 373-375) If appellant was assessed only on the basis of his behavior from 1977 to 1986, he would be high risk. (RT 429)

Rape was "something Mr. James wanted to do, and he did it." There were no mental defenses offered to his crimes at the time; appellant did not claim any lack of volition, either mentally or chemically induced. Assuming appellant has an antisocial personality disorder, it is in remission; given his history of alcohol and drug abuse, he has successfully abstained for almost a decade. (RT 362-363, 408-409, 443-446, 453) Appellant does not meet

the SVP criteria: appellant has neither a valid DSM-IV diagnosis, nor does he meet the legal definition of mentally disordered. (RT 355, 362, 378, 382, 407, 439-441, 446-448)

Appellant

Appellant does not believe he meets the SVP criteria. He was convicted of the requisite crimes, but committed them "because I wanted to." (RT 457-459, 485, 504) In 1977, he broke into his victim's house to rape her because he thought she was attractive and to burglarize her home because he was having financial problems.[27] What began as a burglary in 1986 became a rape because the woman was "fairly good-looking." At that time, what others felt or thought or wanted didn't make any difference: people were objects for appellant's amusement. Appellant committed additional burglaries which did not involve rape, including one where the woman was home alone. (RT 458-460, 504-508, 513-518) Regarding the assault with intent to rape, appellant testified he had been drinking, decided to break in and look for money, found the woman asleep in her bedroom, and decided "it's here, why not." The woman screamed, and appellant ran away. In all cases, he took what he wanted. (RT 459, 485, 511-513, 515)

Alcohol was not the cause of his offenses. (RT 460) Appellant's military discharge was because he went AWOL, not to assault; appellant was sentenced to six months in the stockade and given an undesirable discharge. (RT 481-482) In 1978, he was evaluated as a Mentally Disordered Sex Offender, found unqualified for the program, and given probation. His son was born during his incarceration; the marital problems he was having stemmed from his requirement of unilateral fidelity from his wife as "a matter of pride." Back then, appellant demanded respect from others. (RT 508-511) Between 1983 and 1986, appellant had a good job with Holiday Inn, and didn't need to burglarize. He left his job, moved to Texas, worked a while there, was injured in the car accident, returned, and started his own business with a friend. Again, appellant was financially stable, and did not need to burgle. Then the business partnership fell apart, along with appellant's security. (RT 518-519)

When appellant was first convicted, he did not feel remorse. Sentenced to about 21 years, knowing how sex offenders are targeted in prison by prisoners and staff alike, appellant thought he was never going to

---

27 Appellant told a probation officer he had committed 15 to 20 daylight burglaries as a juvenile in Florida. (RT 515-516)

be released: someone would eventually attack him, forcing him to kill them in defense. Appellant began to look at himself and didn't like what he saw — a man who hated everyone. (RT 461-463) He made a decision to change, and began trying to find ways to change; sometime in early 1994, appellant became cellmates with a Christian and started reading the Bible, first to prove it false, then in quest of spiritual truth. Eventually, appellant was able to rid himself of his prison habits, including drinking, and start to "show other people through kindness instead of through toughness, compassion, and help if I could." (RT 463-465, 489-490) Appellant used to make and drink Pruno, the prison alcohol; he stopped around March, 1994, and no longer has any urge to drink. (RT 465-466) Since appellant's confinement, he found out his father died. Having a great deal been left unsaid between them, appellant felt "quite a bit" of guilt, but his emotional difficulties did not lead to acting out publically or private sexual fantasies. (RT 482-484)

Appellant wishes he could take back what he's done, but realizes he cannot. He understands he not only violated his victims' bodies and homes, but also their emotions and pride. While appellant knows he cannot make up for robbing women of their peace of mind, self-confidence or even self-respect, he would like to have the opportunity to try. (RT 460-461, 485-486) He cares about other people now; he has sympathy for them. He does his best not to lie, both because it's hard to remember and because "it's not the right way to go." (RT 485-486) It took a long time for appellant to understand why he did what he did; at earlier points in his life, he was too shallow to have the necessary introspection or insight. (RT 460)

Appellant was scheduled to be paroled in 1998, but was held for SVP commitment proceedings instead. He interviewed with Drs. Hupka and Korpi, and asked to be housed in Atascadero rather than County Jail because jail inmates were confined for all but four hours a day. Atascadero is very similar to a prison, stricter in some senses: there are weekly random searches, periodic hospital- or ward-wide searches, and biweekly canine ward searches. (RT 466-470) Since his confinement, appellant learned to type and use a computer; he spent two years becoming a paralegal, paying for the correspondence courses from his upholstery shop wages. Appellant also exercises and holds self-initiated Bible study classes. He training for a marathon, but had back problems, and now does more walking. He and several other inmates created a conflict-resolution support system, designed to intervene in patient disputes and help each other as needed. (RT 470-474)

Appellant went through Phase 1 of the treatment program for the first year or year and a half of his confinement, but stopped participating because treatment was no longer required for him to maintain his level, he "was tired of being compared to Jeffrey Dahmer,"[28] and the program is a "farce." A friend of appellant's who continued in treatment was asked to write a fantasy; he did, and the fantasy was returned, with instructions to write a rape fantasy. The friend complied, but the rape fantasy was also returned, with more explicit instructions as to what had to be included, which he then included. This appeared less like treatment than an institutional attempt validate research.[29] Though the program is supposed to provide individual treatment, one is treated as part of a group, and whenever a new member enters the group, the group goes back to the beginning of the program. As far as appellant is aware, no one has completed the program and been released. Appellant's concern with confidentiality was related primarily to the Alcoholics Anonymous program; he attended hospital AA meetings for about three months, mostly listening to the other patient-members. When he went to his team evaluation, he was asked why he was not speaking up more in meetings. Realizing the meetings were being reported, appellant refused to continue to attend. (RT 475-478, 491, 494, 496-501)

Appellant declined to be reinterviewed by Drs. Hupka and Korpi in 2002 because he felt it would be counterproductive: appellant does not believe he has a mental disorder and feels the doctors take what he says and "make it mean" something else. (RT 484-485) In 2001, appellant wrote an article for the Atascadero patient paper in which he referred to those who participated in the treatment program as "collaborator[s]." Appellant encouraged patients not to eat in the dining hall, or participate in anything which justified funding of the hospital. Appellant wrote the piece because Atascadero is supported by free patient labor, because the programs there are a misuse of the SVP law, and because he feels duty-bound as an American citizen to try to correct social ills. Appellant never advocated violence, but did advocate peaceful resistance; appellant does not believe the SVP law is wrong, just wrongly

28 Appellant was speaking both metaphorically and generally: when he was in "the big Phase 1," a large group held in an auditorium, the psychiatrist would compare the program patients to serial killers through the ages. (RT 498-499)

29 Appellant read *Prisoners of Hate* by Aaron Beck, who did the first work on cognitive distortions; an example of a cognitive distortion would be for a rapist to claim his victim "wanted it." The Atascadero program uses the concepts and subsequent therapy in a wholly different fashion than as prescribed by Beck. (RT 491-492)

implemented.[30] (RT 488, 520-522) Appellant has written four articles for the paper, including an essay on behaving with integrity, noting integrity comes from within, a piece on honor, and one on unity. (RT 523)

The homosexual community in Atascadero uses the movie theater and chapel to engage in sexual activity, so appellant avoids those areas. Appellant is also aware that a patient went into an educational area and beat up a female staff member during an attempted rape. This patient is now in prison, having formerly been the "poster boy" for the SVP program, a "phaser," someone who went through the program phases. Another patient used to threaten suicide to be put on individual watch, enabling him to masturbate in front of female staff. Basically, there are many opportunities to engage in overt sexual behavior at Atascadero. Appellant does not take these opportunities, and has no desire to do so. (RT 478-481)

Appellant does not have a mental disorder. He had a problem with his "outlook" at one point in his life, but no longer. (RT 478, 504) Appellant intends never to harm anyone again; he has no needs or wants in that area. Appellant never had rape fantasies, and any fantasies he has at this point are more recollections, and circle around lake-fishing. (RT 481) Whether or not he is released, appellant plans to continue his legal education, motivated by a desire to reform the way the SVP law is applied. If released, appellant will live with his brother and grandmother in Northern California. Appellant believes that having come to know Christ as his savior, he is no longer the person he was before, but is now a person of God. Being a person of God means God has changed him from within; for appellant to attend a program that is less than God would be to turn his back on God and God's works. Appellant's faith will always be part of his life. (RT 487, 503-504)

---

30 More specifically, those who "act out" are sent to jail, convicted, then go on to prison, leaving the more rule-abiding patients in Atascadero. (RT 522) None of the patients boycotted the facilities as a result of appellant's article, including appellant. (RT 523-524)

## STATEMENT OF FACTS

### Prosecution Case

Federal Bureau of Investigation Agent Marc Botello is assigned to the Los Angeles Safe Team, a multi-agency task force that investigates crimes against children. Botello has been specifically trained in computer investigations; on July 10, 2007, Botello was online, posing as a 13 year old girl in a AOL chat room called "Los Angeles." A "predicated" chat room is one in which law enforcement has previously found people trying to meet young girls: "Los Angeles" is a predicated chat room. Botello's screen name was MSMEGAN818; he went by "Megan." "818" was a reference to a San Fernando Valley area code: during his chats with appellant, Botello said she lived in Woodland Hills. Botello's online profile stated that she was going into the 8th grade. No age was listed. Megan's profile was available to anyone who was in the chat room at the time. (RT 1:135-137, 1:139, 1:150-152, 2:174-181)

Using the screen name RJAH4U, appellant sent Botello an instant message, and they began a private chat. During one of their ensuing chats, appellant sent Botello a photograph. (RT 1:144-148) Appellant told Botello that he was 18 years old; he lied. Oftentimes people lie online. Botello told appellant that she had a 13 year old friend who was orally copulating her boyfriend; this was also a lie. Botello told appellant she was 13. (RT 2:193-195, 2:196-199)

"Grooming" is a technique whereby adults attempt to befriend a minor, asking general questions about the minor's family, school, friends, etc., then asking specific questions about sex. Photos are often sent, first of people in bikinis, then of naked adults. Grooming is a desensitizing technique, designed to make the minor comfortable when the groomer begins to ask about sex. In Botello's chat with appellant, appellant asks how long she's been living at her house, if she has friends her age there, where her mother works, if her mother' s at home, if she can still talk on the phone. Appellant sent Botello three photos: one of a woman in a white shirt, one of two women in gymnastics uniforms, and one of a woman in a gymnastics uniform. Appellant wrote to Botello about kissing her. Botello believed appellant was engaged in grooming. (RT 1:154-158, 2:199) Botello sent appellant two photographs of herself after appellant sent one of himself.

Appellant told Botello that he lived near Knott's Berry Farm; Botello said she lived at the Oakwood Apartments. (RT 1:162-166, 2:181-185, 2:216)

At some point, a meeting was arranged via Botello's online communications with appellant and subsequent telephone conversations involving FBI Agent Adrienne Mitchell. The meeting was supposed to occur on July 25, 2007 at 7:30 p.m.; that meeting did not take place, so a second meeting was scheduled for July 26th. Appellant said he would be driving a blue pickup truck. (RT 1:164-167)

During the course of her duties, Agent Mitchell has made approximately 100 telephone calls pretending to be a child. Mitchell has received special training on how to communicate like a child and has spent time in the field interviewing children and teenagers. (RT 1:110-112, 1:136) In July 2007, Mitchell had four separate conversations with a man named "Raj;" she was given the contact number by Botello, who appraised her of his on-line communication with appellant. (RT 1:112) Mitchell didn't know if "Raj" ever left his house, or where he was when they were speaking. (RT 1:115)

In the conversation[1] between Megan and appellant on July 25, 2007 at 7:15 p.m. "Raj" tells Megan he made a "boo-boo," that he's still coming, but got on a wrong freeway, is running about 20 minutes late, and will be there by 8. (CT 36-37) Appellant asks if he can instant message Megan; they decide she will call him at 8. (CT 37)

In the conversation at 7:55 p.m, appellant complains that he got the wrong directions, is stressed out. Megan says, "You're still coming though, right? You said you were coming." Appellant says he needs to get new directions, needs to go back on is computer. Megan volunteers to look up the directions for appellant and call him; appellant agrees. Appellant gives Megan his address, she says she'll call him back. (CT 38-40) In the conversation at 8:05 p.m., Megan gives appellant directions, then tells him that it would take an hour to get to her from appellant's house and her mother gets home at 10. They agree they don't have enough time. Megan suggests they do it a different day. Megan asks if appellant's going to be online tomorrow, suggests they instant message then. They agree on a time to communicate, and again agree that it's too late; appellant says he wants to make it "well worth it." He thanks Megan for calling him, and tells her that she has a cute

---

1 Taken from People's Exhibit No. 2, a transcript of People's Exhibit No. 1, a CD of the conversations played for the jury. (RT 1:113-115)

voice and picture. She thanks him, asks where he's calling from. He says he's using Lauren's cell phone. (CT 41-44)

According to the recording of the conversation of July 26th, at 4:55 p.m., appellant tells Megan what freeway exit he's taken to get to her house. She gives him street-by-street directions to where she is, telling him where to park and meet her. (CT 44-46)

Jeffrey Ferber is a California Highway Patrol investigator, on loan to the FBI's Safe Team. His duties include creating an on-line identity of a young girl. On July 26, 2007, Botello directed Ferber to go to Oakwood Apartments in Woodland Hills. Appellant was stopped inside the parking lot outside the gated compound.[2] His pickup truck was searched, and a duffle bag recovered from the passenger seat containing a bottle of rum, a can of soda, deodorant body spray, candy, a shot glass, two condoms, MapQuest driving instructions from appellant's home address to the Woodland Hills location. (RT 1:116-122, 1:124-126, 2:200-201) According to Botello, these are the kinds of items commonly found with people who are traveling to have sex with minors. They could also be used on a date with someone who was over 18. (RT 2:202-206)

Botello interviewed appellant post-arrest; based on his training and experience, Botello felt appellant was not in the habit of meeting minors. (RT 1:168, 2:173, 2:187-191, 2:195) In the recording of the interview,[3] Botello identifies himself and Brian Sikel of the Sheriff's Department. Botello tells appellant that he's investigating children, kidnapped children, "Internet," and asks for appellant's background information. Botello advises appellant of his Miranda rights; appellant says he is willing to talk. Appellant asks whether, if Botello asks him a question he doesn't like, he can refuse to answer until his lawyer is here, and Botello says that's fine. Appellant signs the form. (CT 48-50)

Appellant says he went to the location to meet his friend Megan, who he has been talking to online for a week. They have been chatting in the AOL "Los Angeles" chat room: appellant's AOL name is RajAH4U. He uses his father's screen name, to chat because his parents put a parental block on the computer and his father won't let him chat. (CT 50-53) Appellant says he chatted with Megan five to ten times. Megan is a girl; she told him she was

---

2 Appellant did not enter the complex's main parking lot. (RT 1:127)

3 Taken from the transcript admitted as People's Exhibit No. 9, prepared from the CD admitted as People's Exhibit No. 8. (RT 169)

18, and goes to school. She said she was on summer vacation. Botello says appellant got directions to Megan's house from Megan; appellant agrees. (CT 53-54) Botello asks appellant what he thinks about all this. Appellant says he's never going to go out of his way to meet someone new online. He says he's a good-hearted person and doesn't want "to go down as a fucking pedophile..." He says he never saw Megan, never touched her. He just arrived to find the police. He originally wanted o go to a movie with Megan, but she said no, there were too many people that knew her, she didn't want to be seen with appellant. (CT 55-56) Appellant says he only has one computer at home. (CT 56)

Botello says they found "some stuff" in appellant's car, and wants to know what appellant's plans were for the 18 year old girl. Appellant says he never said he wanted to have sex with her; he wanted to hang out. Botello asks about the alcohol and condoms. Appellant says it's a guy thing, he just wants to "be prepared." Botello asks if appellant always brings condoms on a date, appellant says not all the time. Botello asked what appellant and Megan talked about, appellant said they talked about kissing. Botello says the condoms were to be prepared if Megan was willing to have sex. Appellant agrees. (CT 56-60) Appellant says Megan said she lived with her mom. He was going to pick her up and go to a mall, to a movie: Megan said he could hang out at her house if he wanted to. He has not met girl online before. (CT 60-61)

Botello says appellant is looking down, "that's deception." He says lying to a federal agent is "another violation, okay. 18 U.S.C. 1001. False information to a federal agent, okay. You could be charged with that, okay." He says that appellant is 23 years old, knows that something is going on, given the police and FBI involvement. He says if appellant starts lying, Botello can walk out, and appellant can "go to court, and just prove without a shadow of a doubt that you're lying to me." He tells appellant not to dig a deeper hole for himself, that he can bring out the chats and show appellant exactly where Megan told him how old she was. He tells appellant to be honest: "That goes a long way. It goes a long way with the, the, FBI. It goes a long way with the prosecuting attorneys. It goes a long with the judge." Botello says it's not his job to put 23 year old kids in jail; it's up to appellant to decide how he wants to handle the situation, "But part of that goes with your cooperation." He asks appellant how old Megan was. (CT 61-63)

Appellant says Megan said she was 13, he told her he was 18. Botello asked whether appellant would have had sex with her if she had been willing; appellant asks if he has to answer, Botello says he doesn't have to answer anything, "but as I told you...." Appellant says he wants to cooperate; Botello says that's his best opportunity. He asks appellant if he would have had sex with Megan, appellant says not the first day. They only talked about kissing and him holding her and watching a movie. (CT 63-65) Appellant reiterates that he has not met other girls. (CT 66)

Sikel tells appellant that they know he's not a horrible person, not a pedophile or predator. (CT 66-67) There is a conversation about appellant's family. (CT 68-70) Appellant admits he tried to go to Megan's the day before but that he got lost. He says he sent two pictures to Megan, one of his penis. He's sent pictures to other girls, who have sent pictures back. Not to girls under 18. He has looked at online porn featuring 18 or 19 year old teens, and once saw site with children around 15 or 16. He didn't remember the name of the site, but got to it via links on other sites. Appellant likes older women. (CT 71-78) In appellant's mind, he is 20. (CT 79) There is a discussion about what is to happen next to appellant. (CT 80)

## Defense Case

Appellant was attracted to the "18" portion of the MSMEGAN818 moniker. He lied, saying he was 18: appellant was 23. When MSMEGAN said she was 13, appellant thought she was lying, playing an online game. She had talked about her girlfriend orally copulating a boyfriend, and that did not sound like a 13 year old to appellant. (RT 2:209-210, 2:215-218) Appellant played back. During their chats, he said he wanted to hold her and kiss her and that he would take her to the mall and Knott's Berry Farm. (RT 2:210, 2:214, 2:218-219, 2:223-226)

Appellant had never chatted with anyone under age online before. He was going to go watch a movie with Megan, see if she was really who she said she was, see if she was attractive. Appellant thought she was at least 18: if she hadn't looked at least 18 when they met, appellant would have left. (RT 2:211-214) He told the officer that "she said she was 13," but appellant didn't believe that. (RT 2:214-215)

The duffle bag had been in appellant's car for a week by the time he went to visit Megan. (RT 2:220-221) Appellant lived at home; he couldn't use his own online ID because his parents' computer has parental controls

blocking access. He has talked to a lot of people online, but never anyone who said they were 13. At the time of the event, appellant was unemployed. (RT 2:226-229)

# STATEMENT OF FACTS

## Prosecution Case

In April 2007, Redondo Beach police officer Alan Beck was working as a detective in the sex crimes desk; his duties included pursuing pedophiles on the Internet. Robbery/homicide detective David Taneman's duties also included periodically participating in Internet investigations. In this investigative capacity, the officers created an online AOL profile using the screen name W Beach Girls 13, and listing activities that a 13 year old girl would enjoy. They would then go into a chatroom and wait to be contacted. A chatroom is an online public venue where people with similar interests can converse. (RT 2:673-676, 2:1548, 3:1869-1870, 3:2110) The officers use Power Tools version 12, a software program that works with AOL to automatically record online chats. The chats are saved on the detectives' computer hard drive, under the subdirectory I.M. Capture, within another subdirectory with the contact's online name and the chat date. In addition to the detectives' computer, there was another computer in the Special Investigation Unit that was sometimes used. (RT 2:685-689, 2:1549-1552, 3:1818-18) In 2005, Beck participated in a half-day police training session on Internet chatting with potential pedophiles. An I.P. address is a number that uniquely identifies a computer online for a particular time and date, akin to a "signature." (RT 2:1543-1548, 3:1817-1818)

On April 20, Beck entered a "Los Angeles" chatroom as W Beach Girls 13, and was contacted by RedDogJS; during the chat, Beck would sometimes be replaced at the computer by crime analyst Gina Quinones. Typically, an officer would carry on between five and ten chats at a time with various contacts: chats are kept separate via tabbing format, which contains the screen name of the person being chatted with. Within the first four lines of conversation, Beck told RedDogJS that W Beach Girls 13 was female, thirteen years old, and asked RedDogJS how old he was. RedDogJS said he was 28. (RT 2:677-680, 2:687-688, 2:690-691, 2:1541, 2:1554-1555, 3:1812-1813, 3:1831-1832, 3:1852-185)

Photos were exchanged via email after RedDogJS asked for pictures. W Beach Girls 13 sent RedDogJS three images of a thirteen-year-old girl; RedDogJS sent W Beach Girls 13 a photograph of appellant at the Grand Canyon. RedDogJS said W Beach Girls 13 was "pretty sexy," and that he wanted to lick her "from our feet all the way up to our pussy" and give her

his "hard cock." RedDogJS asked if she would like to have sex with him; she said maybe. She said she didn't want to get pregnant. He agreed. (RT 2:680-684, 2:695-700, 2:703, 2:714-715, 2:1510-1512, 2:1559-1560, 3:1825-1826) The April 20th conversation was very sexual: oral sex and intercourse and sexual positions were discussed, as well as contraception and the need to keep the contact private because any encounter would be illegal. W Beach Girls 13 told RedDogJS that she was a virgin. He said that he would take it slowly. (RT 2:684-685, 2:700, 2:702-703, 2:706-708, 3:1813) W Beach Girls 13 told RedDogJS that her mother was a nurse and away at work, leaving her in the house alone. RedDogJS asked her if she would go to a hotel; W Beach Girls 13 said that seems scary. He said he would treat her sweetly. There was some discussion about possibly meeting in the late afternoon. (RT 2:696, 2:704-706, 2:708)

On May 1, Quinones chatted with RedDogJS in the "Los Angeles" chatroom; the chat was saved via software. (RT 3:1834-1838) During this chat, RedDogJS and W Beach Girls 13 discussed what she was doing that day. She said she had ditched school because there were parent conferences that day; they discussed meeting the following day. Included in the discussion about what they would do when they met were things like oral copulation, vaginal intercourse, and "getting the female 13 year old wet." She asked RedDogJS if intercourse would hurt, he said it shouldn't as long as he goes real slow. She asked if he would laugh at her, he said no. She asked if he would teach her, he said yes. RedDogJS asked W Beach Girls 13 to keep things between themselves because having sex with an older man is illegal. He asked for another photo; she did not send one. She asked for a photo, and he sent a picture, and said it was old. He said he'd sent a photo previously of himself at the Grand Canyon. (RT 3:1840-1848, 3:1858)

On May 3rd, Quinones chatted with RedDogJS about why they hadn't met the previous day; he said he'd had a hectic day. He asked for more photos, but none were sent. There was a brief sexual discussion in which RedDogJS said he wanted to taste W Beach Girls 13. It was a shorter chat. (RT 2:1257, 3:1848-1852)

On May 23, 2007, Det. Taneman and Quinones were conducting the online chats, including the chat with RedDogJS During that chat, condom use was discussed, and details about where and when they might meet. RedDogJS had some security issues, and was concerned about other people being present; he indicated that W Beach Girl 13 was to say she was

18 years old. RedDogJS said he sold musical equipment and that if anyone asked, she was to say that he was there to talk about pianos. There was additional graphic conversation regarding oral copulation; RedDogJS told W Beach Girl 13 how to orally copulate him. He also indicated that if she wanted to, they could get together again after the first time. Beck also read some of the chat over the others' shoulders. The location for the meeting was set at 220 S. Prospect in Redondo Beach, next to a 7-Eleven. RedDogJS was late to the meeting, and kept writing W Beach Girl 13, saying he was concerned about "the legal issue." Beck went to the meeting site; another detective was parked in the 7-Eleven lot, while a third detective roamed the area. The detectives were in unmarked cars; a patrol vehicle stood by Det. Taneman remained online at the station: he radioed Beck and told him that the suspect said he was in a white van parked at the Pizza Hut parking lot, on other corner of the intersection. (RT 2:709-716, 2:1513, 2:1555, 3:1867-1868, 3:1872-1881, 3:1883-1891, 3:1894-1906, 3:2105, 3:2113)

Beck saw a white van drive from the Pizza Hut lot to the 7-Eleven lot. The detective in the lot radioed that the driver matched the photo sent by RedDogJS The patrol officers then arrested the driver. Beck identified appellant as the driver. (RT 2:716-719, 2:1513) A laptop was open on the passenger seat of the van, keyboard facing the driver. The end of an active chat between W Beach Girls 13 and RedDogJS was on the screen; there was a wireless internet card in the laptop. There were no drugs, alcohol, condoms, hotel reservations, mattresses, or sex toys in the van. The computer was transmitted to Det. Ribitzki, the computer forensic detective. (RT 2:719-725, 2:1513-1516, 2:1555-1559) At some point on the 23rd, Beck printed out copies of the chat; as far as he could tell, the printouts were accurate transcripts. (RT 2:689, 2:1553, 3:1828-1829)

Beck and Taneman interviewed appellant at jail. After advising appellant of his constitutional rights, and obtaining a waiver, Beck showed appellant transcripts of the April 20 and May 23 chats. Appellant said that RedDogJS was his screen name, and no one else in his family has access to that name. Appellant remembered chatting with "W Beach." He initially stated that she was thirteen, then said she was of legal age. Beck showed appellant the first page of the April 20 chat, and appellant agreed that it was an accurate representation of the age discussion had online. Appellant also agreed that the conversation became very sexual. Appellant said he was aware of sting situations involving meetings with minors, and that he himself

had been the attempted victim of check fraud. He said he participated in the chats and came to the meeting with W Beach Girls 13 to test the justice system and that he wanted "to find out on the Internet what was true and not true." (RT 2:1516-1525, 2:1530-1531, 3:1806-1807, 3:1810, 3:2105, 3:2108-2110)

Appellant was glad that law enforcement was on the scene to stop such things from happening. He said he was glad the television program "Dateline: To Catch A Predator" was not there, and if a girl made sexual advances towards him, he would have declined for fear of arrest. (RT 3:1808-1811, 3:1827) Appellant granted Beck permission to search the laptop. He said they would probably find the emailed photos. Beck showed appellant the first page of the May 23 chat, and appellant indicated it was his chat as well. Appellant identified the photo of himself at the Grand Canyon, and said he sent it to W Beach Girls 13 by email. Appellant said he told W Beach Girls 13 that she would have to lie about her age if anything came up. (RT 2:1532-1537)

During the interview, Taneman noticed that appellant was wearing a gold ring with a diamond-studded dollar sign, which Taneman recognized from the photo sent by RedDogJS (RT 3:2106-2107)

Det. Paul Ribitzki works in the Redondo Beach Police Department Computer Forensic Section; he has had over 300 hours of computer forensic training at the California Department of Justice, and is a member of various technology criminal investigation associations. Ribitzki received the laptop taken from appellant's van from Beck; there was a Cingular Wireless card attached to the computer for Internet access. Ribitzki photographed the computer, removed the hard drive, attaching the drive to a hardware device that allows for retrieval of information, but prevents writing on the drive. (RT 3:2117-2124) The hard drive was then processed by Encase, a software program that reads the hard drive bit by bit. Six images were detected on the computer: three sent by police, three by the computer user. The images sent by police were contained in a folder "eight levels down," meaning eight folders within the operating system. The folders were user created. (RT 3:2125-2129, 3:2141-2145, 3:2147-2149) Ribitzki searched for "W Beach Girls 13," finding chat artifacts, or parts of an online chat, in a temporary file; these were also photographed. Those artifacts matched parts of the May 23rd chat provided by Beck. (RT 3:2129-2142, 3:2145-2146, 3:2150)

<u>April 20, 2007 Chat[1]</u>

The chat begins at 2:09 p.m. RedDogJS (RDJS) asks W Beach Girls 13 (WBG13) how old she is. She writes 13; he writes he was going to say "'wanna really partyyy' lol." RDJS tells WBG13 that he is 28. They chat about him coming over; he asks her if she has a picture. He writes she is "way sexy." He writes he'd have to lick her from "toes upp etc…" up her legs and "to her pusssyy of course." He asks if she'd like that, she writes yes, asks what else he would like. He writes that if he saw her, he'd want to give her his "hard cock 4 sure." He asks if she has ever done it before, and she writes she is still a virgin but curious about things. RDJS indicates that he sent a picture from a few years ago in the Grand Canyon. (Supp. CT 2)

RDJS asks if WBG13 would want to have sex with him. She writes maybe, would he teach her the right way. He writes he would. She writes she doesn't want to get pregnant. They discuss her learning, not getting pregnant, using "rubbers." RDJS says he loves oral sex, and they should "69 etc….ummm." He writes he will teach her how to "suck cock real well." He writes it could be "real risky & dangerous in cause of your age." They say they don't want to get into trouble. He writes he would love to "lick your pussy & give it my cock too." They discuss his work schedule and when her mother will be working. RDJS writes he has a van but it would be too dangerous to "get crazy in it…if cops etc came by for any reason… lol." He writes hotels would be better, and explains that they are not expensive. WBG13 writes that she doesn't want to go far from home because she is scared "….a little scared but u seem nice." RDJS writes that he would treat her "w/ sweetness, all around." He writes that he would start kissing her, "take our clothes off," "kiss your lovely chest…nippless…" He writes that his "cock would be getting sooo hard," and then describes orally copulating and vaginally penetrating her. He asks if she's feeling horny and writes that they should "fuck uh…have some good sex." (Supp. CT 3-5)

They discuss time frame. RDJS writes that "it'd have 2 b soooo like 'never happened' thogh," "for hotel I'd say u'r e my lil cousin or something." They discuss whether sex will hurt; he writes that they have to take it "slowwwww & nice." They discuss meeting tomorrow. RDJS writes that he does "wanna hook w/ you though…u're so sweet & sexy & cool." WBG13 writes she will check her mother's schedule. RDJS writes, "& willing." They

---

1 Taken from the transcript introduced as People's Exh. No. 4 (Supp. CT 1)

discuss maybe meeting later tonight; RDJS writes that he has to run. The chat ends at 3:42 p.m. (Supp. CT 5-6)

May 1, 2007 Chat[2]

The chat begins at 9:56 a.m. RDJS asks why WBG13 is home, she writes that there are parent conferences. She reprimands him for flaking on her. He apologizes, confirms that she still wants to get together. They discuss meeting tomorrow; discuss doing everything previously discussed. WBG13 asks RDJS if he is going to "laff" at her. He writes, "of course not." She asks if he will teach her; he writes that he would love to. They set a time. RDJS asks if she is sure that she can keep this "totally secret between u & I." WBG13 writes that he can't tell anyone because her mother will kill her. They discuss using "protection," and exchanging another photo. The chat ends at 10:34 a.m. (Supp. CT 21-23)

May 23, 2007 Chat[3]

The chat begins at 12:56 p.m. WBG13 writes that her mother is home, but leaving soon. The chat ends at 12:59, and a new chat begins. They discuss times to meet and exchanging more pictures. WBG13 accuses RDJS of starting "to flake." He writes that he is swamped working. They plan for him to come to her house. He worries about "'securety' issues," asks if she has siblings, how long her mother will be gone. He tells her that he sells musical instruments, writes that he can "pretend coming over to talk u about pianos, right?" He writes, "u wanna have sex right?" They discuss him being gentle, he writes that he's "never done virgin either, I don't know if I told u." They discuss taking it slow and getting her wet. He asks if she's ever "taken a man's cock in [her] mouth," writes that "all u have to do is squuze it & suck it hard & it's gooood." They discuss timing. He writes that if they get to do it again, "probably could, but let's just do 1st time as 'experiment w/no mor eexpectations' u know & go from here." She writes that she hope he likes her. He writes that he thinks he will. They make a plan to meet around in one hour, around three. The chat ends at 2:04 p.m. (Supp. CT 8-10)

A second chat begins at 3:08 p.m. RDJS says that he's "here." There is a discussion about whether RDJS can make the appointment, he writes that he can stay "at laest hour." RDJS asks for directions; WBG13 gives 220

2 Taken from the transcript admitted as People's Exhibit No. 12. (Supp. CT 20) The transcript of the May 3rd chats, one from 3:52 p.m. to 4:02 p.m., the other from 4:05 p.m. to 4:27 p.m, where RDJS and WBG13 discuss possibly meeting tomorrow morning, are not included here as they were not introduced into evidence. (Supp. CT 23-25)

3 Taken from the transcript introduced as People's Exhibit No. 9. (Supp. CT 7)

S. Prospect as an address, noting that it is next to a 7-11. The chat ends at 3:28 p.m. (Supp. CT 10-13)

A third chat begins at 4:19 p.m. WBG13 asks if RDJS is there, he indicates that he is. He asks her if she is nervous; she writes that she is, asks him the same. RDJS writes "sureh." RDJS writes that he is worried "about the legal issue truly still lol." He writes that "if in case anything were to come up etc, we'd have to keep it as 'you lied about your age' u know...& said u were 18 uknow." WBG13 asks if he is bringing alcohol; they agree that they don't like to drink. RDJS writes that he is worried about her neighbors. He asks about her mother coming home. She writes that she never comes home. (Supp. CT 13-16) They discuss how long it will take him to get there. He asks her if she is sure she wants to; she says yes. She writes that she's taken a shower. They discuss beverages. RDJS writes that he is parked at the "vid place now." The chat ends at 6:16 p.m. (Supp. CT 16-19)

Defense Case

Appellant testified that he repairs and sells musical instruments; his work requires the use of various tools, including hand tools and specialty tools, as well as traveling to where the instrument is located. He used to have a white van for this purpose. (RT 3:2156-2158, 3:2186) Appellant is married, and has three stepchildren, who were 16, 20, and 21 years old in 2007. They "heavily" participate in Internet use. (RT 3:2158-2159, 3:2408) Using the name RedDogJS, appellant personally participated in the April 20, May 1, and May 23, 2007 chats with W Beach Girls 13. He did so "to become part of the enemy": he has been the victim of various theft-related crimes, ranging from the loss of a cellphone to the loss of a $43,000 car, and the police were unable to help him in those situations. He felt it was him against the world when it came to justice. Appellant was also almost the victim of a $18,000 Internet theft, and a month before appellant entered the chat room, $30,000 was stolen online from his grandfather. He went into the chat room to find out what was going on behind the screen: he felt there's no justice system in place to take care of Internet crimes. (RT 3:2159-3:2163, 3:2188-2189)

When appellant saw the W Beach Girls 13 screen name, he thought it was a prostitution ring, or someone selling children. He did not think it was an individual because of the "s." He thought it was an adult, or a computer generated response. He did not believe it was an actual 13 year old girl: there were many "red flags" which led him to this conclusion. For example,

he did not believe that a child who was engaged in this sort of activity would also be staying home to answer the phone for her mother, or the purported child's desire to stay close to home instead of going as far from possible from home, and the use of the word "protection" to refer to contraception, as well as other "adult" language. He was also suspicious of the kind of photos which were sent. The photos that were sent were studio shots, not group shots or more casual photos which would be more available to a real child. There were too many misspelled words for a real 13 year old, and it was too easy for her to get out of school. Online, appellant acted as if he was a criminal, "playing the game on the screen." He felt that he had to keep the game going, and all his online responses were to that end. (RT 3:2163-2176, 3:2182-2182, 2:2191-2203, 3:2409-2416, 3:2420-2435)

Appellant said he was 28 to make himself more attractive to whatever was on the other end of the chat. (RT 3:2173, 3:2194) When he showed up for the meeting, he didn't know what he was going to find. He had his cell phone set to speed dial the police. He did not call the police before going to the meeting because he thought they would not have believed him. He went to a drugstore before driving to the meeting and bought a snack; he did not purchase condoms or alcohol, and did not bring condoms or sexual toys with him the meeting. Appellant did not intend to have sex with a 13 year old girl. When interviewed at the station, he told the police that he engaged in the chat because he was upset about sexual predators on the Internet. (RT 3:2176-2181, 3:2190-2191, 3:2416-2420)

Rebuttal

Appellant did not tell Beck that he was investigating criminal activity. (RT 3:2442-2443)

# STATEMENT OF FACTS

## Prosecution Case

Deborah and Craig J. have two children: Aubrey, from Deborah's first marriage, and Carolee. At the time of trial, Carolee was two and a half years old, Aubrey six and a half. On August 15, 2006, the family was living with Deborah's parents. Craig and Deborah's father worked outside the home from 7:00 a.m. until 3:30 p.m., and Deborah was in nursing school, which began at 7:00 a.m.[1] Appellant had been the family babysitter for four months; Craig dropped the children off on the way to work, and Deborah picked them up between 3 and 4:00 p.m. (RT 3:324-330, 4:609-611, 4:656-657, 4:659) Appellant was living with her partner, Lisa, and appellant's 18-month-old son. (RT 3:327, 4:653)

On August 15th, Carolee was almost 1 year old. That morning, Deborah left at 5:30 for school. She had changed her diaper the night before at 9:30 or 10:00, and could not recall who put Carolee to bed. Carolee was teething, crying. There was nothing unusual with her diaper. (RT 3:330-332, 4:612) There was also nothing out of the ordinary when Craig changed Carolee in the morning. Craig dropped off the girls at 5:45 a.m. before going to work. (RT 4:657, 4:661-662) Deborah was at her clinical site when she checked her voice mail and found messages from appellant saying that Carolee was bleeding and needed to go to the doctor. Deborah thought Carolee might have a urinary tract or kidney infection, as she had in the past. The infection had not resulted in bleeding, and had been treated with antibiotics. (RT 3:332-334, 4:614-616)

When Deborah arrived at appellant's house, appellant and Lisa were calmly sitting on the couch; Carolee was in the swing, and seemed "completely content." The women went outside and smoked a cigarette, and Deborah asked what happened. Appellant told Deborah that Aubrey said that she "didn't do it." (RT 3:334-336, 4:617-618, 4:620) Appellant and Deborah undiapered Carolee, and appellant asked if Carolee looked "larger" than usual. Carolee's vaginal opening looked larger, and there was a little bit of blood in the diaper. Deborah took Carolee to the hospital, bringing the soiled diaper appellant saved. (RT 3:336-339, 3:347, 4:604, 4:620-621, 4:624)

At the hospital, the doctors told Deborah that Carolee had been assaulted. Deborah told one of the doctors that she thought Carolee had

---

[1] Deborah quit school because of the charged incident. (RT 4:653-654)

been injured. Deborah spoke to a social worker and police; Carolee was in the room with Deborah, and seemed all right. Four or five hours later, the sheriff took Deborah and Carolee to a special sexual abuse clinic, where Deborah was interviewed and Carolee examined and photographs taken of the injury. The nurse also suspected Carolee had been sexually abused, and referred Carolee to the emergency room, where a Dr. Cormier stitched and Dermabonded Carolee's laceration. Family members and additional police arrived; afterwards, Deborah and Carolee went to the sheriff's station.[2] (RT 3:339-345, 3:347-350, 4:604-608, 4:625, 4:627, 4:639, 4:748-749) Deborah did not believe her parents could have done anything to hurt Carolee. (RT 4:652-653) Craig had no reason to think anyone at home had hurt his daughter, either purposefully or accidentally. (RT 4:673-674)

The medical evidence

Dr. Stephen Devita is a specialist in family medicine at Kaiser Permanente whose duties include working in Kaiser's urgent care unit. Urgent care services are for ambulatory patients seeking immediate attention; if necessary, patients will be stabilized at the facility then taken to Kaiser's emergency room. (RT 6:1202-1207, 6:1236-1237) On August 15th, Dr. Devita treated Carolee as an urgent care patient. He reviewed the intake document, which noted "blood in diaper" and "urine." Dr. Devita assumed it was a urinary tract infection, which Deborah said Carolee had previously had. Carolee "looked fine," and was not in any apparent distress. (RT 6:1213-1217, 6:1266) Deborah said something about the amount of blood, Dr. Devita examined the diaper, noting that the color and type of bleeding was inconsistent with a urinary tract infection, then visually examined Carolee. There was a large laceration at the bottom of her genitalia, from the posterior fourchette going into the vagina. The site was cut inward, and the hymen torn. Dr. Devita believed the injury was a penetrating injury, though not consistent with sexual penetration. He did not think a hooked plastic toy ladder could have caused such an injury, as it would have produced two cuts instead of one. (RT 6:1218-1228, 6:1233-1253, 6:1255-1265, 6:1269)

Deborah told Dr. Devita that she was worried that abuse was involved, referencing abuse with another child. Dr. Devita thought the injury had features consistent with forcible trauma. (RT 5:1228-1230, 6:1247) Dr. Devita contacted Dr. Gereb, Carolee's primary care physician; Dr. Gereb

---

2 Craig got a voice message from Lisa later that evening, but no message from appellant. (RT 4:672-675)

examined Carolee, a social worker within Kaiser was brought in, and the police called. Carolee was subsequently transported to a sexual abuse examination facility. (RT 5:1230-1235)

Nurse practitioner Marilyn Stotts examined Carolee at the children's assault treatment services facility. Stotts is a board certified sexual assault examiner, working in the field since 1996. She has trained other nurses in children's assault treatment services since 2000, and personally examined approximately 1500 victims, about 700 of whom were children. (RT 4:678-686, 4:690, 5:922-928)

On August 15th, Stotts did an intake interview with Deborah, who was pleasant but upset. (RT 4:689, 4:691, 5:929, 5:931) Stott was surprised by the quantity of blood in Carolee's diaper, and described Carolee's vagina as a "gaping hole." There was a large, deep laceration in the bottom area of Carolee's vagina, going into the posterior fourchette and possibly the perineum (the area between the vagina and the anus). Stott was unable to determine how large the injury was and how deep it went because she did not want to cause additional damage, and because the extant damage obscured closer examination. There was bloody secretion around the vulva. The laceration itself was approximately one centimeter long. Carolee was "docile" during the examination. Stott and a co-worker photographed Carolee, and Stott generated a report based on her examination. (RT 4:692-695, 4:704-705, 4:712-715, 4:718, 4:722-725, 4:727-729, 4:734, 5:912-914, 5:930, 5:932-933, 5:938-939, 5:944-945, 5:955-957, 5:961-962, 5:974, 5:997)

Stott examined both diapers. One contained dark matter that did not appear to be fecal, but could have been blood. (RT 5:934-923, 5:935, 5:946-947, 5:954, 5:961, 5:1006, 5:1009) A urethral prolapse, caused by a urinary tract infection, can cause blood in the urine. Exceptionally poor hygiene could also cause vaginal bleeding, as could a "straddle injury," accidentally hitting or falling onto one's crotch. There was no indication that Carolee had an infection at the time of the examination or had such excessively poor hygiene. Stotts initially considered the possibility of a straddle injury, but dismissed the possibility because Carolee was not walking and was wearing diapers most of the time. Straddle injuries are typically not in the middle of the vagina, and involve areas besides just the hymen and posterior fourchette. Stott was aware of a report some years ago involving straddle vaginal injuries caused by a child sitting on a rubber duck in the bathtub. (RT 5:935-937, 5:980-989, 5:996-998, 5:1003-1006)

A toy plastic ladder with a hooked end, placed into the vagina and pulled it out, could be consistent with injuries like Carolee's. A cutting instrument, such as a knife, could also have caused this sort of damage. (RT 5:999-1002, 5:1012-1013, 5:1015-1017, 7:1522-1523) At some point, Stott advised Ansberry that police should try and find some implement that could have caused Carolee's injuries. (RT 5:948-949, 5:952-963, 5:973) Carolee is the only patient whom Stotts has referred to a hospital for medical intervention. (RT 4:687, 4:730-731)

Carolee underwent a follow-up examination the following day; Stott looked at her afterwards. Carolee was on antibiotics, and cultures taken to detect infection. Additional photographs were taken, showing the ruptured lower portion of the hymen. The extent of the external damage prevented Stott from determining the exact dimensions of the injury. (RT 4:731, 4:735, 4:746-747, 4:749-757, 5:967-968) Stott conducted two additional follow-up examinations, one on August 23rd and another on September 25th. Reports were generated from these examinations. By August 23rd, the hymen had healed significantly, but was still abnormal. By September 25th, there was additional healing, and scar development; the lower portion of the hymen was still cut, and tissue still missing. Stott did not believe Carolee's hymen would heal completely. (RT 4:758-764, 4:766-767, 4:769-778, 4:902-911, 5:919-921) Hymeneal injury may be culturally significant as the intact hymen can be considered a symbol of purity. Stott didn't know if this would affect Carolee. (RT 4:777-778) Carolee's injuries were the worst Stott had seen during her practice. (RT 5:921-922)

Carolee had been previously hospitalized for an ear infection. Appellant called the emergency number after Carolee's eardrum ruptured, and she had begun bleeding from her ear. (RT 4:622-623, 4:675) In June or July 2006, Carolee had a urinary tract infection, which led to blood in her diaper. On the intake form, Deborah indicated Carolee had no such history. Deborah also did not tell the examining nurse that Carolee had previously had a blood blister on her vagina. (RT 4:629-638, 4:675)

Forensic nurse examiner Maryann Lague is a colleague of Stotts; throughout her 41-year career, Lague has performed approximately 22 suspected sexual assault examinations on young children. Lague assisted Stotts in her August 15th examination by holding Carolee while Stotts photographed her. Lague had never seen injuries like Carolee's. It was difficult to determine the exact extent of the hymeneal injury because of fear

of causing further injury or additional bleeding. (RT 8:1822-1832, 8:1847, 8:1-1852-1860) Lague observed the hymen was torn at the bottom in a jagged fashion, consistent with use of a blunt object. The hymeneal opening is approximately 5 mm, or one-third the size of a pencil eraser; the injury was approximately the size of an eraser. (RT 8:1833-1845, 8:1869-1871) The toy plastic ladder was capable of causing Carolee's injury, though both hooks could not have been inserted at the same time. (RT 8:1846, 8:1868-1869, 8:1872-1876) On August 16th, Lague assisted in the follow-up examination. (RT 8:1847-1849, 8:1851-1852, 8:1863-1867)

Dr. Clay Cormier is an emergency room physician at Kaiser; he examined Carolee on August 15th, preparing a report based on that examination. (RT 7:1585-1589, 7:1593-1595) Dr. Cormier found a "small, small laceration" in her genital area, which he sutured and Dermabonded. The laceration was 1 centimeter deep, and appeared to be a recent injury. Dr. Cormier was concerned about possible infection from urine and feces, but neither was present during the examination. Dr. Cormier saw no hymeneal injury, and would have noticed a significant injury. A normal vaginal opening in a child Carolee's age would be about 3 centimeters. Dr. Cormier believed Carolee's injury was caused by blunt trauma, a non-sharp object. It was possible the toy ladder could have caused the injury, though Dr. Cormier could not imagine both hooks being inserted. If the ladder was forcibly inserted and then forcibly removed, he would expect to see greater injury. (RT 7:1588-1592, 7:1595-1600, 7:1603-1605, 7:1607-1619)

The police investigation

After being briefed by patrol officers at Kaiser, Los Angeles Sheriff's Department Detective Charles Ansberry went to Carolee's parents' home, and asked Deborah's father and Craig to come to the station to be interviewed. After those interviews, Ansberry spoke to Deborah's mother and Aubrey, then interviewed Deborah at the hospital. (RT 6:1278-1287) Two days later, he talked to appellant and Lisa at their home. Appellant said she had sole custody of Carolee when Carolee was at appellant's house. Appellant told Ansberry that Craig had dropped Carolee off between 5:30 and 6:00 on the morning of the 15th, she put Carolee in the playpen, her son was in his bed, and she went back to sleep with Lisa, waking around 9:00. She changed Carolee's "particularly messy" diaper; afterwards, she noticed Carolee still smelled, so decided to bathe her and her son. After the bath, she diapered and dressed Carolee. (RT 6:1288-1291,7:1573, 7:1575-1576)

About twenty minutes later, appellant saw a small bit of blood on the front of Carolee's diaper; Carolee was very upset. Appellant, with Lisa present, opened the diaper, found much more blood, and tried to call Deborah. Appellant showed Ansberry the bedroom and bathroom, and discussed the possibility of accident or her son hurting Carolee. Appellant said this could not have happened as she was sitting on the closed toilet while the children were bathing. Ansberry photographed several toys in the tub, including a small plastic ladder. (RT 6:1291-1296, 6:1321, 7:1510, 7:1546-1548) The ladder, or a similar ladder, was later recovered from a defense attorney. (RT 7:1510-1514, 7:1550-1556)

Based on the medical reports, Ansberry arranged for follow-up interviews with Carolee's parents on August 24th. The interviews were conducted by Detective Scott Mitchell, and monitored by Ansberry on closed circuit television. (RT 6:1296-1299) Ansberry returned to appellant's home the following day; Lisa gave him notes concerning the time of the injury, and he arranged for follow-up interviews. On August 29th, appellant and Lisa were interviewed at the station by Mitchell, with Ansberry watching and recording. Appellant was interviewed for three and a half hours; the interview was temporarily stopped after appellant indicated she no longer wanted to participate. (RT 6:1299-1301, 6:1321, 7:1506)

As appellant was escorted out of the building, Ansberry spoke with Lisa, suggesting that she take appellant to lunch and encourage her cooperation. Ansberry stressed that Lisa should be concerned about appellant's son. Afterwards, Lisa left, returning twenty minutes later with appellant. Appellant was taken to a room to be reinterviewed; she asked Mitchell for a room that was not recorded, and was taken to another room, where Ansberry watched and recorded the questioning. During the interview, appellant initially denied any involvement, then confessed after detectives used some deceptive strategies to lure her out. These included telling appellant that she would be less likely to reoffend if she confessed. No threats or force was used. (RT 6:1301-1304, 6:1314-1315, 6:1320-1321, 6:1323, 7:1506, 7:1509, 7:1563-1566, 7:1571)

## Appellant's Interviews[3]
### The first interview

The first interview begins with Det. Mitchell asking appellant who was the most influential person was in her life; appellant says her parents. In response to questions, appellant says she has not had any alcohol recently, or anything to eat that day. She can't eat because she is too upset about the girls, who are like her daughters. She now doesn't trust anyone with her son. She talks about getting her first job, at WalMart; she is supposed to be drug tested today. (CT 3:585-589) Mitchell leaves her with a consent form, returns, and has appellant sign the form after she says she understands its contents. (CT 3:589; RT 7:1567-1568)

Appellant says she is Carolee's babysitter. Carolee's dad drops her off on weekday mornings. She gets along well with Carolee's mother, but there have "always been bad feelings with the dad." She says there's questionable stuff, and she thought "foul play" was going on with both his children. Mitchell asks why a good person would do something like that; appellant says a good person wouldn't, only someone with a "sick and evil mind" would. She says men are known to be sick like that. (CT 3:590-593) Mitchell says the doctors have said that Carolee has internal damage to her vagina. Appellant says she tried to clean it out, but didn't see any damage, just blood clots and old blood, like a nosebleed. Lisa was also in the house. Appellant had woken everyone, Carolee's diapers smelled like poop, so she changed her then put her in the tub. She didn't see any bleeding. (CT 3:593-595)

Carolee played with appellant's son in the tub; after about 20 minutes, appellant took her out and she began screaming. Appellant changed her, dressed her, and tried to feed her but she just kept screaming. Appellant put Oraljel on her for teething, then saw a dot of blood on the back of her diaper. Appellant thought Carolee might be constipated, opened the diaper, saw a lot of clots and old blood and told her partner to call 911. (CT 3:595-596) Appellant tried to clean Carolee with a baby wipe, but Carolee was screaming too hard, so she stopped. Appellant called Deborah and Craig, and Deborah's mother, but no one answered. For the next hour and a half, appellant called, leaving numerous messages, finally telling Deborah that if

---

3 Based on the transcripts introduced into evidence as People's Exhibit Nos. 17 and 18. Ansberry testified the transcript was an accurate, though edited, account of the recordings. The edits included appellant's breaks. (RT 6:1318-1320, 6:1325, 7:1505, 7:1516-1517)

she didn't come home or call back appellant was going to call 911. (CT 3:596-598) Appellant had called 911 a month before when Carolee had a broken eardrum. Carolee's parents seemed upset that she had called because of the expense, and told appellant to call them next time. (CT 3:597-598)

Appellant says Deborah came home twenty minutes after appellant's last call. She showed Deborah the diaper; Deborah said the same thing had happened the night before. Deborah had not seen anything unusual earlier. Mitchell tells appellant that the doctors said some object was put into Carolee's vagina and damaged her. Appellant says she has no doubt that it would, but that she did not see a rip. Mitchell asks if appellant could have caused the injury; appellant says there were toys in the bathtub which Carolee could have sat on, but doesn't think it happened there. Mitchell says that the doctors said someone had messed with the girls. (CT 3:599-602; RT 7:1577)

Reminding appellant of her family and religious ties, Mitchell asks what appellant would say if Deborah asked why she had done this. Appellant says she would say Deborah was on crack, and had the wrong person, to look into her own home. Appellant says Caitlyn was molested; Mitchell says that involved a grandfather; appellant points out that Craig was also around. Appellant says she's had a suspicion about Craig from the beginning. Mitchell offers appellant a restroom break. (CT 3:603-605)

After the break, they discuss the absence of blood in the bath. Appellant explains that Lisa did not help take care of Carolee until after appellant saw the blood, and that Carolee was with appellant from the time Craig dropped her off until Deborah arrived. (CT 3:605-608) Appellant reiterates that Carolee screamed when appellant tried to clean her, and says she kept the first bloody diaper to show the doctors. Appellant says it looked like old blood. Appellant called Sandra to get her opinion; Sandra saw the diaper, freaked out, and said it was old blood. (CT 3:608-610) Mitchell asks if it was possible that Lisa caused the injury, appellant says no, she would never do such a thing and had no access to Carolee. Appellant thinks it's Craig. (CT 3:610-611)

Mitchell asks appellant if she inserted any objects into Carolee's vagina; appellant says no. Mitchell says appellant is a good person, wants to be a good mother but that she absolutely did cause Carolee's injuries; he says he's not worried about it because if she feels sorry for what happened and gets counseling "and/or this will never happen again." He says she can

correct her life and this will be a "bump in the road." He asks if she believes in God, talks about correcting mistakes, says she has to choose between being a good person and a bad person. Asks if she would do it over again, she says no, asks if she feels bad about it, she asks if she can trust him. (CT 3:611-616)

Appellant says, "Craig is fucking with those little girls." Mitchell stops her, asks if she feels sorry for what she did. Appellant says yes; Mitchell asks if she's asked God to forgive her, she says yes, he says for what, she says for her sins. Mitchell wants to talk about those sins. Appellant asks if she's being recorded. Mitchell says yes, asks if she can hide from God, if she's a good person, if she would repeat her mistakes. He asks her what's bothering her, she doesn't want to tell him. He asks if she would hurt Carolee again, what she feels bad about, she says for hurting Carolee. He says studies show there's repeat offending absent remorse, and she says she's sorry, she didn't do it on purpose. (CT 3:616-619)

Appellant says Carolee sat down on the ladder in the bathtub. The ladder "inserted itself." Appellant then says she wants to "end this." Mitchell says he's going to have the detective come talk to appellant, and that he's going to want to know the truth. Appellant says she didn't do it. Mitchell asks appellant what happened; appellant says Carolee sat on the toy ladder. Appellant saw the ladder had gone up into the vagina when she pulled it out. Mitchells says the doctors said the object was inserted, appellant denies this, says Carolee sat on the ladder. Mitchell says that's not true, appellant says she wants a lawyer, wants out. Mitchell says, "Let me get the detective for you right now." Appellant says she doesn't want the detective. Mitchell asks if she only wants to talk to the lawyer. Appellant says she didn't do it on purpose. Mitchell says he's going to get the detective to escort her out of the building.[4] (CT 3:620-623; RT 7:1569)

<u>The second interview</u>

Appellant, Mitchell, and Lisa are present. Mitchell tells appellant that he's disconnected the camera, asks what appellant wants to tell him. Appellant says she didn't want to tell because she thought she would get into trouble. Mitchell ask if Lisa told appellant that the other detective didn't want to separate her from her son. Lisa tells appellant to take her time. Mitchell asks if they had a chance to talk in the parking lot; Lisa says they discussed

---

4 Ansberry testified he did not go into the room, but told Mitchell to let appellant go. (RT 7:1569-1570)

what happened, appellant broke down and said she was afraid everyone would be mad and think she'd done something on purpose. (CT 3:624-626) Mitchell says he never thought she meant to cause bleeding; appellant says she didn't mean to hurt Carolee, and she is scared. Mitchell says he separates good people from bad people, asks if appellant realized Carolee was injured when she inserted the ladder or later. Appellant says she didn't realize Carolee had been injured. Mitchell asks why she did it; appellant says because she knew something was going on with Craig and his daughters. (CT 3:626-628)

Sobbing, appellant says she put the ladder in Carolee and pulled it out. Carolee screamed. Appellant says the ladder didn't go far up, maybe two or three inches. She did it once, and has never done this before, and never done anything to Aubrey. There was a mix of old and new blood. Appellant thought they would investigate Craig, find out he had molested Aubrey and stop him. Mitchell says appellant's advantage is that she has a partner, and that Ansberry's a good guy. Appellant says she wants to go to counseling. Mitchell asks if she's done this before, she says no. (CT 3:629-632)

Mitchell asks what appellant would say to Carolee in fifteen years' time; appellant says she's sorry for "hurting you," and that she "loves you so much." She's sorry for lying and says what she did was stupid. Mitchell leaves to get Ansberry. While he's gone, appellant cries and Lisa says they'll get therapy for appellant. (CT 3:633-634) Ansberry enters, tells everyone to relax. Asks appellant if she intended to hurt Carolee; appellant says no. Ansberry pretends the first interview "never happened," asks appellant to repeat her account of the morning. Appellant says she didn't mean to hurt Carolee, but wanted some way to get her to the doctor so they would find something in both girls. She inserted the ladder in Carolee's vagina, hooked end first. She put both hooks in; she knows one hook went in. She asked Aubrey if anyone touched her, Aubrey said no, that it was just a dream. Appellant apologizes for lying to Ansberry, and Ansberry says he won't hold it against her. (CT 3:634-637; RT 7:1582-1583)

The first time appellant saw blood was in the diaper. (CT 3:637) She was hoping Craig would be arrested, or admit to doing something to the girls. Ansberry says that while appellant's intentions were pure, she did cause Carolee significant injury, and that she would have to be taken into custody at some point. Ansberry and Lisa tell appellant to calm down. Ansberry says appellant came in freely and voluntarily, and will leave the same way. He

asks if anyone forced her to come back, she says she came back because she wanted to do the right thing. She wants to know how long she's going to be in jail; Ansberry says he doesn't know. He says the situation's unique, wonders why she felt so desperate. She says she was "so angry" at Craig. She didn't know you could call DCS.[5] Ansberry says he'll call appellant and arrange a surrender. Appellant says she's scared. He tells them to go home. (CT 3:638-643)

Defense Case

Lisa is appellant's former domestic partner; she is 12 years older than appellant. They became involved in 2003, moving in together in 2004. Appellant's son was born in 2004. In June 2006, they moved into an apartment in a complex. The apartment has two bedrooms and two bathrooms. Lisa was working as an escrow assistant while appellant babysat for neighbors. (RT 8:1924-1930, 8:1933-1934, 9:2224-2226)

On August 15, 2006, Lisa got up at 5:45 and called her bank to verify funds; her paycheck had not been deposited, and she did not have money for gas to drive to work. Lisa decided to wait until 9:00, to talk to her office about her paycheck. Craig dropped off the girls about 7:00. Aubrey fell back asleep on the couch, appellant gave Carolee a bottle and put her in a crib in her son's room. He was sleeping in his parents' bed. Carolee was "fussy," but calmed down with the bottle. (RT 8:1930-1936)

After giving Carolee the bottle, appellant returned to bed with her son. Lisa was watching TV, continuing to call the bank. Lisa left the apartment around 7:30 or 8:00. She drove to a 7-Eleven a mile away, bought cigarettes, and drove back. Everyone was still asleep when she returned. Appellant and her son woke first, then Carolee. She was fussy, with a messy diaper. Lisa described the diaper as "horrific," smelling "really bad." Appellant took Carolee to change her, and Lisa took her son to start a bath. When appellant opened Carolee's diaper, it looked like Carolee had diarrhea, orange-brown in color. (RT 8:1936-1939, 8:1992)

Appellant put Carolee in the tub with her son; Carolee was playful, happy. There were a lot of toys in the tub, including the ladder. The ladder was part of a school ground play set. There was no blood in the water, and Carolee's bottom was clean. Carolee did not seem hurt. Lisa left the bathroom to call her office, returning about seven minutes later. Appellant

---

5 Department of Children's Services. (RT 7:1507)

left the bathroom and Lisa watched the children playing in the tub. Appellant returned, and they took the children from the bath, wrapped them in towels, and took them to her son's room. (RT 8:1939-1945, 8:1992-1993, 9:2186-2187)

Carolee was angry when appellant took her out of the tub. She became increasingly fussy as appellant put lotion on her and diapered her in her son's room. Lisa did not see any blood on the light-colored bath towels. Appellant held Carolee while Lisa went to the kitchen to make cereal for the older children; appellant began making scrambled eggs for Carolee, who was in the walker. Once in the walker, Carolee began screaming. Lisa thought she was frustrated. (RT 8:1945-1952, 8:1989-1990, 9:2185, 9:2187-2189) Lisa received a phone call from work, saying that someone would be bringing her check. The apartment was difficult to locate, so Lisa arranged to meet the person less than a mile away. Lisa drove: the entire trip took 4 minutes and 37 seconds. Lisa is sure of the time because everyone has asked her about this, so she subsequently timed the round-trip drive. (RT 8:1952-1953, 9:2189-2150, 9:2196-2197)

After getting her check, Lisa returned home to say goodbye. When she returned, the older two were eating toast, and Carolee had scrambled eggs, but was still fussing. Appellant was standing at the kitchen counter. Appellant took Carolee out of the walker to change her; when she opened the diaper, Lisa saw a dark red jellied quarter-sized blood clot in the diaper. Both appellant and Lisa became worried, Lisa told appellant to call Deborah. Appellant called repeatedly, but got no answer. She wanted to call Sandra, another mother in the neighborhood. They did not call 911 because Deborah told her not to call after they called once before. Craig later explained that they had Kaiser insurance, but the ambulance took Carolee to a non-Kaiser facility. He said to call them before making any future 911 calls. (RT 8:1953-1959, 8:1991, 8:2107-2108, 9:2130, 9:2190-2194)

Lisa left to cash her check and go to work. She went to a bank, then to Wal-Mart, then to get gas. Appellant called Lisa; pursuant to that call, Lisa tried to find Craig at work, calling him many times along the way. She also tried to call Deborah once before appellant called her back to the apartment. (RT 8:1959-1962) Lisa never saw Sandra in the apartment; Deborah arrived about 10 minutes after Lisa. They went to a bedroom, and showed Deborah the diaper. Deborah said it might be from Carolee's yeast infection. Appellant said it didn't look right, and asked if there was any possible way something

else might have hurt Carolee. Five minutes later, Deborah opened the diaper again, and Lisa saw a new clot inside Carolee's vagina. (RT 8:1962-1966, 8:1987, 9:2108-2111) The adults next smoked a cigarette on the patio as they discussed what to do; Deborah then took Carolee to see a doctor. Lisa left shortly thereafter. She saw Deborah standing outside her car, smoking a cigarette, while Carolee was inside, crying. Lisa asked Deborah why she was smoking another cigarette; Deborah said Kaiser could take forever and she couldn't smoke in the car with Carolee. It was about ten minutes until 1:00 p.m. (RT 8:1966-1968)

Two days later, Det. Ansberry came to the apartment. Lisa took the toy ladder out of the bathtub that night because appellant told her that Ansberry had asked whether Carolee had fallen on it, and Lisa didn't want her son to fall on the ladder as well. She put it in a Ziploc bag and set it on top of the refrigerator; two weeks later, appellant's mother took the ladder.[6] (RT 8:1968-1973, 8:1993, 8:2107, 9:2217-2220, 9:2256-2257, 10:2407) The toy ladder was part of a playground set. (RT 8:1970) Ansberry subsequently scheduled appellant and Lisa for an interview. They went to the station on the 29th at 10 a.m. (RT 8:1970-1974, 8:1993-1994) Appellant went in first; two hours later, Ansberry and Mitchell came out and talked to Lisa for about 15 minutes, telling her that appellant had hurt Carolee. They said that appellant was close to confessing but had asked for a lawyer. They wanted Lisa to talk to appellant about confessing because appellant trusted Lisa. They wanted Lisa in their "circle of trust," telling her to use her relationship with appellant to bring her in. They said regardless of what happened, they were going to report their suspicions to the Department of Children and Family Services. Lisa felt she had to bring appellant back in because she wanted appellant to say that it could have happened accidentally. Lisa thought this would make the investigation "go away." (RT 8:1974-1979, 8:1993, 8:1994-1995, 8:1997, 8:2007-2008, 9:2111-2113, 9:2160, 9:2198-2199)

Lisa went to appellant in the parking lot and appellant said she wanted a lawyer. Lisa asked if she did it; appellant said no, but that they were "making me think maybe I did" accidentally, when she sat Carolee down in the bath. Lisa told appellant to "get your ass back in there and tell them you didn't do it," that this was going to affect appellant's son. Appellant was hysterical, panicked and crying, throughout the conversation. The three

---

6 It was stipulated that the ladder was given to defense counsel, who in turn gave it to police. (RT 12:3031-3032)

returned to the station without eating because they had no money for lunch. (RT 8:1978-1982, 8:1996-1997, 8:2002-2004, 8:2013-2014, 8:2016, 8:2019-2020, 9:2113-2114) After appellant's second interview, they went home. Appellant was confused, said she didn't know what was going on, and denied hurting Carolee. Once home, appellant cried, and continued to be confused. (RT 8:1982-1983, 9:2156)

Appellant held her child during the second interview; Lisa was put behind a desk, and felt intimidated. At one point, she offered the boy to Lisa, but Ansberry told her to continue holding him. Mitchell told appellant the camera had been disconnected. Lisa was shocked, confused when appellant confessed: she felt the detectives were spoon-feeding appellant the information and were not going to stop the interview until appellant confessed. Lisa would sometimes interpret what the detectives were saying for appellant. (RT 8:1983-1985, 8:1987-1988, 8:1997-1998, 8:2000-2001, 8:2004-2009, 8:2014-2019, 8:2020-2022, 9:2114-2115, 9:2118-2129, 9:2131-2140, 9:2150-2154, 9:2159, 9:2164-2177, 9:2183, 9:2203-2208, 9:2210-2215) Lisa never saw appellant do anything harmful to Carolee on August 15th. (RT 8:1997-1998) Appellant discussed Craig with Lisa a couple of times before August 15th: she said she thought there were inappropriate boundaries. For example, appellant once visited the family's home and found Aubrey naked and Craig in his underwear. They had been sleeping in the same bed. Appellant said something to Deborah about the situation. Appellant didn't dislike Craig, however, and the two couples were friends. (RT 8:2010-2012, 9:2142, 9:2199-2201, 9:2227-2228)

At the time of trial, Lisa and appellant were no longer in a relationship. There were a number of issues involved in their breakup, and Lisa would never resume a relationship with appellant. Lisa would not lie for appellant. She had not spoken to appellant about the case since their separation. She could not believe appellant would hurt Carolee, especially to frame Craig. (RT 8:1985-1987, 9:2145, 9:2148, 9:2154-2155, 9:2209)

At about 8:30 a.m. on August 15th, Sandra got a call from appellant. Appellant was upset, saying Carolee was bleeding. Sandra went to the house, and saw two blood clots, dark purple and jellied, like "old blood." One clot was in the diaper, the other was "working its way out" of Carolee's vagina. Appellant as confused, crying, asking why Carolee was bleeding. Sandra said to call Deborah. She did not want to call 911 because Deborah specifically told them that it cost her too much money the last time, and "to

call her first if 911 was needed." Carolee was fussy, crying, but not "major crying." (RT 8:1907-1913, 8:1918-1922) Lisa wasn't present. Sandra stayed at the house for about 25 minutes while unsuccessful attempts were made to reach the parents. (RT 8:1912-1914, 8:1917)

Appellant testified she graduated high school in 2004; she got pregnant and became involved with Lisa in 2003, when she was 17 and Lisa was 28. They were together for three years. (RT 9:2222, 10:2473-2474) Appellant had no animosity towards Craig, but thought he was weird. (RT 9:2227-2228) On the 15th, appellant woke at 6:30, just before Craig dropped off the children. Craig seemed to be in a hurry, and didn't do his usual chat or goodbye game with Carolee, who was a little fussy. Caitlyn went to sleep on the couch, appellant gave Carolee a bottle, and put her in the playpen in her son's room. Appellant went back to sleep, and the boy later woke her. Carolee was up, still fussy. Her son's room smelled "really, really, really" bad, like a messy diaper. Appellant changed Carolee's diaper, but Carolee was still messy, so appellant decided to bathe her. (RT 9:2229-2236, 9:2239-2240)

Lisa ran the bath water, and was in and out of the room while appellant bathed the children. Carolee became happy in the tub. There were a few toys in the tub, including building blocks, letters, and the toy ladder. Appellant did not insert anything in Carolee's vagina during the bath. She stepped out of the room for about one minute at some point, leaving Lisa to watch the children. Lisa helped appellant then take the children out of the bath. Carolee started screaming. (RT 9:2236-2249, 10:2406-2407) Appellant took them to her son's bedroom, dried, diapered, and dressed Carolee in a light yellow dress. She did not notice any blood on the towels or the mat. Carolee was not bleeding, and calmed down a little once dressed. (RT 9:2249-2253)

They went to the kitchen, appellant got Carolee some juice and put her in the walker. Carolee was very upset, screaming. Appellant got breakfast for the other children; Lisa left to get her check, saying she'd be right back. Appellant made scrambled eggs on the stove, and then made four pieces of toast. Carolee was still upset. Appellant gave her some Cheerios, next some eggs and toast. She refused to take the bottle from appellant. Lisa returned, and suggested Carolee was teething. Appellant put Orajel on Carolee's gums, and took her out of the walker. Appellant did not insert anything into Carolee's vagina while Lisa was gone. (RT 9:2258-2273) Appellant put Carolee on the dining room carpet, removed her diaper, and saw a dark red, purplish blood clot in the diaper, and another clot coming out of Carolee. Appellant was

shocked and confused. She showed Lisa the diaper, and asked what they should do. Lisa said not to call 911 because Deborah asked them not to after the ear incident. (RT 9:2274-2284)

They started calling Deborah and Craig's cell and home phones, leaving messages. They called Deborah's mother. They called Sandra; Lisa left, Sandra came over, looked at the diaper, and additional calls were made. Throughout, Carolee seemed fine. She was not screaming or crying. Appellant left another message, saying she would take Carolee to the hospital if she did not hear from Deborah. Deborah then called back. Lisa returned, and Deborah arrived. (RT 9:2284-2297, 10:2402) They smoked a cigarette on the balcony. Deborah said Carolee had been fussy the night before. They went inside and appellant showed Deborah the diaper. Deborah gasped. Appellant did not say anything about Carolee being big, but did tell Deborah what Sandra had said. Deborah said it might be a really bad yeast infection. Appellant had no idea what could have caused the bleeding. When Deborah decided to take Carolee to the hospital, appellant retrieved her old diaper and gave it to Deborah to show the doctors. Deborah asked if she could leave Aubrey, and appellant said yes. (RT 9:2297-2307)

Appellant talked to Det. Ansberry that night, and he came to the apartment on the 17th. About a week later, Ansberry called to set up the station interview. On August 29th, they went to be interviewed. Appellant was brought into the room first; a code had to be entered in order to go into the back of the station. The room was a little over 10 feet wide and slightly deeper. There was one door. Appellant was seated across from the door. She did not feel intimidated, and signed a paper indicating she knew she could leave. When Mitchell told appellant that there was "zero doubt" that she had hurt Carolee, appellant was shocked. She became confused when he continued, not understanding why he was accusing her. She denied doing anything, and started to get upset. Appellant knew Mitchell was an "expert," and figured he wouldn't say something unless he had proof. She started to doubt herself, wondering what could have happened or if anything could have happened to Carolee at her house, such as Carolee sitting on the ladder in the tub. (RT 10:2403, 10:2408-2427, 10:2442, 10:2537-2538, 1:2554)

Appellant did not go into the interview intending to accuse Craig. There were parts of the interview which she didn't remember. She got upset in the interview; the shock of the accusation never wore off. She felt "trapped in a box," like she couldn't say what she wanted to say, and that Mitchell

was pressuring her. As the interview wore on, she started feeling panicky. (RT 10:2427-2442, 10:2451-2453, 10:2513, 10:2558, 10:2572) She didn't know why she said Carolee sat on the ladder. She suggested Carolee was injured in the tub because that was the only explanation she could think of. She told Mitchell that she wanted to leave, and he said he was going to get the detective. As Mitchell walked her out of the interview room, he told her to wait in the sitting room. Appellant waited; she did not think she could leave. (RT 10:2444-2447, 10:2454-2459, 10:2470, 10:2495, 10:2514-2516, 10:2518, 10:2539, 10:2545, 10:2549, 10:2560-2561) She called Lisa, who had the car keys, then met her in the parking lot. Lisa said she'd been with the detectives, who told her that appellant was ready to confess. Lisa said they told her they needed her to bring appellant back in. Appellant told Lisa that she hadn't done it, and Lisa said to go back inside and tell them. Lisa said they would take their son if appellant didn't go back inside. Appellant was crying, panicking. (RT 10:2460-2465, 10:2476, 10:2517-2519, 10:2521, 10:2523-2526, 10:2555-2557, 10:2573-2575)

Appellant could not remember the second interview very well, even after looking at the videotape. She felt she had no control, had "lost her mind." She did not recall hugging Ansberry at the end of the interview. (RT 10:2474-2483, 10:2486-2492, 10:2494, 10:2536, 10:2557, 10:2568, 10:2570) She was not on medication at the time. (RT 10:2515-2516) Appellant did not think Craig was molesting his daughters before the 15th; afterwards, she and her friends had discussed the possibility as an explanation for Carolee's injuries. The two couples were friends, though appellant thought Craig "didn't seem right." (RT 10:2484-2485, 10:2487, 10:2495, 10:2528-2534, 10:2541-2542, 10:2547, 10:2563-2566, 10:2569-2570) Appellant loved Carolee and Aubrey. She did not insert anything in Carolee's vagina. (RT 9:2300)

The medical evidence

Dr. Ronald Miller is a board certified obstetrician and gynecologist, affiliated with St. Joseph Medical Center, Tustin Hospital and University of California Irvine Medical Center, where he was a full-time faculty member until 1988. He has authored about 13 peer-reviewed articles, and his private practice has been limited to gynecology since the 1980s. Dr. Miller has conducted hundreds of thousands of vaginal examinations, thousands of which were on children. He infrequently testifies as an expert in court. (RT 11:2713-2718, 11:2796-2798, 11:2830-2831)

Dr. Miller reviewed the medical/legal reports in the case, including the photographs. None of the photographs depict the injury as described by the emergency room doctor. The hymen appears intact, as was documented in a follow-up exam. There is not a bad laceration, but a straight cut, about a centimeter long. The injuries are exaggerated in the photos because of the level of magnification. Dr. Miller believed there was a lesion; Carolee had a history of multiple doses of antibodies, and multiple significant urinary tract infections. She had bladder catheterization, extensive kidney and bladder x-rays, a spontaneously perforated and bleeding eardrum, diarrhea requiring hospitalization and intravenous fluids, as well as a history of persistent yeast infection and evidence of a ruptured blister frequently associated with a coxskie virus. The tissue around the labia is inflamed, consistent with a yeast infection. There were other classic markers of a yeast infection. Dr. Miller would not expect a positive bacterial result from a specimen taken the next day because the ER doctor had used Benadine, which would kill bacteria, and irrigated the area very thoroughly. The area also looked less inflamed the following day. In sum, there were many predisposing factors for bleeding and weakening of the genital structures, including the hymen. (RT 11:2718-2725, 11:2727, 11:2731, 11:2751-2779, 11:2784-2787, 11:2792-2795, 11:2802, 11:2804-2810, 11:2817-2818, 11:2821-2823, 11:2833)

It would be medically impossible for the toy ladder to have been inserted 2 to 3 inches in Carolee's vagina as was described on the tape. The vagina would only be about 1 inch long. There was no indication of external vaginal injuries, no bruising of the vulva. Dr. Miller could not envision how to replicate the type of internal tear depicted using the toy ladder without causing external damage. Moreover, the vagina and vaginal entrance was much too small to accommodate both hooks of the ladder. The bladder, perineum and rectum would have all been torn had both hooks had been inserted. (RT 11:2725-2730, 11:2737-2742, 11:2745-2749, 11:2780, 11:2788-2791)

Dr. Miller could not rule out trauma, nor could he rule out a spontaneous tearing due to overzealous cleaning of otherwise weakened tissues. (RT 11:2779-2780, 11:2828)

# STATEMENT OF FACTS

## Introduction

Appellant was convicted of leading a five year-old girl with developmental disabilities into his apartment and molesting her; the girl, found disheveled on appellant's back porch, made a licking gesture and told witnesses appellant "hurt her booty." She was unable to identify appellant at trial. Appellant testified the girl came into his apartment of her own accord, then went out back to play with his dog. He told her to go back out front because there were transients in the area. Appellant had a sexual relationship with the girl's mother, which had soured; she knew about his prior molestation convictions. Appellant did not abuse the girl.

Twenty years earlier, appellant grabbed an eight-year-old girl off the street, took her home, put on a ski mask, and had her orally copulate him and lick his rectum. He also attempted intercourse. The girl escaped when they went back outside.

## Prosecution Case

On June 2, 1998, five-year-old Tiana, her mother, Naomi, and her grandmother, Elizabeth, had gone to a doctor's appointment in the morning; the appointment was postponed, and the three stopped by a restaurant for breakfast. At the restaurant, Elizabeth put a sticker on Tiana's jumper. Tiana had a number of different barrettes in her hair. The three then returned home to wait for the rescheduled appointment. Elizabeth waited in her daughter's apartment, while Naomi and Tiana visited Sherise across the street. Tiana and Sherise's four-year-old son, Keifer, went outside to play in the courtyard. (RT 381, 323-386, 393-394, 413, 604-606, 614-615) Both Elizabeth and Naomi could see the children from their windows; Elizabeth checked on them from time to time, while Naomi watched continuously. At some point, Naomi stepped into the kitchen to make the children some Kool-Aid. (RT 387, 607-608, 616)

Keifer and Tiana were playing with cars and making dirt pies in front of the apartment complex. Appellant lived in a downstairs apartment. The apartment manager was working on the sprinkler system, and told the children to get out of the mud; Keifer did, but Tiana didn't. (RT 333-335, 338-339, 359, 368, 370-371, 607) Tiana started playing with appellant's dog. (RT 339-340, 370, 373, 396) As they played, appellant came outside, and either

led Tiana by the hand or called her into his apartment. (RT 335-336, 340-341, 359, 361, 374, 670)

Naomi came back to the window to call the children in for Kool-Aid, but didn't see Tiana. At this same time, Elizabeth also glanced out her window and didn't see her grandchild. (RT 387, 608) Naomi came outside and asked Keifer where Tiana was; Keifer told Naomi that Tiana was in appellant's house. (RT 335-336, 340-341, 359, 374, 389, 608) Naomi didn't believe Keifer, and went to her play aunt's house to see if Tiana had gone there. After her play aunt said she wasn't, Naomi went to her play aunt's daughter's apartment to ask if they had seen Tiana. They hadn't. Naomi then ran upstairs and asked Elizabeth if Tiana was with her; Elizabeth said no, but noted she had just seen Tiana outside. (RT 388, 608-609) Elizabeth and Naomi went out and began calling for Tiana. Naomi again asked Keifer where Tiana was, and Keifer again said that she was in appellant's house.[1] (RT 335-336, 340-341, 359, 374, 388-389, 608)

By this time, neighbors had gathered to look for Tiana. (RT 389) Naomi knocked on appellant's door, but there was no answer. She went upstairs to Ford's house, and got an iron. (RT 609) People began beating on appellant's front door and window, to no effect. (RT 389-390) The group started screaming Tiana's name; Elizabeth told them to be quiet and let her call her granddaughter. (RT 389-390, 609, 624) Tiana answered "huh" from inside appellant's apartment, and people began trying to pull the security bars off the door. (RT 390-391, 399, 614) Unable to open the front door, the group went around back. When Naomi tried to open the back door, appellant slammed it shut. (RT 390, 397, 610) The crowd then returned to the front of the apartment, but someone in the group doubled back, and found Tiana sitting on the porch. Her clothes were on backwards, her underwear inside out, her shoes unbuckled and on the wrong feet, her hair was mussed and some of her barrettes missing, and she was crying. (RT 391-392, 397, 403, 610-611, 613, 623, 653, 662, 665)[2]

Appellant walked into the back yard, and asked what was happening. Naomi hit him with a stick and the crowd jumped him. Naomi called the police; when the officers arrived, there were between 30 and 50

---

1 Keifer testified Naomi asked if appellant "took" Tiana into his house; Keifer said "yes." (RT 341)

2 It was approximately 15 to 20 minutes from the time Tiana was discovered missing until she was found on the porch. Tiana was not dirty when she was found on appellant's back porch. (RT 393, 399) Elizabeth had dressed Tiana properly that morning. (RT 381, 392, 605, 614)

people around the apartment, and more than a dozen encircling appellant. (RT 611, 908-909, 913, 961-963)

Elizabeth carried Tiana upstairs; with her mother acting as interpreter, Tiana said appellant hurt her "booty."[3] (RT 368, 391, 611, 653-654, 659) "Booty" is Tiana's word for her anus. (RT 392, 611) Tiana pointed to her rectum and made a licking motion, and pointed towards a police officer's groin and back at her rectum. She continued licking and saying "it hurts" as she alternated pointing at her vagina, the officer's groin, her rectum, and back again. (RT 654-655, 659, 670-671) Tiana testified appellant took her to the bed, "messed up" her dress and hair, and pulled her "coo-coo."[4] Appellant hurt the front and back part of Tiana's body. She cried, and he gave her an apple. (RT 361, 364-365, 367, 374, 661-662) Tiana told police appellant's bed sheets were white. (RT 656-659, 664)

Before he appeared at back of his apartment, appellant called a neighbor. At some point during the conversation, appellant said he did not want to come "outside." Believing appellant was calling from his apartment, and concerned about the possibility of a second victim, police kicked in the front door. The apartment was empty. (RT 407-408, 913-914, 916-918, 964-967) Police star-69'd appellant, who said he was at a friend's house a block away. (RT 423-425, 916) According to police, appellant was found walking through the alley behind the complex; when the crowd threatened "to do a little neighborhood justice," officers put appellant in a patrol car and removed him from the scene. (RT 427, 652, 656, 667-669, 909-912, 915-916, 962)

After obtaining a warrant, police returned, searched the apartment, and found a blue barrette shaped like a flower under appellant's pillow. The sticker from Tiana's jumper was on top of a blanket or sheet on the bed. A yellow barrette was located in the parkway of the apartment complex. (RT 409-412, 416-417, 928-933, 938) Tiana's fingerprints were on the inside of appellant's front door, and the inside and outside of his bedroom door, below the doorknob. (RT 636-638, 644-648)

---

3 Tiana was taken home by her family and paramedics, and then to two hospitals for examination. (RT 368, 375, 613, 651) Elizabeth testified she asked Tiana at home if appellant had "done something" to her. Tiana said yes, and when Elizabeth asked Tiana to show her, pointed to her genitals and began licking the air. Tiana repeated the licking gesture as she pointed to her back and front. (RT 391-392) Naomi testified Tiana made the licking gesture and indicated she licked a penis while at the first hospital. (RT 612)

4 When asked to define "coo-coo," Tiana pointed to her genital area. (RT 362)

Tiana was physically examined at the second hospital; her posterior fourchette was inflamed, the result of recent trauma. She told the pediatric emergency specialist appellant had licked her "booty" and on her "privates," and complained of pain when urinating. (RT 944-945, 947, 949, 952-955) An area of Tiana's thigh fluoresced under a wood's lamp, indicating the possible presence of semen. (RT 947, 953, 956) The absence of semen in Tiana's mouth was consistent with the four and a half hour interval between her discovery and the examination: saliva naturally cleanses the mouth, and Tiana had eaten an apple in the interim. (RT 950, 954, 1212, 1249-1250, 1252)

Tiana has a speech impediment and epilepsy. She is in a special education class at school. (RT 353, 384, 604, 612, 653)

Prior Offense Evidence

One evening in 1978, then-eight year old Jan was out walking with her brother. (RT 627-628) Appellant began walking and talking behind them. Jan's brother became suspicious, took Jan's hand, and told her to run at the count of three. (RT 628) They began running, appellant grabbed Jan's hood, pulled her backwards, took her into an alley, told her to cover her eyes and not to scream, and brought her to his apartment. (RT 628, 630-631)

Once inside, appellant told Jan to get undressed. He examined her, then put on a ski mask and made her orally copulate him and lick his butt. Appellant attempted to put his penis in Jan's vagina; when that was unsuccessful, he had her orally copulate him until he ejaculated. (RT 628-629, 632) After awhile, Jan fell asleep. She woke to find appellant talking on the telephone; he hung up, then resumed fondling her and having her "do things to him." At some point, appellant told Jan to get dressed, and the two left his apartment. (RT 628, 632) Appellant let Jan go for a moment, and she ran until she found family members out looking for her. (RT 628)

Jan had peeked en route to appellant's apartment, and was able to lead police to appellant. Jan and her brother later testified at appellant's preliminary hearing. (RT 631) Based on this incident, appellant pled guilty to kidnapping, child molestation, oral copulation with a victim under 14 years of age, and assault with intent to commit rape. (RT 633-635)

Defense Case

Midmorning on June 2nd, appellant was standing outside his apartment looking for a friend; they were going to the polls together. (RT

1817) Mr. Middleton, the apartment manager, was also outside. The friend didn't appear, and appellant went back and forth a few times from the sidewalk to his apartment, trying to call his friend. (RT 1817-1818) At some point, appellant noticed Keifer playing outside; he did not notice Tiana until a while later. Appellant gave up on his friend, and returned home to sort laundry in the front room. (RT 1818) His apartment door was open, and he heard Middleton tell the children to get out of the mud and sit on the steps. The children did as they were told. Appellant heard Keifer playing in the mailbox; shortly thereafter, Keifer put his head through appellant's door and asked appellant what he was doing. (RT 1818-1819, 1844, 1859)

Appellant told Keifer he was minding his own business, and asked Keifer what he needed. Keifer said they wanted to see what was going on, pushed the door open, and jumped on appellant's pile of clean laundry. (RT 1819) Tiana followed Keifer inside; Keifer began running around the apartment, as he had done many times before. Keifer also started throwing things and trying to get someone to chase him. Tiana went to play with appellant's dog, who was in the kitchen, behind a safety gate. The dog was kissing Tiana and licking her hands. (RT 1819-1820, 1873-1874) Keifer ran out of the apartment, appellant slamming the door closed behind him. Keifer started kicking appellant's door to get back in, but appellant said he wouldn't allow Keifer inside because he threw things around.[5] (RT 1820, 1856, 1863)

Appellant told Tiana she could not stay in his apartment without her parent's consent. He had her to go out the back door; when she said she wanted to keep playing with his dog, appellant offered to put the dog on the back porch. (RT 1820, 1855) Appellant tied the dog on the back porch, and Tiana went outside. (RT 1821, 1856, 1863) Tiana stayed on the back porch for some time, playing with the dog until appellant told Tiana she needed to go up front, that it wasn't safe to stay in the back. (RT 1821, 1856-1857) There had been vagrants in the neighborhood; because children left the back gates open, anyone could enter the complex from the alley. Tiana said she would go, and appellant laid down to rest. (RT 1821, 1869)

After awhile, appellant heard knocking. He didn't answer. Ten or fifteen minutes later, appellant went to the bathroom and heard more, louder, knocking. Appellant looked out the window before answering the door, and

5 Appellant did not see Keifer or Tiana throw Tiana's barrette or sticker on his bed. (RT 1855) Appellant believed the police planted the sticker during the first search of his apartment. (RT 1860)

saw a crowd of people outside. (RT 1821-1822, 1869-1872) Appellant came out, asking who had been at his door; Naomi swung a broom at appellant, and accused him of having Tiana in his house. Retreating, appellant said he hadn't. Ford hit appellant in the eye with a hot iron, and a male neighbor hit him in the face. Another neighbor was holding a butcher knife. Appellant fell, then scrambled around to reenter his apartment from the kitchen. He put on a jacket and shoes and left the complex. (RT 1822-1823, 1854, 1864-1866)

Appellant walked around the corner to a friend's house, cleaned his face, and called one of his neighbor at the complex.[6] (RT 1823-1824, 1864, 1866-1867) She told him police had arrived and were kicking down his front door. Appellant said he would be there in a minute, and hung up. Before he could leave, the phone rang; it was a police sergeant, asking him to return to the apartment. Appellant explained he'd left because the neighbors were attacking him, but would be right over. (RT 1824-1825, 1868) Appellant was arrested as he was entering the complex through the alley. (RT 1825-1826)

The officers handcuffed appellant and put him in a patrol car parked in front of the apartment building. While appellant was "on display," various residents beat on the car window. (RT 1827-1828, 1868)

Appellant has known Naomi and Tiana since they moved to the complex. Appellant's former roommate was friendly with Naomi; Naomi visited appellant's house a number of times, occasionally with Tiana. (RT 1829, 1850) In October 1997, appellant and his roommate had a joint birthday party for appellant and his roommate's daughter, with the party flowing inside and outside appellant's apartment. Keifer and Tiana came to the party, and put their coats on appellant's bed.[7] (RT 342-343, 377-378, 1829-1830) The following Thanksgiving, there was a small cook-out at the complex, and Naomi and other neighbors went in and out of each other's apartments. (RT 1830) Naomi continued to visit appellant's apartment after his roommate moved out, borrowing money and food; she eventually told appellant she was a former bikini dancer, who would do private dances for

---

6 Appellant's power was shut off; he was able to call earlier because he could plug the phone into an outside supply box and run an extension cord inside the apartment. After he was attacked, he had no time to run cords to an outside power source. (RT 1867)

7 On cross, Naomi testified she had never been in appellant's apartment; her preliminary hearing testimony was she had been in the apartment twice: walking through once that morning to get Tiana, and once to visit appellant's former roommate. (RT 617-620, 623, 625, 1875) Keifer remembered being at the birthday party with Tiana. (RT 342)

pay.[8] Appellant paid Naomi a few times to dance, and ultimately paid her for sex. (RT 1830-1831, 1874) After appellant felt Naomi was becoming greedy, he told her he had no more money. She became angry and accused him of owing her money.[9] She told appellant she would get back at him through one of her "gangster friends." (RT 1831, 1872, 1874-1876)

There is a crawl space underneath the apartment buildings; local children played in the crawlspace, including Tiana and Keifer.[10] Transients slept under there, and there had been problems with transients hiding among the trashcans in the alley and flashing local children. (RT 376-377, 401, 1832, 1843, 1875)

Kenya has known appellant for thirty to thirty-five years, and has visited him at his apartment. On May 17, 1998, as she was coming for a visit, Kenya met Naomi, who was leaving the apartment with appellant. (RT 1808-1810, 1813) Naomi was wearing her pajamas, and carrying a jelly glass containing some sugar. (RT 1810-1812, 1814) That was the only time Kenya saw Naomi. (RT 1813)

No semen or male DNA was found on the swabs taken from Tiana. The wood lamp test was negative for semen fluoresces. (RT 1207-1208, 1210-1211, 1242-1244, 1248) Trace levels of DNA from another source, not appellant, were found in certain samples. (RT 1244-1247) Hair samples from appellant's apartment to be compared with Tiana's hair were too small for testing, and hair taken from Tiana's clothing were not the sort which could be compared to samples of appellant's hair. A hair discovered in Tiana's panties was similar to her head hair and dissimilar to appellant's hair. (RT 1219-1223, 1228-1229) Pubic hair transfers occur in 12% of cases involving known genital contact; prepuberty, there is no pubic hair to transfer or collect. (RT 1225) Braided or otherwise confined hair inhibits normal hair loss. (RT 1226-1227)

Appellant has grandchildren, nieces and nephews that visit him, as well as Keifer and his brother; after twenty-five years without incident, appellant was not afraid to be around children. (RT 1854) Appellant pled guilty

---

8 Appellant previously testified he told Naomi he had been imprisoned on a "sex charge" involving children. He had not otherwise disclosed his prior convictions to any of the neighbors. (RT 1851-1853) Appellant later discovered his former roommate had also been a sex offender. (RT 1851)

9 Naomi denied having sex with appellant for $40.00. (RT 621-622)

10 Tiana testified she had gone inside the crawlspace before. (RT 367-77)

in the 1978 Jan case because of the plea bargain offered by the prosecution, however, he did not assault Jan. (RT 1846-1849, 1860-1861)

There were no sheets on appellant's bed at the time of the incident. (RT 1842) Appellant did not do anything untoward to Tiana; Tiana was just repeating what some adults told her to say. (RT 1850, 1875)

# STATEMENT OF FACTS

## Prosecution Case

At the time of trial, Jada was 7 years old; Eve is her mother, and was appellant's fiancee, and the mother of his son. Eve and appellant were together for about 3 years, and lived together for about five months prior to the time of the charged events. On August 3, 2007, Jada complained about her bottom burning. Eve thought it was because she had eaten a lot of hot Cheetos. Eve put some Vaseline on Jada and asked if anyone had every touched her pee pee or bum. Jada said appellant had put his finger in her pee pee a few days before, while Eve was at work. Jada had cried, and appellant had whipped her bum and pee pee with a belt. Jada said she didn't want appellant to get into trouble. Eve called a friend to pick up the children, went to her mother's house, and called the Sheriff's Department. (RT 2:612-614, 2:617-620) Eve thought appellant and Jada's relationship had improved over its rough beginning; Eve never saw appellant hit Jada. Jada was looking forward to the wedding. (RT 2:615-617, 2:645)

According to Jada, appellant touched her 10 to 20 times, both in and outside her clothing. When he put his finger inside her, it hurt, and Jada would scream and cry. One day he touched her this way three times in the bathroom after Jada came home from school. Another time he pulled her into her mother's bedroom, locked the door, and touched her twice. On a third occasion, appellant touched Jada in the living room while she was watching TV. Appellant never touched Jada in her bedroom. Once, when Jada cried and said she was going to tell her mother, appellant socked her in the nose, making her nose bleed.[1] (RT 2:625-635) Appellant also hit Jada with a belt. (RT 2:634)

Jada did not tell her mother after the first time because she didn't want appellant to get into trouble. She told her mother after appellant hit her because she thought she should. Jada was not afraid of appellant. (RT 2:627, 2:630, 2:632)

The director of the Sexual Assault Team at Antelope Valley Hospital testified that she would not expect physical findings on a 6 year old girl who

---

1 Jada did not tell anyone that appellant hit her in the nose until the day she testified. She told Det. Ansberry that appellant had touched her in her bedroom; she did not say he pulled her into her mother's bedroom, or that he locked the door. (RT 2:641-643)

had been digitally penetrated to the length of a fingernail, or about half an inch. (RT 2:903-905)

Appellant came to the Sheriff's office on August 16, 2007; he was not under arrest. Detective Charles Ansberry drove appellant to another office, where Deputy Mitchell interviewed him while Ansberry surreptitiously observed the interview. The tape is an accurate reflection of what transpired during the interview. The interview was videotaped and audio recorded; afterwards, appellant left the station on foot. (RT 2:637-641, 2:907-910)

Appellant's Interview[2]

Deputy Mitchell says appellant has remorse for touching Jada's vagina five times. Appellant denies being under the influence of alcohol or marijuana at the time of the touchings; appellant says he and his fiancee were under financial stress. (CT 68-69) Based on Ansberry's demonstration, appellant estimates he put his finger about half an inch in the vagina. When asked, appellant says it just happened one time. Ansberry says "Desi" gave him a big number; appellant says three. (CT 70-71)

Ansberry asks appellant to describe one circumstance; appellant says he was dressing her in her mother's room. He did not recall touching her on purpose. The officers reject this account, and ask appellant to tell "the one" where he picked her up in the bathroom. Appellant says he never went in the bathroom and picked her up. The officers tell appellant not to do this, that he is backsliding. They tell appellant they are trying to "solve this problem," not destroy his family. There is a discussion about the need for truth. (CT 71-73)

Appellant says they are mostly in the bedroom; they both put the children to bed, and sometimes Jada wants him to stay and watch a movie with her. Appellant does not volunteer any more information. The officers urge appellant to be truthful, and ask about other locations in the house. Appellant denies touching in any other locations. The officers return to the number discrepancy, and Ansberry again asks appellant to describe an occasion. (CT 74-77)

Appellant says, "watching movies" on the bed. She was lying at the foot of the bed, he was sitting at the head between her and her brother. Ansberry asks if appellant's finger went inside her vagina half an inch; appellant says yes. Appellant says nothing happened, she didn't say anything

2 As transcribed in People's Exhibit No. 1a, introduced at trial. The tape as played was redacted from the original tape. (CT 67, 86; RT 2:909, 2:912)

or ask him to stop. (CT 77-79) The officers ask appellant about stressors and about his sexual relationship with his fiancé. They tell appellant that when they touch ladies, they get aroused. Appellant denies being aroused. They ask appellant what he would say to Desi, he says to tell her he apologizes to her for "doing what I did." (CT 79-81) The officers ask if this means what they've been talking about for a couple of hours, appellant nods. They ask what appellant would say to Eve, and he says "the same thing." (CT 81)

Appellant says he wants to get it all out of the way: what happened was a mistake. The officers ask appellant why he did it more than once. Appellant says things were playing over and over in his mind, "just stress" involving his fiancee. Appellant says he and Jada had problems because she didn't want him to be with her mother. She didn't listen to him. Their relationship now is better than it was; after "the little incidents," they got along well. (CT 81-82)

The officers ask where they can reach appellant, they discuss this and terminate the interview. (CT 82-84)

Defense Case

Appellant testified that he lived with Eve from October 2006 to August 2007. He never put his finger in Jada's vagina or bum, and never touched her outside her clothing in her vaginal or bum area. He had no idea why she would accuse him of touching her. (RT 2:928-929)

Appellant tried to deny touching Jada to the deputy; he was under a lot of stress, and started the interview by saying he did not touch Jada numerous times. He became "frustrated and irritated" during the conversation, and told the deputy "what he wanted to hear." Appellant signed whatever was put before him because he wanted to leave the interview; the deputy told him that he could leave a number of times. Appellant was hung over, having smoked marijuana, and drunk a pint of Hennessy and a few shots of gin at 3:00 a.m. the night before the 9:30 a.m. interview. The officers did not threaten or mistreat appellant during questioning. (RT 2:929-932, 2:935-939, 2:941-942)

In June 2007, appellant began working at Interview Services of America; before then, he was the primary caregiver for the two younger children. Jada was at school during the day. (RT 2:934)

Appellant was convicted of misdemeanor burglary and evading payment of a railroad fare in 2005, and evading payment of a railroad fare in 2006. (RT 2:939-940)

Rebuttal

According to Detective Ansberry, Deputy Mitchell spent two minutes explaining the release form to appellant, advising him to read it, then leaving the room. Appellant appeared to read the form for 2 minutes and 15 seconds of the 7 minutes that Mitchell was gone. Appellant then initialed the form. Ansberry sat very close to appellant before the interview, and detected no odor of alcohol or marijuana smell. Ansberry has been trained in recognizing the effect of drugs/alcohol, and observed no indication that appellant was under the influence. During the interview, appellant was offered a drink of water, use of the restroom, and told he was free to go; there were moments of levity that included appellant. (RT 2:945-949)

## STATEMENT OF FACTS

Prosecution Case

At the time of trial, Nyssa B. was fifteen years old; Nyssa's parents, Pana and Giorgio, divorced when Nyssa was three. Afterwards, Nyssa, her mother, and Nyssa's eight-years-older brother, Cristavao, moved away. Eventually, they moved into a Torrence apartment with appellant, Pana's stepfather.[1] Nyssa called appellant "grandpa," and he lived with the family for the next five years. Nyssa saw her father about once a month from the ages of three to eleven. (RT 2:622-625, 2:903-904, 2:966-968, 2:987-988, 3:1202-1206, 3:1210, 3:1219-1220, 3:1232, 3:1281)

Pana waitressed throughout Nyssa's childhood; appellant was Nyssa's primary caretaker while her mother was at work.[2] He watched her before she began attending school, and picked her up every day from school/daycare once she started. Nyssa shared a bedroom with her mother; appellant slept in the living room on a pull-out couch. The first time appellant touched Nyssa inappropriately, Nyssa was five years old: appellant touched Nyssa's vaginal area over her clothes while they were alone in the apartment. Appellant did not say anything, and Nyssa couldn't tell if it was intentional. It happened again the following day, and seemed intentional. Nyssa did not tell appellant "no," and was scared he was going to do it again. Pana never told Nyssa about improper touching, though her father told her sometime after appellant began touching her. (RT 2:625-631, 2:633-634, 2:904-905, 2:948-951, 2:974, 3:1206-1209, 3:1211, 33:1257-1258)

Appellant began touching Nyssa two or three times a week when they were home alone, usually around 4:00 or 5:00 p.m.. He would touch around her vaginal area, over her clothing at first, then on her skin when she came out of the bath. He also touched her chest, and had her "jack him off," teaching her to masturbate him. Sometimes appellant made Nyssa feel him under his clothing, sometimes he took off his pants. Sometimes appellant would ejaculate, pushing Nyssa aside and running down the hall into the bathroom to do so. The first time appellant had Nyssa touch him, he unzipped his pants, took out his penis, and asked her to touch it.

---

1 When appellant married Pana's mother, she had three daughters from a prior marriage, including Pana. Appellant and Pana's mother then had two daughters and a son of their own. One of the daughters died in a car accident in 1998. (RT 3:1232-124)

2 Pana testified she worked seven days a week, from 7:00 a.m. to 5:00 p.m. Monday through Friday, then taking the night shift to 9:00 p.m. (RT 3:1207-1208)

Other times, appellant had Nyssa straddle his lap, facing him, and would "hump" her so she felt his erect penis. He also rubbed his penis against Nyssa's vaginal area when she was naked. This continued over the years; appellant touched Nyssa "a thousand" times, and she touched his penis "on a daily basis." Nyssa could not describe appellant's penis, and did not know whether appellant was circumcised: she "never looked" at it. Appellant began grabbing Nyssa's chest as she developed breasts. Appellant sometimes told Nyssa to undress, and if she didn't, he would undress her. Each molestation lasted "maybe like an hour." Appellant told Nyssa not to tell, and that she was his favorite granddaughter. Nyssa never told appellant she didn't want to do these things, and never told anyone else what appellant was doing. (RT 2:631-636, 2:905-909, 2:911-912, 2:915-916, 2:951-953, 2:957-961, 2:964-966, 2:970, 2:972-976, 2:988, 2:994-996, 2:1001-1007, 3:1212-1213)

Twice, while Giorgio was visiting Nyssa, he asked about appellant, saying, "Does that old man touch you in any way you don't want? Does he make you feel uncomfortable?"[3] Her father sometimes referred to appellant disrespectfully, and didn't like appellant living with the family. According to Pana, Giorgio started disliking appellant three or four years after their marriage because he felt she was being taken advantage of. To refer to appellant as an "old man" rather than as grandfather or Mr. Sklavos is a sign of disrespect in Greek culture. Giorgio never told Pana that he suspected appellant was molesting Nyssa. Giorgio told Nyssa to tell him if anyone touched her inappropriately; Nyssa could not remember how old she was the first time they had this conversation. She didn't tell her father because appellant told her not to tell. (RT 2:912-913, 2:939-946, 2:953-954, 2:962-963, 3:1244-1247, 3:1281, 3:1289-1291)

Nyssa had a good relationship with both her parents and her brother during the years appellant was abusing her. She had slightly older female cousins living in the area between 1995 and 2004, and saw her aunt Cybil, who lived five blocks away, about once a month. Nyssa talked to Cybil and her sons when they visited. Nyssa knew how to use a telephone from the

<hr/>

3 Giorgio testified that when Nyssa was between five and seven, he told her to tell him if anybody didn't respect her body or harmed her. Giorgio never asked Nyssa specifically if appellant was touching her. Giorgio testified that he told police he didn't like appellant and was shocked to find out about the abuse. According to the detective, Giorgio said he suspected appellant of molesting Nyssa for some time, though she'd denied any abuse until December 2004. (RT 3:1281-1283, 3:1286-1288, 3:1291-1293, 3:1305-1306)

age of nine, but never called anyone for help. (RT 2:934-939, 2:954, 3:1235, 3:1258-1259, 3:1269)

When Nyssa was about seven years old, the family moved to a two bedroom apartment in the same complex. Nyssa's brother had his own room, and Nyssa and her mother shared a bedroom. The molestation continued, and appellant began orally copulating Nyssa,[4] stopping after they moved again, when Nyssa was nine. On more than one occasion, appellant asked Nyssa to orally copulate him, but she refused, and he stopped asking. He usually molested her in her bedroom. (RT 2:908-910, 2:951-952, 2:956, 2:969-970, 2:976)

Pana's stepsister, Cybil, and her children also lived with the family for some period of time before appellant moved in. Her stepbrother, his girlfriend, and her three sons, lived with the family on Eastwood for three or four months while appellant was living there. Nyssa had her own room when the family lived on Eastwood, Pana and appellant slept down the hall in their bedrooms, and Nyssa's brother slept in the converted garage. Nyssa got her period and began developing breasts when she was nine. The abuse stopped when Nyssa was eleven: appellant asked her to masturbate him, she said "no," and ran to a friend's house. (RT 2:911, 2:913-915, 2:917-918, 2:970, 2:988, 3:1211-1212, 3:1234-1235, 3:1269)

According to Nyssa, appellant stopped living with the family after he got "Section 8." The rest of the family moved to El Segundo, and Nyssa and her mother moved to New Jersey when Nyssa began middle school. (RT 2:916) In September 2004, Nyssa told her best friend, Christopher Anders, what had happened with appellant. She told Anders because she was depressed,[5] and because he told her something intimate about himself. She did not tell anyone else about her depression. Anders is four years older than Nyssa, and once worked with Nyssa's mother. Nyssa said her grandfather started molesting her when she was about five, stopping when she was eleven. She did not provide details. Anders became very angry and told Nyssa if she didn't tell her mother, he would.[6] Anders called Pana and

---

4 On cross-examination, Nyssa testified her legs would be on her shoulders, and appellant would be on his knees when he orally copulated her. Between 1995 and 2001, appellant saw a doctor for knee problems. (RT 2:976-977)

5 When Nyssa was eleven or twelve years old, she told Pana she was depressed. Pana asked her why, but Nyssa did not explain until September 2004. (RT 3:1260-1263)

6 Anders testified Nyssa told him in August 2004 while they were alone at the restaurant. He and Nyssa were friends, and spent time together visiting. Nyssa told Anders appellant made

said Nyssa had something to tell her; Pana confronted Nyssa at home, and Nyssa told her about the abuse.[7] Pana was very surprised; she cried, and got angry. She did not call the police. Three months later, on December 11, 2004, Giorgio came to dinner. Nyssa told her father, who got very angry, and contacted the El Segundo police.[8] Late the following night, Nyssa and her parents went to the Torrence police station, where Nyssa was interviewed in front of her mother. At the time of her reporting, Nyssa did not see appellant very often. (RT 2:919-926, 2:978-986, 2:993-994, 2:997-999, 2:1008-1009, 3:1213-1217, 3:1256, 3:1283-1285, 3:1314-1317)

The day after Nyssa went to the station, she was re-interviewed by a detective. A pretext call was arranged, and on December 14, 2004, Nyssa called appellant, spoke with him according to the script she'd developed with the detective. The call was recorded. (RT 2:926-929, 2:955, 2:968-969, 2:994, 2:997-1001, 3:1217-1218, 3:1294-1305, 3:1307-1310) Appellant spoke Greek with Pana; Nyssa speaks some Greek. Pana sometimes spoke to appellant in English. (RT 2:946-948, 3:1250)

According to Pana, she took Nyssa to the doctor as necessary, and attended parent/teacher conferences as scheduled. There were never any signs that anything was amiss. Nyssa's grades were all right until fourth grade, though Nyssa was never a good student. (RT 3:1236-1240) Pana had known appellant since she was two years old, and described their previous relationship as "beautiful." Appellant never molested Pana. (RT 3:1204-1205, 3:1240-1244, 3:1247-1248) From 1995 to 2001, Pana was aware appellant had lung disease, as well as problems with his stomach and his knees, eventually requiring knee surgery. Appellant also took depression medication. (RT 3:1248-1250, 3:1252-1253, 3:1268-1269, 3:1271-1273)

---

her touch him, orally copulated her, and undress her. She said she'd never told anyone about it. Nyssa started crying as she described the molestation, saying it started when she was five or six and ended when she was eleven or twelve. Anders told Nyssa to tell her parents and the authorities; Nyssa did not want to tell, and Anders said if she didn't, he would. Two or three days later, Anders called Pana. (RT 2:1009-1024)

7 Pana testified Nyssa said appellant touched her from the ages of five to ten. Pana stopped calling appellant, but otherwise did "nothing" because she was in shock. Pana knew her ex-husband had asked Nyssa about appellant touching her. Pana's relationship with her extended family ended after Nyssa's allegations. Pana did not contact any other female relatives to see if appellant had molested them. (RT 3:1214-1215, 3:1264-1271, 3:1276-1277)

8 Giorgio testified Nyssa was crying, and said she had something to tell him. He asked what happened, she said she was molested by grandpa. Nyssa said appellant made her "touch his thing" and touched her "private parts." (RT 3:1284-1285)

Pretext call[9]

After an exchange of hellos, appellant tells Nyssa that he has a bad cold. Nyssa tells appellant she wanted to say Merry Christmas; appellant remembers Nyssa's birthday is soon, and asks her what she wants. Nyssa says she wants to ask appellant why he used to touch her when she was little and lived in the apartment. Appellant says he didn't want to "do that" and that he told her to stay away from him, not to come close to him. Nyssa asks if it was her fault; appellant says he is so sick he can't even think right now. Nyssa says she's upset and is not going to tell anyone else. Appellant says he doesn't want to do anything to her, "I just wanna touch you," but not harm her, wants her to be healthy and nice. (CT 1:79-81)

Appellant says he doesn't want anything, and touches her and tells her to go away. Nyssa asks appellant why he didn't tell her to go away if he knew it wasn't right; appellant says he doesn't think either he or she did anything wrong. Nyssa says appellant knows it was wrong; appellant says he knows, but he's "not going." Nyssa says talking about it will give her closure, appellant says good. Appellant agrees with Nyssa that her touching him "wasn't cool," "wasn't right," and "not normal." Nyssa says she's getting better, appellant says good, asks her if she's going to school, says he's proud of her. Nyssa asks him to promise never to do "that" again; appellant promises. Nyssa asks, "You won't ever make me touch you again, right?" twice; appellant repeats "no.... no." Nyssa asks if appellant is sorry, he says he is "very, very, very sorry" but doesn't want to tell anyone. Appellant says "lot of times" he told Nyssa not to come close to him because he didn't want to touch her, or have her touch him. (CT 1:81-84)

Nyssa says appellant never told her that, that she didn't even want appellant around her; appellant capitulates. Nyssa tells appellant to just tell her he's sorry and she'll forget about it. Appellant says he's very very sorry and is telling the truth. Nyssa asks if appellant will ever do it again, appellant says never, no. He says he wants her to be healthy, good in school. Nyssa says she'll talk to him later, appellant says he'll stop by and give her a present, they exchange Merry Christmasses, and appellant wishes Nyssa a good year. (CT 1:84-85)

---

9 The tape of the pretext call was played to the jury; the court told the jury prior to the tape being played that the transcript was substantially accurate, but that they should ultimately be guided by the tape itself. Nyssa testified the tape was accurate. (RT 2:931-933)

Defense Case

      Cybil is appellant's daughter and Pana's half-sister. She lived with Pana and her family in 1995, and never saw anything that indicated appellant was molesting Nyssa. After Pana and her family moved, Cybil's family moved two blocks away from the family. From 1995 to 1999, Cybil visited Pana "all the time," about every other day. Nyssa never said anything to Cybil about appellant, and never made any attempt to avoid appellant, or avoid being alone with appellant. Nyssa did not seem depressed in 2001: she looked and acted like a happy child, outgoing and talkative. Cybil's never seen anything in appellant that would suggest he was a child molester. (RT 3:1339-1347, 3:1351-1357, 3:1376-1377)

      Cybil is a registered nurse. Appellant has medical problems with his lungs, stomach and knees, and has taken a variety of medication for those ailments. Appellant has a scar on his chest. From 1995 to 2004, Cybil saw her father either daily or every other day; in 2004, it was sometimes an effort to understand his speech. In 1998, he was mobile, but very depressed over the death of his daughter. Appellant mumbles, and his speech and mind are not as clear as they used to be. Appellant speaks much better Greek than English. (RT 3:1348-1351, 3:1357, 3:1360-1361, 3:1378) Elison is appellant's grandson. He lived with appellant when he was little, and visits him "all the time." Elison would often walk in unannounced, and never saw appellant molest Nyssa. Appellant is aging; in every conversation, he mumbles or says things Elison doesn't understand. (RT 4:1511-1514, 4:1516-1517) Eudocia was married to appellant for twenty-five years; they divorced around 1987. Appellant has never done anything to suggest he was sexually attracted to little girls. (RT 4:1519-1521) Ikaros is Pana's half-brother. He lived with Pana's family for a month in 2000 or 2001. Ikaros is very close to appellant. Appellant's mental and physical condition has been deteriorating for some time: appellant is nonresponsive and mumbles most of the time. Ikaros visited appellant unannounced, and never saw appellant undressed, or even shirtless. Nyssa's father told Ikaros "many times" that he disliked appellant. (RT 4:1522-1531)

      At the time of trial, Therese Sanchez was sixteen years old. She knew Nyssa from 1994 to 1998, when she lived in Torrence. Therese spent the night with Nyssa once in a while and would otherwise visit. Therese called appellant "Papu," appellant never touched Therese sexually, always treated her well, and never looked at her "sexually weird." (RT 3:1318-

1326) According to the police officer who first interviewed Nyssa, Nyssa said appellant molested her for nine years, from 1995 to 2004, stopping in September 2004. (RT 3:1314-1316)

Appellant testified that he loves Nyssa as his granddaughter. Appellant did not molest Nyssa. Appellant speaks some English, but "not all." Appellant refused when Pana first asked him to come live with her family, but she told him she'd cook, and already had an apartment. Later she asked him to look after Nyssa. Appellant watched Nyssa at home, but very rarely picked her up from daycare. He never had a big fight with Nyssa, and she never threatened or hurt him. He didn't understand why she accused him. Appellant could not remember the contents of the pretext call, though he remembered the call itself. (RT 4:1538-1541, 4:1545, 4:1560-1577)

Appellant required lung surgery in 1959, and remains on medication for that condition. He has had two stomach operations, one in 1975, the other in 1996 or 1997. He had kneecap replacement surgery, and takes medication for heart problems. He has had pain in his knee for many years and cannot run. In 1998, one of his daughters died, and he began to suffer from depression. The depression led to sleep deprivation: "nothing makes" appellant happy. (RT 4:1541-1546)

Dr. Edward Bold had been appellant's physician since 2001, treating appellant for obstructive lung disease. Even when appellant speaks English, it is very difficult to understand him: appellant also "rambles." In 1998, appellant was treated by another pulmonary physician in Dr. Bold's group, and at that time, appellant's lungs were clear and he reported he felt like "he's only 27 years old." Appellant was also seeing a gastroenterologist for a gastric ulcer, and in 1998, stated that he felt the best he'd felt in thirty years. Appellant had lung surgery for tuberculosis in 1959, and continued smoking until 1995; the smoking caused his obstructive lung disease. In 2001, a patient chart notation indicated appellant's ulcer was asymptomatic. Dr. Bold did not recall appellant complaining of hallucinations or delusions in 2004. (RT 4:1547-1558)

Dr. Roger Englebert is appellant's psychiatrist, and also treated appellant in 2004. At that time, appellant was prescribed the antidepressants Effexor and Trazodone. Appellant complained the Trazodone made him too groggy, reducing his nighttime dosage on December 9, 2004: Trazodone may cause marked sedation. The sedative effect can last a relatively long time. (RT 3:1327-1338)

At the time of trial, appellant was seventy-five years old. (RT 4:1541)

## STATEMENT OF FACTS

### Prosecution Case

Chanthou Phan was thirteen years old and living in a foster home at the time of trial; when Chanthou was eleven, appellant and her mother lived together on Cherry Avenue in Long Beach with Chanthou and her siblings: Nhean, Stevie,[1] Marie and Alex. (RT 318-322, 372) The family used the living room as the common bedroom. (RT 322-324, 342)

One morning around Christmas, 2001, when Chanthou and appellant were alone in the apartment, appellant told Chanthou to go to the bedroom. Chanthou did: she was running late for school, starting to get sick, and appellant wasn't going to let her go to school. (RT 324-325, 328) Appellant put Chanthou on the bed and told her he was going to touch her. Chanthou didn't know what that meant. Appellant took off his pants, pulled up Chanthou's skirt, and ripped the front of her underwear.[2] Appellant put his penis in Chanthou's vagina; it felt Alike a knife poking" Chanthou. She told appellant to stop, but he continued to put his penis in and out of her vagina, somewhere between five and ten times. (RT 324-328) Chanthou told appellant to stop or she would tell her mother; appellant told Chanthou not to tell or he would kill her. This scared Chanthou, and she didn't tell. (RT 328-329)

In January, 2002, appellant wouldn't let Chanthou go after her brother, who had left to walk to school: when Chanthou tried to leave, appellant slapped her and put her on the couch. He ripped her bracelet, took off his pants, and choked her. Chanthou said she was going to tell; appellant said, "I'm gonna kill you and your family." Appellant pulled Chanthou's skirt up and put his penis in Chanthou's vagina more than five times. (RT 329-332)

At some point that year, Chanthou and her family moved to Walnut Avenue; while there, appellant put his penis in Chanthou's vagina on more than ten occasions, sometimes in the living room, sometimes in the bedroom, at all different times of day.[3] Sometimes there would be two days between

---

1 Stevie was ten at the time of trial; Nhean was eleven. (RT 354, 371)

2 Chanthou later threw the underwear away. (RT 341)

3 If it was in the afternoon, Chanthou's siblings would be at a friend's house; if it was at night, they would be sleeping. Chanthou shared a bed with Marie, but Marie sometimes slept with her mother. (RT 342-343)

incidents, and sometimes not. (RT 332-335) Once appellant parked in an alley, removed his and Chanthou's pants, laid the seats down, and put his penis in her vagina. (RT 335-336) When appellant first started doing this to Chanthou, she screamed, but nothing happened, she then felt "too dirty," so she let him do "whatever." (RT 337)

Chanthou saw "a white liquid thing" come out of appellant's penis. She told police that she felt hard, round balls down by his penis. (RT 337-338) Appellant has a tattoo on his stomach that said "Khmer" and a tattoo of a man and woman on his arm; Chanthou saw the stomach tattoo the first time appellant removed his pants. (RT 329) In May, 2002, Chanthou told her mother. (RT 338, 361)    Appellant disciplined Chanthou and her siblings by hitting them with his belt. Chanthou did not like that, and she did not like appellant.[4] Chanthou's brother Stevie did not like appellant because he "whop[ped] us" with a belt and was mean. Her brother Nhean did not like appellant because he spanked the children and sent them to their room when they were disobeying. (RT 339-340, 356-357, 359, 362, 374-375) Chanthou would get in trouble with her mother for lying, and would sometimes lie to get other people, like her brothers, in trouble. She never told her brother or her friends at school what happened with appellant. (RT 340, 343)

Stevie once saw appellant take Chanthou into the bedroom and lock the door. Stevie could hear Chanthou crying inside; later Chanthou told Stevie and Nhean that appellant had raped her. Stevie and Chanthou's mother told Stevie to say Chanthou was lying about the rape.[5] Stevie did not know when during the year the rape occurred. (RT 354-358, 360-362) Once, while he was supposed to be sleeping, Nhean saw appellant lying on top of Chanthou on the living room floor for fifteen to twenty minutes. (RT 373-375) Nhean wrote a letter once saying Chanthou was lying about appellant; he wrote the letter because his mother was sad, and he wanted her to be happy. (RT 375-377)

A nurse examined for Chanthou sexual assault; Chanthou told the nurse appellant had raped her twenty or more times, and she had not been sexually active before the rapes. Chanthou also said appellant choked and slapped her, and threatened to kill her if she told. Chanthou said appellant

---

4 Chanthou testified that at first she liked appellant, but when he started acting "too strange" — telling Chanthou to sit on his lap and showing her his penis - she did not like him anymore. (RT 343, 344)

5 At the time of trial, Chanthou and Stevie were living with various foster parents; Nhean was living in a group home. (RT 321, 355, 362, 373)

kept her home from school so frequently her grades had suffered. (RT 605-606, 608-613) Chanthou had fifteen to twenty genital herpes, or HPV, lesions around her vagina, and one genital wart near the anus. Her hymen was a healed transection hymen, meaning it had been cut and healed. The most frequent cause of transected hymens is blunt force trauma such as penile penetration into the vagina. (RT 613-615) Chanthou was also examined by a gynecologist; the gynecologist found four or five genital wart clusters on the buttocks and around the vagina. Her Pap smear was consistent with Condyloma, or genital herpes. Tricolor acetic acid was applied to the warts to reduce their size. (RT 338, 616, 618-620)

Genital herpes can be transmitted without penetration, via external contact with infected genitals or pubic hair; a man might carry HPV without knowing it unless and until he suffered an outbreak of warts. HPV is not necessarily transmitted to every sexual partner, and those with weak or underdeveloped immune systems seem to be more susceptible to infection. (RT 621-623) Genital herpes is incurable: the low risk variety leads to external warts, while the high risk variety to cervical cancer. Women with genital herpes are advised to have their male partners use condoms to avoid transmission. (RT 620-621)

Evidence Code section 1108: Abril Guerro

On a Friday night in January, 1991, when Abril Guerro was twelve years old, she and a group of friends were at church when appellant offered them a ride. Guerro's two friends were dropped off first; appellant was supposed to take Guerro back to the church, but drove up to Signal Hill instead. Once at Signal Hill, appellant started kissing Guerro and saying he wanted to have sex with her. Guerro said no; after awhile, appellant drove the two of them to an alley. He parked and started kissing Guerro again, she began crying, asked him to leave her alone, to either take her to church, or let her out of the car. (RT 364-365, 367) Appellant got on top of Guerro, took her pants down, and put his penis in her vagina. Guerro continued to cry, say no, and ask appellant to leave her alone. (RT 366) After appellant was finished and they dressed, he drove Guerro to church. Guerro was frightened; she did not report the incident until the next Monday at school. (RT 367)

## Sex Offender Registration

Appellant has a prior conviction for child molestation.[6] If convicted of a sex crime in California, one must to register as a sex offender within five days of a birthday, and within five days of moving; the State must also be notified of any current address. On November 5, 1999, appellant registered 1380 Cherry Avenue, on March 6, 2002, he registered 1434 Walnut Avenue, Apartment Number Two, and on May 23, 2002, 1400 Lewis Avenue, Apartment Number A, all in the City of Long Beach. Appellant never registered 1396 Lewis Avenue. There is no 1434 Walnut Avenue in Long Beach. Appellant was arrested at 1396 Lewis Avenue; he told the arresting officers he lived at that location. (RT 379-382, 384-389, 392-393, 396, 398)

## Defense Case

Appellant met Chanthou's mother Jorani on August 6, 2001, at her cousin's house. At the time, appellant was living with his mother at 1380 Cherry Avenue, Apartment A. (RT 627-628, 631-632) When appellant first met Jorani, he did not know she had children. Had he known, he would have stayed away from her because of his registration issues. (RT 631-632)

When Jorani moved in with appellant, Chanthou was "a juvenile out of control": she beat up her brother and sister, and would not help out around the house. Chanthou did not listen to appellant when he told her to leave her siblings alone and help clean, so appellant disciplined her, spanking her with the belt a couple of times. (RT 632-635, 642) Jorani was ready to put Chanthou in boot camp or foster care when appellant moved in; appellant convinced Jorani to let Chanthou live with her grandmother instead. (RT 636) During this period, appellant worked Monday through Friday from 8:00 a.m. to 5:00 p.m.; Jorani was at home, on welfare. Appellant was never alone at the house with the children. (RT 633)

In 1991, appellant got a call from his friend at church to give some people a ride; appellant picked up the two girls and one boy and dropped them all off at the same location, a house the boy identified as his. Appellant left and returned home. Later, appellant learned the three were runaways. The boy was bad: he smoked weed and ditched school. The next day, appellant was arrested for raping one of the girls. (RT 628-630, 638-640) Appellant was beaten up and almost raped while waiting in jail, so he took the deal offered

---

6 Appellant was convicted of one count of violating Penal Code section 288, subdivision (a), and sentenced to six years in state prison on May 13, 1991. (RT 393)

by the District Attorney: three years probation, with a six months suspended sentence. Appellant didn't want to plead because he was innocent, but was told if he did not cooperate, he could be sentenced to life in prison. (RT 630-631, 639-641) Appellant had spent two years on probation when he was arrested, his probation violated, and he was sentenced to six years. (RT 631)

Appellant did not rape Chanthou, or touch her improperly. (RT 628, 635) The current allegations are a ploy by Jorani's family: Jorani's sister Cecilia wants to take Jorani's children away from her so Cecilia can collect Jorani's welfare money and have Jorani take care of Cecilia's baby while Cecilia sells doughnuts at night. (RT 635-636) After Chanthou moved in with her grandmother, Cecilia took Chanthou and made her babysit. Chanthou called Jorani and asked to come home; Jorani asked appellant, and appellant agreed to let Chanthou return because he felt sorry for how she was treated by her aunt and grandmother. When appellant and Jorani tried to get Chanthou back, Pauline got Chanthou to accuse appellant of rape. (RT 636-637)

Appellant has registered with police every birthday and each time he moved. He lived at the Cherry Avenue address until 2002, when he and Jorani moved to 1436 Walnut Avenue, Apartment Two; from there, Jorani moved to 1400 Lewis, Apartment A, while appellant stayed at the Walnut apartment. Eventually, appellant decided to move in with Jorani, and registered that address before officially changing residences. (RT 634, 642-643) "Khmer" is another word for Cambodian. (RT 637)

Appellant does not have genital herpes. (RT 645-647)

Rebuttal

Glenn Winther is the investigator for the defense; he spent approximately 40 hours investigating the defense side of the case. (RT 910)

## STATEMENT OF FACTS

Prosecution Case

    Jane Doe was 14 years old at the time of trial; she was born on July 7, 1994. Appellant became Doe's stepfather when she was about six years old. Doe has a younger sister, Christine, born in 2003. As a father, appellant was "understanding," and helped Doe with schoolwork. He was also the family disciplinarian. When in California, the family lived in a one-bedroom home in Baldwin Park owned by appellant's parents. Doe slept in the bedroom, appellant and Brenda, Doe's mother, slept in the living room, and Christine slept in either location. (RT 2:397-401, 2:404) The house was very small. Appellant's parents lived in the adjacent house, along with appellant's sister and children during the week. Appellant's brother, wife and four children lived next door. According to Doe, the front door was kept open about 20% of the time. (RT 2:417, 3:622-623, 3:665)

    One day in July 2004, while Brenda was at work, after appellant, Christine and Doe returned from Taco Bell, appellant told Christine to go watch TV in the bedroom. There is also a TV in the living room. Appellant and Doe laid down in the living room; appellant hugged Doe, then began touching her chest and vagina over her clothes. (RT 2:400-406, 3:666-667) Appellant next undressed himself and Doe. He unsuccessfully attempted to penetrate her vaginally with his penis, then positioned her on her knees and elbows and tried to Sofially penetrate her. He did not fully penetrate, eventually ejaculating into his shirt. Doe was crying; appellant told her to stop. (RT 2:406-409, 3:667-668, 3:671) Appellant told Doe not to tell anyone. (RT 2:410)

    Halfway through Doe's fifth grade year, the family moved to Texas, returning to the Baldwin Park house when Doe was in seventh grade. Doe wanted to stay in Texas. The abuse continued while they were away, but Doe did not tell anyone because she was afraid. Appellant once told Doe that he was going to kill her, but she didn't believe him. Appellant also told Doe that she and Christine were going to be separated from their mother and no one would believe Doe if she told because it would be his word against hers. The possibility of a separation scared Doe. (RT 2:409-410, 2:413-414, 2:417, 3:659-660)

    The abuse continued from July 2008 to February 2008, while Doe was in 8th grade. Appellant's mother babysat Christine during that time, and

had a key to the house. Appellant closed the windows and doors before each encounter. Once, around 5:00 p.m., after Brenda went to work,[1] Doe and Christine were watching TV in the living room when appellant told Doe to go to the bedroom and undress down to her bra and underwear. He then had Doe masturbate him as he felt and sucked her breasts. Appellant had her lay on the bed; she put her ankles and thighs together, he opened them apart. He lifted her leg, she put it back down; he lifted the other, and vaginally penetrated her with his penis. Eventually, he ejaculated into his shirt. Before Doe went to shower, appellant said that she had to unite with him by not saying anything, reiterating that she and her sister would be separated from their mother. (RT 2:414-420, 2:453-454, 3:609, 6:629-630)

The last time appellant abused Doe occurred around 8:00 p.m. on March 27, 2008, the day before her Holocaust project was due. Doe heard Brenda talking about going to WalMart, so Doe purposefully showered before she and Christine left; while Doe was dressing, appellant told her to go into the living room. The lights were off. Appellant sat Doe on the couch, kneeled in front of her, and had her masturbate him as he rubbed her vagina and sucked her breasts. She wouldn't stop crying; he socked her in the ribs. He ejaculated into his shirt.[2] (RT 2:422-425, 3:607-612, 3:620-622, 3:627, 3:640-643) Doe's mother knocked on the door. Doe ran into the bathroom and washed her hands; when she opened the door, Brenda asked her what was wrong. Doe said, "nothing." Appellant sat on the couch, yelling at Doe about her grades. (RT 2:425-427, 3:613-618) Doe did not see anyone looking through the windows during the incident; she was not crying loudly, as she had during other episodes. (RT 3:619, 3:643-644)

Doe told three of her friends: one in early March or late February, 2007, two in October.[3] She had them promise not to tell. (RT 2:422-423, 3:650-651) At some point, Doe told another friend, Samantha. After that, the

---

1 Doe's mother worked from 7:00 a.m. till 1:00 p.m. during the week, and 5:00 a.m. until afternoon on weekends. Doe would stay up until 1 or 2 a.m.. (RT 3:612-613, 3:631-632, 3:654)

2 Doe told the first officer she spoke to that the incident occurred at 1:00 p.m., and that her sister was in the bedroom watching T.V. (RT 3:607)

3 Patricia Estay was 14 years old at the time of trial; she testified that in October 2007, Doe told her that her stepfather was abusing her. Doe said appellant also hit her, and that she was afraid for her little sister as well. Estay said she told Doe to tell her mother and to go to the school counselor. Doe made Estay promise not to tell anyone. Later, Estay found out that Doe told other people. (RT 3:687-691) Fifteen-year-old Veronique Barjuan testified that she knew Doe during 8th grade. Before Spring Break, Doe told Veronique that she was being molested by her stepfather, and that she was scared. Veronique asked why Doe hadn't told anyone, Doe said she had told some friends. Veronique told her mother that night; her mother told her to tell someone

principal at Doe's school apparently found out: Doe was taken out of class on April 4, 2008, and brought to a room where police officers were waiting to interview her. Doe did not tell the officers that the family lived in Baldwin Park because she was going to school in West Covina. Doe had problems with her grades after moving from Texas. She also tried to inhale a bottle of body spray in 7th grade because she heard that you forget things when you are high. Doe began cutting her arm in 8th grade as a way to deal with the abuse. (RT 2:430-432, 2:451-452, 3:604-605, 3:645, 3:649-650, 3:662-664) Doe told her mother and appellant's mother about the abuse a couple of days before she spoke to the police. (RT 3:602-603) The night appellant was arrested, Doe went to a sleepover at her friend's house which appellant and Brenda said she couldn't attend. According to Doe, she has told "little lies" in the past. (RT 3:645-648)

Doe used to cry for Brenda to stay home, telling her that it was because appellant was strict. She sat next to cousins in large family gatherings. Though she was close to her cousins, she didn't tell any family members about appellant because they would not have believed her. She wrote poems with "clues" which she hoped someone would find, and left a Post-It with "Help me" written on it under her mattress. Doe text messaged her mother on March 31, 2008, saying that "if anything, that I was going to be there and I loved her." Doe highlighted an article titled "I know someone being abused" in her catechism book, hoping someone would see it. Doe acted "loveable" around appellant because there was a good side to him. Doe does not hate appellant. (RT 2:428-430, 2:432-434, 2:446-447, 3:635-637, 3:655-657, 3:674)

Dawn Henry is a sexual assault nurse examiner. She examined Doe on April 8, 2008, taking an oral history before performing a physical examination. The oral history is an informal account of what happened; a nurse examiner also fills out an Office of Criminal Justice Planning standardized report form to document the examination findings. Doe told Henry about appellant's threats, and the different sex acts involved. Doe was calm and articulate. (RT 3:692-697, 3:702-703, 3:705, 3:708-712) Doe's examination revealed abnormal findings: the hymen had a healed "complete" tear that ran the length of the hymen. A hymeneal tear is caused by force, such as a penis or some other blunt object. Doe's tear was not acute, meaning it had occurred

---

at school. Veronique told the nurse, the police were called. Doe seemed scared when she talked to Veronique. She told Veronique not to tell anyone. (RT 3:912-920)

some time before the exam. Henry would have been able to tell if the injury had happened a week earlier. Doe had multiple injuries on her arm, which she told Henry was caused by cutting. One of these was scabbed, others were just linear scars. (RT 3:697-708, 3:717-722) Henry's findings were consistent with the history Doe provided. (RT 3:716-721)

Defense Case

Tomas Iglesia is appellant's brother. He, his wife, and their four children live next door to appellant: the homes are about 20 feet apart. Iglesia's children are 13, 10, 9, and 5 years old. His parents and sister and her four children live in the house behind the two homes. Iglesia and appellant worked together, starting around 5 a.m., returning home about 6:30 p.m. Iglesia's wife was home taking care of the children 80% of the time from 2004 until 2008; his mother also babysat. Iglesia went into appellant's house two or three times a week, and their children played together. The doors between the three houses are never locked. If the blinds are open, someone standing in the courtyard outside Iglesia's house can see into appellant's house. From the courtyard, Iglesia could also hear the shower, television, and conversations in appellant's house. (RT 3:926-934) When Iglesia was in his parents' dining room, he could hear what was happening in appellant's bathroom. In the summer, everyone stayed outside at the pool; in winter, the children jumped rope outside and played basketball on top of the garage. (RT 3:935-936)

Iglesia has known Doe for six or seven years, and believes they have a good relationship. He was amazed at how close appellant's relationship with Doe; appellant is an "excellent father." Doe was occasionally upset when her mother went to work. The only time Iglesia saw Doe withdraw from appellant was when she didn't get her way. Doe seemed like "a normal kid." She lied about the inhalant incident and bad grades. Appellant and his wife talked about divorce three years before the recent allegations. (RT 3:938-941, 3:945-947)

On March 26, 2008, Iglesia, his wife and parents, appellant, appellant's wife and children got together with Hector De la Garza to plan Iglesia's daughter's birthday trip. Iglesia and appellant arrived home from work around 6:30 p.m.; after work, appellant, Iglesia, De la Garza, and Iglesia's parents played pool in the garage. Doe was outside as well, and Iglesia saw appellant's wife's car parked in the driveway. Iglesia heard Doe and Christine

inside appellant's house: he always heard the sounds of appellant's children arguing or being disciplined. Appellant went inside once, to ask for dinner. Iglesia never heard screams. (RT 3:948-956)

Sofia Castrilli, Tomas Iglesia's wife, has lived at the Baldwin Park house for ten years. She went to appellant's house every day between 2004 and 2008. Sofia could hear clearly what happened in appellant's house from the courtyard. She never detected any upset between appellant and Doe. She saw Brenda do an exotic dance involving unbuttoning her pants in front of Doe and other family members at Doe's sixth birthday party. (RT 4:1217-1221)

Kathy Iglesia is appellant's sister. She visited the Baldwin Park compound daily from 2006 to 2008. The family is close; Kathy has a child almost Doe's age. The families kept their doors unlocked and open. Appellant's bathroom window is always open. Doe and appellant's relationship was "really good," and they talked more than Doe did with Brenda. Doe lied to Kathy about using an inhalant. Doe told Kathy that she would "do anything" to move back to Texas. (RT 4:1222-1229)

Mario Fuente is appellant's brother-in-law, and Kathy's husband; he went to the house after work, around 3:30 p.m., a couple of times a week, staying until 7 or 8. Appellant's house is small, about 20 feet by 20 feet. Twelve years ago, Fuente closed off a doorway to create a wall between the living room and another area, creating the bedroom. The wall is hollow: from appellant's parents' house, one can hear what is happening in the living room of appellant's home, and vice versa. (RT 3:957-961, 3:969, 3:971-972) Appellant is a good father; he did more for the children than his wife. Doe and her family lived with Fuente for two weeks in 2006. Doe and appellant have a loving relationship. (RT 3:961-964, 3:967, 3:969-971) Mario's daughter Esme spent a lot of time with Doe, playing and watching TV. Esme does not trust Doe because Doe is a liar. She lied about sniffing chemicals, and would surreptitiously hit, kick and slap Christine. Doe wrote to Esme while she was in Texas; she loved Texas. (RT 4:1246-1253)

Ynez Iglesia is appellant's sister; she was at the house on Christmas Eve 2007. Around 9:00 a.m., the whole family was in the courtyard, dancing. Brenda was playing music from her computer. Appellant was leaning on a car, and Brenda began dancing inappropriately, touching his leg and her butt and breasts. She moved up and down, side to side. Doe was present, watching her parents. Ynez changed the music. (RT 4:1256-1263)

Hector De la Garza is a friend of appellant's; they work together. De la Garza went to appellant's house once or twice a week during 2007 and 2008. Appellant appeared to be a responsible father, Doe never appeared upset. The evening of March 27th, De la Garza went to appellant's house and played pool from 7 to 9 with appellant, his brother and father. Children were playing outside. Appellant's door was open, both cars were there; appellant went into the house a few times for a couple of minutes each time. (RT 3:1014-1027)

Serge Iglesia is appellant's older brother. He lived on the Baldwin Park property from 1999 to 2005, and visits thirteen or so times a year. Appellant was the primary caregiver for his and Doe's children. There was not much privacy among the homes or between family members. Doors were always open and people just walked in, often without knocking. (RT 3:1028-1037) Serge did not agree with Brenda's lifestyle, but felt that was none of his business. Serge saw a shift in Doe's personality after they came back from Texas. Doe became "scary," cold. Brenda was in control of appellant's lifestyle. (RT 3:1037-1041, 4:1203-1204)

Susan Canans is appellant's sister; she lived in appellant's parents' home from 2004 to 2006. She saw Brenda do "exotic" dancing in front of Doe a few times, most recently on New Year's 2008. (RT 4:1205-1208) Appellant' s mother, Josefa Iglesia, did not work outside the home between July 2004 and 2008; her primary responsibilities were taking care of six of her grandchildren. She did not sense any upsets coming from appellant's home. Before appellant's arrest, Brenda and Doe told Josefa that Doe had been abused. When appellant came home, Josefa brought him into the conversation; she felt there was no solution to the problem except to call the police. Brenda grabbed the phone from Josefa and told her not to call, that it needed to be solved in the family. Josefa told appellant and Brenda to stay there; they went back to their home. (RT 4:1210-1215)

West Covina Officer Michael Wratten interviewed Doe on April 4, 2008, and prepared a report based on that interview. Doe said the most recent incident occurred in the middle of the day in mid-March 2008, a Saturday. She said Christine was in the bedroom watching television; no threats or hitting were mentioned. She did not mention washing her hands, or a knock at the door. She said appellant did not ejaculate. (RT 4:1230-1245)

Dr. David Glaser is a board certified forensic psychiatrist with special expertise in criminal psychiatry; he works both as a clinician and as a

consultant, and has extensive experience in forensic psychology. Dr. Glaser teaches graduate psychiatrists at UCLA and the Foreign College of Forensic Psychiatry, and is the only child psychiatrist on staff at the Hollywood Sunset Free Clinic. (RT 3:972-981) In terms of assessing risk factors for sexual abuse perpetrators, Dr. Glaser Sofialogized the practice to assessing risk factors for having a heart attack: the factors are not predictive, but descriptive. Risk factors include past pedophilic behavior, untreated mental illness, alcohol/substance use/abuse, neurological damage, past molestation, sociopathic behavior, and the lack of a meaningful heterosexual relationship in cases of heterosexual pedophilia. Dr. Glaser bases his assessment of someone on a clinical interview and evaluation of documentary materials; he does not consider questions of guilt or innocence, but rather profiles the person to see if they fit the profile of a typical child molester. (RT 3:981-990, 3:1007-1008)

Dr. Glaser evaluated appellant in jail on November 28, 2008, after reviewing the crime reports, criminal complaint, forensic medical report, child abuse report, child court evaluation form, Department of Children and Family Services Report, probation officer's report, and transcript of the preliminary hearing. During the interview, Dr. Glaser assessed appellant's verbal and non-verbal responses to questioning. They discussed appellant's relationship with his wife and with Doe, and went over appellant's sexual, physical, medical, psychiatric history. Appellant's behavior throughout the interview was consistent with truth-telling and appropriate in emotional content, indicating a lack of sociopathy. Appellant was also appropriately upset because he believed false charges were being brought against him. (RT 3:990-998, 3:1005-1006, 3:1009) Dr. Glaser found appellant did not have any risk factors for pedophilia. (RT 3:998-1000, 3:1004)

Rebuttal

Brenda testified that she did not dance in a suggestive manner in front of Doe on Christmas Eve or New Year's Eve in 2007. Doe told Brenda that appellant was abusing her in March 2008. They spoke to appellant's mother. His mother picked up the phone to call the police, but did not call. Brenda did not take the phone away from appellant's mother. Appellant came home and gave Brenda divorce papers: they had been having marital problems for months. He said that she was never going to have Christine. (RT 4:1264-1271, 4:1274, 4:1279-1280) They did well in Texas; they had a bigger house, and Brenda thought appellant had a better job. Doe wanted to return.

She was a good student there. (RT 4:1283-1284) During her relationship with appellant, he used a T-shirt to clean himself after ejaculating. Doe once walked in on appellant and Brenda having sex. (RT 4:1270, 4:1280) Brenda and her daughters continued to live with appellant even after Doe's report, until appellant was taken into custody. (RT 4:1272-1276) She did not tell Doe to lie. (RT 4:1285)

Baldwin Park police officer Jaycon Sanchez interviewed Brenda and Doe on April 4, 2008; he had them review the March 27th report taken by Officer Wratten, and included corrections they made to that report in his report. Brenda told Sanchez that she did not know about Doe's allegations until the police arrived at Doe's school. (RT 4:1289-1292)

Baldwin Park Officer Mark Harvey went to the Baldwin Park home as part of his investigation; he did not notice that noise carried more than in other homes, nor did the walls seem exceptionally thin. He did not conduct any sound tests in the residence, and the doors and windows were closed during his visit. (RT 4:1292-1298)

## STATEMENT OF FACTS

Prosecution Case

On June 22, 2003, Camille T. was eighteen years old, 5'3", and weighed 110 lbs.; she had recently graduated from high school, and was living at home with her parents. She left the house at about 5:15 p.m. that day, with Victor Jimenez, whom she was dating. Camille was wearing a long white skirt, a long white shirt, and a black tank top. She lied to her parents about where she was going. (RT 367-370, 388, 433-434, 445, 460, 734) Jimenez first drove to K's Liquor, bought two 40-ounce bottles of Mickey's malt liquor, and the two went to San Pedro beach, sat, and drank. According to Camille, she drank one of the 40-ounce bottles; Camille testified she'd never drunk alcohol before that day.[1] According to Jimenez, he drank one and a half bottles. (RT 371-373, 435-437, 734-735, 763-764) After an hour and a half, they decided to go to Tommy Pena's house in Carson. Camille testified she felt dizzy, light-headed, and was having trouble keeping her balance; Jimenez helped her into the car. She kept falling, even while still at the beach, and felt Aa little sick." (RT 373-375, 437-439, 739) Jimenez testified Camille was fine when they left the beach, giggling, laughing, walking a little funny: they were both "buzzed." Camille told Jimenez, "I feel good." (RT 736-737, 987)

At Pena's house, Camille and Jimenez joined Pena and another man in the backyard, drinking more beer: Camille had about half a warm 40-ounce bottle of Miller. She kissed Pena. She didn't know why she kissed him, and couldn't remember what Jimenez's reaction was; the kiss was on the mouth, but Aa peck type."[2] According to Camille, Jimenez said they should go to Scottsdale, and Camille agreed. She was still dizzy, still falling down, still Abasically intoxicated." According to Jimenez, Camille wanted to buy a A20 sack" of marijuana, so they went to Scottsdale to find a seller. (RT 375-378, 439-441, 445-446, 745, 756, 764-765-766) Scottsdale is a housing development. According to Camille, when they arrived, a group of twenty to thirty, mostly men, were standing on a front lawn, drinking. Camille did not

---

1 On cross-examination, Camille said she had drank before, "every once in a great while," and had gotten drunk at other parties. In these earlier incidents, she'd fallen down while drunk, but had not had blackouts. (RT 433, 435)

2 Camille later told an officer that, in addition to getting "frisky," when she drinks, she kissed Pena because she thought he was cute. (RT 443-444) Jimenez testified Camille just used the bathroom at Pena's, there was no drinking, and they were only there for ten minutes before leaving. (RT 743-744)

recognize any of them, but "just started like socializing with everyone." She lost track of Jimenez: she later learned he left the party, but did not know why. Someone gave Camille an open Budweiser, which she drank, though she did not recall drinking anything else the rest of the night. She was feeling foggy, light-headed, and kept falling on the pavement; she was "not really" having a good time, and was "getting loud," talking to people more than usual. She probably hugged someone, but didn't remember if she kissed anyone. At some point, she went into a brown truck to look for her purse, and a man came in and asked her to orally copulate him; she said no, and got out of the truck.[3] (RT 378-385, 447-454, 746)

According to Jimenez, there were about ten to fifteen people hanging out in the street and sidewalk area, about nine men and six women. Pena saw someone he knew, so they stopped, and Pena got out. Jimenez just knew one of the women, Vanessa. Everyone was drinking Budweiser. Jimenez and Camille stayed in the car for about an hour after Pena left. Pena told them to come and hang out; Jimenez and Camille then had a beer. Camille had only one beer at the party because everyone quickly emptied the eighteen-pack.[4] Camille was still buzzed, hugging different men and letting them kiss her, telling them, "I want to fuck you." She said she wanted to have sex with "all nine Mexicans." Jimenez did not see her have any problem walking, though he lost sight of her for awhile. She did fall to the ground once, in the alley, about two or three hours after they got to the party. Around 11:00 or 11:30 p.m., a patrol car drove by, and everyone scattered and ran. Jimenez walked around the corner, waited until the police left, then returned to the area, leaving the party about half an hour later. (RT 746-760, 921, 934-935, 939, 984-986, 989) Jimenez saw Camille before he left: she was getting in a white SUV, she asked him for her purse, and he gave it to her. Jimenez did not recognize appellant, but he did not look to see who was driving the SUV. (RT 760-762) Jimenez left Camille because he was mad at the way she was acting.[5] The next day he felt bad about what happened after another woman

---

3 On cross-examination, Camille remembered telling police she was led to the truck by four Hispanic men who were pulling her by the arm. The men stood around the truck while Camille looked for her purse. Camille could not recall if anyone touched her inappropriately while she was in the truck. (RT 452-453, 458-459)

4 Jimenez testified that he told the patrol officer "we" had "some" beers, not that Camille had some beers. He did not say Camille was normally quiet and naive. (RT 925-926)

5 Jimenez testified no one threatened him or talked to him about the case; he found out Pena had been arrested the day after the party. (RT 936-937)

told him Camille had been unconscious, bruised, beaten; when next he saw Camille, all he noticed were a couple of bruises on her calf and above the knee that she'd had at the beach. (RT 766, 927, 935, 984, 988-990, 995-996)

Camille's recollection of the evening was "vague," there were "gaps." (RT 386, 454-455) Shortly after she got out of the brown truck, a police car drove slowly by, its top lights on; everyone started running, Camille went with Pena, "Hector" and "Phillipe"[6] behind one of the houses. There was no one else there. Pena pushed Camille onto the dirt and raped her in front of two other men: he laid on top of her, removed her underwear,[7] hiked up her skirt and put his penis in her vagina. Camille moved "side to side" trying to free herself because Pena was heavy. She did not hit him or scream for help because she was too scared; she did not tell Pena she wanted to have sex with him. Camille felt groggy, "like I was blacking out," "like I couldn't see straight or I couldn't say anything." Pena and Camille did not speak; Pena got off Camille, and Camille did not recall what happened next. (RT 386-391, 455-456, 461, 613-614) She did not look for Jimenez after the incident with Pena, did not recall whether she had anything more to drink, or if she spoke to anyone. She saw a white SUV parked near the houses, and did not remember how she ended up beside the SUV with some other people. She did not recall getting into the SUV, but remembered being inside.[8] (RT 392-393)

Appellant was the driver; Camille had never seen appellant before. There were other people there, talking, but Camille did not remember their conversation. The group stopped at a liquor store; she did not remember if anything was purchased. Camille next remembered waking up and seeing the Motel 6 sign.[9] (RT 394-396, 616-617) Camille then remembered being raped by appellant in a room with one bed: there were a group of six or seven men in the room, "half of them" naked. Camille was naked; appellant was on top of Camille, "going in and out." Camille was "just scared," she "didn't

---

6 "Phillipe" is alternatively designated "Fillipe" in the Reporter's Transcripts.

7 On cross-examination, Camille did not know what Pena had done with her underwear, just that she recalled it later being back on her; she did not remember telling police she put her underwear back on herself. (RT 462)

8 On cross-examination, Camille did not recall telling an officer she was holding Pena's hand as she got into the SUV because she was "feeling frisky." (RT 615-616)

9 On cross-examination, Camille remembered the liquor store was about ten minutes away from Scottsdale, and about twelve or thirteen minutes away from the motel. She remembered they parked in front of the motel. (RT 616-618)

know what to do so I didn't say anything." She did not cry, did not tell him to stop, did not push him, did not try to free herself, did not move side to side. Camille testified she was "less than alert," tired, angry, still drunk. (RT 397-399, 620-624, 655) Camille "never agreed" to go to the motel or to have sex with anyone in the motel room. (RT 400)

After appellant got off of Camille, she felt some pain on her arms, legs and a "sharp, burning" sensation in her vagina, "like dry skin rubbing against another skin." After appellant, another man got on top of Camille and put his penis in her vagina; approximately six men eventually had intercourse with Camille that night. One of them was appellant's co-defendant, Moreno. Camille did not recall seeing Moreno before he raped her. Camille's recollection of events was jumbled. She recalled "Hector" pushing inner thighs to open her legs.[10] (RT 400-403, 406, 425, 428, 704-705) She remembered appellant getting back on top of her a second time, and raping her again; she did not remember how many men who had sex with her in the interim. (RT 403-404) While Moreno was raping Camille, another man poured a cup of water on her vagina. (RT 406-407) Camille identified appellant in a photographic lineup as one of her rapists. (RT 409, 712, 1279) Pena forced Camille to orally copulate him; Phillipe also raped her. When Camille identified appellant as "Blas " to police, she was using the name she remembered hearing others use that night. (RT 409-412)

At some point, appellant[11] gave Camille some methamphetamine, telling her it would "keep her up." Camille had been falling asleep during the rapes, and took the drug because she did not want to sleep. No one threatened her: she just wanted to stay awake "to know what's going to happen." She thought if she refused to have sex with the group, "they might get mad," because she "didn't know what they were capable of."[12] She had never taken meth before, but watched someone else sniff some through a dollar bill. Appellant and Camille were standing near the bathroom sink; Camille had walked to the bathroom on her own. (RT 413-416, 625-628, 708)

---

10 On re-direct, Camille said she never identified who was spreading her legs open. She also had no independent recollection of anyone putting his mouth on her, or of being punched or kicked. (RT 705-707)

11 On cross-examination, Camille testified she did not tell the detective that appellant gave her the drug during her initial interview, but did tell him this later. (RT 626-627)

12 On re-direct, Camille said she told the detectives she was afraid to say no to the sex because "there's a lot of people that I was afraid of saying anything, and so I didn't." After having her recollection refreshed, she said she didn't say no because she was intoxicated and there were so many men she didn't know what to do. (RT 702-703)

The methamphetamine made Camille feel a little less groggy. Camille also vomited twice in the bathroom while at the motel, walking to the bathroom by herself and closing the door before doing so. She could not recall if she showered at the motel or not. By morning, only appellant, Hector and Phillipe were left with Camille. (RT 417-418, 628-630, 653, 686)

Check-out time was noon: the group left the motel in appellant's SUV. Camille noticed they had been in room 125. She did not attempt to run away; she didn't know why not, except she was "just too scared." Camille was still a bit light-headed, felt sick and tired, and had some vaginal pain. There was no bleeding. (RT 417-420, 430, 630-631, 686) The group went back to Scottsdale; Camille then accompanied Hector and Phillipe to someone's house, where Camille was dropped off. (RT 420-421) Camille did not ask to be dropped off at home because she was missing her cell phone, purse, and twenty dollars. She next went with someone else to another house to try and get her belongings back. Someone told her Pena had her things, but Pena was not there. A man at that house forced Camille to orally copulate him in exchange for her property;[13] Hector eventually gave her the purse, but the cash and cell phone were not returned. No one threatened her, or told her not to report what happened. She asked to be taken home, and a neighbor gave her a ride to a spot about seven houses away from her parents' house. This person also did not threaten her, or tell her not to tell. (RT 421-426, 631-632, 649-650, 652, 654-656, 687)

When Camille arrived home, at around 5:00 p.m., she found her parents worried, crying; her uncle arrived about ten minutes later with a patrol officer. Her parents were not angry, but had filed a missing persons report: during the ten minutes between her arrival and the arrival of her uncle and the officer, Camille did not tell her parents she'd been attacked, or that she'd gone to a motel. Camille did tell the patrol officer "some stuff," and was later interviewed by detectives[14] and taken to the hospital for a sexual assault

---

13 On cross-examination, Camille said "they" raped her at the house: "they" included Hector and a second man named Shorty. Camille also testified she did not tell them to stop, or that she wanted to go home; after reviewing the police report, she remembered she told Shorty to stop, pushed him off her, and he stopped. "Hector" was "Shorty." She told the officers one of Phillipe's friends drove her home, but "now that I look back at it it wasn't his friend." She thought Shorty/Hector told someone else to take her home. (RT 633-636, 653, 716)

14 Camille told detectives she was raped at the motel by appellant, Hector, Phillipe, Pena and two other men, and could identify all of them. She thought she told them about going to Pena's house, the party, and returning to Scottsdale afterwards, but wasn't sure if she'd included everything in either that interview, or in a subsequent interview two days later. (RT 669-674, 698-700)

examination. She did not tell the officer about the visit to Pena's house, or the party, or returning to Scottsdale earlier that day, or about having been attacked again at Scottsdale just before going home.[15] Camille told the officer she "vaguely" remembered being at a Motel 6 and having sex with some men;[16] the officer told her uncle and parents. She also told the officer she was intoxicated and "high on meth" at the time. She said the men "were intimidating." Camille had bruises on her body. She told the nurse she had voluntarily ingested drugs in the ninety-six hours before the exam, and drugs and alcohol between the time of the assault and the time of the exam. She had not changed her clothes, but her underwear was missing, having been left behind at Scottsdale earlier that day. (RT 427-428, 636-638, 648, 650-651, 656-659, 663-669, 672, 692-697, 722-728)

Gemma Jones lived in Scottsdale in June 2003; on the 22nd, she called the sheriff's department after watching a rowdy group of mostly men and one woman outside her house: the woman seemed extremely intoxicated, and was being flirtatious, hugging and kissing some of the men. Jones found the men's conduct disturbing, as some were acting aggressively toward the woman. She was about twenty-four feet away from the group, looking through a window. She called after the first five minutes, and watched the group for a total of thirty to forty-five minutes. The group moved further away from Jones over time, drifting as far as forty-one feet away; at one point, they went out of sight, returning a few minutes later. (RT 1055-1063)

The supervisor of Forensic Nurse Specialist, Inc., testified as to the training of the sexual assault nurse examiner who examined Camille, and the general protocol followed by the agency's examiners. The agency works as part of the law enforcement team, and examiners are subject to a process of peer review. (RT 1001-1004, 1040-1048) It is possible to have bruises on the outside of a woman's body, and even a vaginal injury, as a result of either rape or consensual intercourse. The supervisor had examined women after consensual intercourse and usually did not find injury; ten to fifteen percent of the time there might be a single superficial tear or abrasion to the vaginal opening. The supervisor reviewed the report on Camille, and the accompanying photographs, which depicted bruises on the arms and legs and torso and multiple vaginal injuries, and independently concluded

---

15 On cross-examination, Camille said she told all the officers about the party. (RT 691)

16 On re-cross-examination, Camille denied telling the officer this, saying she said she'd been raped; after looking at the report, she could not remember. (RT 730-731)

the degree and number of the injuries were "rather severe" and not from a "typical case." (RT 1005, 1011-1016)

The photographs detailed a "grab bruise" or "fingertip bruise" on the right bicep, seen in cases of unconsensual sex; a cluster of small bruises on the inner right knee, inconsistent with a fall, consistent with pressure to separate the legs; falling bruises on the kneecap and shin, consistent with falling while wearing a long skirt; a small bruise cluster on the outside of the knee; a small, round bruise on the inner back aspect of the thigh, consistent with a fingertip; a deep bruise circled by multiple smaller bruises on the back of an arm, consistent with thumb pressure; fingertip bruises on the inner aspect of the arm; a bruise on the outer knee, consistent with accidental bumping; fingertip bruises on the side of her stomach and on the rear of the torso; and fingertip bruises on the inner arm.[17] (RT 1018-1024) Tears were noted on the labia minor around the urethra and on the outside the aspect of the clitoral hood, on the posterior fourchette, and on the perineum, near the anus, indicating that there were different positions or struggling, so that the penis was unable to find entry. In consensual intercourse, the woman will engage in pelvic tilting to facilitate penile entry; these injuries indicated a lack of pelvic tilting. The supervisor would expect pain. (RT 1026-1029)

By "consensual sex," the supervisor assumed one male partner. Some of the observed injuries could have been caused by a male partner who had been drinking and was "inaccurate." The number of injuries could be increased if a woman had multiple consensual intercourse with multiple partners. (RT 1031-1032) There was a photograph of Camille's neck, which had hickies: the supervisor did not think that information was helpful relative to the degree of force used, though it is "very common" for a rapist to leave a hickey, as it is common in consensual sex. There were no facial bruises or head injuries. The bruises appeared to be from two to four days old; the bruises on the arm were consistent with someone grabbing the arm hard, which could occur if someone was trying to stop the person from falling and the person was "like a dead weight." The knee and shin bruises were consistent with falling. (RT 1033-1037, 1048-1051) The examiner's report described Camille's skirt as clean: it was not soiled, there were no tears. Camille was "clean" and "well-groomed." It was noted Camille bathed prior to the examination. She had changed her underwear, and did not know where the previous pair had gone. Camille indicated she'd engaged in voluntary drug

---

17 People's Exhibit Nos. 13, 11, 15, 12, 14, 25, 27, 16, 26, 23, 24.

use, and voluntary drug and alcohol use between the time of the assault and the time of the examination. She had vomited a couple of times, and thought perhaps one of her partners used a condom. Blood and urine samples were taken. (RT 1037-1040)

The deputy sheriff who first interviewed Camille testified she was flogged down by a man who told her his niece had been assaulted; she followed him to Camille's home, and was waved inside by several other adults. The deputy found Camille sitting on the stairs, crying, her head in her hands. The deputy talked to Camille for about ten minutes, determined she didn't need immediate medical attention, and contacted a handling unit to take charge of the investigation. In her conversation with the deputy, Camille did not say she'd been raped within the last thirty minutes, that she'd just come from Scottsdale, or say anything about the events of the 23rd. She said she'd gone out with Jimenez, they'd started dating, had gone to the beach, then to a party in Scottsdale.[18] Camille said she "vaguely remembered" being at the Motel 6, and said that six men "had sex" with her. She said she'd been drinking, was extremely intoxicated, was intimidated by the men at the motel, and had discovered her cell phone, money and jewelry were missing. She did not say she was raped before going to the motel. Camille's parents did not know what happened to her; they told the deputy she'd not come home the night before, and so they filed a missing person's report. The deputy was instructed to secure the motel room; she spoke to the motel manager, who told her a maid told her one of the rooms had been left "in shambles." The deputy secured that room: photographs[19] of the room and the surrounding area depict a trash bin[20] next to Room 125; the room itself is extremely small, the bathroom smaller. By the time the deputy arrived, the room had already been cleaned by housekeeping. (RT 1202-1213, 1223-1233, 1235-1237)

The deputy interviewed the housekeeper, who said she found wet sheets and towels in the bathroom, beer bottles "everywhere," and used condoms. The bathroom floor was very wet, as if it had been flooded. (RT

18 The deputy also interviewed Jimenez: he said he and Camille were dating, describing her as "quiet and naive." Jimenez said he and Camille each drank a 40-ounce beer at the beach before going to the party, that they were at the beach for about three hours, went to Scottsdale, saw some people he recognized, and he and Camille started drinking Budweiser with the group. Jimenez described Camille as "extremely intoxicated" at the party. Jimenez also said there were two other women at the party. (RT 1215-1216, 1221, 1231)

19 People's Exhibit Nos. 29, 30, 31, 32, 33, 34, 35, 36, 37 and 38.

20 The dumpster was about three-quarters full, and held the contents of "a lot" of trashcans, which included beer bottles, pizza boxes, towels, sheets, etc. (RT 1233-1234)

1213-1214, 1230) The housekeeper testified that when she arrived, there were beer bottles and two boxes in the room, along with a very dirty men's T-shirt, a pair of socks, and many condoms. There was a very dirty towel on the floor in the bathroom, and "a lot of water." She threw the detritus in the boxes and took them to the dumpster. (RT 1245-1250)

Hotel records indicated appellant rented the room at 12:17 a.m. on the 23rd. The hotel clerk testified appellant walked up to the window; she never saw a woman that night. (RT 697-698, 1239-1243) Cindy Buinton was staying in Room 115; while sitting in her car in the parking lot, she saw a white SUV pull in, park, and about fifteen men get out. Several men then quickly carried a girl from the SUV into a room. The girl was asleep, and about five men were holding her by her legs, arms and shoulders, chair-style. People came and went from the room throughout the night; Buinton did not call the police because she "thought there was a party going on." (RT 1253-1261, 1265-1268, 1303)

The dumpster was secured for evidence collection. A criminalist recovered condoms from the trash and another condom from behind the headboard in the room, in addition to removing various towels, sheets, beer bottles and items of clothing. Samples were taken from the condoms, DNA from those samples amplified and analyzed, then compared with reference samples from appellant and co-defendant. The sample from the interior of the headboard condom was a single source match to appellant; the random match statistic was one in 3.41 quadrillion. Co-defendant could not be excluded as a contributor from a sample taken from the exterior of the headboard condom: the random match statistic would be one in thirty Hispanics. Neither appellant nor co-defendant could be excluded as a contributor from the exterior of one of the dumpster condoms.[21] For another dumpster condom, six people were included as possible contributors, including Camille: for that sample, one in five Hispanics would be included as a possible contributor. There were also two semen stains on chairs in the room which did not match any of the reference samples. (RT 1214, 1234, 1522-1555, 1562-1565) Another criminalist testified that a 5', 110-pound woman, who ate a normal lunch, began drinking at 6:00 p.m., drank 40 ounces of Mickey's malt liquor, 20 ounces of Miller beer, four 12-ounce Budweiser beers, having had her last drink at 11:00 p.m., would have a blood alcohol level of between .19 and

---

21 By interior/exterior, the criminalist meant the condom as found: if the condom was inside out, the inside would be the "exterior." (RT 1529)

.21 at midnight.[22] If the last drink was at midnight and there was only one 12-ounce Budweiser consumed, the blood alcohol level would be between .07 and .08: the body eliminates alcohol at a rate of one-third an ounce per hour. Under either scenario, by 7:00 a.m. the next day, all alcohol would have been eliminated from the body. The blood alcohol limit for driving is .08, .40 is lethal; about half of the population with a blood alcohol level between .20 and .03 would pass- or black- out. Someone who'd drank before would have a greater tolerance to alcohol's effects, the more sedentary the person, the more apt to fall asleep. (RT 1574-1579, 1582-1588)

The detective assigned the investigation interviewed Camille on June 24th; Camille identified Pena from a photographic lineup, and identified appellant on June 25th.[23] Six men from the motel room were eventually identified via photographic lineups. Camille told detectives about going to the beach, then to the party, that appellant drove up after everyone ran from the police, Pena took her to appellant's car, Camille got in, appellant drove her and five others to a liquor store, and to the Motel 6. Camille said she saw the motel sign, then "passed" or "blacked" out.[24] When she woke, she found appellant on top of her, having intercourse. Camille said she took methamphetamine around 5:00 a.m., and the rapes ended around 7:00; she slept or rested in between. In some interviews, Camille told the detective there were four people in the car on the way back from the motel; in others, she's said five. (RT 1275-1283, 1294-1295, 1308-1309, 1311, 1318-1319) The detective also interviewed Jimenez on June 26th, who said Camille was extremely intoxicated that night, and he'd seen her with four separate beers while at the party. When the detective re-interviewed Jimenez on July 1st, after appellant and Pena's arrests, Jimenez said Camille had fewer beers than previously reported. Jimenez "wavered back and forth" as to whether Camille was able to take care of herself. (RT 1285-1287)

The detective interrogated co-defendant: co-defendant said Camille was intoxicated at the party, and was being loud, "very friendly," "jumping" around the men, "flirtatious." Co-defendant said he was a friend of appellant's, and got into appellant's car with Camille. They went to a liquor store, then to

---

22 Malt liquor has an alcohol content between four and ten percent; regular beer is about four percent. (RT 1591)

23 The detective mistakenly thought Camille identified co-defendant as Phillipe; at the time of trial, Phillipe had not been identified. (RT 1284-1285, 1304-1306, 1320-1321)

24 Camille thought they were going for more beer, and identified the liquor store on Figueroa Street to the detective. (RT 1294, 1303)

the Motel 6. Once inside, co-defendant said he socialized with some other men, listening to the radio, drinking beer, and eventually falling asleep. He got a ride home from appellant at 1:00 or 2:00 a.m. Co-defendant said no one was naked, or had sex in front of him. (RT 1288-1294, 1508-1514) Appellant spoke to the detective in order to get his car back. The detective collected swabs for DNA testing from appellant and co-defendant. (RT 1505B1506, 1514-1515)

According to the detective, it is three to four miles from Pena's house to Scottsdale, another three or four miles from there to the liquor store, and another few miles to the Motel 6. To drive from Scottsdale to the Motel 6 would take ten to fifteen minutes, maybe less. Camille lives a few miles from Scottsdale. (RT 1313-1316)

At the time of trial, Jimenez had recently become a member of Varrio Catskill Street; Pena is also a member. Nobody told him how to testify. Jimenez testified he wouldn't lie "over this" incident, but would lie for other gang members. Jimenez would not want Pena to look bad. (RT 990-994)

Camille did not make up the story of the rape to get her cell phone back, or to avoid explaining her overnight absence to her parents: she has a pretty good relationship with her mother, though she has lied to her to "cover up" things. The night of the charged incident was the first time Camille had gone out and broken curfew. She's not spoken to Jimenez since the party. She never said to anyone at the party, "I want to fuck all these guys here." (RT 431, 434, 682-683) Camille told one of the investigating officers she "gets frisky" when she starts drinking. "Frisky" means "too friendly," "too friendly" means kissing. (RT 443-444)

Defense Case

Divina Morrison lived in Scottsdale on June 22, 2003; that night she was driving around the development, looking for Ben Guzman, her live-in boyfriend's little brother. On the north side of Scottsdale, she saw forty people at a party, five of them women. Morrison knew many of the attendees, including appellant and co-defendant. She saw a woman in a long white skirt and a black shirt matching Camille's description with co-defendant: the two were "slap-boxing," playing around with each other. A few minutes later, Morrison saw the woman hanging on co-defendant "like if she were a baby," her legs around his waist and her arms around his neck. Co-defendant was

carrying her; she looked happy, as if she'd had a few drinks. Morrison then returned home to the south side. (RT 1602-1608, 1613-1615, 1625)

The next morning, Morrison was in her garage when she watched Guzman being approached by the same woman with two other men: they were looking for a place to have sex. Morrison told them they couldn't have sex in her house, and they left. As they walked away, the woman said, "Where are we going to fuck?" (RT 1610-1613, 1634) Morrison felt disrespected by the woman, whom she thought was misbehaving; at the time, Morrison said she wanted to "whip her ass." Guzman, and two others, later pled guilty to raping Camille. Morrison didn't tell the prosecutor what Camille had said because everyone associated with the defense told her not to. Morrison is not angry at Camille. (RT 1611, 1616, 1621-1622, 1625-1630, 1634-1637)

Sixteen-year-old Vanessa Lopez also lived in Scottsdale on June 22, 2003; that night she saw a young woman in a long white skirt and black shirt "acting up." The party was down the street from Lopez's house; she couldn't see who was at the party. Lopez was watching the woman from her bedroom: she saw her "jumping on top of guys," hugging them, and being too loud. The woman also jumped atop a white car and started dancing; the next day, Lopez noticed sandal marks on the hood. Lopez saw the woman hug three men; she had never seen a girl act like that. At some point, Lopez walked to her garage and asked the woman if she needed help. The woman said, "No, I'm fine. I just want to get fucked some more by these guys." There were three or four men present. Lopez also saw the woman having sex with one man; they were twenty to twenty-five feet away, standing up. Later, the woman left and returned with other men, who Lopez did not recognize. This continued from about 8:00 p.m. until around 1:00 a.m.; Lopez's mother called the security company to quiet them down because she had to be at work by 2:00. (RT 1638-1653) Lopez knows appellant and co-defendant from the neighborhood, just to say hello. Lopez and Morrison did not talk about the case, except to say how bad Camille "makes girls look by doing all this stuff" and that she "gives girls a bad name." (RT 1646, 1653-1654)

A former criminalist with the Los Angeles Sheriff's Department, who had managed the LASD laboratory's blood alcohol testing section, trained officers in alcohol-related investigations, and testified for the prosecution in driving under the influence trials, agreed a 5', 110 lbs. woman who had eaten a normal lunch, then drank a 40-ounce Mickey's at 6:00 p.m., had a 20 ounces of Miller beer an hour-and-a-half later, followed by four 12-ounce

Budweisers, would have a blood alcohol level of .19 to .21 at midnight. If the same woman had one 12-ounce Budweiser, and the rest of the hypothetical was unchanged, her blood alcohol level at midnight would be around .07 or .08. People can function at .19 and .21: functioning is related to alcohol tolerance: the consultant was aware of someone who drove in "the high 4's"; though this was rare. Most people, however, are not unconscious in the .19 and .20 ranges. Alcohol tolerance is acquired either through exposure to drinking or as a matter of natural biological ability. (RT 1802-1803, 1807-1811) Unconsciousness from alcohol occurs when the level reaches that of anesthesia and the person loses consciousness. Blacking out is distinguishable as a phenomenon of short-term memory loss, an altered recollection of events, rather than a loss of consciousness itself. (RT 1811-1812)

Alcohol is a central nervous system depressant; methamphetamine is a central nervous system stimulant. If the hypotheticals included ingestion of a line of methamphetamine between midnight and 5:00 a.m., the woman would be in a heightened state of alertness; she would not go to sleep. (RT 1816-1819) Most people at .19 or .20 are unsafe drivers, though able to operate a car. Impaired memory would be expected at that level; assuming normal tolerance, at .10 and above, some memory impairment might occur, including short-term memory loss or misinterpretation of events. Someone might not remember who was in a room, who had joined or left a group, what words had been spoken. Sobriety would be considered returned when the blood alcohol level was somewhere between .08 and .05, though there would still be some difficulty in recollection. If memory loss occurs, it is permanent. (RT 1820-1824, 1826) Malt liquor could not put someone to sleep after ten ounces, because malt liquor is five to six-percent alcohol; nor is "a couple" of beers enough to put someone to sleep. Eighty ounces of beer consumed over a period of time by someone who weighed 110 lbs. could make someone sleepy by 11:00 p.m.: there is a range of possibility of effect. Someone with a moderate drinking pattern would be in jeopardy and judgment-impaired at a .20: they would not do something "really stupid," but might "decide to tell your boss what you really think of him." The expert did not know Camille's tolerance. (RT 1827-1834)

Paco Ortiz lived in Scottsdale on June 22, 2003; he knows appellant, co-defendant and Guzman. He saw Guzman on the 23rd, walking through an alley with a girl and another couple. The girl was Filipino or Korean, wearing

a black shirt and a white skirt. She was walking behind Guzman, talking and laughing. Ortiz was watching through the window with his wife; he said, "Look through the window and Benny have a girlfriend, look through the window there." Ortiz didn't talk to anyone else about the case, and no one told him what to say. The defense investigator told him what the girl was claiming, and there was talk of it in the neighborhood. (RT 1836-1844)

# STATEMENT OF FACTS

## Prosecution Case

On December 29, 2004, Danielle was fifteen years old.[1] She had met appellant at her friend Ynez's house that September, meeting his twin brother Theo and his cousin Ritchie sometime in November. Danielle and appellant spoke on the phone regularly, and she'd spent some time with the co-defendants, including Friday night visits to their apartment. Before December 29th, Danielle did not have a romantic relationship with any of the co-defendants, and none of them had ever harmed or threatened her. She was not afraid of them. (RT 1:121-127, 1:130-131, 1:139, 1:184-187, 1:193-194, 1:198-205, 2:298-299, 2:309-310, 2:333-335, 2:372, 2:382) Danielle knew appellant was in the SouthSide Chiques gang because he told her, and showed her his gang tattoo. She had also seen him throw up gang signs and yell the gang's name at another gang while driving. Danielle couldn't remember if Ritchie or Theo said anything about SouthSide Chiques, though Theo told Danielle he'd been jumped in the gang when he was younger. Appellant's nickname was Sneaky, Ritchie was Spanky, and Theo was Monstro, or "monster" in Spanish. (RT 1:127-132, 2:374, 2:383-384)

On December 29th, appellant called Danielle to hang out with him, Ritchie and Monica; appellant and Monica were dating. Appellant and Ritchie picked up Danielle around 6 p.m., then met Monica at a liquor store. Afterwards, they got Theo and went to their friend Megan's house. Monica was fourteen at the time, Megan sixteen. At Megan's, the group stayed outside for about an hour; at some point, appellant suggested to Danielle that they have a "foursome." Danielle thought appellant was joking, and laughed it off. (RT 1:133-138, 1:203-204, 1:207-212, 1:222-224, 2:297-298, 2:324, 2:373)

The six friends bought beer, and drove to the co-defendants' one-bedroom apartment in Thousand Oaks. While in the car, Ritchie kissed Danielle. Theo and appellant's godmother was home when they arrived, but left a few minutes later. The co-defendants started drinking. When Theo went to shower, appellant and Monica went into the bedroom. Ritchie and Danielle stayed in the living room with Megan. Ritchie and Danielle were kissing, Danielle sitting on Ritchie's lap. (RT 1:139-143, 1:186, 1:189, 1:197, 1:207-208, 1:213, 1:216, 1:221, 1:224, 2:332, 2:366) About fifteen minutes later,

---

1 Given the scope of review, only facts relative to the gang allegations are set forth.

Monica came out of the bedroom, crying. Danielle asked what happened, and Monica said nothing happened. Danielle, Monica, and Megan talked in the hallway, but Monica did not say she'd been sexually assaulted. A few minutes later, the group decided to leave. Theo was driving, appellant sitting in the front. Danielle and Ritchie sat in the back with Monica and Megan. Monica was dropped off, then Megan. Danielle thought she was to be taken home next, but someone wanted to stop back at the apartment to use the bathroom. Appellant asked Danielle to call Monica and see how she was doing. Danielle called, asked Monica what was wrong, Monica accused Danielle of being with appellant, and hung up. Danielle called her back, and Monica said that appellant had sex with her, she told him to stop, and he didn't. Danielle told Monica that she was on her way home. She then went into the apartment, waiting in the patio. (RT 1:143-148, 1:216-222, 1:225-238, 2:303-304, 2:307, 2:322, 2:332, 2:335-339, 2:343-344, 2:385)

Appellant suggested they go to the back room to talk about Monica. They did, sitting on the bed. Appellant said he had sex with Monica, including oral sex. When she told him to stop, he stopped right away. After Danielle took off her hair tie, appellant played with her hair, then pulled her backwards onto the bed. Appellant kissed Danielle: she was "okay with that." He took off her pants, which was all right as well. (RT 1:148-1:153, 1:190-191, 1:239-249, 2:251-253, 2:344-349, 2:376-378) Theo and Ritchie then opened the door and asked if they could "get in." Danielle yelled "no" and "get out." Appellant got off Danielle, Ritchie grabbed one of her legs, appellant took the other, and Theo got on top of her. Holding Danielle's hands above her head with his forearm, Theo put his finger into her vagina, then put his penis in her vagina. Danielle screamed "no," "get off me," and tried to close her legs. She did not want to have sex with him, Ritchie, or, by that point, appellant. (RT 1:154-159, 2:258-270, 2:340-341-343)

Theo took his penis out of Danielle; she did not think he ejaculated. Next, Ritchie got on top of Danielle. He was wearing boxers, and she could see a tattoo above his knee. Danielle slapped Ritchie. Ritchie said, "You don't even know what you just did," which Danielle took as a threat. Ritchie bit Danielle's upper thigh and shoulder, put his fingers into her vagina and tried to kiss her. Danielle tried to push Ritchie away as he put his penis in her vagina; appellant and Theo stood in the doorway, watching and giggling. Ritchie took his penis out of Danielle and left the room. She didn't think he ejaculated. (RT 1:159-167, 2:271-275, 2:303, 2:326-328) Danielle tried to get

up, but appellant pushed her back down and got on top of her. She told him to get off her, he put his fingers in her vagina, then penetrated her with his penis. Danielle gave up fighting. Appellant took out his penis, ejaculated on Danielle's stomach, and left the room. After a few seconds, Danielle got up, cleaned herself, and dressed. She went onto the patio and smoked a cigarette; the three co-defendants were in the living room. Appellant asked Danielle what was wrong. When Theo came onto the patio and tried to grab her breasts, appellant suggested they take Danielle home. Everyone got into the car, dropping Danielle off at her apartment complex parking lot. (RT 1:167-172, 1:216, 2:276-286, 2:301, 2:330, 2:350-353, 2:380, 2:384-385) No one said anything about the gang, or mentioned the gang's name, before, during, or after the assaults. (RT 2:270-271, 2:279, 2:302-303)

Danielle walked to a nearby park and cried. She stayed there for hours, thinking about what happened, returning home about 3:30 a.m.. Her mother, sisters and brothers were asleep. After telling her mother she was home, Danielle went into her room. Her older brother was there, and they argued. Danielle did not tell her mother or brother what happened. Later that night, she called Monica, and told her she'd been raped. The next day, Danielle was sore and bruised. She told her mother she'd bumped into something. She told her little sister Theoandria that she was making out with appellant, getting ready to have sex, and was raped by Theo, Albert and Ritchie. (RT 1:172-175, 2:282, 2:286-294, 2:304-305, 2:307, 2:349-350, 2:353-357, 2:372, 2:385-386, 2:443-446, 2:449-467)

On December 31, Danielle had plans to go to a party in Oxnard with Monica. Linda, a mutual friend, was at Monica's when Danielle arrived. Danielle told Linda what had happened. The party was at the house of a friend of the defendants. Danielle saw appellant go by the house in a car. They didn't speak. Danielle then saw Ritchie: he said hi, and hugged her. She told Monica "let's go," and they left. (RT 1:175-178, 2:292-293, 2:414) Between December 29th and January 4th, Danielle called appellant's cell phone two or three times; Ritchie usually answered. Danielle testified she called to talk to Monica, or to see if Monica was there, and did not want to talk to appellant or Ritchie. (RT 2:387)

On January 4, 2005, Ynez called Danielle. Ynez said that if Danielle reported the crime, Danielle and her family could be hurt. Danielle became scared, and decided to tell her family what happened; the police were

subsequently contacted. (RT 1:178-184, 2:293-295, 2:311-312, 2:357, 2:366-371, 2:401-405, 2:415-440)

Denise Obuszewski is a senior deputy sheriff with the Ventura County Sheriff's Department. In December 2004, Obuszewski interviewed Monica M., the named victim in count 4, on January 10, 2005: Monica said Danielle called her on December 30, 2005, asking, "What would you do if I had told you I was gang raped?" Danielle refused to elaborate, and Monica called Ynez to find out what happened. When Monica called Danielle back, Danielle said she'd had sex with Theo, appellant, and Ritchie, but only sex with one of them was consensual. Danielle did not say which one. Monica said Danielle orally copulated appellant, but did not know where that took place. (RT 3:561-566)

Obuszewski interviewed Danielle and consulted with a gang expert about the SouthSide Chiques prior to obtaining a search warrant. She searched the defendants' apartment on January 5th; members of the gang unit were at the scene, conducting a probationary search. (RT 3:567-568) An identification card for Theo was found in the bedroom, along with a telephone and address list in a K-Swiss shoe box. Four miscellaneous papers with drawings and gang graffiti, were recovered from the dining room table, along with papers bearing appellant's name; a disposable camera was seized and photographs, depicting the co-defendants, were developed from the film. Clothes in the bedroom closet were photographed, as was a T-shirt in the hamper. The clothes bore the SouthSide moniker, "Sox."[2] The bedroom contained prescription pill bottles and other items with the names of all three co-defendants. (RT 3:582-593)

Gang Evidence

Detective Neail Holland is the Oxnard Police Department's leading gang expert. (RT 3:594-600, 3:657-658, 4:676-677, 4:679-680) According to Det. Holland, there are fifteen gangs and about 2,000 gang members in the Oxnard area, the majority of which are Hispanic. The SouthSide Chiques is a multi-generational Hispanic male, turf-oriented gang which began in the 1960s in the Escalon area of Oxnard. The gang migrated to the Southwinds neighborhood in the 1980s, and became the SouthSide Chiques. At the time of trial, there were more than 150 Southside members. The gang's criminal activities are not geographically limited, the gang is always violent and brutal,

---

2 Danielle told the detective that Ritchie was wearing a black T-shirt marked "SOX" the night of her assault. (RT 3:592)

victimizing anyone who disrespects them. The gang does not have a chain of command, but is very tight-knit, operating according to its concepts of respect, reputation and status. Status is earned by representing the gang favorably, wearing gang clothing, bearing gang tattoos, associating with other gang members, committing crimes, supporting other gang members, and protecting gang turf. The SouthSide Chiques uses the term "SouthSide" in writings, graffiti and tattoos: variants include SOX, for South Oxnard, SSCH, for SouthSide Chiques, and combinations of X, 3, and 13, such as SSX3CH, SSX13CH. "SickSide" is an affectionate nickname, indicating the gang's brutality. White Sox jerseys are worn, as well as other clothes with the SOX logo and K-Swiss shoes, with the double-S logo. "South Pole" logo clothing may be worn, or the San Diego Chargers number 55 jersey, as well as a Raiders jersey, due to a long-standing gang alliance. (RT 3:600-605, 4:680-681)

There are various ways to become a gang member. Someone may be born into the gang by living in the neighborhood or having family members already in the gang; someone may be "crimed" into the gang by committing a crime for the benefit of the gang members, or "jumped in," a timed event in which the prospective member defends himself against being beaten by three or four gang members for about thirty seconds. The most common means of leaving the SouthSide Chiques is to distance oneself geographically and to reduce contact with other gang members. (RT 3:606-607, 4:688-689, 4:691-693)

"Doing work" means contributing to the growth of the gang, typically by committing crimes for the gang with other gang members. Respect is very valuable to a gang member: gang members want to achieve the highest level of respect possible within their group by doing work or doing "missions," preying on rival gangs. Gang members exploit intimidation to further gang interests; gang members communicate only about gang activities. (RT 3:607-611, 4:685-686, 4:689-690) Crimes committed by SouthSide Chiques include felony assault, assault with a deadly weapon, attempted homicide, auto theft, felony vandalism, and drug trafficking. Victims are rival gangs, community residents, residents outside the community, family members, associates, and fellow members of the gang. (RT 3:611) There is a pattern of criminal activity by SouthSide Chiques, as defined by Penal Code section 186.22. People's Exhibit Nos 18, 19, 20, 21, and 22 were certified copies of criminal convictions of three other individuals who were SouthSide Chiques

members at the time they committed their felony offenses. (RT 3:632-636, 4:669-671)

Det. Holland testified that the writing in People's Exhibit No. 8A— "SURX111" and "SOX" written in pen—is consistent with SouthSide gang script. "X111" is the Roman numeral thirteen; the number thirteen is significant because the thirteenth letter of the alphabet is M, which represents, in gang parlance, the Mexican Mafia. The Mexican Mafia is a prison gang with ultimate control, or attempted control over all southern gangs. Because the Mexican Mafia controls Southern California gangs, and SouthSide Chiques is a Southern California gang, use of 13 is a means of paying respect to the Mexican Mafia. Other gang writing on People's Exhibit No. 8 includes "SSCH," "SOXNARD," "Sneakie," "SS13C," "SSXCH." Other exhibits depict "South," written upside down, "SSX3CH," "CH," and "Sur" (short for "Sureno," or south). There is a photo of a hand sign: a 1 with one hand, a 3 with the other. (RT 3:613-615) Monikers are gang nicknames; hand signs are representations of gang letters, used to pay respect to the gang and intimidate others. SouthSide Chiques' most common hand sign is making an "S" with each hand, or a "CH" next to an "S." The exhibits include photos of people wearing White Sox shirts, White Sox hats, "Southside" shirts, "South Pole" shirts, a Raiders hat, a Raiders cap, a black shirt marked "Oxnard 805," a black shirt marked "Gangster Nation/SouthSide," someone with three fingers extended, a "CH" hand display, multiple hand displays of the letter "S." There is a boy wearing a White Sox jersey, and a young boy displaying two "S"s. There is something marked in memory of a fellow gang member who committed suicide. All of these items, recovered in the search of the co-defendants' apartment, are consistent with gang membership; each of the co-defendant appear in various photographs. One photo depicts Ritchie with Gabriel Madrigal and Juvencio Alarcon, other SouthSide Chiques, wearing gang clothing. (RT 3:616-619, 3:620-625) A seized phone list contained SouthSide gang member names/monikers. "Sneakie" is appellant's moniker. (RT 3:625-626, 3:640)

It is common for brothers to be gang members, and common for fathers to have sons display SouthSide indicia. The gang bond is stronger than the family bond; gang members act contrary to "normal human beings." (RT 3:619, 4:687) Gang members commit crimes together because co-perpetration increases the likelihood of success; serves as training for newer gang members; allows the gang members to multi-task or handle

contingencies; provides a gang witness, bolstering the participants' gang status between themselves, and in the larger gang. (RT 3:626-632, 3:643-644)

Det. Holland identified numerous incidents occurring between 1998 and 2005 where police documented the defendants' SouthSide association/conduct, including instances of association, admissions of affiliation, involvement in gang-motivated crime, dressing in gang attire, bearing gang tattoos, and displaying hand signs. (RT 4:694-695) In Det. Holland's opinion, all were active members of the SouthSide Chiques on December 29, 2004, and each was aware of SouthSide's pattern of criminal activity. (RT 4:636-644, 4:660, 4:678, 4:681, 4:690, 4:700-701)

Given a hypothetical detailing the facts of the case as attested to by Danielle, Det. Holland opined the charged crimes would be committed for the benefit of, at the direction of, or in association with, a criminal street gang because three SouthSide Chiques members came together for the purpose of committing a violent crime. By working together, they outnumbered the victim, dividing the "labor in restraining the victim," standing by the door, "possibly preventing escape," and by "mentally containing the victim, three against one, perhaps." The crime was done "in association" because all participants were SouthSide Chiques; each individual derived a benefit from the offense as each was a witness to the other's crimes, and each assisted in the completion of the offense. As each individual's status is elevated, the gang as a whole benefits by increasing community fear/intimidation: the crime would be reported (via media and word of mouth) as committed by three SouthSide Chiques members. (RT 3:645-651, 3:656, 3:658-659, 4:668, 4:693-694)

Not every crime done by a criminal street gang member is necessarily done to further or promote the gang interests, or done in association with the gang. If the hypothetical was changed so the girl had consensual sex with at least two, and probably three, of the men, and there was no mention of the gang that night, and she recalled no gang paraphernalia, words or signs, and one of the men she had sex with was her best friend's boyfriend, which embarrassed her, then Det. Holland would not think the crime was a gang crime. (RT 4:672-675) Det. Holland testified that Hispanic street gangs don't like sex offenses. Rape is frowned upon: if someone was convicted of rape, he would lose status in the gang. A gang member who raped someone would not announce it to the gang, but would instead claim that

law enforcement was fabricating the allegations "to protect their position." There is no evidence the co-defendants' status was elevated because of the rape; the charged events were gang crimes because they were done for the benefit of the individual gang members involved, and done in association with these gang members. (RT 4:677, 4:696-699, 4:702)

Defense Case

At the time of trial, Linda Sauza was fourteen years old. Linda was going to go to the New Year's Eve party with Monica and Danielle; she went to Monica's house, where Danielle told her that she and Monica were at appellant and Theo's house, and that she wanted to have sex with appellant and Theo. Danielle felt bad about having sex with appellant because Monica liked him. (RT 4:738-741, 4:751)

Katrina Lopez was fourteen at trial, and former best friends with Danielle's sister Raimunda. Danielle told Katrina that she went to an apartment with Monica and all three men "just dragged her in a room and like raped her" while Monica was in the house. Katrina thinks Danielle's a liar. Katrina sent Raimunda MySpace message that said, "Damn, you are a drunky shit. As one of your friends is shit. Whoops. Never mind. What a friend you got. Fuck. Don't worry, bitch, your name won't come out of my mouth. You say it's a ho's name, and I don't like hos... So just let you know, you see a fat bitch. Let me tell you something, so get over it, bitch." (RT 4:753-761)

Ynez was sixteen at the time of trial, and had known Danielle for three years, and the co-defendants for two; Ynez and Danielle were no longer friends. On December 29, 2004, Danielle called Ynez in Chicago, and said she had been in the bedroom having sex with Ritchie when appellant came into the room. Danielle said she then went into the living room, and watched a movie with, and had intercourse with, Theo. Danielle told Ynez she didn't do anything with appellant. Ynez thought Danielle was bragging given that Danielle said she wanted to do it again because she had a crush on Ritchie. (RT 4:762-764, 4:766-769, 4:778-779)

Ynez's boyfriend is Eduardo Carrillo; Eduardo is a member of SouthSide Chiques. Ynez knows the co-defendants are also in SouthSide Chiques, though they haven't told her so. (RT 4:769-772, 4:777-778) Ynez is no longer friends with Danielle; their last contact was a call in January 2005. Ynez confronted Danielle about her story, asking if she'd lied. Danielle denied saying she'd been raped, and seemed surprised, asking, "Why would I say

something like that?" Ynez has never threatened Danielle or her family. (RT 4:775-782, 4:786-787)

<u>Rebuttal</u>

Danielle's mother, Christine Lara, does not know any of the co-defendants. She knows Monica and Ynez. On December 29, 2004, Danielle told Lara she was going to spend the night at Monica's, but came home between 3:00 and 4:00 a.m., telling Lara she was home. This was very unusual. Danielle's curfew is 10 o'clock. Lara noticed Danielle was having trouble walking, and looked as if she was in pain, though she was trying to act normally. Danielle gave no sign of being upset; she had not been crying. (RT 4:789-793, 4:801-804, 4:809-810, 4:813-816)

A week later, on January 5th, Danielle told Lara what happened. Lara asked Danielle what her role was in the situation. Due to a series of threatening telephone calls by Ynez and Monica the day before, Danielle was very upset and worried about the safety of her family. Because of caller I.D, Lara knew that Ynez left a threat on the answering service, and had called at least twice on the land line; she did not know how many times Ynez called her cell phone. The next time Ynez called, Lara told her that Danielle didn't live there anymore and not to call again. Lara also had her phone disconnected. (RT 4:794-800, 4:802, 4:805-812, 4:816-817) Lara did not know that her daughter had previously spent time with appellant or Theo. (RT 4:801, 4:816)

## STATEMENT OF FACTS

Prosecution Case

At 8:00 p.m. on June 8, 2007, Los Angeles Police Officer Erika Cruz was working undercover investigating prostitution activity at the corner of Sepulveda and Valerio, part of the "Sepulveda Corridor," a location in the Van Nuys area of Los Angeles County known for street prostitution. Cruz had previously made between 50 and 80 prostitution-related arrests at that corner. Undercover activities include "improptus," spontaneous investigations in which a female officer attempts to get a customer (John) to pick them up. (RT 2:26-27, 2:42, 2:55-57, 2:78-80, 2:124)

Cruz saw appellant driving down Sepulveda. He turned onto Valerio, made a "harsh" U-turn, and stopped at the red tri-light about 15 feet across the street from Cruz. This sort of driving is consistent with how pimps and Johns drive. Appellant rolled down his window and told Cruz to get in; she asked what for, and appellant said that he was a pimp. Cruz told appellant to back up, he reversed and parked. She walked towards appellant while calling Officer Paschal on her cell phone and letting her know that Cruz was possibly "working a pimp." Paschal was Cruz's security officer.[1] (RT 2:28-33, 2:37-39, 2:41-46, 2:50-53, 2:60-61, 2:69, 2:71)

Cruz approached appellant's passenger window and he told her to get into the car, she asked what for, he said he was a pimp, she asked what that entailed, and he said he would take care of her. Appellant asked how much money she had; Cruz said $400. Appellant said if she gave him the money, he would house and clothe her. Cruz said she didn't want to get in his truck if she didn't feel comfortable. Appellant said he was a legit businessman, and took a business card from the center console and waved it at her. Cruz could not read the card. She saw multiple cell phones in the center console. Appellant continued to tell Cruz to get in the car, saying he would not "strongarm" her. "Strongarm" means to take something from someone by force or fear: prostitutes worry pimps or johns will strongarm them for their money. Cruz asked if she could continue working that area,

---

1 Paschal was a more experienced officer than Cruz, and had made numerous prostitution-related arrests in the area. He watched the exchange with appellant while parked across the street, but did not recall anything unusual about appellant's U-turn. (RT 2:67-70, 2:99-107) Paschal overheard appellant and Cruz discuss her working for him and him taking care of her in terms of housing and clothing. He did not hear appellant say that he was a pimp. (RT 2:67, 2:70-71, 2:108-110)

and appellant said yes. Appellant's tone was aggressive. (RT 2:33-35, 2:39, 2:44, 2:53)

Cruz signaled her partners that she had a violation and told appellant to park on the other side of the street. Appellant crossed the tri-light, parked, and was taken into custody. (RT 2:36) Some pimps wear flashy clothing; Cruz could not recall what appellant was wearing. Appellant was driving an ordinary Ford truck. There were no spinner rims, and the stereo was not on. (RT 2:43-44, 2:11-113)

A "gorilla pimp" is a pimp who is aggressive towards prostitutes. Johns, on the other hand, are typically meek, or shy. (RT 2:35, 2:44) "Reckless eyeballing" is when a prostitute makes eye contact with a pimp other than her pimp; once she does so, the new pimp owns her. (RT 2:36-37, 2:62-63) Pimps tend to carry weapons, such as canes, guns and knives, multiple cell phones, money, and condoms.[2] When arrested, appellant had no cane, gun or knife. He also had no money. This was not unusual, as appellant could have dropped off money at his house or at the bank before meeting Cruz. Appellant's center console contained three cell phones, a package of condoms, and a business card. Police did not determine if the cell phones were working. Pimps expect prostitutes to return from work with empty condom wrappers and matching amounts of money. Condoms by themselves are not an indicia of pimping. There were no empty wrappers in appellant's truck. Appellant's business card had appellant's name and "FCBM, First Class Building Maintenance," with a Hollywood address. According to Cruz, pimps carry many kinds of business cards, some real, some fake. About half of all pimps have jobs other than pimping. (RT 2:58, 2:71-74, 2:111-117)

The business relationship between pimp and prostitute involves the woman performing sex for money, then giving the money to the pimp. The pimp puts the prostitute up in a hotel room or lets them stay at the pimp's home; the pimp gives the prostitute food and clothes, and pays for them to get their hair and nails done. Between 95 and 98 percent of the pimps in the Van Nuys area are black men. (RT 2:74-75, 2:110)

Assistant Watch Commander Sergeant Alan Kreitzman was the officer in charge of the investigation. At the time of appellant's arrest, the19-year-LAPD veteran was on his second tour as a Vice investigator. He described the prostitution activities in the area, as well as the nature of improptus. (RT

2 Different cell phones are used to contact different prostitutes. It is also common for Johns to carry condoms. (RT 74)

2:119-122, 2:125-129) According to Kreitzman, pimps are typically young African American males. Pimps pick up the women that come to work the Sepulveda Corridor from other areas, showing them a business card to demonstrate that they are legitimate businessmen. The relationship between a pimp and prostitute is like a situation involving domestic violence. The woman is so involved with the person supporting her that she is not willing to betray him. The prostitute is also afraid of losing her income and being hurt by the pimp: pimps are controlling and aggressive. The prostitute gives the pimp the money she earns from sex, and he gives her money in turn. Pimps' vehicles are often rentals; pimps and prostitutes may stay in motel/hotels, or sleep in their vehicles. (RT 2:122-125, 2:139-142)

 Kreitzman also watched the encounter between Cruz and appellant, finding nothing unusual in appellant's U-turn. Appellant's cell phones, however, were significant because pimps generally carry more than one cell phone. Kreitzman did not know if the phones in appellant's truck were operable, and did not know if anyone checked their content. A follow-up investigation was done on the business card, but Kreitzman did not know if it was a legitimate business. Even if a pimp has a legitimate job, that doesn't mean he is not pimping. Kreitzman did not see appellant engage in any aggressive behavior. (RT 129-144)

Defense Case

 Giselle Vrais is appellant's mother. On June 8, 2007, appellant was living with her and her husband. Vrais's family has owned a building maintenance firm located in Hollywood for 32 years. Appellant works for the business as a janitor. Appellant's hours were from 6:00 or 7:00 p.m. until midnight because that is when the clients' offices are available for cleaning. He worked with his father, though occasionally cleaned a building alone. Appellant worked 40 hours a week, and carried one working cell phone. Appellant "goes through" cell phones, keeping broken and loaner phones in his truck. Vrais recognized two of the three phones found in appellant's truck, as well as appellant's FCBM business card. (RT 2:148-153, 2:156-160, 2:164-165)

 Appellant used his cell phone to talk to his fiancé, Athalia, his sisters, and his male friends. At the time of trial, appellant and Athalia had been together for two years, and had a 2 month old daughter. There was nothing

about appellant's lifestyle that suggested appellant was pimping. (RT 2:153-154)

Athalia Gamboa is appellant's fiancé. They have been together for two and a half years. Gamboa works for the Los Angeles County Department of Probation. Appellant is a janitor for his family's business, working 7:00 p.m. to 12:00 p.m., though sometimes he needs to go in to work during the day to get equipment. Gamboa has never had any reason to believe appellant was engaged in any other business. Appellant uses one cell phone, but often has more than one because he breaks them regularly. Gamboa recognized all three of the phones found in appellant's truck. Gamboa and appellant use condoms. Gamboa was not aware that appellant had relationships with any other women, and had no reason to suspect he might be pimping. (RT 2:166-178)

# STATEMENT OF FACTS

## Prosecution Case

On May 24, 2004, at 6:42 a.m., Claremont police officer Jason Walters was working traffic enforcement on Indian Hill Boulevard, in Claremont. Walters was in uniform, and riding a police motorcycle; the motorcycle is black and white with red and blue lights in front, marked "City of Claremont Police." Walters was parked at 888 South Indian Hill, in the Greyhound Bus depot when he saw another motorcycle traveling 25 mph northbound in the number two lane. As the other motorcycle passed, Walters noticed the registration had expired in 2002. Walters pulled out to initiate a traffic stop, activating his solid red light and calling in the stop to the police dispatcher. Appellant, the rider of the motorcycle[1] looked at Walters in his left rearview mirror, pulled around a stopped van without signaling, and turned onto the 10 Freeway, rolling through the red light on the on ramp and accelerating to a high rate of speed. (RT 38-43, 54-59, 63, 69, 71)

Walters alerted his dispatcher he was in pursuit and started his sirens. Both motorcycles accelerated to about 115 mph onto the eastbound 10 Freeway; appellant passed cars on the right-hand shoulder, moving dangerously in and out of the number four lane. Sixty-five miles an hour is the freeway speed limit, and it is illegal to use the shoulder for passing. Walters followed appellant for a mile, paralleling him from the carpool lane. (RT 44-45, 59-60, 69) Appellant exited the freeway at Mountain in Upland, traveling about 125 mph; by the time Walters was able to safely leave the freeway, he had lost sight of appellant. (RT 46-48)    Walters got the address of the Claremont Auto Repair Shop in Pomona which was associated with appellant, and about 8:44 a.m., went to that location and saw the motorcycle with its expired tags parked across the street. Walters asked a garage worker where "David" was, and the man pointed out appellant: appellant was not wearing the leather jacket. Walters drew his weapon as three other officers[2] - Fate, Fenner, and Newman - arrived. (RT 48-52, 64-71, 87, 96-97, 100, 148-149, 152)

---

1 According to Walters, appellant was wearing a helmet with a clear acrylic face shield in an upright position, a black leather jacket and blue jeans. (RT 53, 64)

2 Fate was wearing a police polo shirt and a pair of slacks with a clip on badge and weapon, Fenner and Newman were both in uniform. (RT 68, 149)

Appellant quickly walked in the opposite direction and got into a white Honda parked in the lot; Walters ordered appellant to stop. Appellant continued getting in the car, put it in reverse and accelerated, causing the rear tires to lose traction, then pulled away. Walters briefly jogged after the car, pointing his gun at appellant and ordering him to stop. Appellant did not obey. (RT 68-72, 85-87, 97-98)

Officer Fenner got into his patrol unit and followed appellant, activating the siren and red light. Appellant drove down an alley behind a shopping center at Foothill and Towne, exited onto Towne, crossed Towne and onto Richmond. Speeding down Richmond, appellant turned onto Regis, Regis to Foothill, went through a stop sign, turning left in violation of a posted sign, and headed eastbound on Foothill. There were several vehicles at the intersection of Regis and Foothill. (RT 87-90, 98-99) Appellant continued accelerating down Foothill, going full speed through a solid red light at Mountain; Fenner slowed to allow for cross-traffic, and continued to follow. There were several vehicles and someone on a bicycle in the intersection: in Fenner's opinion, appellant's driving demonstrated a willful or wanton disregard for the safety of persons/property. (RT 90-93, 99-100) Appellant accelerated to 90 to 100 mph, going through a solid red light with cross-traffic at Mountain and Indian Hill; the posted speed limit is 40 mph. Fenner slowed, appellant continued, Fenner radioed the dispatcher the chase had become too dangerous and Fenner was not going to be able to continue; Fenner's supervisor told him to stop his pursuit. (RT 93-95)

On May 25, 2004, Claremont Officer Eric Huizar was involved in surveilling a maroon Chevrolet,[3] which he had been following for about an hour: appellant was driving with a female passenger, later identified as Nadine Boyle. Huizar was driving an unmarked police car, accompanied by Officer Bennett. At some point, the Chevrolet pulled over[4] and Huizar next saw appellant, about 100 feet away, running through a yard. Huizar, wearing a police polo shirt, khakis, a badge, handcuffs, a gun on his belt and police raid vest, marked "police," with a yellow cloth star on the front and "police" on the back in bright yellow lettering, put on his vehicle's red light and siren, and drove parallel to appellant as he ran, then stopped the car, and he and

---

3 Two other units were also involved in the surveillance. (RT 126)

4 Claremont Officer Franklin was driving a marked patrol car; he pulled up and blocked the Chevrolet, leaving the woman inside to be attended to by Officer Luginbill. Franklin got out of his car and ran towards the location broadcast by the helicopter unit. (RT 232-234)

Bennett jumped out, guns drawn, and ran after appellant. (RT 102-107, 127-131, 172, 178, 185-186) Appellant ran through some brush; once, he tripped and fell face down into some ivy with Bennett, then got up and resumed running through the driveway area of a house. Appellant looked at Huizar as Huizar had his gun on appellant. With about five feet between them, Huizar told appellant if he didn't stop running, he would be shot with a taser. (RT 108-110, 126, 131, 173-174, 186-187)

Appellant continued running;[5] he reached a wrought iron fence gate and jumped, trying to scale the gate, but got caught on the top. Huizar grabbed appellant and tried to pull him off; appellant would not come off, so Huizar hit appellant three or four times "not that hard" in the right upper back. Officers Bennett and Franklin arrived, and the three pulled at appellant; Franklin hit appellant's arms with a flashlight to get him to release the gate. Appellant continued holding on, and the gate was pulled down with him. Appellant was on his knees, still holding onto the gate underneath him; Huizar got on appellant's back and tried putting appellant's arms behind his back; unsuccessful, Huizar put a headlock on appellant, staying on his back. Appellant lifted Huizar up; Huizar pushed appellant down and told him to stop resisting and give up; appellant said, "okay, okay," paused for a moment, then yelled and again lifted Huizar up; Huizar again pushed him back down. Franklin thought appellant couldn't get up because his fingers were caught beneath the gate: "he was trying to get his hand out, and he was pushing up as he was doing it." Franklin also testified appellant kicked Franklin in the leg twice and was kicking Huizar; Franklin hit appellant two or three times in the arm, and hit appellant's leg "I don't know how many times." Huizar saw Franklin hit appellant on top of the head with his flashlight three times; Bennett saw Franklin hit appellant on the forearm. Bennett delivered "knee strikes" to appellant's ribs, and grabbed appellant's groin to gain "pain compliance," to no end. According to Bennett, Franklin pepper-sprayed appellant first, and Bennett then pepper-sprayed him a second time because the first spray did not seem to have any effect. According to Bennett, the second spray also did nothing. Franklin testified he pepper-sprayed appellant in the face, and sprayed himself in the process; spraying appellant had no effect. According

---

5 Franklin testified he saw appellant and the other officers struggling in a bush, then followed appellant when he jumped up, ran around a house and through a yard, catching up with him at the gate. Franklin had his gun on appellant and was ordering him to stop. (RT 221-222, 230, 235) Franklin was in full blue uniform, Bennett was dressed like Huizar, but was wearing a bullet-proof vest instead of a raid jacket. (RT 118, 172, 175, 220)

to Huizar, the struggle between appellant and the three officers lasted a little over five minutes. The officers did not know if appellant was armed. (RT 110-116, 118-121, 131-133, 135-136, 174-177, 180-181, 187-189, 219-228, 235-239)

Huizar and Bennett both put out "906" calls, requesting assistance; Huizar subsequently told Franklin to radio a "999," officer's life in jeopardy, call. Over ten officers responded, some from Claremont, some from Pomona. A Pomona officer pried appellant's hand from the fence with an extended asp baton, a collapsible metal baton, 24" long; appellant was also tasered. (RT 117, 134-135, 137-138, 149-150, 189-190, 225, 230-231, 239) Claremont Officer Newman arrived after appellant had been subdued, and accompanied appellant in the ambulance to the hospital At the hospital, Newman searched appellant, finding a clear plastic baggie containing a usable amount of methamphetamine in his shirt pocket.[6] Taser darts were also removed from appellant and booked into evidence. (RT 133, 136-137, 143-148, 150-153)

After the struggle, appellant's hands were very bloody, cut and bruised. According to Huizar, these injuries were from appellant's holding onto the fence, not from any police action. A taser delivers 50,000 volts at 26 Boyle, a non-lethal electrical shock lasting approximately five seconds, and designed to incapacitate and hurt a subject. Claremont tasers are black with yellow tape; Pomona tasers are yellow. According to Huizar, no taser or firearm was used on appellant. According to Bennett and Franklin, appellant was tasered twice, once by a Pomona officer, and once by a Claremont officer. Franklin testified he thought appellant continued to struggle after being tasered. (RT 115-118, 133, 136-137, 153, 172, 176-177, 180, 188-189, 239-241)

Fenner went to West San Jose, Claremont, and spoke with apartment manager Erica Landis, who gave him appellant's rental application. Landis could not identify appellant at trial, saying that a man and a woman brought her the completed application. The man was wearing dark glasses, and Landis only saw him twice. Landis had rented the unit to Eileen Koontz, who told Landis she was going to let the couple live in the apartment for two months because they were homeless. The application was needed to have a record of the couple's information. Landis never spoke to appellant, and never collected rent from appellant. (RT 95-96, 203-210) Eileen Koontz testified she lived at the apartment with her son, his wife, and his wife's son.

---

6 It was stipulated the baggie contained 0.14 gram of methamphetamine. (RT 217)

Appellant and his girlfriend were supposed to move into Koontz's apartment; they had a child, and Boyle was pregnant. Koontz's son had known Boyle for fifteen years, and was letting her stay because of her condition. According to Koontz, appellant "came and went," and "wasn't there very much." Appellant showered there and stayed "sometimes," but mostly it was Boyle who was being given a place to sleep. Koontz never saw appellant in bed, and didn't know if he slept over or not. Koontz thought appellant had a motorcycle, but didn't know where he kept it; she assumed he parked it in back of the building, but never saw it there. (RT 210-217)

The Pomona Police Department records manager testified appellant's parole date was October 20, 2002; appellant last registered an annual section 290 update on April 15, 2003. Registees are to update their registration within five working days of their birthday; appellant's birthday is April 14th. Huizar ran appellant through the state-wide VCIN system, which monitors section 290 registees: as of May 25, 2004, appellant had neither registered as living in the city of Claremont, nor filed an updated registration. There was no official record of appellant living in Claremont. (RT 74-83, 122-125)

As a result of the struggle with appellant, Huizar strained his left arm and had to wear a split for a few days. Bennett strained his middle back and had a cut and swollen left knuckle. Franklin strained his back, got a small cut on his right hand and popped a knuckle on the left: it got caught in either appellant's beltloop or his belt when appellant yanked his hand free from the gate as Franklin was handcuffing him. As a result of the struggle with police, appellant is now in a wheelchair. (RT 118-119, 181-183, 227, 229-232)

Defense Case

On May 25, 2004, Moinudin Haqqani was living in a second-floor apartment on Old Settlers Lane in Pomona; that afternoon, he heard a noise, went to the window, and saw some officers chasing someone. Haqqani stepped out of his door and watched three officers surround a man on the ground. The man was sitting on, and holding, one of Haqqani's gates. The officers were trying to handcuff the man, asked Haqqani for the address and radioed it into their walkie-talkies. Other officers arrived, and for about twenty minutes, the officers punched the man and shouted at him: one officer was on the man's back, and more than one used a yellow-orange gun which seemed to shock the man: he fell down, "knocked out," and they put his

hands behind his back and handcuffed him. Haqqani saw two tasers pointed at the man's backbone. The man shouted there was a pain, that "it" was hurting him. Haqqani did not see the man using any violence. (RT 155-170)

At the time of trial, Nadine Boyle had known appellant for twenty-five to twenty-eight years and been his girlfriend for six or seven; they had just had a child. The couple lived together in Pomona, on South San Francisco, for four or five years, until the end of January, 2004, and were subsequently homeless, living in the Chevrolet Cavalier and the Honda. A few weeks later, Ben Koontz offered to rentBoyle a room in his apartment at 690 San Jose, in Claremont. Appellant did not move in because only Boyle and her thirteen-year-old son were allowed to stay in the Koontzs' apartment, and because appellant did not like Koontz. Appellant either stayed at a hotel or motel, or his friend Les Young's house in Fontana, only once in a while spending the night withBoyle and showering there in the morning. Watt didn't know if appellant had a regular place to stay. After moving in, Boyle filled out an application for rent form for herself and appellant, signing it for appellant. She completed the form for appellant because she was told that if appellant would be staying there on the weekends or taking showers, they needed his information. On May 8, 2004, Boyle contacted the Claremont police. She testified she did not tell them she'd only been with appellant a few months and that they lived together at the San Jose address. (RT 260-263, 265-271, 277-287)

On May 25, 2004, Luginbill arrested Boyle while she was sitting in the maroon Chevrolet on Old Settlers Road; from inside the car, Luginbill recovered a grocery store Advantage Card, her driver's license, and a cigarette box containing a methamphetamine pipe. Boyle was arrested for possession of the pipe. Luginbill did not find any methamphetamine. After being transported to the Claremont Police Department, Boyle said, "Why should I tell the truth, I'm going to jail anyway." (RT 291-295, 297-298) Luginbill had participated in the surveillance of the maroon Chevrolet from the time Boyle picked up appellant in Pomona until the foot pursuit began in Claremont; Luginbill helped block in the car pursuant to the Ontario Police Department helicopter report. Appellant had been driving the car for about forty minutes before the foot pursuit began. (RT 294, 296-300)

The address on appellant's driver's licence is the address of the pastor of appellant's church. In 1994, appellant pled guilty to fourteen counts

of violating Penal Code section 288, subdivision (a). He was released from prison on May 10, 2002, and discharged from parole on May 19, 2003; on the prison release papers, it states appellant's duty to register is a lifetime requirement; appellant signed the papers. In May, 2003, when appellant called to check his parole status, he was told he no longer had a parole officer. The officer of the day told appellant he no longer had to follow the terms and conditions of his parole, including the registration instructions. Appellant's birthday is April 14th: he registered the San Francisco street address on April 15, 2003: previously, he had registered on October 20, 2002, April 11, 2001, May 4, 2000, one undated registration for a location in Laverne, and a Pomona address registered on August 11, 1999. He and Boyle received their eviction notice January 1, 2004, and moved out forty-five days later. They made makeshift living arrangements for a month, staying at motels or a friend's house for a couple of nights. It was difficult to find temporary quarters for appellant, his pregnant wife, and her thirteen-year-old. Boyle found the Koontz place; appellant disapproved because he did not like Ben Koontz. Appellant did not sign the rental application form. Appellant spent the night a few times that month, never staying longer than a day or two. He also spent a couple of nights with Steve Rohde, and he and Boyle also spent a few nights at her former mother-in-law's house. Appellant usually slept in his car, parked at the Pomona Valley Hospital parking lot, at a motel, using homeless vouchers from church: he never spent more than a couple of nights in any one location. (RT 349-360, 387-388, 401-402, 411-412, 426-434, 460-463)

On May 24, 2004, Appellant was working as the manager for an auto repair shop; he had driven the white Honda to work, arriving between 8:05 and 8:10 a.m. Appellant did not own the motorcycle involved in the freeway chase, but had it in his possession as part of a lien towards purchase of another vehicle.[7] He did not use the motorcycle that morning, and had given the keys and his helmet to David Fried for a test drive five days before. Fried is approximately the same height and weight as appellant, with medium

---

7 There is a DMV document indicating that appellant bought the motorcycle on June 30, 2001; the sale was a lien sale to Auto Center Civic Sales: appellant was the manager, so the sale was done through his name. The lien sales essentially are transactions between shop customers and buyers: if someone can't pay their repair bill, appellant as shop manager might give them a few hundred dollars for the car or give them a credit, fix the vehicle and sell it to a third party. Appellant does not register these cars in his name, just as appellant did not register the motorcycle or apply for a pink slip. He did some work on the motorcycle, which in turn gave him possession, and decided to sell it after changing garages. The motorcycle had no rearview mirrors, but the man who wanted to buy it had put a makeshift mirror using a mirror from another motorcycle. (RT 361, 389-390, 411-414)

brown hair and a mustache; appellant's motorcycle helmet has a large face visor. Fried also borrowed appellant's jacket and gloves because there was a light mist and some showers that day. At the time, appellant did not see the motorcycle parked across the street from the garage; there were four motorhomes bing repaired at the garage. (RT 313-318, 361-362, 400, 415-416)

After arriving at the garage, appellant was admonished by the owner for being late; he returned to his car to get a small tool box out of his roll-away tool kit and an electrical box from the trunk.[8] As he did so, appellant saw, out of the corner of his eye, what appeared to be someone creeping around one of the motorhomes parked in the lot. Appellant was concerned the motorhome was being burglarized, and got into his car, which he was going to move in any event. The view of the parking lot was blocked by the mobile homes: appellant could not have seen anyone standing in the lot. He saw a man in black, partially concealed by the motorhome, crouching, and pointing what seemed to be a gun at him. The man was not wearing a Pomona police department uniform. (RT 316, 318-320, 324-325, 362, 402-403) Appellant started the car and the man "lunged" towards him; appellant gunned the car in reverse, the man with the gun started running and appellant took off, looking over his shoulder[9] as he backed up across the parking lot, past a neighboring liquor store and Arco gas station, then turned and drove down an alley to Towne Avenue. (RT 320-322, 403-404, 406)

Appellant crossed Towne, turning until he reached Foothill Boulevard; he drove fast because he was scared. At some point, appellant heard sirens and saw police cars going in the opposite direction. He looked in the side mirror and saw a police car; the patrol car passed him and appellant then saw another patrol car about a block behind him, with its lights on. Appellant did not think the cars were following him; he drove to Boyle's house, where Betty Koontz told him Boyle had gone to the police station because she'd heard appellant had been arrested for felony evading on the motorcycle. Appellant thought this meant the police had arrested Fried. Appellant had left the motorcycle in lot near work, and left the Honda parked on a street near Boyle's street in Claremont. (RT 322-324, 405-408, 424-426, 452-453)

---

8 Appellant is an electrical technician; his roll away kit contains $20,000 worth of equipment. (RT 316)

9 The Honda did not have a rearview mirror. (RT 321, 323)

Appellant and Boyle spent that night in a motel in Fontana. The next day, while at a nearby park, appellant thought he was being followed by someone in a tan Ford Explorer.[10] Appellant and Boyle started driving, noticed the Explorer following them, appellant made a U-turn and saw a tan Ford Taurus behind the Explorer. Appellant made a few more turns, then stopped, and the cars eventually pulled up alongside. Appellant drove to Target with the Explorer still trailing them; appellant got out, went to the passenger side of the car and spoke to the person sitting there, one of the officers who testified against appellant. Appellant asked the man if he was a police officer and why he was following appellant; appellant "lit up off" the man, saying if the police wanted him, they should just serve a warrant and quit harassing him. The man said he wasn't an officer, closed the electric window and began talking on a cellphone. Appellant walked away, upset at being followed and upset his wife was frightened. He decided to go to the Pomona Police Department, and, as he left the Target lot, was followed by the Explorer. There was no high speed pursuit, no sirens, no lights. At Old Settler's Road, appellant decided to get out of the car and go to a friend's house to call the police and let them know the Explorer, rejoined by the Taurus, was following him. Boyle got in the driver's seat, and was to go around the block and pick appellant up at the friend's home. (RT 326-331, 422-423, 436-441, 459-460)

Appellant walked one or two houses, heard a screech or crash-like noise, turned, and saw that the Explorer had rear-ended his car. Appellant did not notice any car in front of his car. A man in a flight jacket got out, drew a gun on appellant, turned and brandished the gun at Boyle. Appellant could only see a small insignia on the jacket's front, but did not have a chance to see the back of the jacket. The man did not tell appellant to stop, and did not identify himself as a police officer. (RT 331-333, 336, 395, 418) Frightened, appellant ducked into the closest driveway, looked back and saw the man was running at him; appellant ran to the back of the property, jumped a small wall, turned, and saw the man had stopped his pursuit. Worried about Boyle, appellant hopped the wall, went around the house, and came out on the

---

10 As far as appellant knew, there was no reason for him to be under surveillance, though he felt he had been being surveilled for about a year, which included having his apartment broken into and his motorcycle vandalized. He had contacted the police department and was told he had no warrants; he subsequently spoke to a private investigator, who told him to keep notes about anyone following him. (RT 397-398, 420-421, 440-443) Appellant was convicted of misdemeanor battery on a police officer in 2003, and was to work at Tree Farm. When he attempted to comply, he was told no one knew anything about it. Appellant did not go back to court because he didn't know who to report to. (RT 398-400)

other side of the house from where he'd ducked in. There was a five-foot tall wrought iron rolling fence at the end of the driveway. As appellant was running down the driveway, he heard someone yell at him to stop. He did not hear "police." He got to the fence, saw police cars to the right and left, and the Explorer parked five houses away. (RT 333-336, 395-396, 418-419, 447-450)

Appellant stopped and put his hands up; he was tackled from behind and thrown into the fence. He grabbed the top of the fence, which was chest-level, someone grabbed his waist, that someone was joined by a second and then a third person, someone said let go; when appellant did not let go immediately, he was beaten. There were several blows to appellant's ribs, he was hit in the back of the head with something very hard that almost caused him to lose consciousness; appellant held the fence tighter to keep his balance. Someone grabbed Appellant by the feet, belt, pants and legs, lifted him off the ground and began pulling. Appellant continued to hold the fence, afraid of hitting his face on the ground. The fence fell with appellant, the top of the fence coming down on the middle of his arm, his hand turned upright, pinning his arm under the fence. Appellant's other hand was free, and he held the fence with his free hand, trying to move it off his trapped arm. Someone was standing on the fence, appellant yelled to get off his arm, someone told appellant "give me your arm," and "quit resisting." Appellant said he wasn't resisting, and asked again for them to get off the fence, that they were "smashing my arm." Meanwhile, someone was hitting appellant, someone was kicking him, and someone twisted his testicles; appellant was lifted off the ground as he wriggled in pain. (RT 336-339, 419-420, 443-451, 453-454)

People yelled for appellant to give them his arm and leg; appellant yelled back that he couldn't give his arm because it was pinned. He tried to see what was going on and to explain he wasn't resisting, but someone put him in a choke-hold and he was having a hard time breathing. Appellant was punched and kicked in the face and hit in the arms, head and back with what he assumed was a police flashlight. He was sprayed in the face while two people were standing on top of each side of the fence. One officer seemed to be trying to pry the gate up with a metal baton. There was an order to shoot appellant in the back, the officers got off appellant, appellant heard a blast and felt pain in his back as if he was being shocked, then began jumping

around and shaking.[11] Appellant was told again to quit resisting and give them his arm; again appellant tried to tell them he couldn't get his arm out; one of the officers said, AGive him two more." There were two additional blasts and shocks to appellant's back. Something penetrated deep into appellant's skin and there was a great deal of pain. As appellant was being shocked, he heard someone ask, "Do you want me to just let it run?" The device continued to discharge; someone said, "Keep doing it, keep doing it." Appellant felt more darts, but lost count of how many because of the pain. (RT 339-343, 455)

Finally, while continuing to admonish appellant to stop resisting, and while appellant kept yelling he was in pain and get off the gate, "you're standing on my arm," someone began to lift up the gate. Appellant was also lifted, hit on the head with a flashlight, his arm pried out, beaten again on the head with flashlights; when appellant reached up to cover his head, he was hit again, breaking all the fingers on that hand. Appellant was first handcuffed behind his back, but his hands were subsequently moved in front of him because of his injuries. He could not see very well at that point, though he was aware he was searched and put in a patrol car. No baggie was taken from his shirt pocket.[12] Someone came and sat in the car with appellant and asked him if he'd been searched; the person patted him down again. Appellant started to lose consciousness, and was subsequently taken to the hospital. At the hospital, appellant was given morphine for pain; as he was nodding out, someone entered the room, asked the officers there if appellant had been searched, after they said he had, the person took something from appellant's pocket, said, "Oh, look what I got," and walked away. (RT 343-347, 414, 456-457)

Appellant's skull was fractured, his right arm broken in two places and his right wrist broken; he wore a cast on that arm for six to eight weeks. Appellant's left hand is permanently damaged: all the fingers were crushed, and the tendons and nerves were masculated, or shredded. Appellant can only move his thumb and middle finger. Appellant's left wrist was dislocated and fractured, and required stitches. At the time of trial, his left hand was still

---

11 Appellant did not recall trying to kick anyone, but might have struck out while being shocked. (RT 344)

12 On cross-examination, appellant testified he found the shirt, among several shirts, in the car he'd rented to Brian Gotcha from Gotcha Towing, the same man he'd loaned the motorcycle to. Appellant did not know where the baggie of methamphetamine or the pipe came from: appellant does not smoke or do drugs. Watts has had a substance abuse problem, but appellant did not know if the drugs or pipe were hers. (RT 391-394, 414, 457-460)

in a device and still bandaged. Appellant suffered a spinal injury either from the weight of people on top of him or from being beaten on the back, causing a loss of sensation and temporary paralysis of his left leg, and is confined to a wheelchair. (RT 340-349)

Rebuttal

Detective Luginbill, the man in the tan Explorer, testified appellant never spoke to him in the Target parking lot. When Luginbill interviewed appellant on May 26th, he told appellant that he couldn't have spoken to the man in the tan Explorer, because appellant hadn't spoken to him. Appellant told Luginbill that he'd wanted to talk to him, but that Boyle told him not to, and that Luginbill probably just didn't hear him because Luginbill's window was rolled up at the time. Appellant also told Luginbill that he did not have a motorcycle, that there was a floater motorcycle belonging to the garage which appellant had last seen when he and Boyle left it in a bar parking lot next door to the garage. Appellant said nothing about a Brian Fried or anyone wanting to buy or borrowing the motorcycle. When Luginbill asked about the methamphetamine in his pocket, appellant said Brian, of Fried Towing, had been using the white Honda and the shirt appellant was wearing belonged to Brian, so the methamphetamine must be his as well. Appellant did not say Brian's last name was Fried. Appellant said that he'd left the Honda parked on a street near the end of Claremont, near Montavista, about two or three miles from Boyle's apartment. Appellant did not tell Luginbill he'd parked the car near her apartment. (RT 467-472, 477)

Luginbill's Explorer did not crash into the maroon car, but rather parked in front of it; Franklin's marked patrol unit was parked behind the maroon car. Luginbill got out of his car and pointed his gun at Boyle; he was not dressed in black, and did not see appellant. Luginbill did not plant methamphetamine in appellant's pocket, and there was none in his car. (RT 473-476)

Appellant told Luginbill he wasn't sure he had to register, he thought he only had to register while on parole. He also said he'd been living on West San Jose for two weeks, but hadn't finished moving in. When confronted with the signed registration form, appellant said he was dyslexic and couldn't understand the form. He did not say a parole agent told him he did not have to register, or that an officer of the day excused him from registering. (RT

470-471) During appellant's surveillance, Luginbill was aware of the previous pursuits as well as an outstanding warrant on appellant. (RT 472)

A warrant was issued for appellant on October 3, 2003 for failure to appear in Pomona Court; appellant had been released from custody on September 26, 2003, and instructed to return to court on September 25, 2003. There was no notice sent to appellant by the court regarding this warrant. (RT 477-478)

## STATEMENT OF FACTS

Prosecution Case

Counts 1, 2, 3 and 4: Jane Doe #1: Doe #1

On January 17, 1997, Doe #1 was living alone in Long Beach; she went into her bedroom between 11:00 and 12:00 p.m., without giving anyone permission to enter her home. As she was preparing for bed, a man came up from behind, grabbed her arms, and told her to cooperate and she wouldn't get hurt. The man, wearing a navy blue ski mask, forced her onto her bed, removed her underwear and orally copulated her, stopping periodically to talk. If Doe #1 began crying, the man would threaten her again; at some point, he put his mouth on Doe #1's breasts and neck, and asked her to put his penis in her mouth. She orally copulated him, a minute later, he turned her over and put his penis in her vagina, ejaculating outside the vagina one to five minutes later. (RT 798-801, 803-804)

After ejaculating, the man retrieved his underwear, wiped Doe #1's back, and told her he had broken in, waiting while she left the house and returned a video. The man said he walked through her home while she was gone, looking at her things; he asked Doe #1 if she had a boyfriend. She said she did; she told him she went to church. He mentioned things he'd noticed in the house, like a light that needed repair, and asked her when she was to get up the next morning, and if she'd set the alarm. The man did not say anything about himself, or identify himself by name. After twenty minutes, the man dressed and left. Before leaving, he told Doe #1 not to do anything for twenty minutes; after he was gone, Doe #1 called the rape hotline, then the police. The man was in Doe #1's home for at least two hours. (RT 800-802)

The police arrived; Doe #1 was subsequently interviewed by detectives and examined by a forensic nurse specialist[1] ; an external genital swab, a breast swab, and a reference sample was taken and transported to the police department and then to the Los Angeles Sheriff's Department Scientific Services Bureau Crime Laboratory. Approximately two and a half years later, a detective took an oral reference sample from Doe #1 and booked it to the crime lab. (RT 802, 1153-1161, 1418-1420, 1432) Doe #1

---

1 Malinda Waddell, director of Forensic Nurse Specialists, Inc., was the forensic nurse specialist who examined Doe #1. She also hired and trained Toyetta Beukes, Jan Hare, and Sue Gorba. (RT 1153-1155)

described her assailant to the nurse and to the attending officer as 5'6" or less, 140 to 150 lbs., and Hispanic. (RT 811, 1423)

At trial, Doe #1 testified she did not know appellant, but recognized "the shape of his eyelids," "the hair under his lip," and the color of his skin as belonging to the man who raped her. She also thought she would probably recognize his voice if he spoke: Doe #1 told police she believed her attacker was Hispanic because he had a slight accent. She told police she was "almost positive" the man was 5'6" "or less," that he was of average build, about 140 pounds, and had a scar on his upper right thigh.[2] She tried to be as accurate as possible in her post-attack description to police; she was once shown three composite sketches of a suspect, and told the officer she could not eliminate the person represented in the drawing, saying her attacker had the same hooded eyelids, and "could be" the same mouth. (RT 803-804, 813-821, 1423-1424) On January 23, 1997, Doe #1 was shown two photographic lineups; at the first, she indicated one of the individuals "might be" the rapist; the person selected was not appellant, but a Hispanic man named Jesus. At the second, Doe #1 again identified someone other than appellant as possibly being her assailant. She again told police she was "almost positive" her attacker was 5'6" "or less." (RT 823-827, 1424-1426)

At trial, Doe #1 testified she'd seen appellant's picture and read about his prosecution in the newspapers, and believes he is guilty. (RT 808, 821, 830) Defense counsel was 5'6 ½"; when counsel asked appellant to stand at trial, and asked Doe #1 if her attacker was closer to counsel's height or appellant's height,[3] Doe #1 testified her attacker was "probably" appellant's height. (RT 809-811) When appellant was asked at trial to repeat some of the things said during the attack, Doe #1 identified his voice as sounding like the person who assaulted her; appellant did not sound like he had a Hispanic accent. (RT 828-829)

Counts 5, 6, 7, 8 and 9: Jane Doe #2

On May 13, 1998, Doe #2 was fifty-eight years old, living alone in Long Beach. By about 10:30 p.m., Doe #2 had fallen asleep with the television

2 On cross-examination, Doe #1 testified she "might have said" the man was between 5'6" and 5'10", he "might have been" Hispanic, it "might have been" a scar on his thigh, and she "may have" said he was 140 pounds. She also testified she might not be a very good judge of height, and that the scar could have been semen. She said her description to police the night of her attack was as accurate and truthful as she could be "under the circumstances." (RT 804-806, 809-810, 812-813)

3 According to appellant's Penal Code section 969, subdivision (b) packet, appellant is 5'8". (CT 1372)

and light on; she woke feeling a weight on the bed, then a hand over her mouth. A man said, "I don't want to hurt you." Doe #2 testified he spoke in a whispery voice she "probably wouldn't recognize again." (RT 913-915) The man had Doe #2 roll onto her stomach, she said she had a bad back, he had her roll onto her back, her nightgown pulled over her head. She could not see, "and didn't want to." Doe #2 felt the man against her; it felt as if he was naked. The man kept saying things like, "I don't want to hurt you; I just want to make love to you." Doe #2 thought she'd try to cry, but the man's voice got harsh, and he told her to stop it; she decided it was best to "get it over with as soon as possible." (RT 915-917, 925, 1490)

The man fumbled, touching Doe #2's breasts with his hands and mouth, then put his penis in her vagina. She could not tell if he ejaculated or withdrew, but he put his penis in her vagina a second time; he also orally copulated her. Doe #2 did not feel a glove on the man's hand. Throughout, the man continued to tell Doe #2 that he only wanted to make love to her and not to hurt her. After, the man said that he was going to leave and she should count to fifty. She started counting to herself, he told her to count out loud. As Doe #2 heard the man leave, she asked him to close the door so her cats wouldn't get out; she heard him go through the kitchen and close the sliding glass door as he left. Doe #2 then called police. (RT 917-920, 925)

The police arrived, Doe #2 was taken to the hospital and examined by a forensic nurse specialist, who took swabs from Doe #2's body, including an external genital swab, and swabs from Doe #2's breasts, and her right buttock. A reference blood sample and oral sample were collected at later dates. The samples were transported to the Long Beach police and then to the Los Angeles County Sheriff's Department Scientific Services Division. There were multiple bruises on Doe #2's leg; she had genital tears and a hematoma to her genitalia, indicative of sexual assault. The police kept Doe #2's nightgown. (RT 921, 1345-1352, 1403-1404, 1442-1444, 14866-1489) Doe #2 told police and the nurse specialist she believed the man was white, in his 20s, with no body hair. At trial, Doe #2 was unable to identify her assailant. She could only describe him as "fairly young" based on the timber of his whisper. She could not recall why she had said he was white. (RT 921-924, 1490)

Counts 10, 11, 12 and 14: Jane Doe #3

Doe #3 was living alone in a house in Long Beach on July 31, 1998; around 1:30 or 2:00 a.m., she returned home with a friend from Ralphs. The

friend left without coming inside the house, and when Doe #3 went in, she noticed her five cats were under the bed and her back door was open. She closed and locked the door, and took a shower. Her friend called around 2:15 or 2:30 to let Doe #3 know she'd arrived home safely; Doe #3, who had been laying on her bed waiting for the call, then fell asleep. (RT 866-868) She woke about 3:15 a.m. because someone's hand was around her throat. The person took Doe #3's glasses and told her if she screamed, he'd snap her neck. Doe #3 said she wouldn't scream, the man pulled her nightgown over her head and told her to open her legs, she did, and he put his penis in her vagina. The man then took his penis out of Doe #3, lifted her leg and reinserted his penis. Next, the man turned Doe #3 over and put his penis in her vagina a third time while pulling her hair back. Doe #3 was bleeding; the man got a towel from the bathroom, wiped her, laid on the bed, and told Doe #3 to get on top of him because it would be easier for her to "control it." Doe #3 did, and the man's penis again went into her vagina. (RT 868-870, 875)

Afterwards, the man laid next to Doe #3; he told her "it was a date" and to think of him as a lover. The man said she was "really tight" and that he had chosen her because she was a little overweight and "looked like Suzie Homemaker." He said he liked her breasts, and bit and licked them. Doe #3 said her back hurt, and the man rubbed her back. He told her again she was a little bit overweight; he knew she had a bicycle because he had stood outside her door where she kept her bicycle: he told her he'd meet her on the bike path. The man said he "wanted to come," climbed on Doe #3 again, and reinserted his penis in her vagina. Doe #3 thought he may have ejaculated. She told him he was hurting her, that she'd had enough. He said he would leave, but laid back down again, asked what her name was and where she worked and if she wanted him to come back and see her again. Doe #3 said no. The man said that he would send her a guardian angel to watch over her, looked at the angel tattooed on her ankle, and said he liked her angel. He asked if she had a guardian angel watching over her, and she said she didn't think so. The man told Doe #3, "You didn't die tonight." He asked again if she wanted him to return, she said no, and he said he wouldn't be back. He said he knew she was going to call the police, but to wait twenty minutes after he left; he also told her to take a self-defense class "so this wouldn't happen again." (RT 870-872)

The man left; Doe #3 immediately locked her door and called her friend and the police. The police arrived, and took Doe #3 to be examined by

a forensic nurse specialist. Swabs were taken from Doe #3's breasts, vagina, and mouth; a Long Beach detective took an oral reference sample from Doe #3 in 1999. All samples were transported to the Los Angeles County Sheriff's Department Scientific Services Division. Doe #3 had bruises on her arms and legs, multiple tears to her vaginal walls outside the vaginal area, and tears outside her anal area. (RT 872-873, 1352-1355, 1406, 1420-1422)

The assault lasted a hour; at the time of her attack, Doe #3 was a virgin. (RT 873, 875, 897) Doe #3 described her assailant to police as between 5'9" and 6' tall, with hazel eyes and dark hair "like little dreads or curls, but more like dreads," and was thin, but had well-defined arms. The man had a thin moustache, freckles on his shoulder, and wore bicycle gloves on his hands. The fingers were cut from the gloves. He was naked during the assault; he told Doe #3 that his name was "Tino." (RT 873-875, 887, 896) During the assault, Doe #3 peered under her arm to look at her assailant's face. The man saw her do this, and moved the nightgown to block her view. (RT 875)

On August 21, 1998, a few weeks after the attack, Doe #3 saw someone whom she recognized as her attacker parked in an orange truck near her house. The man was wearing a painter's hat; he turned, looked at her, smiled, and slowly drove away. She called the police, telling them she was "almost certain" the person parked in the pickup was the person who assaulted her; a detective subsequently showed her a composite drawing, and Doe #3 said she was "absolutely certain" the suspect was her rapist. Doe #3 saw another composite of the same suspect on another occasion,[4] again identified that suspect as the rapist, and called police. (RT 876-878, 888-895, 1427-1431) Doe #3 testified she told police the man had hazel eyes; at trial, she said they were light hazel to brown. Doe #3 also told police the man's hair was brown, and he had a moustache. Doe #3 could not recall if he had a goatee. Doe #3 testified she "never said" the man was white, possibly Greek or Puerto Rican. She did not recall telling the officer that her assailant had "lots of freckles," or that there were freckles all over the man's body. She described the man to police as "well-tanned"; at trial, she said "olive-colored." (RT 880-888, 894-897) Doe #3 told the forensic nurse specialist

---

4 Doe #3 testified she saw this composite on a store front in Belmont Shore, where it had been posted by Long Beach police. (RT 893, 1430) Doe #3 did not identify any of the suspects in a six-pack shown her by detectives. (RT 895)

the man had freckles on his arm, a thin mustache, and brown, chin-length dreadlocks. (RT 1386)

At trial, Doe #3 believed if she heard her attacker's voice, she would recognize it: when appellant repeated "Don't scream. I'll snap your neck," Doe #3 said it was the rapist's voice, and identified appellant as the man who raped her. (RT 875-876, 878) Doe #3 said she had "not really" followed appellant's story in the newspapers, though she had read some articles about the case, and on the evidence against appellant, including reports that DNA evidence "conclusively proved" appellant was the rapist, and had seen appellant's photograph in those articles. Doe #3 wanted to see appellant convicted. (RT 878-880)

Counts 15 and 16: Jane Doe #4

On September 18, 1998, Doe #4 was fifty-four years old, living in Long Beach with her adult daughter and eleven-month-old grandson; that evening, her daughter was not home. Doe #4 went to sleep around 10:00 p.m., her grandson was asleep in his crib in another room in the house. Around 11:00 p.m., Doe #4 woke to find a man standing beside her bed with his hand over her mouth. The man was wearing a glove, but his fingers were exposed, like a bicycle glove.[5] Doe #4 noticed the man had something covering his face, but could not tell what it was. There was a struggle as the man turned Doe #4 over, face down into her pillow. (RT 1105-1108) It was difficult to breathe; the man told Doe #4, "Stop screaming. Don't make me hurt you." He asked her name, Doe #4 didn't respond, he asked again, she didn't respond, he asked a third time, she told him her name, and he repeated his admonition, calling her by name. Doe #4 stopped struggling, and the man touched her bare breast and put his penis in her anus. After withdrawing his penis, the man pushed Doe #4 down flat, covered her with a blanket, and left. (RT 1108-1109)

The bathroom window had been closed, but unlocked before Doe #4's attack; afterwards, Doe #4 noticed it was open. Doe #4 discovered the telephone by her bed was disconnected, and called police from another telephone. They arrived, and Doe #4 was taken to be examined by a forensic nurse specialist. (RT 1109-1110) An identification technician observed what appeared to be feces on the center of Doe #4's bathroom window sill. Forensic samples were collected, taken to the laboratory, air dried, then frozen and transferred to the crime laboratory. (RT 1143-1152, 1410-1411)

---

5 No fingerprints were found.

Doe #4 told police she thought her assailant was white or Hispanic, had a slight ethnic accent, was of average build, and not of large stature. (RT 1111) Prior to the assault, there was no feces under the bathroom window. (RT 1109)

Counts 17, 18, 19, 20, 21, 22, and 23: Jane Doe #5

On November 21, 1998, Doe #5 was thirty-two years old, and living in a duplex in Long Beach; that night, she came home alone around 10:00 p.m., and went to bed at 10:30 p.m. (RT 926-927) About 2:00 a.m., Doe #5's cat made a sound which woke her; she got up to look for the cat, turned on the light, and found a man in the bedroom doorway, wearing pants, gloves, and a white-hooded pullover jacket with stripes on the chest. Doe #5 could not see his face clearly because she is nearsighted, was not wearing her glasses, and was half-asleep. (RT 928-929)

Doe #5 screamed; the man put his hands over her mouth; they struggled, and fell to the floor. The man was on top of Doe #5, holding her down; he asked why she bit him, and said that if she hadn't bitten him, he wouldn't have had to hurt her and that she should not have "done that." Doe #5 did not recall biting the man. The man told Doe #5 to go close a living room window that had been closed when she went to bed, then to go to the kitchen and close the door and the security door. Afterwards, the man had Doe #5 sit in a director's chair in the living room; he told her he wanted to give her an orgasm, and moved her legs apart. The chair was not sturdy, so the man took Doe #5 to her bedroom and had her lie on her back on the bed. (RT 928-932) He orally copulated Doe #5 for ten to fifteen minutes, then cuddled her and asked if she was married, what her sex life was like, what her name was, did she have children, where she lived, and where she was from. At some point, Doe #5 told the man she was thirsty, and he went to the kitchen; returning with a cup of Pepsi, the man said he intended to "make love" to Doe #5. Doe #5 tried to dissuade him by saying she had Hepatitis B and C and was afraid to take the AIDS test because her "fictitional ex-husband lover" had tested positive for HIV. She asked the man to use a condom, and gave him a box she'd received as a gag gift from a friend. (RT 932-933)

There was another struggle, which Doe #5 again lost. After putting on two condoms, the man put his penis in Doe #5's vagina while Doe #5 laid on her back, begging him not to do so. About five minutes after the initial penetration, the top condom broke; the man removed his penis from Doe #5, replaced the condoms with two new condoms, and re-inserted his

penis. Another five minutes later, the man removed his penis, put Doe #5 on her hands and knees, and entered her from behind. (RT 934-935) At some point, the man took out his penis and repositioned Doe #5 on her side, again entering her from behind; the man then put Doe #5 on her back and "hands over the head to grab the headboard." During these repositionings, the top condom kept breaking, and the man would pull out his penis to replace the condom, then resume penetration. The man also kissed, fondled, and sucked Doe #5's breasts. (RT 935-936, 939)

The sexual activity ended when Doe #5, "torn up badly," couldn't stifle her cries of pain, which stopped the man. He cuddled Doe #5 for hours, telling her that he had never "done it" before, was sorry, wanted her to forgive him, and wanted her address so he could send her flowers. Doe #5 asked the man's name; he said "Max." During their conversation, the man spoke in a deliberate whisper,[6] and appeared drowsy, but not enough to drop his head. Doe #5 lied to the man, saying she was from Poulsbo, Washington; he seemed familiar with the Washington and Oregon area, particularly Seattle, Portland, Puget Sound and the Oregon waterfront.[7] (RT 936-938, 946) The man said he would leave before dawn, and did; he told Doe #5 to wait ten minutes before doing anything, and that the next time this happened, she should kick the person, fight him off. (RT 938) Doe #5 called police as soon as the back door closed; they arrived within two minutes, and Doe #5 was subsequently examined by a forensic nurse specialist, who took an external genital, nipple and breast swabs from Doe #5. An oral reference sample was later taken by a detective. All samples were transported to the Los Angeles County Sheriff's Department Scientific Services Division. Doe #5 had multiple abrasions and lacerations in her labia. (RT 939, 1394-1399, 1406-1407, 1432-1433)

The encounter lasted about three hours. Doe #5 did not see the man's face clearly, and could not identify him. She told police he'd pulled her nightshirt up so she could not see him, but had touched his head once and felt small braids or dreadlocks. She thought the man was 5'8" or 5'9" tall, based on a comparison with her own height, and described him to police as "mocha," possibly a light-skinned Hispanic, with a wiry, muscular build,

6 Doe #5 testified that as the man became sleepy during their conversation, his voice would progress from a whisper to a normal speaking voice; he would then "remember" and return to whispering. (RT 940)

7 On Doe #5's sexual victim assault questionnaire, she indicated her assailant appeared familiar with Portland, Oregon, and did not mention Washington. (RT 945-946)

about 160 lbs.. The man was not fat: he had muscle tone "without a body builder's muscle tone." She felt "a small amount" of hair on his chest. Doe #5 was not able to identify the man from either a photographic lineup or a composite drawing. (RT 939-945, 1435-1436)

Counts 27, 28, 29 and 30: Jane Doe #6 [8]

On August 21, 1999, Doe #6 lived alone in Long Beach; she had fallen asleep in her chair in the front room and was awakened by a hand on top of her head. She said, "not you again."[9] The man answered, but Doe #6 was not sure what he said or if he remembered the previous incident because the man did not know what her colostomy bag was. The man's voice sounded "very similar" to the man's voice in the earlier episode. Doe #6 asked the man how he'd gotten inside, he said he'd climbed through a window. The man told Doe #6 to shut up, took her to the divan, pushed her down, then moved her to a wider window seat. The man digitally penetrated Doe #6's vagina, then put his penis in her vagina. (RT D-16-D-19, D-24-D-26-D-27) Doe #6 could not see the man's face because he'd covered her face with a pair of her shorts. The man's penis slipped in and out of Doe #6's vagina, though she could not recall how many times. The man referred to himself as a "hot cock," and said, "Relax and you will enjoy it." Doe #6 thought he ejaculated. Afterwards, the man put a pillow over Doe #6's face and told her not to move for ten minutes. Doe #6 got up as soon as she heard the floorboards stop squeaking; she went into the kitchen, found the door she had locked was now wide open, the window screen and some of the glass louvered window panes gone. (RT D-20-D-23) Doe #6 called the emergency number; police arrived, and took the plaid throw from the divan. Doe #6 was taken to the hospital, examined by a forensic nurse specialist, samples taken, given to police, then transported to the Los Angeles County Sheriff's Department Scientific Services Division. (RT D-23, 1407-1409, 1444-1446)

Doe #6 only saw the man's right hand, and three or four inches of arm above his wrist. According to Doe #6, she told the police either the man was white or "wasn't black." The bottom of the man's hand was uncallused,

---

8 Testimony of Jane Does #6, #7, and #13 was videotaped before trial pursuant to a Penal Code section 1336 stipulation. (RT D-3-D-5) Doe #6 was approximately 82 years old at the time of her testimony (RT D-10); Doe #7 was 80 years old (RT D-34); Doe #13 was scheduled to be out of state at the time scheduled for trial (RT D-58-D-61). The jury was advised before watching the tapes that they were to consider the testimony as trial testimony, and transcripts of the tapes were provided. (RT 900, 902-903)

9 This referred to Doe #6 's account of a prior rape on August 3, 1999, charged as counts 24, 25 and 26; again, the jury acquitted appellant on those counts.

and he had "bristly," or coarse, hair on his inner thighs. She told police the truth about the incident, including her description of her assailant. (RT D-27-D-33) According to one of the officers at the scene, Doe #6 identified her attacker as white. (RT 1409)

Counts 31, 32, 33, 34, 35, 36, 37 and 38 : Jane Doe #7

On April 2, 2000, Doe #7 was living alone in Long Beach; by 6:00 or 7:00 p.m., she had showered and gone to sleep, wearing an old short nightgown. As was her habit, Doe #7 had locked all doors: she also had sticks behind the doors and windows except for the bathroom window, which she kept partially open for ventilation. Doe #7 woke to find a hall light on which she never used, and then someone "pounced" on her. A gloved hand was put over her face, a finger into her mouth; Doe #7 bit down hard. The glove felt rough, like a work glove. A man rolled up Doe #7's nightgown and used it to cover her eyes and ears, tying it in the back, and putting her hands behind her. He told Doe #7, "Do as I say and I won't hurt you." Doe #7 said she would, and asked him please not to hurt her. The man asked Doe #7 what her name was, and if she was alone; Doe #7 told him her name, and said she had a friend who occasionally came in after midnight to sleep at the house. Doe #7 lied about the friend. (RT D-35-D-39, D-49)

The man asked how long it had been since Doe #7 had been sexually active, she said it had been many years. The man put his penis in Doe #7's vagina, removed his penis, and told Doe #7 to put his penis in her mouth. As she did, she noticed the man had a "metal ring" around his penis. At some point, the man took his penis from Doe #7's mouth and put it back into her vagina; periodically, he had her change positions from her back to her side, removing his penis to do so. Doe #7 didn't remember how many times this happened, though it was more than twice. The man told Doe #7 to lie face down; Doe #7 became worried he would anally penetrate her, and asked him not to, because she had hemorrhoids. He did not. The man had Doe #7 orally copulate him again. Doe #7 could not recall if she orally copulated him two or three times. During the encounter, the man left and went to the bathroom more than once. After the second oral copulation, he went to the bathroom, returned, and put his penis in Doe #7's vagina again. At some point, Doe #7 asked the man for a drink of water; he gave her the bottle she kept on her bed stand. Doe #7 could not remember if the man touched her breasts. Doe #7 was in a lot of pain as the attack happened shortly before she had hip

replacement surgery; she told the man about her discomfort, and he put a pillow on the night stand to support her leg. (RT D-39-D-42, D-46-D-49)

After a while, Doe #7 told the man she was in a great deal of pain; he asked her for five more minutes, and after five minutes, left, telling her not to move for twenty minutes. She didn't hear him, and he repeated the instruction. About ten minutes later, Doe #7 went into her dining room, found the sliding glass door open, then called the emergency number. (RT D-44-D-45) The police arrived, and took Doe #7 to be examined by a forensic nurse specialist. Doe #7 had bruises on her body, and one breast was reddened, in addition to "pinpoint" bruises and multiple tears around her labia and outside her genitalia. Swabs were taken from Doe #7's right shoulder, left breast, right breast and mouth, transported to the police station and then to the crime laboratory; a reference swab was taken at a subsequent date and transported to the crime lab. (RT D-45, 1355-1358, 1411-1412, 1437-1439, 1441, 1444-1445)

During the assault, Doe #7's nightgown periodically "slipped a little" so she would catch "glimpses" of her assailant's face. The man's hair was either dark blonde or light brown, "loose curls" on top and short on the sides, a "neat haircut." She thought his eyes slanted a little on the outside, and noted he had "quite a bit" of body hair, but not dark or black body hair. Doe #7 told police he had a medium build, "not a real big heavy guy"; she testified he seemed "not real tall," with more of a slender build. The room was lit by a light from outside Doe #7's bedroom window, the small nightlight in the base of her night stand lamp, at one point, the light from the television after the man asked Doe #7 to turn it on. Doe #7 said her attacker did not look dark, and described him to police as white. (RT D-43-D-44, D-49-D-53, 1440)

On May 1, 2000, Doe #7 called Detective Kriskovic and told her she'd received a telephone call from a man; after the caller hung up, Doe #7 recognized his voice as her attacker's. Doe #7 testified she wasn't "100 percent sure" it was the same man, but it was a voice that was similar. (RT D-57-D-58)

<u>Counts 39, 40, 41, 42, 43, 44, 45, 46 and 47: Jane Doe # 8</u>

On June 11, 2000, Doe #8 was sixty-one years old, living alone in a mobile home park in Huntington Beach, California. That night, Doe #8 went to bed at eight or nine o'clock. (RT 839-841) Around 1:10 a.m., she woke and saw a nude man standing between her bed and the door; the television was on, and was the only light source in the room. Doe #8 could not see the

man's face because he covered her eyes with his hands right away, putting her down on the bed and saying that if she did what he said, she would not be hurt. Doe #8 thought she began screaming; keeping her eyes covered, the man led her around the room, looking for something to blindfold her with. The man asked for a pair of nylons, Doe #8 said she didn't have any, the man told her to undress, took her shirt, tied it around her head, and led her back to bed. He asked Doe #8 her name, she told him, he said she wouldn't be hurt, just to do what was asked. The man had Doe #8 lubricate herself with her fingers, put his fingers in her vagina, laid her down, put his penis in her vagina, had her orally copulate him, then reinserted his penis in her vagina. Doe #8 also thought the man may have orally copulated her, and that he put his penis in her vagina "at least four" times. (RT 841-846, 848) At some point, Doe #8 told the man she was hurting "a little." Doe #8 was scared, and did not think she was going to survive. (RT 844-845)

The encounter took half an hour or forty-five minutes. The man talked to Doe #8 throughout: he was "nice." He told Doe #8 nicely what to do, asked how many children she had, if she would like a drink of water; Doe #8 said yes, and he gave Doe #8 a drink from the water by the side of her bed. When he was finished, the man tucked Doe #8 in and told her to stay there for five or fifteen minutes, "one of the two," so he could have time to get away; he left, still naked. Doe #8 tried to call the emergency number, but discovered the telephone was disconnected. She dressed, went to a neighbor's house, and police were called. (RT 845-846, 1663)

Doe #8 was examined by a forensic nurse specialist, who took a swab from Doe #8's vagina. No sperm was detected in the sample.[10] Doe #8 described her vagina as "really ripped." According to the nurse, Doe #8 had a large tear along the side of the urethra, two tears above the urethra, two hymeneal tears, a red mass inside her cervix, and a periurethral edema: she was swollen around the urethra. (RT 847, 1400-1404) Later, Doe #8 discovered the man got into her home through a small sliding window, about 48" high and 12" wide: the screen had been ripped out, and outside motion lights disconnected. (RT 847, 849-850)

Counts 48, 49, 50 and 51: Jane Doe #9

On May 11, 2002, Doe #9 was seventy-one years old, living alone in a mobile home park in Los Alamitos. The night before, Doe #9 fell asleep on

---

10 A former Huntington Beach crime laboratory forensic scientist testified that he detected over 120 sperm on one of the vaginal slides. (RT 1663-1670)

the couch, woke at 12:35 a.m., and went to bed. She woke again because she felt someone on her back, a gloved hand over her mouth, choking her and yanking back her head, repeating, "Don't scream. I don't want to hurt you." (RT 958-961) The man removed his hands from Doe #9's mouth, took off her shorty pajama bottoms, and poured something cold down Doe #9's back and into the buttocks area. He then entered her vagina. Doe #9 told the man he was killing her, that she needed water. She reached for a bottle of water on the night stand, took a drink, and dropped the bottle on the floor. Doe #9 couldn't catch her breath; she repeated the man was killing her and she needed more water; he got up and took Doe #9 to the kitchen, walking behind her. After Doe #9 drank a glass of water, the man drank from the same glass, and took Doe #9 and what was left of the water back to the bedroom, setting the glass on the headboard. (RT 960-962)

The man next took Doe #9 to the bathroom and stood her on one leg while stretching the other on the counter; he put a washcloth over the nightlight, then entered her vagina, pulled out and took her back to bed. (RT 962-963) There, the man piled pillows behind Doe #9 and put his penis into her vagina for a third time as he sucked on her breast. Doe #9 testified she kept whining, "you're killing me," and asked how long he was going to stay. The man took Doe #9 by the arm back to the bathroom, and told her to give him ten minutes, to take a shower, and he would be gone. When Doe #9 left the bathroom, she noticed the front door was deadlocked, indicating her attacker had used the back door. After finding her telephone disconnected, Doe #9 retrieved a second telephone, and called police. (RT 963-964)

The police arrived, and Doe #9 was taken to the hospital; she was bleeding down her legs, and was kept in the hospital for three days for congestive heart failure. When the forensic nurse specialist first saw Doe #9, Doe #9 was having a heart attack, so the nurse examined Doe #10 first. Swabs were subsequently taken from Doe #9's breasts, and a reference sample was taken; the samples were delivered to the Los Alamitos Police Department, then transported to the Sheriff's crime lab. When examined, Doe #9 had multiple bruises on her chest, abrasions over her face, there was blood over the inner aspect of her legs and thighs, and she had what appeared to be dried blood in her hair; there was redness, swelling and tears to the genitals. (RT 964-965, 967, 1358, 1362-1363, 1447-1448)

Doe #9 only saw her assailant in the dark. He was wearing white gloves, and his skin was dark. His hair was curly, looked like "a bird's nest,"

wild, parted in the middle, with bangs coming across the forehead from the sides, and very short on the sides. At trial, Doe #9 said she could not tell how tall he was; she described him to police as clean-shaven, 5'6" to 5'7", 160 to 170 lbs., with buzzed or faded, "very short" and tapered upwards, hair, parted in the middle; the man had a thin, muscular build. Doe #9 told the forensic nurse specialist the man was a "thin, wiry" white male in his 20's, not hairy. (RT 965, 968-971, 1385-1386, 1449-1450) Some months later, Doe #9 met another woman, Doe #10, who lived in the same mobile home complex and was also assaulted that night; previously, Doe #9 never met, or had any physical contact with, Doe #10. (RT 966-967)

## Counts 52 and 53: Jane Doe #10

On May 11, 2002, Doe #10 was sixty-eight years old, living alone in the same trailer park as Doe #9. She fell asleep on her couch; she woke to find gloved[11] hands pulling at her face from behind her, covering her nose and mouth. It was difficult to breathe; Doe #10 screamed and struggled, a man told her to shut up and put a small sofa pillow over her face. (RT 972-974) The man took Doe #10 down the hallway, she asked where they were going, he said he was taking her to the bathroom because she was going to call the police. At the bedroom door, the man hit Doe #10 on the right cheek with his fist, knocking her on top of her bed. He took her to the bathroom, threw her face down on the floor and removed her pants. He stopped, and after some period of time, Doe #10 realized he had left. She started kicking the bathroom safety door, hoping to attract a neighbor, getting no response, she returned the way the man brought her; as she went past the service porch, Doe #10 realized her car was missing. (RT 975-977)

Doe #10 called police; she was subsequently examined by a forensic nurse specialist; a blood sample and fingernail scrapings were taken. Doe #10's nose and chin were swabbed, and there were swabs taken from her left face, the outside of her mouth, her neck, and her right and left hands. The samples were booked to the Los Alamitos Police Department and transferred to the crime lab. Doe #10 had abrasions on both sides of her face and back and bruises on her body. Doe #10 did not see Doe #9 on the night she was assaulted, and had no prior contact with Doe #9. (RT 977-978, 1358-1362, 1364, 1447-1448) Doe #10 did not see the face of her assailant, and could not identify him; she thought he was a small person based on her height: she

---

11 Doe #10 testified the gloves felt like they had "steel wool" in them: "they were just tearing my face up and my arms...." (RT 975)

is 4'11 ½". She felt one of the man's forearms, which seemed smooth, or hairless. (RT 973, 978-980)

Counts 54, 55, 56, 57 and 58: Jane Doe # 11

On June 26, 2002, sixty-one year old Doe #11 was living in Long Beach; she spent the evening alone, degrouting a counter, and went to bed around midnight. At around 2:35 a.m., Doe #11 woke to the sound of the dining room floor creaking. She sat up, turned on the lights to find her glasses, picked up the telephone, and started to dial the emergency number. (RT 763-764) A man jumped into the door, hands up and feet sprawled, naked except for socks on his hands and feet, and a T-shirt over his head. He flew at Doe #11, hit her in the jaw, knocked the telephone across the room, and jumped on top of her. Doe #11 began screaming, he turned off the overhead light, she started struggling, he told her to be quiet. Doe #11 realized her neighbors were out of the area, and calmed down. The man began orally copulating Doe #11, keeping one sock-covered hand over her face as he did so; she bit his hand through the sock, and he jerked his hand back, dislocating her jaw. The man told Doe #11 not to fight him. (RT 764-767, 771)

After orally copulating Doe #11 a couple of times, the man put his penis in her vagina. She continued to struggle, he pushed her against the wall, cocking her head to one side. His penis slipped from her vagina; he continued pushing against her until she complained that he was breaking her neck or hurting her. Doe #11 believed the man reinserted his penis at some point. Doe #11 told the man he must have hated his mother or his grandmother, then began reciting the Lord's Prayer. She thought the man started to hesitate, and put her hand up inside the shirt over his face; he had flipped her shirt over her face during the assault. Doe #11 felt chin whiskers. When she first felt his scalp, she thought the man was bald, then felt something "sticking out" that felt like "dry ends of hair" "sticking straight out in front of him." (RT 767-770, 772)

When Doe #11 reached the line "deliver us from evil," the man backed off, removed his penis from her vagina and tried to turn Doe #11 over; thinking he was going to anally attack her, Doe #11 said, "No, not this. Please, not this," and grabbed the man's penis. The man told Doe #11 to turn over, she said no more, and he stopped, rolling her over and putting her sheet over her. He rubbed her back and told her it would be "fine." (RT 770-771) The man told Doe #11 to give him ten minutes before calling the police and not to tell people at her work. She laid face down until he left, then tried

to find her bedroom telephone. Unable to do so, Doe #11 went into another room to use the telephone. The line was still open from her earlier dialing attempt, so Doe #11 went to one of her tenant's houses and asked her to call the emergency number. The assault lasted between twenty minutes and one hour. (RT 772-773, 786)

Police arrived, Doe #11 was taken to be examined by a forensic nurse specialist. A vaginal swab was taken, as well as a reference sample, and clothing collected; police transferred the samples to the crime lab. Sperm was detected on the vaginal sample. Doe #11 had multiple contusions and abrasions on her face, and complained of facial pain. She had abrasions to her forchette area, which was Toluidine positive, indicating fresh injury. (RT 773, 775, 1371-1379, 1381-1383, 1434-1435, 1742-1745) Doe #11 told police she could not identify her assailant. (RT 775) Someone had broken into her home once before, in 1997; she told the officers she thought it might have been the same man.[12] During the assault, she couldn't see anything more than "smooth skin," though wondered if he was wearing "a body suit or something," as it seemed gauzy and she did not see the man's penis when he first leapt into the room.[13] She told police he had no body hair because she could not feel any body hair. Doe #11 also said the man had curly hair on his head, though the police report indicates she said he had straight hair. She noted he had a 3"-long wisp of hair hanging over his forehead. She did not recall telling police the man was either White or Hispanic: she thought she said he was tan, but had no tan lines; the officer testified Doe #11 said the man was 5'8", olive-skinned, with no apparent tattoos or body hair. At a subsequent interview, Doe #11 said he was olive-complected. Doe #11 said the man was a little taller than she is: Doe #11 is 5'6", and guessed her assailant was 5'7" or 5'8". She described him as bigger than her, heavy, but not defined or muscular. He had a goatee, but she did not feel a mustache. (RT 776-780, 782-785, 787-788, 1436-1437) Doe #11 told the forensic nurse

---

12 In 1997, Doe #11 and her partner were in bed when a man came into their room; as soon as the man saw her companion, he turned and ran. The police caught a man fitting the intruder's description riding a bicycle nearby, and asked Doe #11 and her partner to identify him. Doe #11 said she could not identify the man "for certain," but that his silhouette "looked like this guy." It was not appellant. (RT 789-790) In 1998 or 1999, police showed Doe #11 a composite sketch, but Doe #11 could not identify that individual as her attacker. Doe #11 was shown more than one photographic lineup, but was unable to make an identification. (RT 791, 796-797)

13 Doe #11 added the body suit hypothesis on cross-examination; later, she said the man was naked, but might have been wearing "something" because otherwise she couldn't figure out why she didn't see his penis when he first came into the room. (RT 786)

specialist she could not determine her assailant's ethnicity, but said he had a curly goatee, a scarf tied around his head, and wore a white T-shirt. (RT 1380-1381)

Doe #11 did not recognize appellant as her attacker. (RT 773-774) She had seen photographs of appellant in the newspaper, and believes he is guilty based on those reports and what she'd been told by the prosecution. (RT 777-778, 781)

Counts 59 and 60: Jane Doe #12

On August 13, 2002, Doe #12 was seventy-four years old, living in a large house in Huntington Beach; she lives with her grandson, but was home alone that evening. At 11:30 p.m., Doe #12 was in bed, crocheting and watching a baseball game. She heard a noise, got up, and went down the hall, turning on all lights along the way. Seeing nothing amiss, she returned to her crocheting, and began watching the news. She heard a thud, thought she had a prowler, and called 911. Doe #12 was standing in her back room; as she dialed, she heard him "come on the phone," and she was grabbed from behind, sending her glasses and the telephone "flying." Doe #12 yelled, "He's in my house and he's attacking me," turned, and saw a naked man with a towel over his head. She tried to attack his eyes, but couldn't, then tried to remove the towel to see who it was, and couldn't. The man knocked Doe #12's arm away, she grabbed his penis, finding what she thought was mesh underwear. (RT 851-853, 855, 859) The man pushed Doe #12 to the floor and got on her back; the telephone rang and the man got off Doe #12 and ran down the hall. He was naked except for the towel and a black G-string. The towel was rough, "the kind that you have at a car wash"; Doe #12 thought the man was wearing something like a gardener's glove on the hand he had pressed against her face. (RT 853-855, 859, 861)

The police arrived; Doe #12 was subsequently examined, her clothes collected, and swabs taken from her body, including her cheeks and hands. A control sample was also taken and ultimately delivered to the Orange County Sheriff Department crime laboratory.[14] (RT 858, 1128-1131, 1553-1555) Doe #12 W. told police her assailant had "very smooth," hairless

---

14 The criminalist testified the procedure followed in taking samples was: put on a pair of fresh latex gloves, remove and dampen one of the kit's sterile cotton swabs with distilled water, swab the location to be tested, place the swab in one of the kit's plastic test tubes, and put the sealed tube into a marked manila coin envelope. After collection, envelopes are taken to a drying box at the police station, into which swabs are placed in small circles. A fan circulates warm air throughout the box; once dry, the swabs are returned to their containers and booked into evidence. Drying protects the integrity of the evidence. (RT 1131-1136, 1138-1142)

VANESSA PLACE

buttocks, and a "fairly light olive" complexion: he wasn't white or black. (RT 860-862)

Doe #12 did not identify appellant as her attacker. As a result of the assault, Doe #12 had some temporary red marks on her left ear and the left side of her face. (RT 855-858)

Counts 61 and 62: Jane Doe #13

On August 15, 2002, Doe #13 was living in Long Beach, in a guest house behind a larger house occupied by her landlords. The night before, Doe #13 had gone out with her parents, and did not return home until about 1:00 a.m.; she collected her mail, got ready for bed, angled the television towards the bed, turned it on, and fell asleep. Doe #13 was wakened by a gloved hand over her mouth and a voice saying, "Don't fight me." The cloth-back glove had plastic bumps or beading on the front, "like to grip... a BMX bike," or gardening gloves. (Peo. Exh. 8, pp. 65-69, 87-88.)

Doe #13 first played "possum," but the person shook her, apparently wanting her to wake. Doe #13 woke, and fought. She yelled, and the man shook her head up and down, telling her to shut up, not to yell; she began to move left, making a circle as she fought. She tried to slide off the bed, but the man yanked her back. The man got on top of her, Doe #13 realized he was nude.[15] He tried talking to her, telling her not to yell or fight, asking her name, but she continued fighting. She bit his hand, but did not know if she broke the skin. Doe #13 was on her back; the man told her to turn over; she resisted, knowing she would be weaker on her stomach. Doe #13 said her name was Joanna, and asked his name: he said Tito. Doe #13 said she was H.I.V. positive. There was a "slight hesitation," then the man said he didn't care. Doe #13 asked him to use a condom, saying she had one. (Peo. Exh. 8, pp. 69-74, 89.)

The man picked Doe #13 up in a "wrestling move" and threw her on the bed; Doe #13 began moving to the right, but her head became caught between the bed and dresser. Doe #13 told the man he was "tweaking" her neck, the man said he didn't care, and continued choking her between the furniture. Throughout, Doe #13 was scratching her attacker: she had "real long" acrylic nails, "hard and strong." She scratched his chest, his arms, his groin. She stuck her fingers in his left eye, scratching it, and stuck her pinkie up his nose and started yanking and ripping, to "get blood." She grabbed his penis and squeezed "hard." She hit him. She repeatedly kneed him in

15 Doe #13's face was covered at times. (Peo. Exh. 8, p. 91.)

the groin with her right knee, then slid off the bed head first and saw that the man's face was covered by a shirt knotted over his head. (Peo. Exh. 8, pp. 73-76, 83-86.)

The man was sweating profusely: Doe #13's hands slipped on his skin, and he smelt "musty." Doe #13 described his physique as "soft," the sort that might have "been buff, but now it just let itself go." Because of the sweat, Doe #13 testified she could not gauge the amount of his body hair; she told the detective he had some chest hair and hair around his nipples, but not a lot. She felt hair when she grabbed his groin. Doe #13 told the detective she thought the man was 5'9" to 5'10" but not more than 6"; Doe #13 is 5'4" and weighs 120 lbs.: given the man could not overpower her, Doe #13 did not think he was very strong. She thought he was in his 20's to 30's, of average build. His hair was dark, and seemed loosely curly or wavy, "messy." His penis was soft, and Doe #13 told police she thought it was very small. Doe #13 told the detective that when the man said his name was Tito, he said it with an authentic Latino accent; Doe #13 is Latina. (Peo. Exh. 8, pp. 76, 89-98, 102-105.)

Doe #13 ran to her bedroom door and opened it; the man said "wait," Doe #13 turned and saw the man's body was olive-colored. She ran out the door and on through the front door away from her house; she went to the landlord's, hammering on the door and screaming there was a guy in her house, and a young girl who lived there called the emergency number. (Peo. Exh. 8, pp. 76-77, 83, 100-101.)

The police arrived, and Doe #13 was subsequently transported to the station, interviewed, then examined by a forensic nurse specialist. Samples were taken from her palms and fingers, and cuttings from her fingernails; a reference sample was collected, as were Doe #13's clothes; these were transported to the Sheriff's Department crime laboratory. Doe #13 had abrasions on her upper lip and abrasions and bruises with redness on her body. When Doe #13 returned to her home, there was "blood everywhere," on the pillowcases and bedding, blood which had not been there before the assault, and was not Doe #13's. (Peo. Exh. 8, pp. 77-83, 86; RT 1364-1368, 1413-1414)

Doe #13 could not "100%" identify her assailant; when asked on direct examination if anyone in the courtroom looked like the person who assaulted her, Doe #13 identified appellant. When asked on cross-

examination if she could identify her assailant, Doe #13 said, "I cannot." (Peo. Exh. 8, pp. 79-81.)

Counts 63 and 64: Jane Doe #14

On November 7, 2002, Doe #14 was thirty-six years old, living alone in Long Beach. The night before, she went to sleep around 11:00 p.m., she woke sometime in the early morning, and sat up in bed, unable to breathe, then realized there was a latex-gloved hand around her nose and mouth. She panicked, trying to move the hand; a man said, gruffly, "Don't say anything." She kept struggling to remove the man's hand; when he finally moved his hand away, she said she would do whatever he wanted, that she didn't want to get hurt. The man put his hand back over her mouth and told her to be quiet and not do anything; the television was on, and the man covered it with a blanket. Doe #14 reached around in the sheets, trying to find her telephone, but the man came up behind her; she said she'd do whatever he wanted, and asked if she could move her small, elderly dog out of the bed. The man indicated she could, she picked up the dog, went to the living room, was about to open the front door, but the man said, "no." (RT 982-985, 987)

Doe #14 asked if she could let the dog "go to the bathroom," and put the dog on the couch; the man wanted to return to the bedroom, Doe #14 said she needed to use the bathroom, and the man accompanied her; while in the bathroom, Doe #14 asked the man to turn off the bedroom heater. After initially refusing, the man agreed. As soon as he left, Doe #14 locked the bathroom door and opened the window. She noticed the screen was off, realized this was the point of entry, put her head half out the window and began screaming. (RT 985-986) The man appeared outside the window; Doe #14 tried to escape by the door, but the man caught her in the doorway. They struggled, she fell in the hall, kicking and pushing him as he tried to put his hand over her mouth. At some point, his index finger slid into her mouth and she bit him.[16] She then ran out the front door and pounded at a neighbor's door, there was no immediate response; as she turned to another house, the first neighbor opened her door. (RT 986-988, 990-993, 999-1000)

Doe #14's neighbor called police; they arrived, took oral swabs from Doe #14, and booked them into evidence. There was some blood on Doe #14's lips: she was not sure if it was her blood, or her assailant's. Doe #14

---

16 On cross-examination, Doe #14 testified she believed she bit the man "sideways," i.e., across the mouth, running the length of the finger, perhaps close to the knuckle. She did not feel the glove tear from her bite. (RT 991, 994-995)

was examined by a forensic nurse specialist, who took swabs from Doe #14's body. (RT 988, 1068-1075) Doe #14's leg was bruised in the assault. (RT 998-999) Police officers searching the alley behind Doe #14's house found latex gloves in a trash can behind a house about three houses away from Doe #14, and booked them into evidence. The gloves were layered, one glove inside another, so there was more than one glove per hand. There was no blood on the gloves. (RT 1057-1066)

Doe #14 never saw her assailant's face: he kept a dark-colored shirt over his face and head. She told police she thought he was wearing nylon jogging pants because of the sound they made. The pants were dark. Doe #14 is 5'11"; the man was "possibly" two to three inches shorter: 5'8" to 5'9". He had a medium build, and appeared younger than she. The man asked Doe #14 her name once or twice; she asked his, but he did not answer. (RT 988-990, 996-997, 1001)

Appellant's November 7, 2002 arrest

At about 1:01 a.m. on November 7, 2002, Long Beach patrol officer Kevin Delorto received a call about an assault on Euclid Avenue. Delorto was half a mile away, and as he drove towards the location, he saw appellant riding a bicycle in the center of 23rd Street, just east of Euclid, three blocks from the site of the assault. (RT 1023-1027) Delorto jumped out of his car, pointed his gun at appellant and told him to stop. Appellant "looked surprised," and stopped. Delorto asked appellant to get off his bicycle, and told appellant he was being stopped because he didn't have a light on the bicycle and there had been an incident in the area he wanted to question appellant about. Delorto asked appellant who he was, where he was going, and where he had been; appellant gave his name, said he was coming from visiting a friend, John Bracco, who lived near the Java Lanes Bowling Area, on Pacific Coast Highway and Redondo, and was going to his home. (RT 1028-1029)

At the time of his arrest, appellant was wearing blue jeans, a baseball cap, had arm warmers in his pockets, and a beanie cap in the back waistband of his pants. He had a white long-sleeved shirt with a black T-shirt underneath; the black shirt had large lettering across the top. Delorto did a custody search, lifting appellant's shirt to see underneath. There were no bruises on appellant's body or face. (RT 1031-1038, 1040) Delorto noticed appellant had a small bleeding cut below the knuckle on his right index finger, and a second small cut on the corresponding area on the back of the finger. The cut ran around the finger, not the length of the finger; Delorto described

the bleeding as a "trickle of blood," and did not recall any smearing. Appellant said he hurt himself on the gear shifter level while dismounting from the bicycle. (RT 1029-1030, 1036, 1039-1040)

Another officer arrived, took a saliva swab from appellant to be used as a DNA reference sample, and subsequently booked the sample. The officer had received ten minutes training on how to take a DNA field sample two weeks earlier; he wore a pair of gloves while handling the swab, which he believed was sterile. The officer did not have to break a seal to get to the kit, and the swabs were not sealed. The officer removed the swabs, took the sample, then put the swabs in a small cardboard box inside the kit. The officer testified he was "very careful" not to contaminate the swabs, but could not remember if he touched his pen or face with his gloved hand. The officer did not take a swab from appellant's cut. (RT 1042-1056) A methamphetamine pipe was recovered from appellant; in response to the officer's questions, appellant said he was just out for a bike ride. (RT 1045)

The latex gloves found in the alley and appellant's saliva swab were transferred to the Los Angeles County Sheriff's crime laboratory and given to a criminalist for testing. (RT 1077-1082) On November 12, 2002, a reference blood sample was taken from appellant and given to Long Beach police. (RT 1162-1166, 1173-1178)

On November 10, 2002, police followed appellant to a residence in Oxnard. About 8:00 p.m., appellant was arrested, and driven back to Long Beach. (RT 1201-1203, 1211-1212) The Long Beach Police Department created had a task force to catch the Belmont Shore rapist: at least five detectives in the Sexual Assault Unit were involved. Kriskovic was the lead investigator; a composite drawing of the suspect was prepared in 1998 and posted throughout the Belmont Shore area at her direction. The description given the public was of a man with light brown hair, and light brown or hazel eyes. Appellant was darker complected when arrested than he was at trial. (RT 1323-1324, 1326, 1332-1334)

Appellant's Admissions

Appellant's mother was born in the Philippines, as was her son. Appellant's father was Samoan, a member of the United States Navy who died in Vietnam. Mrs. R. is half Filipino and half white. (RT 1113-1114, 1117-1118) On November 7, 2002, Mrs. R. went to the police station to talk to appellant: they met privately for fifteen to thirty minutes. During their meeting, appellant told his mother, "I will pay for my sins." One of the detectives told

Mrs. R. beforehand appellant was guilty. Mrs. R. asked how could they prove it, did he see it; the detective said he hadn't seen it, but appellant would "answer for it" because DNA would prove him guilty. (RT 1114, 1119-1122, 1124)

Mrs. R. told a detective what her son said about paying for his sins, but did not say appellant said he was responsible for these crimes, or that when she asked where she had gone wrong, that he said it was his fault, not hers, because he was the one who did it. Mrs. R. testified she did not say to the detective that she didn't know what went wrong because her son went to church and confession and she had taught him to fear God. (RT 1114-1115) She was very upset when she talked to appellant, and both she and appellant were crying.[17] (RT 1123-1125) Appellant learned to speak English when he was four or five years old. He does not speak Spanish. Appellant is a surfer, spending a lot of time at the beach: his normal complexion is darker than he appeared in court. He has worn his hair in dreadlocks for many years. (RT 1118-1119, 1123) Between August and November, 2002, appellant lived with a girlfriend and another friend, and visited his mother each week. Mrs. R. never saw appellant with an eye injury or deep scratches on his body during that time. (RT 1126-1127)

Mrs. R. was interviewed by Tracy Manzer, a Long Beach Press Telegram reporter; the interview was published on November 13, 2002. In the article, Mrs. R. was credited with saying that appellant told her, "I'm sorry I did it, Mom. I'm going to have to pay for my sins." According to the report, Mrs. R. asked appellant why he did it, why he would hurt her like this, and appellant's "eyes just flooded with tears and he shook his head. He could not say anything." Mrs. R. testified she did not tell this story to Manzer. (RT 1114-1115) Mrs. R. was also interviewed by Michele Geely of Channel Nine News; in her on-camera interview, Mrs. R. said she asked appellant, "Why did you do this?" to which appellant responded, "Mom, I'm going to pay

---

17 The detective who escorted Mrs. R. to her meeting testified the two talked for seventeen or eighteen minutes; afterwards, the detective told appellant his mother was very concerned about his situation and if he "had got right with his mother." According to the detective, appellant said he told his mother he was the one responsible for the rapes, "he was the one in the news," and that it was his fault, not hers. The detective told appellant his mother would probably be approached by the media; appellant asked the detective to tell his mother not to talk to the press. Mrs. R. told the detective what appellant had said, and that she didn't know what went wrong with appellant, because he went to church and confession, and she had always taught him to fear God. On cross-examination, the detective said he "never noticed" whether Mrs. R. or her son had been crying. (RT 1193-1200)

for what I did." Mrs. R. testified she and appellant did not have "that kind of conversation." (RT 1115-1117)

Tracy Manzer testified that when she interviewed Mrs. R. in November, 2002, Mrs. R. told her appellant said, "I'm sorry I did it, Mom. I'm going to have to pay for my sins," and when Mrs. R. asked her son why he did it, why he would hurt her "like this," "his eyes just flooded with tears and he shook his head. He couldn't say anything." (RT 1187-1189) Mrs. R. cried during her interview. (RT 1190)

During the November 10th drive from Oxnard to Long Beach, the transporting officer advised appellant of his Miranda rights, appellant nodded, and said yes when asked if he understood his rights and wished to waive them. The officer asked appellant if he understood what was happening; appellant asked why he was being arrested, and the officer indicated it was for sexual assault. Appellant told the officer he had graduated from Poly High School in 1988, was of Hawaiian descent, had come from Hawaii when younger, had traveled to the Seattle area and returned to Long Beach. There was some discussion about the Navy, ships, and current events: appellant "took a real interest in the Afghanistan situation." The officer described appellant as alert and "pretty intelligent." The transporting officer told detectives he had advised appellant of his rights, and appellant had waived those rights. (RT 1201-1209)

The officer who moved appellant to and from his interrogation by the detectives testified that while driving back to the jail, he asked appellant about an incident on Zandia Street: the officer had been off duty on August 15, 2002, and was curious about the suspect's escape route. Appellant indicated he remembered the Zandia episode; the officer asked if appellant had been on a bicycle or on foot; appellant said on foot; the officer asked if appellant had gone over the back fence through the house behind Zandia; appellant said he had; the officer asked if he had used a nearby pedestrian walkway to get to Lakewood Boulevard; appellant said he had; the officer asked if appellant had gone across Lakewood Boulevard, or gone northbound; appellant said he went northbound. The officer said he'd thought appellant had gone to a parking lot and gotten into a car; appellant said no, he went to the Spires Restaurant, and used a pay phone to call a female friend, who picked him up eight minutes later. Appellant couldn't remember the woman's name, but said she didn't know what had happened . Appellant did not volunteer any

information about being injured that evening. Appellant did not appear to be tired during the 1:00 a.m. drive. (RT 1213-1223)

Appellant's Interrogation/Confession: Untaped

Detective Katherine Kriskovic started interrogating appellant about 9:40 p.m. on November 10, 2002, readvising appellant of his Miranda rights although the transporting officer indicated appellant had already been advised, and waived, those rights. Appellant signed a waiver form, which was then witnessed by Kriskovic and Detective Collette. Kriskovic had prepared a flow chart of various rapes, indicating who the victims were,[18] and whether there was DNA evidence. The chart listed thirty-one rapes, those with DNA evidence were highlighted. Kriskovic told appellant his DNA sample "came back" to DNA taken from Doe #6, assaulted in August, 1999. Kriskovic showed appellant all the points on the chart involving DNA evidence, and how those cases had been linked to the DNA evidence on the Doe #6 case, and thus, to appellant. Appellant told the detectives he could not undo what had been done, and sincerely owed a debt to everybody, listing the city, the State, the detective, "the cops, and all of the residents and all of those people who hated him." According to the detective, appellant "admitted he had a problem." On direct examination, Kriskovic testified she asked if appellant was aware that he had been named The Belmont Shore Rapist; appellant said he had, and that again, he owed a debt for the bad and hideous things he had done. On cross-examination, Kriskovic testified she omitted from her report that when asked if he was the Belmont Shore Rapist, appellant answered, "You tell me." According to Kriskovic, when appellant was asked whether one of his victims had a colostomy bag, he stated he remembered her, but did not know the reason for the colostomy bag, or "why she had it."[19] (RT 1224-1234, 1256, 1282, 1287-1289, 1308, 1330-1331, 1334-1341)

---

18 The flow chart listed the following incidents as connected via DNA evidence: January 1, 1997– Doe #1, Long Beach; May 13, 1998 – Doe #2, Long Beach; July 31, 1998 –Doe #3, Long Beach; September 18, 1998 – Doe #4, Long Beach; November 22, 1998 –Doe #5, Long Beach; August 21, 1999 – Doe #6, Long Beach; April 2, 2000 – Doe #7, Long Beach; June 1, 2000 – Doe #8, Huntington Beach; May 11, 2002 – Doe #9 and Doe #10, Los Alamitos; June 26, 2002 – Doe #11, Long Beach; August 13, 2002 – Doe #12, Huntington Beach; August 15, 2002 – Doe #13, Long Beach. The November 7th incident (Jane Doe #14) was not noted because the DNA results were not then available. Doe #10 was not highlighted as there was no DNA link at the time the chart was prepared. The chart was redacted for trial purposes to eliminate those cases where no DNA evidence linked appellant to the alleged assault, with the exception of the Doe #6 case. (RT 1233-1234, 1256-1257)

19 On cross-examination, Kriskovic acknowledged appellant said, in response to her questions about the colostomy bag, "You were the one that said that to me the whole time. You brought that to my attention the whole time," and when Collette said to appellant that he remembered

Kriskovic asked why appellant had committed his crimes; he said he had made "a lot of bad choices." At about 10:45 p.m., Kriskovic asked if appellant needed anything; he requested a glass of water and some gummy bears, which were provided. Kriskovic asked appellant if he had ever lived in Seattle, and if he had returned to Long Beach in January 1997, before the first assault. Appellant said he had been in Seattle in 1993, 1995 and 1996, spending six months each year on a commercial fishing ship, and had returned in January 1997, possibly the same week as the first assault. Kriskovic asked if appellant committed the crimes represented on the flow chart, or if the detectives were "off base." Appellant said they were not off base, judging by the facts. (RT 1231, 1292-1301)

Kriskovic asked whether appellant remembered his November 7th arrest; he said he did, he had been arrested for paraphernalia and no light, and he was the one the police were looking for that evening. (RT 1230) Appellant was questioned about various odd jobs he had, and about wearing gloves. Appellant said he got gloves wherever he found them, none of them were his, he used whatever was available, from gardening gloves to socks worn on the hands. Appellant wore gloves to prevent his victims from injuring him, not to avoid leaving fingerprints. In response to questioning, appellant said he did not wear masks, but wore beanies which he could exchange with friends: appellant would cut two slits in the top of the beanie, then pull the beanie down so the slits became eye-holes. Appellant said sometimes he did not wear beanies, and would use a T-shirt to hide his face by pulling it over his head. (RT 1234-1235)

When asked about the assault on Doe #13, appellant remembered her as being "tenacious," saying as much as he attacked her, she attacked him. Appellant denied being scratched or bitten.[20] Appellant was asked if he remembered breaking a pot en route to the back of her home: appellant said he did, when asked if he remembered kicking the pot, appellant said no, when asked how he broke it, appellant said, "it just happened to be there,"

---

the "girl" with the colostomy bag, appellant said, "That's what she said earlier." (RT 1308-1309) According to Kriskovic's notes, appellant remembered the bag. (RT 1309)

20 Kriskovic had received a telephone call from Doe #13, who said there was blood on her sheets which was not hers; the sheets were subsequently collected by a forensic technician. Doe #13 told Kriskovic she'd scratched her assailant severely, particularly in the chest, and poked one of her fingers in his eye, and ripped inside his nostril: Doe #13's acrylic nails were horizontally cracked, and Kriskovic collected the nails for genetic material. Pubic-like hair was also gathered from the sheets; Doe #13 shaves her pubic area. (RT 1317-1322)

when Collette asked if he had knocked it over, appellant said, "yeah."[21] Appellant also said he entered through the bathroom window, having picked up a pair of latex gloves from some trash bins behind a nearby grocery store. Appellant said Doe #13 struggled with him, locking him out of her bathroom, that he tried to reach her through the bathroom window from the outside, and that when they fought, Doe #13 bit his finger through the glove.[22] Appellant showed Kriskovic a quarter-inch horizontal cut on his right index finger about a quarter of an inch above his knuckle; on the other side of his hand, appellant had a small blood bruise. Appellant told Kriskovic that Doe #13 had a very old dog, "close to death." Appellant said he had been staying with a friend who lived on Campo Walk in Long Beach, and was helping the friend move to Oxnard when he was arrested. (RT 1235-1237, 1311-1317, 1325)

At 12:15 a.m., appellant had a restroom break, and was questioned for another twenty-five minutes after his return. Kriskovic asked appellant if he'd told anybody about the assaults; appellant said he hadn't. With regard to the assaults of Doe #9 and Doe #10, appellant said he'd been dropped off by a friend named Scott that night to go to an event at the Los Alamitos football field, but had gotten "sidetracked" into a trailer park.[23] Inside the park, he found a trailer with an open door, went inside and sexually assaulted an elderly woman; within five minutes, appellant was in another trailer, attacking a second elderly woman, whom he did not completely sexually assault, took that woman's car from her carport, and left.[24] Appellant said he drove to a small business on 4801 East Anaheim, where he parked and left the car, but there was no particular reason to leave the car in that location. Appellant walked into Recreation Park, an 18-hole golf course, went through "Little Rec," a 9-hole course, and slept nearby at the Colorado Lagoon. (RT 1237-1240, 1243-1244, 1275-1279, 1311) Appellant then indicated he was getting sleepy, and the interview was stopped and appellant transported back to jail. (RT 1240-1241)

---

21 The pot was on the ground, covering a sprinkler head. (RT 1313-1316)

22 At the time appellant was interviewed, Kriskovic did not know about the victim's description of the bite as being horizontal. (RT 1330)

23 The trailer park was a block and a half to two blocks from the Los Alamitos police station on one side, flanked by the 605 freeway and an empty river bed on the other, with residential apartments and a small business district on the remaining sides. There was only one access point to the park, which was otherwise surrounded by a wall, partially made of blocks, partially of chain link. (RT 1275-1277, 1450-1451)

24 Doe #10 told Los Alamitos police she was not sexually assaulted. (RT 1280-1283)

The interrogation resumed the next morning at 9:45 a.m.; appellant was asked if he remembered his rights, appellant said he did, and agreed to continue. Kriskovic told appellant he would be charged with all the DNA cases and, if convicted, would face a long prison term, possibly life. Appellant said he wished none of it had happened, and that he knew what he was doing was wrong when he was doing it; Kriskovic asked him what he meant by that, appellant said wasn't it obvious he was making all of the bad decisions and wrong choices. Kriskovic asked if raping women was wrong; appellant said he knew it was wrong. Kriskovic asked if doing these things was contrary to the way his mother had raised him; appellant said yes. Kriskovic asked how appellant prepared himself when he entered his victims' homes; appellant said sometimes he would enter the home, then undress, and would usually ask the victims to give him ten minutes to dress inside the house and leave. Appellant said he never stole anything from his victims. (RT 1241-1243, 1282, 1289) Kriskovic asked appellant about the attack on Doe #8: appellant said a friend named Donovan dropped him off near the Hilton in Huntington Beach, where he planned to meet other friends. Instead, appellant walked into the nearby trailer park, and broke into Doe #8's trailer through her window; Doe #8's trailer was located near the rear of the park. (RT 1244-1245)

According to Kriskovic, when questioned about the Doe #6 attack, appellant said it was possible he'd taken some of the louvered panes from her kitchen window, but if he did, it was not because of fingerprints. When asked about the attack on Doe #7, appellant said he had never worn a "cock ring." When asked if he orally copulated his victims, appellant said he hadn't; when asked if he'd forced his victims to orally copulate him, appellant said he hadn't; later, appellant said maybe he had. He then indicated he had worn a cock ring once, and that the ring had been given him by an acquaintance. When asked if he'd ever identified himself to his victims, appellant said he didn't remember, asked what names the victims recalled, then denied identifying himself as Max or Tito to any of the victims. (RT 1244-1246, 1309-1310)

Appellant was asked if he had ever come across dogs during these attacks; appellant said he had sometimes, was afraid of the dogs, but would continue and try not to let the dogs bother him. Appellant remembered a large dog on the back porch of the home where the back door was open (Doe #4); Kriskovic asked appellant if that's why he left by the bathroom window rather than the back door, and appellant said yes. (RT 1247) When asked about the

Doe #12 assault, appellant said he'd been dropped off in Huntington Beach by friends, found a home, went through a window, undressed, and attacked the woman: her telephone went flying out of her hands and her glasses fell from her face. Appellant said he did not rape the woman, and, in response to the detective's question, said he was not wearing a G-string. Appellant said generally he wore shoes, hiking boots, thongs, or tennis shoes, and was not necessarily always naked. (RT 1247-1249) Appellant covered the women's faces with anything handy, whether it was their nightgown or a sock. Sometimes appellant would unscrew sensor lights. There was a break at 11:21 a.m., the interview resumed at 11:40 a.m., now with a tape recorder present, for purposes of summarizing the previous interrogation. Appellant can be heard on the audiotaped confession responding to something Kriskovic is doing by saying, "So you're saying to say yes?" (RT 1249, 1258, 1262-1263, 1289-1291, 1303-1304)

During questioning, appellant asked if he could speak to his mother personally because he did not want her to find out about his arrest from the media. Mrs. R. was brought to the station, and met with her son for fifteen minutes. Afterwards, Kriskovic spoke to Mrs. R., who was crying, visibly upset and shaken. Kriskovic gave her a drink of water; Mrs. R. said appellant would have to pay for what he had done. (RT 1249-1250, 1342)

Appellant's Interrogation/Confession: Taped

In the transcribed portion of appellant's interrogation,[25] Kriskovic reviews appellant's arrest and transportation from Oxnard to Long Beach, indicating appellant was advised of his rights during the drive, and again by Kriskovic, and had waived his rights. Appellant acknowledges the waiver. Kriskovic states that they "talked" for a few hours "into this morning," and that appellant was brought back and "talked to" for a few more hours, and that now she wants to summarize "a bit" of what was discussed: there are thirty-one incidents the police believe appellant is responsible for, and thirteen cases where he has been "matched on DNA positively." Kriskovic reminds appellant he is facing a lot of prison time, but notes appellant has been "a gentleman" in talking to the detectives. (CT 906-908)

Kriskovic asks appellant if he was in Seattle in 1996, and if he returned to Long Beach "probably the first or that same week of January 17, 1997." Appellant indicates he was, and did; appellant agrees with Kriskovic's statement that he does not remember specifics about the January 1997

---

25 As redacted for the jury. (CT 906- 934; RT 1091-1101)

case, or of the "following four" cases, or of the May 1998 case, or of the "four more incidents leading up to" the "next DNA case" on July 31, 1998, or of that case. (CT 908-909) With regard to the September 18, 1998 "DNA case," Kriskovic states appellant remembered and told the detectives a German Shepherd or large dog was on the porch, just outside the door "that you were exiting from inside her residence... and that dog scared you, to where you altered your route and you went out in the same manner that you entered [...] through an open window," but that appellant doesn't remember any other specifics. Appellant agrees. (CT 909-910)

Appellant also agrees with Kriskovic's statement that he does not remember specifics of the November 33, 1998 DNA case; Kriskovic notes there were "a couple more, two," then another DNA case on August 21, 1999, about which Kriskovic said appellant had remembered involved an elderly woman with a colostomy bag. Appellant did not respond; Kriskovic prompted appellant again, and appellant said, "You, you were the one that said that to me, the whole time. You brought that to my attention, the whole time." When Kriskovic asked if appellant remembered her having a colostomy bag, appellant said no, when Kriskovic asked if appellant knew what a colostomy bag was, appellant said he had no idea. (CT 910)

Kriskovic noted appellant could give no details on the April 2, 2000 DNA case, despite the fact "you understand that you're [sic] DNA profile is an exact match." The same was true for a June 11, 2000 DNA case out of Huntington Beach. (CT 911) Collette said of the August 21, 1999 case that appellant said he remembered taking the louvers out of the windows; when appellant didn't answer, Collette asked if appellant was "playing games" with the detectives; appellant said "maybe," Collette asked if appellant didn't want to tell them what he'd said before, given appellant had said he remembered "the girl" with the colostomy bag. Appellant responded, "I... That's what she said earlier.... No, I don't remember." When Collette said he'd written the prior statement down, appellant said, "Then why, why don't you guys read your notes. Your guys already read, you guys asked me the questions.... Read your notes then. You'll see the answer." (CT 911) Appellant confirmed that in the Huntington Beach incident, his friend dropped him off at the Hilton, he walked to the rear of the trailer park, entered a trailer and attacked a woman. Appellant acknowledged he unscrewed her outside lights. When Collette returned to the louvers on Prospect, appellant said these were the same questions previously asked, and Collette noted appellant had never

answered. Appellant sighed. Collette asked if it was possible appellant took the louvers, and appellant then said, "O, yes, yes." Kriskovic said "And uh," and appellant answered, "Yes, yes." Kriskovic said appellant was asked if he took them, and had said he left them on the property; Kriskovic noted appellant said it was a possibility he'd taken them because the officers couldn't find them; when asked if that was correct, appellant said, "Maybe... May, maybe." Appellant said he remembered saying he wore a cock ring on April 2, 2000, and that was the only incident in which he wore a cock ring. (CT 911-914)

Kriskovic said the "next DNA hit" was one of the Los Alamitos victims, and outlined appellant's previous account of being dropped off in Los Alamitos by a friend around nine or ten o'clock p.m., intending to go to a school football field, getting "sidetracked" to the trailer park, going through an unlocked door, attacking an elderly woman, and "within five minutes," making his way to another trailer belonging to another elderly woman, attempting to assault her, leaving her trailer and taking her car; appellant said "yes" to each of these statements. Kriskovic noted appellant drove to and abandoned the car at 4801 E. Anaheim Street in Long Beach, but that appellant does not otherwise frequent the area or know anyone who lives there, and was able to pass police cars on the way without incident. When asked by Kriskovic what kind of car it was, appellant said he had "no idea. It's been awhile." Asked if it was a big or small car, appellant said, "Small car, I guess." Appellant could not remember if the woman gave him the keys or if he found the keys, if it was a single key or a ring of keys. (CT 914-916)

Collette asked if appellant walked through the golf course to Colorado, Kriskovic paraphrased, indicating appellant had showed them a route on the map going through the Long Beach Recreation Golf Course area, crossing over 7th Street onto the smaller, "little rec" course, "bunker[ing] down" near the lagoon; appellant confirmed this. (RT 917) "Number 28" on the flow chart was June 2002; Kriskovic said appellant said he wore white socks on his hand, appellant confirmed; "number 29," a DNA case, was in Huntington Beach: Kriskovic said appellant said a friend dropped him off on PCH near Maine Street, where he met with friends who took him to Bolsa Chica and McFadded, appellant confirmed; Kriskovic said appellant said he entered a home through a window, attacked a woman, sending her telephone and glasses flying, appellant confirmed. "Number 30," another DNA case, involved a young lady: appellant said he remembered breaking a pot as he

was walking through her yard towards the rear of her guesthouse. Collette asked appellant if he kicked it with his foot; appellant said no; Collette asked how it happened; appellant said, "It just happened to be there. I just..."; Collette interrupted, "Knocked it over?"; appellant said, "yeah"; Kriskovic offered, "Or stepped on it?" Appellant said, "Possibly." (RT 917-919)

Kriskovic asked if appellant went through the kitchen window, appellant said yes, Kriskovic asked if appellant remembered hearing people in the front house come out after he broke the pot, but before he went into the house, appellant paused, and said yes. Appellant confirmed he attacked the young woman; Kriskovic said, "And I believe you, you said that....," and Collette interjected, "She was tenacious? She attacked you. Correct?" Appellant said yes. Kriskovic said appellant described the woman as tenacious, that she scratched and bit appellant; appellant said no. Kriskovic said that the woman "obviously" fought appellant; appellant said, "Supposedly." Kriskovic indicated appellant denied having scratch marks, and asked if that was because he had a T-shirt over his head; appellant said no. Kriskovic said, "She just didn't scratch you? O.K." Appellant said, "No." (CT 919-920)

Regarding "number 31... the one that was Thursday morning," Kriskovic asked if appellant remembered being stopped and arrested for drug paraphernalia and riding a bicycle without a headlight, and telling the detectives he had attacked a woman in her home wearing a pair of latex gloves he'd found in a trash bin by the Vons/Pavilions near Milikan High School. Appellant agreed he'd entered through a window, and the woman locked herself into the bathroom. Appellant said, "Mmhhmm" when asked if he went outside and attempted to reach her through the window, and did not respond to the question whether he then returned inside and attacked her as she was exiting the bathroom. Appellant confirmed there was a struggle; to Kriskovic's question, "And during that struggle, you did not sexually assault her. Is that correct," appellant said, "No." He confirmed she bit his finger, and showed the injury, and confirmed he fled the scene and disposed of the gloves in an alley trash can a few houses away from the woman's home. Appellant acknowledged he signed a waiver form permitting a detective to take a field saliva sample for DNA. (CT 920-923)

When asked if he was aware he was called the Belmont Shore Rapist, appellant nodded and said yes. Kriskovic asked appellant if he knew how serious the case was and that he was going to prison for "a long

time," yet cooperated anyway, and appellant said yes. Collette asked why, appellant said, "It's the truth," Collette said, "'Cause it's the truth and I think you said you were very sorry for, to the community, the victims. Remember that?" Appellant said yes. Collette said, "I mean you are very remorseful... And you've apologized to us for all these victims...," appellant said, "Yes, sir," Collette said appellant was on the verge of crying, "'cause you feel bad," appellant said, "Yes, sir." Appellant confirmed he had "good intelligence," no mental health problems, and was not on any medication. Collette said appellant said he had "just been making bad decisions and doing hideous things to all these women," appellant said, "Yes, sir." Kriskovic said appellant said he owed a "'Great debt'," appellant said, "Yes, ma'am." (CT 923-925)

Kriskovic asked appellant about a search warrant which had been executed: appellant confirmed he'd asked the detectives not to bother the couple living at the Ximeno address, that there was just a cardboard box with his belongings in the garage. (CT 925) Appellant acknowledged that he'd found his victims by chance, the detectives' supposition that he'd committed the crimes was not "off base," he "probably did all these" though he could not remember specifics, and wore gloves to protect his hands against scratches or "bits [sic]" from the victims, not to "hide fingerprints." Collette urged appellant to say whatever he felt like saying, reminding appellant that he'd earlier expressed remorse, said he'd made "'a lot of bad decisions,'" and the assaults were "just about sex." Kriskovic reminded appellant she'd asked what sort of statement he would make to his victims, adding, "I don't want to read from what I have in my notes. I want you to speak from the heart." Appellant said, "I said I can't undo what I have done and I sincerely regret and I wish that it had never happened." (CT 925-927)

Appellant confirmed he'd said he did not wear masks, but cut eye holes in beanies and pulled them down over his face, and he'd been stopped by police several times over the past five years, but never after a rape. Collette said appellant said this was although appellant had been close enough to the scenes to see the helicopter and "police activity," appellant didn't respond, Collette asked him if he didn't want to answer, and appellant said, "Well, I'm here now." Kriskovic said appellant said he'd not used drugs during the rapes, except for the one Thursday morning, appellant confirmed; Kriskovic said appellant said he'd just had a "small hit... from the pipe you had in your pocket," which was "'Speed,'" appellant confirmed. Kriskovic said appellant admitted having used Ecstacy, "mushrooms acid,"

and marijuana and beer, though not in conjunction with an attack, appellant confirmed. Collette reminded appellant he had been asked why he never hit "those girls who attacked you," and asked appellant if he remembered his answer; when Collette asked if appellant wanted Collette to refresh his memory, appellant said, "Please do." Collette said appellant said, "Well, I've hurt them enough. I was already doing a bad thing. It was needless to hit them back." Appellant said, "Yes, sir." Appellant confirmed he'd never hit anyone. He also confirmed the detectives had explained that he was facing several hundred years in prison and still chose to speak with the authorities, and that they had not threatened him with anything. (CT 927-930)

Appellant asked if his mother knew, and asked if he could have a chance to tell her personally that "I might be gone for a very, very long time." Collette told appellant they could arrange this, adding that appellant's mother was "a victim of this too"; appellant responded, "'Cause, 'cause of my wrongdoing, yes." Collette said appellant's mother was losing her son; appellant said yes; Collette said, "Isn't that true," appellant said, "Yes, sir." Collette said appellant's mother was elderly and had cancer, and asked appellant if he loved his mother, and if they got along, appellant said they did. Appellant asked when he would go to court and if he would be defended, and the detectives told him he'd go to court in two days, and an attorney would be appointed. Appellant asked why the recording and "jotting"; Collette said for accuracy, so no one could misunderstand what was said. Appellant asked if the people he offended would be in court, and Collette told him that if the case went to trial, "every girl" would be called to testify. (CT 930-932)

Appellant then said, "Mr. Collette. No BS aside personally.... What do you think of me personally? As yourself, not your job, not your..," next asking, "Ms. Christine [Kriskovic], in all the cases you've seen, BS aside, what do you think of me personally? Meaning honest." Kriskovic's answer was redacted; appellant's subsequent question was, "What do you think of me personally besides that?" Collette said, "Even though my partner Katherine says she has not a whole lot of regard for you, she has treated you professional, has she not? We've had no problems between the three of us whatsoever? Is that true?" Appellant twice answered, "Yes sir." (CT 932-934)

Trial DNA Evidence
Thomas Fedor

Thomas Fedor is a forensic serologist at the Serological Research Institute, a private sector crime laboratory accredited in 1999. Fedor has a

B.S. in chemistry and an M.S. in cellular and molecular biology, both from the University of Michigan; he has a diploma in criminalistics from, and is a biochemistry/molecular biology fellow with, the American Board of Criminalistics. He began doing forensic DNA work in 1990, and joined SERI in 1996. Once a year, Fedor attends one or two days of a week-long meeting of the California Association of Criminalists; he keeps abreast of current developments and relevant literature through subscriptions to forensic science journals. (RT 1451-1453, 1555-1558) Fedor testified DNA is the chemical containing inherited genetic information; it is possible to determine how many people in the population at large would have a certain DNA profile, calculated from a collection of population surveys. (RT 1453-1454) In PCR/STR analysis, the numbers assigned to a particular allele refer to the number of times an area of DNA is repeated in that location. (RT 1563-1564) If DNA comes from a single source, the peak heights of a genetic type at any given location should be about the same height: some individuals have genetic mutations which result in peak height imbalances, though typically such imbalances are due to a degraded or improperly stored specimen. (RT 1568-1569, 1619-1620)

SERI's primary precaution against evidence contamination is for analysts to only work on one item of evidence at a time; analysts wear latex gloves and surgical masks when working, and change gloves after handling any piece of evidence. Fedor may change gloves while working to minimize the possibility of DNA transfer, and uses new scalpel blades to cut the samples. Different testing phases are done in different locations to further reduce the possibility of transfer, and evidence moves in a single direction from initial examination to subsequent examination to disposal. The most common cause of analyst contamination occurs in transferring samples; the mask and gloves are to keep the sample free of analyst DNA. There are extraction samples which act as controls by going through the entire testing process free of DNA, but these would not indicate sample contamination. (RT 1454-1455, 1506-1510, 1545-1547) In 1997, SERI was performing PCR (polymerase chain reaction) analysis, which is a method of copying DNA so very small samples may be multiplied for testing. In 1998, the PCR method used by Fedor was DQ Alpha or DQA1: the DQA1 refers to a particular testing location where individual DNA differs. Five additional markers were tested in subsequent kits which could be subject to amplification. At the time of appellant's trial, there were fifteen different DNA locations which may be

tested using Identifiler, a STR (short tandem repeats) system. (RT 1455-1457, 1541-1542, 1582)

SERI received evidence from Doe #1 on November 5, 1999; Fedor tested that evidence using the DQA1 and Polymarker system in January, 2000: Fedor was able to determine the DNA taken from the breast swab sample did not come from Doe #1, and generated a profile of the unknown donor. (RT 1457-1458) On January 8, 1999, Fedor tested the Doe #2 right buttocks swab using the DQA1 and Polymarker systems, obtained sperm cells, and generated a DNA profile which was not Doe #2's. This profile matched the profile generated from the Doe #1 sample. (RT 1458-1459) Fedor recovered a mixed sample from Doe #3: the minor components of the mixture appeared to be Doe #3's, and the major components from another donor whose profile matched the donor in the Doe #1-Doe #2 samples. (RT 1459) Using the DQA1 and Polymarker systems, Fedor tested the DNA extract from the Doe #4 bathroom window swab and found the same unknown donor. At the time, Fedor did not calculate the statistical chance of two individuals having this same profile. (RT 1459-1460) Fedor also tested Doe #5's nipple breast swab and discerned a mixture, the major components of which matched the previously-profiled unknown donor.[26] (RT 1460-1461) The remainder of the evidence was returned to the LASD laboratory; in 2003, Fedor re-examined the swabs using PCR-STR technology, as well as examining appellant's blood sample. (RT 1460-1463, 1467)

According to Fedor's analysis, appellant's standard genetic profile at the thirteen tested loci included, at the D3S1358 marker, 16 and 17 alleles, at the VWA marker, a 14, 16, and at D18S51, 14, 14. (RT 1463-1466) As retested, Doe #1's breast swab was a mixture: a mixture can be discerned if there are more than two genetic traits at any one genetic marker.[27] The presence of a Y chromosome indicated the other donor was a male; once Doe #1's profile was deemed the minor donor, due to the relative degree of intensity, the remainder created the major donor profile. The chance a man unrelated to appellant could have been the major donor was one in

---

26 The Doe #2 and Doe #4 evidence was received largely in one batch on November 10, 1998, with another two samples arriving in January; the Doe #5, Doe #1 and Doe #3 samples were received on November 5, 1999. (RT 1503-1506)

27 If a component is less than 10% of the mix, the reaction may not detect that component. Because PCR only amplifies what it detects, small quantities of certain alleles may not be discerned; the analyst would be unaware of this. (RT 1576-1577, 1582-1584, 1591-1592)

forty-seven sextillion. There are six billion people on earth. (RT 1467-1471, 1569-1570)

Retesting the Doe #2 sample, Fedor determined the DNA profile from the sperm cells taken from the right buttocks swab matched appellant's; the chance of a coincidental match was one in eight hundred forty-four septillion. Doe #2's right and left breast swabs also included appellant's profile, with the same one in eight hundred forty-four septillion chance of a coincidental match. Appellant's random match probability on Doe #2's external genital swab was one in seven trillion. Fedor assumed two contributors to the mix. (RT 1471-1475, 1491, 1503, 1605-1607-1608) The Doe #3 breast swab was a mixture; appellant's random match probability was one in nine septillion. The Doe #3 external genital sample did not test positive for male DNA, and there was foreign female DNA in the sample: at the VWA marker, Doe #3 was a 14, 18, and the mixture shows a 14, 18 and a 16, 23. At D21S11, Doe #3 was 29, 32.2; there was also 31.2 and 30. Sometimes, with some ethnicities, the Y chromosome does not amplify properly. (RT 1475-1477, 1597-1601) Appellant's random match probability for a portion of the prepared DNA from the fecal material taken from Doe #4's window was one in eight hundred forty-five septillion, and his match for another portion one in eight hundred forty-four septillion. (RT 1477-1479, 1491-1492, 1502-1503, 1514-1515) The Doe #5 nipple swab was a mixture, Doe #5's DNA was subtracted, and the remaining profile matched to appellant with a one in nine septillion probability ratio. At VWA on Doe #5's external genital swab, there was a 23 marker which belonged to neither appellant (14, 16) nor Doe #5 (14, 15): the sample does not contain sperm, and the male components appear in the mixture to a lesser degree than the female: Fedor could not determine whether the male donor left the 23 allele, or how many people contributed to the mixture. Fedor still matched appellant to the external genital swab sample at a probability of one in nine septillion. (RT 1479-1482) In both the Doe #3 and Doe #5 genital swabs, there were unaccounted-for 16, 23 alleles at VWA. (RT 1601-1603)

Fedor uses the product rule in making his calculations, which looks to population surveys in determining frequency of genetic types at particular locations. For example, at the D3S1358 location, appellant is a 16, 17, and at VWA, a 14, 16. Assuming five percent of the population has a 16, 17 at D-3 and ten percent have a 14, 16 at VWA, then ten percent of five percent will have both results.[28] As all thirteen markers are included in the calculation,

---

28 Some people have three alleles at certain markers. (RT 1567-1568)

the percentage of inclusion becomes very small. The product rule was recommended by the 1996 National Research Committee, a committee of DNA experts appointed by the National Science Foundation; the rule has been implemented and approved by courts, and Fedor believes it generates accurate statistics. (RT 1492-1494, 1539) The population survey used to calculate the percentages was composed of 200 people. At each test locus, there are typically about ten different possible allele combinations. Appellant and most of the victims share a number of alleles at various genetic markers. (RT 1495-1500, 1614, 1618) The statistical analysis Fedor performed assumes unrelated individuals; the databases are racially grouped. (RT 1525-1528)

Fedor is aware of the Promega Conferences on forensic DNA evidence, though he has not attended any: Promega is a testing kit manufacturer. Attendees include the head of the F.B.I., as well as reputable forensic scientists from around the world. Fedor was unaware of a Promega Conference poster entitled, "A nine STR locus match between two apparently unrelated individuals using AMPFESTR Profiler Plus and CoFiler," though he would not be surprised by such a coincidence. Fedor is aware testing tubes can be contaminated with typable DNA, but indicated he could not have contaminated the tubes here with appellant's DNA prior to its receipt. (RT 1510-1513, 1528-1530, 1534, 1542-1545, 1555)

When the reagent batch controls/extractions were received by Fedor from the LASD laboratory in January 1999, they were contaminated with DNA from an unknown source or sources. It is possible the testing was inadequate to contain all the results for the batch controls, given that the DQ Alpha tested positive and the Polymarker negative. These were not retested with the PCR/STR technology because Fedor established the amount of DNA detected was "of no concern." (RT 1515-1520) The extraction blank on the 2003 Doe #5 -Doe #1 samples was also contaminated: there was a 15 allele at the D-8 marker, a 30 allele at D-2, and an 11 at D-16: none of the individuals tested had alleles at that location. Again, Fedor did not retest or check his list of laboratory analyst profiles as possible sources of this contamination because he felt the amount was insignificant. Extraction tubes are tested last, so any contamination could be potentially diminished by the time the batch controls are processed, however, the possibility of intra-sample contamination is increased. (RT 1521-1524)

If there is a single allele difference between profiles, they come from different sources, absent a technical account of the difference. (RT 1540-1541)

The final test results are computer-generated, the product of three different programs that apply various macros to the raw data. All macros are preset; Fedor did not know what the preset analysis was, or how the macros were applied. (RT 1560-1561) According to NRC Guidelines, laboratories should perform validation studies on the testing kits used, and SERI has done such studies on the Identifiler kit, but Fedor has not looked at the studies. He did not know that no mixture study had been done, or the minimum amount of DNA necessary for a reliable result. He was aware that since his testing in this case, the manufacturer of Identifiler had redesigned the kit to eliminate testing artifacts. He did not retest the evidence using the improved kit. (RT 1558-1560, 1565-1567)

On Doe #3 's mixed breast swab sample, there are six peaks (11, 12, 13, 15, 16, 17) at D-8; Fedor's handwritten notes indicate two of the peaks (11, 15) are possible stutter. (Defense Exhibit Y; RT 1570-1571) Stutter is a PCR artifact, and does not represent actual DNA in the sample. Fedor wrote "possible" because those peaks could be DNA, but did not report them as because he did not think they were reliably present, i.e., he thought they were stutter rather than additional DNA. His conclusion was based on the position of the alleles, and their shorter peaks; another analyst could conclude they were real. The Identifiler software has a Kazam macro which is to filter out stutter based on the manufacturer's research; the macro did not identify 11 and 15 as stutter. Fedor did not know what the stutter limit is for D-8; there is no fixed laboratory standard. The Identifiler user manual indicates the limit at D-8 is 8.2 percent. (RT 1571-1575, 1577-1578, 1593-1594) Similarly, at D-21, the computer recognized an allele, meaning there was an allele present of at least 150 RFU intensity. (RT 1579-1580)

Appellant was excluded as a donor from Doe #3's mixed source external genital swab; Fedor did not report alleles at that location which he deemed stutter, though the peaks were not in what he'd called a stutter position, and certain peaks were the same height as peaks identified as reliable. In that sample, Fedor thought the peaks were dye blobs or stutter. He also did not report an off-the-ladder allele because he felt it was not reliably-sized, though it was the same size as the alleles he identified as real, which were the same height, on the ladder, and not dye blobs or baseline noise. As a general rule, peaks from the same donor will be within roughly 70% of the same size of one another. However, degradation, amplification, and DNA quantity, as well as number of contributors and the possibility of genetic

mutation, all affect peak height ratios, and the individual analyst makes the final assessment, which can vary between analysts and laboratories. (RT 1585-1597, 1615-1616, 1619-1621) In the Doe #2 right buttock swab, the 8 peak identified as appellant's allele at CSF was about 30% of the 11 peak also attributed to appellant; again, Fedor assumed two contributors, though there is no way of telling how many contributors there are to any mixture on the basis of the mixture itself. (RT 1608-1614, 1617-1618) Fedor analyzed appellant's profile before testing the Doe #3 sample. (RT 1579)

SERI analysts perform regular proficiency tests, monitored by an outside agency. The laboratory does not keep records of its error rate, or of individual analyst error rate. Once, Fedor switched tubes in a proficiency test, testing the same sample twice; the error was brought to Fedor's attention via defense cross-examination in another case; such an error could not be detected in evidence testing, as the results would not be subject to verification. (RT 1622-1626)

Dr. Paul Coleman

Dr. Paul Coleman is a criminalist at the Los Angeles Sheriff's Crime Laboratory, assigned to the forensic biology section; his primary job responsibility is performing DNA analysis. He has worked at the laboratory since 1989, becoming a DNA analyst in 1991. In 1968, Dr. Coleman received a B.S. in biochemistry from the University of California, Berkeley, and his Ph.D. in biochemistry from the State University of New York, Buffalo, in 1972. From 1972 to 1976, he performed post-graduate research at Columbia University, and currently has a faculty appointment in the Pathology Department at the University of Southern California Medical School. Dr. Coleman took the F.B.I.'s month-long forensic DNA class, has participated in numerous seminars and performed many validation studies at the LASD laboratory. (RT 1629-1631) Precautions taken by the LASD laboratory to avoid contamination include analyst latex gloves, face masks, lab coats, and laminar flow hoods, which direct air flow back towards the analyst. (RT 1631)

In 1999/2000, using the Profiler Plus and CoFiler kits, Dr. Coleman identified a genetic profile from the DNA extracted by Renteria from what was called a "carpet" sample in the Doe #6 case; on February 4, 2000, Dr. Coleman issued his report, which indicated a male donor, and profiled that donor. Dr. Coleman testified the profile was identical to appellant's profile. (RT 1631-1639, 1645-1646) There was no yellow carpet or rug taken in the Doe #6 case: the property report indicates a plaid blanket was seized. (RT

1640-1641) On item 1-E, both Dr. Coleman and another analyst identified an allele at D-21, which both later discarded as unfiltered stutter; on item 2-E (the carpet/blanket), Dr. Coleman initially identified five alleles, striking out one; the other analyst also struck one, but Dr. Coleman could not recall how or why those decisions were reached. If it was an allele, it would have come from a minor contributor, though other alleles also came from minor donors. (RT 1642-1653)

Dr. Coleman takes biannual proficiency examinations; he does not know if anyone at the laboratory has made an error, and believes the laboratory error rate (instances of incorrect genotyping) is zero. (RT 1653-1658) If there was some reason to suspect testing error, such as DNA manifesting in the reagent/control batch, the test would be invalidated and rerun. (RT 1659-1661)

Edward Buse

Edward Buse is a forensic scientist with the Orange County Sheriff's Department Crime laboratory, where he has worked since 1990. Buse has a B.S. in chemistry and a 1995 master's in biology from UCLA, and attended the F.B.I. training classes. (RT 1672) The OSCD crime laboratory takes various precautions against contamination, including sterile gloves, and use of a single-flow model in testing. (RT 1673-1674) The OCSD laboratory performs proficiency tests, but has no error rate. Base was unaware of any false matches. (RT 1739)

Using a Profiler Plus kit with an AB 310 Genetic Analyzer, the laboratory tested the male DNA extracted from vaginal swabs taken from Doe #8.[29] A single source profile was generated, and, according to Buse's July 26, 2000 report, this profile was identical to the profile generated from the Doe #6 carpet/rug stain sample. (RT 1675-1679, 1682) Using the F.B.I. database, Buse calculated the random match probability in the Caucasian population was one in some quadrillion: the laboratory does not perform exact calculations past the trillion mark. (RT 1681, 1684-1685) In 2003, Buse compared the Doe #8 sperm sample profile to appellant's profile, and the match statistic was one in 100 quintillion in the African-American and Southeast Hispanic databases, and one in one septillion in the Southwest Hispanic Database. (RT 1683, 1700-1701)

---

29 Another analyst tested the sample in September/October 2002, and yet another later tested the sample using the CoFiler kit. (RT 1682, 1707, 1709-1714, 1726-1727)

In August 2003, Base also analyzed the Doe #12 samples; the right palm sample was a mixed source sample: Base examined the mixture, determining which were true alleles, decided there were two potential donors, then determined those profiles. One donor was male; the female/major donor profile was consistent with Doe #12's, the minor donor profile consistent with appellant. At VWA, there is a 15, 16: Doe #12 is 15, 15, appellant 16, 14: there was some 14 present, but fell in the stutter position.[30] Neither analyst who initially reviewed the data indicated the 14 was a true allele. (RT 1685-1692, 1708-1710, 1712-1717) Base accounted for the VWA ambiguity by calculating all possible allelic combinations at that locus, finding the chance someone other than appellant was the donor was one in 626 trillion in the Black database, one in 18 quadrillion in the Caucasian database, and one in 13 quintillion in the Southwest Hispanic database; someone of mixed ethnicity would fall somewhere between these frequencies. Base justified inclusion of the VWA marker because although the 14 stutter peak was smaller than what the laboratory deems an allele, it was "a very large peak," "barely below" the stutter cutoff, and a masked or minor peak might lie beneath. The laboratory does not use a stutter filter, using its own guidelines for determining stutter. If the VWA marker were disregarded, the frequency would still be rarer than one in one trillion, but the practice of the laboratory is to include an allele for statistical purposes which would not be designated an allele for allele-identification purposes. (RT 1693-1694, 1701-1706, 1716-1722, 1730-1731) The same sort of calculation was done at FGA, D-18, D-5, and D-13: for example, at FGA, the unknown donor was a 22, and there was a visible 25 peak: had the analyst determined the donor profile at FGA was 22, 25, appellant (22, 21) would have been excluded. (RT 1722-1725)

Before appellant's arrest, the OCSD laboratory had concluded the same male donor had contributed to the Doe #12 and Doe #8 samples, but there was not a match at the VWA marker on the Doe #12 sample. (RT 1699, 1701-1714) There are testing overlaps between the Profiler Plus and CoFiler systems: at D-7, there were two different alleles reported in the two tests. The allele reported by the Profiler Plus and used to declare a match was below the laboratory's 100 RFU cutoff value, designed to remedy things like background electronic noise in the AB 310, which can look like peaks. (RT 1726-1729) Using the OCSD laboratory's statistics, the Promega Conference's nine marker match abstract would have a match likelihood of

---

30 Base testified stutter was present "greater than 95 percent of the time." (RT 1706)

one in 100 billion, even though the individuals were unrelated, and of different races. The black and white donors sampled also shared an allele at three of the remaining four loci. Base did not think this was relevant to the accuracy of his statistical analysis. (RT 1733-1738)

Richard Gustillo

Richard Gustillo is a forensic scientist with the Orange County Sheriff's Department Crime laboratory; at the time of trial, he had been so employed for five years, performing DNA analysis for three. Gustillo has a B.S. in molecular cell biology and a master's in public health from the University of California, Berkeley, and has had intra-laboratory DNA training. Gustillo follows the same anti-contamination procedures as Base. (RT 1746-1748)

On May 11, 2002, Gustillo analyzed the Doe #9 samples using the Profiler Plus and CoFiler tests; a male donor was detected in the mixed right breast sample. Doe #9's profile was deduced out, and a minor donor profile generated. Gustillo compared that profile to appellant's and could not exclude him as a potential donor. The match statistics were one in one trillion, indicating the laboratory limit. (RT 1748-1752, 1756)

Gustillo examined the data from the Doe #10 samples; there was a minor profile on a neck sample in which some alleles matched Doe #9's alleles: Doe #9 also could not be excluded as a possible donor, suggesting a secondary DNA transfer. The match statistic was one in 11,000, a "very insignificant" number. Because the sample was an intimate sample, Gustillo used Doe #10's profile to deduce out the major donor profile. (RT 1752-1756, 1765, 1767-1770) Doe #10's reference sample FGA was reported to be a 22, 22, but her neck swab major donor profile was 22, 24. At D-3, the deduced minor profile was 16, 16 or 16, 17, or 15, 16. There were at least twelve, and probably over one hundred, different genetic variations which could have been created from the deduced minor profile. (RT 1756-1763) The laboratory submitted the results of the breast swab to CODIS, resulting a possible match to a vaginal swab sample from Huntington Beach. (RT 1771-1772) Gustillo reviewed the data for Doe #8, determining there was enough material left for retesting. (RT 1754)

John Bockrath

John Bockrath is a senior criminalist with the LASD Scientific Services Bureau, assigned to the forensic biology section of the crime laboratory; he has a bachelor's degree in physiology from the University of California, San Diego, received intra- and inter-agency training, and has worked for LASD for

about eight years. Bockrath follows the LASD laboratory's anti-contamination procedures. (RT 1773-1776, 1853-1854)

In 1999, Bockrath screened the Does #1 through #5 evidence samples received from Long Beach police, testing for the presence of biological fluids, then transferred those samples to SERI for DNA analysis. Semen was detected in the Doe #4 window sill sample, and DNA extracted. Post-testing, SERI returned the samples to the LASD laboratory, which sent the samples back for retesting in 2003, with appellant's reference sample. (RT 1776-1782, 1813) All items of evidence were delivered to Technical Associates, the defense-appointed laboratory, for retesting in August, 2003. (RT 1817-1819)

Bockrath analyzed evidence from Doe #6: single source male DNA was extracted from the item listed as a carpet stain, and matched to appellant. The match frequency was one and 204 quintillion to 9.7 sextillion. (RT 1783-1788, 1790, 1792, 1809, 1820, 1822-1825) Mixed source DNA was extracted from the vaginal swab samples and another carpet sample; Bockrath examined the analyses results: appellant was not excluded as a donor, though no match frequencies were calculated. (RT 1792-1794, 1842-1843)

Bockrath analyzed the Doe #7 right shoulder sample was a female sample, the breast samples were mixed male-female samples, and a male donor profile was generated based on comparison of Doe #7's profile to those mixtures. Appellant was identified as the major donor of the breast swab samples; the match frequencies were one in 204 quintillion to 9.7 sextillion. The laboratory does not consider this a mixed sample because the male sample is extracted. (RT 1794-1798, 1843-1847, 1854-1861) Bockrath testified an exclusion is defined as "the absence of information showing the individual is present in the sample entirely." (RT 1850)

A male donor was detected in the Doe #11 vaginal swab sample, appellant identified as the donor, and the match frequency calculated at one in 204 quintillion to 9.7 sextillion. The female DNA was the victim's. Blood stain samples were taken from a sock and pillowcase, mixtures detected, and appellant identified as a potential donor. No match statistics were calculated. (RT 1798-1801) The Doe #13 nail cuttings, finger swabs, and pajama bottom and top blood stain samples were screened: a single-source male donor profile was generated from the pajama bottom blood stain sample, matching appellant at a frequency of one in 204 quintillion to 9.7

sextillion. The other samples were analyzed; appellant was not excluded as a donor in any of them. Bockrath did not write the Doe #13 report; if he had, he would have excluded appellant as not all of the genetic markers are present: from the palm sample, appellant is a 28, 31 at D-21, and the sample shows a 30. Four loci have no information; there are multiple interpretations of the sample inconsistent with appellant. (RT 1801-1804, 1848-1853) Four latex gloves, one pair inside another, from the Doe #14 case were screened, and a single source profile generated from the index finger blood stain sample on one glove which matched appellant. A middle finger blood stain sample on another glove matched Doe #14. Bockrath did not know which hand either glove came from; the gloves were also generally swabbed and tested, and mixed source samples found: it is a possibility that in swabbing the gloves, the mixture was created. (RT 1805-1807, 1825-1829)

The laboratory generally does not calculate match statistics from mixtures, though TWGDAM guidelines recommends doing so. (RT 1845-1846) All calculations were done using the FBI database. (RT 1808-1809) The Doe #6 sample was used as the male donor profile sample for comparison purposes. Bockrath did not report a male donor profile, or a statistical report, in the Doe #6 case until after looking at data from the Doe #7 case. (RT 1856-1861)

Defense Case
DNA Evidence
Dr. Elizabeth Johnson

Dr. Elizabeth Johnson is a consultant in forensic biology/forensic DNA; she has worked in forensics for thirteen years, including as a senior forensic scientist at Technical Associates, a private laboratory, and as director of the Harris County Medical Examiner's DNA laboratory in Houston, Texas. Dr. Johnson has a B.S. in chemistry from Wallford College, and a Ph.D. in immunology from the Medical University of South Carolina, and did four years post-graduate work in molecular biology/gene expression. She has performed many thousands of DNA tests, and is familiar with the various PCR/STR tests used in appellant's case. Dr. Johnson is a member of the American Academy of Forensic Sciences, and regularly attends national meetings of DNA scientists and the Promega international symposium. (RT 1889-1892) Dr. Johnson did not review the testing in appellant's case. (RT 1892)

Dr. Johnson explained the basic double helix structure of DNA, its inherited composition, and how DNA tests sample genetic regions, which are composed out of a few thousand base pairs from the three billion base pairs which make up one person's entire DNA strand. Most of the DNA molecule is the same among individuals; those small regions of variance is what forensics examines. DNA from the same gene pool is even more similar. DNA is located in the cell nucleus; dead cells have no nucleus, and red blood cells no nucleus containing DNA. (RT 1892-1895) PCR is a method of DNA copying: the two-strand DNA molecule is unzipped, a chemical introduced which binds to each strand, this strand copied by a thermocycler, and the process repeated until the sample amount of DNA is multiplied billions of times, enabling testing. A laboratory can use as few as ten to twenty cells to detect DNA: this low detection level makes the system very sensitive to contamination, especially contamination by other evidence, either in the laboratory or at the crime scene. (RT 1895-1897) STR refers to the repetition of base codes in sequence, which shows up in DNA charts as a peak, measured by the number of times the sequence is repeated. There is a difference between length and sequence, so someone could have the same length or number of repeats, but in a different order than another person; this is not detected by Profiler Plus/CoFiler or Identifiler. (RT 1897-1900)

No one knows what causes stutter: as the polymerase copies the strand Stutter is an artifactual peak, but the only way of knowing a particular peak is an artifact is if there is a single source sample which can be used as a reference sample. If it is not an artifact, then a mixture is indicated. There are guidelines based on validation studies used in determining stutter, such as peak height that is ten percent of a primary peak. As primary peaks get higher, more stutter is expected. (RT 1900-1903) Mixtures are preliminarily detected by the presence of more than two peaks at any locus; once a mixture is determined, stutter needs to be identified. A minimum of two contributors to the mix can be assumed, but there can be no certain maximum. It is usually safe to assume an intimate sample will contain DNA from the person it was collected from, but this does not mean that profile should be subtracted out to see what remains. Depending on the relative contributions to the mixture, it may not be possible to subtract one donor type: a 50/50 or 70/30 mix will not produce enough difference in peak height to warrant assigning peaks to a particular profile which can then be subtracted. The best way to deduce mixture profiles is to analyze them in the absence of a reference sample, as

such samples lead to examiner bias: it is "very easy" for an analyst, knowing the reference profile, to read that profile into the evidence. Potentially correct interpretations are discarded in favor of identifying the victim or suspect profile. (RT 1904-1909)

The practice of designating major/minor profiles varies between laboratories; the notion someone cannot be excluded as a contributor simply means the analyst cannot tell if the person is included in the mixture, though there are indications against inclusion. (RT 1909-1911) Nor can profiles be accurately deduced from three- or four-allele mixture locus, even taken from an intimate source sample: if, for example, the sample was 7, 8, 9, and victim a 7, 9, the perpetrator could be any combination including an 8: 7, 8 or 8, 8 or 8, 9. If there was a suspect who was a 8, 9, you would not be able to tell if that suspect was really the perpetrator. If the sample showed four alleles not drastically different in height, it would be impossible to tell which pairs went together: if there was a 10, 11, 12, and 13, it could be 10, 11 and 12, 13, or 10, 13 and 11, 12. Peak height is not an indication that alleles are pairs because as DNA is amplified, the predicted ratio of equal peaks falls apart, creating peak imbalance. This is sometimes due to one allele amplifying more efficiently than another, sometimes due to genetic mutation. (RT 1913-1916)

In one mixture interpretation study by Margaret Klein of the National Institute of Standards and Technology, which produces standard reference material for DNA testing and controls, mixed source samples were sent to forty-five different laboratories, and various interpretive errors reported; another mixture interpretation error study was done by Drs. Carl Ladd and Henry Lee, both reputable forensic scientists with the Connecticut State Police Crime Laboratory, published in the Croatian Medical Journal, and one published at the American Academy meeting. The Orange County crime laboratory was one of the study participants. (RT 1919-1923) Laboratory errors, such as incidents of contamination, are published via conference posters/presentations and inter-laboratory discovery throughout the forensic community so such errors can be recognized and avoided by other laboratories. Some errors are impossible to detect, including errors which are not reviewable by an overseer because they do not appear in the laboratory reports, such as mislabeling or sample switching, and errors due to prior contamination of evidence, as when a lab tests evidence contaminated at a crime scene, or retests evidence contaminated at another lab. Contamination may be present even if the blank is not contaminated; evidence been contaminated by the presence of other

evidence a week earlier. (RT 1938-1942) The Promega Conference poster concerned a thirteen-locus test in which unrelated donors matched at nine STR loci, and one allele at four remaining loci. The significance of this match was both donors were incarcerated in the Arizona prison system, meaning the involved database was relatively small, and the statistical probability of such a match remote – somewhere around one in seventy-five million. (Def. Exh. WW) A subsequent study found three more pairs of inmates who matched at nine loci; again, the statistical probability of this would be in the billions (the Hispanic match was one in 110 billion, another match one in 2.1 billion). The study demonstrates the gap between mathematical computations and reality, as well as suggesting a problem with the random match probability equation relative to a small database. (RT 1943-1951, 1956-1957) Following correct laboratory protocols does not necessarily lead to accurate separation of mixed samples. DNA evidence can be retested; Dr. Johnson did not retest the evidence in this case, or review reports relating to that evidence. (RT 1953-1955)

Dr. Laurence Mueller

Dr. Laurence Mueller is a professor in the Department of Ecology and Evolutionary Biology at the University of California, Irvine; his research focuses on population genetics and evolutionary biology. Population genetics studies the genetic variation within groups of individuals, and trying to understand the forces that cause different populations in different locations to become different, and why individual populations change relevant proportion of genetic variations over time. Forensic DNA typing uses principles and techniques from molecular genetics with regard to extraction, typing and comparison of DNA samples, and tools of population genetics to understand the statistical chance of another random person sharing that genetic pattern, or the value of the match. (RT 1976-1977) Dr. Mueller received his B.S. in chemistry and a master's degree in biology from Stanford University, and a Ph.D. in ecology from the University of California, Davis; he is a member of the Society for the Study of Evolution and the Ecological Society of America. Among Dr. Mueller's publications are two chapters in books on forensic DNA typing, one in an ecological theory book, around seventy-five articles in peer-reviewed journals, five in the area of population genetics and statistics; he is editor of the journal Population Ecology, and reviews publications for approximately two dozen journals, including Science Proceedings of the National Academy of Sciences and Genetics, American Journal of Human Genetics, Genetica,

and Theoretical Population Biology, and has acted as a study evaluator for a number of granting agencies, including the National Institute of Health and the National Science Foundation. He was invited to both National Research Councils to speak on DNA typing, has testified as an expert in forensic DNA statistical and interpretation analysis over one hundred times. As a population geneticist, Dr. Mueller uses the same sort of calculations and statistics used in forensic DNA analysis. (RT 1978-1982)

Dr. Mueller was familiar with DQ Alpha Polymarker, Profiler Plus and CoFiler kits. He reviewed the reports on the evidentiary samples from the three testing laboratories, including supporting documents indicating how calculations were performed, proficiency tests and laboratory protocols contained in the laboratory manuals. He did not examine the electropherograms. The focal point of Dr. Mueller's review was to see if proper statistics were calculated based on the samples as analyzed by each laboratory. Laboratories should establish formal criteria for determining allelic matches because those criteria will be relied upon in assigning reliable match statistics(RT 1982-1987)

None of the crime laboratories in this case had protocol which would provide sufficient detail for analyzing mixtures to prescribe match criteria in all cases. A mixed sample definitionally contains at least two people; there is no definitive way for telling what the maximum number of contributors could be, given the possibility of allelic overlap There are several proposed calculations other than random match probability for generating a statistic that would account for all possible mix contributors, each proposal assuming that all alleles appear in the mixed sample. (RT 1987-1990) In appellant's case, a number of genetic markers indicated at least two alleles in were known to be mixed samples. The difficulty then lies in determining which allele or combination of alleles came from which person: each person might have two copies of different alleles, though usually there is overlap. For example, if a mixed sample shows a 16, 17, and the victim is a 16, 17, then the other donor could be a 16, 16, or a 17, 17, or a 16, 17: statistically, all possible types, including the victim's, would have to be included. It is not scientifically valid to pick out major and minor profiles in a forensic setting and perform a statistical analysis of either profile in isolation because of the high error rate: mistakes are made in identifying minor donors up to 30% of the time, and the certainty of the analyst in the accuracy of the test is not an indicator of the actual accuracy of the test. (RT 1990-1993)

None of the testing laboratories performed accurate calculations in appellant's case: the match definition used by SERI was not sufficiently precise to allow an unambiguous definition of what constitutes inclusion. OCSD has the same problem, as demonstrated by samples where analysts use "novel" match criteria, applied inconsistently in the statistical analysis. For example, in the Doe #12 case, the VWA locus did not have a recognizable allele that appellant has; the normal genetic definition of a match is that all of a person's alleles, i.e., his entire genetic profile, must be present in the evidence sample. The OCSD analyst continued to include appellant as a possible contributor even though one of his alleles was not present; the statistical modification the laboratory then used was improper because it did not modify the equation for all genetic markers. If a more flexible definition for a match is to be used, it must be used at all loci, not just those needed to match a particular defendant. Additionally, the x-factor equation used did not account for all possible types which the laboratory might call inclusions: if the sample was 15, 16, and appellant was 14, 16, and was not excluded though the 14 allele could not be reliably counted, a consistent statistical approach would be to also include 15, 14, or 15, x in the overall calculation. Failing to do this renders the match statistic too rare. (RT 1993-1998) Allelic overlap is expected in mixtures because human beings share a great deal of genetic information, and some alleles tested are quite common. The LASD laboratory did not generate statistics for the mixed samples, which is inappropriate in a court case. Simply indicating there are two genetic samples and that a defendant can't be excluded as a possible donor is not helpful unless there is some indication how many other people might be excluded. The existence of a single source sample does not affect the statistical inadequacy because each sample must be analyzed separately: single source samples don't ameliorate mixed sample issues. Dr. Mueller did not recall the LASD laboratory having a written protocol to the effect that statistics should only be calculated for single source samples. Some other laboratories will extract a minor donor profile and assign a statistical significance, though there is a laboratory in Connecticut which refuses to do such calculations because they cannot be done reliably. (RT 1998-2000)

The nine-loci match phenomenon implies that other small database calculations are not necessarily as reliable as previously thought, and that in interpreting DNA patterns, analysts must look at each locus individually and not be swayed by previously matching loci. There is nothing in thirteen-loci

testing that would make it more immune to the same sorts of discoveries. (RT 2000-2003) Error rates, or false positive matches, can be calculated for forensic laboratories based on proficiency testing conducted by an outside agency. Dr. Coleman's statement that the LASD lab had a zero error rate was inaccurate because it did not reflect how error rates are computed: the zero needs to be a zero of another number. As zero usually means less than one, the laboratory would have to indicate whether it was less than one in one hundred, or less than one in a quadrillion. For a lab error rate to be wholly negligible, it would have to be less than one in a quadrillion. This would give the correct confidence interval (e.g., 99% accuracy) for the type of proficiency test done. (RT 2003-2006)

According to standard statistical calculations, the LASD analysts could have made 360 errors in their proficiency tests; none were made, leading to a confidence interval of 95% that there are fewer than one error in 120 chances, or samples tested. For the Orange County laboratory, there was a 95% certainty the error rate was less than one in 89 samples tested. For Tom Fedor at SERI, approximately one in 68, as there was one false match made: the exact error rate could be as high as one in 13 or as low as one in 2700.[31] For court purposes, the type of error is less significant than the fact of error, and the error rates here are typical of the industry. An error rate of one-in-hundreds/thousands of tests affects the random match probability statistic insofar as that statistic may be a product of either computational error (someone other than the defendant was the donor) or technical error (the samples were erroneously processed/interpreted). False matches are rare, but do occur. The random match probability statistic does not mean there is only one person in 844 septillion who has this profile, but rather reflects the chance that an unrelated person randomly selected from the population would share this profile. (RT 2006-2012) NRCII rejected the combination of error rate with match probabilities, and recommended retesting as the best error protection. Dr. Mueller did not combine the error rate with the match probability, but rather calculated them separately and indicated the relationship between the two numbers needed to be considered in context. NRC recommendations are followed to varying degrees by the forensic

---

31 Dr. Mueller analogized the error rates shown by periodic proficiency tests to a batter who gets a hit at each of his first ten at bats: he is batting a thousand, but the more games played, protection statistics (and real-life experience) demonstrate his batting average will drop. (RT 2013, 2020-2022)

community; a number of reputable forensic scientists disagree with NRCII about error rate calculation. (RT 2012-2014, 2017-2020)

Based on the analysts' interpretation of the evidentiary samples, the Doe #2 right buttocks sperm, Doe #6 carpet stain, Doe #8 vaginal swab sperm, Doe #11 vaginal swab/male fraction, Doe #13 pajama blood stain, and Doe #14 index finger blood stain samples provided matched appellant's reference sample. The random match probability calculation on the Doe #14 sample was accurate using the standard formula and data base. (RT 2014-2017) These matches, and their statistical significance, do not alter the importance of either lab error rates or the protocol for interpreting mixtures. (RT 2022)

Non-DNA evidence

The sexual assault nurse examiner who examined Doe #14 on November 7, 2002, prepared a report based on that examination and on the police officer's contemporaneous interview with Doe #14. (RT 1967-1970) At that time, Doe #14 described her attacker as a thirty-year- old Hispanic male, and said she'd locked herself in the bathroom, he'd kicked the door in, and they'd struggled: she bit the knuckle of his index finger and kicked him. Doe #14 also said when she tried to escape out the bathroom window, she saw her attacker's face there. Doe #14 told the officer and the nurse that during the assault, she kept trying to turn and see what the assailant looked like. Doe #14 described the man as wearing a black shirt tied over his head, and black pants. (RT 1970-1975)

The officer who swabbed appellant when he was detained on November 7, 2002 told appellant he was being swabbed because of sexual assaults in the Long Beach area: appellant was cooperative, signing a consent form after it was read to him. There were two other men in the area also interviewed by police that evening. (RT 2034-2039) Appellant did not attempt to flee the area during his surveillance. (RT 2040-2041)

It was stipulated Doe #9 told police her attacker was a man, 5'6" to 5'7", 160 to 170 pounds, dark hair, "muscular," with a thin build, "very powerful." She described his hair as "a bird's nest with a part in the center of his head, and the rest combed back." (RT 2042) It was also stipulated that when police asked Doe #10 if she had been sexually assaulted, she said no. (RT 2042-2043)

Detective Kriskovic testified that the protocol for responding to a sexual assault report includes a forensic team going to the scene, looking for

trace samples at the relevant locations, such as fibers and hairs, and dusting for fingerprints. Any other items which might contain evidentiary material might be collected and sent to the laboratory for further examination. (RT 2043-2051) The laboratory return on the Doe #1 case indicates hairs and fibers were collected from her clothing; in each of the charged cases, this sort of evidence would be sought. Nothing like this was introduced. Depending on the case, either members of the Long Beach police or the Los Angeles Sheriff's Department would be responsible for collecting and preserving such evidence. Two locations linked to appellant were searched, and 83 oral swabs taken from other possible suspects, one of whom had the same name as appellant. According to the reports received by the detective, those suspects were excluded. (RT 2051-2056)

CPSIA information can be obtained at www.ICGtesting.com
Printed in the USA
BVOW08s1618160114

341909BV00002B/5/P